D1156151

The Illustrated Dictionary of

HINDU ICONOGRAPHY

Other books by the same author
A Dictionary of Hinduism
Ancient Indian Magic and Folklore

The Illustrated Dictionary of

HINDU ICONOGRAPHY

Margaret Stutley

Routledge & Kegan Paul
London, Boston, Melbourne and Henley

First published in 1985
by Routledge & Kegan Paul plc

14 Leicester Square, London WC2H 7PH

9 Park Street, Boston, Mass. 02108, USA

464 St Kilda Road, Melbourne,
Victoria 3004, Australia and

Broadway House, Newtown Road,
Henley-on-Thames, Oxon RG9 1EN, England

Set in Linotron Times
by Input Typesetting Ltd, London
and printed in Great Britain
by Billing & Sons Ltd, Worcester

© Margaret Stutley 1985

No part of this book may be reproduced
in any form without permission from
the publisher, except for the quotation of
brief passages in criticism

Library of Congress Cataloging in Publication Data

Stutley, Margaret, 1917–

An illustrated dictionary of Hindu iconography.
Bibliography: p.
1. Gods, Hindu, in art—Directories. 2. Art, Hindu—Dictionaries.
3. Hinduism—Dictionaries. 4. Hindu symbolism—Dictionaries.
I. Title.
N8195.A4S78 1984 704.9'48945'0321 84–6861

British Library CIP data also available

ISBN 0-7100-9294-6

Contents

Ref.
N
8195
.A4
S78
1985

In memory of my husband

1892–1980

DABNEY LANCASTER LIBRARY
LONGWOOD COLLEGE
FARMVILLE, VIRGINIA 23901

Introduction

Iconography means literally 'writing in images' which is a means of understanding the religious, philosophical, symbolical and mythological aspects of a religion, in this case the aggregate of cults, sects and philosophies known in the West as Hinduism. Lack of knowledge concerning Indian iconography is one reason why Indian art has seldom been fully appreciated in the Occident. Another is that Europeans today do not regard images and symbols as vehicles of spiritual truths, but as means of self-expression, or for emotional, sensational, intellectual or aesthetic satisfaction. But once the limiting effect of national and individual taste has been overcome, Indian art, and indeed all Oriental art, opens out new vistas of interest and thought.

The simplest to the most sophisticated art exists side by side in India, but its extent and profundity is not fully realized even by Indians themselves. It is only now that India's enormous range of superb folk arts is being appreciated and studied.

No sacred art can be termed ugly, grotesque, exotic or unnatural when seen and understood from the viewpoint of its own cultural environment, and with the necessary 'key' to unlock its symbolism. Thus a person having no knowledge of Christianity would be unable to comprehend the symbolism of a cross with a dead man nailed to it, yet to a Christian it is immediately significant.

The iconography of the subcontinent stems from prehistoric times, but our knowledge of it commences with the archaeological discoveries in the Indus Valley in north-west India, where a number of seals have been unearthed, one of which portrays a horned human figure, seated in a yogic position, which some Indologists have assumed to be an early prototype of Śiva. Other seals depict beautifully executed animal figures, and some portray deities standing under boughs or tree arches – a motif from which derived the aureole (*prabhāmaṇḍala*), with its stereotyped leaves or flames. Lannoy[1] points out that the style of prehistoric Indian art 'has remained a part of a living tradition for 7,000 years', and that the 'neolithic tribal rock-paintings of central India bear a close resemblance to the "dream murals" of the Saora tribe in Orissa and to the folk murals with which houses are commonly decorated in many regions today'.

The *Ṛgveda* (*c.* 1500 BC) contains the germ of future iconography in its descriptions of the Vedic deities. Later the *Purāṇas*, *Mahābhārata*, *Rāmāyaṇa* and other texts added further details. Gradually this mass of material was systematized by the priests and image-makers, but was attributed to mythical sages including Bhṛgu, Atri, Vasiṣṭha, Kaśyapa and others to make the texts more authoritative in the eyes of the laity. However, despite the rules laid down in iconographical texts there were regional differences in the treatment of images. Furthermore, the artist-craftsmen did not all follow the same texts, or they followed texts

which are no longer extant: therefore a number of icons do not conform entirely to the rules.

The measurements for every part of the body were laid down in the *Śilpa Śāstras*:[2]

> The reason for this lies in a special characteristic of Indian thought which denies any reality to change and individuality. Ideal forms and recurring patterns of events are more real and important than continuity or any individual event. Time and change are condensed into closed spatial ideas. A splendid visual example of this is the way the many arms of the dancing Śiva seem to sum up in the one image a whole series of postures. Every sphere of thought . . . is dominated by the concept of perfect pattern types.

The artist-craftsmen themselves frequently used yogic techniques to visualize the ideal appearance of each deity to be portrayed.

The people of the Indus Valley civilization produced well-designed moulded ornaments of gold and silver, but by far the largest finds consist of variously shaped beads fashioned from a variety of materials including agate, carnelian, chalcedony, felspar, shell, steatite, faience and pottery. The nine auspicious gems (*navaratna*) are the ruby, diamond, pearl, coral, sapphire, emerald, topaz, cat's eye, and jacinth which, when set in a single ornament, were believed to protect the wearer, and attract to him beneficent planetary influences. It was, and is customary for both men and women to wear jewellery, and this love of adornment continued throughout the centuries.

Unfortunately there is a gap of about a thousand years from the end of the Indus Valley civilization (*c.* 1750 BC) to the beginning of the Mauryan Empire (3rd century BC) during which practically nothing of artistic importance has been discovered, although doubtless there would have been wooden carvings and buildings soon destroyed by the rigours of the Indian climate, or by the nomadic invaders who had no need of houses or temples, and who were culturally much inferior to the Indus Valley people.

Indian paintings, images, or composite figures are 'pictures' of the many aspects of religious belief and function as 'aids' to meditation and the comprehension of spiritual truths by the worshipper according to his level of understanding. Thus an image is intended primarily to express certain ideas, rather than to portray the likeness of any earthly thing. It is 'a visual symbolism, ideal in the mathematical sense'.[3] Most Hindu art was initially intended to remind the illiterate laity of religious truths and sacred stories, as were the painted frescoes in Christian churches in the Middle Ages.

An icon should be regarded as a reflected image or shadow of the Supreme Being (that is, in the philosophical sense, the Absolute), which is necessarily without form or attributes (*nirguṇa*), but few people are able to worship an abstraction, therefore the godhead was conceived of as a Being with attributes (*saguṇa*), the creator, preserver and destroyer of the cosmos.

All deities are envisaged under a number of aspects and forms which bear different names, emblems and symbols. Thus Śiva as the Cosmic Dancer is called Naṭarāja, as the Supreme God Mahādeva, as the destroyer of the Triple City, Tripurāntaka, and so on. The gentle

and benign aspect of his consort is called Pārvatī, as the gracious corn-goddess she is Gaurī, and as the terror of Time that destroys all creatures and things, Kālī.

Every deity has its own symbolic geometrical diagram (*yantra*), sound-form (*mantra*), and icon. All parts of an image have significance: the pedestal, position of the body, limbs and hands, the ornaments, crowns, garments, attributes, emblems, weapons, as well as the accompanying minor divinities, animals, birds, fish, trees, plants and flowers. As the universe is divinely created everything in it must be worthy of worship, and hence forests, mountains, rivers and constellations serve as the chief 'temple' of the Hindu, whereas ordinary temples are places where a specific aspect of deity is honoured with offerings of flowers, incense and water, an element that pervades all life. The cult of images allows the devotee to focus on, and worship, the invisible through the visible, 'to look behind the gods for the Absolute One, the Unnameable Integration'.[4]

The jewellery and garments of deities generally speaking, reflect those worn by the upper classes in whichever part of India the image was made. Garments are also an indication of status – thus Skanda the god of war wears military garb. Viṣṇu, Indra and Kubera who represent ideal kingship wear elaborate royal crowns, robes and ornaments, while Śiva, Brahmā and Agni, who represent the ideal ascetic, wear the scanty garments of *yogins*. Most goddesses are portrayed wearing the fine draperies and jewels of the upper classes. Similarly, the conception of the divine celestial worlds of the gods, with their musicians, dancers and attendants, is based on the medieval Courts, and reflects the taste of the rulers under whose auspices the temples were erected.

Many of the oldest jewellery designs continue to be reproduced in base metals by Indian peasant craftsmen, whereas the jewellery of the upper classes was much influenced by foreign, and changing, fashions. The striking similarity between Sumerian, Babylonian, Egyptian, Etruscan and Indian jewellery is due to the fact that all the main cities of the ancient world were connected by overland and sea routes along which a variety of merchandise travelled from country to country.

Plinths or pedestals were a convention devised to elevate the image above the transitory world of mankind, and to indicate what the deity portrayed was supposed to be doing. Thus a triangular pedestal should be used when the god is witnessing amusements; a rectangular lion-seat (*siṃhāsana*) when being bathed; an octagonal seat (*yogāsana*) during invocation; a circular lotus seat (*padmāsana*) during meditation; and a hexagonal 'pure seat' (*vimalāsana*) when offerings are made.[5] Even the three varieties of sculptural reliefs have significance; high relief conduces to spirituality, success, enjoyment, liberation, and to all good things; moderate relief to enjoyment and liberation; and low relief to material success, pleasure, and sensuous enjoyment. The different horizontal levels of a composition also have meaning: the lower level may represent the underworld, the next the earth, the upper the celestial world; or the lower level denotes the earth, the next the atmosphere, and the top the heavenly worlds.

Exquisite animals, birds and luxuriant plant life are portrayed frequently in sculptures and paintings, both for their beauty of form and symbolism, and as manifestations of the cosmic life-force existent in every form. These beautiful representations show that the Indian

artist-craftsmen, like the ancient Egyptians, were able to reproduce naturalistic forms as well as the 'artificial' figures of divinities required by theological considerations.

Many deities are portrayed with a multiplicity of arms and heads to distinguish them from human beings and to suggest a transcendent mode of being, far above that of ordinary life. They also indicate the immense potential of the Divine.[6] It follows from this that human sages, *ṛṣis* and heroes are depicted with two arms only. The 'creator' Brahmā is shown with four heads, each facing a different direction, to indicate that he is all-seeing and all-knowing. Knowledge is also symbolized by the snow-white wild goose which is his mount, a bird signifying the 'One Spirit', the cosmic life-force pervading the earth, the waters, atmosphere and the heavens, for the goose is at home in all these regions. Its whiteness denotes purity, and its graceful, lofty flight is likened to the spiritual efforts of the devout Hindu to attain *brahman*.

Multi-headed deities can be interpreted in a number of ways. Some have their origin in mythological stories; or in the inner visualizations of *yogins* during meditation; or they represent an amalgamation of particular elemental powers, as in the case of the five-faced Śiva; or signify a part of the god's essence; or indicate diverse mythological exploits performed simultaneously by the deity concerned.

Some composite images such as that of Hari-Hara-Pitāmaha represent the triad of Viṣṇu (Hari), Śiva (Hara), and Brahmā (Pitāmaha) which indicates a 'syncretism' of the three cults. The androgynous figure of the Goddess (Devī) and Śiva (Ardhanārīśvara), suggests an amalgamation of the Mother-goddess and Śaiva cults.

The sacred emblems and symbols associated with deities function as 'conductors' between the icon and its underlying idea. Increasing knowledge of symbols results in ever enlarging and evolving spheres of meaning because every symbol can be interpreted from various points of view and levels of reference. Both emblems and symbols are believed to have affinities with the divine and therefore may themselves be objects of worship, but they, like images, remain mundane objects until rendered sacred by means of ritual.

A symbol may mean different things to different people. In fact it can represent anything the observer thinks, or decides, it should mean. This can be clearly seen in the swastika, which for thousands of years in the East has been a solar symbol, a sign of life, good fortune and happiness. It is worn as an amulet and also placed on cattle, horses and other livestock to protect them from harm, especially from the baneful effects of the Evil Eye. Even in Europe it was long regarded as a luck-bringer and was depicted on the National Savings books issued during the First World War, and miniature swastikas were often included among the auspicious objects suspended from charm bracelets, but after Hitler adopted it as the symbol of the Nazi party, it became in the West a symbol of genocide, hatred and cruelty.

Colours also play a part in symbolism, and may denote the three *guṇas*, which when variously combined, determine the characteristic quality of every person and thing. White expresses the *sattva guṇa*, the quality of light, truth, knowledge, intellect, and the glorious side of life; black represents the *tamas guṇa* the principle of passivity, inertia, negation, darkness, and the fearsome aspect of life; and red the *rajas guṇa* which is creative, active and expanding.

Apart from images, natural objects are also venerated, such as the *śālagrāma* stones – the fossilized shells of an extinct species of mollusc, which Vaiṣṇavas regard as being permeated with the very essence of Viṣṇu, thereby indicating his omnipotence and capacity to assume any and every form, but *śālagrāmas* should be worshipped only if no image of Viṣṇu is available. To Śaivas the *liṅga* of Śiva is represented by the white stones (*bāṇa-liṅga*) found in the Narmadā river, while Śāktas, who regard the godhead as the Great Mother, may worship her in almost any object including a book, stone, sex emblem, water, icon or *yantra*, for she represents universal energy, and hence she is worshipped in objects, but the objects themselves are not worshipped.

Indians have never believed that any one religious system is suitable for all time and for all men – a fact confirmed by the teaching concerning *karma* which maintains that individuals vary enormously in their physical and emotional make-up as well as in their mental, moral and spiritual capacities. Therefore each individual, being at a different stage of development, requires a particular method or way suited to his level of understanding.

The godhead is conceived of as an abstract Supreme Spirit, and therefore no eternal, external purpose, or limiting First Cause, is superimposed on the natural dynamic world process. Man is part of Nature and not apart from it as in the teaching of the Semitic religions. Therefore all representations of natural forms, whether of insect, bird, animal or plant, are no less important and detailed than that of man, for each has its place in the cosmos.

Aesthetics have never been given a separate independent value in India 'as only in the tremendous Summum is all perfection invested'.[7] Instead the underlying harmony of unity behind multiplicity is striven for. No false distinctions are made between art (for which there is no Sanskrit term) and craftsmanship, since for thousands of years every skilled craftsman produced objects which were both beautiful and functional – a tradition which has lasted longer in Asia than elsewhere. Today in Europe and America the combination of beauty of line and function is found mainly in the work of engineers, in fine ships, harbours, bridges, dams, 'planes, and similar works. All these forms are governed by scientific principles and functional necessity. Coomaraswamy, quoted in Anand (1957),[8] long ago pointed out the Western indifference to real values which 'is reflected in the current distinction of Fine and Decorative art, it being required that the first shall have no use, the second no meaning'.

Deities are represented in gentle and in terrifying aspects to reflect the dualism of the terrestrial world. Thus Śiva on the one hand embodies sexuality, fertility, and the abundance of Nature, but on the other he represents the 'great ascetic' whose sexual passions are completely sublimated.

The rich profusion of divinities, godlings, myths, emblems, and symbols in the Hindu tradition arises primarily because it is not one religious system with a fixed canon of belief, but an amalgamation of magico-religious teachings, cults, sects, philosophies, tribal and folk beliefs, which constitute a way of life and the basis of the social system. Its very complexity illustrates man's diverse views of the Divine which range from the simplest to the most sophisticated. This immensely complex conception of divinity contains strands from three originally separate religious traditions: the Dravidian, Aryan and aboriginal. The Dravidians

were in India before the third millennium BC and were agriculturists whose gods were connected with the deified Earth. The successive waves of Aryans entered India from the north-west from the second millennium onwards. They possessed horses and probably iron weapons which enabled them to subdue the Dravidians who had neither, but gradually the old Dravidian deities reappeared and many were assimilated into the Hindu 'pantheon'. With the mergence of these three traditions a number of archaic, primitive, ambiguous, sublime, and contradictory conceptions were retained, yet again this very diversity emphasizes the countless aspects of the Divine and the many 'ways' to liberation. None the less the underlying unity of the Supreme Spirit behind all transitory forms was never lost sight of. Thus in the words of Kṛṣṇa: 'Howsoever men approach Me, so do I welcome them, for the path men take from every side is Mine.'

Notes

1 Lannoy, *The Speaking Tree*, p. 5.
2 Rawson, *Indian Sculpture*, p. 114.
3 Coomaraswamy, *The Transference of Nature*, p. 28.
4 Organ, *The Hindu Quest*, p. 112; and see *Maitri Upaniṣad*, 4, 6.
5 *EHI* I, pt i, p. 20.
6 Hocart, *Acta Orientalia*, vol. vii, pp. 91ff., 1929; and *EHI* I, pt i, p. 27, state that the number of hands represents the number of attributes of the individual deity.
7 *Facets*, p. 155.
8 Anand, *The Hindu View of Art*, pp. 109f., Appendix I.

English subjects and Sanskrit equivalents

Activities, the five	Pañcakriyā
Age, the first (the Golden Age)	Satya II
Ages, of the world	Yuga; Kali II; Kalpa; Manvantara
Alloy for bronze casting	Aṣṭadhātu
Alloys, the	Pañcaloha
Alms-bowl	Bhikṣāpātra
Altar	Vedi
upper part of	Uttaravedi
Altar stone, for offerings	Balipīṭha
Ambrosia	Amṛta
vessel	Amṛtaghaṭa
Amulet	Rakṣā; Kavaca I
of kuśa grass	Pavitra
of pearl shell	Kṛśana
Ancestor	Pitā
Ancestors, sphere of	Pitṛloka
Animal, male	Vṛṣan
Animals	
Antelope, black	Kṛṣṇamṛga
Ass	Gardabha
Bitch of Indra	Saramā
Buffalo	Mahiṣa I
black	Ugra III
Bull of Śiva	Nandin
Camel	Uṣṭra
Cat	Mārjāra
Cattle	Paśu I
world of	Goloka
of abundance	Pṛśni I
presented to priest	Vaitaraṇī II
deer, golden	Hemamṛga
spotted	Kilāsī
Dog	Śvan
as mount	Śvāśva
Elephant	Gaja
Frog	Maṇḍūka
Gazelle	Hārin; Mṛga
Goat, ram	Aja; Chāga; Meṣa
Horse	Aśva: Haya
as symbol of knowledge	Haya
as symbol of military power	Aśvaratna

as symbol of potency	Vājin
miraculous	Kuvalaya
of the Maruts	Eta
of the sun	Etaśa
Ichneumon, mongoose	Nakula II
Iguana	Godhikā
Jackal	Śṛgāla
Lion	Siṁha
Lizard, chameleon	Saraṭa; Godhā
Mare	Vaḍabā
Monkey	Vānara
Ram	Meṣa
Rat	Mūṣa
Scorpion	Vṛścika
garland	Vṛścikamālā
Sheep	Avis
Snake	Nāga
Tortoise	Kūrma; Kacchapa; Akūpāra; Kaśyapa II
vehicle	Kūrmāsana II
Wolf	Vṛka
Animals, lord of	Prajāpati
Animals and birds, fabulous	Gajasiṁha; Gaja-virāla; Gajavṛṣabha; Gaṇḍabheruṇḍa; Garuḍa; Ihāmṛga; Jala-turaga; Jalebha; Kinnara(s); Mahāpāriṣada(s); Makara I; Mātaṅganakra; Nandinī; Narasiṁha; Pāriṣada(s); Pṛśni I; Śabala; Śarabha; Śārdūla; Sīsara; Sthauṇa-Narasiṁha; Sugrīva; Surabhi; Tārkṣya; Turaga; Uccaiḥśravas; Uraga I; Uṣṭrapāda; Vāsuki; Vyālaka; Yāḷi
Archer, stance of	Ālīḍhapada
Architect, sculptor	Sthapati
of universe	Viśvakarman
Architecture, treatise on	Mānasāra
Architecture, science of	Vāstuvidyā
Armlet	Aṅgada; Bāhuvalaya;
in snake form	Bhujaṅgavalaya; Keyūra; Sarpamastaka
Armour	Kavaca
Arms, four	Caturbhuja
Arms, ten	Daśabhuja
Arrow	Bāṇa; Śara
Arrows, the five, of Kāma	Pañcaśara
Art, practice of	Śilpa
Art treatise	Śilpaśāstra
Asceticism	Tapas
Ashes	Bhasman; Vibhūti II
bath of	Bhasmasnāna
Aspects of a deity	
mild	Saumya III
of Gaṇeśa	Santāna I
terrific	Ghora; Ugra I; Raudra
terrific, of Śiva	Ugra II
Atmosphere, region of	Bhuvarloka
Aureole, halo	Bhāmaṇḍala

of flames	Jvālamālā
large	Prabhāmaṇḍala
circular or oval	Prabhāvalī; Śiraścakra
makara shaped	Makaramukha
Bag, purse	Koṣa
Band	
round chest	Uras-sūtra
to support one leg	Ardhayogapaṭṭa
to support two legs	Yogapaṭṭa
broad	Udarabandha
Banner, flag	Dhvaja
of Arjuna	Kapidhvaja
of Balarāma	Tāladhvaja
of Indra	Vaijayanta
of Kāma	Makaradhvaja
of Śiva	Vṛṣabhadhvaja
of smoke	Dhūmaketu
Banyan, undying	Akṣayavaṭa
Battle array, personified	Senā
Bees, row of	Madhukara
Beings, mythical	Pāriṣada(s) (see also under Demons)
Bell	Ghaṇṭā
attached to leg	Bhṛṅgipāda
Bells, garland of	Ghaṇṭamālā
garland of small	Kiṅkiṇī
Bird, aquatic	Cakravāka II
Birds	
Cock	Kukkuṭa
Crane	Bagalā I; Sārasa
Crow	Kāka
Dove	Kapota
Eagle, mythical	Suparṇa
or bird of prey	Śyena
Francoline partridge	Kapiñjala
Gander, goose, geese	Haṃsa I
frieze	Haṃsabandhana
highest	Paramahaṃsa
Heron	Baka
blue-necked	Nīlakaṇṭha II
Indian cuckoo	Kokila
Mynah	Sārikā
Owl	Ulūka
Parrot	Śuka
Peacock	Mayūra; Śikhin
feather	Mayūrapattra
of Kārttikeya	Paravāṇi
young	Śikhipota
Raven	Droṇakāka
Wagtail	Khañjana
Black, dark blue	Nīla I
Black elephant-demon	Nīla II
Boar, primeval	Ādivarāha
Boar form of Viṣṇu	Emūṣa; Varāhāvatāra

Body, positions of	Ābhaṅga; Ardhaparyaṅkāsana; Ardhasamasthānaka; Āsanamūrti; Atibhaṅga; Bhadrāsana II; Bhaṅga II; Bhujaṅgāsana; Dhanurāsana; Dhyānāsana; Dvibhaṅga; Garuḍāsana; Guptāsana; Halāsana; Kaṭisaṃsthita; Kukkuṭāsana; Lalitāsana; Mahārājalīlā; Maṇḍūkāsana; Muktāsana; Pādasvastika; Padma III; Paryaṅkāsana; Pralambapadāsana; Pratyālīḍhapada; Pretāsana II; Rājalīlāsana; Samapādasthānaka; Sarvaṅgāsana; Śavāsana; Siddhāsana; Sopāśrayāsana; Sthāṇu; Śukhāsana; Svastikāpasṛta; Tribhaṅga; Ugrāsana; Ūrusaṃsthitamudrā; Utkaṭāsana; Utkuṭikāsana; Vaiśākhāsana; Vajrāsana; Vīrāsana; Vīrasthānaka(mūrti); Vṛkṣāsana
Bone	Asthi
basket for bones	Asthimañjūṣā
having a necklace of	Asthimālin
***vajra** (thunderbolt) of*	Asthisambhava
Book, treatise, manuscript	Pustaka; Śāstra
in aphoristic style	Sūtra I
medical	Suśrutasaṃhitā
Bow	Cāpa; Dhanus
Indra's	Indracāpa; Indradhanus
Indra's magic	Vijaya I
magical	Gaṇḍiva
Śiva's	Ajagava II
Viṣṇu's	Śārṅga
Bowl	Pātra
as emblem of Earth-goddess	Sasyapātra
of medicinal herbs	Oṣadhipātra
sacrificial	Arghyapātra
Brahmās, the five	Pañcabrahmā(s)
Breast-band	Kucabandha
resembling a snake	Sarpakucabandha
Breath (see also Vital air)	Prāṇa
control of	Prāṇayāma
Burial or cremation place	Śmaśāna
Rudra's	Rudrākrīḍa
Butter, clarified	Ghṛta (Ghee)
Caste, class	Varṇa
Ceremony, to choose husband	Svayaṃbara
Chalice for libations	Arghā
Chariot	
magical	Puṣpaka
one-wheeled	Ekacakra
self-propelling	Vimāna I
of victory	Jaitraratha
Charioteer	Sūta I
Indra's	Mātali
Child	Bāla
Chisel, stonemason's	Taṅka
Churning of the ocean	Samudramathana
Circles, mystical, of the body	Cakra II

Circumambulation	Pradakṣiṇā
path	Pradakṣiṇā(patha)
Cities, the three	Tripura
burning of	Tripurāntakamūrti
goddess of	Tripurasundarī
City, golden, mythical	Hiraṇyapura
sacred	Ayodhyā
Clarified butter (ghee) vessel for	Ājyapātra
Club, mace, of Viṣṇu	Kaumodakī
Collyrium	Āñjana
Compiler, editor, arranger	Vyāsa
Concentration, meditation	Dhāraṇā; Dhyāna
last stage of	Samādhi
Conch, Kṛṣṇa's	Pāñcajanya
Consecration	Abhiṣeka
Corpse	Śava
as seat	Pretāsana I; Mṛtaka
-like posture	Śavāsana
Śiva as	Śiva-śava
Cow	
of plenty	Surabhi
symbol of earth	Dhenu
wish fulfilling	Kalmāṣī; Kāmadhenu
Cowherd	Gopāla
royal	Rājagopāla
Cowherdesses	Gopī(s)
Craftsman	Śilpin
of the gods	Tvaṣṭar
Craftsmen, divine	Ṛbhu(s)
Creases or lines on neck	Kambugrīva
Crown	Karaṇḍamakuṭa; Kirīṭamakuṭa
Cup	Caṣaka
skull-	Kapāla I
Dance	
art of	Nāṭyaveda
circular, of Kṛṣṇa	Rāsa
cosmic	Tāṇḍava
of destruction	Samhāratāṇḍava
of joy	Ānandatāṇḍava
lord of	Naṭarāja
Śiva's	Caturam; Caturatāṇḍava; Gajatāṇḍava; Karaṇa(hasta)mudrā; Kaṭisama; Kuṭṭita; Lalāṭatilakam; Lāsya; Nādānta; Talasaṃphoṭitam
of Śiva, pose of	Vaiṣṇavasthāna
stance	Nāṭyasthāna
well-known works	Bharatanāṭyaśāstra; Nāṭyaśāstra; Bhujaṅgatrāsitakaraṇa
twilight	Sandhyā(tāṇḍava)
of Umā and Śiva	Umā-tāṇḍava
Dancers, celestial	Cāraṇa(s)
Death, personification of	Mṛtyu
noose of	Mṛtyupāśa

English subjects and Sanskrit equivalents

Deities, thirty-three	Trāyastriṁśa
Deity	Deva; Devatā
chosen	Iṣṭadevatā
demigod	Vasu
female, protective	Yoginī II
folk	Vyantaradevatā(s); Yakṣa; Yakṣī
household, family	Gṛhadevatā; Kuladevatā(s); Kulanāyaka
human	Manuṣyaprakṛtideva(s)
intermediate	Sādhya
path of	Devāyatana
Deity, aspect of	
creative	Sakriya
peaceful	Śāntamūrti; Saumya III
reclining	Śayanamūrti
Delusion	Moha
Demigods	Kuṣmāṇḍā(s)
Demonesses	Grahī(s); Pūtanā; Śakunī; Yoginī I
Demons, demigods	Bhūta I; Asura(s) I and II; Bhairava II; Bhūtagaṇa; Daitya(s); Dānava(s); Kuṣmāṇḍās (see also Beings, mythical)
causing eclipses	Rāhu
dog	Sīsara
dwarf	Apasmāra
flesh-eating	Rākṣasa; Piśāca(s); Pramatha(s); Roga
lord of	Bhūtanātha; Bhūteśa
mother of	Bhūtamātā
of battle	Garuḍa(s); Graha I; Kabandha; Kumbhāṇḍa(s)
Devotees	Bhakta(s)
Devotion, adoration	Bhakti
Diagram, symbolic	Yantra; Bhūpura
container for	Yantrapātra
for meditation	Maṇḍala
	Nandyāvarta; Pañcakoṇa
of Viṣṇu	Viṣṇuyantra
Discipline	Sādhana
Divinities, minor	Āvaraṇadevatā(s)
Donation, gift	Dakṣiṇa II
Door (arch)	Toraṇa
Door (portal)	Dvāra
guardians of	Dvārapāla(s)
Dress	
northern style	Udīcyaveṣa
of deerskin	Upavīta I
Drum	
large	Ḍhakkā; Mṛdaṅga; Muraja
long	Mardala
pot-shaped	Ghaṭa
small	Ḍamaru; Huḍukka; Paṇava; Tablā
war	Dundubhi II; Kavaca II
Ear-ornament	Avataṁsa; Nakrakuṇḍala; Kuṇḍala
Earth, the	Bhūrloka
personified	Pṛthivī

Egg, Brahmā's	Brahmāṇḍa
Egg, cosmic	Hiraṇyagarbha
Elbow	Kūrpara
Elements, the	Bhūta II
Elements, primary	Tattva
Elephant, demon	Nīla II
Elephant	Gaja
goad	Aṅkuśa
mythical	Abhramū; Airāvaṇa; Diggaja
state	Kuvalayāpīḍa
vehicle	Gajavāhana
Enchantment, witchcraft	Kṛtyā
Engraving	Paṭṭa I
Essence, supreme	Paramātman
Exorcising aspect of gods	Abhicārikamūrti
Eyes, the three	Trilocana; Trinayana
Faces, one of the five, of Siva	Sandyojāta
Faces, six, of Skanda	Ṣaṇmukha; Śaravaṇabhava
Festival of Indra	Indramahotsava
of spring	Holākā
Fever	Jvara
Fire	Agni; Anala I and II
domestic	Gārhapatya
drill	Araṇi
essence of	Tejas
pit	Agnikuṇḍa
receptacle	Vahnikuṇḍa
sacred	Āhavanīya
	Anala II; Vahni
shovel	Dhṛṣṭi
southern	Dakṣiṇāgni
Fish	Matsya II; Mīna
pair of	Matsyayugma
Fish-eyed goddess	Mīnākṣī
Fixative for image	Aṣṭabandhana
Flavour, quintessence	Rasa
Flavour, aesthetic experience	Rasāvādana
Flesh, meat	Maṁsa
Flowers	
arrow of	Puṣpaśara
presentation of	Puṣpāñjali
rivers of	Puṣpodaka
wreath of	Puṣpapaṭṭa
Fly-whisk	Cāmara
Food, goddess of	Annapūrṇā
Food, sacrificial	Iḍā
Footprint	Pāduka
Footprints, the three-footed	Tripādaka
Footstool	Pādapīṭha
Form(s), shape(s)	Mūrti; Rūpa
destructive	Saṁharamūrti(s)
diversity of	Rūpabheda

own	Svarūpa
Fresco	Citrabhāsa
Fruit	Phala
Ganges, river	Gaṅgā
Garden, celestial	Caitravana
Garland	Mālā
long, of Viṣṇu	Vanamālā
of lotus eyes	Kamalākṣamālā
of skulls	Kapālamālā
of snakes	Sarpamālā
Garment	
long	Colaka
loincloth	Kaupīna
of muslin	Dukūla
pleated	Kaccha I and II
	Kañcuka
yellow, of Viṣṇu	Pītāmbara
Girdle, belt	Mekhalā; Avyaṅga
of gems	Ratnamekhalā
of sun-god	Yāvīyāṅga
	Kāñcīdāma
waistband	Kaṭibandha
Goat-faced	Chāgavaktra
Goat-headed	Ajamastaka
Goddess	Devī
Tutelary	Grāmadevatā
Goddesses, the Nine Durgās	Navadurgā(s)
Goodness, purity	Sāttvaguṇa
relating to	Sāttvika
Guardians	
the eight	Aṣṭadikpāla(s); Dikpāla(s)
female	Digdevī(s)
of temple	Vimānapāla
Guild	Śreṇi
Hair, hair style	Dhammilla
curls, crest of	Alaka-cūḍaka
curls, matted	Jaṭā; Jaṭābandha; Jaṭāmaṇḍala; Jaṭāmukuṭa
decoration of	Patrapaṭṭa
erect	Keśamaṇḍala; Ūrdhvakeśa; Jvālakeśa
crown like	Keśamakuṭa
of goddesses	Keśabandha
long	Keśa
one plait	Ekaveṇi; Veṇi
of Śiva	Kaparda
three thick loops	Śikhāṇḍaka
turban style	Śirastraka
Half-moon	Ardhacandra
Hammer	Mudgara
Hands, arms, positions of	Mudrā; Hasta; Abhayamudrā; Āñcitamudrā; Añjalimudrā; Arālamudrā; Ardhacandramudrā; Ardhāñjalimudrā; Ardhapatākāmudrā;

Āścaryamudrā; Āvāhanamudrā; Candrakāla;
Caturahastamudrā; Cinmudrā; Ḍamaruhasta;
Dānamudrā; Daṇḍahastamudrā; Dhenumudrā;
Dhyānahastamudrā; Gajahastamudrā; Haṃsamudrā;
Hastasvastika; Iṣṭapradāmudrā; Jñānamudrā;
Kartarīmudrā; Kaśyapamudrā; Kaṭaka;
Kaṭi(hasta)mudrā; Kūrmamudrā; Laṅgūlamudrā;
Lolahastamudrā; Mayūramudrā; Mukulamudrā;
Muṣṭimudrā; Nāgamudrā; Namaskāramudrā;
Netramudrā; Nidrātahastamudrā; Padmahasta;
Padmakośa; Patākāhastamudrā; Prasādamudrā;
Pravartitahasta; Samādhimudrā; Sāñjalimudrā;
Śuci(hasta)mudrā; Śukatuṇḍa; Surabhimudrā;
Svakucagrahamudrā; Svastika II; Tāmracūḍāmudrā;
Tarjanīmudrā; Tripāṭakā(hasta)mudrā;
Vandanamudrā; Varadamudrā; Vismayahasta;
Vitarkamudrā; Vyākhyānamudrā; Yonimudrā

Headed, five-	Pañcaśiras
three-	Triśiras I and II
Heaven, paradise	Svarga
lord of	Vaikuṇṭhanātha
of Viṣṇu	Vaikuṇṭha I
Hell	Naraka; Pātāla; Tala
Hermitage, Ashram	Āśrama I
Hero, leader	Vīra
Hexagon	Ṣaṭkoṇa
Holy man	Sannyāsin
Hoof-print, auspicious	Nandipāda
'Holy of Holies'	Garbhagṛha
Honey	Madhu II
vessel	Madhupātra
Hookah	Hukkā
Horn	Śṛṅga
Horsewhip	Ceṇṭu (Tamil)
House, ideal design of	Vāstumaṇḍala; Vāstunara
House, protector of	Vāstoṣpati
Husband and wife	Dampati
'Hymn', song of praise	Sūkta
Iconometry, measurements	Aṅgula; Aṣṭa-tālam; Pramāṇa; Tālamāna
Image, likeness, form	Acalamūrti; Ākṛti; Arcā(bera); Bera; Bhoga; Mūrti; Pratīka; Pratimā
anointing eyes of	Cakṣurdana
base of	Kūrmaśila
ceremony	Nyāsa
composite	Ekapādamūrti
	Ekapādāsana
endowing with breath	Prāṇapratiṣṭhā
erecting	Sthāpana
	Sūkṣma I
in 'holy of holies'	Sthānakamūrti
of household deity	Devarūpa
metal	Lohaja

pedestal for	Piṇḍikā
portable	Cala
processional	Utsavabera
small, on Viṣṇu's crown	Yogāsana(mūrti) II
subsidiary	Parivāradevatā(s); Pārśvadevatā
temple	Vimānadevatā
temporary	Kṣaṇika
wax model of	Madhūcchiṣṭavidānam
maker of images	Rūpakāsa
Image-maker	Pratimākāra; Takṣaṇa
Images, five	Pañcadehamūrti
Incarnation	
complete	Pūrṇāvatāra
	Yānaka-Narasiṁha
divine	Avatāra; Aṁśa II
temporary	Āveśāvatāra
Incarnations, the ten	Daśāvatāra
Initiation	Dīkṣā II; Upanayana
personified	v. Santāna II
Invocation, ceremony	
to prepare image	Āvāhana
personified	Svadhā; Svāhā
Island	
rose-apple	Jambudvīpa
Jar, auspicious	Bhadrakumbha (see also under Pot)
with holes	Galantī
Javelin, short	Bhindipāla
Jewel, gem	Ratna
emerald	Maraka
fabulous	Syamantaka
magical	Maṇi
wish-fulfilling	Cintāmaṇi
worn by Śiva	Arkapuṣpa
worn on forehead	Caṭulātilakamaṇi
worn on head	Cūḍāmaṇi
Jewels	
crown of	Ratnamakuṭā
earring of	Ratnakuṇḍala
garland of	Ratnamālā
girdle of	Ratnamekhalā
headband of	Ratnapaṭṭa
the Nine	Navaratna
Seven	Saptaratna
vessel of	Ratnakalaśa
Judge of the dead	Yama
Knife, dagger	Churī
Knowledge	Jñāna; Vidyā
eye of	Jñānanetra
lords of	Vidyeśvara(s)
mudrā	Jñānamudrā
primeval	Ādyāvidyā

receptacle of	Jñānabhāṇḍa
secret doctrine	Guhyavidyā
Ladle	Darvī
large	Dhruvā
Lamp	Dīpa
tree	Dīpavṛkṣa
festival	Dīvālī
Lance, iron	Ayaḥśūla
Law, justice, duty, etc.	Dharma I
Left	Vāma
Left-hand deity	Vāmadeva
Left-hand Tantric cult	Vāmācāra
Liberation	Mokṣa
Life, principle of	Ātman
Life, one of the stages of	Brahmacārin
Line, straight	Ṛjulekhā
Line on neck	Trivali
Liquor, intoxicating	Madya
Loin-cloth	Kaupīna
Lord	Pati; Īśvara
Luck	Lakṣmī
bad	Papī lakṣmī
Man as manifestation of Viṣṇu	Nara II
Man as mount for deity	Nara I
Mango fruit	Āmraphala
Manifestation, incarnation	Avatāra
beginning of	Bindu
of a deity	Vibhava; Vyūha(s)
Mankind	Puruṣa I
Mark, sign, characteristic	Lakṣaṇa I and II; Liṅga
auspicious	Śrīvatsa
Śaiva	Tiryakpuṇḍra
sectarian	Tilaka; Puṇḍra
Vaiṣṇava	Ūrdhvapuṇḍra
Marriage	Vivāha
Mask, protective	Kālasiṁhamukha
Mask of glory	Kīrttimukha
Men, one of the five classes of	Haṃsa II
Mercury	Budha
Messenger	Dūta
of death	Kāladūta
Metals, the five	Pañcaloha
Milky Way, the	Mandākinī
Mirror	Darpaṇa
Moon	Candra; Soma; Indu
crescent	Candramaṇḍala
Moon-crested	Candraśekharamūrti(s)
Mothers, the divine	Mātara(s)
the seven	Saptamātara(s)
the eight	Aṣṭamātara(s)
the nine	Navaśakti(s)

Mountain

gold	Meru
lamp in the shape of	Merudīpa
mythical	Cakravāla; Kailāsa; Mahodaya; Mandara
Mouse, rat	Ākhu; Mūsaka
Multiform	Viśvarūpa I
Music, teacher of	Vīṇādharadakṣiṇāmūrti
Musical instruments	
bamboo flute	Veṇu
cymbal	Tāla
flute (?)	Tuṇava
Indian flute	Vallakī
lute	Sitār; Vīṇā
lute, magic	Kalāvati
Musical notes, personified	Saptasvaramaya
Musicians, celestial	Aśvamukha(s); Gandharva(s)
leader of celestial	Tumburu

Naked	Digambarā
Name and form (or aspect)	Nāma-rūpa
Nature, symbol of	Ajā
Navel	Nābhi
-born	Nābhija
lotus	Padmanābha
Net, snare	Jāla I
Indra's	Indrajāla
Noose, fetter	Pāśa
of Brahmā	Brahmapāśa
of time	Kālapāśa
of Varuṇa	Dharmapāśa; Varuṇapāśa
Nymph	Apsaras; Gandharvī; Rambhā

Objects, the eight auspicious	Aṣṭamaṅgala
Oblation	Homa
Obstacle, personified	Vighna
conqueror of	Vighnajit
lord of	Vighneśa
Offering	Bali II
Offspring personified	Santāna II
votive	Devadāna
Oneness, state of	Nirvāṇa
Ornaments	
ankle chain	Pādasara
anklet with bells	Nūpura
band of Viṣṇu	Śirobandha
bracelet	Kaṅkaṇa; Valaya
breast	Stanottarīya
diadem	Śekhara
earring	Kuṇḍala; Lambapattra; Makarakuṇḍala; Maṇikarṇikā; Karṇika; Nāgakuṇḍala; Patrakuṇḍala; Śaṅkhapatrakuṇḍala; Tāṭaṅka; Simhakuṇḍala; Sarpakuṇḍala

finger ring	Aṅgulīya
on foot	Mañjīra
garland	Mālā
magical, of Viṣṇu	Kaustubha
necklace	Maṇimālā; Ekāvalī; Graiveyaka; Phalakahāra; Stanahāra
nose	Vesara
pearl	Mauktikajālaka; Hāra
pendants	Lambaka
chain	Channavīra
of tiger claws	Vyāghranakha
torque	Kaṇṭhī
Pair, couple	Maithuna
Palace, celestial	Vimāna II
Parasol	Chattra; Ābhoga
white	Sitātapatra
Perfected persons	Siddha(s)
Pestle	Musala
Phallus	Liṅga
aniconic	Bāṇaliṅga
channel	Nāla
of crystal or quartz	Sphaṭikaliṅga
divine	Daivikaliṅga(s)
erect	Ūrdhvaliṅga
face	Mukhaliṅga
five-faced	Pañcamukhaliṅga
fluted	Dhārāliṅga
four-faced	Caturmukhaliṅga
fundamental	Mūlavigraha I
half-moon shaped	Ardhacandrākāra
of ice	Kedārnātha
immovable	Acalaliṅga
of light	Jyotir-liṅgam
lines on	Brahmasūtra
man-made	Mānuṣaliṅga(s)
miniature phalli, 108	Aṣṭottaraśataliṅga
one face	Ekamukhaliṅga
processional	Calaliṅga
root	Mūlaliṅga
symbol of five sects	Pañcāyatanaliṅga
technical term for	Śirovarttana
Pillar, post, column	Yūpa; Indradhvaja; Puṣpabodhikā
cosmic	Skambha
Indra's	Indrakhīla
sacrificial	Vanaspati
votive	Garuḍadhvaja
Plaque, for worship	Ayāgapaṭṭa
Planet, Saturn	Śani
Planets, the nine	Navagraha(s)
Plant (see under Tree)	
Play, sport	Līlā
Plinth, base	Pīṭha; Karṇikā

English subjects and Sanskrit equivalents

Plough, ploughshare	Hala
personified	Śunā-sīra
Poison	Halāhala; Kālakūta
remover of	Viṣaharī
Pole Star	Dhruva
Portal of rays	Prabhātoraṇa
Positions, yogic	Āsana; Kūrmāsana I; Svastikāsana; Yogāsana
Pot, vessel, pitcher	Kumbha; Kamaṇḍalu
-bellied	Tuṇḍila
drinking	Pānapātra
libation	Upacāra
ritual	Jhārī
symbol of universe	Kalaśa
representing a village deity	Karaka; Vardhanī
Power(s)	
creative	Māyā; Śakti I
destructive	Nirṛti(s); Vidyāśakti
goddess of creative	Māyādevī
magico-ecstatic	Siddhi I
superhuman, yogic	Vibhūti I
terrible	Ugra I and II
Preceptor, teacher, spiritual guide	Guru
Priest(s)	Brāhmaṇa; Ṛtvij
Quality, characteristic	Guṇa(s)
Receptacle for	
offerings	Iḍāpātra
sacred ashes	Juli
holy water	Prokṣaṇīpātra
fire	Vahnikuṇḍa
bowl-shaped	Kuṇḍika
Reed-pen	Lekhanī
Regions, the three	Tribhuvana
Relief, sculptural	
half	Citrārdha
high	Citrāṅga
moderate	Ardhacitrāṅga
Religious life, stages of	Āśrama II
Reliquary	Dhātugarbha
Representation	Pratibimba
Ribbons, tassels, etc.	Paṭṭikā
ropes of	Ūrumālā
Rice, ear of	Kaṇiśa
Ritual	
left-hand	Vāmācāra
right-hand	Dakṣiṇācāra
tantric, the '5 Ms'	Pañcamakāra
utensil	Upabhṛt; Juhū; Sruva
River	Gaṅgā; Narmadā; Yamunā; Sarasvatī
mythical	Vaitaraṇī I
Rosary	Akṣamālā; Sūtra II
Royalty, symbols of	Rājakakuda
Ruler, universal	Cakravartin

Sacred knowledge	Veda (see also under Knowledge)
arranger of	Veda-Vyāsa
bearers of	Vidyādhara(s)
Sacred thread	Yajñopavīta; Upavīta II
of black antelope hide	Kṛṣṇājinayajñopavīta
of cloth	Vastrayajñopavīta
	Upavīta II
of deerskin	Ajinayajñopavīta
of Gaṇeśa	Vyālayajñopavīta
of Śiva	Sarpayajñopavīta
Sacrifice	Yāga; Yajña
personification of	Yajña-Nārāyaṇa
Saint, holy man, teacher	Sādhu
'Saints'	Āḷvār(s) (Tamil)
Sandals, wooden	Pādarakṣa
Scimitar	Ardhacakrakṛpāṇa
Sceptre, symbol of royalty	Rājadaṇḍa
Seat, throne	Āsana; Pīṭha
auspicious	Bhadrāsana I
lotus, of Brahmā	Kamalāsana
hexagonal	Vimalāsana
lotus	Padmapīṭha I and II
royal	Rājāsana
supported by Garuḍa	Garuḍāsana
triangular	Anantāsana
Seat, throne	
antelope and lion supports to	Mṛgasimhāsana
'Great Pedestal'	Mahāpīṭha
lion and horse supports to	Haya-simhāsana
having a makara for a,	Makarāsana
meditation	Yogāsana
Swastika	Svastikāsana
tortoise-shaped	Kūrmāsana
[and see under Positions, yogic]	
Seed-syllable	Bīja; Mantra
of Brahmā	Brahmabīja
Seer(s), sages	Ṛṣi(s); Muni; Nārada; Nara-Nārāyaṇa
mythical	Śukra
seven great	Maharṣi(s)
thumb-sized	Vālakhilya I
tiger-footed	Vyāghrapāda
Vedic	Viśvāmitra
wife of	Ṛṣipatnī
Serpents	Nāga; Ādināga; Ahi; Ahirbudhnya
the eight	Aṣṭanāga(s)
frieze of	Nāgabandha
goddess of	Manasā
human-faced	Uraga I
king of	Kāliya; Śeṣa; Takṣaka; Vāsuki
noose of	Nāgapāśa
votive stones	Nāgasil(s)
	Uraga I
Shell, fossilized	Śālagrāma II

earring	Śaṅkhapatra-kuṇḍala
treasure, of Kubera	Śaṅkhanidhi
of Viṣṇu	Śaṅkhapuruṣa
Shrine, place of pilgrimage	Tīrtha
Sisters, the eight	Aṣṭasvasāras
Skeleton	Kaṅkāla
staff	Kaṅkāladaṇḍa
Skill, accomplishment	Yukti
Skin	Ajina
black antelope	Kṛṣṇājina
shield	Carma
tiger	Vyāghracarma; Kṛtti
Skull	Muṇḍa I and II
Skull-cup	Kapāla
Skull carrier	Kāpālika
decoration	Kapālin
garland	Kapālamālā; Muṇḍamālā
garland of Śiva	Ruṇḍamuṇḍadhārī
of demon	Rākṣasa-muṇḍa
Skulls, five	Pañcakapāla
Sky, lords of the quarters of	Dikpāla(s)
Sleep	Svapna
Sound	Nāda
sacred	Mantra; Oṃ
South; right(hand)	Dakṣiṇa I
Spirit, individual self	Jīva
individual 'soul'	Paśu II
Spirits of mountains	Parvata(s)
Spiritual essence	Sutrātman
Spoon or ladle, ritual	
of aśvattha wood	Upabhṛt
long-handled	Juhū; Sruk
small	Sruva
Spring	Vasanta
Staff	
of ascetics	Yogadaṇḍa
bamboo	Śalākā
Brahmā's	Brahmadaṇḍa
herdsman's	Pāśupata I
of Śāsta	Śikhādaṇḍa
of Śiva	Pināka
of Yama	Yamadaṇḍa
Stone, auspicious, of Gaṇeśa	Svarṇabhadra
Sugar-cane	Ikṣu(kāṇḍa)
bow, of Kāma	Ikṣukodaṇḍa
Sun	Sūrya
coming from the	Vaivasvata
Suttee	Satī
Swastika	Svastika
left-handed	Sauvastika
Sweetmeat	Laḍḍu; Modaka
Sword	Asi; Khaḍga

Tale(s), ancient, traditional	Purāṇa(s)
Teacher	Ācārya I; Guru
Temple, complete	Vimāna III
Temple, outer niche	Devakoṣṭha
Texts, metaphysical	Upaniṣad(s)
Texts, non-Vedic	Āgama(s); Tantra
Thousand	Sahasra
-eyed	Sahasrākṣa
-petalled lotus	Sahasrāra
phalli	Sahasraliṅga
Thunderbolt	Aśani I; Vajra; Kuliśa; Śamba
Time, cosmic	Kāla
face of	Kālamukha
noose of	Kālapāśa
personified	Uccadevatā; Kālī II
staff of	Kāladaṇḍa
Tongue(s)	Jihvā
of Agni	Kālī I; Saptajihva
Tower gateways	Gopura(s)
Treasures, mythical	Nidhi(s); Aṣṭanidhi(s)
Tree, or plant	Vṛkṣa
aromatic	Haridrā
banana	Kadala
basil, holy, personified	Tulasīdevī
berries for rosaries	Rudrākṣa
bilva fruit	Śrīphala
breadfruit, fruit of	Panasa(phala)
China rose	Javā
citron	Jambhīra(phala); Mātuluṅga
coconut	Nārikela
creeper, wish-fulfilling	Latā; Kalpalatā; Kalpavallī
of Bāla-Gaṇapati	Panasa(phala)
of Durgā	Badarī I
fig tree	Nyagrodha; Pippala; Vaṭa
flame of the forest	Parṇa
flower of immortality	Kuṣṭha
flower not offered to Śiva	Ketakī
of gandharvas	Plakṣa
of Gaṇeśa	Kevaṛā (Hindi)
goddesses	Vṛkṣadevatā(s)
grass	Darbha; Muñja
grass, bunch of	Kūrca
grass, bundle of	Tṛṇa
hard wood	Śamī
hemp	Bhaṅga I; Vijaya II
of immortality	Soma
of Indra's paradise	Pārijāta
of Kṛṣṇa	Tulasī
lotus	Padma I
blue	Utpala; Nīlotpala; Puṣkara
flower	Puṣpa; Vikasitapadma
garland	Padmamālā
white	Puṇḍarīka I

magical, and medicinal	Varaṇa; Yamalārjuna; Oṣadhi
of Manasā	Nāgadru
mango, divine	Kālāmra; Sahakāra
myrobalan	Āmalaka I
the nine (plants)	Navapatrikā(s)
of paradise	Mandāra; Kalpadruma
of Piṅgala-Gaṇapati	Tila
pomegranate fruit	Dāḍimaphala
radish	Mūlaka
for 'rosaries'	Nīm
rose apple	Jambu
of Rudra	Arka II
of Śītalā	Kikar
of Śiva	Bakula; Bilva; Dhattūra; Nameru; Kaḍamba; Aśoka I
sacred to Soma	Kiṅśuka
symbol of food and strength	Uḍumbara
teak	Śāka
of Vārāhī	Karañja
of Viṣṇu (Kṛṣṇa)	Tulasī; Aśvattha
water-lily, white	Kalhāra; Kumuda
Trees, five of Paradise	Pañcavṛkṣa
one of	Haricandana
Triad	Trimūrti; Hari-Hara-Pitāmaha
Triangle	Trikoṇa
Troop, multitude	Gaṇa
of storm gods	Marutgaṇa
Turban, headband	Śirastraka; Uṣṇīsa
Tusk, having one	Ekadanta
Twilight, personified	Sandhyā
Unicorn	Ekaśṛṅgin
Universe, the	Brahmacakra
creation, preservation and dissolution of	Sṛṣti-sthiti-saṁhara
dissolution of	Mahāpralaya
ultimate forces of	Brahman (neuter)
Vase, full	Pūrṇakalaśa
Vehicle, mount	Vāhana
of Brahmā	Haṁsa I
of Skanda	Śikhivāhana
of Viṣṇu	Garuḍa
Victory, banner of	Vaijayantīpatākā
Victory, garland of	Vaijayantīmālā
Vital air, breath	Prāṇa; Pavana II
endowing image with	Prāṇapratiṣṭhā
Void, zero	Śūnya
Volcano	Jvālāmukhi
Votive slabs	Viṣṇupaṭṭa(s)
Votive stones	Nāgasil(s)
Vulva	Yoni

Water	Jala
Water-horse	Jala-turaga
Way, path	Mārga
auspicious	Pathyā
goddess of the	Mārgavatī
Weapons	Āyudha(s)
deified	Śastradevatā
personified	Āyudhapuruṣa; Triśūla
Axe	Kuṭhāra
Battle-axe	Paraśu
Bow, magic, Indra's	Vijaya I
Brahmā's	Parivīta
Club	Khaṭvaṅga; Saunanda; Parigha
Dart, spear, personified	Senā; Śūla
Lance, iron club	Tomara
Rod, iron, sharpened	Paṭṭīśa
Shield	Kheṭa
Spear, javelin	Śūla; Śakti II; Vijaya II; Amogha-śakti
Stick, crooked	Vakradaṇḍa
Sword	Khaḍga
Sword, of Indra	Parañjaya
Sword, of Viṣṇu	Nandaka I
Trident	Triśūla; Śūla
Wheel, discus	Cakra I
personified	Cakrapuruṣa
of Viṣṇu	Śudarśana; Vajranabha
Whip	Kaśā
Winnowing basket	Śūrpa
Wisdom	Buddhi
Witchcraft personified	Kṛtyā
Words, sacred	Mantra
magic science of	Mantraśāstra
lords of	Mantreśvara(s)
World	Loka
of cattle	Goloka
dissolution of	Pralaya
substance, nature of	Prakṛti
Worlds, mystical names of	Vyāhṛti(s)
three	Trailokya
Worship, homage	Pūjā
of women	Strīpūjā

Abbreviations

ABORI *Annals of the Bhāndārkar Oriental Research Institute*

AIA *The Art of Indian Asia*, Heinrich Zimmer, ed. J. Campbell

Aspects *Aspects of Early Viṣṇuism*, Jan Gonda

AV *Atharva-Veda Saṁhitā*, tr. W. D. Whitney

BIP *The Beginnings of Indian Philosophy*, F. Edgerton.

Bṛhadd. *Bṛhad-Devatā*, tr. A. A. Macdonell

CC *Change and Continuity in Indian Religion*, Jan Gonda

Chān. Up. *Chāndogya Upaniṣad*

CHI *The Cambridge History of India*, ed. E. J. Rapson, 6 vols. 1922–0000

Cults *The Cults of the Greek States*, Lewis Richard Farnell

DH *A Dictionary of Hinduism*, Margaret and James Stutley

DHI *The Development of Hindu Iconography*, J. N. Banerjea

EBS *The Early Brahmanical System of Gotra and Pravara*, John Brough

EHI *Elements of Hindu Iconography*, T. A. G. Rao

EM *Epic Mythology*, E. W. Hopkins

EW *History of Philosophy: Eastern and Western*, S. Radhakrishnan

Facets *Facets of Indian Thought*, Betty Heimann

HCIP *The History and Culture of the Indian People*, ed. R. C. Majumdar *et al.*

HP *Hindu Polytheism*, Alain Daniélou

IAL *A Comparative Dictionary of the Indo-Āryan Languages*, R. L. Turner

Iconog. Dacca *Iconography of Buddhist and Brahmanical Sculptures in the Dacca Museum*, N. K. Bhattasali

ID *Iconographic Dictionary of the Indian Religions*, Gösta Liebert

IHQ *Indian Historical Quarterly*

IT *The Indian Theogony*, Sukumari Bhattacharji

IWP *Indian and Western Philosophy: A Study in Contrasts*, Betty Heimann

JAOS *Journal of the American Oriental Society*

JRAS *Journal of the Royal Asiatic Society*

Kauṣ. Br. *Kauṣītaki Brāhmaṇa*, tr. A. B. Keith

MBh *Mahābhārata*, tr. P. C. Roy, Calcutta, 12 vols, n.d.

Myths *Myths and Symbols in Indian Art and Civilization*, Heinrich Zimmer, ed. J. Campbell

Nir. *The Nighaṇṭu and the Nirukta*, tr. Lakshman Sarup, Delhi, 2nd repr., 1967

Principles *Principles of Composition in Hindu Sculpture*, Alice Boner

PSPT *The Significance of Prefixes in Sanskrit Philosophical Terminology*, Betty Heimann

PTR *Paurānic and Tantric Religion*, J. N. Banerjea

RV *Ṛgveda*

SED *Sanskrit-English Dictionary*, M. Monier-Williams

Suś. Sam. *Sushruta Saṁhitā*, tr. and ed. Kaviraj Kunjalal Bhishagratna

Śvet. Up. *Śvetāśvatara Upaniṣad*

Tait. Sam. *The Veda of the Black Yajus School entitled Taittirīya Saṁhitā*, tr. A. B. Keith

Trilogie *Trilogie altindischer Mächte und Feste der Vegetation*, John Jacob Meyer

TT *The Tantric Tradition*, Agehananda Bharati

VP *Viṣṇu Purāṇa*

VS *Viṣṇuism and Śivaism: A Comparison*, Jan Gonda

VSM *Vaiṣṇavism, Śaivism and Minor Religious Systems*, R. G. Bhandarkar

WI *The Wonder that was India*, A. L. Basham

A The first 'imperishable' letter of the Sanskrit alphabet, and the first sound in the manifested world which represents the beginning of all knowledge. It is also the first of the three sounds of the sacred mantra *AUM* (*OM*) which stands for Viṣṇu.

v. Brahmabīja.

Ābhaṅga A slightly bent position of the body of standing images when in meditative pose, with most of the weight on one leg.

v. Bhaṅga II.

Abhayamudrā (Also called *śāntida*.) A gesture (*mudrā*) which dispels fear because the presence of the divinity gives reassurance and protection to the devotee. In this *mudrā* the palm and fingers of the right hand are held upright and facing outwards.

The *abhaya* and *varada mudrās* are the earliest and most common *mudrās* depicted on Hindu, Buddhist and Jaina images.

Abhicāra 'Magic'. The employment of incantations, spells or rites intended to cause harm.

v. Abhicārikamūrti; Agni.

Abhicāradevatā v. Kṛtyā.

Abhicārikamūrti 'Enchanting', 'exorcising'. A terrifying aspect or form of particular deities venerated by those who wish to harm their enemies by magic (*abhicāra*).

Viṣṇu is occasionally depicted in this form when he wears few ornaments or none at all, and is *never* accompanied by his consorts, or any divine beings, or human devotees. He is portrayed with two or four arms and is clothed in black. His eyes look upwards.[1] This inauspicious image should never be placed in towns or villages, but only in forests, marshes, on mountains, or similar solitary places, and should face the direction of the enemy who is to be injured. If the image is to be housed in a shrine or temple, the building should be asymmetrical.[2]

[1]*EHI*, I, pt i, p. 90.
[2]Ibid., p. 84.

v. Abhicāra; Agni; Abhicārikaśayanamūrti.

Abhicārikaśayanamūrti A form of Viṣṇu reclining on the coils of the serpent Ādiśeṣa. The latter has two heads and the body is shown in two coils only. There are no attendant deities.

Abhiṣeka 'Consecration', usually by sprinkling water from a shell (*śaṅkha*) over an image.

Abhīṣṭadevatā or **Iṣṭadevatā** The 'chosen deity' of a worshipper.

Ābhoga 'Winding', 'curving'. Name of the parasol (*chattra*) of Varuṇa which denotes sovereignty. The expanded hood of a cobra also serves as a canopy over many Hindu, Buddhist and Jaina deities.

Abhramū Name of the mate of Indra's white elephant Airāvaṇa. Her name means 'to fashion' or 'to bind together (*mu*) clouds (*abhra*)', a reference to her capacity to produce the fertilizing monsoon clouds.

v. Gaja.

Abja 'Lotus', which is born or produced from water.

v. Padma; Nīlotpala.

Abjaja or **Abjayoni** 'Born in, or from a lotus'. An epithet of Brahmā who was born in a lotus (*padma*) which emerged from Viṣṇu's navel.

v. Abja; Anantaśayana.

Acalaliṅga or **Sthirasthāvaraliṅga** 'Immovable *liṅga*'. Name of a class of stone *liṅgas* of which there are nine varieties.

Acalamūrti or **Mūlabera** 'Immovable'. A large image made of stone or masonry permanently fixed in a temple. A portable image is called *cala*.

v. Dhruvabera; Mūlamūrti.

Ācārya I. A master, spiritual guide, temple priest, or teacher, especially one who invests a student with the sacred thread (*yajñopavīta*), and instructs him in the Vedas.

II. A class of Tamil *vaiṣṇava* teachers who regard the Āḷvārs as incarnations of Viṣṇu's weapons.

v. Āyudhapuruṣa.

Acyuta 'Never falling'. One of the twenty-four aspects of or names of Para-Vāsudeva (Viṣṇu), the wielder of the discus. The utterance of the name Acyuta with those of Ananta and Govinda (also names of Viṣṇu), will destroy every disease.

Acyuta is portrayed holding a mace, lotus, discus and conch.

Ādarśa or **Darpaṇa** 'Mirror'. An attribute of a number of goddesses including Caṇḍā, Mahiṣāsuramardinī, Pārvatī, the Nine Durgās (*navadurgās*), Tripurasundarī and others. The female half of the androgynous Ardhanārīśvara holds a mirror. It is rarely depicted in the hands of gods.

Adhikāranandin A companion of Śiva, regarded as an anthropomorphic form of his white bull, or a form of Śiva himself.[1]

Adhikārandin's image resembles that of Śiva except

1

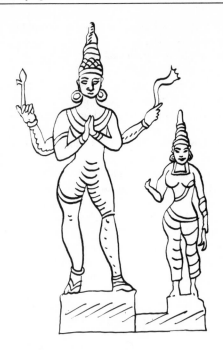

that his front hands are placed together in *añjali* pose.
[1]*EHI*, II, pt ii, p. 458.

Adhokṣaja v. Caturviṃśatimūrti(s).

Ādimūrti A four-armed form (*mūrti*) of Viṣṇu in his primeval personification in which he is depicted seated in *sukhāsana* on the coils of a snake, with one leg folded and resting on the reptile, the other hanging down. The five or seven cobra heads form a canopy above the deity who holds the usual emblems of Viṣṇu. His two wives accompany him.

Ādināga or **Ananta Nāga** A serpent, the tutelary deity of Ahicchatra, the capital of Pañcāla. Ādināga is variously depicted as a huge cobra with one or more heads; or with the upper part of the body human, the lower serpentine, or as a young, handsome man with snake hoods above his head.

Ādi-nātha v. Siddha(s).

Ādiśakti The 'primeval *śakti*'. One of Śiva's five *śaktis*.

Ādiśeṣa The 'primeval Śeṣa'. The King of the *nāgas* and of the subterranean regions (*pātāla*). The serpent body of Ādiśeṣa forms the couch on which Viṣṇu sleeps his fecund sleep between the devolution of one universe and the evolution of the next.
v. Anantaśayana; Vāsuki.

Aditi Name of the Vedic divine mother-goddess who embodies the primordial vastness of Universal Nature symbolized by a cow. She represents extension, breadth, and hence freedom.[1] She is the mother of the three worlds (*AV*, VIII, 9ff.), and of the primordial gods, whom she supports and who in turn sustain her.

Her sons are the twelve Ādityas.
[1]Gonda, *Some Observations . . .*, pp. 75ff.
v. Kāmadhenu.

Āditya(s) 'Descendants of Aditi'. Collective name of the twelve sons of the goddess Aditi, who are all fundamentally aspects of light. The sun-god Sūrya is called the Āditya and is their chief.

Twelve separate shrines in the sun-temple of Konarak are dedicated to the Ādityas. All are depicted four-armed, the only difference in the images being the objects held in their back hands. The front hands hold lotus flowers, emblematic of the sun-god. In Vedic times the Ādityas numbered six, seven or eight. Later there were twelve representing the twelve months of the year.

The twelve Ādityas are: Dhātṛ, depicted holding a lotus garland and water-vessel; Mitra (three-eyed) holding a *triśūla* and *soma* (?); Aryaman, with discus and *kaumodakī*; Rudra, with rosary and discus; Varuṇa with discus and noose; Sūrya with water-vessel and rosary; Bhaga with *triśūla* and discus; Vivasvān with *triśūla* and garland; Pūṣan with two (or four) lotuses; Savitṛ with club and discus; Tvaṣṭṛ, with sacrificial ladle (*sruk*) and *homajakalika* (?), and Viṣṇu with a discus and a lotus.[1]

Separate images of the Ādityas are rare. Usually they are portrayed on detached frames set up behind the gun-god Sūrya, or depicted on the *prabhāvalī* of a Sūrya icon.[2]
[1]*EHI*, I, pt ii, p. 310.
[2]*DHI*, p. 441.

Ādivarāha The 'primeval boar (*varāha*)'. An epithet of Viṣṇu, referring to his boar incarnation (*avatāra*). He is portrayed four-armed with the body of a man and the head of a boar. Two hands hold a shell and discus, his other hands support the Earth-goddess (Bhūmidevī) whom he has raised up from the bottom of the ocean. Her hands are in *añjali mudrā*. She is decked with flowers and jewellery and looks joyously, but shyly, at Ādivarāha.

The *Śilparatna* states that Ādivarāha should have a club and lotus and carry Bhūmidevī on his tusk, or seated on his left elbow. She holds a blue lotus (*nīlotpala*). One of Ādivarāha's feet should rest on the serpent Ādiśeṣa, the other on a tortoise (*kūrma*). The same text states that he may be depicted wholly in boar form.[1]
[1]*EHI*, I, pt i, p. 134.
v. Varāhāvatāra.

Aḍiyars v. Aḷvār(s).

Ādyā Śakti The primary *śakti* or primordial active female principle.

Ādyāvidyā 'Primeval knowledge', symbolized by

Viṣṇu's mace.

v. Gadā; Āyudhapuruṣa.

Āgama(s) A collection of traditional religious teaching contained in non-Vedic texts. When an attribute of a deity it is depicted as a manuscript or a book.

The *Āgamas* are the basic texts of Tantrism, but there is no fixed authoritative canon. Because of the esoteric nature of the Tantric cults there are many manuscripts still unknown to Indologists.

Agastya A notable sage or *ṛṣi*, the patron 'saint' of the Dravidians, who was responsible for introducing the Vedic religion into southern India. He embodies the power of teaching, and is regarded as an adept in sorcery and witchcraft.

He was born from a jar (*kumbha*) along with Vasiṣṭha, when Mitra-Varuṇa was sexually stimulated by the sight of a beautiful goddess and his semen fell into a jar.

Agastya is depicted as of small stature, pot-bellied (*tundila*) showing the *vyākhyanamudrā* – the gesture of explanation or teaching. His emblems are: a tiger-skin (*ajina*), rosary (*akṣamālā*), a small box or a hookah, and a band round his knees (*yogapaṭṭa*) as a support during meditation.

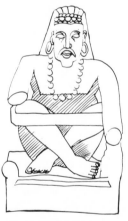

Aghora-Bhairava v. Mahādeva.

Aghoramūrti I. An *ugra* form of Śiva which depicts him standing naked (or wearing an elephant hide or lion-skin), with eight, ten or thirty-two hands, and carrying a trident, drum, skull, mace, sword, bow and arrow and a rope noose. His ornaments consist of snakes and scorpions. His body is smeared with the white ashes of corpses. He may wear garlands composed of skulls, and short daggers. His ten-armed form shows the *abhaya* and *varada mudrās*. His hair flames upwards and his expression is fierce. Two small tusks protrude from the corners of his mouth. His general aspect resembles that of Kāla (Time and Death).

The *Prapañcasāra Tantra* describes him as single-faced, three-eyed and with a black complexion. He counteracts adverse astrological influences and the baneful effects of planets.[1]

[1]*Iconog. Dacca*, p. 119. Not all *aghora* forms depict him as terrifying in appearance (*DHI*, p. 482).

II. Name of the southern face of the five-headed (*pañcānana*) form of Śiva, which represents the principle of intellect (*buddhi tattva*) or eternal law (*dharma*). The other faces are called Vāmadeva, Tatpuruṣa, Sadyojāta and Īśāna.

Agni The god of Fire. An important Vedic deity and one of the triad (*trimūrti*) of that time, with Indra and Sūrya.

Agni exists in all three regions as terrestrial fire, as lightning in the atmosphere, and as sun in the sky. Fire links heaven and earth, and was an essential part of Iranian and Vedic sacrificial ritual.[1]

As his flames always rise heavenwards Agni acted as bearer of the oblations to the deities, and is said to have as many forms as there are sacrifices. The Vedic fire sacrifice symbolically reproduced the cosmic order and strengthened the creative potencies of the gods.

There are ten main forms of fire (*agni*), the first five are natural forms and the next five ritual forms: (1) ordinary fire, either visible or potential, i.e., concealed in fuel; (2) lightning; (3) the Sun; (4) the fire of the digestive process common to all living beings; (5) fire of destruction (volcanic fire), born in the primeval waters where it remains dormant until the end of the age when it flares forth and destroys the world; (6) the *brahma-agni* which appears spontaneously during sacrifice when a specific *mantra* is uttered whilst the fire-sticks (*araṇi*) are revolving; (7) *prājāpatya-agni*, the fire given to a student when he is invested with the sacred thread; (8) *gārhapatya-agni*, the householder's fire, the centre of domestic rituals; (9) *dakṣiṇa-agni*, the southern fire of the ancestors who dwell in the south – this fire is also used for rites of exorcism; (10) *kravyāda-agni*, the funeral fire which should never be approached by the living.[2]

Agni is said by some to be formless (*apuruṣavidhāḥ*), but the *Ṛgveda* describes him as butter-backed, with seven tongues (flames) which are named. His tawny beard denotes that he is the oldest of the gods, his jaws are sharp, his teeth golden. Fiery red horses draw his chariot. He is two-headed, four-armed, with a smoking banner and head-dress, and accompanied by a ram or goat. He holds an axe, torch and fiery javelin, as well as a rosary. Metaphysically he represents the *rajoguṇa*, the 'active principle and he is the greatest manifestation of energy on earth'.[3] His goat also symbolizes the same *guṇa*. His somewhat obese body signifies his creative

and productive powers.

Agni is the demon destroyer *par excellence* (*RV*, III, 20, 3).

Fire is the symbol of cosmic destruction at the end of the age and therefore is associated with the destructive aspect of Śiva. But fire also destroys ignorance and by extension it symbolizes knowledge (*jñāna*) and hence Agni is worshipped for intellectual brilliance and for longevity.

When fire is an emblem of a deity it is always held in the left hand to denote its destructive properties. It may be depicted as a flame or flames, or a torch, and when an independent cult object, a jar with flames.

[1] See Stig Wikander, *Feuerpriester in Kleinasien und Iran*.

[2] *HP*, pp. 89 f.

[3] Bowes, *The Hindu Religious Tradition*, pp. 101 f.

v. Naṭarāja; Tapas; Svāhā; Ardhacandra; Vāma.

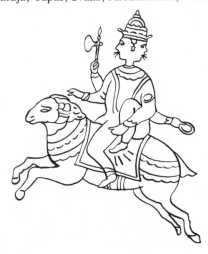

Agni-Durgā An eight-armed, three-eyed form of Durgā, whose emblems are: a discus, sword, shield, arrow, noose and goad. One hand is in *varada* pose, the other in *tarjanī*. On her crown the crescent moon is depicted. Her mount is a lion. On either side two celestial females stand in reverential attitude, each holding a sword and shield.[1]

[1] *EHI*, I, pt ii, pp. 343f.

Agnihotra The 'oblation to fire'. In the Vedic age milk was offered to the god of fire Agni, at dawn and at twilight.

Agnijāta-Subrahmaṇya 'Subrahmaṇya born by Agni'. An aspect of Subrahmaṇya, with two faces and eight arms. In his three right hands he carries a *sruva*, rosary and sword. The remaining hand is in swastika *mudrā*; in the left hands he carries a *vajra*, cock, shield, and vessel of ghee (*ājyapātra*).[1]

[1] *EHI*, II, pt ii, p. 441.

Agnikuṇḍa The sacrificial fire-pit.

v. Vallīkalyāṇasundara.

Āhavanīya The eastern fire of the home which receives the oblations. It is one of the three sacred fires, and is the womb (i.e. seat) of the god of fire, Agni, who carries the oblations to the gods.

Ahāyavarada A *mudrā* beckoning the devotee in order to bestow a boon.[1]

[1] C. Sivaramamurti, *The Art of India*, p. 535, fig. c.

Ahi Name of the serpent slain by Indra. The name is also applied to Agni and Rāhu.

Ahirbudhnya The 'Serpent of the deep', 'sea-snake'. A Vedic deity and one of the eleven Rudras (*ekādaśa-rudra*). His *mudrā* is the *tarjanī*, and his emblems a rosary, goad, discus, small drum, mace, iron club, skull, sword, axe, trident, etc. Sometimes he is depicted with sixteen arms.[1]

Heesterman[2] suggests that Ahirbudhnya represents the vertical rotation of the cosmic forces of fertility 'from sky to earth and back again to the sky, recalling the well-known cycle in which the two fundamental elements fire and water alternate with each other in upward and downward movement'.

[1] *EHI*, II, pt ii, p. 389.

[2] *The Ancient Indian Royal Consecration*, pp. 120, 121, n. 37.

Aihole A neglected village in Mysore, twelve miles east of Badami, containing many famous Calukyan temples.

Aindrī or **Indrāṇī** The *śakti* of Indra and name of one of the seven (or eight) mothers (*mātṛkās* or *śaktis*). Later there were sixteen mothers, each of whom emerged from the body of their respective god. Therefore they are characterized by the forms, ornaments and vehicles of their god.

v. Saptamātara(s); Mātara(s).

Aiṅgiṇī A name of Gaṇeśānī, the *śakti* of Gaṇeśa.

Airāvaṇa or **Airāvata** Name of Indra's white, four-tusked elephant, the celestial ancestor of terrestrial elephants.

Airāvaṇa emerged from the churning of the ocean (*samudramathana*), and is said to have been formerly an ancient serpent king.[1] The divine animal is regarded as a rain-giver, being the 'animal-shaped archetype of the rain-bestowing monsoon-cloud'.[2]

[1] *HP*, p. 109.

[2] *Myths*, p. 53.

Airāvata v. Airāvaṇa.

Aiyanār or **Hari-Hara-putra** A Tamil tutelary deity adopted into the Hindu pantheon and said to be a son of Śiva and Mohinī (a female form assumed by Viṣṇu). This was an attempt to combine the Śaiva and Vaiṣṇava cults.

Aiyanār is seldom depicted and then usually in

terrific form, black, with furious expression and dishevelled hair. His mount is a black horse or white elephant. His *mudrās* are *abhaya*, *kaṭaka* and *varada*; a cock is depicted on his banner. His sacred thread (*yajñopavīta*) is white. He may hold a whip, bow and arrow, sword, axe, staff, shield, and a spray of leaves.

Aja or **Chāga** I. Ram or goat, the mount (*vāhana*) of Agni, Kubera, and Maṅgala (Bhauma). The goat is also sacred to Pūṣan. According to the *Tait. Saṁ.* (I.2,7c), the goat is 'the bodily form of penance'.

II. In astronomy Aja is equated with the sign Aries.

Ajā 'She-goat', a vehicle of Īśāna and an aspect of Pārvatī.

Ajā symbolizes undifferentiated nature (*prakṛti*).[1]

[1]*HP*, p. 285.

Ajagava I. The 'southern' path of the sun, moon and planets.

II. Name of Śiva's bow (also called Pināka), which came down from heaven at the birth of Pṛthu. It is emblematic of Śiva, Skanda, Durgā, and Nandā, a four or eight-armed form of Pārvatī.

Ajakālaka A *yakṣa*. His right hand holds a half-opened lotus flower, his left hand is in *kaṭihasta* pose. He stands on a composite animal with the tail of a *makara* and forelegs of a lion or tiger.[1]

[1]*DHI*, pp. 342f.

Ajamastaka 'Goat-headed', a characteristic of Agni who is depicted with one or two goat heads. Dakṣa, Naigameṣa, Naigameya and Revatī are also goat-headed.

Ajanta A village in the province of Maharashtra with a famous monastery and cave temples dating from the first to the seventh centuries. There are about thirty caves in all, some of which were never finished. It has been suggested that these caves are a 'symbol of the unconscious – a dark space full of latent images'.[1]

[1]Sahi, *The Child and the Serpent*, p. 66.

Ajina 'Skin' of an animal worn on the body of a deity or held in the hand. It is characteristic of Ardhanārīśvara, Bhairava, Cāmuṇḍā, Candraśekhara, Durgā, Gajāsuramūrti, Hayagrīva, Kaṅkalamūrti, Liṅgodbhavamūrti, Mahākāla, Mahā-Sadāśiva (Mahāsadāśiva-mūrti), Paraśurāma, Śiva, Vīṇādharadakṣiṇā, and others.

Ajinayajñopavīta A sacred thread composed of deerskin (*ajina*).

Ajitā 'Unconquered'. Name of a female doorkeeper (*dvārapālikā*) of the goddess Gaurī.

Ājya Clarified butter (*ghee*).

v. Ghṛta; Ājyapātra.

Ājyakumbha v. Ājyapātra.

Ājyapātra or **Ājyakumbha** Vessel containing ghee (*ājya*), an emblem of Agni, Brahmā, Yajñamūrti, and Agnijāta-Subrahmaṇya.

Ākhu or **Mūṣaka** 'Mouse', 'rat'. The mount (*vāhana*) of Gaṇeśa, elder son of Śiva. The mouse represents tenacity of purpose and the capacity to overcome all obstacles.

v. Vināyaka.

Ākhuratha 'Having a mouse as a chariot (i.e. vehicle)'. An epithet of Gaṇeśa.

Ākṛti 'Image, likeness, outward appearance'.

v. Pratimā; Rūpa; Mūrti.

Akṣamālā A rosary or string of beads which may consist of pearls, bones, dried seeds, berries, and skulls for demonic rites.

The creator Brahmā and his consort Sarasvatī hold a rosary which signifies the eternity of cyclic time and the spiritual aspect of Brahmā.

A rosary may also be held by Agni, Ahirbudhnya, Aja, Ardhanārīśvara, Bhadrakālī, Bhṛṅgin, Bṛhaspati, Budha, Lakulīśa, Umā, Śiva, Sūrya, the *ṛṣis*, and others.

When Jñāna-Dakṣiṇāmūrti holds a rosary it denotes 'the string of thirty-six *tattvas*, or stages of evolution through which the Paramaśiva [the highest Śiva] unfolds himself into the manifold worlds, and through which, in the reverse order, he finally re-integrates the multiplicity of things into primordial essential Unity'.[1]

The usual number of beads in a rosary is 'fifty, corresponding to the number of characters of the alphabet beginning with *a* and ending with *kṣa* (hence symbolically *a–kṣa*, in spite of the fact that *akṣa* properly means "grain" of which the rosary is composed'.[2]

[1]*Principles*, p. 205.

[2]*ID*, p. 9.

Akṣara 'Imperishable', 'indestructible', a term applied to the mantra *OṀ* and equated with the neuter *brahman*.

Akṣayavaṭa The 'undying banyan' tree. A sacred tree (*vṛkṣa*) in Allahabad, said to be the place where Rāma, Sītā and Lakṣmaṇa took refuge.

Akūpāra The mythical tortoise or turtle on which the earth is supposed to rest.

v. Kūrma.

Alaka-cūḍaka 'Crest of curls'. Name of a hair-style appropriate for particular goddesses.

v. Mukuṭa.

Alakṣmī 'Bad luck'. Name of an inauspicious goddess (also known as Jyeṣṭhā), the opposite of Lakṣmī, goddess of prosperity and good luck.

Alakṣmī's mount is an ass (*gardabha*).

Alambana vibhava The 'principal factor indicating the emotional flavour (*rasa*) of a work of art'.[1]

[1]Sivaramamurti, *Art of India*, p. 550.

Alampur A town in Andhra Pradesh situated on the banks of the Tungabhadra river near its confluence

with the Kistna. The town contains some fine eighth-century Śaiva temples, but all are named after Brahmā. They are important for the study of Western Calukyan architecture.

Ālīḍhapada or **Ālīḍhāsana** Names of the stance of an archer in which the right knee is forward and the left retracted.[1]

The two goddesses Uṣā and Pratyūṣā, when accompanying Sūrya, are portrayed in this posture, and also female doorkeepers, *ḍākinīs*, Hanumat, Tripurāntaka, Hayagrīva, Vārāhī, Mahālakṣmī, Mahāmāyā, and others. The opposite posture is that of *pratyālīḍhāsana* in which the left leg is advanced and the right retracted. Mahiṣa-suramardinī or Kātyāyanī Durgā may be depicted in this pose.

[1]Bhattacharya, *Indian Images*, pt i, pp. 48, 50.

v. Āsanamūrti; Yogāsana; Padmāsana.

Ālingahasta The 'embracing arm' *mudrā* characteristic of Ālinganamūrti.

Ālinganacandraśekharamūrti v. Ālinganamūrti.

Ālinganamūrti or **Ālinganacandraśekharamūrti** A Śaiva image where Śiva is depicted embracing his consort Umā (Pārvatī). The four-armed Śiva stands by his consort and embraces her with his front left hand. She holds a flower in her right hand, or embraces Śiva with her right arm round his waist.

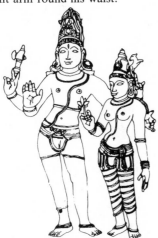

Āḷvār(s) (Tamil) 'Lost in god'. The collective name of the ten or twelve Tamil Vaiṣṇava 'saints', the wandering 'troubadours' of South India during the seventh and eighth centuries. They composed songs and dedicated them to Viṣṇu. Some of the Āḷvārs were of low birth and one was a woman. All of them influenced the *bhakti* movement.

The Śaiva counterparts of the Āḷvārs were the Aḍiyars or Nāyanmārs who flourished for seven centuries from the second to the ninth century AD.

v. Andal; Appar; Nammāḷvār.

Āmalaka I. The myrobalan tree associated with Viṣṇu. II. The fluted, cushion-shaped object at the top of a north Indian temple spire representing the fruit of the myrobalan, and also signifying the highest heavens.[1]

[1]Sivaramamurti, *Art of India*, p. 550; Rawson, *Indian Sculpture*, p. 42.

Amastaka 'Headless', a characteristic of Rāhu and Chinnamastakā (Chinnamasta).

Ambā 'Mother'. An aspect of Pārvatī. She carries a child (bāla), water-vessel, lotus and noose. Her *mudrā* is *abhaya*.

In the languages of southern India Ambā becomes Ammā and is frequently affixed to the names of goddesses and females in general.

v. Ambikā.

Ambikā A Hindu goddess often identified with Ambā. She is the Jaina counterpart of 'Durgā, one of whose early appellations is Ambikā; Kuṣmāṇḍinī, another name of the Jaina goddess, appears also to have been derived from an epithet of Durgā, which is Kuṣmāṇḍī or Kuṣmāṇḍā'.[1]

Ambikā is distinct from Pārvatī, Durgā and Kālī, when she is one of the central Śākta cult deities. Her vehicle is a lion (*siṁha*); her *mudrā*, *varada* or *kaṭaka*. She may have three eyes, and two or four arms. Her emblems are a mirror, sword, shield,[2] and sometimes a child.

[1]*DHI*, p. 563.
[2]*EHI*, I, pt ii, p. 358.

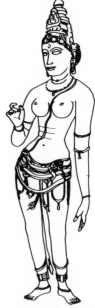

Ammā 'Mother' v. Ambā.
Amogha-śakti The name of Indra's Spear.
v. Śakti II.

Āmraphala Mango fruit, an emblem of Bāla-Gaṇapati, and of the boy Skanda when depicted with his parents Śiva and Umā.

v. Somāskandamūrti.

Amṛta 'Immortal'. The ambrosia, the food or drink of the gods. According to the *Atharvaveda* (IV, 35,6) *amṛta* was produced during the cooking of the sacrificial rice-mess. *Amṛta* possesses a potency that over-powers death. A later myth states that Dhanvantari, the physician of the gods, emerged from the churning of the ocean (*samudramathana*) holding a chalice of *amṛta*.

A jar containing ambrosia is also emblematic of Garuḍa who succeeded in stealing the *amṛta* from the gods, and of Lakṣmī (in some forms), and of Viṣṇu.

The moon is the vessel of *amṛta* which is drunk by the ancestors (*pitṛs*) and is constantly refilled, a reference to its waxing and waning.

v. Amṛtaghaṭa.

Amṛta-bandhu The 'friend of *amṛta*'. An epithet of the horse which emerged simultaneously with the *amṛta* from the churning of the ocean.

Amṛtaghaṭa or **Amṛtakalaśa** A vessel containing the nectar of immortality (*amṛta*), held by some deities including Brahmā, Dakṣiṇāmūrti and Lakṣmī.

An *amṛtakalaśa* is placed on the top of a temple and indicates the aim of spiritual aspiration which is always upwards.

Amṛtakalaśa v. Amṛtaghaṭa.

Aṃśa or **Aṇśa** I. 'Apportioner', 'distributor'. Name of one of the Ādityas who represents booty and wealth and perhaps personifies the sacrificial share which belongs to gods and kings.

II. When the emblems of the aspects of divine power are personified they become saints and achieve the purpose of their earthly incarnation. In them a portion of Viṣṇu's divine power is incarnated.[1] Sometimes a vehicle (*vāhana*) of a god is regarded as a partial manifestation of a deity, such as the snake Ananta, a theriomorphic form of Viṣṇu.

Aṃśa is 'often used as an equivalent of *avatāra*, since all incarnations are supposed to be contemporaneous with their prototypes'.[2]

[1]*EHI*, I, pt i, p. 120.
[2]*ID*, p. 18.

Anala I. 'Fire'. Name of one of the eight Vasus, the presiding deity of gold (*svarṇa*). His emblems are: a rosary, skull-cup, sacrificial ladle (*sruva*), and a spear.
II. According to the injunctions of the Vedas, Purū-ravas made fire threefold, and offered oblations to attain reunion with his beloved Urvaśī. The three fires are: *gārhapatya*, *dakṣiṇāgni* and *āhavanīya*, and hence the term *anala* is also a symbolic name for the number

three.

Ānanda 'Joy', 'happiness', epithets of Śiva and Balarāma.

Ānanda tāṇḍava 'Dance of joy or ecstasy'. Śiva, as lord of the dance (Naṭarāja), dances on the back of the dwarf Apasmāra. His right leg is slightly bent and the left slightly raised and turned towards the right leg. Śiva's figure is surrounded by a flaming circle of rays (*prabhāmaṇḍala*) which symbolize the continuous growth, decay and renewal of Nature. Strands of matted hair spread outwards like wings from his head-dress. Dhattūra flowers decorate his hair. On the right side of his head a small figure of the celestial river-goddess Gaṅgā is depicted. The lower part of her body resembles flowing water. Her inclusion in the image reflects the myth that Śiva received the celestial Ganges on his head, his matted locks slowing down the rushing waters which would otherwise have flooded the earth.

Śiva has four hands, the upper right holds a small drum, the lower right is in *abhaya mudrā*, the lower left arm is stretched gracefully across his body with the hand pointing to his upraised foot; the palm of the upper left hand forms a crescent (*ardhacandra*) which holds fire (*agni*).

v. Ardhacandramudrā.

For illustration see Naṭarāja.

Anaṅga 'Bodiless'. An epithet of Kāma, the god of love. Śiva had reduced him to ashes by a single glance from his third eye, a punishment for having attempted to disturb his (Śiva's) austerities (*tapas*) by arousing his love for Pārvatī. Later Śiva relented and allowed Kāma to be reborn as Pradyumna, Kṛṣṇa's son.

Ananta I. 'Endless'. One of the names of the world-snake, the king of *nāgas*, whose coils form a couch and its hoods a canopy for Viṣṇu (in his aspect of Ādimūrti).

The *Viṣṇudharmottara* (Book III, ch. 65, verses 2ff) describes Ananta as four-armed, with many hoods and with the beautiful Earth-goddess depicted standing on the central hood. In the two right hands he holds a lotus and pestle, in the left, a ploughshare and conch-shell. There is 'little doubt that Ananta in this context is no other than an incarnation of the Lord Viṣṇu',[1] but he is only a partial (*aṃśa*) incarnation. One form of Balarāma is said to be an incarnation of Ananta.

Ananta symbolizes the cosmic waters, that is the undifferentiated state of the cosmos before creation, and the eternity of time's endless revolutions. The waters are the source of the new world, and hence Ananta also represents abundance and fertility *in potentia*. His colour is purple.

[1]*DHI*, p. 347.

v. Anantaśāyana; Ādiśeṣa; Śeṣa.

II. An epithet of Śiva; of a *dikpāla*, and of a form of Viṣṇu having twelve arms, four heads, and a tortoise (or Garuḍa) as a vehicle.[1] Five of the right hands carry a club, sword, discus, *vajra* and goad. The sixth hand is in *varada mudrā*; the left hands hold a conch-shell, shield, bow, lotus, staff and noose.[2]

[1]*ID*, p. 15.
[2]*EHI*, I, pt i, p. 257.

Anantāsana 'Eternal seat'. Name of a triangular seat or throne (*āsana*).

v. Pīṭha.

Anantaśāyana or **Śeṣaśāyana** or **Jalāśāyin** An aspect of Viṣṇu depicted recumbent (*śayana*) on the coils of the cosmic snake Ananta with the snake's seven hoods forming a canopy over the 'sleeping' god. The serpent lies on the waters of the shoreless cosmic ocean.

Fully recumbent images of Hindu and Buddhist divinities are rare, though in some late medieval and modern *śakti* images, such as that of Kālī, Śiva is sometimes depicted lying under the feet of the principal deity. In some reliefs, which indicate a sectarian bias, a god of one cult is shown lying prone under the feet of a deity of another cult, as in the Śarabha hybrid form of Śiva when Narasiṁha, the man-lion incarnation of Viṣṇu, is shown under Śarabha's feet.

Anantaśāyana embodies the three cosmic functions of creator, preserver and destroyer. When Viṣṇu awakes from his yogic 'sleep' (*yoganidrā*) a new world begins to evolve. This myth is beautifully depicted at Ellora (Cave XV). The sleeping Viṣṇu reclines on the coils of Ananta. From Viṣṇu's navel emerges a lotus stalk, on the flower of which is seated Brahmā the 'creator' of the new world. The small figure of Lakṣmī massages his feet which lie in her lap. As Viṣṇu is at rest during the vast period between the devolution of one universe and the evolution of the next, he holds none of his usual emblems, but they are depicted in personified form below the coils of the snake, with two guardians at either end.

v. Padma; Vaṭapattraśāyin; Madhu; Kaiṭabha.

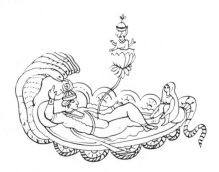

Añcitamudrā 'Bent', 'cupped hand', a *mudrā* in which the fingers are separated and turned towards the palm. Naṭarāja shows this *mudrā*.

v. Caturatāṇḍava.

Andal Name of the only woman among the twelve Ālvārs. She was a poetess who sang the praises of Viṣṇu. She holds a flower in one hand, the other arm hangs down gracefully by her side.

In some southern Indian temples a separate shrine is dedicated to her as an incarnation of Nīladevī, Viṣṇu's third consort.

Andhakāsura The *asura* who embodies darkness (tamas) or spiritual blindness so holding all creatures in thrall. One myth relates that he wished to abduct Pārvatī from Kailāsa, but was killed by Śiva.

v. Kaṅkaladaṇḍa; Andhakāsuravadhamūrti.

Andhakāsuravadhamūrti A fierce, eight-armed form of Śiva in which he killed the *asura* Andhaka.

In a sculpture from the Ellora caves, Śiva is portrayed holding a trident which is driven into the body of Andhaka whose blood drips into a cup held by the goddess Yogeśvarī (Kālī). Śiva also holds a cup to catch the blood, as well as a small drum and sword. One hand is in *tarjanī* pose. Yogeśvarī carries a curved dagger. Above her head is a half-human, half-bird *ḍākinī* waiting to devour the *asura*'s flesh. Devī is seated on a lotus-pedestal gazing towards Śiva.

Aṅgada An elaborate ornamental armlet worn on the upper arm.

v. Keyūra.

Aṅgiras Name of a Prajāpati. His wife is Lajjā or Svadhā, his son Bṛhaspati.

Aṅgula 'Finger', 'finger's breadth', a measurement in iconometry. Twelve *aṅgulas* make up one *tāla*. The face of an image is taken as twelve *aṅgulas* and the breadth of the face is the same as the height, but in some Dravidian images the face was made oval by increasing the height to thirteen or fourteen *aṅgulas*.

The *aṅgula* has served as a unit of measurement for centuries. In the *Ṛgveda* (X. 90) the cosmic man (Puruṣa) is said to have covered the whole universe and to have exceeded it by ten *aṅgulas*. According to the *ŚBr.* (X, 2.1,2) Prajāpati measured the fire-altar by finger breadths. It is by means of man 'that everything is measured here, these fingers are his lowest measure . . .'.[1]

[1]*DHI*, p. 316.

Aṅgulīya 'Finger-ring', a characteristic of Śiva.

Anila I. 'Wind'. A name of Vāyu, god of the winds, who is also one of the Lokapālas.

II. Name of one of the Vasus who holds a rosary, goad and spear, and wears the sacred thread.

III. The 'immortal air' to which at death mortal breath

returns (*Īśā Upaniṣad*, 17).

Aniruddha I. 'Unopposed', 'unobstructed'. Name of the grandson of Kṛṣṇa, and son of Pradyumna. A minor cult grew up around Aniruddha.

II. Name of one of the twenty-four aspects of Viṣṇu (*caturviṁśatimūrti*) who holds a discus, mace, conch and lotus.

Añjalimudrā A gesture (*mudrā*) of devotion and respectful greeting in which both hands are clasped together with the fingers upwards and palms touching, and held near the chest. Devotees and minor deities are often portrayed in this pose including Garuḍa, Hanumat, Kāliya, Yama, and others.

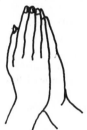

Añjana 'Collyrium', a black pigment applied to the eyelashes or used as an eye-liner. It is characteristic of the goddesses Lalitā, Rājarājeśvarī and Tripurasundarī.

Añjana is said to give protection against demons and spells as well as curing jaundice and other diseases (*AV*, IV. 9).

Aṅka 'Figure, symbol'.
v. Rūpa.

Aṅkāḷamman (Tamil) A South Indian goddess who wards off demons and evil from her devotees. She is one of the Nine Śaktis (*navaśakti*) of Śiva, and represents Kālī in her fierce form. Her emblems are a small drum entwined by a snake, a skullcup, sword and noose.

Aṅkuśa 'Elephant-goad', a sharp metal hook mounted on a stick. It is an emblem of Gaṇeśa, Indra, Skanda, Śiva, Annapūrṇā, Agni, Bhairavī, Cāmuṇḍā, Brahmā, and of some minor deities.

The *aṅkuśa* denotes the activity of a deity and 'the

selective faculty in choosing what is enjoyable for the *ātman* as soul'.[1] In South India it is a symbol of royalty and also one of the eight auspicious objects (*aṣṭamaṅgala*).[2]

[1]*EHI*, I, pt i, p. 294.
[2]*ID*, pp. 17f.

Annānām pataye 'Lord of food' An epithet applied to Śiva.
v. Annapūrṇā.

Annapūrṇā 'Filled with (or giver of) food'. Name of a gentle form of Pārvatī who averts famine. She is said to have distributed food (*anna*) to Śiva and to the other gods. All creatures are produced from food, live by food, and pass into food. It is also 'the magic substance of communion or the means for paying religious debts in the sacrifice'.[1]

Annapūrṇā is usually portrayed standing holding a jewelled bowl of food and a ladle. She wears ruby bracelets and a heavy necklace. A crescent moon adorns her hair or crown.[2] Her emblems are the elephant-goad, moon, pearl garland, bowl and a large sacrificial ladle (*sruk*) which sometimes contains food.

According to the *Śatarudrīya*, Annapūrṇā feeds the whole universe from the alms collected by Śiva in his form of Bhikṣāṭanamūrti and hence he has the epithet *annānām pataye*, Lord of Food.[3]

[1]Lannoy, *Speaking Tree*, p. 161.
[2]*EHI*, I, pt ii, p. 371.
[3]Sivaramamurti, *Śatarudrīya*, p. 92.
v. Bhūteśa.

Aṁsa v. Aṁśa.

Antarīkṣa The firmament where dwell the *gandharvas*, *apsarasas*, and *yakṣas*.

Antaryāmin v. Vyūha(s).

Anugrahamūrti(s) Peaceful and beneficent forms of Śiva when in the act of bestowing favours or grace on his devotees. One such act relates to the boy Caṇḍeśa who cut off his father's leg when he kicked the *liṅga* Caṇḍeśa was worshipping. At that moment Śiva appeared with Pārvatī and embraced Caṇḍeśa, decorated him with his own flower garland, and appointed him a member of his household.

In his benign forms Śiva is always accompanied by Pārvatī, for she is said to keep him in a peaceful frame of mind.

The Kirātārjuna, Nandīśānugraha and Rāvaṇānugrahamūrti aspects are included among the *anugrahamūrtis*.[1]

[1]*ID*, p. 19.

Apa Name of one of the eight Vasus whose emblems are a goad, plough and spear.

Aparājita I. 'Invincible'. An epithet of Viṣṇu and Śiva, and of a mythical sword.

II. Name of one of the eleven Rudras (*ekādaśarudras*), depicted in *tarjanī* pose. His emblems are: rosary, goad, discus, small drum, mace, bell, sword, shield, snake, lotus, alms-bowl, sharp-edged iron rod, spear, lance (or iron club), and trident.

Aparājitā I. 'Invincible'. A name of Durgā whose mount is a lion. Her emblems include a sword, shield, snake, Pināka, arrow, and the snake Vāsuki. The last is worn as a bracelet. Aparājitā is three-eyed and wears her hair braided (*jaṭābhara*) with the crescent moon on it.[1]

[1]*EHI*, I, pt ii, p. 369.

II. Name of a female doorkeeper of the goddess Gaurī.

Aparṇā 'Without a leaf'. Aparṇā was originally a non-Aryan goddess worshipped by the Śabaras, Pulindas and other tribes. Her name derives from the extreme austerities (*tapas*) that she practised, one of which was to give up all food. She is the embodiment of female asceticism and hence became the *śakti* of the greatest of all male ascetics, Śiva.

Apasmāra or **Mūyalaka** A demon-dwarf personifying the evils of ignorance, but according to the *Suś. Saṃ.* (I, p. 302) the dwarf personifies leprosy. Śiva's right foot rests on Apasmāra and denotes his 'world-creative driving of life-monads into the sphere of matter, the lifted foot symbolizing their release. The two feet thus denote the continuous circulation of consciousness into and out of the condition of ignorance'.[1]

Apasmāra's *mudrā* is *añjali*. He sometimes accompanies Śiva Candraśekharamūrti, and is occasionally represented under the feet of Vyākhyānadakṣiṇāmūrti. His right hand is in *sarpa mudrā*, and he holds a cobra in his left.

[1]*AIA*, p. 122.

v. Ānanda tāṇḍava; Naṭarāja.

Appar A Śaiva poet-saint of southern India, usually portrayed standing on a lotus plinth with his hands in *añjali mudrā*. Sometimes he is bald, or his hair is tied up in a topknot.

v. Āḷvār(s); Bhakta; Kaṇṇappa-Nāyanār.

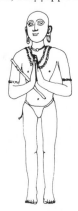

Apparsvāmigal (Seventh century.) A famous *bhakta* (devotee), who carries a staff with a triangular metallic piece at the top intended to remove grass growing in temple areas. Apparsvāmigal had vowed to do this in every temple he visited.

v. Āḷvār(s); Bhakta.

Apsaras (pl. **Apsarasas**) 'Going in the waters'. Seductive, eternally young nymphs, the celestial dancers of the gods. They took shape in the causal ocean and emerged from it during the churning of the ocean (*samudramathana*). Their bodies consist of the five elements: earth, water, fire, air and ether (space). They represent 'the unmanifest potentialities, the possible worlds, which exist in the divine Mind',[1] but which may never come to exist physically.

The Apsarasas' fish-shaped eyes denote the flickering glances of young girls' eyes which are called 'silver fishes'.[2] The nymphs do not have any special iconographic traits, but are usually depicted standing (*samabhaṅga*) on *bhadra-pīṭhas*. Occasionally they are represented as beautiful aquatic birds. (*ŚBr.*, XI, 5.1,4).

Both Gandharvas and Apsarasas 'stand' on forest trees, or dwell in them, especially the *nyagrodha*, *aśvattha* and *udumbara*, from which the sounds of their cymbals and lutes may be heard. The *Skanda Purāṇa* states there are 35 million Apsarasas, but according to the *Mahābhārata* only 'seven times six thousand'.

[1]*HP*, p. 304.

[2]Rawson, *Indian Sculpture*, p. 116.

Apurusavidhāḥ v. Agni.

Arālamudrā A *mudrā* similar to the *patākā(hasta)-mudrā*, except that the forefinger is bent. The *arāla-mudrā* symbolizes a bird, blame, or the drinking of poison.[1]

[1]*ID*, p. 20.

Araṇi 'Fire-drill', which consists of two pieces of wood used to create fire by friction, a process likened to procreation, with Agni (fire) as the offspring. The fire-drill is a characteristic of Gaṅgeya-Subrahmaṇya.

Arcā(bera) An image or icon of a deity. When sanctified by special rites the god it represents is said to take up his abode in it and thus for ritual purposes it becomes the embodiment of that specific deity.

Ardhacakrakrpāṇa 'Scimitar'. An emblem of Chinnamastā.

Ardhacandra 'Half-moon', an emblem of Rāhu.

Ardhacandrākāra 'Having the form of a half-moon'. Name of the top of a *liṅga* which is half-moon shaped.

Ardhacandramudrā A gesture (*mudrā*) in which the palm of the hand is held upwards and curved to form a crescent. Sometimes a 'bowl' of fire is held in this hand. Seven flames make up the fire which represent the seven tongues or flames of Agni. The bowl is held by Naṭarāja.

Ardhacitrāṅga 'Moderate relief'. One of the three kinds of sculptural relief, which is said to be conducive to enjoyment and to liberation.
See Introduction, p. ix.

Ardhalakṣmīharī 'Part Lakṣmī and part Hari (Viṣṇu)'. An aspect of Viṣṇu.

Ardhanārīśvara A gentle (*saumya*) aspect of Śiva in androgynous form which denotes the inseparability of all male and female forms, the cause of creation in the world. The same notion is conveyed by the symbol of the *liṅga* emerging from the *yoni*. The right half of the image represents Śiva, the left Pārvatī.

Much symbolism attaches to the Ardhanārīśvara aspect which denotes the Sāṃkhya dual principle of the Cosmic Puruṣa and Prakṛti, as well as personifying the 'abstract Vedāntic principle of Brahman in his Yogeśvara aspect'.[1] From the philosophical point of view this composite form represents the creative union of the active and passive principles. 'The male principle is also represented as Fire, the devourer, while the female principle is Soma, the devoured offering. The Hermaphrodite is then the embodiment of the cosmic sacrifice, the image of the universe'.[2]

[1]*IT*, p. 206.
[2]Vijayānanda Tripāṭhī, 'Devata tattva', *Sanmarga III*, 1942, cited in *HP*, p. 203.
v. Vāma.

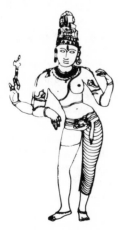

Ardhāñjalimudrā Pose in which one hand is held up against the chest, instead of two, as in the *añjalimudrā*.

Ardhaparyaṅkāsana Name of a yogic pose (*āsana*) signifying an attitude of comfort with one leg folded and placed horizontally on the seat and with the knee resting on the *pīṭha*, the other leg resting lightly on the ground. Saraswati[1] regards the *lalitāsana* and *ardhaparyaṅkāsana* poses as identical, but Liebert[2] states there is a slight difference in the position of the legs.
[1]*A Survey of Indian Sculpture*, p. 128.
[2]*ID*, p. 22.
v. Paryaṅkāsana.

Ardhapatākāmudrā A *mudrā* in which the ring and little fingers are bent. It denotes a dagger, temple, tower, and other things.[1]
[1]*ID*, p. 22.

Ardhasamasthānaka 'Half-straight standing posture', in which the feet are placed in a number of different positions, but are distinguished from the *sama* position where the feet are placed side by side. Sometimes the legs may be in the stance of an archer shooting arrows as in the images of Rāma, Lakṣmaṇa, Sūrya, and others, or in the pose of Kṛṣṇa playing his flute (Veṇugopāla), or of Śiva or Kṛṣṇa dancing.

Ardhayogapaṭṭa 'Half *yogapaṭṭa*', also called *ardhayogāsana*. The name of a cloth or band placed round the body and one leg of a person sitting in meditation pose.
v. Yogāsana.

Ardhayogāsana v. Ardhayogapaṭṭa.

Arghā (Hindi) 'Chalice' used to make libations. It symbolizes the *yoni*.[1]
[1]*ID*, p. 22.

Arghyapātra 'Sacrificial bowl' intended to hold rice or water.

Ariṣṭa Name of a demon in the form of an ox.

Arjuna 'White'. Name of the hero of the *Mahābhārata* who was an apotheosed human hero as was Vāsudeva (Kṛṣṇa). Arjuna was the third of the five Pāṇḍava princes whose paternity is mythically ascribed to Indra, and hence Arjuna is regarded as an *avatāra* of Indra. His wives are Draupadī and Subhadrā. His main attribute is a weapon given him by Śiva. According to the *ŚBr.*, (V, 4.3,7), Arjuna is a mystical name of Indra.
v. Pāśupatāstra I.II.

Arka I. 'Light-bringer'. An epithet of the Sun. The *Maitrī Upaniṣad* (6,8) identifies Arka with the *ātman*.
II. A plant (*Calotropis gigantea*) closely associated with Rudra and hence inauspicious, but an amulet of *arka* wood is said to give virility (*AV*, VI.72). This plant is sometimes used in the solar cult. Its leaves, if worn on the body of a prince, ensure the success of his mission (*Agni Purāṇa*, I, p. 496).

Arkapuṣpa 'Ray-flower'. Name of a jewel worn on the right side of Śiva's crown.

Aruṇa 'Red', 'the Reddish One', 'dawn'. Name of the charioteer of the sun-god Sūrya, and brother of the fabulous bird Garuḍa. Aruṇa's body protects the world from the full heat of the sun.

Aruṇa is perfectly formed except for his feet and ankles which never developed. This reflects the myth that his mother Vinatā, a wife of Kaśyapa, bore two sons Aruṇa and Garuḍa, both associated with some aspect of the sun. The sons were born from eggs of which initially there were three, but in her impatience to hatch them she broke one from which streaked forth a flash of lightning. She broke another and inside was Aruṇa, a radiant youth but with no feet, who though able to stand was unable to walk.

Arundhatī 'Fidelity'. The morning star personified as a goddess, the wife of Vasiṣṭha. She is portrayed with a calm, austere expression, and holds leaves, flowers and water indicating that she is engaged in worshipping the gods.[1]

[1]*EHI*, I, pt ii, p. 369.

Arūpa 'Non-form'. v. Rūpa.

Aryaman 'Chivalry', the quality of being an *āryā*, one who is honourable or noble.

Aryaman embodies chivalry and maintains law, order, and the duties of an aristocratic society. He is an aspect of the sun-god Sūrya, but has few individual traits. His emblems are a discus, mace, and two lotuses.
v. Āditya(s).

Aṣāḍha Name of a month (June–July). Its presiding deity is Ṣaṇmukha, the six-headed form of Skanda.

Āsana 'Seat', 'throne' or a 'seated position' which, with *mudrās*, indicate the different moods and actions attributed to various images of the deities. In *yoga* the term 'signifies a variety of modes of sitting partly with the help of which abstract meditation is performed by a devotee'.[1]

Sometimes *āsana* refers to the animal or object associated with a particular divinity and which forms a seat for it.

Traditionally there are said to be 8,400,000 *āsanas* of which only eighty-four are known to man. Śiva created them by assuming the characteristic stance (*sthāna*) of each one, but some were obviously adopted from the

stances of warriors in battle. Many of these positions have passed into the dances of India.

Strictly speaking *āsana* refers to a sitting posture only, but as far as iconography is concerned it includes riding an animal, standing, or reclining, and thus has come to have an extended meaning as well as including such positions as *pratyālīḍhāsana* (*ālīḍhapada*). Tantric *āsanas* frequently consist of skulls, corpses, a funeral pyre, or similar macabre objects.

[1]Bhattacharya, *Indian Images*, pt i, p. 47.

v. Kūrmāsana; Sukhāsana; Padmāsana; Yogāsana; Pīṭha.

Āsanamūrti 'Sitting posture' of a yogin; also a term for a seated image of a god.

Aśani or **Vajra** I. 'Thunderbolt'. Name of one of the eight forms of Agni.
II. Name of one of the eight elemental forms of Śiva. This terrifying (*ugra*) aspect denotes the power of destruction exercised through the elements.

Āścaryamudrā A gesture (*mudrā*) expressing astonishment or surprise.
v. Vismayahasta.

Asi or **Khaḍga** 'Sword'. Brahmā created the sword as a divine being and presented it to Rudra who in turn passed it on to Viṣṇu.[1]

[1]*EM*, p. 176.

Asitāṅga v. Bhairava.

Aśoka I. 'Absence of sorrow'. A flowering tree (*Saraca indica*) sacred to Śiva.

When Damayantī was seeking Nala she circumambulated an *aśoka* tree thrice and begged it to assuage her grief. An *aśoka* is said to blossom when touched by the leg of a beautiful chaste girl. Kāma, the god of love, is worshipped with garlands of red *aśoka* flowers.
II. Name of the great Mauryan Emperor who reigned from 273 to 232 BC.

Āśrama I. 'Hermitage' of a *ṛṣi* or holy man.
II. Name of the four stages into which the religious life of a brahmin is divided, viz., *brahmacārin*, *gṛhastha*, *vānaprastha* and *sannyāsin*. These stages exemplify how life ought to be lived.

Aṣṭabandhana A kind of cement, consisting of eight (*aṣṭa*) ingredients and used to fix an image to its base.

Aṣṭadhātu An alloy consisting of eight (*aṣṭa*) metals used in North India for casting bronze images. The metals are: gold, silver, copper, tin, iron, lead, quick-silver, zinc (or brass or steel).[1]

[1]*ID*, p. 26.

Aṣṭadikpāla(s) The eight (*aṣṭa*) guardians of the eight quarters of the world who are represented in most temples. This is an ancient Hindu concept. There is some variation in the lists, but in the *Purāṇas* they are given as Indra (E), Yama (S), Varuṇa (W), Kubera

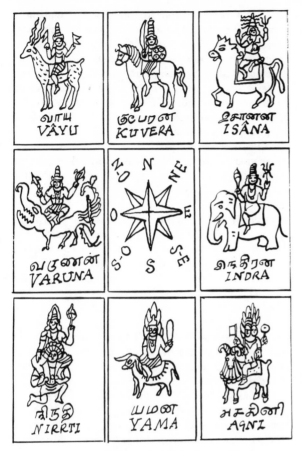

VĀYU / KUVERA / ISĀNA / VARUNA / INDRA / NIRRTI / YAMA / AGNI

Kaumārī, Cāṇḍikā (or Nārasiṁhī), Vārāhī, and Māheśvarī. Metaphysically they 'are the ruling deities of the eight passions of the human mind'.[1]

The Mothers have similar headdresses, symbols, ornaments and lower garments to those of their respective consorts.

[1]Bhattacharya, *Indian Images*, pt i, p. 42.

v. Saptamātara(s).

Aṣṭamūrti The eight (*aṣṭa*) forms of Śiva, viz., the five elements, sun, moon and the sacrificer. The world is a product of these eight forms and can only exist and fulfil its task when they co-operate.[1] The *aṣṭamūrti* may be represented by eight *liṅgas*. When portrayed as deities they are three-eyed and resemble Śiva, and carry his emblems.[2]

[1]*VS*, p. 41.

[2]*EHI*, II, pt ii, pp. 405f.

v. Mūrtyaṣṭaka.

Aṣṭanāga(s) The eight serpents who, with the goddess Manasā, are worshipped in Bengal during the rains and especially on Nāgapañcamī day which usually falls in the month of *śrāvaṇa* (July–August).[1]

[1]*DHI*, p. 346.

Aṣṭanidhi(s) The 'eight treasures (*nidhis*)' of Kubera depicted as eight jars full of coins.

Aṣṭasvasāras 'Eight Sisters', the eight aspects of Śiva's *śakti* divided into two groups of four, the first group containing the gentle aspects: Pārvatī, Umā, Gaurī and Jagadambī, the second the terrific forms: Kālī, Durgā, Cāmuṇḍā and Maheśvarī.

Aṣṭa-tālam A measurement in which ordinary human bodies are made eight times the length of the face. The latter is measured from the top of the forehead to the tip of the chin.

v. Tāla; Aṅgula.

Asthi 'Bone'. This is held by Śiva in some representations and also by Cāmuṇḍā and Durgā. It indicates the transitory nature of all life forms.

v. Asthimālin.

Asthimālin 'Having a necklace of bones', i.e. skulls. An epithet of Śiva.

Asthimañjūṣā 'Bone-basket'. A bowl-shaped receptacle for relics.

Asthisambhava 'Consisting of bones', i.e. the *vajra*, which was made from the bones of the *ṛṣi* Dadhyac the son of a fire-priest.

Aṣṭottaraśatalinga A *mānuṣaliṅga* with 108 miniature *liṅgas* carved on it.

Astra 'Missile', 'arrow' or 'weapon'.

v. Āyudhapuruṣa; Pāśupatāstra.

Astramantra A *mantra* consisting of the sound *phaṭ*, used to charm weapons, and to protect one against malevolent forces. It is also employed ritually for the

(N), Agni (SE), Nirṛti (SW), Vāyu (NW) and Īśāna (NE).

Aṣṭākṣara The eight-syllabled *mantra* of Viṣṇu uttered thrice daily to obtain liberation – '*Aum nama Nārāyaṇāya*'.

Aṣṭamahālakṣmī The 'Eight Mahālakṣmīs' – a group of Lakṣmīs, bringers of good fortune and prosperity.

Aṣṭamaṅgala The eight (*aṣṭa*) auspicious objects necessary for a great occasion such as a coronation which always included an overflowing vase representing abundance, a swastika signifying good luck, and vessels full of jewels representing prosperity, etc. Later the eight lucky objects were a lion, bull, elephant, water-jar, fan, flag, trumpet and lamp; or alternatively a brahmin, cow, fire, gold, ghee, sun, water and a king. In South India the eight objects are: a fan, full vase, mirror, goad, drum, lamp and two fish.

v. Maṅgala.

Aṣṭamātara(s) or **Aṣṭamātṛkā(s)** The 'Eight Mothers' – a group of eight mothers or *śaktis*, viz., Indrāṇī, Vaiṣṇavī, Cāmuṇḍā (or Śāntā), Brahmāṇī (Brāhmī),

purification and dedication of a devotee's body, and when worshipping deified weapons.

v. Āyudhapuruṣa.

Asura(s) I. 'Lord'. Very ancient demi-gods frequently mentioned in the Vedic period. Varuṇa is called the great Asura in the *Ṛgveda* (I.24,14), Savitar is identified with the golden-handed Asura (I.35,9), and Rudra is the Asura of mighty heaven (II.1,6), but Svarbhānu, one of the demons causing eclipses, is referred to as a descendant of Asuras (V.40,5ff.).

II. 'Anti-god'; 'demon'. The last meaning was in general use from the late Vedic period onwards.[1] The Asuras then came to represent the opposite of everything the gods stood for.

The Asuras have large, terrifying, round eyes, surmounted by curling brows, huge distorted ears and heavy tusks. They are usually four-armed, each hand carrying weapons. They wear many ornaments including the *kirīta*.

The Asuras frequently fought the gods, yet were said to be the elder children of the creator Prajāpati, the gods (*devas*) being the younger children (*Bṛhadāraṇyaka Up.*, 1.3,1). 'The common descent of antagonistic figures constitutes one of the favourite themes to illustrate the primordial unity-totality.'[2]

Daniélou[3] suggests that the term *asura* could 'come from the . . . root *as*, meaning "to frighten away", and thus represent the fearful aspect of deities. The name is undoubtedly of Indo-Iranian origin.'

Among the Asuras are included *rākṣasas*, *piśācas*, *nāgas*, *daityas*, *dānavas* and others.

[1]*Facets*, p. 159.
[2]Eliade, *A History of Religious Ideas*, I, p. 204.
[3]*HP*, p. 140.

Aśva, **Haya** or **Vājin** 'Horse'.[1] A symbol of energy and of luminous deities, especially the sun, and hence seven golden horses pull the sun-god's chariot. The horse was all-important to the nomadic tribes of the Aryans and hence much symbolism became attached to it.

A horse is the vehicle of Kubera, Revanta, Aiyanār, Śukra, and a white horse is the vehicle of the future *avatāra* Kalkin and of Mallārī-Śiva. The mooncoloured horse Uccaiḥśravas is the mount of Indra. In the *Ṛgveda* bay horses are associated with him, as well as the horse-headed solar Viṣṇu Hayaśiras.[2]

The head of a horse is particularly potent and sacred and signifies knowledge (*jñāna*). A charger symbolizes military strength.

[1]*Aśva* means literally 'pervader' (*HP*, p. 128).
[2]*HP*, p. 128.

v. Aśvaratna; Hayaśiras; Hayagrīva; Aśvamukha(s); Aśvinīkumara.

Aśvamastaka 'Having a horse-head'. Hayagrīva is

depicted with a horse-head, or with a human head having one or more miniature horse-heads in the hair.

Aśvamukha(s) 'Horse-faced'. Celestial musicians having human bodies and horse-heads.

Aśvamukhī Mare-headed *yakṣīs*, depicted on an erotic frieze at Aihole. They are the familiar Indian 'nightmares' who carry men off for sexual purposes.

Aśvaratna 'Horse-treasure' – a charger symbolizing military power and a sign of a universal monarch (*cakravartin*).

Aśvarudha A form of Devī depicted riding a horse and carrying a golden cane. She has three eyes; on her crown there is a crescent moon.[1]

[1]*EHI*, i, pt ii, p. 371.

Aśvattha The tree (*Ficus religiosa*) sacred to both Viṣṇu and the historical Buddha. The *aśvattha* was worshipped during the Indus civilization. It is the eternal tree of life and the abode of a deity, as well as being a cult object. The male element[1] in fire is represented by the *aśvattha*.

[1]*EM*, p. 6.

v. Vṛkṣa.

Aśvin(s) 'Possessing horses'.[1] Two very early pre-Vedic gods who know all the secrets of plant life. They became the physicians of the gods, and the guardians of the divine nectar (*amṛta*).

The Aśvins are seldom depicted and then only as part of other compositions. They are represented as horse-headed human figures and are sometimes placed on either side of Sūrya. At other times they are shown as handsome youths adorned with lotus garlands riding in a three-wheeled chariot drawn by speeding horses, by flying birds, winged steeds, or by buffaloes. One Aśvin carries a book, the other a water-jar or a vessel containing *amṛta* or curative drugs (*oṣadhipātra*).

The *Aṃśumadbhedāgama* describes them as two-armed and horse-faced and seated together on a lion seat (*siṃhāsana*). Each wears a sacred thread, many ornaments, garlands of yellow flowers and a *jaṭā-makuṭa*. Their colour is red; their eyes lotus-shaped; their *mudrā*, *abhaya*. They are accompanied by two goddesses holding fly-whisks. The *Suprabhedāgama* states that they should wear white garments and turbans.

Sometimes the Aśvins are said to be 'personifications of *prāṇa* and *apāna*, the two vital airs which sustain animal life'.[2] They are also associated with marriage and with protecting their worshippers from distress, disease, and the 'arrow' of death. They represent the third social class (*viś*) (agriculturists and merchants). Rams, being symbols of fertility, are sacred to the Aśvins.

[1]But the *Nirukta* states that they were so called because

they pervaded everything (*vyaśnuvāte*), one with moisture, the other with light.

[2]*EHI*, II, pt ii, p. 543.

Aśvinī 'Mare'. The wife of the twin Aśvins, later said to be their mother.

Aśvinīkumara The 'mare's boys'. An epithet of the twin Aśvins, their mother Aśvinī having assumed the form of a mare when they were born.

Atapatra A 'large umbrella'.

v. Chattra.

Atharvaveda v. Veda.

Atibhaṅga Name of a standing position where the body is very bent denoting violent motion or dynamic action, as in some of the dancing figures of Śiva. It is a more extreme form of the *tribhaṅga*.

v. Āsana.

Atiraktāṅga An aspect of Bhairava sculptured in one of the Ellora cave temples. He is represented as a skeleton-like figure. Seated nearby, and holding his leg, is the emaciated figure of Kālī.

Ātman The non-material indestructible vital essence or principle of life, which remains the same throughout the series of lives. It is present in all creatures, persons and things.

Atri 'Eater', 'devourer'. Name of one of the seven mythical sages or *ṛṣis*, all of whose names were originally epithets of fire, which possibly explains the magical potency of Atri's name, as even the gods have 'no alternative but to make effective such prayers as are either associated with Atri's name or are composed according to the pattern evolved by Atri'.[1]

Atri sprang forth from Brahmā's eyes, and although destroyed by Śiva's curse, was reborn from the flames of a sacrifice performed by Brahmā. Atri signifies the power of detachment.[2]

[1]Rahurkar, *Seers of the Ṛgveda*, p. 62.

[2]*HP*, p. 323.

AUM v. OM.

Āvāhana Ceremony of invocation to prepare an image for worship (*pūjā*).

Āvāhanamudrā 'Invocation' *mudrā* in which both hands are joined but outspread with the thumbs joining the lowest knuckle of the ring-finger.

Āvaraṇadevatā(s) General name for minor divinities placed in the precinct (*āvaraṇa*) of a shrine or temple, the main cult images being in the 'Holy of Holies' (*garbhagṛha*). The artistic treatment of the *āvaraṇadevatās* is more spontaneous and relaxed than that of the cult images in the depiction of which the artist is bound by canonical regulations.

Avataṅsa 'Garland', 'ear-ornament', or a flower placed behind the ear.

Avatāra 'Descent', a divine incarnation, which 'descends' to earth in bodily form to protect gods, priests, holy men, and all creatures from evil, and to safeguard the teaching (*Bhāgavata Purāṇa*, 8,24,5).

The term *avatāra* is usually applied to the incarnatory forms of Viṣṇu, and sometimes to the twenty-eight aspects or forms (*mūrtis*) of Śiva. Although there are said to be innumerable incarnations Viṣṇu's main *avatāras* are: Matsya (Fish), Kūrma (tortoise), Varāha (boar), Narasimha (man-lion) – an intermediate creature between man and beast, Vāmana (dwarf), Paraśurāma, Rāmacandra, Balarāma, Kṛṣṇa, and the historical Buddha. The last four represent the qualities of outstanding men. Kalkin is the future incarnation who will appear at the end of the present age.

v. Amśa; Āveśāvatāra; Vibhava.

Āveśāvatāra A temporary incarnation (*avatāra*) such as Paraśurāma. Great *ṛṣis* and *munis* thus are said to be 'possessed' (*āveśa*) of god-given power.[1]

[1]*EHI*, I, pt i, pp. 120f.

v. Amśa.

Avis 'Sheep', identified with the earth and sacred to Varuṇa.

Avyakta Natural objects venerated as cult objects, such as the *śālagrāma* pebbles sacred to Viṣṇu, and the white stones (*bāṇaliṅga*) sacred to Śiva.

v. Vyaktāvyakta.

Avyaṅga 'Girdle'. Name of a girdle deriving from the woollen thread worn round the waist by Zoroastrians. The sun-god's girdle is called *yāvīyāṅga*.

Ayāgapaṭṭa A sculpture plaque used for worship.

Ayaḥśūla 'Iron lance'. Lances are carried by Śaiva devotees.

Ayodhyā Name of an ancient city on the banks of the Gogra river, and one of the seven Hindu sacred cities. To die there ensures eternal bliss.

Ayonijā 'Not born from a womb'. An epithet of Sītā who was 'born' from a plough-furrow.

Āyudha(s) A general name for weapons, and of Indra's bow in particular. The various weapons of the gods are personified and commonly called *āyudhapuruṣas*.

Āyudhapuruṣa or **Śastradevatā** A weapon of the gods represented anthropomorphically. These personifications have a place in ritual and in ceremonies for protection. Sometimes they are regarded as a partial incarnation (*amśa*) of the activity of the deity with whom they are associated.

The personified weapons should be depicted as two-armed figures and wearing the *karaṇḍamakuṭa*. The weapon they represent is usually shown behind them, or in their hands, or on their heads. When in the last position the hands of the *āyudhapuruṣa* should be in *añjali mudrā*.[1]

The most common of the *āyudhapuruṣas* is the

personified discus (*cakra*) of Viṣṇu, which is described in the *Viṣṇudharmottara* as a round-eyed, fat male figure, with drooping belly. Sometimes he holds a fly-whisk (*cāmara*).

The sex of the personified weapons are determined usually by the gender of the word denoting them, but *cakra* which is neuter should be shown as a eunuch, yet in late Gupta and medieval art it is depicted as a male. The masculine personified weapons have the word *puruṣa* (man) added, e.g. *cakrapuruṣa*, and female ones have *devī* (goddess) added, e.g. *gadādevī*. The personified club (*gadā*) is depicted as a beautiful woman wearing a long garland, necklace, bracelets and jewelled head-dress. She holds a club and sometimes a fly-whisk. A number of other weapons and emblems are also personified in late iconographic texts, including the spear (*śakti*) depicted as a female, red in colour, and seated on a wolf (*vṛka*); the staff or rod of punishment (*daṇḍa*) is portrayed as a black, red-eyed man of fearsome countenance; the sword (*khaḍga*) is a dark-complexioned man; the noose (*pāśa*) is denoted by a seven-hooded snake; the banner (*dhvaja*) as a strong, yellow-complexioned man with open mouth; the trident (*triśūla*) as a dark-complexioned handsome man; the conch-shell (*śaṅkha*) as a white male with lovely eyes; the hatchet (*heti*) as a woman; the sling for throwing stones (*bhindi*) as a man; the arrow (*bāṇa*) as a fine-eyed male with a red body, but according to the *Vaikhānasāgama* the arrow should be shown as a three-eyed, black eunuch dressed in white. The personified bow (*dhanus*) is portrayed as a female figure with a stringed bow on her head.

A *cakrapuruṣa* found at Sharishadaha, Bengal (now in the Asutosh Museum, Calcutta), is carved on both sides with the same device – a four-armed figure dancing on the shoulders of Garuḍa in the centre of a beautifully carved wheel (*cakra*), the spokes consisting of twelve carved lotus buds. The front hands of the personified *cakra* beat out the time of the dance; the back hands hold a discus and mace. This discus is emblematic of Viṣṇu and is said to be partly endowed with his character, and hence it became an independent cult symbol.

[1]*EHI*, I, pt i, pp. 288f.

v. Śudarśana; Gadā.

B

Badami A village in the Bijapur district of West India, famous for its Vaiṣṇava and Śaiva cave temples. Origi-

nally it was known as Vatapi, capital of the early Western Calukyas.

Badarī I. The ju-jube tree (*Zizyphus jujuba, Lam.*) in which dwells the goddess Durgā. Viṣṇu has the title Lord of Badarī.

II. Name of a place in the Himalayas sacred to Viṣṇu in his dual form of Nara-Nārāyaṇa.

Bagalā I. 'Deceitful'. The designation of cranes, said to be the most deceitful of birds.

II. Name of the eighth *mahāvidyā*, the crane-headed goddess (also called Vīrarātrī) who represents the power of cruelty, black magic, poison and all destructive forces. She embodies the secret desire to kill, which is often unrecognized by the individual, yet colours his or her actions – a desire reflected in the heart of every living being. Bagalā rules over the subtle perception which makes us feel distant from the death or misery of our fellow beings. 'She incites men to torture one another . . . [and] revels in suffering.'[1] She is described as two-armed. Her right hand grasps the tongue of an enemy whilst the left tortures him. Her garments are yellow, her weapon is a club.

Originally Bagalā was an ancient folk or village goddess (*grāmadevatā*) later identified with Durgā.
[1]*HP*, p. 283.

Bahurūpa One of the eleven Rudras (*ekādaśarudra*) whose emblems include a drum, discus, snake, trident, goad, rosary, bell, skull-cup, skull-topped staff, water-vessel and bow. His *mudrā* is *tarjanī*.

Bāhuvalaya 'Armlet', 'bracelet', worn by men and women. It is usually plain, but is sometimes decorated, or it may be shaped like a snake (*nāgavalaya*) with its tail in its mouth. The snake signifies cyclic time. The terrific forms of Śiva wear these armlets and also Garuḍa.

Bajibandha A band of beads worn above the elbow.

Baka 'Heron'. A bird-shaped *asura* symbolizing treachery and vanity.

v. Bakāsuravadha.

Bakāsuravadha The 'killing of the *asura* Baka' – a heroic deed performed by Kṛṣṇa.

Bakula or **Vakula** Name of Śiva and of the tree (*Mimusops elengi*) with which he is identified. A *yakṣa* named Candramukha is also said to dwell in it.

Bakura A horn, trumpet, or other wind instrument used to rally troops in battle. The twin Aśvins blew the *bakura* to frighten away the *dasyus* during the advance of the Aryan invaders.

Bāla 'Child', often associated with the mother-goddesses, including Ambā, Ambikā, Durgā, Hārītī and Ṣaṣṭhī.

v. Bāla-Kṛṣṇa.

Bālā A four-armed form of Devī. She has a red

complexion and is seated on a lotus throne. Her emblems are a rosary and book; her *mudrās* the *abhaya* and *varada*.[1]

[1]*EHI*, I, pt ii, p. 372.

Balabhadra 'Whose strength is good'. An epithet of Balarāma.

Baladeva v. **Balarāma**.

Bāla-Gaṇapati Gaṇeśa (Gaṇapati) portrayed as a four-armed child (*bāla*) holding a mango (*āmraphala*), a sugar-cane symbolizing fertility, a banana or plaintain, and a fruit of the Jaka tree (*Artocarpus integrifolia*). In his trunk he holds a wood apple (*Feronia elephantum*).

Bāla-Kṛṣṇa Kṛṣṇa depicted dancing, or as a chubby, naked child (*bāla*) crawling on all fours and holding a pat of butter in one hand, the other resting on the ground. Sometimes he wears a small fancy cap and a few simple ornaments.

Kṛṣṇa is the only incarnation (*avatāra*) of Viṣṇu to be worshipped as a child, as a youth and as a lover, all 'forms fit for exhibiting the various kinds of *bhakti* or love'.[1]

[1]*EHI*, I, pt i, p. 215.

v. Vaṭapattraśāyin.

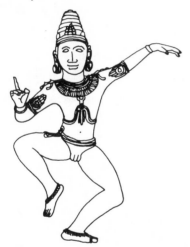

Bālāmbikā 'Girl-mother'. A goddess identical with Kanyā Kumārī and highly esteemed by South Indian Tantrists.

Balapramathanī 'Destroying power'. An aspect of Devī portrayed as reddish or white and carrying a skull-cup and noose.[1]

[1]*EHI*, I, pt ii, p. 364.

Balarāma 'Rāma the strong', or Baladeva the 'god of Strength', the elder brother of Kṛṣṇa. Balarāma is a 'partial' *avatāra* of Viṣṇu, or of Ananta.[1]

Balarāma is rarely worshipped. His image is seen only in company with Kṛṣṇa, on whose right side he stands as befits an elder brother. Both he and Kṛṣṇa

appear to have been historical figures who became identified with agricultural deities. In the *Viṣṇu Purāṇa* Balarāma appears as a culture hero associated with irrigation, viticulture and agriculture. Metaphysically he represents the destructive power of Time (*kāla*).

Balarāma is depicted as fair, strong, and two-armed. He holds a plough and pestle, and wears the usual Vaiṣṇava crown and ornaments, except that he has only one earring. When he is portrayed with four arms he carries a pestle in the back right hand and a discus in the front right; the back left hand carries a plough, the front left a conch.

Just before his death as he sat in meditation beneath a tree on the ocean shore, the serpent Ananta emerged from his mouth and glided towards the ocean from whence the Ocean god rose with offerings to meet him. The snake represents Balarāma's life-essence returning to the waters – the non-manifested substratum in which everything exists *in potentia*, and to which every manifested thing returns. 'In India the serpent and the saviour are two basic manifestations of the one, all-containing, divine substance. And this substance cannot be at variance with either of its polarized mutually antagonistic aspects. Within it the two are reconciled and subsumed'.[2]

[1]Some Vaiṣṇavas do not regard Balarāma as an *avatāra* of Viṣṇu and his place is taken by the Buddha.

[2]*Myths*, pp. 89f.

v. Revatī II; Devakī; Aṃśa.

Bāla-Subrahmaṇya The 'child (*bāla*) Subrahmaṇya (Skanda)'. He is depicted dancing and holding a lotus. His *mudrā* is *varada*. This image resembles that of the child Kṛṣṇa dancing (Navanītanṛtta-Kṛṣṇa), except that Bāla-Subrahmaṇya's left leg and not the right is raised.

Bālasvāmin A form of Skanda as a child (*bāla*) standing by his parents. When portrayed alone he may hold a lotus in his right hand with his left resting on his hip (*kaṭyavalambita*).[1]

[1]*EHI*, II, pt ii, p. 439.

v. Somāskandamūrti.

Balavikarṇikā 'She who is deaf to power'. Name of a benign goddess who represents the gentle aspect of Durgā. Her emblems are a rosary and skull-cup (*kapāla*).

Bali I. An *asura* king and son of Virocana. Bali had gained dominion over all the gods and worlds by his valour and asceticism (*tapas*). Then Viṣṇu, at the request of the gods, assumed his dwarf incarnation (*vāmanāvatāra*) and requested Bali to grant him the land he could cover in three strides. Bali agreed, and immediately the dwarf grew into a vast figure and in two steps had covered the whole world. He placed his

third step on Bali's head and sent him down to reign over the nether regions. In sculptures depicting this scene Bali and his wife Vindhyābalī are portrayed granting the land to Vāmana. Bali holds a golden vessel indicating that he is about to pour the water ceremonially in proof of his gift.[1] He wears a loin-cloth (*kaupīna*) and a ring of sacred *kuśa* grass.

[1]*EHI*, I, pt i, p. 166. An image of Bali should measure 120 *angulas* in height (*Bṛhat Saṃhitā*, ch. 57).

v. Trivikrama; Vāmanāvatāra.

II. A technical term for an offering of grain or rice to particular gods, household divinities, spirits (*bhūtas*), birds, animals, and inanimate objects. The *bali* offering is part of the daily worship carried out by householders.

Balibera Name of an image in a temple to which offerings (*bali*) are made during daily worship.

Balipīṭha A stone altar in the shape of a lotus flower, erected at the main entrance of a temple, and on which offerings (*bali*) of rice are placed.

Bāṇa 'Arrow', 'short stick'. A bow and arrows are carried by a number of Viṣṇu's incarnations (*avatāras*) particularly Rāma, and an arrow *inter alia* is carried by the fierce form of Śiva called Kaṅkāla. Five flower arrows are associated with Kāma, the god of love. Indra's arrow has a thousand feathers and a hundred barbs.

Arrows were believed to bring disease and death, and hence the twin Aśvins (the physicians of the gods) were urged to deflect them. In many cultures arrows have phallic significance. In India they are used in rites to ensure male offspring. Śiva's arrow and *linga* are identical, being vehicles of his energy.[1]

The bow and arrow symbolize the power and strength belonging to heroic warriors, and hence Indra's arrow embodies the force necessary for victory. His consort Indrāṇī also represents divine power and is called the 'goddess of arrows'.

[1]*Myths*, p. 186.

Bāṇaliṅga Egg-shaped white stones found in the Narmadā river and worshipped as an aniconic form of the *linga* of Śiva. Being small, these stones are intended for individual worship at home, or they may be carried on the person as amulets.

Bandha or **Bhāra** A term applied to a head-dress.

v. Keśabandha.

Barabar (Bihar) The situation of a number of caves excavated from the granite hills on the bank of the Phalgu River, some sixteen miles from Gaya. One of the caves was carved out during the reign of Aśoka.

Baṭuka- (or **Vaṭuka-**) **Bhairava** A *ugra* form of Śiva depicted as a hideous nude youth (*baṭuka*) usually accompanied by a dog. His expression is fierce and fang-like teeth or tusks protrude from the corners of

his mouth. His eyes are round and rolling, his hair stands on end. He may have two or four arms, or eight arms with snakes as ornaments. He wears wooden sandals, and may wear a skull-garland or garland of small bells, a skull-girdle and heavy circular earrings. Sometimes he holds a severed human head which is licked by his dog.

The *Sāradātilaka Tantra* (ch. 20, p. 59) describes the *sāttvika*, *rājasika* and *tāmasika* aspects of Baṭuka (v. Guṇa(s)). The *sāttvika* image shows a naked, fair young deity with joyful face and beautiful ornaments, carrying a trident and staff. This aspect is said to prevent unnatural death among his devotees. The *rājasika* image depicts a resplendent smiling god adorned with a blood-red garland and wearing an elephant hide. His four hands hold a trident and skull, and show the *abhaya* and *varada mudrās*. The *tāmasa* or *tāmasika* image portrays him as blue and naked, wearing a garland of skulls, and holding in his eight hands a drum, goad, sword, lasso, snake, bell and skull. One hand is in *abhaya* pose. His ornaments are snakes. The dog is not mentioned.[1]

[1]*Iconog. Dacca*, pp. 133f.

v. Bhairava; Ghaṇṭā; Svarṇākarṣaṇa-Bhairava.

Bel v. Bilva.

Bera A body or effigy; an icon.

v. Rūpa.

Bhadra 'Auspicious', 'fortunate'. An epithet of Śiva, Mount Meru, etc.

Bhadrā 'Auspicious'. A name of the goddess Lakṣmī who is depicted on a lotus plinth, a characteristic of many deities especially during the Gupta and post-Gupta periods. Bhadrā's emblems are a rosary, blue lotus, trident, and a fruit of some kind, the last indicating the fertility of the plant world.

Bhadraghaṭa 'Vase of fortune' associated with Lakṣmī, goddess of good fortune. (Cf. the Greek and Roman cornucopia.)

v. Kamaṇḍalu; Kalaśa; Bhadrakumbha; Kumbha.

Bhadra-Kālī I. Originally a nature-goddess, later adopted by Śaivas. She emerged from Umā's wrath when her husband Śiva was insulted by Dakṣa who had omitted to invite him to attend his ṣacrifice.

Bhadra-Kālī is the terrific form of Pārvatī and is worshipped by those who wish to harm their enemies. Small tusks protrude from the corners of her mouth indicating danger and destruction. Her hair flames upwards, and sometimes her head is encircled with a row of skulls. She carries various weapons in her twelve (or eighteen) hands – weapons which protect her devotees from all dangers. She therefore shows the fear-dispelling *abhaya mudrā*. Her mount is a lion, or a chariot drawn by four lions. She is three-eyed, and holds fire, rosary, moon, rod, bow and arrow, water-vessel, sword, skin of a black antelope, lotus, spear, conch-shell, two sacrificial spoons (*sruk*, *sruva*), trident, etc.

II. Name of one of the mothers (*mātṛs*) attendant on Skanda.

Bhadrakumbha The 'auspicious jar (*kumbha*)'. A gold jar used solely for the consecration of kings (*abhiṣeka*).

Bhadrapīṭha v. Bhadrāsana.

Bhadrāsana or **Bhadrapīṭha** I. An 'auspicious seat', or the name of a rectangular seat or throne. Its height is divided into sixteen parts,[1] sixteen symbolizing perfection and totality.

[1]*EHI*, I, pt i, p. 20.

II. A sitting (*āsana*) posture with 'the heels of the legs, which cross each other . . . placed under the testes and the two big toes of the feet are held by the hands'.[1] This posture is said to bring material wealth.

[1]*DHI*, p. 270.

Bhaga Name of a Vedic deity, an Āditya son of the cosmic mother-goddess Aditi. He dispenses wealth, booty, and other boons, and personifies the ancient Aryan custom of annually dividing tribal property among the adult males. To receive a share denotes full membership of the tribe and hence the honorific Bhagavant (holder of a share).

Edgerton[1] regards Bhaga as Fortune personified, but Yāska states that he is the presiding deity of the afternoon. His emblems are a discus, two lotuses and a trident. His wife is Siddhi.

[1]*Beginnings of Indian Philosophy*, p. 115.

Bhagavadgītā The 'Lord's Song', that is the song of Lord Kṛṣṇa which forms part of the sixth *parvan* of the Epic *Mahābhārata*. Its extraordinary success derived from its new doctrine of *bhakti* which 'suited the feudal ideology perfectly. Loyalty links together in a powerful chain the serf and retainer to feudal lord, baron to duke or king.'[1]

[1]Kosambi, *The Culture and Civilisation of Ancient India*, p. 208.

Bhagavān 'Lord'. An epithet of Viṣṇu, Kṛṣṇa, and sometimes of Śiva. As an appellation for a deity it ranks higher than *deva*.[1]

[1]*ID*, p. 26.

Bhagavant v. Bhaga.

Bhāgavata 'Relating to or coming from Bhagavān', i.e. Kṛṣṇa. Name of a theistic cult, and a member of it. The importance of worship is stressed rather than sacrifice.

Bhagavatī 'The Lady'. A benign aspect of Pārvatī (Devī) who embodies the combined energies of Śiva, Viṣṇu and Brahmā.

Bhagīratha A son of Dilīpa and great-great-grandson of Sagara, a legendary king of Ayodhyā. The *Viṣṇu Purāṇa* relates how Bhagīratha guided the celestial Ganges down to earth and into the sea, and hence the Ganges is also known as Bhāgīrathī.

Bhāgīrathī v. Bhagīratha.

Bhairava I. 'Terrible'. Name of one of the fierce (*ugra*) aspects of Śiva when he destroyed the three cities of the *asuras*.

Bhairava is usually depicted accompanied by a dog or riding on one, hence his epithet Śvāśva 'whose horse is a dog' (*śvan*). He is probably the same as the village-godling Bhairon who is worshipped in the form of a black dog, or of a red stone.

Bhairava is specially worshipped by outcaste groups, and the association with dogs probably stems from Manu's rule that only outcastes should be allowed to keep dogs and asses. Bhairava is also the name of the southern face of the five-faced Śiva.

A wolf (*vṛka*) may sometimes accompany Bhairava instead of a dog. His *mudrā* is *kaṭaka*; his emblems a skull-cup, skull-topped club, bracelets, fire, a tiger or elephant skin, short javelin, drum, snakes, trident and garland of skulls.

Bhairava has eight main forms, viz., Asitāṅga, Ruru, Caṇḍa, Krodha, Unmatta, Kapāla, Bhīṣaṇa and Saṃhāra, each of which is divided further into eight minor forms, making sixty-four in all. Those headed by Asitāṅga should be golden-coloured with good physique and carry a trident, drum, noose and sword. Those presided over by Ruru are pure white, wear ornaments set with rubies, and carry a rosary, goad, manuscript and *vīṇā*. Caṇḍa's group are blue, and carry fire, spear, club and a bowl-shaped vessel (*kuṇḍa*). Krodha's group are smoke-coloured, and carry a short and a long sword, shield and axe. Unmatta's are white and handsome, and carry a *kuṇḍa*, shield, club (*parigha*) and a short javelin (*bhindipāla*). Kapāla's and Saṃhāra's groups are red, and the colour of lightning respectively. They carry the same weapons as

Unmatta's group.[1]

[1]*EHI*, II, pt i, pp. 180f.

v. Bhairavī.

II. There are a number of terrifying spirits called *bhairavas* who, with ghosts (*pretas*), demons (*bhūtas*), vegetal spirits (*śākinīs*) and others, are attendant on Śiva. Sometimes the *bhairavas* are regarded as different aspects of Rudra-Śiva.

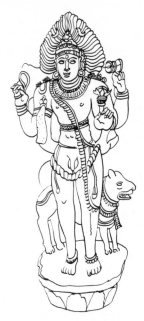

Bhairavī 'Terror', or the 'power to cause terror'. Name of a goddess, the sixth *mahāvidyā* (represented as Kāla-rātrī), and one of the ten personifications of Śiva's energy. Bhairavī is red-complexioned and holds a noose and goad. She may have twelve arms.

Bhairavī represents the silent, inevitable power of death which begins with conception and continues through life: therefore she is popularly regarded as a demoness.

v. Bhairava.

Bhairon (Hindi) A village godling, the personification of a field spirit, who later became 'the only form of the god [Śiva] recognized by particular peasant communities . . . in northern India'.[1] Bhairon is connected with the cult of dogs.[2]

[1]*ERE*, II, p. 539.

[2]*ID*, p. 37.

v. Bhairava.

Bhakta(s) Particular Śaiva and Vaiṣṇava devotees whose images may be set up in temples. They may be represented anthropomorphically, or in the case of Śaiva *bhaktas* as *liṅgas*, or occasionally as Śiva himself. Vaiṣṇava *bhaktas* are usually portrayed as they were

in life and sculpted according to the *aṣṭa-tāla* measure. Their hands may be in *añjali* pose, or carrying an object associated with them. A monarch who is a *bhakta* should be portrayed wearing a *kirīṭa* or *karaṇḍamakuṭa*.[1]

[1]*EHI*, II, pt ii, p. 475. For a list of Śaiva and Vaiṣṇava *bhaktas* v. ibid., pp. 475f.

v. Bhakti; Ālvār(s); Kaṇṇapa-Nāyanār.

Bhakti 'Devotion', 'worship'. Concentrated or ecstatic adoration of one's chosen deity (*iṣṭadevatā*).

Bhakti is represented allegorically by the intense love of Kṛṣṇa and Rādhā. The *Bhagavadgītā* emphasizes the importance of *bhakti* which now permeates every Vaiṣṇava and Śaiva cult.

v. Bhakta.

Bhakti-Vighneśvara An aspect of Gaṇeśa depicted as white and with four arms. He holds the following emblems: a mango, bowl containing rice and milk, a coconut, and a piece of sugar-cane.

Bhālacandra 'Having the moon (*candra*) on his forehead'. Name of an aspect of Gaṇeśa. The moon indicates his association with Śiva who also bears a crescent moon on his head-dress.

Bhāmaṇḍala 'Aureole, circle of light', shown round the figures of some gods. Probably it is the same as *prabhāmaṇḍala*.[1]

[1]*ID*, p. 37.

Bhaṅga I. Also called *vijayā*. Hemp (*Cannabis indica*), a plant and narcotic drug commonly called *bhang*, said to be one of the 'five kingdoms of plants' ruled by Soma.

II. 'Bending'. A term referring to particular positions in which a standing human body may be depicted.

v. Ābhaṅga; Tribhaṅga; Dvibhaṅga.

Bhānu 'Light' or 'shining'. An epithet of the sun-god Sūrya.

Bharata I. Name of Rāma's half-brother, sometimes regarded as a partial (*aṃśa*) *avatāra* who represents the personified discus (*cakra*) of Viṣṇu. His emblems are a bow, arrow, sword and shield.

v. Bhārata I; Śatrughna.

Bharata II Name of an ancient sage, said to be the author of the Bharatanāṭya-śāstra.

Bhārata I. A descendant of Bharata, a tribal group prominent in Vedic times.

v. Bhāratī; Mahābhārata.

II. The modern name for India.

Bharatanāṭyaśāstra 'The dance of Bharata'. A standard work on classical Hindu dancing and drama, attributed to the ancient sage Bharata. It states that Śiva performed 108 varieties of dance at different places and on various occasions. Of the 108 there are nine main varieties: (1) corresponds to the Naṭarāja figure,

and is also known as Ānanda tāṇḍava 'dance of ecstasy'; (2) Tāṇḍava, the dance Śiva performed on the burning ghats; (3) Nādānta, similar to Naṭarāja figure except that Śiva stands on his left leg with the right leg raised; (4) similar to Naṭarāja except for the hair-style and head ornaments – in this form Śiva's hair flies outwards forming a halo or circle round his head. Varieties 5, 6, 7, and 8 are similar and may be grouped together. In 5, he has two eyes and eight arms; the right hands carry a trident, rope, noose and drum respectively – the lowest hand is in *abhaya mudrā*; the left hands hold a flame of fire, a skull and a bell, with the lowest arms in *gajahasta mudrā*. In 6, he has two eyes and sixteen hands; the right hands hold a drum, thunderbolt, trident, rope noose, chisel, staff and a snake – the lowest hand is in *abhaya mudrā*; the left hands carry a flame, sword, mace, banner, skull and bell, with the lowest arm stretched across the body in *gajahasta mudrā*. The seventh form has three eyes and eight arms, the two lower arms on the left being in *gajahasta mudrā* (it is unusual to have two arms in this position). The eighth dance pose is the same as the seventh except that the god has only six arms. The ninth form differs considerably from the rest, as Śiva here has four arms and the usual emblems, but there is no demon beneath his feet and he stands on a bare plinth; the left leg rests on the plinth and his right leg crosses over below the left knee so that the toes of the right foot rest on the plinth near the left foot.

Bhāratī A minor Vedic goddess who represents eloquence and hence is often associated with the goddesses Sarasvatī and Iḷā. All three personify various aspects of worship.

Bhāratī became the tutelary deity of the Bhāratas. She is sometimes mentioned as one of Gaṇeśa's consorts.

In the Śākta cult Bhāratī is a name of the four-armed goddess Mahāsarasvatī whose emblems are a rosary, an elephant-goad, a musical instrument and a manuscript.

Bhārgava-Rāma An epithet of Paraśurāma as the offspring of Bhṛgu (patronymic Bhārgava).

Bhāskara 'Making light'. An aspect of the sun-god Sūrya whose mount is a horse (a solar animal in many mythologies), or he is seated in a chariot drawn by seven horses.

Bhasman Sacred ash, said to be the *semen virile* (*vīrya*) of Śiva. Burning reduces substances to their pure primal state, and thus ashes are regarded as a pure substance.

v. Vibhūti II; Bhasmasnāna.

Bhasmasnāna 'Ash-bath', a ceremony said to be a remedy for all ills, and instituted by Śiva when he

'bathed' in the ashes of Kāma the god of love.

v. Bhasman.

Bhauma I. Also called Maṅgala. The personification of the planet Mars and one of the Nine Planets (*navagrahas*). Tuesday is named after him. In single figures Bhauma is represented with four hands. The two back hands carry a thunderbolt and stick, the two front hands are in *abhaya* and *varada mudrās*. His mount is a goat; his golden chariot is octagonal and drawn by eight red horses who sprang from fire. The fire and the red horses represent fury, and the blood spilt in battle. He may carry a spear, or a club and trident.

II. A magical weapon.

Bhava 'Existence', 'becoming'. Name of one of the eight elemental forms of Rudra-Śiva representing the watery element. Bhava is a peaceful (*saumya*) form, Lord of cattle and of men, and protector of the seven worlds. He married Satī, a daughter of Dakṣa.

Bhava is always closely associated with Śarva. When shown as attendant on Śiva he is equated with Parjanya, god of rain.[1]

[1]*HP*, p. 205, and v. *ŚBr.*, VI.1,3,15.

v. Bhavānī; Mūrtyaṣṭaka.

Bhavānī 'Giver of existence'. A goddess, the consort of Bhava. Bhavānī is also the popular name of the great goddess Devī in the Śākta cult.

Bheka 'Frog'.

v. Maṇḍūka.

Bheraghat (Madhya Pradesh) situated some thirteen miles from Jabbalpur. It has a large tenth-century temple containing sixty-four *yoginī* figures and images of the *mātṛkās*, etc.

Bhikṣāpātra 'Alms-bowl' (sometimes confused with the *kapāla*). It indicates the mendicant aspect of particular gods such as Brahmā, Bhikṣāṭanamūrti, Gaṇeśa and others.

Bhikṣāṭana(mūrti) A form (*mūrti*) of Śiva as a naked beggar accompanied either by a dwarf who carries an alms bowl (*bhikṣāpātra*), or by a wild animal (*mṛga*).

Having cut off one of Brahmā's heads Śiva became guilty of the terrible crime of brahminicide. Brahmā's skull stuck fast to the palm of his hand until he expiated his crime by living the life of a beggar for many years.

Sometimes his hair stands on end, or is arranged in a large *jaṭābhāra*. A bell is tied to his right leg indicating that he is outside the Vedic religion. He carries a staff with the bones of Brahmā and Viśvaksena attached to the top. Snakes encircle his body. He carries

a skull-cup and a drum, and sometimes a small bunch of peacock feathers. A dog accompanies him.

v. Kaṅkālamūrti; Śvan.

Bhīma I. 'Tremendous', 'fearful'. Name of one of the eight elemental forms of Rudra, the presiding deity of space (*ākāśa*).

II. A prince, the second of the five sons of *Pāṇḍu*, the chief heroes of the *Mahābhārata*. Bhīma was a powerful man and a heroic warrior. He is said to be the spiritual son of the wind-god Vāyu, and is venerated because of his enormous strength. His emblem, the mace, symbolizes the strength needed to crush enemies.

Bhīmādevī A terrifying goddess, the consort of Īśvara (Śiva). A dark blue rock in a mountain shrine in Gandhara was supposed to represent her.[1]

[1]Watters, *On Yüan Chwang*, vol. I, pp. 221f.

Bhindi A sling or 'catapult'.

Bhindipāla A short javelin or arrow shot through a tube, and emblematic of Bhairava, Nandīśa, Nirṛti, etc.

v. Āyudhapuruṣa.

Bhiṣaṇa v. Bhairava.

Bhoga 'Enjoyment', 'wealth'. A class of Vaiṣṇava images of which there are four varieties. The *bhoga* aspect of Viṣṇu is worshipped to attain worldly enjoyment, wealth, and pleasure; the *yoga* aspect signifies spiritual realisation and hence is venerated by ascetics; the *vīra* aspect signifies military skill and power and is worshipped by warriors and kings, and the *abhicārika* form by those wishing to injure or destroy their enemies. Viṣṇu's *bhoga* form may have two or four hands.

v. Bhogāsanamūrti; Bhogaśayanamūrti; Abhicārikamūrti; Utsavabera.

Bhogaśakti Name of the *śakti* of Śiva when in his Sadāśiva aspect.

Bhogāsanamūrti A form of Viṣṇu in which he is portrayed sitting in *lalita* pose on a lion throne (*siṃhāsana*) with his consorts Lakṣmī and Bhūmi on his right and left sides respectively. His *mudrās* are the *abhaya* and *varada*; his emblems, the discus and conchshell, or the mace and lotus.

v. Bhoga.

Bhogaśayanamūrti Name of a reclining form of Viṣṇu with two or four arms, accompanied by Lakṣmī who holds a lotus in her right hand, her left is in *kaṭaka* pose, and by Bhūmi. She holds a blue lotus in her right hand, the left is in *kaṭaka mudrā*.

v. Bhoga; Anantaśāyana.

Bhogasthānakamūrti Name of a standing, four-armed figure of Viṣṇu. He shows the *abhaya* and *kaṭaka mudrās*; his emblems are a discus and a conch-shell.

Bhogavatī Name of the capital city of the underworld Nāga realm also called Pātāla or Niraya. It is ruled by the serpent Vāsuki.

Bhramaramudrā 'Bee-hand pose'. In this pose the forefinger is bent so that the tip touches the first joint of the thumb. This *mudrā* indicates silence, a bee, parrot, crane or sexual union (*yoga*).[1]

[1]Coomaraswamy, *Mirror of Gesture*, p. 35.

Bhṛgu Name of one of the seven great *ṛṣis* and ancestor of Paraśurāma. He is said to have compiled a book containing the astrological charts of all present and future living beings.

His name is connected with iconography because many of the artist-craftsmen attempted to systematize the different canons of art by attributing them to various mythical sages including Bhṛgu, Atri, and others.

Bhṛṅgipāda A bell attached to a cord or chain and worn on the right leg of the Naṭarāja and Bhikṣāṭana forms of Śiva.

Bhṛṅgi or **Bhṛṅgin** The 'Wanderer'. A devout *ṛṣi*, an exclusive worshipper of Śiva and one of the Śivagaṇas. Once when the gods and *ṛṣis* were reverently circumambulating Śiva and Pārvatī on the sacred mountain Kailāsa, Bhṛṅgi neglected to pay homage to Pārvatī which so enraged her that she reduced him to a mere skin-covered skeleton unable to stand on his emaciated legs. Śiva took pity on him and provided him with a third leg. To save Pārvatī's honour Śiva united his body with hers (see Ardhanārīśvara), to compel Bhṛṅgi to venerate them both, but the determined sage assumed the form of a beetle, bored a hole through the composite body, and continued to circumambulate Śiva alone.[1]

Bhṛṅgi is usually represented as a three-legged, emaciated ascetic standing at the side of, or dancing, near Naṭarāja. This naive story probably reflects the disagreements of some Śaiva devotees when attempts were being made to amalgamate the principal cult deities of Śaivism and Śāktaism.

[1]*EHI*, II, pp. 322f.

Bhū 'Earth'. The first of the three regions (*tribhuvana*): earth, firmament and heaven.

v. Bhūmidevī; Pṛthivī.

Bhūdevī v. Bhūmidevī.

Bhujaṅgāsana 'Snake (*bhujaṅga*) sitting', a position in which the *yogin* lies on the stomach with the palms of the hands on the ground near the shoulders.[1]

[1]*ID*, p. 41.

Bhujaṅgatrāsitakaraṇa A technical term for the well-known dance form Ānanda tāṇḍava, where the dancer is portrayed at the moment when he suddenly lifts up his leg as though he had seen a snake (*bhujaṅga*)

nearby, and appears to be off balance.

Bhujaṅgavalaya Also called Sarpavalaya or Nāgavalaya. 'Armlet' or 'bracelet' having the form of a coiled snake (*bhujaṅga*) and worn by Śiva, Garuḍa and others. 'Its circumference has to be at least a fourth larger than that of the wrist on which it is worn; at the junction of the tail with the body of the snake, the hood rises; it has to be twelve *aṅgulas* high, seven in width and one in thickness. Two fangs have to be shown in the mouth so as to be visible outside'.[1]

[1]*EHI*, I, pt i, p. 24.

Bhūmidevī or **Bhūdevī** The goddess (*devī*) personifying the earth, and the consort of Viṣṇu. She holds a blue lotus (*nīlotpala*).

Bhūdevī is naturally seen in the image of Viṣṇu's boar (*varāha*) incarnation since she represents the earth which he raised from beneath the waters. She is seldom worshipped as an independent deity. When Viṣṇu is depicted reclining on the cosmic serpent Ananta accompanied by his two consorts, Bhūdevī either stands, or sits, on his left. She resembles Lakṣmī except that she wears a sacred thread instead of a breast-band. She stands on a lotus plinth and shows the *abhaya mudrā*. Sometimes she holds a pomegranate, water-vessel and one bowl containing curative herbs, and another containing vegetables. She may be depicted seated on four elephants representing the four quarters of the world.[1]

Bhūmidevī is a village deity (*grāmadevatā*) and hence is worshipped by many agriculturists. She has many names including Mahī, Pṛthivī, Satyabhāmā and Vasudhārā.

[1]*EHI*, I, pt ii, p. 376.

Bhūpura Name of the square enclosure which is part of a *yantra*. Four gates in the four directions of space are depicted on it. The square symbolizes the substratum of the earth in Indian mythology.

Bhūrloka The earth (*bhū*) and the lower regions.

v. Bhūmidevī.

Bhūta I. 'Demon', 'spirit', 'ghost'. The spirit of a person who has died violently. Such demonic *revenants* roam about at night to injure or destroy men.

The term *bhūta* includes all demonic beings who haunt trees and desolate places, and who follow armies. A number of magical practices are connected with them.

v. Bhūtanātha; Bhūtamātā.

II. A term for the five elements. Rudra is called Bhūteśvara 'Lord of all the elements'.

v. Bhūtamālā.

Bhūtagaṇa 'Multitude of demons (*bhūtas*)'. A decorative motif on some temples depicting a number of dwarfish figures.

Bhūtamālā 'Garland of the elements'. Name of Viṣṇu's garland consisting of five rows of jewels: pearl, ruby, emerald, sapphire and diamond, symbolizing the five elements. The garland is also called *vanamālā* (garland of the forest) and represents the power of illusion (*māyā*) possessed by Viṣṇu.

v. Bhūta II.

Bhūtamātā 'Mother (*mātā*) of demons (*bhūtas*). A terrible aspect of Pārvatī who dwells under an *aśvattha* tree. Her consort, Śiva, is called lord of demons, Bhūtapati. Bhūtamātā's mount is a lion, or she sits on a lion throne. Her emblems are a sword and shield. A *liṅga* may be depicted on her pearl head-dress or on her body.[1]

[1]*EHI*, I, pt ii, p. 362.

Bhūtanātha or **Bhūtapati** 'Lord of ghosts (*bhūtas*)'. An epithet of Śiva who dances with the ghosts of the dead on battlefields and in burial grounds.

v. Paśupati.

Bhūtapati v. Bhutanātha.

Bhūteśa 'Lord of spirits (*bhūtas*)'. One of the elemental forms of Rudra Śiva who represents physical wellbeing and speech, which are expressed through, and sustained by, the body, 'speech is the outward projection of the mind, and food is the substance of life and thought. All physical matter used in the making of physical bodies is spoken of as food. . . . The spoken word is also the materialized, the transmissible form of thought moving from body to body as the food of the mind.'[1]

In later mythology *bhūta* came to mean ghosts and evil spirits.

[1]*HP*, p. 210.

v. Bhūtanātha; Annapūrṇā.

Bhuvaneśa-Gaṇapati 'Lord of the world'. An eight-armed form of Gaṇapati (Gaṇeśa), whose emblems are: an elephant-goad, tusk, bow, noose, conch, an arrow made of flowers, and shoots of paddy grass.[1]

[1]*EHI*, I, pt i, p. 58.

Bhuvaneśvara now Bhubaneswar. The capital of Orissa in which there are a number of temples dating from AD 750–1100. The goddess Bhuvaneśvarī is the tutelary deity of Orissa

Bhuvaneśvarī 'Mistress of the World'. Name of several goddesses and of a particluar one who, as ruler of the universe is called Queen of Queens (Rājarājeśvarī). She is one of the *mahāvidyas* and embodies the totality and power of transcendental knowledge that sustains the world, 'fragments of which are revealed in the Vedas'.[1] The *Bhuvaneśvarī Tantra* describes her with the moon, i.e. the cup of *soma*, as her diadem. She has three eyes, large breasts and smiling countenance. She grants boons and allays the fears of her devotees.

Her emblems are an elephant-goad, noose, a chalice containing the elixir of life (*amṛta*), a mace representing the power to act, a shield signifying the power of knowledge, a *bilva* fruit indicating that she is the giver of the 'fruit' of actions. The *bilva* is also callled the fruit of fortune (*śrīphala*). On her head are depicted a *liṅga* representing the male principle, the Cosmic Man, a serpent symbolizing cyclic time, and a *yoni* signifying the abundance of Nature. These three things 'show her to be the manifest form of the Transcendent Immensity Para-Brahman, which supports the trinity of Nature, Person and Time'.[2] Her *mudrās* are the *abhya* and *varada*. In some ways she resembles Sarasvatī who is also a divinity of knowledge, although their emblems and attributes are different.

[1]*TT*, p. 334.

[2]*HP*, p. 279.

Bhūvarāha 'The earth (*bhū*) and the boar (*varāha*)'. The boar incarnation of Viṣṇu when he lifted the earth (represented by Bhūdevī) from beneath the waters.

Bhuvarloka The region (*loka*) above the earth corresponding to the atmosphere which stretches from the earth to the planetary sphere (*svarloka*). Here dwell the Munis, the Siddhas, the spirits of the dead and other supranatural beings.

Bīja 'Seed syllable' or basic thought-form, said to be the root of all language. A *bīja* is a mystic syllable which contains the essence of a *mantra*. *Bījas* are common to all Indian religions, especially Tantrism. *Bījamantras* have an important role in ritual and are often incorporated in *yantras*.

v. OṀ; Akṣara; Mantra.

Bīja-Gaṇapati A form of Gaṇeśa (Gaṇapati) when depicted eating a citron (*jambhīra*).

Bījamantra 'Seed-*mantra*'. The main monosyllabic *mantras* are called basic or seed-*mantras*. Each deity has its own *bījamantra* which when ritually uttered is said to be a kind of manifestation of the deity evoked because it is the true name of the god which perforce must respond to it. *Mantras* are used in many religions including Christianity. Thus 'the transmutation of bread and wine in the Roman Catholic ritual is done through a mantra and cannot be done without it'.[1]

The basic seed-*mantras* 'have correspondences in all the spheres of manifestation. Each form grasped by the mind or the senses has an equivalent in terms of sound, a natural name.'[2]

[1]*HP*, p. 335, n.2.

[2]Ibid. The primordial language is believed to have been monosyllabic.

v. Bīja; OṀ.

Bikkavolu A village situated midway between Samalkot and Rajahmundry (Andhra Pradesh) which contains temples of the early Eastern Calukyan period.

Bilva or **Bel** The sacred wood-apple tree (*Aegle marmelos*), regarded as a vegetal form of Śiva, and hence the fruit of the *bilva* is venerated, 'and may be co-ordinated with a *liṅga*'.[1] Śiva is sometimes depicted with a *bilva* wood staff (*bilvadaṇḍa*).

[1]*ID*, p. 43.

v. Avyakta; Vṛkṣa; Bhuvaneśvarī.

Bilvadaṇḍa v. Bilva.

Bindu 'Drop', 'point limit', 'dot' denoting the beginning of manifestation from the undifferentiated or non-manifested state which is the productive point of potentiality. It also signifies the meeting place of the individual and universal spirit, as well as symbolizing the 'void' (*śūnya*). All evolutionary and devolutionary developments exist *in potentia* in the *bindu*. Tantrists regard it as the source of the universe and equate it 'with semen . . . as the empirical substance which can transform a man into a godlike being'.[1]

When the *bindu* develops in space it expands in the four directions and symbolizes 'the expansion of the point in space as well as of the reduction of space to unity. It thus shows the dominion of one power over multiplicity.'[2]

[1]Lannoy, *The Speaking Tree*, p. 344.

[2]*HP*, p. 353.

Brahmā A Vedic god and a member of the orthodox brahmanical triad (*trimūrti*). Brahmā is the personification of the neuter *brahman* which is without attributes or qualities; its essence is Reality (*sat*). Brahmā represents the equilibrium between the two opposing principles – the centripetal and the centrifugal – represented by Viṣṇu and Śiva respectively. In Vedic literature Brahmā embodies spiritual power. Traditionally Brahmā is regarded as the founder of what Westerners call Hinduism, but which Indians call the eternal *dharma* (*sanātana dharma*) whose origins are lost in antiquity.

The *Muṇḍaka Up.* describes him as the first of the gods, the creator of the universe and the sustainer of the world. He embodies the life-force 'the dynamics of which may be expressed in generation or destruction',[1] and hence he represents *rajoguṇa*, the power of activity.

The *Bṛhatsaṃhitā* (ch. 57, verse 41) describes Brahmā as four-headed (*caturmukha*), holding a water-vessel and seated on a lotus. The vessel is the 'Wisdom Vase', symbol of the earth, the container and sustainer of all things. The lotus also represents the unfolding of creation. This is one of the earliest iconographic descriptions of Brahmā, but the text does not mention the number of hands or his goose mount (*haṃsavāhana*). The goose is the bird 'mask of the creative

principle, which is anthropomorphically embodied in Brahmā'.[2] Brahmā's four heads signify that he sees in all directions and hence is all-knowing, and so can control the universe. Originally he had five heads but one was cut off by Śiva (See Brahmaśiraśchedaka-mūrti). The *Rūpamaṇḍana* states that the four heads symbolize the four Vedas, the four *yugas*, and the four castes.

Images of Brahmā often appear as accessory figures (*āvaraṇadevatās*) in the shrines of major cult figures as in the Anantaśāyana reliefs. In the triad (*trimūrti*), Śiva or Viṣṇu occupy the central position, *never* Brahmā.

In standing images Brahmā is portrayed with his matted hair twisted up and arranged in the shape of a high crown. He wears jewelled earrings, sacred thread and ornaments and holds a rosary; his front right hand is in *abhaya mudrā*, his left in *varada*, or resting on his hip.

[1]*Facets*, p. 108. Brahmā represents 'a strange equilibrium in Nature which prevents the excessive predominance of one thing over another . . . this balance . . . is the real principle of things. Creation does not proceed with forms that develop independently and then come to balance one another. It starts from a state of balance from which opposing tendencies, opposing species, opposing forces, develop evenly' (*HP*, p. 233).

[2]*Myths*, p. 48.

v. Liṅgodbhavamūrti; Brāhmī; Brahmacakra; Brahmavṛndā; Hiraṇyagarbha; Parivīta; Sarasvatī.

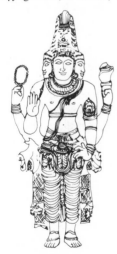

Brahmabhāga v. Mānuṣaliṅga(s).

Brahmabīja The 'seed-*mantra*' (*bīja-mantra*) of Brahmā is AUṀ (OṀ). In this context A symbolizes Brahmā, U Viṣṇu, and M Śiva.

Brahmacakra 'Brahmā's wheel', that is, the universe.

Brahmacārin A young brahmin, who before marriage undergoes a rigorous discipline for a prescribed period in the house of his religious teacher. This is the first of the four stages (*āśramas*) in the life of a Hindu. The others are: householder (*gṛhastha*), living an ascetic life in the forest (*vānaprastha*), and a holy man (*sannyāsin*).

Brahmacāriṇī 'Observing chastity'. Name of an aspect of Durgā who has a rosary and ritual water-vessel as emblems.

Brahmacāri-Subrahmaṇya Subrahmaṇya represented as a *brahmacārin*. His emblems are a rod or staff signifying punishment and the rule of sovereign power; a loin-cloth; girdle of sacred *muñja* grass, a *vajra* and a sacred thread. He has a tuft of hair on his head.[1]

[1]*EHI*, II, pt ii, p. 443.

Brahmadaṇḍa 'Brahmā's staff'. Brahmā's mythical weapon.

v. Daṇḍa.

Brahman (neuter) The ultimate substratum of the forces of the universe, the 'Self-existent' which is quality-less (*a-guṇavat*). The immensity of this divine reality is beyond the comprehension of man because only a small fragment of *brahman* is manifest. *Brahman* is the 'essence' in all things, and hence cannot be an object of knowledge.[1] Only the deities, minor manifestations of *brahman*, can be approached by man. The neuter *brahman* remains unchanged behind changing phenomena and hence exists in Absolute Time, not in relative Time as do mortals. It is indivisible unity and hence is called *pūrṇam* 'the full and complete', that is, inexhaustible plenitude. This reservoir of being exists *in potentia* before the arising of any form (*RV*, X, 129).

[1]Coomaraswamy, *Transference of Nature*, p. 209, n.92.

v. Brahmā.

Brāhmaṇa 'Brahman', 'priest', a member of the first caste, the sacerdotal class. A *brāhmaṇa* who fails in his sacred duty will be reborn as an Ulkāmukha, a demonic spirit (*Manu*, XII, 71).

The 'priest is the microcosm of the macrocosmic *Brahman*, or Divine substratum, the point where the sacred in man meets the universal sacred priest as repository of universal *brahman*'.[1]

[1]Lannoy, *The Speaking Tree*, p. 143.

v. Brahmacārin; Brahmaṇaspati.

Brahmaṇaspati The 'Lord of Prayer' who became omnipotent through prayer (*RV*, II, 24,15). The creation of the priestly order is attributed to him, and he is regarded as a special intermediary of gods and priests.

v. Bṛhaspati.

Brahmāṇḍa 'Brahmā egg'. Name of the cosmic golden egg that circumscribes the totality of manifestation and

from which Brahmā was born. It is divided into twenty-one regions, the earth being the seventh from the top.

Brahmāṇī v. Brāhmī.

Brahmanya v. Skanda.

Brahmapāśa 'Brahmā's noose'. Name of Brahmā's mythical weapon.

Brahmāsana v. Padmāsana.

Brahmaśāstā A four-armed form of the South Indian deity Śāstā whose *mudrās* are *abhaya*, *kaṭi* and *varada*. His emblems are a rosary, water vessel, spear and *vajra*.

Brahmaśiras Another name for Śiva's favourite spear (*śakti*) Pāśupata, with which he kills the *daityas* in battle. At the end of the ages he will destroy the universe with it.

Brahmaśiraśchedakamūrti An aspect of Śiva when he cut off one of Brahmā's five heads with his left thumbnail, the use of the left hand indicating contempt. For this heinous crime of brahminicide Brahmā's skull stuck fast to his hand until he had expiated his crime. The expiation consisted in living as a Kāpālika for twelve years.

Śiva should be portrayed four-armed, three-eyed, with a *jaṭāmakuṭa*, and wearing a *patrakuṇḍala* in the right ear and a *nakrakuṇḍala* in the left. His right hands hold a *vajra* and axe, the left, Brahmā's skull and a trident.[1] According to some Purāṇas and Śaiva Āgamas this aspect is the same as Śiva's Bhairava form.

[1]*EHI*, II, pt i, pp. 174f.

Brahmasūtra Particular lines which are traced on a *liṅga*. Without them it is unsuitable for worship.

Brahmavidyā 'Knowledge about the *brahman*', i.e., transcendental knowledge, the basic knowledge (*vidyā*) which Brahmā gave to his eldest son Atharvan, who taught it to the *ṛṣi* Angir from whom it was passed on to Bhāradvaja Satyavāha and to Aṅgiras. The goddess Umā personifies this knowledge (*Kena Up.*, 3,25).

Brahmavṛndā The 'Immense Grove', i.e. the universe where Brahmā dwells.

Brāhmī or **Brahmāṇī** Another name for Sarasvatī, a consort of Brahmā. Brāhmī was a non-Vedic goddess later adopted as Brahmā's *śakti*. She is included among the seven or eight divine mothers, and symbolizes pride. Her mount and emblems are the same as those of her consort. Her yellow garments symbolize the Veda. She has four arms, four faces, a bright golden body, and carries a trident and rosary. Her two front hands are in *abhaya* and *varada mudrās* respectively. She wears a *karaṇḍamakuṭa*, and sits under a *palāśa* tree. The *Viṣṇudharmottara* states that she has six hands and her garment is a deerskin.[1]

[1]*EHI*, I, pt ii, p. 384.

v. Saptamātara(s).

Bṛhaspati 'Lord of prayer'. A son of Aṅgiras and one of the two spiritual preceptors of the gods and the *daityas*, the other being Śukra.

In later Hinduism Bṛhaspati became the planet-god Jupiter, one of the nine so-called planets (*navagrahas*). According to the *Skanda Purāṇa* he had worshipped Śiva for a thousand years, and to reward him Śiva made him the planet Jupiter.

Bṛhaspati is auspicious and hence the lucky day (Thursday) is named after him.

In compositions he is portrayed seated in a silver chariot drawn by eight tawny horses. When alone he stands on a lotus plinth. He has four hands, three of which carry a rosary, book, and water-vessel, with the fourth in *abhaya* pose. In some representations he holds a bow and arrow, golden axe, and book. When depicted with two arms he holds a rosary and book. The earliest portrayals of Śukra and Bṛhaspati depict them beardless.

Bṛhaspati represents the ideal *brāhmaṇa* who sanctifies the sacrificial rites of his earthly counterpart, the priest. He gains and holds for the gods 'the magical powers obtained by the sacrifice'.[1] He is the presiding deity of mental powers, the teacher of astrology and astronomy and controller of the planets. He is probably identical with Brahmaṇaspati since both are said to be lords of prayer.

The *Ṛgveda* describes him as seven-faced and with seven rays, sharp horns, and blue-backed. He holds a bow and arrows, a golden hatchet or iron axe. Other texts state his emblems to be a book and rosary, the last two indicating his austere meditative nature.[2]

[1]*EM*, p. 65.

[2]Bhattacharya, *Indian Images*, pt i, p. 33.

Bṛhatsaṁhitā The 'great compendium'. Name of a work by Varāhamihira (sixth century AD) dealing mainly with the astrological significance of the heavenly bodies and their relationship to human behaviour, but part of chapter 57 contains the earliest datable information concerning iconometry.

Buddha 'Enlightened'. The title of the founder of Buddhism, who is sometimes regarded as an incarnation (*avatāra*) of Viṣṇu. He is portrayed with a strong physique, and fair complexion. On his feet and hands are the marks of a lotus. He has short curly hair, and long ear lobes. The whole figure should exude tranquillity and compassion. He is seated on a *padmāsana*, and wears the yellow garment of ascetics. On his shoulder there should be a piece of clothing (*valkalā*) made from bark. He shows the *abhaya* and *varada mudrās*.[1]

[1]*EHI*, I, pt i, p. 219.

Buddhi 'Wisdom,' 'divine knowledge'. A goddess

personifying wisdom and regarded as one of Gaṇeśa's consorts. In many mythologies wisdom is personified as a female, including the Mahāyāna Buddhist Prajñā-pāramitā, the goddess personifying the Scripture of the same name and the Biblical Sophia.

v. Siddhi.

Budha 'Mercury'. Name of a planet-god, son of Soma (the Moon) and Tārā.

Budha is included among the Nine Planets (*navagrahas*) which came to occupy an important place in the religious life of India, especially eastern India. They give rain, peace, prosperity and longevity to their devotees.

In shrines Budha is placed either in the north-west or the western corner. In compositions he is depicted riding in a chariot drawn by eight reddish horses, or by one or more lions. His colour is yellow or green. In his four hands he holds a sword, shield and club. The fourth hand is in *abhaya* pose. He wears golden ornaments and garlands of yellow flowers.[1] When portrayed alone he stands on a lotus plinth, or is seated on a coiled serpent. He is said to increase the influences exercised by neighbouring planets.

[1]*EHI*, I, pt ii, p. 320.

C

Caitanya (AD 1485–1533). I. Name of the founder of one of the four principal Vaiṣṇava sects, born in Nadiya (Bengal). He brought about a revival of *bhakti* based solely on the *Bhāgavata Purāṇa*. His followers regard him as an incarnation of Kṛṣṇa and of Rādhā.

Caitanya is usually depicted nearly naked and of fair complexion. This fairness identifies him with the fair Rādhā.[1]

Although Caitanya did not think of his experience of God as sexual, his use of sexual similes paved the way for the intense eroticism of the Vaiṣṇava poets such as Jayadeva, Caṇḍidāsa and Vidyāpati.

[1]Kennedy, *The Caitanya Movement*, pp. 17ff; Monier-Williams, *Brahmanism and Hinduism*, p. 142.

II. The term *caitanya* is used to indicate the divine power present in an image.[1]

[1]*ID*, p. 51.

Caitravana Indra's celestial garden.

Cakra I. 'Discus' or 'wheel'. A steel disc with sharpened edges much used in ancient warfare. It represents power and protection. In Buddhism it symbolizes the Law (*dharma*).

'The Indian cyclical concept of continuous change is associated with the wheel . . . the perfect shape with the focal point of the universe situated at its centre in mysterious stillness.'[1] This idea is represented in part of a carved ceiling from Harasnath (tenth century), now in the Sikar Museum, Rajputana, which depicts four figures with curved backs in the shape of a whirling wheel. The hub is an open lotus flower into which a scarf is disappearing. The latter denotes that 'total escape from this universe [is] through the hole in the wheel' (*Jaim. Up. Brāhmaṇa*, I.3,5).[2]

Viṣṇu's own *cakra* is named Śudarśana. He holds it in his upper right hand which represents the cohesive tendency.

The *cakra* may be represented with eight (or six) spokes denoting the eight directional points and signifying universal supremacy. Coomaraswamy[3] considers it originally represented the sun which traverses the world like the triumphant chariot of a universal monarch (*cakravartin*). The rim of the wheel symbolizes the world in its entirety, the unending, inexorable progression of the cycle of life, death, and rebirth. The rotary movement of the wheel denotes creation (or evolution) out of the non-manifested substratum, and the devolution or re-absorption into the non-manifested, thus indicating the necessity for change which has both creative and destructive aspects. Śiva is closely associated with the Wheel of Time (*kālacakra*) in which all forms arise and disappear. The Year (representing Totality), is regarded as a revolving wheel on which the gods move through all the worlds (*Kauṣ. Br.*, xx.1.).

The weapons of the gods are often personified, and the *cakra* is portrayed as a heavily ornamented man with large belly and round, staring eyes.

A large number of Buddhist and Hindu deities have the *cakra* as an emblem, including Balarāma, Brahmā, Cāmuṇḍī, Caṇḍā, Devī, Gaṇeśa, Hari-Hara, Indra, Kārttikeya, Rudra, Sarasvatī, Senānī, Skanda, Sūrya, Varuṇa, Vāyu, Veṇugopāla, Yajñamūrti and Yama.

[1]Lannoy, *The Speaking Tree*, p. 290.

[2]Kramrisch, *The Hindu Temple*, II, p. 403.

[3]*A History of Indian and Indonesian Art*, p. 41.

v. Cakrapuruṣa; Āyudhapuruṣa(s); Cāmuṇḍā; Brahmacakra.

II. The six circles or depressions of the body serving mystical purposes. They are: *mūlādhāra*, the part above the pubis; *svādhiṣṭhāna*, umbilical region; *maṇipūra*, pit of the stomach; *anāhata*, root of the nose; *viśuddha*, hollow between the frontal sinuses; *ajñākhya* the union of the coronal and sagittal sutures. Various faculties and divinities are believed to dwell in these hollows.[1]

[1]*DH*, p. 58.

Cakradānamūrti v. Viṣṇvanugrahamūrti.

Cakrapāṇi 'Holding a discus (*cakra*) in the hand'. An epithet of Viṣṇu.

Cakrapuruṣa 'Wheel-man'. A personification of the discus (*cakra*), the special emblem of Viṣṇu.
v. Āyudhapuruṣa(s).

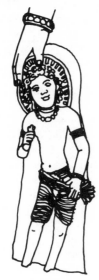

Cakravāka I. Name of the chief of the Nāgas (Nāga-rāja), depicted on one of the Bharhut railings as a human figure standing on a rock at the side of a lotus lake. He wears a heavy turban above which are five snake-hoods.

II. A species of aquatic bird said to mourn when separated from one another: hence the bird symbolizes conjugal fidelity and love.

Cakravāla or **Lokāloka** A mythical mountain range encircling the outermost of the seven seas, which divides the visible world from the region of darkness. The sun rises and sets within this circular barrier. Beyond it is the region of perpetual darkness encompassed by the shell of the cosmic egg.

Cakravartin 'Universal ruler'. *Cakra* in this context denotes the wheel of a monarch's chariot rolling unimpeded over his domain. According to the *Matsya Purāṇa*, the birth of a Cakravartin heralds a new age in which he embodies the *dharma* (Law, Duty, Justice, etc.). The *cakra* is also one of the Seven Gems (*saptaratna*) possessed by a Cakravartin, and symbolizes the heroic aspect of the great ruler who is born with the sign of Viṣṇu's discus on the palm of his hand, as well as other auspicious marks on his body.
v. Cakra I.

Cakṣurdāna 'The gift of sight'. The ceremony of anointing the eyes of an image during consecration to give it the 'gift of sight'.
v. Prāṇapratiṣṭhā.

Cala 'Movable'. Portable images of deities carried in procession during religious festivals. *Calcala* are medium sized images, but difficult to move because of their weight.
v. Acalamūrti.

Calaliṅga A *liṅga* carried in religious processions.

Calcala v. Cala.

Cāḷukya Name of a dynasty that ruled the Southern Deccan (AD 550–753), with its capital in Badami. It is also the name of a school of art. The Cāḷukyas conquered the Pallavas, but later were overthrown by the Rāṣṭrakūṭas.

Cāmara 'Fly-whisk', 'Chowrie'. A number of long yak hairs made into a brush. The *cāmara* is part of the insignia of royalty and is also associated with a number of Buddhist and Hindu deities including Gaṅgā, Mahākāla, Mahāmāyurī, Gāyatrī (Sāvitrī), Viṣṇu, Yamunā, and some female attendants of the gods. Viṣṇu's *cāmara* signifies Eternal Law (*dharma*). When subsidiary female figures in a group hold fly-whisks it signifies that they are attendants (*cāmara-dhāriṇī*).[1] Viṣṇu's personified club (*gadādevī*) holds a *cāmara*, as does his personified discus (*cakra*).[2]

[1]Kramrisch, *Indian Sculpture*, p. 9.
[2]*EHI*, I, pt i, pp. 242f.

Cāmuṇḍā or **Cāmuṇḍī** One of the most terrifying forms of the goddess Durgā who symbolizes universal death and destruction as well as delusion (*moha*) or malignity (*paiśunya*). Her countenance is frightening, tusks protrude from the corners of her mouth, and she wears a garland of skulls and a tiger-skin garment. Snakes peep out from her erect hair. Her body is withered and emaciated. Sometimes she carries a sword, noose, and heavy club.

According to the *Mārkaṇḍeya Purāṇa* (ch. 87, verse 25) the goddess Kālī sprang from Ambikā's (i.e. Durgā's) forehead, and is a personification of her wrath when she battled against, and vanquished, the demons Caṇḍa and Muṇḍa, the two generals of the demonic Śumbha. Ambikā then gave Kālī the name Cāmuṇḍā (a contraction of Caṇḍa and Muṇḍa) for her valiant deed.

Cāmuṇḍā's Danturā form signifying plague and famine, portrays her with protruding teeth, long ear lobes resting on her shoulders, and with a cruel smile on her broad face.

Cāmuṇḍā's vehicle may be a corpse (*pretāsana; mṛtaka*), or a lion (*siṃha*) or an owl (*ulūka*). Occasionally her vehicle is a plump, smiling boy showing the *abhaya mudrā* – perhaps an assurance 'that the last word in creation [is] not Death, but Life, and Life ever-renewing'.[1]

The *Agni Purāṇa* gives eight varieties of Cāmuṇḍā

represented by the Eight Mothers: Rudracarcikā, with six arms, holding a skull, knife, javelin and lasso, and the two ends of an elephant hide. Rudra-Cāmuṇḍā with eight arms holding the above emblems as well as a human head and a drum. Mahālakṣmī with eight arms and four faces. Siddha-Cāmuṇḍā with ten arms – the right hands hold a javelin, sword, drum and bone; the left hands a shield, bell, mace (khaṭvāṅga) and trident. Siddha-Yogeśvarī, with twelve arms, holding the same attributes as Siddha-Cāmuṇḍā as well as the lasso and elephant-goad. Rūpa-vidyā is also twelve-armed and probably a seated form of Siddha-Yogeśvarī. Kṣamā has two arms, and is portrayed as an old woman surrounded by jackals. Dantūrā is portrayed squatting with one hand on her knee.[2]

[1]Iconog. Dacca, p. 209.

[2]Ibid., pp. 209ff.

v. Kālikā; Kṛśodarī; Saptamātara(s).

Cañcalā or **Lolā** The 'Fickle One'. An epithet for Lakṣmī, the goddess of fortune and luck.

Caṇḍa I. 'Fierce'. An asura general of Śumbha.

v. Cāmuṇḍā.

II. Name of a leader of one of the eight groups making up the sixty-four Bhairavas.

III. A form of Śiva Bhairava, or of an attendant of Śiva.

IV. Name of one of Yama's ministers.

Caṇḍā An aspect of Mahiṣāsuramardinī and also one of the Nine Durgās (navadurgās). Her mudrā is abhaya; her emblems include an elephant-goad, discus, a large and a small drum, mirror, bow and arrow, mace, sword, shield, hammer, axe, spear, conch, trident, vajra, etc.

Caṇḍakhaṇḍā An aspect of Durgā whose vehicle is a kite or other bird of prey (śyena).

Caṇḍanāyikā Name of one of the Nine Durgās (navadurgās).

Caṇḍarūpa Name of one of the Nine Durgās (navadurgās).

Caṇḍavatī Name of one of the Nine Durgās.

Caṇḍeśa or **Caṇḍeśvara** Name of a young Śaiva devotee (formerly called Vicāraśarman) who, when his father kicked the liṅga the youth was worshipping, instantly struck out and cut off his father's leg, whereupon Śiva, pleased with the youth's devotion, appeared with his śakti, embraced the boy and gave him the name Caṇḍeśa and appointed him chief of the gaṇas. Śiva also presented him with his own divine garland of flowers.

Caṇḍeśa is always portrayed as a human being, sometimes with his hands clasped in front of his chest and with a long-handled axe resting on his left shoulder. He may be portrayed sitting, standing or seated in sukhāsana pose. Sometimes his wife Dharmanītī accompanies him. She wears many ornaments and jewels and carries a blue lotus.[1]

[1]EHI, II, pt ii, p. 467.

v. Anugrahamūrti(s).

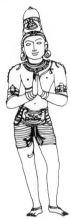

Caṇḍeśvara I. 'Lord of Caṇḍeśa'. An epithet of Śiva.

v. Caṇḍeśa.

II. Name of a boon-granting aspect (anugrahamūrti) of Śiva.[1]

[1]ID, p. 55.

Caṇḍī (or **Caṇḍā**) Two of the many names of the Great Goddess (Devī) whose sacred animal is the iguana. Caṇḍī is also called Śrī, one of the six aspects of the goddess Gaurī.[1]

Caṇḍī is the embodiment of the vast, uncontrollable intensity of divine energy and divine Wrath (Manyu) which may take the forms of Mahālakṣmī, Mahākālī or Mahāsarasvatī, according to the task to be performed. Manyu may be seen as male or female, depending on the inclination of the devotee.[2]

The Viṣṇudharmottara as quoted in the Vācaspatya describes her as a beautiful young women of golden complexion seated on a lion. In her twenty hands she carries a trident, sword, conch-shell, discus, arrow, spear, vajra, drum, parasol, snake-noose, shield, axe, goad, bow, bell, banner, club, mirror and hammer. One right hand is in abhaya mudrā.[3]

[1]DHI, p. 502.

[2]HP, p. 259.

[3]EHI, I, pt ii, p. 346.

v. Mahiṣāsuramardinī.

Caṇḍikā A goddess who symbolizes desire (Kāma). She is sometimes identified with Cāmuṇḍā.

Caṇḍikāśakti The personification of Caṇḍī's energy which emerged from the goddess' body 'howling like a hundred jackals' (Mārkaṇḍeya Purāṇa, ch. 88, verse 22.).

v. Śivadūtī.

Candra or Candramās (In Pauranic mythology called Soma). The name of the moon, and of the Moon-god. The personified moon represents the end of evolution: the sun, the origin of evolution. Sun and Moon together 'constitute the cosmic sacrifice; their relationship is the nature of all the forms of life'.[1]

The Moon emerged from the churning of the ocean (*samudramathana*) because all things exist *in potentia* in the primordial ocean. Candra's two- (or three-) wheeled chariot is drawn by an antelope or by ten thin white horses. When depicted alone he stands on a plinth with a halo behind his head. Sometimes he has four hands, in which case two hold lotus buds indicating his aquatic nature, or a club. The fourth hand is in *varada mudrā*. His colour is white and he wears a golden sacred thread.

[1]*HP*, p. 48.

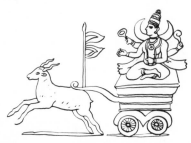

Candrabimba v. Candramaṇḍala.

Candragupta (322–298 BC) 'Moon-crested'. The first ruler of the Maurya dynasty.

Candrakāla 'Moon-time'. A *mudrā* in which the index and next two fingers are closed onto the palm, with the thumb and little finger extended to represent the crescent moon. It also denotes Śiva, boar-tusks, and eyebrows.

Candramaṇḍala or Candrabimba The crescent moon usually portrayed on the head or held in the hand of a deity. It is emblematic of various forms of Śiva including Ardhanārīśvara, and of Annapūrṇā, Bhadra-Kālī, Candra, Gaṇeśa, Rāhu and the goddess Śrī.

As a *yantra*, the moon sickle symbolizes air.[1]

[1]*ID*, p. 55.

Candramās v. Candra.

Candramukha Name of a *yakṣa*, and of a *bakula* tree in which Candramukha dwells.

Candraśekharamūrti(s) 'Moon-crested'. Images which have a moon depicted as a head ornament. Śiva wears a crescent moon on his head-dress which probably symbolizes the horns of his sacred bull. He is four-armed and holding an axe, the blade of which faces away from him, and a black antelope (*kṛṣṇamṛga*) his front hands are in the *abhaya* and *kaṭyavalambita mudrās*. In his left ear he wears a *ratnakuṇḍala*, *śaṅkhapatra* or *padmapatra*; in the right a *makara* or lion-shaped earring (*siṃhakuṇḍala*). He also wears rings, bracelets and anklets.

There are a number of varieties of the Candraśekharamūrtis known by different names, but the five most important are: Kevalamūrti, Umāsahitamūrti, Āliṅganamūrti, Paśupatamūrti and Raudrapaśupatamūrti. There is a close resemblance between Candraśekhara and Nandīśa.

Candravamśa The Lunar Dynasty[1] said to have been founded by Candra (the Moon) according to pauranic mythology, but traditional history ascribes its foundation to Yayāti's two sons, Puru and Yadu.

[1]For the genealogical table of the Lunar Dynasty see Dowson, *A Classical Dictionary of Hindu Mythology*, p. 68.

v. Sūryavamśa.

Cāpa or Cāpaka 'Bow'.

v. Dhanus.

Cāraṇa(s) 'Wanderers'. The celestial panegyrists and dancers of the gods.

Carma Lit. 'skin'. A shield made of dried skin or hide; one of Durgā's weapons.

v. Kheṭa.

Caṣaka 'Cup' or 'wine-glass'. Emblem of Kubera, Kūṣmāṇḍa-Durgā, Vāruṇī and Vasanta.

Caṣāla v. Yūpa.

Caṭulātilakamaṇi A circular jewel worn on the forehead attached to a jewelled 'ribbon' placed over the centre parting of the hair.

Caturahastamudrā A hand pose used in dance in which the little finger is vertical, the other three fingers stretched at right angles to the little finger, with the thumb placed in the middle of the three fingers. Śiva shows this *mudrā* in the *caturatāṇḍava* dance. It signifies a jackal, a cunning enemy, or a pander.[1]

[1]*ID*, p. 58.

v. Caturam.

Caturam Name of a dance-pose of Śiva. He has four or sixteen arms. One arm is in *gajahasta mudrā* and one hand is in *caturahastamudrā*. His legs are bent outwards, one foot rests on the plinth, the toe of the other also rests on it.

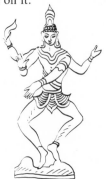

Caturānana or **Caturmukha** 'Four-faced'. An epithet of Brahmā. Each face looks in a different direction and hence denotes dominion (cf. *caturbhuja*). There are a number of four-faced divinities including Aghoramūrti, Ananta, Brāhmī, Varuṇa and Viṣṇu in his Caturmūrti aspect.

v. Caturmūrti(s); Brahmā.

Caturatāṇḍava A dance pose slightly different from the Naṭarāja pose. Both legs are bent sharply at the knee but with the right leg higher than the left. Śiva is depicted in this pose with his right leg on top of the dwarf Apasmāra who is sitting on the ground.

A sixteen-armed form of Śiva in this pose is portrayed at Badami (Cave 1). He stands in *atibhaṅga* pose with his hands holding different weapons and objects, or showing various *mudrās* – *abhaya*, *añcita* and *gajahasta*. His serene face contrasts with the violent movements of his arms, signifying that he is the motionless centre from which all creation spreads outwards towards the periphery and death. His sacred bull Nandi stands on one side, and on the other Gaṇeśa and a seated drummer. In this group Apasmāra is not depicted.

Caturbhuja 'Four-armed'. A number of divinities are shown with four arms which signify their divinity and superhuman powers. The arms also denote the four quarters of the universe and hence absolute dominion.

Caturmukha v. Caturānana.

Caturmukhalinga A *linga* with four (*catur*) faces portrayed on it. Each face represents one of the four aspects of Śiva; the fifth aspect is the *linga* itself.

Caturmūrti(s) or **Caturvyūha(s)** I. A composite form of Viṣṇu consisting of the subtle bodies of Vāsudeva, Saṃkarṣaṇa, Pradyumna, and Aniruddha. The 'concept of "One in Four" described in the cult treatises as . . . "Viṣṇu Caturmūrti" is strikingly illustrated by the four-faced, four-armed (or rarely more) early mediaeval Viṣṇu images from Northern India, mostly Kashmir'.[1] One such icon depicts the central human face as that of Vāsudeva, those to the right and left are of a lion (representing Saṃkarṣaṇa) and a boar (representing Aniruddha). The hidden face at the back represents Pradyumna.[2] Vāsudeva wears a jewelled crown and ornaments. He holds an open lotus flower. His back left hand rests on the head of a small figure, with its right hand raised, looking towards the deity. This is Viṣṇu's personified discus (*cakrapuruṣa*). The four faces of this composite icon typify *bala*, *jñāna*, *aiśvarya* and *śakti*.

[1]*DHI*, pp. 408, 387.

[2]The *Viṣṇudharmottara* (III, 47, 2–17) states that the human face (eastern) is that of Vāsudeva, the southern lion-face Saṃkarṣaṇa, the boar face (northern) Pradyumna, and the hidden western one, Aniruddha. The

second and third faces are 'primarily associated with the Pāñcarātra Vyūhas and not with the Nṛsiṃha [Narasiṃha] and Varaha incarnations' (*DHI*, p. 409).

v. Āyudhapuruṣa; Pāñcarātra.

II. A syncretistic representation of Brahmā, Viṣṇu, Śiva and Sūrya.[1]

[1]*ID*, p. 59.

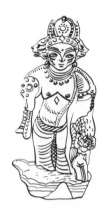

Caturviṃśatimūrti(s) The twenty-four aspects (*mūrtis* or *vyūhas*) of Vāsudeva-Viṣṇu represent some of the main tenets of the Pāñcarātra system, viz., those connected with the *vyūhavāda*.[1] All these images are identical except for the various positions of the four emblems of the four-armed Viṣṇu – conch-shell, discus, club and lotus.[2] Rao[3] points out that the number of possible permutations of four things 'taken four at a time is exactly twenty-four, and the order in which the permutations of these four articles among the four hands is to be observed in passing, as in a circle, from the upper right hand to the upper left hand, thence to the lower left hand, and from there, lastly, to the lower right hand'.

All these figures are portrayed standing and wearing the *kirīṭamakuṭa* crown and usual Vaiṣṇava ornaments. Each stands on a lotus base (*padmāsana*). The names of the icons are: Keśava, Nārāyaṇa, Mādhava, Govinda, Viṣṇu, Madhusūdana, Trivikrama, Vāmanāvatāra, Śrīdhara, Hṛṣīkeśa, Padmanābha, Dāmodara, Saṃkarṣaṇa, Vāsudeva, Pradyumna, Aniruddha, Puruṣottama, Adhokṣaja, Nṛsiṃha (Narasiṃha), Acyuta, Janārdana, Upendra, Hari and Kṛṣṇa.[3]

[1]*DHI*, p. 236. The twenty-four images represent the twenty-four most important of the thousand names of Viṣṇu.

[2]For the arrangement of the four emblems according to the *Rūpamaṇḍana*, and the variations according to the *Padma Purāṇa* see *HP*, p. 154.

[3]*EHI*, I, pp. 227f.

Caturvyūha I. 'Four kinds of manifestation (*vyūha*)'. A four-faced form of Viṣṇu.

v. Caturmūrti(s).

Catuṣkoṇa 'Quadrangular'. A *yantra* symbolizing the earth. A quadrangle with another inscribed inside it represents heaven and earth.

Caurī v. Cāmara.

Ceṇṭu (Tamil) 'Horse-whip', an emblem of Aiyaṉār and of Śiva Vṛṣavāhanamūrti.

Chāga 'Goat'. Goats pull Pūṣan's chariot and are connected with Agni in funeral rites, and as his mount, they represent his generative power. In another context the goat symbolizes all cattle. A she-goat (*chāgā*) is associated with Īśāna, and represents the power of nature (*prakṛti*).[1]

[1]*HP*, p. 211.

v. Aja I and II; Ajā.

Chāgā v. Chāga.

Chāgavaktra 'Goat-faced'. Name of a companion of Skanda-Kārttikeya. Skanda himself is sometimes described as 'goat-headed' when he is known as Naigameya.[1] Dakṣa and Revatī may also be represented as goat-headed.[2]

[1]*DHI*, p. 363.

[2]*ID*, p. 8.

Channavīra Name of an 'ornament made of two chain-like objects worn crosswise on the torso, one in the *upavītī* and the other in the *prācīnāvītī* fashion . . . with a flat disc placed on their junction near the centre of the chest'.[1] But Rao considers it to be a jewelled disc, either tied on the *makuṭa* or hung by a string round the neck so that it lies on the chest. When worn by women the string hangs between the breasts and round the waist. Lakṣmī, when accompanying Viṣṇu and Bhūmidevī, wears a *channavīra* and Bhūmidevī wears a *yajñopavīta*. The *channavīra* is also worn by Kṛṣṇa, and Lakṣmaṇa whose warlike qualities it symbolizes.

[1]*DHI*, p. 291.

See illustration of Pārvatī.

Chattra 'Parasol', 'umbrella'. An emblem of royalty and of delegated power. The *chattra* is consecrated by particular *mantras* which ensure victory. It is also an emblem of Varuṇa who is regarded as the first consecrated king and hence the embodiment of kingship. Other deities who have this emblem include Sūrya, Revanta and Vāmanāvatāra. The parasol of the last represents Viṣṇu's heaven, Vaikuṇṭha, where there is no fear or unhappiness. The vertical handle of the parasol represents the *axis mundi* and indicates that the deity or dignitary below the parasol is the centre of the universe.

Chāyā I. 'Shadow'. One of the consorts of Sūrya (Ravi) the Sun. After Sūrya's marriage with Viśvakarman's daughter, Saṃjñā, she found she could not bear his great effulgence, so deserted him but left behind her shadow as a substitute. She then took the form of a mare but the Sun discovered her and assuming the form of a horse united with her. From their union were born the Aśvins, the twin horse-headed gods of agriculture.

II. The wife of the boar incarnation (*varāhāvatāra*) of Viṣṇu.

Chāyātapa 'Shadow and sunlight', 'chiaroscuro'; 'pairs of opposites'.[1]

[1]Coomaraswamy, *Transference of Nature*, p. 219.

Chinnamastā or **Chinnamastakā** The 'Beheaded'. The headless form of Durgā representing the Power of Sacrifice, venerated by the Śāktas of Bengal. Chinnamastā is one of the ten *mahāvidyās*.

Once the world has become stable it exists by means of burning, destruction and devouring. The cosmic sacrifice signifies this continuing process, and man's sacrificial rites co-operate with this process. The headless form of Śiva named Kabandha presides over the cosmic sacrifice. As the Vedic sacrificial victim was always beheaded, the embodiment of the Power of Sacrifice, Chinnamastā, is also headless. At the end of the sacrifice the head of the victim is symbolically rejoined to the body, signifying the ultimate resurrection of all forms.

The *Chinnamastā Tantra* describes the goddess as striding naked into battle holding her own severed head and a knife or scimitar. She has three eyes; the jewel on her forehead is bound on by a serpent. She drinks from the stream of blood-nectar flowing from her own beheaded body, and sits erect above the god of love Kāma.[1] She wears a skull-garland, and iconographically is similar to the Buddhist goddess Vajrayoginī.[2]

[1]*HP*, pp. 280f.

[2]*ID*, p. 61.

v. Mahāvidyā(s); Muṇḍamālā.

Churī or **Churikā** 'Knife', 'dagger'. An emblem of Cāmuṇḍā, Chinnamastā, Durgā, Kālī and others.

Cihna 'Mark, sign, characteristic'. 'A generic term for a "symbol" signifying one or other of the deities . . . [and] also a mark consisting of the male and female signs'.[1]

[1]*ID*, p. 61.

v. Mahālakṣmī.

Cinmāyā Devī A goddess representing pure consciousness.

v. Yogeśvarī.

Cinmudrā The gesture (*mudrā*) of exposition in which the tips of the thumb and index finger touch to form a circle, the remaining fingers being kept open and the

palm facing outwards. This *mudrā* signifies realization of the Absolute.[1] The mudrā is also called *vyākhyāna* and *sandarśanamudrā*.

[1]*ID*, p. 62, citing Thapar, *Icons in Bronze*.

Cintāmani The 'wish-fulfilling gem', which may be held, or worn on the body. The possession of such a gem is the mark of a world ruler and constitutes one of the 'seven gems' (*saptaratna*).

Cīraka A four-strand necklace of pearls worn by Skanda.[1]

[1]Bhattacharya, *Indian Images*, pt i, p. 56.

Citra 'Representative art'. A term applied to an image made in the round with all the limbs clearly delineated.
v. Citrārdha.

Citrabhāsa 'Written images'. A term for fresco or mural paintings, and for paintings on pieces of cloth.

Citragupta Name of the scribe of the lord of Death, Yama. Citragupta holds a book and a pen with which he records the good and bad deeds of mankind. The book is called *Agrasamdhānī* (Main Records).

Citragupta was born from the body of Brahmā who allowed him to share in the oblations offered in the fire sacrifices. His nine sons became the ancestors of particular castes of scribes. His image is made of iron with black attributes.

Citrānga 'High relief', said to be the best of the three varieties of sculptural relief, since it conduces to spirituality, success and liberation. The others are *ardhacitrānga* and *abhāsangha*.

Citraratha The King of the Gandharvas, the musicians of the gods.

Citrārdha 'Half-relief'.
v. Citrānga.

Citravastra 'Embroidered clothes'. A characteristic of Śiva Śrīkantha (Nīlakantha).[1]

[1]*ID*, p. 63.

Cola Name of an ancient South Indian dynasty and of a school of art which flourished between the ninth and fourteenth centuries AD.

Colaka A long garment reaching to the feet and depicted on images of Sūrya.
v. Udīcyaveśa.

Cūdāmani A jewel worn by men and women on the top of the head.

Cūlakokādevatā or **Ksudrakokā** Name of a *yaksinī* who is depicted, and named, on a Bharhut pillar. She wears a *channavīra* ornament, and her mount is an elephant.

D

Da v. Damaru.

Dādimaphala 'Fruit (*phala*) of the pomegranate tree'. A symbol of fertility because of its many-seeded fruits. It is sacred to Ganeśa, Bhūmidevī, Dhūmornā and Kubera.

Daitya(s) Sons of Kaśyapa (one of the ten Prajāpatis) and Diti. They are the implacable enemies of the gods. The *daityas* figure only in post-Vedic literature where they are represented as demons or *asuras*. They were probably native tribes who opposed the invading Aryans.
v. Brhaspati; Śukra; Dānava(s).

Daiva The act of divination from omens and portents.

Daivikalinga(s) 'Divine *lingas*'. A class of immovable (*acala*) *lingas*, flame-shaped, or resembling hands held in the *añjalimudrā*.

Dākinī(s) Buddhist and Hindu Tantric quasi-divine beings, eaters of raw flesh. They may have developed from the Ghosinīs mentioned in the *Atharvaveda* as the female attendants of Rudra. The *Agni Purāna* (I, p. 538) calls them 'malignant spirits'. Coomaraswamy suggests that the *dākinīs* were originally *yaksinīs*.[1]

A demoness called Dākinī (sometimes regarded as a *śakti*) is attendant on Kālī who, as all-devouring Time, feeds on human flesh. The demoness Pūtanā who tried to poison the infant Krsna was a *dākinī*.

[1]*Yaksas*, pt i, p. 9.

Daksa I. 'Skilled', 'able'. The personification of ritual power which links men with the gods. His father was Brahmā, and his wife Prasūti. He had many daughters, thirteen of whom were married to Dharma or Kaśyapa. One daughter, Svāhā, married Agni, another, Satī, married Śiva, and a number of others married Candra.

Daksa omitted to invite Śiva to attend his sacrifice which infuriated Pārvatī, but Śiva, as the *yogin par excellence*, remained unconcerned. However, seeing Pārvatī's great distress he decided to avenge the insult, whereupon he created (or assumed the form of) Vīrabhadra who destroyed the sacrifice and beheaded Daksa. Later he relented and restored Daksa to life, but gave him the head of a goat. Sometimes Daksa is depicted supine with the terrifying form of Vīrabhadra

dancing on his body.

v. Dakṣa-Prajāpati.

II. Name of a sun-god (*āditya*) symbolizing the creative aspect of the sun.[1]

[1]*IT*, pp. 216f.

Dakṣa-Prajāpati Dakṣa as one of the ten primeval progenitors (Prajāpatis). Sometimes Dakṣa is portrayed with the head and ears of a goat.

v. Dakṣa I.

Dakṣiṇa I. 'Southern', 'right'. In most religions the right side is regarded as auspicious, the left inauspicious. Thus people keep their right side towards a venerated person or object. Similarly temples and shrines are circumambulated in a clockwise direction; an elder brother is always placed to the right of younger ones.

The right symbolizes the male principle and hence figures of women are always placed to the left of men. Most male symbols are carried in the right hand or hands, although some weapons, because of their destructive power, are carried in the left hands of gods, the left being the side of misery, destruction and death. Therefore offerings to demons and other inauspicious spirits are offered with the left hand.

Shells with right-hand spirals are particularly auspicious. The right-handed swastika is lucky. The fear-removing *mudrā abhaya* is always performed with the right hand.

v. Dakṣiṇācāra; Vāma; Svastika; Dakṣiṇāmūrti; Pradakṣiṇa; and for further beliefs associated with the right and left, Robert Hertz, *Death and the Right Hand*, 1960.

II. 'Gift', 'donation', given to priests for performing the sacrificial ritual. Thus material goods are given in exchange for a spiritual good.

Dakṣiṇācāra The 'right-hand' Tantric ritual, so called to distinguish it from the more extreme 'left-hand' (*vāmācāra*) form of *śakti* worship. This ritual is also called *pratinidhi*, 'worship through substitutes'.

Dakṣiṇāgni The 'southern fire' (also called *anvāhārya-pacana*) into which the monthly offerings to the *pitṛs* are placed. The *pitṛs* (ancestors) dwell in the south, the realm of the dead.

The god of fire Agni resides temporarily in the *āhavanīya* and *dakṣiṇāgni* fires, and is visible in the shape of the flames. He serves as messenger (*dūta*) to the invisible gods.

Dakṣiṇākālikā A Tantric form of the goddess Durgā.

Dakṣiṇāmūrti The 'southern (*dakṣiṇa*) image'. A peaceful form of Śiva as the supreme *yogin* and teacher of knowledge, music and the Veda. He represents the ideal of altruistic asceticism that leads to union with *brahman*. Dakṣiṇāmūrti is the archetypal *yogin*

immersed in contemplation of the pure void of his own being, and hence totally beyond the reach of the attractions and distractions of the world. When deities are shown in yogic postures they wear few ornaments, since the yogic ideal is to remain detached from mundane things.

Dakṣiṇāmūrti represents indrawn power, quiescence and blissful serenity, and is identified with the immovable centre of all manifestation. He draws into himself all forms as well as Time which annihilates form, and thus this aspect of Śiva signifies the centripetal force of intension, involution, and absorption.[1] Therefore those who have exhausted the effects of their actions (*karma*) gravitate towards absorption into the Unmanifested.

This deity represents the true knowledge that exists *in potentia* in the solar sphere (*sūrya-maṇḍala*) and flows down from the sun, that is from the north to the south, from above to below, and so towards disintegration and death. For this reason Dakṣiṇāmūrti is the presiding deity of death.[2] But this deity may be viewed from four different aspects, as a teacher of *yoga*, of knowledge (*jñāna*), of the *vīṇā*, and as the expounder of *śāstras*, Vyākhyānadakṣiṇāmūrti. Furthermore, Dakṣiṇāmūrti is closely associated with trees and is said to be of their very nature.[3]

The *Dakṣiṇāmūrti Upaniṣad* states that Dakṣiṇāmūrti is the Supreme Deity. The book he holds contains all wisdom, his rosary represents the *tattvas*; the banyan tree under which he sits symbolizes *māyā*, and his bull mount, the law (*dharma*). Sometimes he has a square lion throne denoting his supreme power and authority over the universe. The earth itself was regarded as square (*RV*, X, 58,3). Peacock feathers are associated with this deity and signify immortality.[4]

[1]*Principles*, p. 203.

[2]*HP*, p. 208. The realm of the dead is in the South.

[3]Sivaramamurti, *Śatarudrīya*, p. 10.

[4]Sastri, *South Indian Images of Gods and Goddesses*, p. 90.

v. Jñāna-Dakṣiṇāmūrti; Siṃhā.

Ḍamaru A small double-sided drum shaped like an hourglass and carried by Śiva, especially when represented as the Cosmic Dancer Naṭarāja, when it denotes primordial causal sound (*nāda*), the rhythmic pulsing of the creative forces as the universe evolves, and hence Śiva has the epithets Ḍa (sound) and Nādatanu (consisting of sound). Great power is inherent in the sounds of the drum[1] which mark the evolution and devolution of universes through the aeons.

The upward pointing triangle of the drum represents the *liṅga*, the downward watery triangle the *yoni*. The two denote the two aspects of creative force. At the

meeting-point of the triangles creation begins, when separated the dissolution of the world occurs.

Many deities have a drum as an emblem, and include Aghoramūrti, Baṭuka-Bhairava, Bhikṣāṭanamūrti, Sadāśiva, Cāmuṇḍā, Caṇḍā, Hara, Īśāna, Kālī, the Nine Durgās (*navadurgās*), Sarasvatī, and others.

[1]Cf. the Siberian Shaman who, by means of rhythmic drumming, is mystically conveyed to heaven. Liebert (*ID*, p. 66) states that the drum 'is a symbol of non-Aryan origin (and is found already as a pictogram in the Indus Valley script), and signifies Śiva as a shamanistic ascetic'.

v. Dundubhi II; Ḍamaruhasta; Trikoṇa.

Ḍamaruhasta A position of the hands (*mudrā*) (similar to the *tripaṭākāhasta*), in which a small drum (*ḍamaru*) is held lightly between the index finger and the little finger as in figures of Śiva Naṭarāja. Sometimes the drum is suspended from a ribbon.

Ḍamaru-madhya 'Kettledrum'. The figures of goddesses and women are broad in the upper half of the body and slighter in the lower, and are likened to the middle of a kettledrum.[1]

[1]Saraswati, *A Survey of Indian Sculpture*, p. 126.

Dāmodara 'Having a rope around the waist'. An epithet of Kṛṣṇa which refers to his foster mother's attempts to tie him up with a rope to prevent his running away. 'Later this epithet is explained as "the Self-restrained"'.[1]

[1]*ID*, p. 67.

Dampati 'Husband and wife'. Name applied to erotic temple sculptures symbolizing married bliss.

Dānamudrā Another name for the *varadamudrā* in which the position of the hands (*mudrā*) indicates the bestowal of gifts.

Dānava(s) Sons (or descendants) of Danu and Kaśyapa. Sometimes the *dānavas* are represented as celestial powers (*asuras*) opposed to the gods (or as native tribes who opposed the Aryan invaders).

The *dānavas* represent the creative and destructive aspects of the world-process which are necessarily interwoven.

Daṇḍa 'Staff, rod, club', signifying power and sovereignty. When depicted in the hand of Kālī (who represents the inexorable power of Time), it denotes destructive power and the force by which law and order are maintained. The *daṇḍa* is personified as the son of Dharma and Kriyā (*Manu*, VII,14). It was created expressly by Śiva to destroy evil and was presented to Viṣṇu, one of whose functions is to maintain the universe. Viṣṇu is said to have transformed himself into the *daṇḍa*.[1]

The rod is an emblem of Yama, of Śiva in his destructive aspects, and of Bhadra-Kālī, Cāmuṇḍā, Gaṇeśa, Hayagrīva, Jyeṣṭhā, Mahiṣāsuramardinī, Nirṛti, Ṣaṇmukha, Vāyu, Yajña, etc.

The *daṇḍa* is the weapon of the southerly direction, the realm of the dead, and hence it is Yama's weapon. It is also personified as a form of Yama himself, who is the embodiment of punishment. It protects the worshipper against evil forces even as the ancient Egyptian god Tanen's staff gave magical protection as well as 'the likeness of the god'.[2] When the rod is depicted between two dots it symbolizes the *liṅga*.[3]

[1]*Aspects*, p. 124.

[2]Reymond, *Mythological Origin of the Egyptian Temple*, p. 205.

[3]*ID*, p. 68.

v. Daṇḍadhara.

Daṇḍadhara 'Rod (*daṇḍa*) bearer'. An epithet of Yama, the ruler of the dead who metes out punishment.

Daṇḍahastamudrā A *mudrā* in which the arm is held stiffly across the body like a stick. It indicates power, strength, and the ability to mete out punishment.

The arm 'may be held at the height of the hip, or of the shoulder, or above the head, in this latter case not crossing the body'.[1]

[1]*Principles*, Glossary, p. 249.

v. Daṇḍa.

Daṇḍāsana Name of a certain form of seat, and of a yogic position.

v. Diti.

Daṇḍī or **Daṇḍa** An attendant and doorkeeper of Sūrya. He holds a rod (*daṇḍa*) and stands on the left of the deity. Daṇḍī personifies Yama's rod and is sometimes regarded as a form of Yama himself.

Daṇḍī is usually depicted with another attendant called Piṅgala. Both wear foreign dress and sometimes hold a long rod or staff and lotus, or a pen and inkpot.[1]

[1]*DHI*, p. 435.

Daṇḍin or **Daṇḍī** 'Carrying a stick'. An epithet of a brahmin when in the fourth stage of his life (*sannyāsin*). The members of an ascetic order carry their rods of office wrapped in cloth dyed with ochre, which are never allowed to touch the ground.

Danta 'Tooth', 'fang', 'tusk'. Gaṇeśa is often depicted holding one of his broken tusks. 'Protruding fangs are

characteristic of terrible deities such as Baṭuka-Bhairava, Cāmuṇḍā, Kubera, Nirṛti, etc. Indra's white elephant Airāvaṇa has four tusks signifying its divine origin. Demons and some temple door guardians (*dvārapālas*) are also portrayed with fang-like teeth to terrify demons and other enemies of the faithful.

Danturā 'Having protruding teeth'. An epithet of the dreaded goddess Cāmuṇḍā who engenders epidemics.

Danu or **Dānava** I. The handsome son of Śrī who was transformed into the monster Kabandha when he offended Indra. According to another myth Indra left him as a headless trunk.

II. A daughter of Dakṣa who married Kaśyapa. Their children were *dānavas*.

Darbha A species of sacred grass (*Saccharum cylindricum Lambk.*) said to have been formed from Viṣṇu's hair.

Darpaṇa Small circular or oval hand mirror of highly polished metal mounted on a handle. Rati, the consort of the god of love, holds a mirror, and also Pārvatī when joined with Śiva in androgynous form. Some other goddesses also have a mirror as an emblem including Ambikā, Cāṇḍā, Lalitā, Mahiṣāsuramardinī, the Nine Durgās (*navadurgās*) and Tripurasundarī.

When Cāmuṇḍā is depicted with a mirror (symbolizing knowledge) she reflects the bliss of pure consciousness (*cidānda*). It also symbolizes 'the unmanifest aspect of Śiva'.[1]

[1]Lannoy, *The Speaking Tree*, p. 356.

Darvī 'Ladle'. An emblem of Yajñamūrti the personification of Sacrifice.

Daśabhuja 'Ten-armed'. The ten arms of particular deities represent the ten quarters of the sky and by extension symbolize universal dominion.[1]

[1]*ID*, p. 69.

v. Aghoramūrti.

Daśakaṇṭha 'Ten-necked'. An epithet of Rāvaṇa who is depicted with ten heads.

Daśānana 'Ten-faced'. An epithet of Rāvaṇa.

Daśāvatāra The ten main incarnations (*avatāras*) of Viṣṇu, viz., Matsya (fish), Kūrma (tortoise), Varāha (boar), Narasiṃha (man-lion), Vāmana (dwarf), Paraśurāma, Rāma (also called Rāmacandra), Kṛṣṇa, the Buddha (sometimes his place is taken by Balarāma, the elder brother of Kṛṣṇa), and the future *avatāra*

Kalkin. The first five incarnations accord with modern theories of evolution.

Dasyu or **Dāsu** An *asura* or demon. A term applied to the indigenes who were often regarded as demonic or as barbarians by the invading Aryans.

Dattātreya I. A manifestation of Viṣṇu in particular, and also an incarnation of the triad (*trimūrti*), that is, Hari (Viṣṇu), Hara (Śiva), and Pitāmaha (Brahmā). This mythological combination indicates an attempt to amalgamate the three cults.

The brahmin Dattātreya suffered from leprosy and was cursed by the gods to die at the next sunrise, but his wife's intense devotion enabled her to prevent the sun from rising until the gods removed the curse. Impressed by her devotion they granted her a boon and she wished that the three gods constituting the *trimūrti* should be born as her sons.

Dattātreya may be portrayed either as the above three gods standing or sitting side by side with their usual emblems and mounts,[1] or as Viṣṇu seated in yogic posture but wearing the headgear and ornaments of Śiva. Another form portrays him with three heads (each representing one of the three gods), and attended by four dogs (representing the four Vedas) and a bull.[2]

[1]*EHI*, I, p. 251.

[2]Ibid., p. 255.

v. Hari-Hara-Pitāmaha.

II. Name of a teacher of the Asuras who later became identified with Viṣṇu. The creation of the *soma* plant is attributed to Dattātreya as are the Tantras and tantric rites. His *śakti* is Lakṣmī; his emblems a rosary, discus, water-vessel, conch-shell and trident.[1]

[1]*ID*, p. 70; *HP*, p. 183.

Deśika-Subrahmaṇya The 'teacher Subrahmaṇya (Skanda)'. In this form Subrahmaṇya taught Vedic lore to his father Śiva.[1]

Deśika-Subrahmaṇya's mount is a peacock; his *mudrās*, abhaya, varada and vyākhyāna; his emblems, a rosary and a spear. He has six arms.

[1]Śiva when a disciple is called Śiṣyabhāvamūrti.

Deva A deity. Although the godhead is beyond the spheres of name and form, it can be approached by man only by means of audible, visible and tangible means. It may be viewed with attributes (*saguṇa*) or without (*nirguṇa*). When regarded with attributes the godhead may be spoken of as He or She; when regarded as *nirguṇa*, it is spoken of as It. The Śāktas worship the Supreme Deity as a female principle (Devī).

Power, and the capacity to give, are the chief characteristics of *devas*. Everything that man receives apart from his own efforts, such as health, illness, prosperity, are 'given' by the gods. By the time of the *Brāhmaṇas*

the notion of *deva* was extended so that 'anything having power was a *deva*. The charisma itself was the divine essence, and it might be found in a man, animal, or plant, river or even a stone. Brahman the Real could be revered only in the forms of Its manifestation. . . . The gods become cultural archetypes. Neither gods nor men denote absolute reality. They are both phenomenal. They are experienced reality, not Reality itself.'[1]

The gods are portrayed with young shining faces and their eyes gaze into the unknown distance as well as within. Their eyes are not ordinary organs of sense but denote the meeting place of the inner and outer worlds. The immense latent energy of the gods combined with tranquillity give their images a dreamy aloofness.

Deity necessarily takes the simultaneous synthetic view of the world, that is the unity of opposites, whilst man perforce takes the analytical view of separateness and difference, but for the empirical world opposites are necessary since without them there would be only the immovable unity of changelessness, with no possibility of development. Basically the Vedic gods were believed to be one. They are different aspects or facets of reality as in *RV*. (III.55,1); 'Great is the single Godhead of the *devas*'. From this idea rose the upaniṣ_adic doctrine of the one reality manifesting itself in countless divine forms.

[1]Organ, *Hindu Quest*, pp. 162f; and see Bowes, *The Hindu Religious Tradition*, p. 31.

v. Devatā; Bhagavān; Īśvara; Devī; Iṣṭadevatā.

Devadāna A 'gift to the god', a votive offering given to a temple.

Devadatta 'God-given'. Name of Indra's conch-shell (*śankha*).

Devakī Wife of Vasudeva and mother of Kṛṣṇa and Balarāma.

Devakoṣṭha A niche in the outer walls of a temple in which are placed effigies of subordinate deities.

Devaloka The world or sphere (*loka*) of a divinity.

Devarāja 'King of gods'. An epithet of Indra.

Devarṣi A divine seer (*ṛṣi*) such as Nārada, Nara and Nārāyaṇa, the Vālakhilyas, etc.

Devarūpa An effigy or figure (*rūpa*) of a deity worshipped in the home.

Devasenā The divine army (*senā*) personified as a goddess, one of the wives of Skanda the war-god. She stands on Skanda's left and holds a blue lotus in her right hand, the left arm hangs down gracefully by her side. Her complexion is red, and her countenance is smiling.[1]

[1]*EHI*, II, pt ii, p. 445.

v. Devasenāpati.

Devasenākalyāṇasundaramūrti Name of a composite sculpture depicting Subrahmaṇya (Skanda) smiling, and taking the hand of Devasenā in marriage. It is doubtless copied from the Kalyāṇasundara form of Śiva which represents his taking the hand of Pārvatī in marriage.

Devasenāpati Skanda as the husband of Devasenā. He is portrayed four-armed, with two hands in *kaṭakamudrā* signifying the missing bow and arrow, or holding a bunch of peacock feathers and a *vajra*,[1] or a shield and bird (*kukkuṭa*).

[1]*ID*, p. 72.

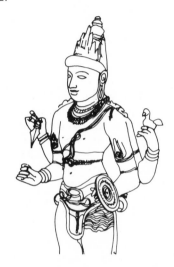

Devatā A celestial being, a deity. A term applied to minor divinities and having the meaning of potency.[1]

[1]Organ, *Hindu Quest*, p. 103. Man contains all potencies (*devatās*) because 'all deities are seated in him, as cattle in a cow-stall' (*AV*, XI, 8,32. Edgerton's translation).

v. Deva.

Devatāpratimā An image (*pratimā*) of a deity (*devatā*).

Devāyatana I. The 'path of the gods' – the way followed after death by ascetics and others who have attained the knowledge which leads to liberation.

II. The dwelling of the gods, i.e., a temple.

Deveśvara 'Lord of gods'. An epithet of the sun-god Sūrya.

Devī 'Goddess'. A general name for any goddess, but particularly the Great Goddess (Mahādevī), the female energy of Śiva.[1]

Devī represents Divine Power conceived as the Universal Mother who is known by many names including Pārvatī, Kālī, Śakti, Umā, Cāmuṇḍā, etc.[2] Devī is the embodiment of creative energy. She also represents the fundamentally changeless supramundane substratum underlying the flux of the world process, and hence personifies the same neutral essence as does *brahman*. There were only a few Vedic

goddesses who were on the whole beneficent, but the post-Vedic ones symbolize fertility and hence represent the pleasant as well as the unpleasant aspects of life and its concomitant, death. Therefore Hindu deities have two aspects, gentle and protective on the one hand, and fierce, cruel and destructive on the other, signifying the realities of the life process.

Vaiṣṇavas and Śaivas acknowledge the power of the goddesses, but venerate them only as consorts of the two chief deities, whereas members of the Śākta cult regard the Devī (śakti) as the Supreme Principle, the origin of the manifested world and hence the embodiment of all energy and activity. Without her active help the gods become as 'corpses'.

A goddess accompanied by her consort is portrayed two-armed with a voluptuous figure and smiling countenance. She usually holds a flower in kaṭaka pose, the other arm hanging down gracefully by her side. She wears numerous articles of jewellery and ornaments. When depicted alone she may be mild, fierce, destructive, and ugly or beautiful. She assumes different names according to the aspect portrayed. Usually she is four-armed and holds the same emblems as her consort as well as wearing a similar head-dress and ornaments. But when two-armed she may carry a parrot, mirror or blue lotus, or weapons.

The main goddesses are fairly easy to identify.[3] Pārvatī in her Umā or Gaurī aspects is distinguished from Lakṣmī by the absence of a breastband and flower garland. Sarasvatī carries a rosary and sometimes a vīṇā; her mount is a goose (haṃsa), or occasionally a peacock (mayūra). Lakṣmī carries the discus and conch of Viṣṇu, or holds lotus flowers in her two back hands. She, like Sarasvatī wears the characteristic Vaiṣṇava crown and long flower garland. Mohinī, the beautiful female form assumed by Viṣṇu, is two-armed and usually portrayed nude and without emblems. Minor goddesses are difficult to identify unless seen in their proper context or with their respective consorts.

[1]In this universal aspect Devī may 'be represented by the yantra śrīcakra' (ID, p. 72).

[2]Sometimes the Devī is worshipped and named according to her imagined age. Thus when a baby she is called Sandhyā; at two years old Sarasvatī; at seven years, Caṇḍikā; at eight, Sāmbhavī; at nine Durgā or Bālā; at ten, Gaurī; at thirteen Mahālakṣmī; and at sixteen Lalitā (EHI, I, pt ii, pp. 332f). Her names also change in different world-periods, as they do according to her achievements, such as killing various asuras.

[3]The fact that there are so many goddesses shows the gradual adoption of non-Aryan deities into the expanding Hindu cults.

v. Deva; Annapūrṇā; Rati; Rukmiṇī; Sītā; Mahiṣāsuramardinī; Gāja-Lakṣmī; Śakti; Yantra.

Ḍhakkā A large drum, emblem of Aghora, Caṇḍā, Īśāna, Kaṅkālamūrti.

Dhammilla A mode of dressing the hair in the form of a knot. This style is worn by the wives of governors of minor privinces.[1]

[1]EHI, I, pt i, p. 30.

Dhanada 'Wealth-giving'. An epithet of Kubera.

Dhana-Lakṣmī A form of the goddess Lakṣmī denoting wealth.

Dhanapati 'Lord of riches'. An epithet of Kubera.

Dhaneśvarī 'Divinity of wealth'. An epithet of the goddess Sarasvatī.

Dhanurāsana A yogic posture in which one lies on the belly and raises the head and feet to form a bow (dhanus) shape.

Dhanus 'Bow'. The bow (signifying sovereignty) and arrow (bāṇa) are carried by some of Viṣṇu's incarnations, especially Rāma. The bow may be curved, or have three or five bends in it, and appears proportionately too big for the image with which it is associated. Indian bows of Mauryan times were five or six feet long and usually made of bamboo. Subsequently bows became smaller and were fashioned from horn.

Bows were personified and named. Viṣṇu's two bows are called Śārṅga and Cāpa; Śiva's Ajagava or Pināka, and Arjuna's Gāṇḍiva. Bows are also associated with Skanda, Mahiṣāsuramardinī, Candeśvara, Brahmā, Indra, Aiyanār, Cāmuṇḍā, Gaṇeśa, Śarabha, Senāpati, and others.

Apart from the association of the bow with royalty, it also symbolizes the destructive aspect of individual existence, the inevitable disintegrating tendency present in all life forms. The quiver represents the storehouse of good and bad deeds.

v. Āyudhapuruṣa(s); Vijaya.

Dhanvantari The physician of the gods and the embodiment of Hindu classical medicine (āyurveda) who arose during the churning of the ocean (samudramathana). He is depicted as a handsome man holding a bowl of ambrosia (amṛta) in both hands. Sometimes he is portrayed seated before a shield on which Viṣṇu's special emblems are displayed.

Dhāralinga A class of Śaiva mānuṣalingas having five, seven, nine, twelve, sixteen, twenty-four or twenty-eight vertical flutes on the cylindrical shaft which function as drainage channels for the water libations poured on the top of the linga.

Dhāraṇā Intense one-pointed concentration or meditation on an image, or a mental visualization of a deity without the aid of an icon.

Dhāraṇī 'Earth'. A goddess personifying the earth, and regarded as an *avatāra* of Lakṣmī.

v. Pṛthivī.

Dharma I. There is no single equivalent term in English for *dharma* which covers moral and religious duty, universal law and order, custom, principle, justice and religion. It is 'an intellectual tenet and/or psychological, social and religious attitudes all in one'.[1] It includes 'concern for others as a fundamental extension of oneself'[2] and is the cohesive ideal in society.

Śiva's bull Nandi symbolizes the divine *dharma* which is firmly established on 'four feet', which represent truth (*satya*), purity (*śauca*), compassion (*dayā*), and charity (*dāna*) respectively. All the notions associated with the meaning of *dharma* are personified in a god of the same name.

[1]*Facets*, pp. 158f.

[2]Potter, *Presuppositions of India's Philosophies*, p. 8.

II. A minor *avatāra* of Viṣṇu who sprang from the right side of Brahmā when he had created the universe. Dharma wore earrings, a white flower garland, and white sandal paste on his body. He had four legs and resembled a bull. He radiates truthfulness, mercy, peacefulness and kindness. The *Āditya Purāṇa* states that he should be portrayed white, four-faced, and with four arms and legs. One right hand holds a rosary, the other rests on the head of the personified form of *vyavasāya* (industry). One left hand holds a manuscript, the other is placed on the head of a fine bull.[1]

[1]*EHI*, I, pt i, p. 266.

Dharmanītī The wife of Caṇḍeśa.

Dharmapāśa Name of the noose (*pāśa*) used by Varuṇa to control and bind demons. The noose was used as a weapon in prehistoric times, but Varuṇa's is a magical weapon by which he effortlessly captures those who disobey the law (*dharma*).

Dharmarāja 'King of the Law (*dharma*)'. An epithet of Yama, the judge of the dead and guardian of the south (the sphere of the dead – and hence the south is regarded as inauspicious).

Dharmarāja holds the club of Time and Death (*kāladaṇḍa*) and a rope noose. His countenance with two large tusks or horns is terrifying. His mount is a black buffalo, an animal symbolizing death in Indian and other mythologies.

Dhātā, **Dhātar**, **Dhātṛ** 'Establisher', 'creator', 'supporter'. One of the synonyms of Brahmā, Prajāpati, and the name of an Āditya.

Dhātar has a cosmogonic role as Creator of the sun, moon, heaven, earth, light, etc, and is associated with conception. He is invoked to give wealth, longevity, immortality and rain, the last being contained in a huge skin bag in the skies which he unties (*AV* VII,18). He holds lotuses in his two natural hands, a lotus-garland (or fillet of lotus seeds) in his right back hand, and a water-vessel in the back left.

Dhātar v. Dhātā.

Dhātṛ v. Dhātā.

Dhātrī-Sūrya The gods Dhātrī (Dhātā) and Sūrya conjoined.

Dhattūra, **Dhatūra**, **Dātura** 'Thorn-apple' (*Datura alba* or *D. stramonium*). A *dhattūra* flower is usually worn on one side of the head by some forms of Śiva such as Candraśekharamūrti, Dakṣiṇāmūrti, Gajāsuramūrti, Kaṅkālamūrti and Naṭarāja.

Dhattūra is often used as an aid to seduction and robbery in the east, when incense is laced with stramonium.

Dhātugarbha A bell-shaped receptacle for ashes or relics (*dhātu*).

v. Vibhūti.

Dhaumya One of the 108 names of the sun-god Sūrya.

Dhenu A milch cow symbolizing the abundance of the earth. The nectar-yielding cow was fashioned by the Ṛbhus and is said to be an animal-form of the goddess Vāc (*Bṛhadd.*, II, 78).

Dhenuka An ass-shaped demon who lived in a palm-grove. He was killed by Balarāma.

Dhenumudrā 'Cow-gesture (*mudrā*)'. A *mudrā* in which the fingers are placed together in imitation of a cow's udder. This *mudrā* is displayed during the purification of ritual objects.[1]

[1]*HP*, p. 378.

Dhiṣaṇā Name of a goddess of abundance and wife of the gods who is closely connected with the preparation of the *soma* juice and with the *soma* bowl itself which she personifies.

Dhṛṣṭi A small wooden fire shovel, used ritually to separate the burning coals of the altar fire, and so control fire and make it serve man instead of harming him.

Dhṛtarāṣṭra I. The name of a King, the blind son of Vyāsa and Ambikā, and ruler of the Kuru kingdom. By his wife Gāndhārī he had a hundred sons, the eldest being Duryodhana. Dhṛtarāṣṭra renounced his throne and Duryodhana became king and led the Kauravas in the war against the Pāṇḍavas.

v. Mahābhārata.

II. Name of a many-headed serpent, one of the thousand serpent sons of Kadrū.

Dhruva The 'fixed' Pole Star, also called the Pivot of the Planets (*grahādhāra*) which was placed in the heavens by Viṣṇu. All celestial luminaries are bound to the Pole Star by aerial cords. Dhruva is personified as an *avatāra* of Viṣṇu and called Dhruva-Nārāyaṇa. His emblems are the discus, water-vessel, spear and

rosary.

Dhruvā The largest of the three sacrificial ladles which is said to sustain the earth.

v. Juhū; Sruk.

Dhruvabera or **Yogabera** or **Mūlavigraha** A large icon permanently established in a temple or shrine. As an object of devotion it is called *dhruva-deva*.

v. Acalamūrti.

Dhūmaketu The 'smoke-banner' of Agni, god of fire.

Dhūmāvatī The 'Smoky One'. Name of a fierce goddess, the seventh Mahāvidyā, who personifies the final destruction of the universe when only the smoke from its ashes remains. Thus Dhūmāvatī is shown without possessions and personifies poverty. She is portrayed with protruding teeth or fangs, cruel eyes, long nose and hag-like appearance. Her emblems are a skull-cup, sword, skull-garland, and winnowing basket.

Dhūmāvatī is associated with the inauspicious goddesses Alakṣmī (misfortune), and Nirṛti (misery and decay).

Dhumorṇā 'Shroud of smoke'. A goddess personifying the smoke of the funeral pyre. She is one of the wives of Yama, ruler of the dead, and is depicted seated on his left lap. Her emblem is the pomegranate, symbol of fertility and of death.

Dhūmrāvatī or **Dhūmra-Kālī** Name of a terrible goddess whose emblems are a garland of skulls (*muṇḍ*_ *amālā*), skull-cup, sword, and fangs.

Dhūrjaṭi 'With matted hair'. An epithet of Śiva who wears the matted hair common to *yogins*.

Dhvaja 'Banner', 'flag' or 'votive column', on which is portrayed the mount of the deity associated with the banner. It is included among the eight auspicious objects (*aṣṭamaṅgala*). Because of the banner's association with a particular deity it was worshipped 'and its accessories constituted an object of the highest religious importance'.[1] The erection and worship of Indra's banner ensures prosperity and happiness. Viṣṇu's banner was produced by his own lustre or energy (*tejas*).

A flag-staff (*dhvajastambha*) is placed in front of the central shrine of Śaiva temples and represents the fiery *liṅga* aspect of Śiva. Sometimes the flag is attached to the roof of a temple and is represented by a narrow vertical wooden frame, but when placed inside the building the flag-staff must penetrate the roof so as to indicate infinite height.[2]

[1]*Aspects*, pp. 254, 257; see also Eliade, *From Primitives to Zen*.

[2]*Aspects*, pp. 255f; and see Kramrisch, *Banner of Indra*, pp. 197ff.

v. Dhūmaketu.

Dhvaja-Gaṇapati A four-armed form of Gaṇeśa. He holds the following emblems: rosary, rod or club, water-vessel and manuscript.

Dhvajastambha v. Dhvaja.

Dhyāna Undistracted attention, the first stage in yoga praxis, visualization or contemplation of a mental image.[1]

[1]Coomaraswamy, *Transference of Nature*, p. 220.

Dhyānabera A metal image used for private worship.

Dhyānahastamudrā, or **Yogamudrā** or **Samādhimudrā.** The gesture (*mudrā*) of meditation (*dhyāna*) in which the right hand is placed palm upwards in the palm of the left, and both rest on the crossed legs (*padmāsana*).

Dhyānāsana A sitting pose for meditation (*dhyāna*).

v. Dhyānahastamudrā.

Digambara 'Sky-clad', that is, naked. An epithet of the goddess Kālī, consort of Śiva the Lord of Yoga.

Digdevī(s) or **Dignāyikā(s)** The female counterparts of the guardians of the four quarters of the world (*dikpālas*) who wove the splendour and fame of kings into pearly strings which they wore.[1]

[1]*Indian Antiquary*, VI, p. 65, cited by Kramrisch, *Hindu Temple*, II, p. 340, n. 136.

Diggaja An elephant accompanying a *dikpāla*, a guardian (*pāla*) of the four cardinal and four intermediate points of the compass. The eight male elephants (sometimes accompanied by eight female elephants) also guard and support the regions of the world. Figures of these animals are often placed in temples.

Dikpāla(s), **Dikpālaka(s)**[1] or **Lokapāla(s)** The concept of the eight divine guardians of the four quarters and the four intermediate quarters is very ancient, but there are variations in the lists. According to the *Purāṇas* the guardians are: Indra (E), Agni (SE), Yama (S), Nirṛti (SW), Varuṇa (W), Vāyu (NW), Kubera (N), Īśāna (NE). A king is said to be the embodiment of the eight Lokapālas (Manu, V,96).

The guardians play an important part in the design of temples and cities. Much Indian architecture is built on the square (indicating the Absolute), which is fixed by the cardinal points.[2]

[1]*Diś* (direction) becomes *dik* in compounds.

[2]Volwahsen, *Living Architecture*, p. 44.

v. Diggaja; Diśā.

Dīkṣā I. A name of the wife of Soma, the Moon. She is also called Rohiṇī.

II. 'Initiation', 'consecration', 'dedication', which occurs in all religions from the most unsophisticated to the most advanced. In Hinduism there are many kinds of *dīkṣā* which may be used for good or evil purposes.

Dīpa 'Light', 'lamp'. Lakṣmī is especially associated with light and with lamps which are often placed in shrines as votive offerings. She is often portrayed

standing holding a lamp with one wick (*dīpalakṣmī*). A circular lamp with a back piece (intended for a niche) depicts figures of Lakṣmī and Gaja-Lakṣmī. Plates with a number of wicks are held by figures of *gopīs* (*dīpagopī*); lamps with five wicks, or with stands for five lamps, are used in the worship of Śiva, five being his sacred number.[1] The lighting of lamps both dispels darkness and protects against demons who are most dangerous at night.

[1]*ID*, p. 81.

v. Dīvālī.

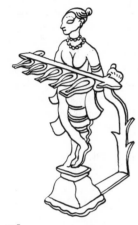

Dīpagopī v. Dīpa.

Dīpalakṣmī v. Dīpa.

v. Dīvālī.

Dīpavṛkṣa 'Lamp (*dīpa*) tree (*vṛkṣa*)'. A lampstand resembling a tree.

Dīpti A form of Devī who radiates light. She is seated on a moon-shaped throne.[1]

[1]*EHI*, I, pt ii, p. 368.

Diśa Name of a goddess who personifies the ten directions of space.

Diti 'Limited'. A Vedic goddess, the mother of demons (*asuras*) and sister of Aditi. When Indra slew Diti's sons she determined to avenge them by producing a child even more powerful than Indra. But Indra, realizing her intention, entered her womb and cut the foetus into forty-nine pieces with his *vajra*. The pieces became the Maruts, the howling storm-gods.

She is depicted seated on a *daṇḍāsana* ('staff-seat'), and wears many ornaments. She carries a blue lotus and a fruit and has a child on her lap.[1]

[1]*EHI*, I, pt ii, p. 369.

Dīvālī or **Dīpāvalī** Lit. a 'row of lamps'. Name of a new moon festival held in the month of *āśvina* or *kārttika* (mid October to mid November) to celebrate the reappearance of the sun which had been 'hidden' during the rainy season by the malevolent water-spirit.

v. Dīpa; Dīvālīmātā.

Dīvālīmātā 'Mother of the *dīvālī*'. An epithet of Lakṣmī who is worshipped at night with rows of lighted lamps at the *dīvālī* festival.

v. Dīpa.

Dolahastamudrā v. Gajahastamudrā.

Draupadī 'Daughter of Drupada'. A patronymic of the daughter of the King of Pañcāla. Her proper name is Kṛṣṇā. Draupadī was born from the sacrificial fire and was regarded as an incarnation of Indrāṇī. Draupadī became the common wife of the five Pāṇḍava princes.

Droṇakāka 'Raven', the mount of Śani, the inauspicious planet Saturn, whose colour is black or dark blue, and hence his mount is also of the same inauspicious colour.

Dukūla A flimsy 'muslin' cloth worn by women and depicted on the female side of Ardhanārīśvara.[1]

[1]*ID*, p. 83.

Dundubhi I. 'Drum'. Name of the buffalo-shaped demon said to resemble a cloud from which the 'roaring' sound of a drum can be heard, and hence thunder is iconographically represented by a drum. Śiva and the other gods unsuccessfully attacked Dundubhi with tridents, but finally the demon was killed by means of *mantras*, thereby indicating that the power of sound is greater than that of weapons.

II. A war-drum whose thunderous sounds terrifies the enemy and vanquishes them. It also drives away bad luck and endows Indra's followers with vigour, as well as possessing curative properties (*Suś. Saṁ.*, II, pp. 737f.).

v. Ḍamaru.

Durga Name of an *asura* conquered by the goddess Durgā from which act she received her name.

Durgā 'The Inaccessible'. An ancient goddess, a spirit of vegetation who over the centuries absorbed the main traits of a number of tutelary and tribal divinities and demonesses until finally she became the supreme goddess of many names. She is the *śakti* of Śiva whose vegetal form is that of the *bilva* tree. She sustains both men and animals with food produced from her body. Her nature is ambivalent, for she is the life-force which brings forth all creatures whose lives end in death which she also embodies.

The primitive traits[1] in this composite goddess are seen in the human sacrifices formerly offered to her, and the present-day animal sacrifices still surviving in parts of India. But Durgā also has a beneficent side. She saves men from difficulties and is 'the sole refuge of men'.[2]

Vaiṣṇavas regard Durgā as a sister of Viṣṇu and therefore represent her with the discus (*cakra*) and conch-shell (*śaṅkha*) of Viṣṇu, as well as the emblems of Śiva. She is depicted wearing the head-dress of Śiva

and other ornaments. She has three eyes, a handsome face, large bust, hips and thighs. She may have four or more hands. The upper pair carry a discus and conch, the others hold Śaiva emblems. She is unyielding and unattainable by force, but bestows her favours when pleased by acts of complete surrender on the part of her devotees.

Durgā's vehicle is a lion (siṃha), an animal symbolizing supremacy, power, authority, kingship and energy. At other times her mount may be a tiger, vulture, or the fabulous leogryph.

[1]Banerjea (*DHI*, pp. 173, 490) considers that some of her characteristics derive from prehistoric times; Campbell (*Masks of God*, II, p. 171) suggests affinities with village cults of Melanesia and New Guinea and with 'Near Eastern matrices of civilization'; Payne (*The Śāktas*, p. 6) considers her name to be aboriginal. See also *IT*, p. 165.

[2]Woodroffe, *Hymns to the Goddess*, pp. 70f.

v. Cāmuṇḍā; Navaśakti; Badarī I; Mahiṣāsuramardinī; Aparṇā; Kālī; Pārvatī; Śakti I; Nīlakaṇṭhī.

Durgā-Lakṣmī The two goddesses combined in one figure.

Dūrvā A sacred grass (*Cynodon dactylon*) common to marshland, and offered to Śiva and the Pitṛs without the inner shoot, but with it to Viṣṇu and to solar deities. It is sacred to Gaṇeśa. At the Dūrvāṣṭamī festival the grass is deified and worshipped.

Dūrvāṣṭamī v. Dūrvā.

Dūta 'Messenger'. An attendant on a god.

Dūtī 'Female messenger'. An attendant on a god or goddess.

Dvāra 'Door or portal, gateway', which from early Vedic times had a highly symbolic significance, whether as the entrance to the sacrificial enclosure, the temple, the palace or to an ordinary house. The doors and niches of temples signify the passage of man to God, and are places of initiation and manifestation.[1] They also denote rain bestowed on the sacrificer (Ait. Br., II,4).

A plain door brings bad luck to the household, therefore doors should be richly decorated with auspicious symbols such as a vessel of abundance (a kind of cornucopia), fruit, flowers, foliage, and birds. The bottom eighth of a door is unlucky. The figure of Lakṣmī is often portrayed on the doors and lintels of houses to bring good luck and to avert evil influences. The doorjambs should never be plain but comprise two, three, five, seven, or nine parallel perpendicular pillars, each carved with different designs.[2]

[1]Kramrisch, *Hindu Temple*, II, p. 322.

[2]For detailed descriptions of temple doors v. Bhattach-aryya, *Canons of Indian Art*; and J. C. Harle, *Temple Gateways of South India*.

v. Dvārapāla(s).

Dvārakā 'Many-gated'. Name of Kṛṣṇa's capital city.

Dvārapāla(s) or **Dvārapālaka(s)** Door (*dvāra*) guardians placed at the entrances to Vaiṣṇava and Śaiva temples. They are two- or four-handed and carry the emblems of their respective deity. The Vaiṣṇava guardians are named Jaya and Vijaya, but the Śaiva guardians have no special names. Temples dedicated to goddesses are guarded by female door-keepers.

Subrahmaṇya's door-keepers are called Sudeha and Sumukha. When two-armed the right hand should be in *abhaya* pose, the left hand holds a club. When four-armed, the back hands holds a *vajra* and spear, one of the front hands holds a club, the other is in *abhaya mudrā*. They wear many ornaments and *karaṇḍa-makuṭas*. Both have tusks protruding from their mouths. Sudeha and Sumukha should stand at the right and left side of the entrance respectively (*Kumara Tantra*).[1]

[1]*EHI*, II, pt ii, pp. 449f.

v. Dvāra; Bhadraghaṭa; Sumukha; Dvārapālikā.

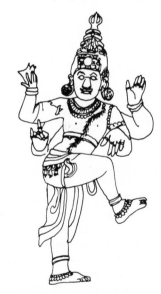

Dvārapālikā A female door-guardian.

Dvibhaṅga 'Twofold (*dvi*) bend (*bhaṅga*), a slightly bent, graceful pose of the human body.

v. Ādināga.

Dvimukha or **Dviśiras** 'Two-headed'. Some deities are portrayed two-headed including Agni, Śarabha, and Yajñamūrti.

Dviśiras v. Dvimukha.

Dyauspitar or **Dyauspitā** 'Sky-father'. The personification of the sky or Heaven as a deity whose consort is

Mother earth, Pṛthivīmātā.

v. Dyāvāpṛthivī.

Dyāvāpṛthivī 'Heaven (Dyaus) and Earth (Pṛthivī)', said to be the parents of the gods who are invoked to give their worshippers food, success, prosperity and heroic strength.

Egāttalā Name of a non-Aryan divinity, the tutelary goddess of Madras.

Ekacakra 'One (eka) wheel (cakra)'. A reference to the sun's one-wheel chariot drawn by seven horses. The sun was visualized as a wheel moving across the sky.

v. Sūrya; Cakra.

Ekadanta or **Ekadaṇṣṭra** 'Having one tusk'. An epithet of Gaṇeśa. 'Eka' indicates the one Supreme Being and danta is indicative of strength. Gaṇeśa should be portrayed with a broken tusk, but he is often depicted without the right tusk.

Ekādaśarudra The 'Eleven Rudras', often depicted with sixteen arms and wearing a tigerskin. They hold a representation of the moon and an axe. There are several variant lists of the names of the eleven Rudras which signify the innumerable manifestations of Rudra, an essential factor in the Viśvarūpa aspect of Śiva.[1]

According to the *Śilparatna* all Rudras should have three eyes, four arms, jaṭāmakuṭas, and be draped in white garments. They should stand erect (samabhanga) on a lotus plinth, and be adorned with flower garlands and many ornaments. Their mudrās are abhaya and varada; their back hands carry an axe and antelope.[2]

[1]Sivaramamurti, *Śatarudrīya*, p. 106.

[2]*EHI*, II, pt ii, pp. 386f.

Ekamukhaliṅga A *liṅga* with Śiva's head portrayed on it.

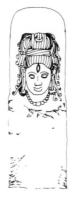

Ekānaṁśā or **Subhadrā** A goddess (an aspect of the Great Mother-goddess) whose cult was important in Eastern India in medieval times. Her dark complexion suggests a Dravidian origin.

There are two-, four- and eight-armed forms of Ekānaṁśā. When two-armed she is portrayed between Baladeva and Kṛṣṇa because she is closely connected with the Viṣṇu-Kṛṣṇa cult. Her left hand rests on her hip, the right holds a lotus. In four- or eight-armed images one of the right hands is in varada pose. She may also hold a mirror (darpaṇa) (*Bṛhatsamhitā*, ch. 57, verses 37ff).

Ekanayana or **Ekanetṛ** 'One-eyed'. An epithet of Kubera, and of one of the Vidyeśvaras whose emblems are a chisel and trident; mudrās, abhaya and varada.[1]

[1]*ID*, p. 85.

Ekanetra A form of Śiva. Ekanetra has a benign expression and is three-eyed and four-armed and wears a jaṭāmakuṭa and ornaments. He carries a trident and hatchet in two hands, the remaining two are in varada and abhaya mudrās.

Ekapādamūrti 'One-footed'. A type of Śaiva composite image depicting Śiva standing on one leg with the figures of Viṣṇu and Brahmā projecting from his left and right sides respectively, with their front hands in añjali pose. In sculptures they should be portrayed from the waist upwards and with one leg bent and held above ground level. Brahmā has four faces and four arms. He carries a sacrificial ladle (sruk) and a water-pot. Viṣṇu has four arms, the front two hands are held in añjali pose, the back hands hold a conch and discus. The group may be surrounded by a prabhāmaṇḍala. The *Uttara-kāmikāgama* states that the figures of Brahmā and Viṣṇu should be sculptured according to the proportions prescribed for female divinities.[1] The three figures conjoined signify the Śaiva trimūrti; the Vaiṣṇava trimūrti has Viṣṇu as the central figure with Brahmā and Śiva as accessory figures.

[1]*EHI*, II, pt ii, p. 399.

Ekapādāsana A term applied to figures depicted standing on one (eka) foot.

Ekapādaśiva A form of Śiva when standing on one foot (pāda).

v. Ekapādamūrti.

Ekarudra A form of Śiva, which resembles that of Ekanetra in all respects.[1]

[1]*EHI*, II, pt ii, p. 403.

v. Ekapādamūrti.

Ekasamapāda v. Ardhasamasthānaka.

Ekaśṛṅgin 'Unicorn'. An epithet of Viṣṇu. It has been suggested that the horn may be the remains of Viṣṇu's theriomorphic aspect especially as his boar form is said to be one-horned.[1]

[1]*EM*, p. 206.

Ekāvalī A single string of beads, pearls or flowers.

Ekaveṇī 'One (*eka*) braid of hair'. A hair-style worn by women as a sign of mourning for a dead, or long absent, husband. Sītā wears her hair in this fashion.

Elāpatra The *nāga* king, sometimes portrayed as a serpent, or a human being with serpent hoods behind his head.

Elephanta A small island near Bombay, famous for the magnificent reliefs in its caves.

Ellaman or **Ellaiyamman** (Tamil) 'Lady of the boundary'. A goddess, one of the Nine Śaktis in South India,[1] who protects the boundaries of the village fields.
[1]*ID*, p. 86.

Elūrā or **Ellora** Name of a number of cave temples situated near Aurangabad, and containing reliefs dating from the fourth to the eighth or ninth centuries. The caves are cut into the side of a crescent shaped hill and cover more than a mile.

Emūṣa The name of the boar (*varāha*) form of Viṣṇu when he raised up the earth on his tusks from below the primordial waters. Emūṣa is black with a hundred arms (*Tait. Ār.*, 10,1,8).
v. Avatāra; Pṛthivī; Viṣṇu.

Eta The steed or steeds of the Maruts – perhaps a kind of spotted deer, the skins of which the Maruts wore over their shoulders.

Etaśa 'Dappled horse'. One of the horses of the sun (Sūrya). The horse is connected with solar symbolism in many mythologies.
v. Aśva.

G

Gada Name of a demon killed by Hari (Viṣṇu). From Gada's bones Viśvakarman made a club (*gadā*) which he presented to Viṣṇu.

Gadā 'Club', 'mace', which may be of various shapes and fashioned from wood or iron. It was a favourite weapon of ancient Indian warriors, and was personified as a beautiful goddess of the same name (Gadādevī) who holds a fly-whisk (*cāmara*).

The club symbolizes the power that ensures conformity to universal law[1] and also represents the Sāṃkhya principle called *buddhi*. It was invoked (along with other weapons) to protect its owner.

According to the *Kṛṣṇa Upaniṣad* the club is Kālī, the power of time that destroys all that opposes it.
[1]*EHI*, I, pt i, p. 293.
v. Āyudhapuruṣa(s); Kaumodakī; Cakra.

Gadādevī v. Gadā.

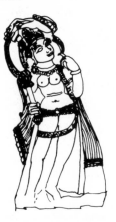

Gaja 'Elephant'. Elephants both symbolize and support the earth, and also represent strength, sovereignty, wealth, virility, gentleness and calmness – the virtues attributed to outstanding men. In ancient times only kings were allowed to own elephants, and hence they represent royalty.

In Pauranic mythology elephants are symbols of fertility because of their association with rain. They are likened to rain-clouds walking on earth. By their magical presence rain-clouds are attracted to the land. (The Sanskrit term *nāga* signifies both cloud and elephant).
v. Airāvaṇa; Gaṇeśa; Gajendra; Gaja-Lakṣmī; Maṅgala; Mataṅga.

Gajādhipa 'Lord of elephants'. An epithet of Gaṇeśa.

Gajahastamudrā A *mudrā* in which one arm is held across the body like an elephant's trunk. It indicates power and strength and is seen in figures of Śiva Naṭarāja and some other figures of deities when depicted dancing.
v. Bharatanāṭyaśāstra.

Gaja-Lakṣmī Name of an image of Lakṣmī depicted with an elephant (*gaja*) on each side. Their raised trunks sprinkle water over her which suggests that she

is a mother-goddess. Sometimes the mother of the Buddha is similarly portrayed and it is difficult to know which of the two is represented.

Gaja-Lakṣmī is four-armed and seated in *padmāsana*. She holds a conch-shell and a bowl of ambrosia (*amṛta*) in the lower hands, (or they are placed on the knees with the palms facing outwards), with lotus flowers in the upper hands. This motif has long been popular and appears on a coin from Kausambi (third century BC), and on later coins.

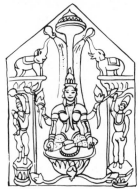

Gajamukha or **Gajamastaka** 'Elephant-headed', a characteristic of Gaṇeśa.

Gajamukhāsura The 'elephant-headed *asura*' whom Gaṇeśa vanquished. The *asura* then transformed himself into a rat which became Gaṇeśa's mount.

v. Ākhu; Gajāsuramūrti.

Gajānana 'Elephant-faced', an epithet of Gaṇeśa.

Gajāṅkuśa 'Elephant-goad'.

v. Aṅkuśa.

Gajāntaka A destructive form of Śiva when he overcame the elephant-demon (Gajāsura) created by the *ṛṣis* of Dārukāvana and which terrified the gods and people. Śiva is depicted wearing, or holding up, the flayed hide of the *asura*. A tenth-century benedictory verse praised Gajāntaka who brings prosperity.[1]

[1]Tewari, *Hindu Iconography*, p. 37.

v. Gajāsuramūrti.

Gajasiṃha A composite animal, half elephant (*gaja*) and half lion, which signifies strength and sovereignty.

v. Gaja; Siṃha.

Gajāsura An elephant-demon.

Gajāsuramūrti or **Gajāsurasaṃhāramūrti** An image showing a terrific form of Śiva when he killed the elephant demon Gajāsura.

Śiva is depicted dancing vigorously on the elephant's head with the animal's hide arranged behind him like a *prabhāmaṇḍala*. He may also hold a tusk, club, *dhattūra* flowers, alms-bowl, bell, drum, sword, skull-topped staff, antelope (or the animal springs towards him), snake and spear. The weapons are the attributes of the heroic warrior: the alms-bowl denotes the ascetic aloofness of the deity and thus represents the perfect blending of opposites.

v. Gajatāṇḍava.

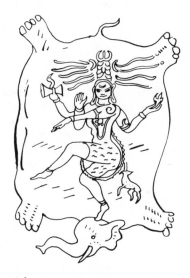

Gajāsurasaṃhāramūrti v. Gajāsuramūrti.

Gajatāṇḍava A particular dance position in which Śiva Naṭarāja is portrayed with one foot on an elephant's head.

v. Gajāsuramūrti.

Gajavāhana 'Elephant mount'. A South Indian form of Skanda who has an elephant as a mount (*vāhana*). This aspect of Skanda portrays him with his hands in *abhaya* and *varada mudrās* and holding a spear and cock (*kukkuṭa*).[1]

[1]*ID*, p. 88.

Gaja-virāla A representation of the leogryph (*śārdūla*) when depicted with an elephant (*gaja*) head; when with a man's head it is called Nara-virāla; and with a lion's, Siṃha-virāla.

Gajavṛṣabha A composite figure of an elephant and a bull (*vṛṣabha*).

Gajendra The king of elephants who represents the power of faith. He invoked Viṣṇu to save him from the clutches of a snake-like aquatic monster. A relief from Deogarh shows the elephant's legs held in the coils of the water-snake. From the water, lotuses grow up. Among them are the figures of a *nāga* and a *nāginī* with their hands in *añjali mudrā*. Above the elephant, Viṣṇu rides on Garuda. Viṣṇu is four-armed and holds the mace (*gadā*) symbol of power and destruction. At the top of the group four celestial *vidyādharas* fly towards him and hold a great crown (indicating the heavens), above his crowned head.

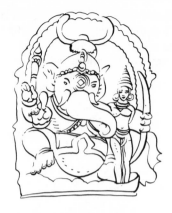

Galantī or *Galantikā* A holed water-jar, out of which water drips onto a *liṅga*, or onto a sacred *tulasī* plant.

Gaṇa 'Troop', 'multitude'. A class of minor deities, often of grotesque appearance, whose leader is Gaṇeśa. They are attendant on Śiva and also associated with his Vedic counterpart Rudra, who in turn is associated with the Marut *gaṇas*.

Banerjea[1] points out the similarity of *gaṇas* and *pramathas* to some of the composite figures on Indus Valley seals. The *gaṇas* are often depicted dancing, or playing musical instruments, or rushing through the air whilst supporting the chariots of the gods. *Gaṇas* playing the flute, drum and cymbals (the usual instruments comprising an Indian orchestra), accompany Śiva when depicted as the personification of the seven musical notes in the magnificent fifth-century Vākāṭaka sculpture from Parel.

Gaṇas are usually portrayed as dwarfish and pot-bellied, yet there is a lightness about their bodies which appear to be inflated by air. Their slender limbs depict a tension between the perfect and its opposite.[2] Their sturdy bodies also help to set off the physical charms of other figures in a composition.[3]

[1]*PTR*, p. 65.
[2]Kramrisch, *Indian Sculpture*, p. 49.
[3]Saraswati, *A Survey of Indian Sculpture*, p. 85.

Gāṇagopāla or **Veṇugopāla** A form of Kṛṣṇa when he delights the herdsmen, girls and cows with his enchanting music. He stands erect with the left leg resting on the ground; the right leg is placed across in front or behind the left leg so that the toes touch the ground. The flute is held in both hands. He stands in *tribhaṅga*. His head may be ornamented with bunches of peacock feathers.

Gaṇapati I. 'Lord of *gaṇas*'. An epithet of Gaṇeśa. *Ga* means wisdom and is the first syllable of the term *gyana* meaning wisdom, *ṇa* stands for liberation and *pati*, lord or master.[1]

[1]Thapar, *Icons*, p. 94; *EHI*, I, pt i, p. 46.
II. An epithet of Brahmaṇaspati, the lord and leader of the heavenly hosts (*gaṇas*).

Gāṇapatya 'Adherent of Gaṇapati'. A cult whose followers regard Gaṇapati (Gaṇeśa) as the Supreme Deity. Later six sub-sects rose, each regarding, as the Supreme God, one of the six aspects of Gaṇeśa known as Mahā, Haridrā, Svarṇa, Santāna, Navanīta, and Unmatta-Ucchiṣṭa, respectively. Gaṇeśa is a most popular deity and is venerated by many Hindus, Buddhists and Jainas.

Gāṇapa(tya)liṅga and **Gāṇapa** Two names of two classes of immovable *liṅgams*, shaped like a cucumber or citron and said to have been erected by *gaṇas*.[1]
[1]*ID*, p. 89.
v. Acalamūrti.

Gaṇḍabheruṇḍa A fabulous double-headed bird.

Gandhāra A region now in Pakistan. It is famous for its eclectic sculptures influenced by Iranian, Greek and Roman cultures, and dating from the first to the sixth centuries AD.

Gandharva(s) Quasi-divine, fabulous half-bird (or half-horse) and half-human figures, or wholly anthropomorphic. Jainas, Hindus and Buddhists regard them as beneficent beings who confer boons on those they favour.

Gandharvas and Apsarasas represent the immense potentiality of the Unmanifested, and are celestial beings born of the *sattva* tendency, the tendency towards light, and hence are depicted flying towards the heads of deities. Sometimes they are portrayed as handsome men or beautiful women (*gandharvī*), with or without wings attached to their shoulders. Daniélou suggests they may be connected with centaurs.[1] They may wear a crown and earrings and play a *vīṇā*, for they are the musicians of the gods. In composite groups they act as accessory figures to the main cult-icons. Sometimes they are represented in pairs, the male playing a musical instrument, the female dancing. The chief *gandharva* is called Viśvāvasu, 'beneficent to all'; their overlord is Varuṇa.

[1]*HP*, p. 307.n7. See also Renou and Filliozat, *L'Inde classique*, I, p. 329.

v. Guṇa; Gandharvī.

Gandharvī A seductive water-nymph and daughter of Surabhi (*RV*, X,11). In later mythology she is regarded as the ancestress of horses.

v. Gandharva(s).

Gaṇḍiva A magical bow with two inexhaustible quivers, presented to Arjuna by Agni.

Gaṇeśa or **Gaṇapati** 'Lord of hosts (*gaṇas*)'. An independent folk deity of obscure origin somewhat similar to *yakṣas* and *nāgas*.[1]

Gaṇeśa is one of the most popular Indian deities, a god of wisdom (*buddhi*), bestower of boons, giver of success in all undertakings, and the overcomer of obstacles – hence his epithet Vighneśvara. He is invoked before all religious ceremonies (except funeral rites), and before any new undertaking. His worship has a place in marriage ceremonies and in Tantrism.

Various stories purport to explain his strange appearance, but Coomaraswamy[2] suggests that his elephant head corresponds to the 'elephantine glory' (*hastī-varcas*) and 'force' attributed to Bṛhaspati in the *Atharvaveda*. Rao[3] considers that his capacious belly represents the innumerable beings floating in space (*ākaśa*). Daniélou[4] states that Gaṇeśa expresses the unity of the microcosm (man) and the macrocosm pictured as a mighty elephant, the most powerful of all animals, and also signifies that the Manifest Principle (all forms being limited) is inferior to the Unmanifest represented by the elephant head. The gigantic limbs of the human part of the figure indicate the potentiality of the human mind which is raised to partake of some of the immense power of the elephant (= the Unmanifested).[5]

Gaṇeśa may have four or six arms, and two or three eyes. The Tantras describe him as having eight or more arms. His colour is red and he is worshipped with red flowers. His huge ears resemble winnowing fans and denote the power to winnow out the dust of vice and virtue in the words addressed to him, leaving real values to be apprehended. In other words the Absolute (which necessarily is changeless) is obscured by the continual flux of the manifested world.

Among his attributes and emblems are the rosary (emblematic of Śaiva mendicants and *yogins*); a broken tusk, symbol of *māyā*, source of all manifested forms; a noose to catch delusion (*moha*), the obstacle in the way of those seeking spiritual progress; the goad, insignia of the ruler of the universe; and the auspicious right-turning swastika, which represents the development of the multiple from the basic unity, the central point.

His *mudrās* are the *abhaya* which shows that he is beyond the sphere of Time and Death to which all fear pertains, and the *varada*. He may hold a net, wood apple and a sweetmeat (*modaka*) or rice-cake (*laḍḍu*). His sacred thread consists of a serpent.

Occasionally Gaṇeśa is depicted on a pedestal of skulls instead of the usual lotus plinth. The skulls denote the seed of death which ripens in Time and so destroys all forms and all achievements. Another interpretation is that Gaṇeśa has overcome death and hence sits above the skulls representing death.

Gaṇeśa may be depicted sitting, standing or dancing. When sitting, his left leg is generally folded and resting on the seat with the right leg hanging down. His trunk usually turns to the left, but occasionally it is rolled up, or turned slightly to the right, which indicates that there are many ways of overcoming obstacles and attaining liberation. His plump physique signifies general wellbeing and wealth. His mount is a mouse or rat (*ākhu*).

[1]Coomaraswamy, *Yakṣas*, pt i, p. 7. Gaṇeśa is said to be a son of Śiva and Pārvatī, but it seems that he was a prehistoric cult-deity later adopted by Śaivas and Vaiṣṇavas.

[2]Note by Coomaraswamy in Zimmer, *Myths*, p. 138n.

[3]*EHI*, I, pt i, p. 61.

[4]*HP*, p. 295.

[5]Kramrisch, *Indian Sculpture*, p. 15.

v. Nṛtta-Gaṇapati; Siddhi II; Ucchiṣṭa-Gaṇapati; Bāla-Gaṇapati; Taruṇa-Gaṇapati; Vīra-Vighneśa; Heramba; Vināyaka; Gaṇeśānī.

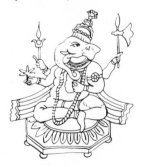

Gaṇeśānī The *śakti* of Gaṇeśa. His other wives are Siddhi (Success) and Ṛddhi (Prosperity). The former personifies the success which her consort Gaṇeśa bestows on his devotees, the latter denotes that she is the personification of prosperity.

v. Vināyikā.

Gaṇeśvara 'Lord of *gaṇas*'. An epithet of Śiva and of Viṣṇu.

Gaṅgā The name of one of the most sacred rivers of India and its personification as a goddess, who symbolizes the purity derived from the primordial waters, and hence her colour is white.

The river itself is regarded as a boon sent from heaven. It is the principal artery for transportation as well as bringing fertility throughout Bengal. Villagers often make baked clay figures of Gaṅgā for ceremonial use which afterwards are thrown into the Ganges.

Gaṅgā gives joy, prosperity and liberation in this life and the hope of a happy future life. Her waters wash away the sins of those whose corpses or ashes are placed in her waters. She is the aquatic form of Śiva.[1]

A small figure of Gaṅgā is depicted on the right side of the head-dress of Naṭarāja. She is portrayed as a beautiful woman with the lower half of her body resembling flowing water, which reflects the myth that formerly the Ganges was a celestial river, and there was no water on the earth until the royal *ṛṣi* Bhagīratha begged her to descend to earth. But the enormous volume of water threatened to overwhelm the earth. Whereupon Śiva agreed to receive the full force of the waters on his head so that his matted locks would break their fall.

Gaṅgā and Yamunā are frequently depicted on

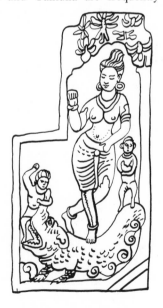

temple doors of the Gupta and early medieval period. Sometimes two fish indicate their presence.

The famous Besnagar Gaṅgā stands gracefully on the back of a *makara* whose mouth is held open by a small male figure who may be Bhagīratha. Gaṅgā is represented as a mermaid wearing a crown and having the Śaiva mark on her forehead. Sometimes her mount is a fish, and her emblems are a fly whisk, water-vessel and a lotus.

[1]Sivaramamurti, *Śatarudrīya*, p. 77.

v. Gaṅgāputra; Gaṅgādharamūrti.

Gaṅgādharamūrti A form (*mūrti*) of Śiva when he received the celestial Gaṅgā on his head. Śiva is depicted standing on his right leg with the left slightly bent. His consort Pārvatī stands on his left. Śiva is three-eyed and four-armed. His front left arm embraces Pārvatī; the front right touches her gently on the chin. The back right hand is raised high above his head and holds a thick matted lock of his hair upon which the tiny figure of Gaṅgā is shown descending from the heavens. Pārvatī looks upward apprehensively, being jealous of Gaṅgā. Sometimes a number of sages are included in the group.

Gaṅgāputra 'Son (*putra*) of Gaṅgā'. An epithet of Bhīṣma who was the youngest of Gaṅgā's and King Śāntanu's eight sons, all of whom, except Bhīṣma, were drowned by their mother.

Gaṅgāvisarjanamūrti Śiva in the act of giving up his second wife Gaṅgā to console Pārvatī who was jealous of her. Gaṅgā is depicted seated on his head-dress.

Gāṅgeya-Subrahmaṇya Subrahmaṇya (Skanda) the son of Gaṅgā. He has three eyes and four arms. In his right hands he holds an axe and a water-pot (*pūrṇakumbha*); in his left hands a fire-drill (*araṇi*) and a cock. He wears a *karaṇḍamakuṭa* and is adorned with blue lotus flowers (*nīlotpala*). A cock is depicted on his banner.[1]

[1]*EHI*, II, pt ii, p. 441.

Garbhagṛha 'Womb-house'. The 'womb' or innermost sanctuary of a temple enshrining the main deity. The *garbhagṛha* is windowless[1] and the image is kept in artificial dimness since too much light would detract from the magic power of the icon – a notion probably deriving from the earlier dark cave temples. The *garbhagṛha* is the meeting place of the divine with the worshipper and a linking of the mythical past with the present. It is also 'the container of the seed "of universal manifestation"'.[2] From this place the temple extends horizontally and vertically. The horizontal expansion represents the existential developments in space and time; the vertical, the ascending spiritual hierarchies of the universe.

[1]The *garbhagṛha* is always square (*EHI*, II, pt i, p. 91n.).

[2]*Principles*, p. 24.

Gardabha 'Ass'. A vehicle of the inauspicious goddesses Alakṣmī (Jyeṣṭhā), Kālarātrī, Nirṛti and Śītalā.

Gārhapatya The domestic fire, one of the three sacred fires. It is always kept alight from the time a man establishes his own household until his death, when it is passed on to his son who in turn transmits it to his descendants, thus linking the generations. The fire-god Agni is always present in it.

Garuḍa The fabulous King of the birds who personifies the wind and the sun, and also represents the esoteric teachings of the Vedas – the magic words by which man moves from one world to the next with the speed of lightning. He also symbolizes courage. Garuḍa appears to be a later version of the fabulous winged beast depicted on the golden Sumerian sacrificial goblet of King Gudea of Lagash (*c.* 2600 BC).[1]

Garuḍa is the vehicle of Viṣṇu, and is often depicted with the upper part of his body that of a bird with powerful wings, and the lower half that of a man.[2] Sometimes his face has almost human features except for a long beak. He has two or four arms. When four-armed he holds in the upper hands an umbrella and pot of ambrosia (*amṛta*), with the lower hands in *añjali* pose indicating worship, reverence and obeisance to the deity. A two-armed form portrays him with snakes, and with wings on his shoulders. He wears a high pointed crown and long garland. On the gold and silver coins of the imperial Guptas Garuḍa is represented as a plump bird. The *Viṣṇudharmottara* (III, ch. 54, verses 1ff) calls him Taksya and it states that he should have a beak-like nose, four arms, face with round eyes, breast and legs of a vulture and two wings. The back hands hold a parasol and a jar of ambrosia; the front hands are in *añjali* pose.[3]

The *Śilparatna* gives two different descriptions of Garuḍa. One describes him as golden yellow from feet to knees, white from knees to navel, scarlet from navel to neck, and jet black from the neck to the head. The eyes are yellow and the beak blue. His expression should be fierce. One of his two hands should be in *abhaya mudrā*. The other description states that he should have eight hands, six of which carry a pot of ambrosia, a club, conch-shell, discus, sword and snake.

The *Purāṇas* state that he is the son of Kaśyapa and Vinatā and is thus the half-brother of the *nāgas* (snakes), sons of Kaśyapa by his wife Kadrū. The latter had ill-treated Vinatā and imprisoned her, but finally Garuḍa was able to obtain her release by promising Kadrū that he would bring her a portion of the elixir of life (*amṛta*) from Indra's heaven. Having obtained it he then slew Kadrū's thousand snake-children and

thereafter became the enemy of all snakes. The capacity to cure snake venom is attributed to him, and the emerald, a talisman against poison, is also associated with him.

[1]*AIA*, I, p. 50. Grunwedel, *Buddhist Art*, p. 51, suggests that the parrot and the West Asian griffin were the bases on which the modern iconography of Garuḍa was developed. See also *ID*, p. 92.
[2]But on the earlier Buddhist monuments of Sanchi, Garuḍa is portrayed as a mythical bird (*DHI*, p. 52.).
[3]*EHI*, I, pt i, p. 286.

v. Garuḍa(s); Garuḍāsana; Garuḍadhvaja; Garuḍamaṇḍapa; Garuḍa-Nārāyaṇa.

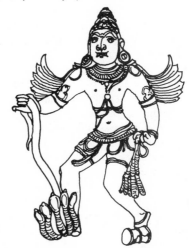

Garuḍadhvaja A votive pillar or column surmounted by a figure of Garuḍa erected in front of Vaiṣṇava temples.

Garuḍamaṇḍapa A small hall for Garuḍa in a Vaiṣṇava temple.

Garuḍa-Nārāyaṇa A form of Nārāyaṇa (Viṣṇu) when depicted seated on Garuḍa and carrying the usual four emblems of Viṣṇu.

Garuḍa(s) Demonic forms which appear in battle, sometimes as giant birds of prey.

Garuḍāsana Name of a yogic posture, or of a throne supported by Garuḍa.

Garutmān A solar bird.

Gaurī 'Yellow', 'brilliant'. A gentle, benevolent aspect of the goddess Pārvatī,[1] the consort of Śiva (and of Varuṇa). She is usually portrayed as a two- or four-armed beautiful woman of white complexion: her upper hands carry a rosary and a water-pot, the others are in the *abhaya* and *varada* poses respectively. Other emblems associated with her are the mirror, fish, lotus, trident and long garland. Gaurī images are similar to those of Lakṣmī, but may be distinguished from the latter by the absence of a breast-band and flower

garland. Her sacred mount is the iguana. Occasionally her mount is a lion, wolf, pig or goose.[2] She embodies ideal motherhood, and universal force (*Agni Purāṇa*, I, p. 407). Payne[3] suggests that she was a goddess of the harvest and ripened corn, or perhaps named after the Gaura buffalo.

There are six varieties of Gaurī, viz., Umā, Pārvatī, Śrī, Rambhā, Totalā and Tripurā.

[1]Gaurī was probably an aboriginal folk goddess later identified with Pārvatī. Durgā is sometimes called Jagadgaurī.

[2]*Iconog. Dacca.*, p. 199.

[3]*The Śāktas*, p. 7; Auboyer, *Daily Life in Ancient India*, p. 145.

Gaurītāṇḍava Śiva dancing with Gaurī. He holds a snake in one left hand. Nandin stands on his right and Gaurī on his left.

Gaus Cow. The most sacred animal in Hinduism whose symbolic quasi-divine status stems from the Indus civilization. The cow represents the abundance of the all-nourishing mother-earth (Bhūdevī). Everything about her is sacred. She is also a lunar and a vegetal symbol.

Gāyatrī or **Sāvitrī** A goddess who may be Sarasvatī or a goddess identified with her. She is the wife of Brahmā and mother of the personified four Vedas.

Gāyatrī personifies the sacred *gāyatrī mantra* (*RV*, III,62,10) which is addressed to the sun and recited daily by orthodox Hindus. Her images, either alone or with Brahmā, are rare; sometimes she is represented with five heads (*pañcaśiras*).

Ghaṇṭā 'Bell'. A small bell is carried by Kālī and Śiva. It is one of the numerous objects associated with the sacrifice as well as being an independent cult object. The sound of Śiva's bell (or drum) symbolizes creation and indicates his mystic sound-form (*mantra-svarūpa*).[1]

Śiva's consort Durgā is also called Ghaṇṭī and has the bell as one of her twelve weapons. Its sound strikes terror into the enemies of her devotees. The sound of every musical instrument is said to be contained in the peals of a bell.

A number of deities are associated with the bell, including Aghoramūrti, Cāmuṇḍā, Durgā, Kaumārī, Mahādeva, Mahākāla, the Nine Durgās (*navadurgās*), Pārvatī, Ṣaṇmukha, Sarasvatī and Skanda.[1]

[1]*EHI*, I, pt i, p. 294.

v. Bhikṣāṭanamūrti.

Ghaṇṭākarṇa 'Bell-eared'. A demon attendant on Skanda and Śiva. He presides over cutaneous diseases. His emblems are a garland of bells (*ghaṇṭamālā*) and a hammer (*mudgara*).

Ghaṇṭamālā 'Garland (*mālā*) of bells', an emblem of Ghaṇṭākarṇa.

Ghaṇṭī v. Ghaṇṭā.

Ghaṭa A pot-shaped drum, an emblem of *gaṇas*, Ahirbudhnya and others.

Ghaṭotkaca 'Pot-headed'. A son of Bhīma and the demoness Hiḍimbā. He is described as bald with a head shaped like a water-pot and with terrifying eyes, large mouth, arrow-shaped ears, sharp teeth and copper-coloured lips.

Ghora Name of a terrific aspect of Śiva and other deities. The opposite of *aghoramūrti*.

v. Ugra.

Ghoṣiṇī(s) Female attendants on Rudra.

Ghṛta or **Ājyapātra** 'Clarified butter (*ghee*)'. Because of its fatty nature it symbolizes prosperity and fertility, and therefore the fertilizing rain is called 'fatness' in the *RV* (I,164,47). It is equated with ambrosia (*amṛta*). The ceaseless flowing of the butter in Vedic ritual symbolizes 'the creative process of cosmic and individuated life'.[1] It also possesses curative properties, bestows longevity, and gives protection against evil spirits and inauspicious planets (*Suś.Saṁ.*, I, pp. 441,443).

[1]Agrawala, *Vedic Fire*, p. 11.

Girija-Narasiṁha 'The mountain-born Narasiṁha'. A form of the man-lion at a mountain cave entrance. He is depicted sitting on his heels, and with the following emblems: mace, discus, lotus and conch-shell.[1]

[1]*ID*, p. 95.

v. Narasiṁha.

Girīśa 'Mountain lord'. An epithet of Śiva.

Girisutā 'Daughter of the mountain'. An epithet of Gaurī.

Godā 'Giver of cows', an epithet applied to Indra.

Godhā 'Lizard', 'alligator', frequently used for divinatory purposes, and associated with Pārvatī, Mahiṣāsuramardinī, Caṇḍī, Śrī. It is also portrayed on many South Indian reliefs of Umā-Maheśvara.[1]

[1]*DHI*, p. 172.

v. Godhikā.

Godhikā 'Iguana'. An emblem of Gaurī.

Gokarṇa A vessel with a spout. An emblem of Viṣaprahamūrti.

Goloka The world (*loka*) of cattle. Name of Kṛṣṇa's paradise (because he gave shelter to cows), situated on Mount Meru where dwells the wish-fulfilling cow Surabhi. This world is the highest of the Vaiṣṇava heavens, above the worlds of men (*manuṣyaloka*), of gods (*devaloka*), and of brahmans (*brahmaloka*).

Gomukha A gargoyle.

Gopāla or **Govinda** 'Cowherd'. An epithet of Kṛṣṇa which refers to the time he lived among the cowherds and *gopīs* in Vṛndāvana.

Gopī(s) The cowherd girls among whom the youthful Kṛṣṇa lived. Each girl thought that he loved her only. The *gopīs* are often depicted dancing a circular dance

with Kṛṣṇa on the banks of the Yamunā. This idyllic picture denotes the abstract relation of the deity (Kṛṣṇa) to his devotees, and also signifies that the incarnate God can be all things to all beings. Furthermore, it emphasizes that love for the divine may be as consuming as the love of man and woman.

In some contexts the *gopīs* have 'been regarded as a multiple form of the *śakti*'.[1]

[1]*ID*, p. 96.

v. Rādhā.

Gopura(s) Huge, elaborately carved towers over the gateways of South Indian temples. The wild profusion of living forms shows delight in the glories of cosmic creation and the luxuriance of nature.

Many of the 108 dance forms of Śiva Naṭarāja are sculpted on the *gopuras* of the Naṭarāja temple at Chidambaram.

v. Dvāra.

For details of the gateways v. J. C. Harle, *Temple Gateways in South India*.

Govardhana The mountain near Mathurā which Kṛṣṇa lifted up to protect the cowherds and their cattle from the incessant rains sent by Indra in an attempt to retain his sovereignty, and hence Kṛṣṇa's epithet Govardhanadhara 'upholder of Govardhana'.

v. Govardhana-Kṛṣṇa.

Govardhana-Kṛṣṇa Kṛṣṇa depicted holding up Mount Govardhana to protect the *gopīs*, herdsmen, and cows from the floods sent by Indra.

Govinda Lit. 'Obtainer of cattle'. An epithet of Kṛṣṇa (Viṣṇu).

v. Gopāla; Acyuta

Graha I. 'Seizer'. A class of demons who 'seize' their victims and inflict all manner of illnesses including insanity. A grasping demoness (*grahī*) is said to cause wasting illnesses.

II. Name given to a planet which can 'seize' human beings.

v. Navagraha(s); Nakṣatra.

Grahādhāra v. Dhruva.

Grahī(s) 'Seizers'. Malevolent demonesses who enter infants and cause them to die. They also seize and kill men.

The Grahīs are said to emerge from the *rājasa* essence of the goddesses Gaṅgā, Umā and the Kṛttikās (nymphs). Bhattacharji[1] states that 'Grahī is almost a synonym for Nirṛti'.

[1]*IT*, p. 101.

v. Guṇa(s).

Graiveyaka A broad jewelled necklace depicted on *yakṣas* and other figures. Sometimes jewelled pendants are attached to the necklace.

Grāmadevatā(s) Tutelary goddesses (*devatās*) of villages (*grāmas*) and towns. Eliade[1] suggests they are pre-Dravidian, and their association with a water-vessel or jar (symbolizing the womb) indicates a close connexion with the ubiquitous fertility cult. Their shrines are often situated under trees. They may be portrayed with two, four, six or eight arms (or occasionally none at all), but their usual icons are simple stone images of the female organ of generation (*yoni*).

[1]*Yoga*, p. 349.

v. Aiyaṉār.

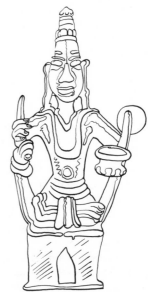

Gṛdhra 'Vulture' associated with Ketu and Śani. A number of vultures are characteristic of Durgā.

Gṛdhramastaka 'Vulture (*gṛdhra*) headed'. An epithet of Garuḍa.

Gṛhadevatā or **Gṛhadevī** 'Household deity (*devatā*)'. Name of a tutelary deity of a house who may be represented by a *śālagrāma*, *bāṇaliṅga*, *tulasī* plant, a water-jar, or a small image of a deity.

v. Jarā II.

Guḍimallam liṅga A stone carving of one of the earliest *liṅgams* known. It stands five feet above floor level and is about a foot thick, and depicts a two-armed figure of Śiva in high relief. He stands on the shoulders of Apasmāra whose figure is portrayed to the waist only. Śiva holds a ram in his right hand and a small water-vessel in the left. A mace or battle-axe rests against his left shoulder.

Guha The 'Secret One'. An epithet applied to Skanda.

v. Guha-Subrahmaṇya

Guhā 'Cave'. v. Guha-Subrahmaṇya; Skanda; Guhyaka.

Guha-Subrahmaṇya A four-armed, three-eyed aspect of Subrahmaṇya (Skanda) whose *mudrās* are the

abhaya and *varada*. His emblems are a trident and *vajra*. He wears a gold *kirīta* set with rubies. His colour is black and his garments white.

Guha means 'hidden' or 'secret'. This aspect is associated with the story that Śiva's seed 'fell' into the river Gaṅgā but the river-goddess refused to allow it to remain in the waters, whereupon it was hidden among the rushes on the bank. From these rushes Skanda was born and hence he has the epithet Guha.

Guhyaka 'Concealed', 'hidden'. A class of eleven godlings or spirits some of whom dwell in caves and other secret places. They are attendant on Kubera who is himself a god of 'hiding'.

The Guhyakas guard, and hide, Kubera's Nine Treasures (*nidhis*). They are described as half-horse or half-bird beings who carry Kubera's palace wherever he desires.

v. Guhyakapati.

Guhyakapati 'Lord of *guhyakas*'. An epithet of Vaiśravaṇa (Kubera) and of Revanta. The latter saves people from the terrors of lonely places and from disasters.

v. Guhyaka.

Guhyavidyā 'Secret doctrine or knowledge (*vidyā*)'.

Guṇa(s) 'Quality, property, characteristic', that which constitutes all creation. Theoretically there are three main *guṇas*: the *sattva*, pure, ascending; *tamas*, obscure, inert, descending; and *rajas*, active and expanding. Their symbolic colours are white, black and red respectively. The *guṇas* are also traditionally associated with caste (*varṇa*), thus the brahmans represent the *sattvaguṇa*, the *kṣatriyas* and *vaiśyas* the *rajas*, and the *śūdras* and Untouchables the *tamas*.

v. Prakṛti; Sāṁkhya.

Gupta Name of a famous dynasty in Magadha in northern India, and an important period for art from the fourth to the sixth centuries AD.

Guptāsana A posture (*āsana*) resembling the *vīrāsana* except that the feet remain hidden under the *dhotī* (a cloth worn round the waist and passing between the legs and tucked in at the waist).

Guru A spiritual preceptor or teacher.

H

Haimavatī Metronymic of Pārvatī the daughter of Himavat.

Hala or **Sīra** or **Lāṅgala** 'Plough', emblematic of agriculture and of Balarāma, and hence his epithets Haladhara and Halabhṛt (plough-holder). In war it was probably used as a weapon.[1] The plough is also associated with some other deities including Balabhadra, Ṣaṇmukha, Śarabha, Sarasvatī, Trivikrama, and Vārāhī.

[1]*EHI*, I, pt i, p. 7.

Halabhṛt v. Hala.

Haladhara v. Hala.

Halāhala A deadly poison which emerged from the Churning of the Ocean (*samudramathana*). Śiva held it in his throat, thus saving all beings from death.

v. Nīlakaṇṭha.

Hālāhala Name of a demon in the shape of a buffalo, killed by Śiva's *gaṇas*.

Halāsana 'Plough position'. A yogic posture (*āsana*) in which one lies on the back with arms straight down and palms on the floor. It is said to resemble a plough (*hala*).

Halāyudha v. Rāma.

Halebid A village in Mysore State, originally the ancient city of Dvarasamudrā, the capital of the Hoysalas. It contains a fine Śaiva temple.

Haṁsa I. The wild goose (representing the creative principle), and hence the creator Brahmā has the goose as his vehicle. Sometimes he is depicted seated in a chariot drawn by seven geese. Other deities associated with the *haṁsa* are Sarasvatī, Brahmāṇī, Candra and Varuṇa.

In Vedic India (and in the Shamanistic cults of northern Asia), the goose was closely associated with the sun and represents the male principle of fertility. It also symbolizes divine knowledge, purity, and the life-force or cosmic breath (representing the rhythm of life), *ham* being its exhalation and *sa* its inhalation. This movement of cosmic breath denotes the return of the individual life-force to *brahman*, its cosmic source. Images of Śiva and his *śakti* represent anthropomorphically the in-going and out-going vital breath.

Two geese with a lotus (*padma*) depicted between them denotes the cosmic breath dwelling in the mind of spiritually perfected persons who subsist on the honey of the full lotus of knowledge.[1] 'The lofty flight of the goose is likened to the spiritual efforts of the devout Hindu to attain *brahman*.'[2] Thus a person who has perfected himself and lives constantly in communion with the Supreme Being is called a *paramahaṁsa*,

for the goose is forever free from limitation, being at home on the waters, on earth, and in the sky. It migrates over great distances and so represents the perfectly free wanderer.

[1]Kramrisch, *Hindu Temple*, II, p. 345.

[2]*DH*, p. 108; and see Vogel, *The Goose in Indian Religion*.

v. Haṃsamantra; Brahmā; Paramahaṃsa; Prāṇayāma; Haṃsabandhana.

II. Name of one of the five different types or classes of men. According to Varāhamihira they are: Haṃsa, Śaśa, Rucaka, Bhadra and Mālavya, who are born when the planets Jupiter, Saturn, Mars, Mercury and Venus are in the ascendant respectively. The height and girth of the first type should be 96 *aṅgulas*, and the rest 99, 102, 105 and 108 respectively.[1]

[1]*DHI*, pp. 311ff.

III. A deity sometimes regarded as an *avatāra* of Viṣṇu.

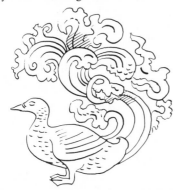

Haṃsabandhana A frieze (*bandhana*) consisting of geese (*haṃsas*) often depicted on temples and denoting purity and spiritual striving.

Haṃsamantra The *mantra* of the goose (*haṃsa*) which consists of the two sounds produced in breathing. Its utterance is said to bestow goodness, pleasure, prosperity and liberation.

v. Haṃsa I.

Haṃsamudrā The goose (*haṃsa*) *mudrā* in which the thumb, forefinger and middle finger are joined and the others outstretched. It signifies initiation, the marriage thread, a drop of water, and holding a garland.

Haṃsasiṃhāsana 'Goose-lion throne (*āsana*)'. A throne or seat with figures of geese and lions on its supports.

Haṃsavāhana 'Having a goose (*haṃsa*) as a mount'. An epithet of Brahmā.

Hanumān, Hanumat, Hanumant The monkey-chief, son of Vāyu and Añjanā, who is portrayed as a dwarfish human being with a monkey's head and long powerful tail. His colour is red. His hands are in *añjali* pose, or his right hand is placed palm downwards on his mouth,

indicating silent respect and complete obedience, or he holds both hands up. Sometimes the faithful ape is depicted kneeling on one knee before his master the solar hero Rāma, whom he accompanied in the war against Rāvaṇa, the demon king of Laṅkā (Ceylon). Hanumān's emblems include a club, bow, *vajra*, and the representation of the top of a mountain. The last reflects the story that when Rāma and his followers were wounded particular curative herbs were required to save them, but Hanumat, not knowing which herbs to bring, brought the whole mountain. Occasionally he is shown holding two cylindrical objects, probably *liṅgas* which Rāma had deputed Hanumān to fetch from some sacred place.[1]

A pre-Aryan monkey cult flourished in much of India and is still popular. Hanumān presides over every settlement, the setting up of his image being a sign of its establishment. His cult became associated with that of Viṣṇu.

[1]*EHI*, I, pt i, p. 193.

v. Mahodaya; Rāmacandra.

Hara A name of Śiva, and of one of the eleven Rudras (*ekādaśarudra*), when he represents the inexorable power of disintegration in time that destroys every manifested creature and thing, culminating in the destruction of the universe. Hara is popularly regarded as the embodiment of sleep and remover of pain. Meditation on Hara dispels ignorance.[1] His *mudrā* is the *tarjanī*; his emblems the rosary, goad, drum, mace, skull-topped staff, snake, axe, spear, trident, lance, *vajra* and pot-shaped drum.

[1]*VSM*, p. 107.

Hāra 'Necklace', 'garland of pearls'. A common adornment of many deities especially goddesses. The earlier necklaces are usually short and broad and made up of a number of sections. Later they became longer.

v. Niṣka.

Hara-Gaurī v. Umā-Maheśvara.

Hara-Pārvatī A composite form of Śiva (Hara) and Pārvatī. She holds a blue lotus and a mirror. Śiva is depicted with the *liṅga* erect (*ūrdhvaliṅga*).

v. Ardhanārīśvara.

Harappā A village in the Indus Valley now part of Pakistan. It was once situated on the banks of the Ravi, a major tributary of the Indus, but the rivers in this area often form new channels because they flow through deep alluvium. Excavations have revealed the remains of an advanced city culture dating from about 2500–1800 BC.

Harasiddhi A four-armed form of Durgā who fulfils the desires of her devotees. Her emblems are a drum, water-vessel, sword and drinking bowl.[1]

[1]*EHI*, I, pt ii, p. 343.

Hari 'Remover of sin'. A name of Viṣṇu[1] the 'Consoler', who appears in every age to remove ignorance, evil and sorrow. Hari is said to be present always in beautiful frescos.[2]

[1]In Vedic usage the name Hari is also applied to Agni, the solar Viṣṇu, Indra, Yama and Śiva.
[2]*DHI*, p. 222.

v. Hari-Haramūrti.

Hari-ardhamūrti v. Hari-Haramūrti.

Haricandana The sandal-tree, one of the five trees of Paradise.

v. Vṛkṣa.

Haridrā (*Curcuma longa*). Turmeric, an aromatic plant of the ginger family. Gaṇeśa as the four-armed three-eyed Haridrāgaṇapati, has offerings of turmeric made to him and hence his colour is yellow.

Haridrāgaṇapati holds a noose, goad, sweatmeat and tusk.[1]

[1]*EHI*, I, pt i, p. 59.

Haridrāgaṇapati Also known as Rātri-Gaṇapati.

v. Haridrā.

Hari-Haramūrti or **Hari-ardhamūrti** A composite image in which the right half of the body represents Śiva (Hara) with his usual emblems and ornaments, and the left half Viṣṇu (Hari), holding a discus and conch-shell. The left half is often 'made in a female shape (as the *śakti* of Śiva), probably signifying Mohinī as the female aspect of Viṣṇu'.[1] The union of the two deities denotes the synthesization of the Śaiva and Vaiṣṇava cults. A story relates that Viṣṇu had once informed some *ṛṣis* that he and Śiva were the same and that Śiva was contained in him. Another myth states that during the Churning of the Ocean (*samudramathana*) Viṣṇu assumed the form of the enchantress Mohinī with whom Śiva fell in love. From their union was born the child Hari-Hara named after the two deities.

Metaphysically Śiva represents goodness (*śivam*) and the state of being above all attributes.[2]

From the philosophical point of view Hari-Hara indicates the coincidence of opposites mutually supporting each other. It is a living duad making visible the paradoxical aspect of reality which consists of an endless process of preservation and destruction. It also symbolizes the ultimate unity of time and space, Śiva representing Time (Mahākāla) and Viṣṇu, space.

One of the earliest stone reliefs of Hari-Hara is at Badami. The four-armed figure stands erect, the back right and left hands hold a battleaxe entwined by a snake, and a conch-shell respectively. The front right hand is broken, but was probably in *abhaya mudrā*; the front left is in *kaṭihasta* pose.

[1]*ID*, p. 101.
[2]Bhattacharya, *Indian Images*, pt i, p. 23.

Hari-Hara-Pitāmaha A triad (*trimūrti*) consisting of Viṣṇu (Hari), Śiva (Hara) and Brahmā (Pitāmaha). This composite triad is regarded as the son of Atri (or of Kauśika) and Anasūyā. Dattātreya is said to be the incarnation of the triad.

The *Rūpamaṇḍana* describes the triad as having four faces,[1] [three is more usual], six hands and a single body standing on a pedestal. The right hands carry a rosary, trident and club, the left holds a water-vessel, skull-topped staff and discus. Some of these six objects are emblems of Brahmā (rosary and water-vessel), of Viṣṇu (discus and club), and of Śiva (trident and skull-topped staff).

[1]*ID*, p. 101.

Hari-Hara-putra v. Aiyaṇār; Śāsta.

Harijan (Hindi) 'The people of God (Hari)'. A euphemism used by Mahatma Gandhi to describe the Untouchables.

v. Varṇa.

Hārin 'Gazelle', 'antelope', a symbol of peace. This animal is often associated with Śiva and with Candra.

v. Mṛga.

Hārītī I. A consort of Kubera. She may be depicted with a child or children.

II. The Buddhist goddess of smallpox.

Hasta(s) or **Mudrā(s)** Particular positions of the arms and hands each of which has a specific meaning or meanings. Many *mudrās* are used in Indian dances. Some of these poses are depicted on pre-historic Indian seals, amulets and figurines.[1]

In India and in other countries, the hand was thought to possess protective powers, thus the sacrificer lays down his hand palm upwards and prays: 'Shield me from all evil spirits' (*ŚBr.*, XIV,1.3,24).

There are sixty-four *mudrās* mentioned in various texts but the most usual are: *lolahasta, kaṭihasta, gajahasta, alingahasta, nidrātahasta, abhaya, varada, añjali, kaṭaka, vismaya, tarjanī, tripaṭākā, ḍamaru, ardhacandra, yoga* or *dhyānahasta* and *cinmudrā* (see under their respective names).

[1]Poduval (Administration Report, pp. 6f.) has recog-

nized 64 *mudrās* in art and 108 in Tantrism. See also Coomaraswamy, *The Mirror of Gesture*.

Hastasvastika 'Crossing the hands', a pose which suggests devotion.

Hastin 'Elephant'.

v. Gaja.

Hastināpura A city some fifty-seven miles north-east of Delhi. Most of the city has been washed away by the Ganges.

v. Maya.

Haya 'Horse', a symbol of knowledge (jñāna) and of the sun, and hence this animal is associated with solar gods, with kingship, and with protection. The future incarnation of Viṣṇu will appear at the end of the age as a white horse called Kalkin.

v. Vājin; Hayagrīva.

Hayagrīva A Vaiṣṇava deity portrayed with a human body and a horse's head, perhaps originally a deity of a horse-cult which became assimilated to Vaiṣṇavism. It is regarded as a manifestation of Viṣṇu who became incarnated in this form to destroy the *rākṣasa* of the same name.

Hayagrīva may have four or eight hands carrying various emblems associated with Viṣṇu. His *mudrā* is *jñāna*; his emblem, a manuscript representing the Vedas. According to the *Viṣṇudharmottara* he should be eight-armed. He carries the conch-shell, discus, club and lotus respectively in four hands. The remaining four are placed on the personified forms of the four Vedas. He should wear many ornaments. Hayagrīva is a god of learning and has similar functions to those which are attributed to the goddess Sarasvatī.[1]

Viṣṇu's future incarnation Kalkin is also sometimes depicted horse-headed but with only two arms. In Pauranic mythology Hayagrīva was a demon killed by Viṣṇu in the form of a horse-headed man. Van Gulik[2] suggests that there are two Hayagrīva traditions, one referring to the demon who stole the Vedas from Brahmā, the other to the divine Hayagrīva who retrieved and guarded the lost Vedas.

[1]*EHI*, I, pt i, pp. 260f.

[2]*Hayagrīva*, p. 19; and see Bosch, 'The God with the Horse's Head'.

Haya-siṃhāsana Name of a throne or seat with the figures of horses (*haya*) or lions (*siṃha*) carved on the supports.

Hayaśiras and **Hayaśīrṣa** Two horse-headed forms of Viṣṇu, sometimes identified with Hayagrīva. Brahmā requested Hayaśīrṣa to rescue the Vedas from the bottom of the ocean where they had been hidden by the two *dānavas*, Madhu and Ketu.

Hemādri An author who lived in the 13th century AD.

Hemāmbikā 'Golden mother'. A Tantric mother-goddess whose shrine is at Palghat, South Malabar. She is represented by a pair of hands protruding from a well.[1]

[1]*TT*, p. 99.

Hemamṛga 'Golden deer'. The *rākṣasa* Mārīca assumed the form of a marvellous golden deer to attract Rāma away from his home, and so enable Rāvaṇa to abduct Sītā.

Heramba[1] Name of a five-faced, eight-armed form of Gaṇeśa. Each one of the four faces looks in one of the four directions, and the fifth, on the top of the head, faces upwards. Heramba carries various emblems, including a rosary, tusk, sweetmeats, axe and noose. The two lower hands are in *abhaya* and *varada mudrās*. His mount is a lion or a rat; his colour is golden yellow.

An image of Heramba from Rampal (near Dacca) shows him with six miniature figures of Gaṇeśa on the top of the *prabhāvalī*, which represent the six sub-sects of the Gāṇapatya cult.

[1]A name of uncertain origin. 'Hera' means 'demonic illusion' and also is a term for 'buffalo'. The latter 'indirectly connects Gaṇeśa both with Yama who rode a buffalo in the Epics and Purāṇas and with Pārvatī' who killed a demon in the shape of a buffalo (*IT*, p. 184, n.1.); Rao (*EHI*, I, pt i, p. 47) states that 'he' represents helplessness and *ramba* denotes the protection afforded weak beings to safeguard them; hence Heramba means 'protector of the weak'.

Heruka Originally a name of Gaṇeśa, and later a popular Mahāyāna Buddhist deity.

v. Pañcakapāla.

Heti Any weapon, a hatchet, etc.

Himavat The personification of the Himalayas of North India. Pārvatī and Gaṅgā are his daughters.

Hiraṇyagarbha 'Golden germ (or womb)'. The golden cosmic egg from which the universe issued, and a name of Brahmā in his creative aspect; or a name of a son of Brahmā.

The Golden Germ 'expresses itself in the form of a vibrating energy (*spandana-śakti-rūpa*). It divides itself into the causal mass of potentialities (the causal waters, *rayi*), and the breath of life (*prāṇa*) pictured as the wind that creates the waves in the causal ocean from which all forms develop'.[1] Thus, in the symbol of the egg, womb, life, death and tomb are signified.

[1]*HP*, p. 238.

Hiraṇyakaśipu 'Golden-robed'. A *daitya* king (a son of Diti) who ruled over the whole earth. He personifies evil and ignorance. He hated Hari (Viṣṇu), but his son Prahlāda was a devout Vaiṣṇava. Failing to dissuade his son from worshipping Viṣṇu, he persecuted him dreadfully. One day he sarcastically asked him where his god was that he did not rescue him from his suffer-

ings. Prahlāda answered that he was everywhere, even in the pillar before them, whereupon Hiraṇyakaśipu contemptuously kicked it. Immediately it split open revealing Viṣṇu in his composite man-lion form (Narasimha) which sprang forward and killed the demon.

Hiraṇyakaśipu and Narasimha are usually depicted locked in a life and death struggle. The former's weapons are a sword and shield.

Hiraṇyākṣa 'Golden-eyed'. A *daitya*, brother of Hiraṇyakaśipu.

Hiraṇyākṣa threw the earth into the ocean, for which act he was killed by Viṣṇu in his boar-incarnation (*varāhāvatāra*). According to the *Viṣṇudharmottara* Hiraṇyākṣa represents ignorance which is overcome by eternal wisdom and almighty power incarnated as Varāha-Viṣṇu.[1]

[1]*EHI*, I, pt i, p. 135.

v. Varāhāvatāra.

Hiraṇyapura 'Golden City'. The mythical aerial city of the *asuras* built by the magician Maya (or by Brahmā or Viśvakarman). Every desirable object is contained in it and there is no unhappiness.

Holākā or **Holī** A spring festival with obvious fertility connotations, dedicated to Kṛṣṇa and the *gopīs*. It includes erotic games, songs and obscenities, jumping over bonfires and throwing red powder and coloured water over friends and neighbours. Some features of the 'festival seem to go back to a prehistoric matriarchal stage. In some places one man (called the *kolīna*) has to wear woman's clothing and join the dancers about the *holī* fire'.[1]

[1]Kosambi, *Culture and Civilisation*, p. 47. See also Auboyer, *Daily Life*, p. 144; *Trilogie*, pt 1, 'kāma'.

Holī v. Holākā.

Homa The act of making an oblation to the gods by throwing ghee (*ghṛta*) into the sacrificial fire.

Hṛṣīkeśa An aspect of Viṣṇu.

v. Caturvinśatimūrti(s).

Huḍukka A small hand drum.

Hukkā Water-pipe (hookah). An emblem of Agastya.

I

Icchāśakti The tantric *śakti* of desire.

v. Pañcabrahmā(s).

Iḍa I. Sacrificial food, or a libation personified as a cow symbolizing nourishment and abundance, or as a goddess of abundance. Iḍā is sometimes equated with the earth.

v. Vaivasvata.

II. One of the three subtle arteries of the body.

v. Triśūla.

Iḍāpātra An oblong wooden vessel with a handle to hold offerings of milk, curd, rice, etc.

Ihāmṛga A fabulous animal consisting of parts of beasts, birds, and reptiles according to the artist's fancy.

v. Makara; Śarabha; Śārdūla.

Ikṣu(kāṇḍa) 'Sugar-cane', associated with agricultural fertility and with Gaṇeśa.

v. Iksukodaṇḍa.

Ikṣukodaṇḍa 'Sugar-cane bow', especially associated with Kāma the god of love, and with Tripurasundarī, Veṇugopāla, Skanda and others.

v. Ikṣu(kāṇḍa).

Ikṣvāku I. Name of a king and of a people who settled in eastern India between the rivers Son and Ganges. Possibly they were the first cultivators of sugarcane (*ikṣu*) in that region and derived their name from it.[1]

[1]Roy, 'Food and Drink in Ancient India', p. 225.

v. Sūryavamśa.

II. Founder of the Solar dynasty.

Iḷā A goddess, probably another name for the goddess Iḍā.

Indirā 'Powerful One'. Name of the goddess Lakṣmī, wife of Viṣṇu.

Indra Name of the war-god of the Aryans, the embodiment of valour, strength, courage and leadership, and consequently the ideal of the warrior class. He was also a culture hero[1] and the maintainer of royalty. From being one of the foremost Vedic gods he gradually declined in importance and became the leader of the Lokapālas and lord of the eastern direction.

Sometimes Indra is portrayed standing in front of his mount, the four-tusked white elephant Airāvaṇa. When portrayed with a third eye it is placed horizontally on his forehead.[2] A four-armed image from the Cidambaran temple shows him in the *varada* and *abhaya mudras*. His back hands carry an elephant goad and *vajra*.[3] The last was said to have been fashioned from the *ṛṣi* Dadhica's bones, or was made by Tvaṣṭṛ, or by the Ṛbhus. The *vajra* was a terrifying weapon and probably made of iron. It is possible that Indra, as leader of the invaders, 'introduced this new metal, and this perhaps accounts for his victory over a bronze-using people'.[4]

Indra is depicted with radiant countenance, a thick neck and large belly. He carries a spear and goad. His chariot is drawn by magnificent bays which in some mysterious way are linked with his power (*RV*, I, 82,6). His worshippers pray to him to obtain cows for them, and hence he has the epithet Godā (giver of cows). He also conquers demons and destroys great cities.

The *Purāṇas* describe Indra as golden or tawny, bearded, young, riding a magnificent white horse called Uccaiḥśravas, or riding a white elephant. His charioteer is Mātali. His banner, Vaijayanta, is gold and dark-blue and became the object of a separate cult. Among his emblems are a hook, noose, the bow Vijaya, the sword Parañjaya, and the conch-shell Devadatta.

[1]P. Thième, 'The Aryan Gods of the Mitanni Treaties', *JAOS*, no. 4, 1960.

[2]*Bṛhat. Sam.*, ch. 57, verse 42, cited in *DHI*, p. 523. Śiva's third eye is placed vertically on the forehead.

[3]*EHI*, II, p. 520, p1. CL.

[4]*IT*, p. 264, n.1.

v. Govardhana; Lokapāla(s); Indrāṇī; Kalpavṛkṣa; Vṛṣan; Jaitraratha.

Indracāpa 'Indra's bow', a name of the rainbow.

Indradhanus 'Indra's bow', also called Vijaya (victory).

Indradhvaja A wooden pillar erected before a temple and especially associated with royalty.

Indrajāla 'Indra's net (or snare)', i.e. the act of magic. In order to terrify enemies, phantom armies are conjured up (*Agni Purāṇa*, II, p. 870).

Indraketu 'Indra's banner'. v. Indramahotsava.

Indrakhīla 'Indra's post'. A pillar or column dedicated to Indra and placed at or before a city gate; it is also the name of a large slab of stone placed at the entrance of a house.

Indrākṣī A form of Devī. She has a bright countenance and holds a *vajra* in one hand: the other is in *varada* pose. Her garments are yellow and she wears many ornaments.[1]

[1]*EHI*, I, pt ii, p. 370.

Indramahotsava 'Great festival of Indra'. The ceremony of raising Indra's pole or standard (*indradhvaja*) conducted by the *purohita* or chaplain of a king. The pole signifies Indra's many victories and those of his worshippers.

Indrāṇī or **Śacī** Indra's consort (*śakti*) and the embodiment of power. Her father was the *asura* Puloman (hence her patronymic Paulomī). Her mount is usually an elephant, but when she is represented as one of the seven or eight mothers (*mātaras*), a lion. Her emblems are a rosary, elephant goad, water-vessel, a flower or leaves of a tree, a *vajra* and a spear. Her colour is red and she wears a *kirīta* and various ornaments. She dwells under a *kalpaka* plant. She may be portrayed with two, three, or a thousand eyes, and four or six arms.[1]

[1]*EHI*, I, pt ii, p. 385.

v. Saptamātara(s).

Indu 'Moon'. Another name of Candra and of Soma.

Indus Valley North West India. An advanced culture existed here from about 2500–1800 BC. Many remains of this civilization have been excavated at the main cities of Harappā and Mohenjodaro, and from the smaller towns of Chanhudaro and Lothal on the seaplain of Kathiawar about 450 miles south-east of Mohenjodaro. This civilization covered a huge area extending beyond the main Indus Valley from the Arabian Sea to Delhi.

Among the most interesting remains are the steatite seals with reliefs and inscriptions, but the latter remain undeciphered. A number of small lively figurines of animals and nearly nude women with huge, elaborate head-dresses have been discovered. Marshall et al.[1] have pointed out that the Mohenjodaro people worshipped their deities in anthropomorphic and in aniconic forms. Other seals depict theriomorphic or therioanthropomorphic figures.

[1]*Mohenjo-daro and the Indus Civilization*, I, p. 56.

Īśa or **Īśāna** I. 'Ruler', 'Lord', from the root *īś* 'to have power'.

Īśāna is the name of one of the five divine aspects of Śiva[1] (represented by his five faces), and represents the fifth face which looks upward and 'is beyond the comprehension of even the *yogīs*'.[2] When Īśāna is depicted as a separate deity he is shown with ten arms and five faces, each with three eyes. He holds the Vedas, an elephant goad, noose, hatchet, skull, drum, rosary and trident and shows the *abhaya* and *varada mudrās*;[3] his mount is a goat. When portrayed two-armed he carries a trident and skull-cup, or one hand is in *varada* pose; when four-armed, two hands play upon a *vīṇā*, the others are held in *varada* and *abhaya mudrās*. His mount may be a white bull, or he is seated on a lotus (*padmāsana*). He wears a white sacred thread or one consisting of a snake.[4]

Īśa represents the total potentiality of all knowledge and presides over all forms (*Śvet. Up.*, IV,11; V,2).

[1]And the name of one of the eight elemental forms of Rudra.

[2]*DHI*, pp. 460, 573.

[3]*Śivatoṣiṇī*, 1.1,16, quoted in *HP*, p. 211.

[4]*EHI*, II, pt ii, p. 538; and see p. 367.

II. Īśa is a name of Brahman-Ātman, 'when conceived in the personal aspect, especially in the theistic Upaniṣads'.[1]

[1]*DHI*, p. 75.

v. Brahman (neuter); Ātman.

Iṣṭadevatā The deity 'chosen' by an individual to be the god to which all his worship is directed. Iṣṭadevatā is also the term applied to the icon of the chosen deity, and to the main deity in a temple.

Iṣṭapradāmudrā The gesture (*mudrā*) indicating the 'granting of wishes'.

v. Varadamudrā.

Iṣu 'Arrow'.

v. Bāṇa.

Īśvara[1] 'Lord', the creator and ruler of the universe, the personification of the Absolute. This term is different from *deva* (god) who is 'a god charged with a limited function'.[2] Īśvara is also an epithet of Śiva who is the archetypal *yogin*.[3] In Tantrism Īśvara represents 'the first creative stir . . . that arises in the changeless Parabrahman; cosmic ideation'.[4]

[1]See Shastri, 'History of the word Īśvara', pp. 492ff.

[2]*AIA*, I, p. 96, n.24.

[3]Eliade, *Yoga*, p. 75.

[4]*Principles*, Glossary, p. 251.

Itarajanāḥ 'Other folks', an allusion to *yakṣas* and other hidden spirits.

Itihāsa Epic legend or story.

J

Jagadambā or **Jagadambī** or **Jaganmātā** 'Mother of the world', a dynamic mother-aspect of the Great Goddess Devī.

Jagaddhātrī 'Sustainer of the world'. An epithet of Pārvatī, Durgā and Sarasvatī, who are depicted with four arms, their mount being a lion (*siṁhāsana*).

Jagadgaurī 'World Gaurī'. A form of Pārvatī and of Manasā. Jagadgaurī has four arms. Her emblems are a discus, lotus, club and conch-shell.

Jaganmātā v. Jagadambā.

Jagannātha 'Lord of the world'. A form of Kṛṣṇa (Viṣṇu) especially worshipped at Puri. Wooden images of Jagannātha, Balarāma and Subhadrā are enshrined in the main sanctum at Puri and renewed every twelve years. The old images are buried in a quiet part of the temple compound.[1] These images are without arms or legs. Jagannātha's form is represented as a log of wood marked with two big eyes.

[1]*DHI*, pp. 211f.

Jaitraratha 'Chariot of Victory'. Name of Indra's chariot which, as lightning or as a meteor, descends to earth with a thunderous roar. It is decorated with gold and drawn by peacock-coloured horses. It contains all weapons because Indra is a god of war. His dark-blue and gold banner on a yellow pole flies above the chariot and symbolizes victory.

Jaka v. Panasa(phala).

Jala 'Water'. The purifying, fertilizing and life-preserving power *par excellence*. Water also represents the non-manifested substratum from which all manifestation arises.

Jāla I. 'Net', used as a war weapon by Indra and by Yama, ruler of the dead.

II. Name of the network of which a crown (*kirīta*) is made.

Jalandhara-vadhamūrti or **Jalandhara-haramūrti** A terrifying aspect of Śiva when he killed the *asura* Jalandhara. Śiva is two-armed, three-eyed, and red, signifying his fiery wrath and the killing of the demon. His emblems include a parasol and water-vessel. A crescent moon and Gaṅgā are depicted on his dishevelled headdress. He wears sandals. Jalandhara's hands are shown in *añjali mudrā*. He wears a crown, ornaments, and a sword.[1]

[1]*EHI*, II, pt i, pp. 191.

Jalāśayin or **Jalāśayana** 'Lying on the water'. A form of Viṣṇu reclining on the primordial waters during the interregnum between the end of one world and the evolution of the next. This form is similar to that of Anantaśāyana or Śeṣaśāyana.

v. Mahāpralaya.

Jala-turaga 'Water-horse'. A fabulous animal often depicted with the water-elephant (*jalebha*). The water-horse represents the waters as the source of life.

v. Jalebha.

Jalebha or **Jala-hastin** The fabulous water-elephant often portrayed with the water-horse (*jala-turaga*) as vehicles of *yakṣas* and *yakṣīs*. The *jalebha*, like the water-horse, *makara*, and the brimming vase, symbolize the immense potentiality of the waters as the source of life.[1]

[1]Coomaraswamy, *Yakṣas*, pt ii, p. 50.

Jāmadagnya v. Rāma.

Jāmbavān or **Jāmbavat** King of the Bears (probably the name of a leader of an aboriginal tribe), who aided Rāma in his fight against Rāvaṇa.

Jambhīra(phala) or **Jambhara** or **Jambīra** The fruit (*phala*) of the citron, emblematic of *yakṣas* and of Brahmā, Īśāna, Kubera, Lakṣmī, Pārvatī, Sadāśiva and Viśvarūpa.

Jambu 'Rose-apple tree' (*Eugenia jambolana*). Its fruit

is emblematic of Taruṇa-Gaṇapati.

v. Jambudvīpa.

Jambudvīpa 'Rose-apple island'. According to ancient Indian cosmology, Jambudvīpa is one of the seven great insular continents each surrounded by one of the seven seas of salt water, sugarcane juice, wine, clarified butter (*ghee*), curds, milk and fresh water, all of which symbolize fertility and abundance.[1]

On Mount Meru, situated in the middle of Jambudvīpa, grows the enormous wish-granting *jambu* tree.

[1]Cf. *TT*, p. 60.

Janādana Viṣṇu as 'giver (*dana*) of rewards' that is, the 'fruits' or consequences of man's deeds.

Jarā I. 'Old age, personified as a daughter of Death (Mṛtyu).

II. The child-stealing, flesh-eating demoness (*rākṣasī*) who can assume any form at will (*kāmarūpiṇī*). She is worshipped in palaces, and by the laity, and hence is called Gṛhadevatā 'goddess of the household'. A householder who draws her figure, surrounded by her children, on the walls of his house will be prosperous.[1]

[1]*DHI*, p. 380, and see Banerjea, 'Some Folk Goddesses', pp. 101 ff.

Jaṭā 'Matted hair', a sign of mourning, and also characteristic of ascetics, Brahmā, and especially of Śiva as the great *yogin*. Jaṭā also signifies indifference to mundane things.

v. Jaṭāmaṇḍala; Jaṭābandha.

Jaṭābandha or **Jaṭābhāra** An elaborate method of braiding or tying together Śiva's matted hair (*jaṭa*) to resemble a crown. When in dancing poses his matted locks fan out on either side of his face. *Bhaktas*, *sādhus* and Aiyanār also wear *jaṭās*. Some Indologists consider these two terms signify slightly different modes of dressing the hair.

v. Jaṭāmaṇḍala; Naṭarāja; Jaṭāmukuṭa.

Jaṭābhāra v. Jaṭābandha.

Jaṭāmaṇḍala A circle of matted hair (*jaṭā*), dressed erect as in portrayals of Bhairava, Kālī and Kubera which signifies their destructive aspect.

Jaṭāmukuṭa or **Jaṭāmakuṭa** 'Crown of matted hair (*jaṭā*)'. An elaborate hairstyle where the matted locks are built up to resemble a crown adorned with decorations. When worn by Śiva and his *śakti*, the crescent

moon is depicted on the crown as well as a skull, and a cobra is coiled on the left side. When worn by Brahmā, the moon, skull and cobra are omitted.

v. Jaṭā.

Jaṭāyu or **Jaṭāyus** A chief of the Gṛdha (Vulture) tribe who assisted Rāma in his struggle with Rāvaṇa. Jaṭāyu is regarded as a son (or *avatāra*) of the fabulous bird Garuḍa.

Javā The 'China rose', a flower sacred to Durgā and to Kālarātrī.

Jaya Name of one of the two door-keepers (*dvarapālas*) of Vaiṣṇava shrines, the other being Vijaya. They are four-handed and carry Viṣṇu's usual emblems.

Jayā The name of one of Ṣaṇmukha's *śaktis* and of a door-keeper of the goddess Gaurī.

v. Vijayā.

Jayadurgā 'Victorious Durgā'. A four-armed, three-eyed form of Durgā whose radiance spreads throughout the three worlds.[1] She is worshipped by those who desire to attain *siddhi*. Her emblems are a discus, sword, conch-shell and trident; her colour is black, her mount a lion. A crescent moon is depicted on her crown.

[1]*EHI*, I, pt ii, p. 344.

Jayanta I. 'Victorious'. An aspect of Śiva, of the Āditya (the Sun), and of Skanda. They hold the usual weapons and emblems of Śiva, and their *mudrā* is the *tarjanī*.

II. Name of a son of Indra.

Jayantī 'Victorious'. Name of a daughter of Indra, and an epithet of Durgā whose emblems are: a sword, trident, shield and spear (or knife, *kunta(?)*). She is worshipped by those who are happy.[1]

[1]*EHI*, I, pt ii, p. 369.

Jhārī A ritual long-necked pitcher with a spout.

Jihvā 'Tongue'. Agni has seven names, tongues, or flames.

The goddess Kālī is portrayed with her tongue lolling out to indicate her thirst for blood.[1]

[1]*ID*, p. 113, suggests that when she is shown dancing on the body of Śiva, the lolling tongue may indicate civility, because in parts of India, Burma and Tibet it is so regarded.

Jīva or **Jīvātman** The individual self or spirit. A person who has achieved spiritual freedom, but is still manifest in human form, is called *jīvan-mukta*.

Jīvan-mukta v. Jīva.

Jīvātman v. Jīva.

Jñāna Sacred 'knowledge' gained by meditation. v. Jñānadakṣiṇāmūrti.

Jñānabhāṇḍa 'Receptacle of knowledge' symbolized by a water-vessel, an emblem of Sarasvatī (Lakṣmī).[1]
[1]*ID*, p. 113.

Jñānadakṣiṇāmūrti Śiva, as the universal teacher, the embodiment of knowledge (*jñāna*), that is, the esoteric knowledge of *ātman* (*ātma-vidyā*) which Śiva confers on his devotees. *Jñāna* is not mundane knowledge and 'cognition, but the irrefutable intuition of a single, all-including entity, other than which nothing persists'.[1]

Jñānadakṣiṇāmūrti is depicted four-armed, seated in *ardhaparyaṅkāsana*, and holding a rosary in the back right hand, and a vase with foliage, or a blue lotus, in the left; the lower right is in *jñānamudrā*. At other times he is depicted in *siddhāsana*, a yogic pose which represents 'the inflow, intension, withdrawal and concentration of energy',[2] or in *utkuṭikāsana*.
[1]*TT*, p. 16.
[2]*Principles*, p. 202.
v. Dakṣiṇāmūrti; Siṃha; Akṣamālā; Padma I; Yoga-Dakṣiṇāmūrti.

Jñānamudrā The 'gesture (*mudrā*) of knowledge' in which the tips of the thumb and index finger touch to form a circle, and the hand is held against the heart. This *mudrā* is sometimes identified with the *dhyāna mudrā*.

Jñānamudrā is characteristic of Hayagrīva, Jñāna-dakṣiṇāmūrti, Tatpuruṣa, Vyākhyānadakṣiṇāmūrti, and others.[1]
[1]*ID*, p. 113.

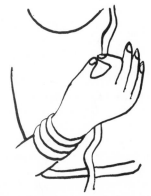

Jñānanetra 'Eye (*netra*) of knowledge'. Name of Śiva's third eye which is portrayed vertically on his forehead,

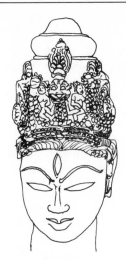

whereas Indra's is depicted horizontally.
v. Trinayana.

Jñānaśakti A goddess personifying the power of knowledge.
v. Pañcabrahmā(s).

Jñānasambandha (Seventh century AD) 'Friend of knowledge'. A South Indian Śaiva devotee, and author of some 'hymns'. He is usually depicted as a child with one finger pointing (*sūcimudrā*), the other hand holding a skull-cup (*kapāla*).

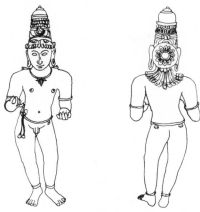

Juhū A long-handled, tongue-shaped wooden sacrificial offering-spoon used to pour the sacred ghee (*ghṛta*) onto the fire which is said to sustain the sky. The spoon is an emblem of Yajñamūrti,[1] the personification of the Sacrifice.
[1]*ID*, p. 114.
v. Upabhṛt; Sruk; Sruva; Darvī.

Juli A bag, filled with the sacred ashes (*vibhūti*) of cow-dung, and carried by Śiva.[1]

[1]*ID*, p. 114.

Jumna v. Yamunā.

Jvāla 'Flame'.

v. Jihvā; Agni; Jvālakeśa; Jvālamālā.

Jvālakeśa Hair depicted flaming upwards. Śiva's matted locks (*jaṭās*) are described as tawny like the flames of Agni. Agni and Bhairava are also depicted with their hair dressed in this way, which indicates their fearsome and destructive aspects.

v. Keśamaṇḍala.

Jvālamālā An aureole of flames surrounding the whole body.

v. Prabhāmaṇḍala.

Jvālāmukhi 'Mouth of fire'. A volcano, or any place from which subterranean fire issues. It is often worshipped as an aspect of Durgā.

Jvalitaśikhā 'Flaming hair'.

v. Keśamaṇḍala.

Jvara 'Fever', personified as a god of the same name (Jvaradeva). Fever is said to be the king of diseases and is described as having three feet, and three heads each with three glowing red eyes. He is short and hairy and may have a tawny beard.[1]

[1]Stutley, *Ancient Indian Magic and Folklore*, p. 12.

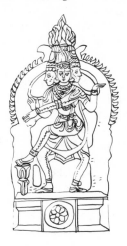

Jyeṣṭhā[1] or **Alakṣmī** An ancient South Indian goddess who became popular in many parts of India. She is the elder sister of Lakṣmī (goddess of good fortune), but represents the opposite qualities. Jyeṣṭhā is now identified with Śītalā, the goddess of smallpox, and also resembles the Buddhist smallpox goddess Hārītī.

A crow (symbolizing dead ancestors) is depicted on her banner and her mount is an ass – an animal used ritually to expiate sexual offences.[2]

Sometimes Jyeṣṭhā is depicted as a hideous old woman, long-nosed, with sagging lips, long pendulous breasts and sagging belly, a description reminiscent of some medieval European witches. Although Viṣṇu is said to have bestowed on her a boon, he nevertheless muttered the *rudramantra* to protect himself from her evil influence.[3]

Lions draw her chariot and tigers follow it. Her emblems are a staff, skull-cup, blue lotus, arrow and broom. Her *mudrās* are the *abhaya* and *sūci*.

The *Viṣṇudharmottara* distinguishes two forms of Jyeṣṭhā, namely Rakta-Jyeṣṭhā and Nīla-Jyeṣṭhā. Both are portrayed as two-armed, seated figures with their feet touching the ground. These aspects of the goddess are propitiated by heroes.[4] She is sometimes identified with the inauspicious goddess Nirṛti.

[1]See Banerjea, 'Some Folk Goddesses', pp. 101ff.
[2]Renou and Filliozat, *L'Inde classique*, I, p. 536.
[3]*EHI*, I, pt ii, p. 398.
[4]Ibid., p. 395.

Jyotir-liṅga The unbounded, effulgent *liṅga* of light, a form assumed by Śiva to compel Brahmā and Viṣṇu to acknowledge his supremacy. Traditionally there are twelve *jyotir-liṅgas* situated in various parts of India which are worshipped as luminous symbols of Śiva.

v. Liṅgodbhavamūrti; Liṅga.

K

Ka 'Who?' The nameless source of universal power, later identified with Prajāpati.[1] This nameless being was the first originator of creation (*RV*, X, 129,7). Oblations are offered silently to Ka because everything not 'named' belongs to him.[2]

[1]*Aitareya Brahmana*, 3,10; *ŚBr.*, IV,5.6,4.
[2]St Paul (Acts xvii,23) mentions an altar in Athens inscribed 'To an unknown god'.

Kabandha A giant *rākṣasa* (probably the leader of an Indian aboriginal tribe who painted terrifying faces on their persons). The *Rāmāyaṇa* (III, 69,27) describes them as headless, devoid of neck, having the face

Kaccapa

where the belly should be and with an enormous eye protruding from the centre of the chest.

Indra is said to have struck Kabandha with his thunderbolt, so driving his head into his body, but Rāma granted his dying wish that he should be cremated, and as the flames rose heavenwards, Kabandha appeared in his own beautiful *gandharva* form.

v. Danu I.

Kaccapa v. Niddhi(s).

Kaccha I. A style of dress in which the cloth is folded and finely pleated.

II. A cloth worn round the hips, passed between the legs and tucked in behind, similar to the *dhotī*.

Kacchapa 'Tortoise'.

v. Kūrma; Kacchapeśvara.

Kacchapeśvara 'Lord of the tortoise (*kacchapa*)'. An epithet of Śiva. This appears to be a Śaiva counterpart to Viṣṇu's tortoise incarnation (*kūrmāvatāra*).

Kadala 'Banana', often depicted in the hands of Bāla-Gaṇapati.

Kaḍamba A tree sacred to Kṛṣṇa and to Śiva.

Kadrū 'Reddish-brown'. A wife of the *ṛṣi* Kaśyapa, and mother of *nāgas*. Before Kaśyapa retired to the forest he promised his two wives, Kadrū and Vinatā, as many children as they desired. Kadrū asked for a thousand, Vinatā for two, but stipulated that they must be superior to Kadrū's. Kaśyapa agreed and in due course the offspring were born as eggs. From Kadrū's a thousand tiny serpents emerged, among which were Śeṣa, Vāsuki and Manasā.

v. Vinatā; Garuḍa.

Kailāsa A mountain peak said to be part of the Himālaya on which were situated various paradises of the gods, especially those of Śiva and Kubera. On its summit a huge jujube tree grows, from whose roots the Ganges (Gaṅgā) rises. Kailāsa 'is conceived as resembling a *liṅga*',[1] representing the centre of the universe.

[1]*ID*, p. 116.

v. Meru.

Kairava 'White lotus'.

v. Puṇḍarīka.

Kaiṭabha The name of a demon who, with another called Madhu (symbolizing the *rajo-* and *tamoguṇas* respectively), emerged from Viṣṇu's ear whilst he was sleeping on the primordial waters at the end of the age. They intended killing Brahmā and destroying the new world which was about to be created, but Viṣṇu suddenly awoke and destroyed them (*Mārk. Pur.*, 81, 41–53).

v. Anantaśāyana; Yoganidrā; Guṇa.

Kāka 'Crow'. An unlucky bird, probably so regarded because of its colour. A crow is the vehicle of the

unlucky planet Śani (Saturn), and it is also depicted on the banner (*kākadhvaja*) of the inauspicious goddess Jyeṣṭhā. The bird 'is popularly regarded as being related to the soul of a deceased person'.[1]

[1]*ID*, p. 116.

Kākadhvaja 'Crow-banner'.

v. Kāka.

Kalā 'Art'. Any kind of accomplishment depending on skill.

Kāla 'Black'; 'Time'. Kāla (Śiva) and Viṣṇu are regarded as aspects of Cosmic Time (Mahākāla) which is present before existence. Relative time as perceived by man measures the duration of individual existence and is an apparent division of continuous cyclic Time in which all creatures are born, increase, reach their peak, and then progressively deteriorate as the Wheel of Time revolves *ad infinitum*. Hence there is no absolute beginning or absolute end of time. All existence moves successively from a state of non-manifestation to a state of manifestation and back again.

Kāla is the destroyer of worlds. Hence he is called 'the Black', although the actual destructive function is assigned to his *śakti* Kālī.

Kāla is said to be 'the cook of creatures' by creating and bringing them to fruition when they are fit to be swallowed by Death. He has fierce red eyes and holds a noose (*pāśa*) with which to ensnare his victims.

v. Kālacakra; Kālapāśa; Kālasimhamukha.

Kāla-Bhadrā 'Time (or Death) Bhadrā'. An aspect of Śiva's *śakti* who is worshipped in burial grounds.

Kāla-Bhairava 'Death (or Time) Bhairava'. The black divinity of death represented by the southern aspect of Śiva called Dakṣiṇāmūrti. There are eight different Bhairavas.

v. Kāla.

Kālacakra 'Wheel (Cakra) of Time'. Time regarded as cyclic and symbolized by a rotating wheel.

v. Kāla.

Kalacūri Name of a dynasty which ruled in Central India from the sixth century AD. During this dynasty the earliest Śaiva caves (nos 21 and 29) at Elūrā were excavated.

Kāladaṇḍa The staff (*daṇḍa*) of Time'. An emblem of Yama, (ruler of the dead), signifying that the passing of time results in death.

v. Kāladūta; Kāla.

Kāladūta 'Messenger (*dūta*) of death'. Any omen or sign of approaching death such as illness, weakness, old age (Jarā), or the sight of a pigeon (*kapota*), or other inauspicious bird or animal.

v. Kāla.

Kālaharamūrti or **Kālāntakamūrti** An aspect of Śiva as the conqueror of Time (Kāla) and hence of Death.

v. Kālārimurtī.

Kālakañja or **Kālakeya** Name of particular *asuras*, sons of Kaśyapa and the evil spirit Kālaka.

Kālakeya v. Kālakañja.

Kālakūta The 'Black (or death) substance'. The poison which emerged from the churning of the ocean and which Śiva half swallowed and held in his throat to preserve the world from its fearsome effects.

v. Samudramathana; Nīlakaṇṭha; Halāhala.

Kālāmra The divine mango tree growing on the eastern side of Mount Meru. Its juice endows women with perpetual youth.

Kālamukha The 'face (*mukha*) of Death (*kāla*)'.

v. Kīrttimukha; Mṛtyu.

Kālāmukha(s) Members of a Śaiva sect who mark their foreheads with a black streak. They are said to be born of human and demonic parents.

Kālapāśa The 'noose (*pāśa*) of Time' with which Yama (ruler of the dead) ensnares his victims when their 'time is up'.

Kālarātrī Name of the goddess (either Kālī or Durgā) when personifying Time (Kāla), and the last night of the age when the world is destroyed by the passing of Time.

Kālarātrī is also a *mahāvidyā*. Her mount is an ass; her emblems a *vīṇā*, China-rose flower, a cup of blood, and a garland of skulls. She is portrayed naked, signifying the levelling effect of time in which everything is destroyed. Sometimes she wears pointed iron ornaments on her left ankle.[1]

[1]Bhattacharya, *Indian Images*, pt 1, p. 40; *EHI*, I, pt ii, p. 359.

v. Pralaya; Kālī.

Kālārimūrti Name of Śiva in the act of punishing death personified (Kāla or Yama), for attempting to seize the young sage Mārkaṇḍeya who was worshipping a *linga*. In his terror at the sight of Kāla, Mārkaṇḍeya clutched the *linga*, whereupon Śiva appeared and kicked Kāla in the chest. In the *Bṛhadīśvara* temple, Tanjore, Śiva is portrayed in the centre niche dancing triumphantly after his victory. In the left hand niche Yama rushes towards his victim, in the other, Mārkaṇḍeya is shown clutching the *linga*.

Kālāri's emblems are a skull-cup, sword, shield, antelope, axe, snake noose, trident and *vajra*. Kāla is depicted in *añjali mudrā*.

Kālāri may be depicted three-eyed, four- or eight-armed, and with small tusks protruding from his mouth. When eight-armed he holds the trident, axe, *vajra*, sword, shield and noose. His *mudrās* are *sūci* and *vismaya*.

Kālarudra 'Time (*kāla*) Rudra'. Rudra in the form of the fire that will destroy the world at the end of the age.

v. Pralaya; Kālarātrī.

Kalaśa 'Water-pot', 'pitcher', around which much symbolism has grown up. In ancient India the *kalaśa* symbolized the universe, and later, when the theory of the *maṇḍala* was established, it became an integral part of the mandalic liturgy. The 'vase is the first *maṇḍala* into which the deities descend and arrange themselves'.[1]

[1]Tucci, *Tibetan Painted Scrolls*, I, p. 327, n.33; v. also Coomaraswamy, *Artibus Asiae* (1928–9), pp. 122f.

v. Pūrṇakalaśa; Brahmā; Kumbha; Bhadraghaṭa; Kuladevatā(s).

Kālasimhamukha Another name for the *kīrttimukha*, a magically protective mask. It represents Time, and Death which inevitably occurs in time.

v. Kāla.

Kalāvati The magic lute of Tumburu.

Kalavikarṇikā An aspect of Devī who carries a skull-cup and spear and is bluish in colour. She removes the fears of her devotees.

Kāleśvara 'Lord of Time'. An epithet applied to Śiva.

v. Kāla.

Kalhāra 'White water-lily'. An emblem of Ūrdhva-Gaṇapati.

Kali I. Name of one of the pieces used in games of dice. It is marked with a single dot and is the formidable losing die (*AV*, VIII,109,1), later personified as the destroying spirit of time (*kāla*).

II. Name of the last of the four mythical periods (*yugas*) of the world's duration. The present age is the *kali* age and is regarded as an evil period.

Kālī I. Name of one of Agni's seven tongues or flames.

II. The *śakti* of Śiva who symbolizes the power of time (*kāla*) in which all forms come into manifestation and in which they also disintegrate. Kālī is described as a two- or four-armed, hideous, naked woman who devours all beings. She may hold a noose, *vajra*, skull-topped staff, sword and a severed head. The last reminds all beings that there is no escape from time and that individual lives are but minute episodes in the time continuum. Her four arms signify the four

directions of space, identified with the complete cycle of time. The weapons point to her destructive powers. Her nakedness denotes the stripping off of all the veils of existence and the illusion (*maya*) arising therefrom. Her colour is black, the colour in which all distinctions are finally dissolved in the universal darkness of eternal night, in the midst of which she stands upon 'non-existence', that is, non-manifestation, the dormant but potentially dynamic state that precedes manifestation. The corpse (*sava*) of Siva on which she is sometimes depicted, either standing or dancing, represents non-manifestation. Her *mudras* are the *abhaya* and *varada*, the former indicating that she allays the 'terrors of Time' for her devotees because death is the gateway through which the eternal spirit passes from one body to another. The *varada mudra* indicates that she bestows the gift of true perception leading to liberation (*moksa*).

Sometimes her mount is a leogryph (*yali*); her emblems include a goad, drum, bow, sword, skull-cup, skull-garland, noose, head of a demon, trident and dagger. Another emblem is the left-handed swastika.

Kali dancing in cremation grounds and wearing a garland of skulls signifies the universality of death, and also that the heart of the devotee is made empty by renunciation.

v. Kalika; Kapalin; Kala.

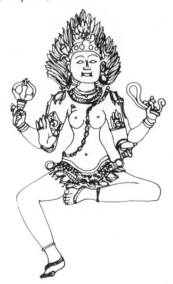

Kalika A variety of Camunda and one of Durga's many names. As Kalika she represents Absolute Time, from which Brahma, Visnu, Mahesvara and other gods were born. At the time of the dissolution of the world (*pralaya*) the gods will be absorbed into her.[1] Her consort is Nairrta, and her mount an ass. She is depicted naked and wearing a necklace of skulls.

[1]*Nirvana Tantra*, cited by Rawson, *The Art of Tantra*, p. 184.

Kalikatandava A dance form of Siva in which he is portrayed with eight arms. His *mudras* are *abhaya* and *gajahasta*; his emblems a bowl of fire, drum, bell, skull-cup, noose and trident.

Kaliya The demonic five-headed aquatic serpent king (*naga*) (usually depicted as a five-headed snake) who dwelt in a deep pool in the river Yamuna, from which he emerged periodically to ravage the countryside. On one occasion the child Krsna jumped into the pool and was quickly surrounded by snakes, but Balarama, who was nearby, called to him to use his divine powers. Immediately Krsna overcame the snakes and danced upon the middle hood of Kaliya until he begged for mercy and admitted Krsna's supremacy (*VP*, V,7.).

Usually Krsna is portrayed wearing full regalia, and dancing with his left foot placed on the head or body of a youthful human-headed snake. In his left hand Krsna holds up triumphantly the snake's tail; his right hand is in the *abhaya mudra*. The serpent king's hands are in the *anjali mudra*, denoting obeisance. This story may reflect a victory of the Krsna cult over an ancient snake cult.

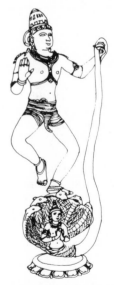

Kalki or **Kalki** or **Kalkin** The tenth and future incarnation of Visnu who will appear at the end of the present age (*kaliyuga*) of wars, vice and crime, to re-establish righteousness and virtue.

The *Mahabharata* and the *Puranas* describe Kalki as a hero mounted on a white horse (sometimes the horse is depicted with wings), and bearing a blazing sword, or as a two-armed giant with a white horse's head,[1] or simply as a magnificent white horse.

The *Viṣṇudharmottara* describes Kalki as a powerful man with angry countenance, riding a horse and holding a sword in his raised hand. He may also have other emblems including a discus, shield, conch-shell, and an arrow. In reliefs portraying the ten chief incarnations (*daśāvatāras*) of Viṣṇu, Kalki is shown as the last figure.

[1]This form is differentiated from that of Hayagrīva who has four hands.

v. Yuga I.

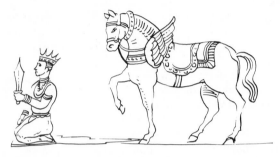

Kalkin v. Kalki.

Kalmāṣī The mythical wish-fulfilling speckled cow of the Vedic sage Jamadagni.

Kalpa The duration of a world, an enormous period of time called a 'day and night of Brahmā'. This day is divided into fourteen parts called *manvantaras* (reign of a Manu). Each one lasts for 4,320,000 human years.

Hindus and Buddhists picture the universe as evolving and devolving over immense periods of time. It has taken the West more than 2,000 years to arrive at a similar concept.[1]

[1]Capra, *The Tao of Physics*, p. 209.

v. Yuga.

Kalpadruma 'Tree of a world period (*kalpa*)'. One of the five trees (*pañcavṛkṣa*) of Indra's paradise which fulfils all desires and bestows innumerable gifts. It is sacred to Indrāṇī.

Kalpakalatā Flowers of the *kalpaka*-creeper, emblematic of some forms of Gaṇeśa.

v. Lakṣmī-Gaṇapati; Piṅgala-Gaṇapati.

Kalpalatā A fabulous long creeping plant often depicted on temple reliefs and linking gods, men, animals and plants together. It denotes the life-force which is shared by all living things. The creeper is said to grant the wishes of those who revere it.

v. Kalpavallī.

Kalpavallī The wish-fulfilling celestial creeper.

Kalpavṛkṣa The celestial wish-fulfilling tree and the general name of the five great trees of Indra's paradise.

The capital of a stone column (*c.* third century BC) discovered at Besnagar depicts a banyan tree yielding abundance and enclosed by a railing. Bags and vases overflowing with coins are shown under the tree, as well as a conch-shell and lotus exuding coins.

Kalyāṇasundaramūrti An auspicious aspect of Śiva when taking Pārvatī's hand (*pāṇigrahaṇa*) in marriage, an obligatory act in the marriage ceremony and which constitutes the first part of it after which the bride should stand on the left of the groom.[1]

Śiva has four hands, the upper ones holding a battleaxe and antelope, the front right arm extended to hold Pārvatī's hand. Sometimes Viṣṇu stands near Pārvatī, giving her away whilst other sages witness the event. Viṣṇu may hold a water-vessel; the pouring out of water marks the giving of the bride to her husband, and Brahmā, as the officiating priest, is sometimes depicted tending the sacred fire during the ceremony. The Lokapālas may be depicted in two parallel rows above in the celestial sphere. Varuṇa is shown on a *makara*, Indra on an elephant, Agni on a ram, Yama on a buffalo, Vāyu on a stag, Īśāna on a bull, and Nirṛti on a man. Vidyādhara couples and other celestial beings fly towards the two main figures. Pārvatī, being bashful, looks down and sees the scene reflected in Śiva's shining nails.[2]

The Kalyāṇasundara form is also called Vaivāhika or Śivavivāha (*vivāha* and *kalyāṇa* mean marriage). It resembles the group showing Subrahmaṇya marrying Senā (Devasenākalyāṇasundara).

[1]Tewari, *Hindu Iconography*, p. 29. But some authorities state that Pārvatī should be standing to the right of Śiva (*EHI*, II, pt i, p. 340n.).

[2]Ibid., p. 33.

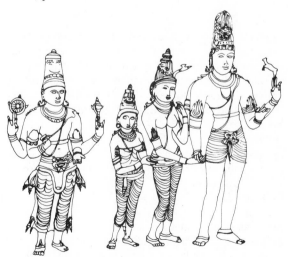

Kāma The god of love. In the *Ṛgveda* (X,129,4) *kāma* represents the creative principle, the primeval impulse behind existence.

When Śiva was engaged in meditation Kāma dis-

charged an arrow at him in an attempt to divert his attention to his wife Pārvatī, but instantly Śiva reduced him to ashes with a glance from his third eye. Kāma's widow Rati (personifying affection and sensual delight), begged Śiva to restore her husband. He agreed, but only as a mental image, and hence Kāma's epithet Ananga (bodiless). He is also called Manmatha and Pradyumna and regarded as an aspect of Viṣṇu.

Kāma may be depicted as a proud two-, four- or eight-armed youth with a parrot or a peacock as a mount, or a *makara*, a symbol of sensuality. In two-armed forms he carries a flowery bow (because flowers are often used by lovers); in eight-armed forms he carries a conch-shell, lotus, bow and arrow; his remaining hands rest on the bodies of his consorts.[1]

[1]Bhattacharya, *Indian Images*, pt i, pp. 30f.

v. Prīti.

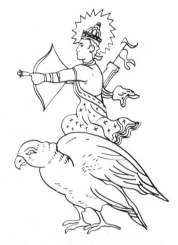

Kāmadhenu The mythical wish-fulfilling Cow of Plenty which emerged from the Churning of the Ocean (*samudramathana*). She is also called Surabhi, Aditi, etc.

Kāmadhenu symbolizes the abundance and proliferation of Nature and hence stands for generation and motherhood. Her son is Bhṛngi (the Wanderer), Śiva's bull.

Kāmakāla The symbolical union of Kāma with Kāla represented by Śiva and Lalitā. The *śrīcakra yantra* also symbolizes this union. Kāmakāla 'may also be represented by erotic sculptures'.[1]

[1]*ID*, p. 122.

v. Yantra.

Kāmākhyā v. Kāmākṣī.

Kāmākṣī or **Kāmākhyā** 'Wanton-eyed'. A cruel form of Durgā to whom formerly human beings were sacrificed, and now animals. Her chief temple is in Assam.

Kamalā 'Lotus-born'. A name of Śrī Lakṣmī, the goddess who dwells in the lotus. She embodies all that is desirable and presides over fertility and over the precious jewels and minerals of the earth. She stands on a lotus plinth and holds two lotuses. Her *mudrās* are the *abhaya* and *varada*.

v. Mahāvidyā(s); Padmā; Kamalayoni.

Kamalākṣamālā 'Garland (*mālā*) of lotus eyes'. Name of a particular kind of garland emblematic of Brahmā, Sarasvatī and Śiva.

v. Akṣamālā.

Kamalanayana 'Lotus-eyed'. The eyes of divine figures are elongated and shaped like lotus petals, a sign of beauty.

Kamalāsana 'Having a lotus-seat'. An epithet of Brahmā who is portrayed seated on a lotus (representing his creative function), which springs from Viṣṇu's navel.

v. Padma; Kamalayoni.

Kamalayoni 'Lotus-born'. An epithet of Brahmā who emerged from the lotus growing from the navel of the sleeping Viṣṇu.

v. Padma; Anantaśāyana.

Kamaṇḍalu Small water-pots of various shapes used by ascetics and denoting the mendicant's life. Brahmā has a water-pot as an emblem, as do a number of other deities including Sarasvatī, Śiva, Agni, Varuṇa, Gangā, Bhadra-Kālī.

When regarded as filled with ambrosia (*amṛta*) it symbolizes knowledge and immortality.

v. Aṣṭamangala; Bhadraghaṭa; Pūrṇakalaśa; Kuṇḍika; Kalaśa.

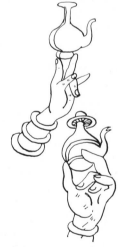

Kāmānkuśa The 'goad of love' with which Kāma excites lovers.

Kāmāntakamūrti[1] A three-eyed, four-armed form (*mūrti*) of Śiva reflecting the story that Kāma had disturbed his meditations by aiming at him his flowery arrows (which arouse sexual desire). Śiva is portrayed in *yogāsana*. His countenance is angry and Kāma lies

dead before him, burnt to ashes by the fiery glance of his third eye. Kāma's consort Rati stands horrified nearby. Kāmāntaka's *mudrās* are *patākā* and *sūci*; his emblems, a rosary and snake.

[1]This form is similar in most respects to Yoga-Dakṣiṇāmūrti.

v. Ananga.

Kāmāri 'Love's adversary'. An epithet of Śiva denoting that he is beyond the sway of emotion, being the *yogin par excellence*.

v. Dakṣiṇāmūrti.

Kambugrīva The lucky three lines or creases on the neck depicted on images of deities, and of the Buddha.

Kaṃsa A demon, reborn as the tyrannical King of Mathurā (son of Ugrasena), who tried unsuccessfully to kill the young Kṛṣṇa, since it had been foretold that he would be killed by the eighth child of his cousin Devakī.

v. Balarāma; Kṛṣṇa.

Kāñcīdāma A girdle, to which are attached small bells held in place by rows of ornamental chains.

Kañcuka A jacket-like garment sometimes worn by Lakṣmī. It is also a term for armour.

Kaṇiśa 'Ear of rice', sometimes held by Gaṇeśa and Vasudhārā.

Kaniṣka A famous ruler of the Kuṣāna dynasty of Mathurā (second century AD), who greatly encouraged all forms of art throughout his vast empire.

Kankāla 'Skeleton' or 'necklace of skeletons', worn by Kankālamūrti, by Kālī, and by some other Tantric goddesses.

v. Kapālin; Kankālamūrti.

Kankāladaṇḍa A staff (*daṇḍa*) surmounted by a skeleton of a human being or a demon. Thus Śiva carries the skeleton of Andhakāsura whom he killed, and also that of Viṣvaksena.

v. Kankālamūrti.

Kankālamūrti A fierce (*ghora* or *ugra*) form of Śiva. According to the *Āditya Purāṇa* he wears a necklace of skeletons (*kankāla*) said to comprise all the skeletons of Viṣṇu's various incarnations. Another story relates that Śiva and Brahmā quarrelled over which one of them was supreme. When Brahmā would not yield, Śiva cut off his fifth head, for which crime of brahminicide he was condemned to wander about the country begging for food with Brahmā's skull stuck fast to his hand until the sin was expiated.

Śiva is depicted as a mendicant wearing few ornaments and sometimes with snakes encircling his body. He is usually represented with one foot in front of the other as if walking. He has four arms and holds a drum and drumstick in his front hands. He wears wooden sandals. Sometimes he has a long staff topped by Brahmā's skull, or a trident with the corpse of Viṣvaksena fixed to it.

As Kankāla, Śiva killed Viṣṇu's door-keeper Viṣvaksena who had refused him admittance. His *mudrā* is *kaṭaka*, and he wears a tigerskin, *dhattūra* flowers, and holds a bunch of peacock feathers and a staff or rod. Sometimes he is accompanied by a *gaṇa* and deer which indicates that he is lord of animals, Paśupati.

Śiva's consort Devī should *never* accompany his Kankāla form nor the Bhikṣāṭana, Haryarddha, Ardhanārīśvara, Sukhāsana, Kāmāntaka and Dakṣiṇāmūrti forms.[1]

[1]*EHI*, II, pt i, p. 117.

v. Kankāladaṇḍa; Kapālin; Bhikṣāṭanamūrti.

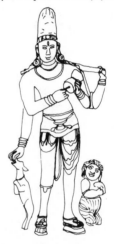

Kankaṇa and **Valaya** A simple bracelet worn by goddesses and minor divinities.

Kaṇṇappa-Nāyaṉār (Tamil) A famous *bhakta* (devotee) who is depicted with his hair arranged in an elaborate bun. His hands are in *añjali mudrā*.

v. Bhakti.

Kaṇṭhī Necklace or torque.

Kanyā 'Virgin', 'young girl'. An epithet of Pārvatī before her marriage to Śiva.

Kapāla I. 'Skull-cup', fashioned from the top half of a human skull. Some of Śiva's terrific forms such as Bhairava and Kankālamūrti have this emblem as do the fierce forms of Pārvatī (Kālī, Durgā).

The *kapāla* is used in Tantric ritual. In sculpture it often resembles a spherical or oval bowl.

v. Kapālin.

II. Name of a leader of one group of eight of the sixty-four Bhairavas.

Kapālamālā or **Muṇḍamālā** 'Skull-garland', associated with some Śaiva and Tantric divinities, including Bhairava, Cāmuṇḍā, Chinnamastakā, Durgā, and

Kāpālika

Kaṅkālamurti.

v. Kapālin.

Kāpālika 'Skull-carrier'. Name of a South Indian medieval extremist Śaiva sect organized in small monastic communities. It appears to be an offshoot of the Śaiva Pāśupata cult. Rāmānuja, Madhvācārya and others disapproved strongly of this cult's antisocial practices which Banerjea[1] suggests derive from the worship of the fierce form of Rudra-Śiva. The Kāpālikas wear crystal beads or a *liṅga* of crystal (*sphaṭika*), a crescent moon ornament, and matted hair. Their supreme deity is Bhairava.[2]

[1]*DHI*, pp. 451f; and see also Lorenzen, *The Kāpālikas and the Kālāmukhas.*

[2]*EHI*, II, pt i, p. 27.

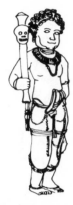

Kapālin 'Adorned with skulls'. An epithet of Śiva who, at the destruction of the universe (*pralaya*), will be alone among the ashes of the destroyed worlds, wearing a garland of skulls (*kapālamālā*). The latter symbolizes the endless evolutions and devolutions of universes, and the inseparability of life and death.

Kaparda Name of a hair-style in which the hair is twisted up spirally in the shape of a cowrie shell. Śiva's hair is dressed in this way, hence his epithet Kapardin, 'wearing the *kaparda*'. Rudra and Pūṣan also have this epithet.

Kapardin v. Kaparda.

Kapidhvaja The 'monkey (*kapi*) banner' of Arjuna.

Kapiketana 'Having a monkey as a symbol', said of the Pāṇḍu prince Arjuna whose banner-emblem was a monkey (*kapi*).

Kapila (*c*. seventh century BC)[1] According to tradition the founder of the Sāṃkhya system. He was one of the chief sages and philosophers to introduce into the Sanskrit Aryan civilization the ancient knowledge inherited from the earlier inhabitants of India.[2] He is sometimes considered to be an incarnation of Viṣṇu or of Agni.

Kapila is portrayed bearded, eight-armed and showing the *abhaya* and *kaṭimudrās*. His emblems are the discus, staff, plough, water-vessel, sword, noose and conch-shell. He is seated on a lotus throne (*padmāsana*). His eyes are nearly closed indicating meditation (*dhyāna*). His chest is well developed signifying his yogic breath-control. His feet are marked with a lotus, and he wears a *yajñopavīta*.

The *Vaikhānasāgama* describes him as eight-armed; three right hands carry the discus, sword and plough, the fourth is in *abhaya mudrā*. Three of the left hands carry the conch, noose and club (or staff), the fourth rests on his hip in *kaṭyavalambita* pose.[3]

[1]Radhakrishnan and Moore, *Sourcebook in Indian Philosophy*, p. 425.

[2]*HP*, p. 182.

[3]*EHI*, I, pt i, p. 248.

v. Kaṭisaṃsthita.

Kapiñjala The Francoline partridge. Indra is said to have assumed the form of this bird. Its cry, when heard coming from the south (the region of the *pitṛs*), is a good omen. The bird also gives protection against thieves and evildoers.

Kapitthaka or **Kapittha** Wood-apple (*Feronia elephantum*), a plant used by the Gandharva to cure Varuṇa of impotency (*AV*, IV,4,1). It is emblematic of Bāla-Gaṇapati and of some other aspects of Gaṇeśa.

Kapitthamudrā The 'wood-apple *mudrā*', in which the hand is closed with the thumb protruding between the forefinger and the middle finger. It denotes Lakṣmī, Sarasvatī, the offering of incense, and sexual intercourse.[1]

[1]*ID*, p. 127.

Kapota A dove or speckled-necked pigeon. A bird of ill-omen in the Vedas and later works. It is the messenger of Nirṛti, sender of misfortune, misery, decay, etc. If it perches near the fire it is a death omen.

Karaka A pot filled with water and decorated with mango leaves which represents the deity in village festivals.

v. Grāmadevatā.

Karālī I. Name of one of Agni's seven tongues of fire. II. An epithet applied to Kālī and Cāmuṇḍā.

Karaṇa(hasta)mudrā A dance pose in which the hand is outstretched horizontally with the index and little fingers extended, the thumb presses the two remaining fingers against the palm. This *mudrā* is associated with Śiva Naṭarāja and with Hayagrīva, and Yama.

v. Ḍamaruhasta.

Karaṇḍamakuṭa or **Karaṇḍamukuṭa** A small crown resembling an inverted bowl or basket.[1] It is simpler than the crowns of chief deities, and is worn by goddesses when accompanying their consorts, and by minor divinities. It indicates subordinate status.

When Skanda is depicted as a child accompanying his parents he wears a *karaṇḍamakuṭa*.

[1]Sometimes the crown resembles a pile of pots (Sivaramamurti, *Art of India*, p. 552).

v. Somāskandamūrti.

Karañja A tree (*Pongamia glabra*) sacred to the goddess Vārāhī.

Karatāla or **Tāla** Metal cymbals used to accompany songs and dances. They are rarely depicted and then only in the hands of minor figures.

Karihasta A position identical with the *gajahastamudrā*.

Karīṣin 'Abounding in dung', an epithet applied to Śrī.

Karivarada 'Conferring a boon on the elephant'. An aspect of Viṣṇu in which he saved Gajendra, the king of elephants, from the clutches of an aquatic monster.

Kārkoṭaka Name of one of the seven great *nāgas*. His colour is black, and on his hood are three white stripes.[1]

[1]*EHI*, II, pt ii, p. 557.

Karma An act or its performance, irrespective of purpose. In Brahmanical literature *karma* refers to the practice of religious duties, especially those pertaining to the sacrifice. Later *karma* was identified with *dharma* and defined as good or bad according to the intention of the performer of the action which determines his 'fate' in future incarnations, but the essential Self remains unaffected by each new 'impersonation'. Metempsychosis should be 'regarded from the biological angle as a quasi-mechanical urge for attaining the least impeded form for the development of the innate main tendency by means of future manifestations'.[1] Thus *karma* became an ethical doctrine (*jñāna-mārga*) and associated with the 'fruits' or consequences of actions (*karmaphala*), which may operate in the present life or come to fruition in future lives. One who has freed himself from *karma* realizes the harmony of *all* nature, and acts accordingly.

[1]*Facets*, p. 52.

Kārmuka 'Bow'.

v. Dhanus.

Karṇapūra A flower-shaped earring.

v. Kuṇḍala.

Karṇika Round earrings (*kuṇḍala*) sometimes depicted on images of Kālī, and others.

Karṇikā 'Pericarp of a lotus flower'. Name of a small base (*pīṭha*) combined with a larger one. Some deities are seated on a lotus plinth (*padmapīṭha*), with one or both feet resting on a smaller lotus, the latter signifying their divine status.

Kartarīmudrā A *mudrā* in which the index, second and little fingers are held upright to support an emblem between the first and second fingers whilst the thumb and ring finger are pressed against the palm of the hand. This *mudrā* indicates lightning, death, disagreement and opposition.

Kārttikeya 'Associated with *kṛttikās*'. Name of a folk divinity (said to be a son of Śiva), who incorporates a number of regional god-concepts and beliefs and hence his many names: Skanda, Kumāra, Subrahmaṇya, Mahāsena, Guha, etc.

Kārttikeya has long been associated with war, and was the tutelary deity of the Yaudheyas, an ancient military tribe[1] whose emblem may have been a peacock (*mayūra*), a bird always associated with Kārttikeya.

Skanda is sometimes associated with the Seven Mothers (*saptamātaras*), and takes the place of Gaṇapati or Vīrabhadra as one of the guardians of the Mothers. In South India Kārttikeya is worshipped under his name Subrahmaṇya and his Tamil appellation Murugan. In Bengal, clay figures of Kārttikeya are made and worshipped annually in the month *kṛttika* (October to November), by people desiring children.

A peacock, symbol of immortality, is Kārttikeya's mount; his wife is Kaumārī or Senā (the personification of the army of the gods), but his South Indian consort is Vallī or Mahāvallī. He is said to be eternally young, perhaps because war is a young man's occupation. His favourite weapon is the spear or javelin (*śakti*); his banner bears the emblem of a cock, and he also carries one. This bird symbolizes solar energy from which derive the seasons and cyclic Time. Sometimes Kārttikeya is depicted seated on a peacock with its beautiful tail feathers forming an aureole behind him. He holds his great club or battleaxe in his left hand, and in his right a fruit which the peacock pecks. His *mudrās* are *abhaya* and *varada*.

An eleventh-century relief from Puri (Orissa) depicts Kārttikeya standing before a rectangular slab originally situated on the west side of a Śaiva temple. He stands gracefully in *dvibhaṅga* on a beaded lotus base. A peacock stands on his right on a small lotus base. Kārttikeya's right hand rests gracefully on the back of a cockerel. Below the bird is the small figure of Devasenā, her right hand raised in adoration towards the deity. Kārttikeya wears large circular beaded earrings and his hair is dressed in three thick loops (*śikhāṇḍaka*) characteristic of boyhood. Flower-like ruffles above the ears are held in place by pins. Aśoka leaves frame his face. His many ornaments include a double bead choker and a long necklace from which tiger claws (*vyāghranakha*) and discs are suspended. The necklace also implies boyhood. Four thin lines across the left shoulder and chest suggests a diaphanous covering. His short loincloth (*kaupīna*) is fastened with an elaborate buckled girdle edged with tiny bells. Male and female

Vidyādharas fly towards him on the right and left side respectively.

[1]V. V. Mirashi, 'The Śaiva Ācāryas of the Māttamayūra Clan'.

v. Kārttikī; Kumāra; Ṣaṇmukha; Kukkuṭa.

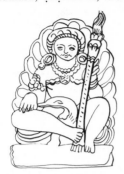

Kārttikī A *śakti* of Kārttikeya.

Kaśā 'Whip', an emblem of Revanta.

Kāśī The resplendent city of Śiva, who is Lord of Kāśī (Kāśīnātha). Kāśī is one of the seven sacred cities of India, and the earliest name of the city of Vārāṇasī (Benares). Since the sixth century BC it has been a great centre of learning and a place of pilgrimage for Hindus, Buddhists and Jainas.

Kaśyapa I. An ancient sage, the embodiment of the power of procreation. By his thirteen wives he became the father of gods, *asuras*, snakes, mankind and all other living creatures. He is 'an archaic manifestation of the "Lord of all creatures" (Prajāpati) who procreated the universe'.[1]

[1]*AIA*, p. 52.

v. Kadrū.

II. 'Tortoise', the mount of the river-goddess Yamunā.

v. Samudramathana; Kūrmāvatāra.

Kaśyapamudrā 'Tortoise hand pose' in which the fingers of the hands are intertwined in various ways which represent 'the *liṅga* within the *yoni*'.[1]

[1]*ID*, p. 130.

Kaṭaka A *mudrā* the same as, or similar to the *Siṃhakarṇamudrā* in which the tips of the fingers are loosely placed near the top of the thumb to form a ring to hold flowers or a necklace. It is said to resemble the ear (*karṇa*) of a lion (*siṃha*).

The hands of a number of goddesses are depicted in this position to enable fresh flowers to be inserted in them. Similarly the hands of Rāma and Lakṣmaṇa are portrayed in this pose to enable a bow and arrow to be inserted in them.

v. Kaṭisama.

Kaṭibandha or **Kaṭisūtra** An elaborate waistband worn round the hips to support a loincloth. It may have a number of strings hanging from it, or tassels and bows

on the hips, and a lion or snake's head clasp. It is worn by Brahmā and some forms of Śiva and other divinities.

v. Kāñcīdāma; Mekhalā.

Kaṭi(hasta)mudrā A position in which one arm hangs down gracefully by the body, the hand resting gently on the hip indicating ease and relaxation. Lakṣmī, Skanda, Ajakālaka, and sometimes Viṣṇu are depicted in this pose.

v. Kaṭisaṃsthita.

Kaṭisama A dance pose of Śiva in which his legs are slightly bent and crossed near the ankles but not touching each other, and with the outer edge of one foot resting on the plinth, the other standing firmly. This is also known as the *svastika* pose.

Śiva has eight arms, one of the right hands is held near the navel in *kaṭaka* pose holding a lotus, one of the left hands rests on the hip. He wears an animal skin, a *kaṭibandha* and sacred thread. His *mudrās* are *ardhacandra*, *kaṭaka* and *tripaṭākā*.

Kaṭisaṃsthita or **Katyavalambitamudrā** A position of ease in which the left arm hangs down with the hand resting gracefully on the loin. This is a common pose in images of ancient and medieval India.

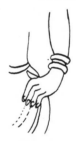

Kaṭisūtra v. Kaṭibandha.

Katyavalambitamudrā v. Kaṭisaṃsthita.

Kātyāyanī An aspect of the goddess Durgā also called Mahiṣāsuramardinī.

Kauberī Wife of Kubera and daughter of the *dānava* Mura. She is also called Yakṣī or Cārvī.

Kaumāra Name of an important cult in South India who regard Kumāra (Skanda) as the Supreme Being.

Kaumārī Also called Senā. Name of the *śakti* of Kumāra (Skanda), the embodiment of valour and courage.[1] She is depicted four-armed and seated in an attitude of ease (*lalitāsana*) with one foot on the ground, the other bent and resting on the seat. A child is seated on her lap. She wears many ornaments and her hair is dressed in *śikhaṇḍaka* style as is Kārttikeya's. Her mount is a peacock; her *mudrās*, *abhaya* and *varada*.

Kaumārī may hold a staff, bow, banner, bell, watervessel, cockerel (or goad), lotus, axe, spear, etc. Her sacred tree is the *udumbara*. The *Viṣṇudharmottara*

states that she has six faces and twelve arms.
[1]*EHI*, I, pt ii, pp. 387f.
v. Saptamātara(s).

Kaumodakī Name of Viṣṇu's magical mace or club
(*gadā*) presented to him by Varuṇa (or by Agni). It
symbolizes sovereignty, the invincible power of know-
ledge and of Time in which all things are destroyed.
Therefore it is also associated with the goddess Kālī
who represents the power of time. When personified,
the club is depicted usually as a female figure, and very
occasionally male.
v. Āyudhapuruṣa; Saptamātara(s); Gadādevī.

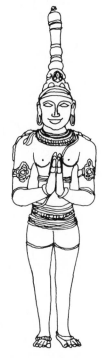

Kaupīna 'Loin-cloth', worn by Kārttikeya, Bali and
others.

Kauśikī Name of a goddess who sprang from the cells
(*kośa*) of Pārvatī's body, and hence her name.[1]
[1]*Iconog. Dacca*, p. 191.

Kaustubha The magical jewel sometimes depicted on
Viṣṇu's chest. It was obtained with thirteen other
jewels from the churning of the ocean (*samudrama-
thana*). The *Bhāgavata Purāṇa* describes it as a kind
of ruby 'brilliant as a thousand suns'.[1] It represents
consciousness which is manifested in everything that
shines.[2]
[1]Bhattacharya, *Indian Images*, pt i, p. 55.
[2]*HP*, p. 157.

Kavaca I. 'Armour', 'cuirass', and a name of amulets
and *mantras* which give protection against danger as

does armour. Such amulets are worn by Sūrya, Viṣṇu
and Yajña.
II. 'War-drum', associated with Ahirbudhnya and
Cāmuṇḍā.

Kedāreśvara Śiva as Lord of the Fields and also of the
Kedāra peak in the Himàlaya.[1]
[1]Sivaramamurti, *Śatarudrīya*, p. 49.
v. Kedārnātha.

Kedārnātha A famous Śaiva *liṅga* in the form of a
natural conical mass of ice, worshipped in the
Himālaya.
v. Kedāreśvara.

Keśa and **Keśara** 'Long hair', 'mane', characteristic of
Narasiṁha and Hanumat.

Keśabandha Name of hair-styles in which the hair is
combed straight back from the forehead and knotted
to make a large bun, or drawn up into a bun placed
on the top of the head. Jewellery and flower-garlands
are often added. A number of goddesses wear these
styles.

Keśamakuṭa or **Keśamukuṭa** A hair-style in which the
hair is twisted into a crown-like arrangement.

Keśamaṇḍala A method of dressing the hair so that it
stands up around the head. Agni's flaming hair is
depicted in this style, and also Śiva's in his terrific
forms. Cāmuṇḍā and Kālī also wear the same style
which signifies their destructive aspects.

Keśamukuṭa v. Keśamakuṭa.

Keśara v. Keśa.

Keśava 'Long-haired'. A name of an aspect of Viṣṇu-
Kṛṣṇa worshipped by those wishing to counteract bad
omens. In Indian belief hair is a form of the 'external
soul', and the 'procreative life substance'.[1]

Keśava holds a lotus, conch-shell, discus and club,
in his lower right, upper right, upper left and lower
left hands respectively.
[1]Heesterman, *Ancient Indian Royal Consecration*, p.
215.
v. Keśin.

Keśin 'Having a mane'. A *daitya* who assumed the form
of a horse[1] and attacked Kṛṣṇa who destroyed him,
and hence Kṛṣṇa has the epithet Keśava.
[1]Or he 'possessed dark horses' (*AV*, XI,2,18).

Ketakī A flower which should never be offered to Śiva.
Brahmā, when seeking the top of Śiva's fiery *liṅga*
of light, caught a petal of a *ketakī* flower which had

fallen aeons before from Maheśvara's (Śiva's) head, and lied that he had reached the summit of the *linga* and brought back the petal as proof.

v. Lingodbhavamūrti.

Ketu A demon (*dānava*) the twin brother of Rāhu. Ketu is one of the personifications of the Nine Planets (Navagrahas) who are propitiated in times of danger, because all calamities derive from the anger of the gods.

Ketu personifies the descending node of the moon. His chariot is drawn by eight (or ten) green, grey, or red horses, or by a vulture or frog. His *mudrās* are the *añjali* and *varada* or *abhaya*; his emblems, a lamp, club and spear.[1] He is portrayed as a black (or purple) serpent-headed man.

Both Ketu and Rāhu are deemed inauspicious. They are said to be the two halves of a serpent-demon who was cut in two by the Sun-god, but the two halves remained alive to trouble the gods.

[1]Bhattacharya, *Indian Images*, pt i, p. 31; *EHI*, I, pt ii, p. 322.

v. Śani.

Kevalacandraśekharamūrti or **Kevalamūrti** A benign form of Śiva when depicted alone (*kevala*) that is, without his *śakti*. His emblems are a chisel (*tanka*) and an antelope, and his *mudrās* are the *abhaya* and *varada*. He stands erect (*samabhanga*).

v. Umāsahitacandraśekhara.

Kevalamūrti v. Kevalacandraśekharamūrti.

Kevalanarasimha v. Narasimha.

Kevaṛā (Hindi). Name of a flower (*Pandanus odoratissimus*) associated with Gaṇeśa.

Keyūra or **Angada** An armlet, either with a floral design, or shaped like a snake and worn on the upper arm.

v. illustration of Garuḍa.

Khaḍga 'Sword'; 'large sacrificial knife'. An emblem of the warrior (*kṣatra*) class. The sword signifies the power of destruction as well as spiritual wisdom which cuts through ignorance (*avidyā*). The latter is represented by the scabbard.

Swords, according to their size and markings, are regarded as auspicious or inauspicious, those shaped like bamboo leaves being the most valued.

v. Āyudhapuruṣa; Nandaka; Parañjaya; Kheṭaka.

Khadira A tree whose wood was used for making sacrificial posts, ladles and amulets.

v. Sruk.

Khajurāho Situated in Madhya Pradesh, twenty-five miles north of Panna. A number of fine sandstone temples built by the Chandellas are situated there.

Khañjana 'Wagtail', a bird sacred to Viṣṇu.

Khaṭvānga 'Club', also called Pānsula. It consists of a long arm or shin-bone surmounted by a skull. Later it was made of wood. Rao[1] considers it to be a weapon of 'remote antiquity'

[1]*EHI*, I, pt i, p. 7.

Kheṭa or **Kheṭaka** A shield which may be square, oval, oblong or round, with a handle at the back by which it is carried.

Some Vaiṣṇava deities carry a shield, and it is also associated with Skanda, Ambikā, Bhairava, Cāmuṇḍā, Durgā, Mahiṣāsuramardinī, Nirṛti, Senāpati and others. Various emblems and devices may be depicted on it.

v. Carma.

Kheṭaka v. Kheṭa.

Kikar A tree (*Acacia arabuca*), the dwelling-place of Śītalā.

Kilāsī 'Spotted deer', which draw the chariot of the Maruts (storm-gods).

Kimpuruṣa(s) A class of semi-divine beings born from Brahmā's shadow. They wear fine garments and carry swords.

v. Kinnara(s).

Kinkiṇī 'Small bell'. Bells are attached to the anklets of dancers and mark the rhythm of the dance.

Kinnara(s) Mythical semi-divine beings, the descendants of the ancient *ṛṣi* Pulastya. They have human bodies and horse heads, or *vice versa*; or human faces and bird bodies. With the *gandharvas* they form a

celestial choir in Kubera's paradise. Śiva is their lord.

Kinnarī(s) Female kinnara(s).

Kiṁśuka A tree (*Butea frondosa* or *monosperma*) sacred to Soma.

Kirātamūrti Śiva assumed the form of a Kirāta (a member of an aboriginal tribe living in caves in northeast India), when he fought Arjuna who claimed to have killed the same boar as Śiva. When Arjuna found that his weapons were useless against the Kirāta he realized the divine nature of his adversary, whereupon he worshipped him. This gratified Śiva who then presented him with the invincible weapon, Paśupata. Kirāta's *mudrā* is *kaṭaka*.

v. Kirātārjunamūrti.

Kirātārjunamūrti A group showing Śiva in the act of handing over the magical weapon Paśupata to Arjuna. Śiva stands erect, holding a bow and arrow, sword, antelope, axe, spear, conch-shell and club (?). Arjuna shows the *añjalimudrā*.

v. Kirātamūrti.

Kirīṭa v. Kirīṭamakuṭa.

Kirīṭamakuṭa or **Kirīṭa** A conical crown with ornamental top surmounted by a central pointed knob. A central design or large jewel is depicted on the front, with small stones set around the edge. The crown symbolizes 'the Unknowable reality',[1] and is worn by

Kṛṣṇa, Nārāyaṇa,[2] Indra, Kubera, Sūrya, Lakṣmī and Pārvatī.

[1]*HP*, p. 158.

[2]Rao, *EHI*, I, pt i, p. 29, states that among the gods this crown should be worn exclusively by Nārāyaṇa. Among humans by a *cakravartin* whose rule extends to the shores of the four oceans, as well as by a chief governor (*adhirāja*).

v. Karaṇḍamakuṭa.

Kīrti 'Fame', 'glory' personified as a *śakti* of Keśava (Viṣṇu). Her emblem is a water-jar and a blue water lily. She wears jewelled ornaments and is seated on a blue water lily (*nīlotpala*).[1]

[1]*EHI*, I, pt ii, p. 366.

Kīrttimukha 'Face of Glory'. A magically protective mask. It has the features of a man or lion. Usually the lion features predominate and it is then called *siṁhamukha* (lion-face).[1] Life-giving powers radiate from the lion, the solar animal *par excellence*.

The mask is placed on the lintels of Śaiva temples and sanctuaries, on belt-clasps, on the cornices and walls of temples and at the top of *prabhāmaṇḍalas*, and sometimes on the top of Śiva's head-dress. The mask is a manifestation of the terrifying aspect of Śiva and also is an art motif used to express Supreme Reality. It also represents the Sun, Time, Death, and the cosmic fire which periodically destroys the worlds, leaving only Śiva.

The *makara* and *kīrttimukha* forms are closely related. Kramrisch[2] points out that both the '*śārdūla* and *makara* are hypostases of parts of the *kīrttimukha*, i.e., the Lion and the Dragon, but they each have a body . . . fully "animal"'.

The *kīrttimukha* motif is of great antiquity in Indian art[3] and is modelled on the skull of Death, but with blazing eyes filling the fleshless sockets.

[1]Other animals may be combined in the *kīrttimukha* including the ram, serpent, fish or bird.

[2]*Hindu Temple*, II, p. 333 n. 108.

[3]Sivaramamurti, *Art of India*, p. 552.

v. Kālasiṁhamukha; Yāli.

Kodaṇḍa 'Bow'. Name of Rāma's great bow.

v. Dhanus.

Kokāmukhā The wolf-faced aspect of Durgā who glories in battles.

Kokila The 'Indian cuckoo' whose cry inspires love.

Kokkara An early musical instrument which when scraped rhythmically has an hypnotic effect similar to the rhythmic sounds of *vodun* drums and some forms of 'beat' music. The *kokkara* is used as an accompaniment to the recitation of divine names.

Konārak Name of a town and the remains of the largest temple in Orissa dedicated to the Sun (Sūrya). The

various tiers of the pyramidal roof of the audience hall depict beautiful girls playing musical instruments; on another building dancers are portrayed. Together they 'conjure up a festival of music and dance for the rising sun'.[1] Originally the hall and tower stood on a chariot-shaped base with twenty-four wheels (representing the twenty-four hours of the day). Magnificent friezes portray erotic scenes, elephants and birds.

[1]Sivaramamurti, *Art of India*, p. 499.

v. Maithuna.

Koṣa 'Purse', 'bag', associated with Kubera, Śukra and Maṇibhadra.

Krauñca The personification of a mountain in the eastern Himālaya said to have been split by Kārtti-keya's lance. For this feat he has the epithet Krauñ-cabhettā. He has six faces and eight arms, or one face and four arms, and carries a number of weapons. His vehicle is a peacock.[1]

[1]*EHI*, II, pt ii, p. 438.

Krauñcabhettā v. Krauñca.

Kravyāda-agni v. Agni.

Krīyāśakti The 'action' *śakti* whose colour is red.

v. Pañcabrahmā(s).

Krodha 'Wrath'. Name of a leader of a group of eight Bhairavas. There are sixty-four Bhairavas in all, sub-divided into groups of eight.

Kṛpāṇa 'Sword', 'dagger'.

v. Khaḍga.

Kṛśana A pearl-shell said to be an efficacious amulet (*AV*, IV,10). Pearls decorate Savitṛ's golden chariot.

Kṛṣṇa 'Black', 'dark blue'.[1] Name of the only complete incarnation (*pūrṇāvatāra*) of Viṣṇu. Kṛṣṇa was of royal descent, the son of Devakī, sister of the tyrannical King Kaṁsa who, having been warned that he would be destroyed by the eighth child born to Devakī, decided to kill the infant. But Kṛṣṇa's father exchanged his son for the daughter of a cowherd born about the same time at Gokul, a place outside Kaṁsa's kingdom. Kṛṣṇa's brother Balarāma accompanied him and they both grew up in the care of the cowherds (*gopas*) and their relatives. His foster parents were Nanda and Yaśodā.

Kṛṣṇa was a mischievous child, always playing pranks on the *gopīs*, sometimes stealing their butter, or their clothes when they were bathing. Icons often depict him as a child (Bāla-Kṛṣṇa) crawling on his knees and holding a butterball.

In his youth Kṛṣṇa acted as a herdsman, and with his flute was said to control domestic and wild animals, as did the Greek Orpheus. Sometimes he is shown dancing a circular dance with the *gopīs* on the banks of the Yamunā. Many women loved him, but his favourite was Rādhā. Their intense love symbolizes the union of the Cosmic Man (*Puruṣa*) with Nature (*prakṛti*). From their union the universe was manifested. Two other wives were Rukmiṇī (an incarnation of Lakṣmī), and Satyabhāmā (Bhūmidevī). Stories of his love affairs were greatly exaggerated over the years.

Kṛṣṇa is venerated under several forms – as an infant, a young cowherd playing a flute, as the lover of the *gopīs*, and as a master of *māyā*.

Kṛṣṇa may have four or more arms. He may be accompanied by Garuḍa. He holds a discus, staff, and the iron club Kaumodakī. He wears a *channavīra* and a *kirīta*, or his hair is curled up and tied in a knot on the top of his head. Sometimes he carries a conch-shell. In many respects his image resembles that of Rāma.

Kṛṣṇa is the source of everything and hence all opposites are contained in him.

[1]In paintings Kṛṣṇa is usually depicted dark blue, a colour which associates him with vegetal and chthonic powers. He is said to assume the form of various fig trees (*Aspects*, p. 104).

v. Krṣṇā; Kāliya; Bāla-Kṛṣṇa; Veṇugopāla; Yaśodā-Krṣṇa; Bhakti; Bhagavadgītā; Pūtanā; Vāṭapattraśāyin.

Kṛṣṇā I. The 'Black One'. Name of a consort of Kṛṣṇa. She is depicted two-armed; her *mudrā*, *añjali*; emblems, rosary and water-jar. She dwells in the midst of the sacrificial fire-pit (*agnikuṇḍa*).[1]

[1]*EHI*, I, pt ii, p. 370.

II. Name of the common wife of the Pāṇḍava princes, who is more usually known by her patronymic Draupadī.

Kṛṣṇājina 'Black antelope skin', used ritually in Vedic times. It is emblematic of Śiva and Bhadra-Kālī.

v. Kṛṣṇājinayajñopavīta.

Kṛṣṇājinayajñopavīta A sacred thread (*yajñopavīta*) consisting of black antelope skin and with the elongated head of an antelope in place of the usual knot.

Kṛṣṇamṛga 'Black antelope', characteristic of Candraśekharamūrti.

Kṛśodarī A four-armed goddess typical of a skeleton (*kaṅkālī*) goddess.[1] Her body is emaciated and her staring and erect hair signifies famine. Her mount is a corpse. She wears a tiger- or leopard-skin and holds a sword, the corpse of the demon Muṇḍa whom she has killed, a trident, and another three-pointed iron weapon (*paṭṭiśa*), perhaps a *vajra*. Her ornaments are bones. She is often confused with Cāmuṇḍā, but the latter has the distinguishing mark of the emaciated eye.[2]

[1]Bhattacharya, *Indian Images*, pt i, p. 41.
[2]Ibid.; Liebert (*ID*, p. 141), states that Kṛśodarī is a variety of Cāmuṇḍā.

Kṛtti 'Skin', 'hide', especially that of a tiger. Some forms of Śiva are depicted wearing a tiger-skin.
v. Kṛśodarī.

Kṛttikā(s) Name of the inauspicious constellation, Pleiades, which was believed to contain six stars personified as the six nymphs and wives of the *ṛṣis* who nursed the infant Skanda (Ṣaṇmukha). The constellation is sometimes represented by a flame or a sword.
v. Kārttikeya.

Kṛttivāsa A skin or hide garment. Kṛttivāsa is an epithet of Śiva who, as an ascetic, wears a tiger's skin.

Kṛtyā 'Enchantment', 'witchcraft', personified as a divinity (*abhicāradevatā*) to whom sacrifices are offered for magical purposes. She is described as blue and red and clings closely to her victim (*RV*, X,85,28ff.).

Kṣamā I. 'Patience' personified as a calm, beautiful girl, one of Dakṣa's daughters. She is accompanied by jackals (*sṛgāla*), and holds a trident. Her *mudrā* is *varada*. She sits on a lotus throne, a *yogapaṭṭa* supporting her legs.
II. Name of one of the Eight Mothers. She is represented as an old woman.

Kṣaṇika A temporary icon (often fashioned from clay) which is destroyed after its ritual use.

Kṣatriya A member of the *kṣatra* class consisting of nobles and warriors.

Kṣemaṅkarī A four-armed form of Durgā who bestows health on her devotees. Her *mudrā* is *varada*; her emblems, lotus, trident and drinking-vessel.

Kṣetra 'Field', 'ground', an area of any geometric figure.
v. Yantra.

Kṣetrapāla 'Lord or guardian of the field'. A tutelary deity of South India whose shrine is usually in the north-east corner of a town or village.

Kṣetrapāla is identified with Bhairava and like him is depicted nude and accompanied by a dog. He has three eyes and two, four, six or eight hands. Fangs protrude from the sides of the mouth. He wears a sacred thread made of snakes (*nāgayajñopavīta*) and carries Śaiva emblems and weapons to protect the community.

As a protector of a sacred city like Vārāṇasī, Prayāga, etc., Kṣetrapāla carries a long or short sword and a shield.[1] Different images of Kṣetrapāla represent different *guṇas*. The two- or four-armed form denotes the *sattvaguṇa*; the six-armed form the *rajas guṇa*, the eight-armed the *tamas guṇa*.
[1]Sivaramamurti, *Śatarudrīya*, p. 106.

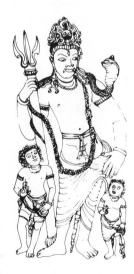

Ksudhā The 'Great hunger'. A name of Mahākālī.
v. Mahālakṣmī.

Kubera or **Kuvera** Also called Vaiśrāvaṇa, Dhanapati and Dhanada. Originally Kubera was an earth spirit deriving from the aboriginal folklore of India (*AV*, VIII,10,28), the leader of *yakṣas*, *guhyakas* and *rākṣasas* who guard his nine divine treasures (*nidhis*).

A curious myth purporting to describe Kubera's origin is given in the *Varāha Purāṇa*. When Brahmā desired to create the universe, a shower of limestones poured from his face accompanied by a hurricane. Then Brahmā calmed the fury of the storm and the mass of stones assumed the form of a benign divinity whom Brahmā made Lord of Wealth and guardian of the riches of the gods.[1]

The *Rūpamaṇḍana* prescribes an elephant as Kubera's mount, and adds that he should carry a club, money-bag, pomegranate and a water-vessel. His wife is Bhadrā or Kauberī. Two of his personified treasures, Śaṅkhanidhi and Padmanidhi, may be depicted as goddesses who stand on his right and left respectively.

A relief from Khajurāho depicts Kubera seated on a mongoose which vomits out jewels. His right hand holds a huge club with a blade of a battleaxe attached, his left, a snake. He wears heavy earrings and necklaces of pearls as does the mongoose. In some representations his necklace consists of golden coins (*niṣka*); sometimes coins are depicted spilling out from vases.

Kubera reveals the mineral wealth of the earth to man. He dwells in a magnificent palace set in beautiful gardens on Mount Kailāsa. As he is associated with generative power he is invoked at weddings. His mount is sometimes a ram or a horse which also signifies virility. Like Kubera some forms of Śiva are pot-bellied as are Gaṇeśa and *yakṣas*. This appears to be a trait of non-Aryan gods and is probably a sign of well-being.
[1]*EHI*, II, p ii, pp. 534f.

v. Nidhi(s); Nakula; Lokapāla.

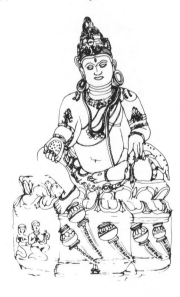

Kubuddhi Name of one of Gaṇeśa's consorts.
Kucabandha A flat band worn by some goddesses to

hold the breasts in place, e.g. Lakṣmī, Vallī, Durgā and Rukmiṇī.
v. Bhūmidevī.

Kudu A horseshoe-shaped gable window.

Kukkuṭa 'Cock'. The emblem on the banner of Aiyanār and Skanda. The bird indicates the realm of time and the rising sun.
v. Kārttikeya.

Kukkuṭāsana 'Sitting like a cock'. A position similar to *padmāsana*, but with the whole weight of the body resting on the two arms placed on the ground, the body thus being suspended in the air.

Kuladevatā(s) 'Household gods', sometimes represented by a jar or pot (*kumbha*) and worshipped by members of a family (*kula*) on special occasions.

Kulanāyaka A family (*kula*) deity.

Kulika Name of one of the seven great *nāgas* whose colour is red. His hoods bear the mark of the crescent moon.[1]
[1]*EHI*, II, pt ii, p. 557.

Kuliśa A synonym for the thunderbolt (*vajra*), and a term for an axe or hatchet.

Kumāra 'Boy', 'youth'. An epithet of the eternally young Skanda, one of Śiva's sons, who married Indra's daughter Senā, the personification of the army of the gods.

Kumāra represents the energy, heroism and high spirits of the young. Hari (Viṣnu) presented him with a cock and a peacock; Sarasvatī and Brāhmī, a lute and a goat, and Śiva a ram. Kumāra's *mudrās* are the *abhaya* and *varada*; his emblems a sword, shield, cock and spear.

Kumārī I. One of the seven holy rivers that wash away sin.
II. 'Virgin'. An epithet of Durgā.

Kumbha 'Pot', 'pitcher'. Water-vessels are identified with mother-goddesses and thus represent the womb, the 'generative pot'. Some Śaiva sects also invoke Śiva in vessels filled with water.[1]

Painted pots are often placed in fields and are symbolic of the Divine, the container of all blessings including fertility and food.
[1]*EHI*, II, pt i, p. 10. Pots are all-important to the Indian peasant for food and water, and hence are used

to represent divinity.

v. Kalaśa; Kumbhamātā; Kuladevatā(s).

Kumbhakarṇa 'Pot-eared'. Name of a *rākṣasa*, son of Viśravas and Keśinī and brother of Rāvaṇa.

Kumbhamātā The 'Pot (*kumbha*) goddess', the tutelary divinity of a village (*grāmadevatā*) represented by a pot.

Kumbhāṇḍa(s) Demonic beings attendant on Rudra. Their testicles are said to resemble pitchers (*kumbhamuṣka*).

Kumbhapañjara A recessed pilaster decorated with a vase motif.[1]

[1]Sivaramamurti, *Art of India*, p. 552.

Kumbhodara 'Pot-bellied'. Name of the lion (symbolizing greed), on which Śiva first sets foot when mounting his bull Nandi.

Kumuda 'White water-lily' (*Nymphaea alba Roxb.*), perhaps the same as the white lotus (*puṇḍarīka*). The *kumuda* is an emblem of Candra (the Moon).

Kuṇḍa 'Pot', 'bowl', a receptacle used for ghee, oil, or fire during worship. It is an emblem of Aghoramūrti and Bhairava.

Kuṇḍala 'Earring'. The constant wearing of large, heavy earrings resulted in elongation of the ear lobes which was said to be a sign of wealth, nobility and greatness. The Buddha is always depicted with long ear lobes.

Originally all earrings, necklaces and other ornaments were amulets worn to protect different parts of the body. The most elaborate earrings are worn by chief deities and are of various sizes, shapes and designs. Minor deities wear simple ones consisting of plain bands or rolled sheets of gold (*pattrakuṇḍalas*). *Ratnakuṇḍalas* are circular and set with gems; others resemble a coiled serpent (*sarpakuṇḍala*), or a lion's head (*siṃhakuṇḍala*); or the shape of a *makara*. They may be fashioned from metal, silver, gems, ivory, shell, wood, etc. When gods are depicted in their terrific forms they may wear lion-shaped earrings; goddesses when accompanying their consorts, plain earrings, but when portrayed alone they may wear one snake earring in the right ear.[1]

[1]Thapar, *Icons*, pp. 44f.

v. Ardhanārīśvara; Lambapattra.

Kuṇḍalinī Name of the *śakta* goddess personifying the latent energy which lies at the base of the spinal column (*mūlādhāracakra*) like a female serpent coiled eight times, which can be awakened by yogic techniques, and raised from the lowest *cakra* to the highest, the *sahasrāra* at the top of the skull. With the achievement of this difficult feat a wonderful vision of the great goddess Devī will be seen and liberation attained. The awakening of Kuṇḍalinī mystically represents 'liber-

ation' (*mokṣa*), the reintegration of the individual into the Universal Self (*ātman*).[1]

Kuṇḍalinī represents the supreme *śakti* (*paramaśakti*), the unbounded energy that gives birth to the universe. Without *śakti* nature remains inert or 'like a corpse'.

[1]Daniélou, *Yoga*, p. 108; and see Woodroffe, *Serpent Power*, p. 242; and Eliade, *Yoga*, p. 270.

v. Śava; Śakti; Cakra II.

Kuṇḍikā A bowl-shaped vessel, similar to a *kamaṇḍalu*.

Kuntala A hair-style adopted by Indirā (Lakṣmī).

Kuntī or **Pṛthā** Wife of Pāṇḍu.

v. Mahābhārata; Pāṇḍavas.

Kūrca A 'bunch of *kuśa* grass', an emblem of Brahmā and of some forms of Śiva.

Kūrma The [cosmic] 'tortoise'. Its lower shell represents the earth, the curved upper shell the sky, and its body the atmosphere (*ŚBr.*, VI,1.1,12). It also signifies the 'life-sap' or vital element in the creative process, and hence it is associated with the creator Prajāpati who assumed the form of a tortoise and then produced all creatures.

In one of Viṣṇu's 'descents' to earth he assumed the form of a tortoise (*kūrmāvatāra*). A tortoise was also used to support the churning stick when the gods and *asuras* churned the ocean (*samudramathana*). Later the tortoise came to symbolize the ideal man, disciplined, restrained and calm.

Ananta, Rāhu, Yamunā, Hayaśiras and the Earth-goddess have a tortoise as a mount.

v. Kūrmaśīla; Kūrmāsana; Kaśyapa I.

Kūrmamudrā A hand-pose in which 'the fingers are contracted and closed around the flowers that contain the force of the devotee's life-breath'.[1]

[1]*AIA*, I, p. 319.

Kūrmāsana I. 'Tortoise seat'. A yogic position in which the heels are placed crosswise under the gluteals. This position is depicted on some Indus Valley seals.

II. The tortoise mount of the goddess Yamunā which represents the stability beneath the waters when the divine tortoise supported the churning stick on its shell at the time of the churning of the ocean.

III. A wooden, oval pedestal or seat shaped like a tortoise. It should be four *aṅgulas* in height and twelve in breadth, and with the head and feet of a tortoise.[1]

[1]*EHI*, I, pt i, p. 20.

Kūrmaśīla The stone base or support of an image.

Kūrmāvatāra The tortoise (*kūrma*) incarnation (*avatāra*) of Viṣṇu. It is sometimes depicted with the upper part of the body human and the lower that of a tortoise. He is four-armed and carries a conch-shell and discus; his *mudrās* are *abhaya* and *varada*. He wears ornaments and a *kirīṭamakuṭa*. He may be portrayed entirely in tortoise form.[1]

[1]*EHI*, I, pt i, p. 128.

v. Samudramathana; Viṣṇu.

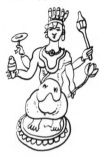

Kūrpara 'Elbow'. A posture of Śiva when depicted with his elbow resting on the back or head of his bull Nandi. Sometimes he is portrayed in this stance without the bull.

v. Vṛṣavāhana(mūrti).

Kurukullā Name of a Tantric goddess portrayed in a boat of gems.

Kuśa A grass (*Desmostachya bipinnata*) regarded by Hindus as one of the most sacred of Indian grasses. The stalk is sacrificially pure, and the top is sacred to the gods. When struck against the side of the body it averts evil influences (*Mārk. Pur.*, 51,16). Some images of Brahmā depict him holding a bunch of *kuśa*.

Kuṣāṇa One of the nomadic tribal groups forming the Turanian and Scythian ethnic conglomerates which spread over parts of northern and north-western Asia, and which later became a vast empire.

v. Kaniṣka.

Kuṣmāṇḍās A class of demigods or demons attendant on Śiva. They can assume any form at will, and are said to cause diseases. .

Kuṣmaṇḍī or *Kuṣmaṇḍā*. A form of Durgā holding a cup or wine-glass (*caṣaka*).

Kuṣṭha The 'flower of immortality', the visible manifestation of *amṛta* (*AV*, V,4,3). It is an aromatic plant (*Costus speciosus* or *arabicus*) said to grow in the third heaven under the great *aśvattha* tree where the gods foregather.

Kuṭhāra A kind of axe associated with Gaṇeśa, Aghoramūrti and Tatpuruṣa.

Kuṭṭita A dance-pose of Śiva in which one foot rests firmly on the ground, the other foot 'standing on the toe, strikes the ground with the heel'[1] to mark the rhythm of the dance.

[1]*Principles*, Glossary, p. 252.

v. Lalita.

Kuvalaya Name of the miraculous horse which destroyed the *daitya* Pātālaketu when he attempted to disturb the ṛṣi Gālava's meditations.

Kuvalayāpīḍa Name of Kaṁsa's huge state elephant (or a *daitya* in the form of an elephant), which was placed at the entrance to the wrestlers' arena to attack Kṛṣṇa, but the latter seized the animal by its tail, and whirling it round, killed both the animal and its keeper.

Kuvera v. Kubera.

L

Laḍḍu or **Laḍḍuka** A sweetmeat made from pulses or cornflour mixed with sugar and spices and fried in *ghee* or oil. Gaṇeśa often holds a sweetmeat in his trunk.

v. Modaka.

Laguḍa 'Club'. v. Gadā.

Lakṣaṇa I. 'Mark', 'sign', 'characteristic', 'symbol', 'attribute', also a formula giving measurements laid down for icons.

II. Marks or characteristics of the body which are regarded as auspicious or inauspicious. For example, the lowered eyelids of gods indicate the serenity of the inner mind.[1]

[1]Kramrisch, *Indian Sculpture*, p. 63.

Lakṣmaṇa A brother of Rāma, and the embodiment of loyalty. Lakṣmaṇa is regarded as a partial incarnation of Viṣṇu. His colour is pale gold. He wears a flat ornament on his chest, and holds a bow.

Metal figures of Rāma, Sītā and Lakṣmaṇa are depicted standing, and each image is cast separately. Lakṣmaṇa stands on the left of Rāma, and his figure is smaller than Rāma's, but in similar pose and wearing similar ornaments and high Vaiṣṇava crown.[1] The faithful ape Hanumat often accompanies the group.

[1]Thapar, *Icons*, p. 64.

v. Rāmacandra.

Lakṣmī Originally a goddess personifying the earth, and later goddess of beauty and good fortune who is worshipped in several forms. She became identified with Śrī[1] the wife of Viṣṇu. Because of her association with prosperity she is also associated with Kubera, god of wealth.

Lakṣmī usually holds a lotus and is depicted on a lotus plinth. It seems that she was the model for the figures of Māyā, the Buddha's mother, which are

carved on the Buddhist monuments of Sanchi. She is immensely popular with both Hindus and non-Hindus. Her figure is depicted on the doors and lintels of houses to bring good luck to the inhabitants. Her chariot is pulled by lions, and tigers follow her.

She usually has two arms, and occasionally four. Her throne is an eight-petalled lotus resting on a lion. She carries a long-stemmed lotus flower, a *bilva* fruit, pot of ambrosia and a conch-shell. Her mount may be Garuḍa, or an owl; her *mudrās* are *abhaya* and *varada*, *kaṭaka*, and *lolahasta*. Her main emblem is the lotus, but others include a water-vessel, discus, club, shield and conch. She accompanies Viṣṇu in all his incarnations but under various names. In Tantrism she is one of the ten Mahāvidyās.

[1]In some texts Śrī and Lakṣmī are differentiated (Bhattacharyya, *Canons of Indian Art*, p. 412). Lakṣmī is also known as Padmā and Kamalā.

v. Lakṣmī–Gaṇapati; Lakṣmī-Nārāyaṇa; Gaja-Lakṣmī; Mahālakṣmī; Dīpa; Dvāra.

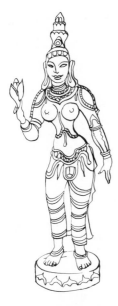

Lakṣmī-Gaṇapati A representation of a four- or eight-armed Gaṇapati with the goddess Lakṣmī seated on his left thigh. She holds a lotus flower in her left hand and embraces Gaṇapati with her right. Other emblems associated with this couple include a goad, discus, tusk, water-vessel, noose, *kalpaka* flowers and the fruits of the *kapittha*, but there are variant lists in the texts.

v. Kalpakalatā.

Lakṣmī-Narasiṁha The man-lion *avatāra* of Viṣṇu with his consort Lakṣmī seated on his lap. When accompanied by Lakṣmī, Narasiṁha is always portrayed in peaceful pose, instead of his usual fierce appearance.

Similarly when Pārvatī accompanies Śiva she exerts a calming effect on him.

Lakṣmī-Nārāyaṇa A representation of the four-armed Nārāyaṇa (Viṣṇu) with his consort Lakṣmī seated on his left thigh. (This is similar to Śiva's Umā-Maheśvara form). Lakṣmī holds a lotus in her left hand, her right arm embraces Nārāyaṇa. Viṣṇu holds a discus and conch-shell, one hand is in *varadamudrā*, the left round Lakṣmī's waist. His mount is the Garuḍa bird. Sometimes Viṣṇu and Lakṣmī are portrayed as one body, the left side representing Lakṣmī, the right Nārāyaṇa. The right hands hold a discus, club, lotus and conch-shell; the left hands a vessel of ambrosia, mirror, lotus and manuscript.

v. Ardhanārīśvara.

Lakulīśa 'The Lord with a club', the founder or systematiser of the Śaiva Pāśupata cult.[1] His four chief followers were Kuśika, Mitra, Garga and Kaurusya, traditionally regarded as the leaders of the four subsects of the Pāśupata cult.

Lakulīśa's image is often found in Orissa, Gujarat, and the Kathiawar Peninsula. An inscription in the temple of Nātha in Rājputāna states that Śiva became incarnate as a man with a club;[2] some *Purāṇas* describe him as the twenty-eighth and last incarnation of Śiva. His emblems are a rosary, club, skull-cup and trident. He is portrayed ithyphallic, a pose denoting fertility.

[1]See Banerjea, 'Lakulīśa, the Founder or Systematiser of the Pāśupata System', pp. 32ff.; *IT*, p. 148.
[2]*VSM*, p. 116.

Lalāṭatilakam or **Ūrdhvatāṇḍava** An unusual dance pose of Śiva in which he stands with his left foot on the back of the demon Apasmāra, the right leg lifted high in the air so that the heel is level with his forehead. He has eight or sixteen hands, each carrying an emblem, except the top two. This pose resembles the tail of a scorpion and is called *vṛścika*. His *mudrās* are *añjali*, *patākā* and *abhaya*; his emblems, a drum, banner, skull-cup, snake and trident.

Lalita A dance-form of Śiva; and also a *mudrā*.

v. Naṭarāja.

Lalitā A four-armed form of Pārvatī personifying playfulness, as the source of creation. She is portrayed as a playful, amorous girl whose form is the universe. Her emblems are a goad, mirror, lotus, noose, fruit, conch-shell, small box containing collyrium, sugarcane bow, and five arrows. The *śrīcakra* or *śrīyantra* symbolizes the union of Śiva with Lalitā.

v. Mahāvidyā(s); Līlā; Yantra.

Lalitāsana A seated position (*āsana*) indicating relaxation and royal ease, in which one leg is placed on the *pīṭha*, the other hangs down and sometimes rests on a small lotus flower base.

Lambaka 'Pendants' which form part of Gaurī's ornaments.

Lambakūrcāsana A seat (*āsana*) made from long grass, a characteristic of Brahmā.

Lambapattra 'Long-leaf'. A woman's earring, also worn in the left ear by some forms of Śiva,[1] and denoting his female aspect.

[1]*ID*, p. 151.

v. Ardhanārīśvara; Kuṇḍala.

Lambodara 'Having a large belly'. An epithet of Gaṇeśa. A large belly indicates prosperity and well-being.

Lāṅgala 'Plough'.

v. Hala; Lāṅgalin.

Lāṅgalin 'Having a plough'. An epithet of Balarāma.

Lāṅgūlamudrā A *mudrā* in which the palm is slightly hollowed and the ring finger stretched out, the other fingers slightly bent as if holding a round object.[1]

[1]*ID*, p. 151.

Laṅkā Name of a town in Ceylon and for the whole island, now called Sri Lanka. It was the capital of the *rākṣasa* King Rāvaṇa killed by Rāma.

The tutelary goddess of the island was Laṅkinī who challenged the monkey-king Hanumat when he landed on the island, but he easily knocked her down with a blow from his left fist, the use of the left indicating his contempt for her.

v. Laṅkādāhin; Vāma.

Laṅkādāhin 'Burner of Laṅkā'. An epithet of the monkey-king Hanumat whose burning tail set fire to the city of Laṅkā.

Laṅkinī v. Laṅkā.

Lāsya A gentle lyric dance representing love and tenderness, and performed by Śiva.

Latā General name for any creeping plant. The elegant curve of a sword blade, or a woman's graceful slender body, is also called *latā*.

Laukika-devatā(s) 'Folk-divinities' such as Skanda and Viśākha.[1]

[1]*DHI*, p. 362.

Lekhanī 'Reed-pen', 'writing instrument' used with an ink-stand and associated with Agni, Brahmā and Piṅgala-Gaṇapati.

Līlā 'Play', 'sport', 'unmotivated manifestation', the purposeless interplay of cosmic forces – an endless continuum of cyclic time – in which the One becomes the many and the many return to the One.

Creation, duration and destruction are ethically neutral factors in the world-process and represent the constantly changing energies of the life-force. Thus there cannot be one fixed moment when creation takes place, but only the continuous evolution and devolution of worlds in cyclic time.

From the cosmic viewpoint Śiva Naṭarāja includes the three phases of his 'play' (*līlā*), in creation (*sṛṣṭi*), preservation (*sthiti*), and dissolution (*saṁhara*) of the universe. *Līlā* indicates the spontaneous, effortless manner in which the infinite potentialities of nature are carried out. From the viewpoint of man these three phases refer to the individual essence emerging from the non-manifested state into existence, and after many lives, final reabsorption into the Unmanifested. The creation of all forms and their ultimate reintegration into his own essence represents Śiva's divine 'play'.

v. Līlāmūrti.

Līlāmūrti A 'playful' aspect of some gods especially Śiva and Kṛṣṇa.

v. Līlā.

Liṅga 'Mark', 'sign', 'characteristic', 'phallus'. The last is an ancient symbol of cosmic energy in India and in ancient Greece. In India human sexual power is felt to be of transcendent origin.

The *liṅga* of Śiva is especially worshipped in the form of a stone or marble column and represents the undivided causal principle of the universe[1] and transcendental power, the subtle body which is not destroyed by death. The *liṅga* is the 'fundamental form' (*mūlavigraha*) of the cosmic deity Śiva.[2] According to the *Liṅga Purāṇa* (1,11,22), the *liṅga* represents pure consciousness, the *yoni*, the source of creation, the universal mother. The part of the *liṅga* concealed in the *yoni* denotes divinity veiled by ignorance (*avidyā*), the exposed part, divinity unveiled.

As Śiva signifies the Absolute he is necessarily signless (sexless), without colour, taste or smell, or any qualities whatsoever. Therefore this unmanifest being can be perceived only through his creation, the sign of which is the *liṅga*, the giver of life, 'one of the shapes under which the nature of the shapeless can be represented'.[3] Hence it is the visible sign of unmanifest nature (*avyakta*), whilst the female generative organ (*yoni*) represents manifest nature (*vyakta*).

Formerly there were twelve main *liṅgas*, but now the number is said to be thirty millions. Some are made of sand, flour, or cooked rice, and may be used once for worship and then destroyed. Others belonging to the wealthy, or to well-endowed temples, may be fashioned from gold, silver, crystal, quartz, emerald or other precious gems. The size of a *liṅga* is usually determined by the size of the temple housing it.

Some ancient *liṅgas* are depicted with a five-headed snake forming a canopy over them. (The number five is sacred to Śiva.) Or they may be intertwined with a snake (representing fertility). In Dravidian belief the snake was emblematic of both death and fertility.[4] When the *liṅga* represents Svayambhū, the 'Self-origin-

ated' it is depicted as 'rounded at top and bottom to show that it does not 'stand' or 'arise from' anywhere or anything in our space or time. It may thus look egg-shaped, and recall the Cosmic Egg.'[5]

The shaft of the *linga* should be divided into three parts: the lowermost, square, and placed in the ground, the middle octagonal and placed in a hole cut in the pedestal, the top, cylindrical. Certain proportions are laid down for the making of a *linga* and one that is out of proportion is said to cause devastation to its country of origin; one shorn of its sides brings destruction to the town in which it is situated; and one with a hole on top brings ruin to its owner (*Bṛhat. Saṃ.* 57, 53–55).

'In marking the lines (*sūtras*) on the surface of the stone *linga* . . . the part marked out should resemble the nut of the (human) *linga*. Similarly the *pīṭha* for the *linga* . . . [should] be in the shape of the *bhaga* (the human pudendum)'.[6]

Lakṣmī is sometimes portrayed carrying a *linga* set in a *yoni* base symbolizing the single, timeless, immutable essence beyond change and duality. Mahālakṣmī and Bhūtamātā are depicted with a miniature *linga* on their heads. In *yantras* an upward-pointing triangle represents the *linga* and denotes its fiery energy, solar heat, royal splendour, the power of *tapas*, and the lifeforce of semen: a staff (*daṇḍa*) between two dots also represents the *linga*. Stones similar in form to the *linga* have been found in the cities of the Indus Valley civilization,[7] but over the centuries the *linga* has become so stylized as to be almost unrecognizable.

[1]Therefore *lingas* are sometimes engraved with the *śrī yantra* for meditation as a symbol of the emergence of creation which arises from the undifferentiated ground of being (Rawson, *Art of Tantra*, illus. pl. 172). Details of various kinds of *lingas* are given by Rao, *EHI*, II, pt i, p. 75–102.

[2]*AIA*, I, p. 359.

[3]*HP*, p. 222.

[4]*IT*, p. 152.

[5]Rawson, op. cit., p. 193.

[6]*EHI*, II, pt i, p. 62, n.4.

[7]Allchin, *The Birth of Indian Civilization*, p. 312.

v. Guḍimallam linga; Bāṇalinga; Jyotir-linga; Mukhalinga; Lingodbhavamūrti; Yoni; Dhārālinga; Mānuṣalinga; Trikoṇa; Lingāyat; Śirovarttana; Brahmasūtras; Aṣṭottaraśatalinga; Sahasralinga; Yantra.

Lingāyat A Śaiva sect whose members wear a miniature *lingam* on a chain round their necks or tied up in a silk cloth which is bound round the right arm. It must never be removed from the person of the wearer.

This sect is often identified with that of the Vīraśaiva which came to the fore in the twelfth century AD and which regards Śiva as the self-existent Eternal Principle and the *lingam* as the unifying principle of Śiva and Śakti.[1]

[1]*EW*, I, p. 395.

Lingodbhavamūrti An aspect of Śiva as an endless pillar of light resembling a *linga* and representing the axis of manifestation developing from the point limit (*bindu*), the centre of the universe. This icon is often seen in southern India, and is placed in the niche on the western wall of the central shrine (*garbhagṛha*) of temples.

This form (*mūrti*) reflects the story that once Brahmā and Viṣṇu were arguing as to who was supreme, whereupon Śiva appeared as an immeasurable blazing pillar of light. Brahmā and Viṣṇu were anxious to discover the beginning and end of this great column so Brahmā assumed the form of a goose (*haṃsa*) and flew quickly upwards, whilst Viṣṇu transformed himself in a boar (*varāha*) and dug furiously at ground level, but without success. Brahmā also failed to reach the end of the column, but seeing a flower falling to earth from above lied by saying that he had reached the top. Finally, the two deities realized the supremacy of Śiva, and venerated the fiery *lingam*. In this group Śiva is depicted as a four-armed figure sculpted inside a *linga*, but only from his knees upwards, therefore no one can measure his height. His *mudrās* are *abhaya*, *kaṭi* and *varada*; his emblems, an elephant-hide, the bow Pināka, an antelope, axe, trident and sacred thread.

v. Linga; Ketakī.

Lohaja A metal image cast usually by the 'lost-wax' process. Various alloys and metals are used including gold, silver, and copper.

v. Madhūcchiṣṭa-vidānam.

Loka 'World', 'region', 'sphere' of a deity. There are a number of classifications, one of the most usual being the three worlds of heaven, earth and the nether region. There are said to be seven regions upwards from the earth, and seven downwards.

Lokanātha 'Lord (or protector) of the world (*loka*)'. Title of one of the thirty-nine incarnatory forms of Viṣṇu listed in the *Sātvata Saṃhitā*. Lokanātha is also a title of Sūrya, Brahmā, Śiva and many other gods; of the Buddha, bodhisattvas, and terrestrial rulers.

Lokapāla(s) 'World (*loka*) protectors'.

v. Dikpāla(s).

Lolā or **Cañcalā** The 'Fickle One'. An epithet of

Lakṣmī, the goddess of fortune.

Lolahastamudrā A *mudrā*, often seen in South Indian figures of goddesses, in which one arm hangs gracefully by the side of the body 'like the tail of a cow'. This position is adopted by female figures when they have no emblems to hold.

M

Madana 'Seducer of the mind'. An epithet of Kāma, god of love.

Madanā A wife of Śāsta.

Madanagopāla 'Herdsman of love'. A name of Kṛṣṇa's four- or eight-armed form, often represented leaning against a cow. His upper hands carry Viṣṇu's emblems, the lower hands hold a flute (*veṇu*).
v. Veṇugopāla.

Mada-Śakti v. Manmatha.

Mādhava Son or descendant of the Yādava Madhu. Kṛṣṇa was initially a Yādava ruler, but later was regarded as an incarnation of Viṣṇu.

Mādhavīdevī A name of the Earth-goddess.
v. Pṛthivī.

Madhu I. Name of a demon (*dānava*). He and another called Kaiṭabha are depicted standing near Viṣṇu in his Śeṣaśāyana form.
v. Madhusūdana; Hayaśiras.

II. 'Honey', regarded as the very essence of plants and saps. It is 'also an offering to the chthonian powers and the souls of the deceased'.[1]

[1]*Aspects*, p. 16.

Madhūcchiṣṭa-vidānam The waxen model of an icon used in the *cire-perdue* technique of bronze casting.

Madhukara A row of bees forming Kāma's bowstring.

Madhupātra 'Honey (*madhu*) vessel (*pātra*)'. A flower-shaped vessel for holding drinks. An emblem of Balarāma.

Madhusūdana 'Destroyer of Madhu'. One of the thirty-nine incarnations of Viṣṇu who destroyed the demon Madhu.

Madhva or **Madhvācārya** (thirteenth century AD). Name of a famous *bhakta* and founder of a Vaiṣṇava dualistic *dvaita* sect.

Mythologically Madhva is regarded as an incarnation of Vāyu, god of the wind, and is represented as a *sannyāsin*. His *mudrā* is *cin*; emblems, staff, water-vessel and manuscript. He wears a sectarian mark (*tilaka*) on his forehead in the form of a U or a Y with a dot in the middle.

Madirā Goddess of wine, and wife of Varuṇa. She is also called Vāruṇanī.

Madya 'Intoxicating liquor', generally forbidden to *brāhmaṇas*, but used ritually in some Śākta cults.
v. Pañcamakāra.

Mahābhārata A famous Epic describing the struggle between two families for possession of Upper India (Bhārata). See Bibliography under Roy, P. C.

Mahādeva or **Maheśamūrti** 'Great God'. An epithet applied to Śiva as the Supreme God.

When the two other gods of the triad (*trimūrti*) requested Śiva's aid to destroy the three fabulous cities of the *asuras*, they bestowed on him part of their own powers and henceforth he was known as Mahādeva. He represents reproductive power which perpetually recreates that which he destroys. His symbol is the *liṅga*, the instrument of reproduction, which may be worshipped alone or combined with the *yoni*, also represented by Śiva's consort, *Śakti*. Mahādeva is also regarded 'as a substitute for the impersonal Brahman Itself'.[1]

Mahādeva is represented with two male and one female face, and each face signifies one of his aspects. The right hand face is Aghoramūrti or Aghora-Bhairava, the central Saumya (Tatpuruṣa), and the left Śakti (Vāmadeva-Umā). His attributes are a goad, mirror, bell, sword, shield, axe, noose, trident and *vajra*.

[1]*Facets*, p. 66.

v. Mahādevī; Maheśamūrti; Tripura.

Mahādevī 'Great Goddess'.[1] The supreme goddess of the Śāktas who has a peaceful and a destructive aspect. Mahādevī is Śiva's *śakti* who represents all aspects of his cosmic energy, and when embraced by Śiva the universe is created. Their earliest representations were aniconic – cone-shaped or phallic-shaped stones denoting the male principle, circular stones with a hollow centre signifying the female.

The *Varāha Purāṇa* describes her as a beautiful virgin distinguished by three colours from which she created the *śaktis* of the three deities comprising the *trimūrti*. White became Brahmā's *śakti*, red became Lakṣmī, Viṣṇu's *śakti*, and black Pārvatī, Śiva's *śakti*.

[1]The title Mahādevī is also applied to Sarasvatī and

to some other goddesses.

v. Devī.

Mahāgaṇapati A ten-armed image of Gaṇapati with his *śakti* which represents one of his six aspects. His colour is red: his emblems a tusk, club, water-vessel, lotus, noose, pomegranate, sugarcane, ear of rice, and a wood-apple.

v. Gāṇapatya(s).

Mahāgaurī 'Great Gaurī', an aspect of Durgā. Her mount is a white elephant.

Mahākāla 'Great Time'. A destructive aspect of Śiva as Lord of Eternity which swallows all the ages and cycles of Time, dissolving everything and every being into the motionless ocean of eternity, the substratum from which the manifested world comes into existence and to which, at the end of each age, it returns.

Mahākāla is the male counterpart of the goddess Mahākālī who symbolizes the irresistible force of Time. The colour of both is black. Sometimes Kāla (Time personified) and Mṛtyu (Death personified) accompany him.

Mahākāla is portrayed with four hands carrying the usual emblems of Śiva. His face is fierce with protruding eyes. His mount is a lion; his emblems, a tiger-skin, staff, club, skull-cup, skull-topped staff, necklace of skulls (representing the myriads of creatures who have died), and an axe. He is five-headed and each face has three eyes. His *mudrā* is *ālingahasta*.

v. Kālī; Mahāpralaya.

Mahākālī A fierce form of Pārvatī representing the power of Time. The worship of Mahākālī shows a number of archaic features connected with blood sacrifice.

Mahākālī is depicted with four or eight hands, bulging eyes, and small fangs protruding from the corners of her mouth. Her hair flames upwards to indicate her fearsome character. She wears a skull-garland (*muṇḍamālā*), and a skull or skulls on her head-dress, a snake emerges from her hair. She wears fewer ornaments than Pārvatī as this is an *abhicārika* form. In some icons she carries a trident, or her hand is in *abhaya mudrā* to indicate that she removes the fears of her devotees and defends them against all dangers. Among her attributes are: a goad, discus, club, water-vessel, skull-cup, sword, shield, noose, conch-shell, *vajra*, and a wooden pestle. Her colour is jet black. She may be portrayed narrow-waisted, or with a plump body.

v. Bhadra-Kālī; Mahāpralaya; Mahākāla; Mahālakṣmī.

Mahālakṣmī 'Great Lakṣmī', (the *śakti* of Nārāyaṇa), the primary goddess who embodies the three *guṇas*. She is the supreme source of all power and all manifes-tations of divinity emerge from her. To Śāktas she is the Divine Mother and supreme deity worshipped under the name Śakti.

At the dissolution of the universe she assumes the form of Mahākālī in which the third *guṇa* predomin-ates. In her secondary, four-armed aspect she is blue in colour, wears a skull-garland, and holds a sword, skull-cup, severed head and a shield in her four hands. In this aspect she is known by many names including Mahāmāyā, Mahāmārī, Kṣudhā, Tṛṣā, Yoganidrā and Kālarātrī. The goddess Mahāsarasvatī, in whom the *sattvaguṇa* predominates, also emerged from Mahālakṣmī.[1]

Mahālakṣmī is three-eyed and wears a male and a female mark (*cihna*), and holds the club Kaumodakī, a skull-cup, shield, trident, wood-apple fruit and a citron. A miniature *linga* is portrayed on her head. She is ever youthful and seated on a giant lotus flower rising from the Ocean of Milk (representing abundance). She embodies the eternal power of fascination.

[1]*DHI*, p. 496, and see *EHI*, I, pt ii, pp. 334f.

v. Cāmuṇḍā; Gaja-Lakṣmī; Devī; Pralaya; Samudramathana.

Mahāmaṇḍūka v. Maṇḍūka.

Mahāmārī 'Great Death', a goddess personifying cholera.

v. Mahālakṣmī.

Mahāmāyā Also called Tripurā-Bhairavī. A goddess (a mother-aspect of Pārvatī), personifying the tran-scendent power of illusion (*māyā*), that is the unreality of the universe as contrasted with the reality of the Supreme Spirit.

Mahāmāyā is said to have emerged from the *linga* (*Kālikā Pur.*, ch. 76, vv. 88–93).[1] She is depicted seated on a white-skinned corpse.

[1]Cited in, *Iconog. Dacca*, p. 193.

v. Cāmuṇḍā; Mahālakṣmī; Yoganidrā; Māyā.

Mahānāga 'Great serpents (*nāga*)'. A group of seven snake-gods: Ananta, Takṣaka, Karkoṭaka (Karka); Padma (Puṇḍarīka); Mahābja (Mahāpadma); Śankha (Śankhapāla) and Kulika.

Mahāpadma I. One of the eight treasures (*nidhis*) of Kubera.

II. Name of one of the seven great Nāgas whose emblems are a rosary, and water-vessel. The mark of a trident is depicted on its hood.[1]

[1]*ID*, p. 160; *EHI*, II, pt ii, p. 557.

v. Mahānāga.

Mahāpāriṣada(s) Animal and bird-faced followers (*gaṇas*) of Śiva and Skanda.[1]

[1]*DHI*, p. 356.

Mahāpīṭha 'Great Pedestal'. Name of a seat (character-istic of Śiva)[1] overhung by a wish-fulfilling tree (*kalpa-*

vṛkṣa) instead of a *prabhāvalī*.
[1]*ID*, p. 160.

Mahāpralaya The total dissolution of the universe at the end of each age, over which the goddess Mahākālī presides. During this time Brahmā dissolves into Viṣṇu, since Viṣṇu contains within himself the eternal possibilities of manifestation which appear, disappear and reappear in cyclic time *ad infinitum*: hence there is no definite beginning to any series of worlds or beings, because at the dissolution, the unliberated spirits remain latent with their individual *karma*, to start again within a new evolutionary period.

v. Pralaya; Mahākāla.

Mahārājalīlā A comfortable sitting posture with the hands resting on the knees.

Mahārātrī Name of the goddess symbolizing the fearful night when the world is destroyed leaving only Śiva, the embodiment of eternity, the 'substratum from which all the secondary cycles of time and the energies which rule them are formed'.[1]

[1]*HP*, p. 268.

v. Mahākāla; Mahāpralaya.

Maharṣi(s) The seven great *ṛṣis* or seers, mentioned in the *Ṛgveda*. In the *Viṣṇu Purāṇa* they are given astrological significance as stars in the constellation Ursa Major.

Mahāsadāśivamūrti A complex form (rarely portrayed) of Sadāśiva intended to illustrate esoterically the philosophy of the Śuddhaśaiva cult based on the twenty-eight Śaiva texts (*āgamas*) said to have been directly revealed by Śiva.

Mahāsadāśiva is portrayed with twenty-five heads representing the twenty-five *tattvas*. The heads are arranged in tiers of one (the topmost), three, five, seven and nine. He has fifty arms and seventy-five eyes. He carries many weapons and emblems and wears a tiger-skin, skull-garland, and ornaments consisting of snakes.

Mahāśakti 'Great Śakti'. The mother-aspect of Devī worshipped by Śāktas.

Mahāsarasvatī The white tertiary goddess (the embodiment of *sattvaguṇa*) who emanated from Mahālakṣmī. She is four-armed and holds a rosary, goad, *vīṇā* and manuscript. She has many names including Mahāvidyā, Mahāvāṇī, Bhāratī, Vāc and Brāhmī.

Mahāsena A name of Kārttikeya (Skanda), the embodiment of the army (*senā*) of the gods.

Mahāśveta An earth-goddess, a consort of Sūrya.

Mahāvallī A consort of Subrahmaṇya. She has a black complexion and smiling face. Her left hand holds a lotus, the right hangs gracefully by her side.

v. Devasenā.

Mahāvāṇī v. Mahāsarasvatī.

Mahāvidyā(s) 'Great (or transcendent) knowledge'. Ten tantric goddesses or *śaktis*, each representing part of the total *persona* of Kālī herself. Before a devotee can attain integration and liberation 'Kālī must be known in the full gamut of her transformations'.[1]

The Mahāvidyās personify divine knowledge (*vidyā*) which transcends intellectual cognition and wisdom. It dispels illusion and leads to liberation (*mokṣa*).

The names of the Mahāvidyās are: Black Kālī (or Lalitā), goddess of Time; Tārā, an emanation of Kālī – these two suggest the identity of Time and Space; Ṣoḍaśī, the embodiment of the sixteen modifications of desire. She also represents totality and perfection. Bhuvaneśvarī represents the forces of the material world; Bhairavī, the infinity of forms, desires and emotions that attract and distract mankind; Chinnamastā, the embodiment of eternal night; Dhūmāvatī, the destruction of the universe by fire; Bagalā embodies jealousy, hatred and cruelty; Mātangī, royal dominion; and Kamalā (identified with Lakṣmī), represents pure consciousness of self.

[1]Rawson, *Art of Tantra*, p. 132; and see *HP*, pp. 268ff. This cult was prominent in medieval Bengal (*HCIP*, IV, p. 286).

v. Mahāpralaya.

Mahā-Visnu 'Great Visnu'. Name of a South Indian form of Viṣṇu when accompanied by his two wives. He is depicted seated at ease (*lalitāsana*); his *mudrās* are *abhaya* and *varada*; his emblems, a discus and conch-shell.

Mahāyogin The Supreme Yogin. A title given to a divinity, and especially to Śiva, the *yogin par excellence*. He is represented naked (*nagna*) being beyond all the attractions and conventions of the world, and smeared with purifying ashes (*vibhūti*). He embodies *tapas* and meditation through which unlimited powers are attained.

As the supreme *yogin*, Śiva 'makes use of his *yakṣa* power. To set forth multiples of his own body is a manifestation of a power which draws upon the inexhaustible supply diffused throughout the world, but concentrated in the divinity or the *yogin*.'[1]

[1]Kramrisch, *Indian Sculpture*, p. 175.

v. Yoga.

Mahā yuga v. Yuga I.

Maheśamūrti or **Maheśvara** 'Supreme Lord'. A triple-headed form of Śiva as Lord of Knowledge. This aspect also represents Śiva's creative, preserving and destructive aspects. Formerly this icon was thought to portray the triad (*trimūrti*), but all the three heads are of Śiva and all three wear the *jaṭamakuṭa*, worn only by Śiva, or Brahmā (who is sometimes depicted four-headed), and *never* by Viṣṇu. Sometimes Maheśa assumes the

form of a flaming sword which cuts through ignorance (*avidyā*).

When Maheśa is accompanied by his *śakti* Gaurī, she shows the same *mudrās* as Śiva and holds two blue lotus flowers (*nīlotpala*).

v. Mahādeva; Maheśvarī.

Maheśvara v. Maheśamūrti.

Māheśvarī or **Śaṅkarī** 'Supreme Goddess', the four-armed *śakti* of Maheśvara. Her mount is the bull Nandi; her emblems a rosary, drum, bow and arrow, bell, antelope, axe, trident and *vajra*. She is included among the seven or eight Mothers, and symbolizes avarice (*lobha*) or anger (*krodha*).

The *Viṣṇudharmottara* states that she should have five faces, each having three eyes, and two hands in *abhaya* and *varada* pose, and holding the above emblems.[1]

[1]*EHI*, I, pt ii, p. 387; *ID*, p. 164.

v. Nandaka; Saptamātara(s).

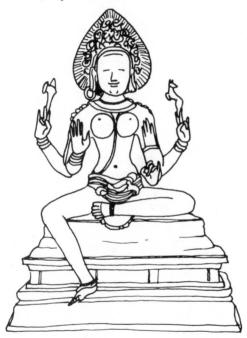

Mahī 'Great'. Name of the Earth-goddess (also called Bhūmidevī and Pṛthivī), from whom flows all prosperity.

Mahiṣa I. 'Buffalo'. A symbol of death and hence the mount of Yama, ruler of the dead. It is also the mount of Vārāhī, and a symbol of Hayagrīva.[1]

[1]*ID*, p. 164.

v. Mṛtyu.

II. A demon capable of assuming any form, but called Mahiṣa when in the likeness of a buffalo. By his great power he defeated the gods and established himself in heaven, whereupon the gods became homeless. Viṣṇu and Śiva advised them to concentrate their powers against the demon. This they did and exhaled the enormous power of their wrath as jets of fire from which emerged the goddess Durgā, fully armed with weapons given her by the gods, and mounted on a lion.

v. Mahiṣāsuramardinī.

Mahiṣāsuramardinī 'Slayer of the buffalo demon'. Name of Durgā when in the act of slaying the demon who had assumed buffalo (*mahiṣa*) form (symbolizing evil and death). In this context Durgā represents an emanation of the divine essence, an invincible fragment of absolute being which assumes the form of the cosmic mother, but at other times it may appear as a divine animal, hero, or avenging monster.

A seventh-century AD representation of this myth from Māmallapuram depicts the eight-armed youthful Durgā mounted on a lion (or *śārdūla*), and holding a sword and bow. She pulls the bowstring back to her ear, and carries more weapons in her other hands. But her calm countenance shows no exertion, nor does her lion, which moves majestically among the fallen enemies. She is unhurried because she is beyond time. The demon holds an huge mace (*gadā*), and is being showered by Durgā's arrows. His demonic followers (placed on the inauspicious left side), are all heavy, coarse males indicating their earthbound nature, but on Durgā's right the figures are feminine, light and graceful, thus signifying that the power of fiery energy or spirit can overcome crude strength. The demons hold the parasol of universal kingship over Mahiṣa's head. These two antagonistic groups indicate the

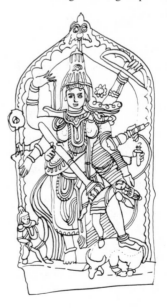

eternal struggle between good and evil, a struggle in which 'the alternating prevalence of one over the other constitutes the evolution of the cosmic process in creation, duration and dissolution'.[1]

Mahiṣāsuramardinī is usually portrayed with ten arms (but sometimes as many as twenty). She carries a trident, sword, spear, discus, goad, shield, battleaxe, rope noose, small bell (the sound of which 'bewitches' the enemy), a *vajra*, and staff or rod. The *Śilparatna* describes her as having three eyes and standing in *tribhaṅga*. In her right hands are a trident, sword, spear, discus, and a stringed bow, in her left hands a noose, goad, shield, axe and bell. The severed head of a buffalo lies at her feet with blood gushing from its neck as the demon leaves the body of the animal and reverts to his own shape.[2] He carries a sword and shield and has a terrifying countenance.

[1]*Principles*, p. 240.

[2]Rao, *EHI*, I, pt ii, p. 354, suggests that this story may indicate the substitution of a 'buffalo-totem worship by a form of goddess worship among certain early primitive tribes in the country'.

v. Caṇḍī.

Mahodaya 'Great prosperity'. The rock (*śaila*) mountain, the top of which the monkey Hanumat broke off when he was unable to distinguish the curative herbs required for the injured Rāma. After Rāma's recovery Hanumat replaced it. He is sometimes depicted carrying a pyramidal-shaped object which represents the mountain.

Mainda An *asura* in the form of an ape. He and his brother Dvivida are sons of the twin Aśvins.[1]

[1]*EM*, pp. 103, 168.

Maithuna or **Mithuna** A pair or couple, symbolizing non-duality or reintegration. Thus in a true union of man and woman a state of bliss is reached momentarily in which duality vanishes, and thus *maithuna* signifies release (*mokṣa*), and the reunion of essence and nature. 'In India, ritualized eroticism and mystical union are the two aspects of a single phenomenon – the attempt to transcend antinomies',[1] and hence couples are depicted on some temple walls, e.g. Koṇārak and Khajurāho, and on the door-jambs of the *garbhagṛha*. The *maithuna* motif is also common to Mahāyāna Buddhist sculpture where it signifies the union of the cosmic Buddha with Wisdom (*prajñā*), personified as a female.

[1]Lannoy, *Speaking Tree*, p. 66.

v. Pañcamakāra.

Makara I. A fabulous aquatic animal, a frequent motif in early Indian art. It appears to have been inspired by the crocodile, dolphin and elephant, and may be of South Indian origin.[1]

The *makara* represents the life-force of the waters and also the arising of darkness into the world of light. It also signifies the fearful and the benign powers of the waters and hence is the mount of Varuṇa, lord of the waters, and of the river-goddess Gaṅgā.

Like other creatures associated with water, it has metaphysical significance which identifies it with 'absolute reality concentrated in water'.[2] Because of its connexion with the life-force the *makara* is depicted on Kāma's banner, and also on the backs of thrones, on the architraves of early *toraṇas*, and as a head-dress ornament. Rāma wears *makara*-shaped earrings.

Both the *makara* and *kīrttimukha* motifs 'appear on the majority of French and Spanish Churches built in the twelfth century'.[3] *Makaras* are also depicted on the fifteenth-century chancel screen in Llanrwst Parish Church (North Wales).

[1]'Makara in the Early Chinese Buddhist Sculpture', *JRAS*, 1951, pp. 134ff. See also Vogel, 'Le Makara dans la sculpture de l'Inde', pp. 133ff.

[2]Eliade, *Patterns*, p. 193.

[3]B. Rogers, 'An Archaeological Pilgrimage to Santiago de Compostela'.

v. Makaradhvaja; Makaramukha; Makarāsana; Makarakuṇḍala.

II. Name of one of Kubera's personified treasures (*nidhis*).

Makaradhvaja A 'banner (*dhvaja*) marked with a *makara*', a characteristic of Kāma.

Makarakuṇḍala 'Earring (*kuṇḍala*) in the shape of a *makara*', made of metal, ivory or wood. It is usually

worn by men, and by Viṣṇu and Śiva in their right ears. Two *makarakuṇḍalas* represent 'intellectual knowledge (*sāṅkhya*) and intuitive-perception (*yoga*)'.[1] When Śiva wears a *makarakuṇḍala* in his right ear and a circular earring in his left, they symbolize his male–female bi-unity. Rāma also wears *makarakuṇḍalas*.

[1]*HP*, p. 158.

v. Ardhanārīśvara; Rāma.

Makaramukha 'Mouth of a *makara*'. Name of an aureole (*prabhāvalī*) arising from the mouth of a *makara*, which is a frequent art motif.

Makaramukhapraṇālī A gargoyle with a *makara* motif.[1]

[1]Sivaramamurti, *Art of India*, p. 553.

Makarāsana 'Having a *makara* as a seat' or mount (*vāhana*). The goddess Gaṅgā has a *makara* mount.

Makaratoraṇa A *makara*-decorated gateway.

Mālā 'Necklace, rosary, wreath or garland'. Garlands may be made of flowers, berries and beads, or from the wood of sacred trees. Good spirits are said to dwell in garlands. Indra's garland of never-fading lotuses gives protection and victory in battle. The garlands carried by Vidyādharas also denote victory.

Members of Śaiva cults wear garlands of *rudrākṣa* berries; Vaiṣṇavas wear *tulasī* garlands; and Śāktas, dead men's teeth or similar relics. Śiva wears a garland of skulls at the time of the dissolution of the world (*pralaya*) when only he remains. In this context the garland signifies the successive evolutions and devolutions of worlds and their inhabitants through cyclic time. Viṣṇu's garland is the garland of victory (Vaijayantī) made of five rows of fragrant flowers, or five rows of jewels, signifying the five spheres of the senses. Brahmā's rosary represents his spiritual aspect and the eternity of cyclic time.

v. Akṣamālā; Vanamālā; Mallāri-Śiva; Vaijayantīmālā.

Mallāri-Śiva A terrific (*ugra*) form of Śiva in which he destroyed the *asura* Malla. Śiva is depicted on a white horse accompanied by seven dogs (*śvan*); his emblems are a small drum and a sword. The crescent moon appears on his *jaṭāmakuṭa*, his earrings are white and shining, his necklaces consist of pearls and rubies, and he wears a flower-garland. A number of snakes cling on his body, and his armlets consists of snakes.

Māmallapuram (now Mahabalipuram) 'City of Malla' situated on the coast thirty-five miles south of Madras. Most of the famous rock-cut temples and carvings there were carried out under the auspices of Narasiṁhavarman I (*c.* 630–70), the greatest of the Pallava rulers.

Maṁsa 'Flesh'. A piece of meat is a characteristic of Durgā in her form of Śivadūtī and of Vāruṇī.

v. Pañcamakāra.

Manasā A folk-goddess of snakes, sister of the serpent king Ananta and mother of the *muni* Astīka. In most early snake-cults the snakes were the objects of worship, whereas in the Manasā cult it is the goddess herself as leader and controller of snakes and destroyer of poison, and hence she is never depicted in snake form. Her mount is a serpent (or occasionally a *haṁsa*), and a seven-headed *nāga* forms a canopy over her.

An image of Manasā now in the Indian Museum has the usual emblems of Sarasvatī,[1] except for a snake canopy and a jar depicted on the plinth with two cobras emerging from it. Her left hands hold a book and vase of nectar (*amṛta*), and one right hand holds a rosary; the other is in *varada mudrā*. On her right a *liṅga* is depicted, on her left a miniature figure of Gaṇeśa.

Some icons depict her holding a snake in two hands and with a child on her lap. These icons resemble those of the Mahāyāna Buddhist goddess Hārītī.[2]

Bhattacharya states that the juice of a cactus called *nāgamātā* or *manasā* cures snake-bite. Also a species of the plant *phanu-manasā* resembles a cluster of expanded cobras' heads. 'The discovery of this Indian plant, so useful in curing snake-bites, seems to be the origin of this goddess and partly her representation.'[3]

[1]Sarasvatī is also said to be a destroyer of poison, and she is invoked for this purpose in the *Atharvaveda*.

[2]*Iconog. Dacca*, p. 221 ff. The Buddhist snake-goddess Jāṅgulī may be the same as Manasā.

[3]*Indian Images*, pt 1, pp. 39f.

Mānasāra Name of the standard treatise on architecture and sculpture, composed *c.* AD 600. There are many similarities between it and the canon of Vitruvius (15 BC).

Mandākinī 'The Milky Way'. Name of the celestial Gaṅgā (Ganges) sacred to the *pitṛs*, which flowed across the sky and onto Śiva's tangled hair and thence to earth.

Maṇḍala A circular diagram or complex design, capable of innumerable variations, and used to aid meditation. Its meaning develops from the centre to the periphery, and hence 'the wider the circles of its application grow, the more divergent become its defined meanings'.[1] A *maṇḍala* signifies water and cosmos and is a device 'used in all Indian religions and held in all to be endowed with magic power'.[2]

When viewed from above, Hindu temples are *maṇḍalas* in stone. The most famous architectonic *maṇḍala* is the Buddhist *stūpa* of Borobudur (Java), which devotees circumambulate as they ascend the successive terraces representing various psychic levels.

[1]*Facets*, p. 102. See also Tucci, *The Theory and Practice of the Maṇḍala*; G. Combaz, 'L'Évolution du stūpa en

Asie', pp. 124ff. Eliade (*Myth of the Eternal Return*, p. 83) points out similarities in appearance and intent between *maṇḍalas* and the 'sand-paintings' of the North American Navajo Indians.

[2]*ID*, p. 168. *Maṇḍala* is also the name of the ringlike arrangement of the *jaṭābandha* (ibid).

v. Yantra; Pradakṣiṇā.

Mandanagopāla An eight-armed form of Kṛṣṇa. In his three right hands he holds a lotus, axe and discus; in the corresponding left hands, a bow of sugarcane, a noose and conch-shell. The two remaining hands hold a flute to his mouth.

Mandapa A temple porch or pillared hall.

Mandara The mythical white mountain supported by Viṣṇu in his tortoise incarnation (*kūrmāvatāra*), and used as a pestle by the *devas* and *asuras* (the joint powers of nature) to churn the ocean.

v. Samudramathana.

Mandāra The coral tree (*Erythrina indica*), one of the five trees of Indra's paradise (*svarga*). The leaf consists of three leaflets which symbolize the triad (*trimūrti*), the large central one represents Viṣṇu, the one on the right Brahmā, that on the left, Śiva. Gaṇeśa sometimes holds a bunch of *mandāra* leaves.

Maṇḍūka or **Bheka** 'Frog'. A *maṇḍala* or plan for erecting temples which consists of sixty-four squares called *maṇḍūka*, and denotes that the building will remain firm and motionless like a frog.

The primeval frog Mahāmaṇḍūka represents the enormous energy which supports Śeṣa, the world serpent on whom rests the universe.[1] A frog is a characteristic of Bṛhaspati and Ketu.

[1]Kramrisch, *Hindu Temple*, I. p. 48.

v. Maṇḍūkāsana.

Maṇḍūkāsana 'Sitting like a frog', a yogic posture.

v. Maṇḍūka.

Maṅgala I. 'Auspicious', probably a euphemism for the god of the planet Mars[1] with whom the war-god Kārttikeya is identified. His colour is red (representing the cruelty and carnage of war). His golden chariot is drawn by eight ruby-red horses or by a goat[2] or a lion. His emblems are a club, spear and trident.

[1]In Tamil this planet is called Cevvāy 'the red one', and hence the name *maṅgala* may be a reflection of an older, now forgotten identification of Śiva as the god of the planet Mars (*ID*, p. 169).

[2]Bhattacharya, *Indian Images*, pt i, p. 31.

v. Bhauma I.

II. A term for anything or any event or thing, regarded as auspicious such as an amulet, a good omen, etc.

Maṅgalā 'Auspicious'. A four- or ten-armed form of Durgā whose mount is a lion. She is depicted heavily ornamented and wearing a *jaṭāmakuṭa*, and carries a trident, rosary, bow, mirror, arrow, shield, sword and moon. The remaining hands are in *abhaya* and *varada mudrās*.[1]

[1]*EHI*, I, pt ii, p. 359.

Maṇi A magic pearl or jewel used as an amulet to protect the wearer and to fulfil his desires.

Maṇibhadra Name of a *yakṣa* king, brother of Kubera, and patron of travellers and merchants. His emblems are a club, water-vessel, jewel and purse.

Maṇikarṇikā A jewelled earring (*kuṇḍala*) worn by Lakṣmī.

Māṇikkavācakar A Śaiva 'saint' or *bhakta*, depicted standing on a lotus plinth and carrying a book.

v. Āḷvār(s).

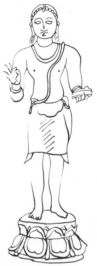

Maṇimālā 'Necklace of jewels (*maṇi*)'.

v. Akṣamālā; Mālā.

Mañjīra An elliptical ornament worn on the top of the foot.[1]

[1]*ID*, p. 170.

Manmatha Name of the god of love, Kāma, who carries a sugarcane bow in his left hand and flowery arrows in his right. He is handsome and wears many ornaments and a flower-garland. Sometimes other figures are depicted with Manmatha including his friend Vasanta, the personification of Spring. His flag-bearer is horse-headed and said to produce erotic feelings. A *makara* or a fish with five flowery arrows are depicted on his banner. His two consorts, Prīti (Love) and Rati (Delight), stand on his right and left side respectively.[1]

According to the *Viṣṇudharmottara* Manmatha should be eight-armed: four hands carry a conch-shell, discus, bow and arrow, and the remaining four are placed on the breasts of his beautiful consorts Rati, Prīti, Śakti and Mada-Śakti.

[1]*EHI*, I, pt i, p. 277.

Manonmanī A form of Devī, having a blue or black complexion, a large face and carrying a skull-cup and sword. She bestows wealth on her votaries and terrifies their enemies.[1]

[1]*EHI*, I, pt ii, p. 364.

Mantra An auditory representation of a deity. Śaivas and others are 'convinced that the *mantra* is a form or representation of God himself, the phenomenal world being the materialization of the *mantras*, without which no cult is possible'.[1]

A *mantra* may consist of a sacred magico-mystical syllable (*bīja*), or verse, a Vedic 'hymn', or combinations of words said to possess divine power, by which something is produced and crystallized in the mind. The culture of the Vedic Aryans was so completely oral that they 'believed that a deity could be compelled by utterance of the correct verbal formula to do exactly what the worshipper desired. Here we have . . . the magical power of the Word – which has at no stage in the cultural evolution of India been wholly abandoned'.[2] Thus *mantras* correctly uttered or sung became part of the liturgy of the sacrifice, as well as ensuring communication with the chosen deity. *Mantras* were handed on from a preceptor to a disciple during the prescribed initiation ritual. Originally *mantras* were orally transmitted from the *ṛṣi* or seer 'who first experienced them; otherwise they are not considered alive'.[3] Increased mental powers may result from the use of *mantras*. The meaningless so-called wild (*śabara*) *mantras* are said to have celestial resonance and great efficacy and are 'used in some forms of magic ritual all over India'.[4]

A *mantra* is a kind of '"momentary deity", whereas the visible, tangible image is the manifestation for sight and touch. The two supplement and complete each other',[5] and represent the name and form respectively of the divine essence.

[1]*VS*, p. 65. According to ritual logic 'there exists a correlation between the ritual act and the results to be expected (Gonda, *Loka*, p. 145, n.5).
[2]Lannoy, *Speaking Tree*, p. 271. Cf. the Word (Logos) in Christianity.
[3]*HP*, p. 336f.
[4]Ibid., p. 337 and see pp. 341ff for various *mantras*. The ancient Hebrew 'Whisperers' repeated passages from scripture or uttered unintelligible sounds to effect cures and to give protection against poisonous reptiles.
[5]Zimmer, *AIA*, p. 112.
v. Mantraśāstra; Mantreśvara(s); Bījamantra; Gāyatrī.

Mantraśāstra The 'magic science', the 'systematic application of magic incantation in ritual . . . Words, magical formulae, sacred verses – *mantras* – exist in relation to the divine as the *yantra* to the gods; words are machines'.[1]

[1]Lannoy, *Speaking Tree*, p. 275.

Mantreśvara(s) 'Lords of the Śaiva *mantra*-formulas'. The five formulas are associated with the five aspects of Śiva.[1]

[1]*DHI*, p. 480, n.1.

Manu[1] The mythological progenitor of mankind, and universal law-giver.

[1]The *Nirukta* 12,33, derives Manu from the root *man* 'to think'.
v. Manvantara.

Mānuṣa 'Man', occasionally seen as a mount (*vāhana*) for a deity.
v. Nara; Manuṣaliṅga(s).

Mānuṣaliṅga(s) *Liṅgams* fashioned by man (*manuṣa*), which consist of three parts: a square base (*brahmabhāga*), an octagonal middle section (*viṣṇubhāga*), and a topmost section (*rudrabhāga*). The last is also known as *pūjābhāga* because it is worshipped by sprinkling water, and placing flowers, on it. There are a number of varieties of *mānuṣaliṅgas*, some based on the different measurements of the three sections of the *liṅga*, others on the number of flutes carved on it, or on the treatment of the *rudrabhāga*.
v. Mukhaliṅga; Liṅgodbhavamūrti.

Mānuṣyaprakṛtideva(s) Lit. a *deva* of human origin, that is, a deified human being. Famous heroes, *ṛṣis* and other spiritually outstanding people have been elevated to the status of minor divinities, or as in the case of Kṛṣṇa, to the position of the Supreme Being.

Manvantara An age of Manu consisting of 4,320,000 years.

Māra 'Killing', 'death', an epithet of Kāma. In Buddhism Māra is the Tempter.
v. Mṛtyu.

Manyu 'Wrath' and its personification.
v. Caṇḍī.

Maraka 'Emerald'. One of the Nine Gems (*navaratna*), and a protection against poison.

Mardala A long drum beaten by the hands. The same as the Tamil *mattaḷam*.

Mārga 'Way'. There are four *mārgas* or ways to spiritual perfection: by knowledge (*jñāna*), by acts (*karma*), by devotion (*bhakti*), and by *yoga* (mental and physical discipline). These ways are not mutually exclusive, because each individual selects and adapts the way or ways that accord with his preferences and tendencies.

Mārgabandhu v. Mārgavatī.

Mārgavatī Goddess of paths and roads, and hence the protectress of travellers.· Śiva as Mārgabandhu also presides over the smallest path as well as the broadest highway.[1]

Marī

[1]Sivaramamurti, *Śatarudrīya*, p. 75.
Marī. (Hindi Mārī māi). A goddess (identified with Durgā), personifying pestilence and death (*māra*). Her sister is Śītalā. Her emblems are a small drum entwined by a snake, a skull-cup, sword, noose, trident and a parrot (*śuka*).

Mārīca v. Hemāmbikā.

Marīci 'Light'. Name of one of the seven great *ṛṣis*, the first of the ten Prajāpatis or secondary creators, born of Brahmā.

Mārjāra 'Cat', the mount of Ṣaṣṭhī.

Mārkaṇḍeya A *bhakta* who, seeing the earth about to be engulfed by water, begged Viṣṇu to save him. Viṣṇu replied: 'Look at me who in the form of a child am lying on a *vaṭa*-tree leaf. I am Kāla (Time and Death); enter my mouth and shelter therein'. Mārkaṇḍeya obeyed and found an assembly of gods, spirits, and the whole world contained within Viṣṇu. This *Mahābhārata* myth is an initiation ritual by which through 'death' or the relinquishing of the limits of individuality, the worshipper becomes one with the deity. Mārkaṇḍeya was also given the boon of remaining eternally sixteen years old, regarded in India as the ideal age. His *mudrā* is *añjali*, his emblem a flower (*puṣpa*).

Mārtāṇḍa 'Sprung from a lifeless egg (*mṛtāṇḍa*)'. An aspect of the sun-god.

Mārtāṇḍa was one of Aditi's eight (or twelve) sons, who was cast away to die, then brought back to life only to be abandoned again. Mārtāṇḍa represents the principle of continuity.[1]

[1]Heesterman, *Ancient Indian Royal Consecration*, p. 36, n. 26.
v. Āditya(s).

Mārttaṇḍa-Bhairava A syncretistic representation of Sūrya and Śiva Bhairava, depicted three-headed and with the following emblems: rosary, discus, drum, skull-cup, sword, blue or red lotus, noose, spear and trident.[1]

[1]*ID*, p. 174.
Marutgaṇa The Vedic Maruts (storm-gods) form a troop (*gaṇa*) numbering 'thrice sixty' or 'thrice seven'. They are the offspring of the Earth-goddess and Rudra who had assumed the forms of a cow and a bull respectively.

The Maruts are described as brilliant, ruddy, golden and shining like lightning (*vidyut*). They carry golden axes or spears, and sometimes bows and arrows. Their garments and ornaments are golden.

Those requiring lasting strength and vigour (*ojas*) worship the Maruts, who are the divine prototype of the common people (*viś*).[1]

[1]F. Edgerton, *Beginnings of Indian Philosophy*, p. 118, n.3.

Maruts Vedic storm-gods, the allies of Indra.

v. Marutgaṇa.

Maṣībhājana 'Ink-stand', associated with Agni, Brahmā, and Piṅgala-Gaṇapati.

Mastaka 'Head', 'skull'.

v. Chinnamastā, Muṇḍa; Kālī.

Mātā or **Mātṛ** *Mātā* means both 'mother' and 'moon'. The mother's womb measures[1] out the potential of each created being, and hence the mother represents the mortal, the finite, the Earth, whilst the father represents the infinite, the unmanifested sphere.

[1]Similarly the moon measures out time (Gonda, *Four Studies in the Language of the Veda*, p. 168).
v. Saptamātara(s).

Mātali Name of Indra's charioteer (*sūta*).

Mataṅga 'Elephant'. An epithet of Śiva as the world ruler, dispenser of justice, embodiment of kingly virtues and destroyer of evil.

v. Gaja; Mātaṅgī.

Mātaṅganakra A fabulous elephant-fish.

Mātaṅgī 'Cow-elephant', representing the power of domination. Mātaṅgī is an epithet of Kālī.

v. Mahāvidyā(s).

Mātara(s) or **Mātṛ(s)** or **Mātṛkā(s)** 'Divine mothers'. A class of tutelary goddesses usually numbering seven (but sometimes eight, sixteen, sixty-four or more), whose traditions link them with the Vedic Gñās (spouses of the gods) and with the still earlier mother-goddesses belonging to the folk level of popular religion.

The Mothers represent the prodigiously fecund forces of nature as well as its destructive aspect. In India power is regarded as an independent entity, and the Mothers became equated with the energies (*śaktis*) of the gods. Each mother thus wears the same ornaments and emblems as her respective god. The Mothers are often depicted with children.

The Mothers assisted Caṇḍikā in her great struggle against the *asura* Śumbha. After Śumbha's defeat the Mothers, intoxicated with blood, broke into a wild dance of victory (*Mārk. Pur.*, 88.11f.).

Banerjea[1] suggests that the term 'mother' may be an euphemism applied to a class of fierce *yoginīs* or similar beings. They are usually portrayed seated in *lalitāsana* or *ardhaparyaṅkāsana*.

The Seven Mothers (Saptamātaras) are often depicted on rectangular stone slabs, with the figures of their respective mounts on the plinth. Vīrabhadra and Gaṇeśa are shown at either end and function as guardians.

[1]*DHI*, p. 494. Śāktas maintain that the Mothers preside over impurities (*malas*) and over the sounds of language, being identified with the fourteen vowels

plus the *anusvāra* and *visarga* (*SED*).

v. Aindrī; Oṁ; Vāc.

Mathurā Name of an ancient city, one of the seven sacred cities of India, and the birthplace of Kṛṣṇa who lived with the cowherds on the Mathurā plains.

Mātṛ v. Mātā.

Mātṛkāśakti The 'mantra-mother', the Tantric supreme Logos.

Matsya I. 'Fish' The first *avatāra* of Viṣṇu, portrayed either as a great fish,[1] because all manifestation arises from the waters (which represent non-manifestation), or as half-man and half-fish. The human part of the body is four-armed and shows the *abhaya* and *varada mudrās*. His emblems are a discus, conch-shell, club and lotus.

At the end of the last age when the world was submerged under the ocean, a demon snatched the Vedas from the hands of the creator and disappeared into the ocean, but Matsya helped Manu to recover them.

The fish incarnation is also associated with a similar Deluge story to that of the Sumerian and later Hebrew myths.[2] One day Manu Satyavrata (patronymic Vaivasvata) whilst bathing found a tiny fish in his hands which begged him to remove it from the sea where small fish were in constant danger of being devoured. Manu accordingly placed it in a bowl of water, which it quickly outgrew, as well as successively larger and larger vessels, until finally Manu returned it to the sea. It then warned him of the impending Deluge and directed him to put a pair of all living creatures, and the seeds of all plants, into a boat. He was then to board the vessel and when a great fish (*jhaṣa*) appeared he should use the body of the serpent Vāsuki as a rope and attach it to the horn of the fish, which would tow the boat to safety. Manu then realized that the great fish was none other than Viṣṇu. Manu followed the instructions and the fish towed the boat to a mountain and then showed Manu how to let the vessel slide down safely as the waters subsided.

[1]The fish, tortoise and boar may have been tribal totems taken over by Brahmanism.

[2]*DHI*, p. 413. The fish, tortoise and boar *avatāras* were originally associated with Brahmā Prajāpati, but with the development of the Vaiṣṇava Bhāgavata creed, were transferred to its composite cult-god. Leibert (*ID*, p. 176) states that 'according to some scholars the fish-sign in the Indus script signifies a god.'

II. A fish is the mount of Varuṇa and Gaṅgā, and an emblem of Gaurī, Śivadūtī and Vārāhī. Two fish symbolize Gaṅgā and Yamunā the two river-goddesses, and a fish is depicted on Kāma's banner.

v. Matsyayugma; Mīna; Makara.

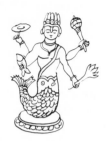

Matsyāvatāra v. Matsya.

Matsyayugma 'Pair of fishes', one of the eight auspicious emblems (*aṣṭamaṅgala*), signifying increase as fish breed rapidly. In Buddhism and Jainism *matsyayugma* represents happiness.

v. Matsya II.

Mātuluṅga 'Citron', 'pomegranate', 'sweet lime'.

v. Jambhīra(phala).

Mauktikajālaka 'Pearl-festoons', often depicted as ornaments on the bodies of deities.

Maunavratin A form of Viṣṇu when performing a vow of silence. He is depicted with his right fist clenched and raised to his mouth with the index finger touching the chin or corner of the lower lip. This is an 'unnamed' *mudrā* and denotes silence.

Maurya Name of a dynasty (322–186 BC), and of an ancient tribe of north-east India, little influenced by Aryan religion and polity who were ruled by an aristocratic military (*kṣatra*) government.[1] The Mauryas' emblem was a peacock (*mayūra*).

[1]Law, *Tribes in Ancient India*, p. 288.

Maya An architect of non-Aryan stock, builder of the magnificent palace of the Pāṇḍu princes at Hastināpura. Maya is regarded as the terrestrial counterpart of Viśvakarman, the architect of the gods.

Māyā 'Creative power'. In the *Ṛgveda* this term means supernatural power and skill, that is, Indra's occult power that creates manifold forms out of one:[1] in the *Atharvaveda* it means magic or illusion. But for 'Sāṁkhya and Yoga, the Upaniṣads, Jainism, Tantrism, Śaivism and the southern schools of *bhakti*, *māyā* is not unreal but a cosmic play' (*līlā*).[2] To others it came to signify the psychological state of one under the spell of the relative and transitory display of the manifold forms of the world which is erroneously taken for ultimate reality. In other words the unifying substratum of *brahman* is not perceived as the basis of all manifestation.

Hindus regard all forms as relative and ever-changing *māyā* conjured up by the supreme magician of the divine play. A selfish man deludes himself that he is the actor, but all actions occur in time, by the interwea-

ving of the forces of nature. In the flux of *māyā* all forms are re-created and then dissolved into the primordial unity or non-manifest condition of *brahman*.

Māyā indicates that gods and demons may assume visible transitory forms (*meyas*), the manifoldness of which 'are a reflection or manifestation of the Ultimate, but never the Ultimate itself. This lies before, and after, all its emanations.'[3]

[1]Bowes, *The Hindu Religious Tradition*, p. 152; *EW*, I, p. 66.

[2]Lannoy, *The Speaking Tree*, p. 287. The word illusion is derived from the Latin *ludere*, to play.

[3]*Facets*, p. 90. When the concept of *māyā* is 'confronted with the postulate of absolute permanency . . . it gains the meaning of transitoriness and thus . . . that of illusionary reality only' (ibid., p. 125).

v. Māyādevī; Śaṅkarācārya.

Māyādevī The goddess (Devī) personifying *māyā*, regarded as the source of the cosmos.

Māyā is also an 'epithet of Durgā as a mother-aspect of Pārvatī'.[1] The secret of the identity of opposites is contained in Māyā for she represents both creation and destruction, evolution and annihilation. Māyādevī is the name of the wife of Pradyumna.

[1]*ID*, p. 177.

Mayūra 'Peacock', a bird said to have been produced from feathers which fell from the fabulous Garuḍa bird.

The peacock represents immortality and hence is regarded as the traditional killer of serpents which symbolize cyclic Time. It also signifies love.

The bird is associated with Durgā and with Kārttikeya, the mysterious, eternal boy. Kārttikeya, as lord of immortality, conquered the serpent power of Desire which operates in Time, and hence he has the peacock Paravāṇi as his mount. Peacock feathers are associated with Dakṣiṇāmūrti.

v. Mayūramudrā; Mayūrapattra; Maurya.

Mayūramudrā 'Peacock *mudrā*', in which the third finger touches the thumb, the middle finger is straight and slightly bent forward and the other fingers extended. It indicates a peacock's beak, a creeper, or a bird of omen (*śakuna*).[1]

[1]Coomaraswamy, *The Mirror of Gesture*, p. 29.

Mayūrapattra 'Peacock feather'. A bundle of peacock feathers is emblematic of Skanda, Bhikṣāṭanamūrti, Kaṅkālamūrti, Śrīdevī, Devasenāpati, and of Śiva when dancing his morning and evening twilight dance (*sandhyātāṇḍava*).

v. Mayūra.

Mayūrāsana 'Sitting like a peacock (*mayūra*)'. A yogic position in which the legs are crossed (*padmāsana*), the body leans forward, hands placed palm downwards on the floor and the body raised and supported on the hands.

Medhā Name of the *śakti* of Śrīdhara.

Medhādakṣiṇāmūrti An aspect of Śiva when teaching the highest philosophy by silence, coupled with the *cinmudrā* in which the tip of the index finger is placed on the top of the thumb thus making a circle which denotes 'the oneness of *jīvātmā* and *paramātmā* . . . [which] leads on to *ānanda* or bliss'.[1]

[1]Sivaramamurti, *Śatarudrīya*, p. 83.

Medinī Name of the Earth-goddess.

v. Pṛthivī; Mahī.

Mekhalā A wide girdle or belt (characteristic of goddesses) which being circular indicates a dynamic form full of tension and perpetual movement. The circle is also said to have protective powers. Technically the girdle should be composed of eight strings.[1]

Wearing a *mekhalā* had ritualistic significance for the three upper classes (*Manu*, II, 42ff.). The broad, jewelled belts depicted on figures of goddesses functioned as long-life charms (*AV*, VI,135,5).

[1]Bhattacharya, *Indian Images*, pt i, p. 57.

v. Parjanya.

Menā or **Menakā** I. A mountain goddess, the wife of Himavat (the personified Himālaya), and mother of Gaṅgā and Pārvatī.

II. An *apsaras* who seduced the *ṛṣi* Viśvāmitra and became the mother of Śakuntalā.

Meru or **Sumeru** The mythical gold mountain in the Himālaya, visualized as the axis of the universe and abode of the gods, which in primordial times represented the common spiritual centre for mankind in the Golden Age (*satya yuga*), 'when divine knowledge was accessible to all'.[1] Meru is said to contain the germinal image of the divine.

[1]*Principles*, p. 245.

v. Kailāsa.

Merudīpa 'Meru lamp (*dīpa*)'. Name of a square plate with a handle. A number of small oil lamps are arranged in tiers on the plate, which represent Mount Meru.

Meṣa 'Ram'. The mount or vehicle of Agni, Kubera and Varuṇa.

Mīna 'Fish'. Name of the zodiacal sign Pisces.

v. Matsya I and II; Matsyayugma; Mīnākṣī.

Mīnākṣī 'Fish-eyed'. An ancient South Indian cult goddess regarded as a consort of Śiva and daughter of Kubera. From her connexion with Kubera, Coomaraswamy suggests that she is a *yakṣiṇī*.[1] Her slightly bulging oval eyes are a sign of beauty in South India.

[1]*Yakṣas*, pt i, p. 9.

Mīnamithuna 'Pair of fishes'.

v. Matsyayugma.

Mithuna v. Maithuna.

Mitra 'Friend'. I. A Vedic solar divinity (one of the Ādityas) representing the beneficent aspect of the sun-god and guardian of faithfulness and contracts. Mitra is equivalent to the Avestan Mithra who, under the name of Mithras, was widely worshipped in the Roman Empire.

Mitra is two- or four-armed; his emblems are two lotuses, *soma* and a trident; horses pull his chariot. His two door-keepers, Daṇḍa and Piṅgala, carry swords.[1]

[1]*EHI*, I, pt ii, p. 302.

v. Āditya(s).

II. Name of one of the four chief disciples of Lakulīśa.

Modaka 'Sweetmeat', especially a rice-cake, 'but it is also used as a common term for several closely allied attributes which are all fruits (*phala*) and symbols of agricultural fertility, such as *āmra, dāḍima, ikṣu, jambhīra, jambū, kadala*, etc.'.[1]

[1]*ID*, p. 179.

v. Gaṇeśa; Laḍḍu.

Moha 'Delusion', the conceiving of appearances as things in themselves and being attracted to them regardless of their transitory nature.

Mohenjodaro 'Town of the dead'. One of the chief cities of the Indus Valley civilization, where excavations have revealed remains of a sophisticated culture dating from about 2500 BC.

Mohinī The seductive female form assumed by Viṣṇu to bewitch and distract the *asuras* and so deprive them of their rightful share of the ambrosia the elixir of immortality. In another myth Viṣṇu again assumes the form of the Enchantress to test the sages of the Dāruka-vana forest who were given to boasting about their chastity.

Śiva is said to have fallen in love with this enchanting aspect of Viṣṇu, so making him realize the power of Viṣṇu's *māyā*. From their union was born Aiyanār.

Mokṣa 'Liberation, realization or perfection'.

Mṛdaṅga A large barrel-shaped drum often depicted in the hands of the divine attendants of the gods.

Mṛga 'Antelope, gazelle, deer'. An ancient Indus Valley symbol of the Lord of Animals, and of all living beings.

Śiva carries an antelope in his left upper hand. 'It is held in several ways and sometimes the position of its tail helps to differentiate between the various schools.'[1] In early images of Śiva the animal has its tail and head pointing towards the deity.[2] Śiva's antelope denotes his rulership over nature.[3] The dark kindling-wood of the sacrifice is likened to a black deer.

The antelope is also associated with Vāyu, god of the wind, and with the goddess Śānti, the embodiment of peace and tranquillity. A white antelope draws the chariot of the moon (Candra).

[1]Thapar, *Icons*, p. 42.

[2]Ibid., p. 134.

[3]Sastri, *South Indian Images*, p. 267, states that the animal denotes the occasion when Śiva destroyed Dakṣa's sacrifice, and the personified Sacrifice assumed the form of a deer, in an attempt to escape Śiva's wrath.

v. Mṛgaśiras.

Mṛgasiṃhāsana 'Antelope-lion-seat'. Name of a pedestal or seat with antelopes carved on its supports.[1]

[1]*ID*, p. 180.

Mṛgaśiras 'Deer's head', name of an auspicious constellation.

Yajña, the personified Sacrifice, assumed the head of a deer and was killed by Vīrabhadra at Dakṣa's sacrifice. Brahmā transformed him into the constellation *mṛgaśiras*.

v. Mṛga.

Mṛtaka or **Mṛtakāsana** 'Corpse', on which particular deities including Cāmuṇḍā, Nirṛti, Kālikā and the Mothers may sit, stand or tread.

v. Pretāsana; Śava; Nara.

Mṛtyu The personification of death[1] who dwells in the sun, and hence the sphere of death is in the highest sky. Death does not die for he dwells within the immortal (*ŚBr.*, X,5.2,3ff.). Mṛtyu is completely fearless for every creature fears him.

[1]Cf. the Babylonian, Greek, and Welsh gods of death: Mu-u-tu, Thanatos and Angau respectively.

v. Yama; Mṛtyupāśa.

Mṛtyuñjaya 'Conquering death'. An epithet of Śiva when overcoming Death (Mṛtyu). His *mudrās* are *dhyāna* and *jñāna*; his emblems, a tiger-skin, rosary, water-vessel, skull-cup, antelope, garland of skulls on his head, noose and trident.

Mṛtyupāśa Death's noose (*pāśa*) which ensnares all creatures.

v. Mṛtyu; Yama.

Mudgara 'Hammer', emblem of Aghoramūrti, Caṇḍā, Mahākāla, Mahiṣāsuramardinī, the Nine Durgās, Śarabha and others.

Mudrā I. 'Sign', 'seal', symbolic hand and arm poses which are used to express feelings, emotions, facts, thoughts or metaphysical meanings, mythological events, and to evoke supranatural beings. *Mudrās* 'have been elaborated into a language so rich and subtle that entire narratives can be carried through in mime alone – no setting or explanation is necessary.'[1] *Mudrās* are also used in dancing.[2] Belief in the magical power of hands or fingers is widespread in many cultures. A person exhibiting a *mudrā* is supposed to transform himself into a conductor of mystic forces (hence the objection to pointing in many countries).[3]

There are many *mudrās* in Hindu and Buddhist iconography, but the most usual are the fear-removing *mudrā* (*abhaya*) and the *varada*, the bestowing of boons.

[1]Rawson, *Indian Sculpture*, pp. 147f.

[2]The important text book *Viṣṇudharmottara* of medieval artists emphasizes the need for a knowledge of dancing. *Mudrās* have influenced the dance cultures of the Orient, the South Pacific (especially the Hawaian *hula*), and Spain.

[3]*DH*, p. 195; van Gulik, *Hayagrīva*, pp. 51f. For dance *mudrās* see Poduval, *Kathākil and Diagram of Hand Poses*; and Coomaraswamy, *Mirror of Gesture*.

v. Añjali; Kaṭaka; Ḍamaruhasta; Ardhacandramudrā; Lolahasta, Āliṅganāmūrti; Nidrātahasta; Tarjanī; Gajahasta; Patākāhasta; Vismaya.

II. Parched grain.

v. Pañcamakāra.

Mukhaliṅga 'Face-*liṅga*'. A *liṅga* having one or more human faces depicted on it which represent various aspects of Śiva. The number of faces varies according to the purposes for which the *mukhaliṅga* is required. A one-faced *liṅga* should have the face near the top, and should be erected in villages. Two-faced *liṅgas* should be placed on hills or near the border of enemy country, because this type, and five-faced *liṅgas*, are used in rites to injure enemies;[1] three-faced *liṅgas* should be placed in temples with three doors; and four-faced ones in four-doored temples,[2] with each head facing one of the four directions. The *Rūpamaṇḍana* lays down that the western face should be white, northern red, southern black and fierce, and eastern, the colour of glowing fire. The four figures on the sides of the *liṅga* should be depicted only as far as the chest indicating that the source of the *liṅga* is incomprehens-

ible to man.

Mukhaliṅgas may be round, hexagonal or octagonal, and sometimes studded with a number of small knobs representing a hundred or a thousand small *liṅgas*. The plinths may be of any shape. Five-faced *liṅgas* have four faces on the sides and one on top facing upwards, which symbolize the five aspects of Śiva, named Sadyojāta, Vāmadeva, Aghoramūrti, Tatpuruṣa and Īśāna.[3]

[1]Bhattacharyya, *Canons of Indian Art*, pp. 397f.

[2]But this ruling is not always followed.

[3]*DHI*, p. 460. Columnar altars with figures of Śiva depicted on them are mentioned in the earlier sections of the *MBh*.

v. Pañcadehamūrti; Pañcamukhaliṅga; Mūlaliṅga; Piṭha; Mūlavigraha I; Sahasra.

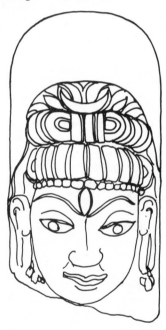

Muktā 'Pearl'. One of the Nine Gems (*navaratna*).

Muktakeśī 'Dishevelled hair'. A form of Durgā whose *mudrās* are the *abhaya* and *varada*. Her emblem is a sword.

Muktāsana A yogic position in which the ankles are placed against the genitals, with the soles of the feet together and the knees outspread.

Muktayajñopavīta A sacred thread composed of pearls (*muktā*).

v. Yajñopavīta.

Mukulamudrā A *mudrā* in which the tips of the fingers and thumb are brought together to form the shape of a bud which it signifies, as well as indicating an offering, the *yoni*, a virgin, etc.

Mukunda v. Nidhi(s).

Mukuṭa 'Crown or coronet'. Most deities have elaborate hair-styles and crowns, some of which are characteristic of particular gods. Others have their hair piled up to resemble crowns, and ornamented with various jewels and other decorations.

Ascetics and *ṛṣis* do not wear crowns but merely tie up their matted hair which indicates their non-attachment to mundane things. In ancient India the head-dress indicated the rank of the wearer, and also that of divinities.

v. Jaṭāmukuṭa; Kirīṭamukuṭa; Karaṇḍamukuṭa.

Mūladevī The 'root (*mūla*) goddess' who occupies the innermost shrine of a temple (*garbhagṛha*).

Mūlaka 'Radish', an emblem of some forms of Gaṇeśa.

Mūlaliṅga The 'root (*mūla*) *liṅga*' which is placed in the innermost shrine of a temple and never moved.

v. Garbhagṛha.

Mūlamūrti 'Fixed (or root) idol' of a temple.

v. Acalamūrti.

Mūlavigraha I. 'Fundamental (*mūla*) form', the *liṅga* which is the elemental form of Śiva.

v. Liṅga.

II. A permanently established icon in a temple or shrine.

Mūlayantra The root diagram or *yantra* which represents a deity.

Muṇḍa I. Name of a *daitya*, one of the mighty generals of the *asura* Śumbha who fought against the goddess Cāmuṇḍā. His emblem is a skull or severed head (*muṇḍa*).

II. 'Severed head', 'skull', emblematic of Cāmuṇḍā, Chinnamastā, Kālī, Mahākāla, Maṅgala, Śiva and the Nine Durgās, and others. Muṇḍa is sometimes synonymous with *kapāla*.

v. Muṇḍamālā.

Muṇḍamālā 'Garland (*mālā*) of skulls (or severed heads)', emblematic of Bhairava, Cāmuṇḍā, Dhūmrāvatī, Durgā, Mahākāla, Śiva, Vīrabhadra, and others denoting their destructive aspects. The wearing of a skull-garland is 'probably a vestige of a skull cult'.[1]

[1]*ID*, p. 18.

Muni 'Sage, seer, inspired person', especially one who has taken a vow of silence, who possesses magical powers, and who has transcended all earthly desires.

Muñja A tall sedge-like grass used ritually for purificatory purposes.

Mura or **Muru** A five-headed *daitya* (*dānava*) who joined the demon Naraka in his fight against Kṛṣṇa.

Muraja A large drum, an emblem of royalty, and also associated with Nandīśa.

Muralī Kṛṣṇa's divine flute (*veṇu*).

Murāri 'Enemy (*ari*) of Mura'. An epithet of Kṛṣṇa who killed the demon Mura.

Mūrti 'Manifestation, form, likeness, image, statue' which represent the different aspects and icons of the gods. Every icon denotes the superhuman force embodied in some deity, but divine forces may also exist in oral and written forms, and thus *mantras* may be used to evoke deities.

v. Pañcaloha; Trimūrti.

Mūrtyaṣṭaka The 'eight forms' of Śiva: Bhava, Śarva, Īśāna, Paśupati, Ugra, Rudra, Bhīma and Mahādeva. These eight names were received by Śiva when he was produced by Prajāpati. They also represent the lords of the various *tattvas* such as fire, air, earth, etc.[1] All these forms are usually four-armed; their *mudrās* are *abhaya* and *varada*; their emblems, *jaṭāmukuṭa*, antelope, chisel or hatchet.

[1]*EHI*, II, pt ii, p. 403.

v. Aṣṭamūrti; Santāna II.

Muru v. Mura.

Murugan 'Young man'. The Tamil name of Kārttikeya (Subrahmaṇya).

Mūṣa or **Mūṣaka** 'Rat', 'mouse'. The mount of Gaṇeśa. Although a very small animal, the rat can enter houses, granaries, larders, and also overcomes many obstacles which man puts in its path. Sometimes he is depicted with one paw and his lower jaw resting on a bowl of sweets (*laḍḍu*) which he guards for his master.

v. Ākhu.

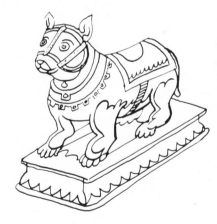

Musala A wooden pestle, a cylindrical rod of hard wood also capable of being used as a weapon. Balarāma's pestle-shaped club (*gadā*) is named Saunanda.

A wooden pestle signifies agriculture and is an emblem of Ananta, Ardhanārīśvara, Cāmuṇḍā, Gaṇeśa, Mahākālī, Sadāśiva, Vīrabhadra, Ṣaṇmukha, Śarabha, Skanda and others.

Muṣṭimudrā A *mudrā* in which the fist is clenched and the thumb held across the fingers. Kṛṣṇa shows this

mudrā when he fights Madhu. It also denotes holding a mace or spear,[1] also strength and wrestling.

[1]Coomaraswamy, *Mirror of Gesture*, p. 30; *ID*, p. 186.

Mūyaḷaka The Tamil name of Apasmārapuruṣa.

Nābhi 'Navel', 'centre'. Cosmogonically *nābhi* signifies a central point, such as the mythical Mount Meru regarded as the centre of the earth, the seat of the life-force and meeting-place of heaven and earth.[1]

Brahmā sprang from the lotus (*padma*) emerging from Viṣṇu's navel, the centre of universal energy. For this reason most figures in Indian sculpture have the navel distinctly marked. Its creative significance is reflected in *RV* (x, 82,5): 'On the navel of the unborn stood that in which all beings stood.'

[1]Compare the Greek *omphalos* at Delphi, believed to represent the centre point of the earth where men and gods meet.

v. Nābhija.

Nābhija 'Navel-born'. An epithet of Brahmā, a secondary creator born from the navel of Viṣṇu.

v. Nābhi; Anantaśāyana.

Nāda 'Sound'. In Tantrism *nāda* refers to the primordial sound-vibration at the beginning of creation, and is symbolically represented by a stroke (—), said to be a 'fifth sound'.[1]

[1]*ID*, p. 186.

Nādānta A dance pose of Śiva similar to that of Naṭarāja, except that Śiva stands on the left foot with the right leg raised (the reverse of the Naṭarāja representation).

Nādānta represents the kinetic aspect of deity by which the universe is created, maintained, and finally destroyed.

Nādatanu v. Ḍamaru.

Nadīdevatā 'River (*nadī*) goddess'. Although the water in a river is constantly changing, yet it has a distinct body in which dwells the spirit that controls it.

Rivers, especially the Ganges, Jumna and Sarasvatī are deified as goddesses who represent abundance. The figures of such divinities are often placed as guardians of temple doors and depicted in attitudes of devotion and repose, the flowing waters being indicated by their graceful swaying stances resembling the undulating movements of aquatic plants. To venerate the river-goddesses is equivalent to bathing ritually in their purifying waters.

The forms of the river-goddesses of northern India are derived from those of the *yakṣī*-dryads, which, despite their vegetal and apparently terrestrial habitat, remain primarily spirits of the waters.

v. Gaṅgā; Yamunā; Sarasvatī.

Nāga In Indian mythology a general term for quasi-divine beings half-human and half-serpent, who guard the mineral wealth of the earth. They may be represented as three-, seven-, nine-, or ten-headed. Sometimes they are portrayed as handsome men wearing crowns, large earrings and jewelled ornaments. They are courageous, quick and violent, as well as being endowed with superhuman power, potency, skill and wisdom.

Many Jaina, Hindu and Buddhist statues have backgrounds or canopies formed by snakes and trees, which probably denote a very ancient non-Aryan serpent cult combined with the worship of trees and rivers. Snakes were popular household guardians, and also guardians of rivers, tanks, lakes and wells. In Mysore, women desiring children set up votive *nāga* stones under trees, which may depict Mudāmā the South Indian serpent-mother, or a pair of serpents entwined with the heads facing each other.[1]

The three *nāga* kings, Vāsuki, Takṣaka and Śeṣa dwell in wonderful sub-aquatic paradises, or in inaccessible mountain caves.

Snakes symbolize the eternity of cyclic time, because of their capacity to slough their skins and their apparent immortality. Sometimes Śiva holds the head of a snake which in this context symbolizes the inviolability of his Law,[2] and his creativity.

Heimann points out that although the forms of Gaṇeśa and *nāgas* are not natural, they 'express that fusion of cosmic forces prescribed by Indian mythology, which has never died'.[3]

A snake or snakes form the mount of Manasā and Hayagrīva, and for the reclining form of Viṣṇu (Anantaśāyana). Sometimes a five-headed snake represents Gaṇeśa.[4]

[1]This motif is depicted on the sacrificial goblet of the Sumerian King Gudea (*c.* 2600 BC), now in the Louvre. Serpents with bodies interlaced are frequently depicted on Vaiṣṇava temples (Kramrisch, *Hindu Temple*, II, p. 314).

[2]*Principles*, p. 183.

³*IWP*, p. 110.
⁴*ID*, p. 187.
v. Nāgasil(s).

Nāgabandha A 'frieze of *nāgas*' depicted on temple walls.

Nāgadru A species of Euphorbia (*E. antiquorum*) (from which the drug euphorium is produced), sacred to Manasā. *E. lingularia* is also sacred to her.

Nāgakal(s) v. Nāgasil(s).

Nāgakuṇḍala An earring (*kuṇḍala*) in the shape of a snake.

Nāgamudrā A hand-pose in which the fingers are held in a cupped attitude resembling the hood of a snake.[1]
[1]*ID*, p. 187.

Nāgāntaka 'Destroyer of serpents', an epithet of Garuḍa, the enemy of snakes (*nāgas*).

Nāgapāśa A magical noose (*pāśa*) consisting of a snake. This noose called Viśvajit is Varuṇa's favourite weapon. It is also emblematic of Caṇḍā, Ketu, Kṣetrapāla, the *asura* Śumbha, and some forms of Śiva.

Nāgasil(s) or **Nāgakal(s)** Votive stones set up under trees in Mysore by women desiring children. Some have serpents depicted on them. Before being erected the tablets are placed in a pond for six months to be imbued with the life-force of the watery element with which snakes are associated.
v. Nāga.

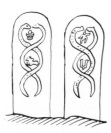

Nāgavalaya A snake-shaped armlet or bracelet.
v. Bāhuvalaya.

Nāgayajñopavita A sacred thread composed of a snake (*nāga*), and worn by Caṇḍeśvara, Vīrabhadra, Kṣetrapālas and some forms of Śiva.
v. Yajñopavīta.

Nāgeśvara Śiva as lord of snakes.

Nāgī or **Nāginī** A female snake-goddess and aquatic snake-spirit, symbolizing 'both the primordial sacrality concentrated in the ocean and the earliest aboriginal cultural forms'.[1]

A Nāgī may be depicted with the lower half of the body as a snake, the upper half human and carrying a sword and shield. She wears necklaces and a high crown.
[1]Eliade, *Yoga*, p. 351.
v. Nāga.

Nagna 'Naked'. Kālī is depicted naked and also Baṭuka-Bhairava, Bhikṣāṭanamūrti, Śītalā and Kālarātrī.

Naigameṣa A ram-headed demon especially dangerous to children. Coomaraswamy[1] states he is antelope-headed and connected with procreation in both Hindu and Jaina mythology, whilst in the Epic he is a 'goat-faced form of Agni'.
[1]*Yakṣas*, pt 1, p. 12.

Naigameya A form of Skanda when depicted goat-headed (*chagavaktra*).[1] Naigameya is said to be Skanda's son, or his playfellow.
[1]*DHI*, p. 363 and cf. p. 562.

Nairṛta 'Belonging, or consecrated to Nirṛti', god of misfortune, decay, destruction and death. The goddess Nirṛti's demonic offspring are called Nairṛtas, and Nairṛta is her male counterpart. He carries a sword.
v. Naraka.

Nakrakuṇḍala An earring in the shape of a *makara*.

Nakṣatra(s) A cluster of stars, or a constellation which represents the twenty-seven divisions of the lunar zodiac. In later works twenty-eight independent asterisms are listed and each is used as a basis for the casting of horoscopes, the *nakṣatras* being supposed to exert great influence on human beings for good or ill.

The *nakṣatras* are deified as goddesses, the daughters

of Dakṣa and wives of Candra (Moon).

Nakula I. Name of one of the twin Pāṇḍu princes, his brother being Sahadeva. Both are regarded as incarnations (*avatāras*) of the twin Aśvins.

II. An ichneumon or mongoose, the enemy of snakes and mice. It is said to be capable of cutting a snake in two and then rejoining the two halves (*AV*, VI, 139,5). It protects itself against snake-venom by means of the plant *nākulī*.

The mongoose is also thought to be a receptacle for all gems and hence is portrayed vomiting out jewels. Its association with gems also connects it with Kubera, god of wealth, with Śrīdevī, and with *yakṣas*.

Nāla The tubular projection of the plinth of a *liṅga* which acts as a channel for the water poured onto the top of the *liṅga*.

Nālikera v. Nārikela.

Nāma-rūpa 'Name and form' (or aspect). The world can only be known by means of name and form. 'India's magical positivism assumes that an object's name is the key to its very essence, while the second possible approach to things is through *rūpa*.'[1]

The name possesses creative power[2] for by means of Name and Form the impersonal *brahman* was able to 'descend' into the world he had created (*ŚBr.*, XI,2.3,3).

[1]*IWP*, p. 85.

[2]Cf. the Old Testament name Yahweh that was so potent that its utterance was forbidden.

Namaskāramudrā 'Salutation or adoration *mudrā*'. A hand-pose similar to the *añjali mudrā*, except that the hands touch the forehead instead of being held against the chest.

Nameru The tree (*Elaeocarpus ganitrus*) sacred to Śiva.

Nammāḷvār A famous Tamil poet and singer, depicted with a dark skin indicating that he was a *śūdra*. His *mudrā* is *abhaya*; his emblem a manuscript; and the tamarind tree is associated with him. He wears necklaces, bracelets and earrings, and has a distinctive hair-style.

v. Āḷvār(s).

Nanda 'Joy, delight'. Name of Kṛṣṇa's foster-father.

Nandā 'Joy'. A form of Pārvatī described in the *Viṣṇudharmottara* as having four arms and being white-complexioned. One hand is in *varada* pose, another in *abhaya*. The third and fourth hands carry a lotus and goad respectively, or a sword and shield. Her vehicle is an elephant. Other texts state that she has eight arms. She may carry an arrow and the bow Ajagava, a bell, noose and conch-shell.

Nandaka I. 'Gladdening'. Name of Viṣṇu's sword (*khaḍga*) which represents pure knowledge (*jñāna*) whose substance is wisdom (*vidyā*) which cuts through ignorance (*avidyā*). The latter is represented by the scabbard, and also that darkness which is the form of divinity.[1]

[1]*HP*, p. 160.

II. Name of one of the eight or nine treasures (*nidhis*) of Kubera.

Nandi-liṅga Śiva's bull combined with the liṅga.

Nandin or **Nandī** 'The Happy One'. Name of the white, black-tailed bull, the mount of Śiva. Nandin is also known as Bhṛṅgi (the Wanderer). An image of Nandī is placed in the outer hall of Śaiva temples, and looks towards Śiva. Probably the bull was formerly a theriomorphic form of Śiva, who was known to the Greeks as the god of Gandhāra in bull form. Heimann[1] points out that the animal form expresses particular qualities more effectively than is possible anthropomorphically.

A fine South Indian basalt statue of Nandin wearing elaborate harness and collar is now in the Ashmolean Museum, Oxford. The downward-pointing triangle on the bull's forehead recalls the triangular marks on the figures of sacred cattle from Ur.

Nandī may be depicted standing or lying down. When lying down his left leg is bent at the joint as if ready to rise instantly to do Śiva's bidding.

The bull is emblematic of moral and religious duty, justice, and law (*dharma*), and represents the qualities of the strong, hence it is the mount of Śiva the great *yogin*. It also represents virility and indicates that most creatures are governed by their instincts, but Śiva,

having completely conquered lust, rides on the bull, that is, he masters it.

Nandī was probably an ancient non-brahmanic deity taken over by brahmanism. When Nandī is portrayed as Lord of Joy (Nandikeśvara) he is in human form with a bull's head. He is regarded as one of the mythical teachers of music and dancing.

[1]*Facets*, p. 116. Gonda (*VS*, p. 76) considers that Nandin represents the fertility aspect of Śiva.

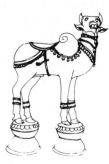

Nandinī The mythical 'cow of abundance' who yields all manner of desirable things; her milk rejuvenates mankind for a thousand years.

v. Kāmadhenu; Sahasra.

Nandipāda An auspicious symbol, the hoof-print of Nandī.

Nandīśa or **Nandikeśvara** 'The Lord Nandin', or the 'Lord of Nandin'. When depicted in human form he has three eyes, a red complexion, and four arms. His emblems include a rosary, drum, club, antelope, trident and *vajra*; his *mudrās* are *añjali* and *tarjanī*.[1] Nandikeśvara is more often depicted as a bull than as a duplicate of Śiva.

[1]*ID*, p. 191; *EHI*, II, pt ii, pp. 459f.

v. Adhikāranandin; Nandin.

Nandīśānugrahamūrti A beneficent aspect of Śiva when in the act of granting Nandīśa a longer lease of life, and freedom from disease, old age and pain. Śiva also gave him his flower-garland, whereupon Nandīśa 'became a duplicate of Śiva, with three eyes and ten arms'.[1]

[1]*EHI*, II, pt i, p. 212.

Nandivaktra v. Pañcānana.

Nandyāvarta Name of a diagram resembling a hooked cross.

Nara I. 'Man'. Occasionally a man is the mount (*vāhana*) of a deity such as Kubera and Nirṛti.

II. A manifestation (*vyūha*) of Viṣṇu as Vāsudeva.

Nārada One of the seven great *ṛsis*, author of the *Nāradīya Dharma Śāstra*, a work on law and behaviour. Some *Ṛgveda* hymns are also attributed to Nārada as well as works on musical theory. The invention of the *vīṇā* is attributed to him and he is the leader of the celestial musicians. He represents the power of persuasion.[1]

[1]*HP*, p. 323.

Naraka 'Hell'. One of the many hells personified as a son of Nirṛti. The Buddhist and Hindu hells are not places of eternal torment like the Christian hell.

Nara-Nārāyaṇa Two famous ancient *ṛsis* regarded as incarnations of Viṣṇu and sons of Dharma. Their extreme asceticism (*tapas*) terrified the gods who sent the most beautiful nymphs (*apsarasas*) to tempt them, but Nārāyaṇa struck his thigh and from it arose a nymph even more exquisite than the celestial ones. Her name was Urvaśī (born of a thigh). According to the *Mahābhārata*, Arjuna and Kṛṣṇa were, in a former incarnation, Nara and Nārāyaṇa.

Nara should be portrayed with a powerful physique, grass-coloured, and with two heads. Nārāyaṇa should be four-armed and of blue complexion. Both should be clad in deerskins and seated under a *badarī* tree, or in an eight-wheeled chariot.[1]

[1]*EHI*, I, pt i, p. 276.

Naranārī 'Man-woman'.

v. Ardhanārīśvara.

Narasimha or **Nṛsimhāvatāra** The 'man (*nara*) lion (*simha*)' incarnation (*avatāra*) of Viṣṇu, depicted with a lion face and human body.

The man-lion cult is of ancient origin and arose when courage and valour were worshipped as aspects of divinity. Therefore Narasimha was eminently suited for worship by kings and warriors, and was invoked especially to protect his worshippers from the incantations of enemies.

Narasimha is also said to embody the verses of the *Yajurveda* because strength and courage are said to flow from them.[1]

[1]*HP*, p. 169.

v. Hiraṇyakaśipu: Sthauṇa-Narasimha; Śarabha; Yānaka-Narasimha.

Narasimhī The *śakti* of Narasimha, sometimes included among the seven or eight mothers (*mātaras*), or the Nine Śaktis (*navaśaktis*).

v. Yānaka-Narasimha.

Naravāhana 'Having a man as a *vāhana*', an epithet of Kubera.

v. Nara I; Nairṛta.

Nārāyaṇa 'The abode of man', or 'moving on the waters'. An aspect of Viṣṇu (Nārāyaṇa) when sleeping on the serpent floating on the primeval waters during the interregnum when the universe dissolves into its formless (that is, undifferentiated) state at the end of the age. He represents the primeval cosmic man. From Nārāyaṇa's navel a thousand-petalled golden lotus grows on which is seated Brahmā, 'creator' of the universe. The lotus symbolizes creation and 'is a transformation of a portion of the substance eternally contained within the god's gigantic body. It is an epiphany of those dynamic forces of the creative process which had been withdrawn into the body (that is, into the cosmic waters) at the time of the dissolution.'[1] The figure of Nārāyaṇa, the serpent and the waters are triune manifestations of the single cosmic substance or 'energy underlying and inhabiting all forms of life'.[2]

[1]*AIA*, I, p. 166.

[2]*Myths*, p. 61.

v. Anantaśāyana; Padma.

Nārikela or **Nālikera** 'Coconut', a symbol of fertility and an emblem of Lakṣmī.

Narmadā One of the sacred rivers of Central India and the name of the goddess personifying it. Śiva is said to dwell in every white pebble found in the Narmadā.[1]

[1]*VS*, p. 113.

Narmadeśvara 'Lord of Narmadā'. A term for the white stones found in the Narmadā river.

Nāṭaka A form of *śakti* depicted as a dancing figure, or figures, on temple walls.

Naṭarāja or **Naṭeśa**, **Naṭeśvara**, **Nṛteśvara** 'King of the Dance', Śiva, as the Cosmic Dancer whose dancing ground is the universe. His dance gives a rotatory creative movement to the universe and stabilizes it; the rhythm combines the benign and malign aspects of life.

Dancing is an ancient form of magic which transforms the dancer into a supranormal being. It can also induce trance and ecstatic states, as well as experience of, and mergence with, the divine. Thus in India dancing constitutes part of worship (*pūjā*). It was believed to influence the fertility of the earth and of man. The Vedic gods created the earth by a kind of 'dance' (*RV*, X,72,6).

Naṭarāja manifests eternal energy in its five activities: (*pañcakriyā*);[1] projection or creation (*sṛṣṭi*); maintenance (*sthiti*) or duration of the world process;

destruction (*samhāra*) or reabsorption; concealment (*tirobhava*), the veiling of Reality by apparitions, illusion and the display of *māyā*; and favour or grace (*anugrahamūrti*) bestowed on the devotee. Śiva exhibits these co-operative mutual antagonisms simultaneously in the position of his hands and feet, and thus holds the balance between life and death.

Naṭarāja holds a small drum (*ḍamaru*) in his upper right hand to beat out the rhythm of the unfolding universe, sound being associated with 'space' in India (the first of the five elements), from which all other elements unfold. Thus the combination of sound and 'space' signify the first moment of creation. His lower right hand shows the fear-removing gesture (*abhaya*), his upper left hand is in half-moon pose (*ardhacandra-mudrā*) supporting a tongue of flame which signifies fire (*agni*) that finally destroys the world and is then quenched in the cosmic waters. So the hand holding the drum and the one holding fire balance the interplay of creation and destruction, life and death, and signify Nature's endless productivity as well as her inexorable destruction of all manifested forms. The second left arm is held gracefully across the chest (*gajahastamudrā*) with the hand pointing to the uplifted foot. The latter denotes favour or grace and is thus a refuge for the devotee. One foot rests on the back of Apasmāra, the embodiment of heedlessness and forgetfulness, which signifies concealment – the blind life-force and man's abysmal cruelty and ignorance. Only with the conquest of ignorance comes the attainment of true wisdom.

Surrounding Śiva's figure and emanating from him is a large aureole of flames (*prabhāmaṇḍala*) representing the vital processes of Nature kept going by the tremendous energy of the dancing god within. Much symbolism is associated with the flames which represent the transcendental power of wisdom and truth, as well as the *mantra OM* which signifies the totality of creation. The flames may also denote the destructive aspect of deity when, after eons of time have been rhythmically stamped out by Śiva's dancing feet, the universe devolves and is finally destroyed by fire. But the frenetic dynamism of the dance never affects the god's essence which remains forever 'neutral' during the evolutionary and devolutionary progression of worlds *ad infinitum*. Thus Nature is seen to work through creatures both human and animal, *but never for them*. Śiva's calm countenance remains forever unmoved by the joys and sufferings of creatures. His ineffable smile is that of a *yogin* who dwells in the blissful peace of transcendental self-absorption.

From the philosophical viewpoint Śiva represents both the archetypal dancer and the archetypal ascetic. (His matted hair marks him as the *yogin* of the gods.)

As the archetypal dancer he represents the impersonal, everchanging life-force, aimless, disinterested, as the myriads of worlds, galaxies, and beings take shape and pass away. As the archetypal ascetic he represents the Absolute where all distinctions melt away. The same notion of matter is conveyed to the Hindu by the Naṭarāja icon, and 'to the physicist by certain aspects of quantum field theory. Both the dancing god and the physical theory are creations of the mind: models to describe their author's intuition of reality.'[2]

[1]Śiva's dancing forms are numerous and include Tāṇḍava or Nādānta, Lalita, Lāsya, Kaṭisama, etc., described in Bharata's *Nāṭyaśāstra*.
[2]Capra, *The Tao of Physics*, p. 45. Modern science now teaches that all matter is animate.
v. Lilā; Naṭeśvara; Nāṭyaśāstra; Kuṇḍala; Nṛtyamūrti; Nāṭyaveda.

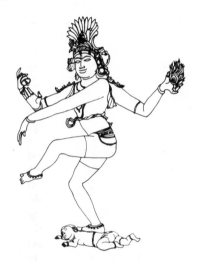

Naṭeśa v. Naṭarāja.
Nāṭyaśāstra[1] A work on dancing describing the 108 dance modes attributed to Śiva.
[1]Translated by Manomohan Ghosh; and see Harle, *Temple Gateways in South India*.
v. Bharatanāṭyaśāstra.
Nāṭyasthāna 'Dance stance'. A representation of a deity in a dancing pose, as Naṭarāja, Kṛṣṇa, Gaṇeśa, Cāmuṇḍā and others.
Nāṭyaveda The art of the dance (*nāṭya*). Dancing is associated with most religions and is an ancient form of magic which transforms the dancer into a supranormal state. The dance 'is a measured sequence born of . . . space and time, which essentially constitute this world of manifestation. Therefore dance is the prototype of universal creative activity. The whole of the universe displays movement, emerging and dissolving according

to the alternating time phases of birth and death, or evolution and involution.'[1]
The *Viṣṇudharmottara* (Book III, ch. 2, vv. 1–9) states that complete mastery of iconography is unattainable without a knowledge of dancing [and music].[2]
[1]*Principles*, p. 168.
[2]*DHI*, p. 277.
v. Nāṭyaśāstra; Naṭarāja.
Navadurgā(s) 'The Nine Durgās'. A group of nine goddesses representing different aspects of Durgā. One is placed in the centre of a circle, the other eight corresponding to the eight points of the compass. All are seated on lotus plinths and show the *tarjanī mudrā*. The central image is the colour of fire and has eighteen hands. She is seated on a lion and adorned with ornaments. In her eight left hands she holds a tuft of hair from the *asura* she has killed, and a shield, bell, mirror, bow, banner, drum and noose. The right hands carry a spear, *tanka*, trident, *vajra*, conch-shell, goad, cane, arrow or *cakra*. The other eight figures of Durgā, each coloured yellow, red, black, blue, white, grey, turmeric-yellow and pink respectively, have sixteen hands.[1]
[1]*EHI*, I, pt ii, p. 357.
Navagraha(s) The Nine Planets and their deities are worshipped as minor gods especially in South Indian Śaiva temples.

The Nine Planets are traditionally designated as Ravi (Sun), Soma (Moon), Maṅgala (Mars), Budha (Mercury), Bṛhaspati (Jupiter), Śukra (Venus), Śani (Saturn), Rāhu and Ketu (the ascending and descending nodes of the moon). They are worshipped in times of danger, for all troubles derive from the anger of the gods. They are frequently portrayed on rectangular stone slabs placed in temples to which they give magical protection. The sun-god Sūrya may be placed in the centre. Bṛhaspati holds a book and rosary, Śani a bow and arrow, Maṅgala a spear, and Soma, a water-pot. Śukra has a rosary and water-pot, Budha a mace and showing the *varada mudrā*. Rāhu holds an unobscured part of the sun's disc, and Ketu's body ends in a serpent tail. He holds a sword.

According to their relative positions in the heavens, the Planets are said to control the destinies of mankind, and hence are of great astrological significance. They also bestow on living beings the fruits of their good and bad actions. Thus Viṣṇu as Janārdana (giver of rewards), takes the shape of the planets. Śani, Rāhu and Ketu are the three inauspicious planets, and in South India are believed to be responsible for children's illnesses.[1]

[1]Diehl, *Instrument and Purpose*, p. 193. Until well into the eighteenth century in the United Kingdom, planets

were believed by many to cause disease. Thus when paralysis or sudden death occurred the person was said to be 'planet-struck' or 'blasted' (*DH*, p. 207).

Navanīta v. Gāṇapatya.

Navanītanṛtta-Kṛṣṇa 'Butter-dance Kṛṣṇa'. An image depicting Kṛṣṇa as a child dancing for joy having obtained a butterball to eat. He stands on his left leg which is slightly bent at the knee, the right leg is lifted up as if dancing. The right hand is in *abhaya* pose or holding a butterball, the left arm stretched outwards. Kṛṣṇa may be nude and wearing ornaments, or clothed.

Navapatrikā(s) 'Nine Plants'. Name of an autumnal ceremony in Bengal associated with Durgā and indicating her vegetal character. The nine plants are: rambhā (plantain), kacvī (*Arum colocasia*), haridrā (turmeric), jayantī (barley), bel (wood-apple), dāḍima (pomegranate), aśoka (*Saraca indica*), mānaka (Arum Indicum) and dhānya (paddy). One of Durgā's nine aspects (*navadurgās*) are said to dwell in each of the nine plants and to protect their worshippers. These aspects are Brahmāṇī, Kālikā, Durgā, Kārttikī, Śiva, Raktadantikā, Śokarahitā, Cāmuṇḍā and Lakṣmī.[1]

[1]*DHI*, pp. 490, n.1; and 500, n.1; where variant lists of *navapatrikās* are given.

v. Navaratna.

Navaratna 'Nine Gems'. An amulet made of nine precious stones, each gem representing one of the Nine Planets (*navagrahas*). A pearl represents the full moon, a ruby the sun, topaz Jupiter, diamond Venus, emerald Mercury, coral Mars, sapphire Saturn, cat's eye or moonstone, the waxing moon (Rāhu), and sardonyx the waning moon (Ketu).[1]

[1]*ID*, pp. 194f; Crooke, *Things Indian*, p. 393.

Navaśakti(s) 'Nine Śaktis' (or *mātaras*), named Vaiṣṇavī, Brahmāṇī, Raudrī, Māheśvarī, Narasimhī, Vārāhī, Indrāṇī, Kārttikī and Pradhānā.

v. Saptamātara(s).

Nāyanmār(s) v. Aḷvār(s).

Netramudrā 'Eye-gesture'. A hand position in which the thumb and little finger are linked, the other three fingers held erect in front of the eyes.

Nidhi(s) Mythical 'treasures' usually represented by a jar full of gems. Initially the term meant 'store' or 'receptacle' for liquids, etc., and later 'treasure' generally. The plural refers to Kubera's eight (or nine) personified 'treasures', namely Padma, Mahāpadma, Makara, Kaccapa, Mukunda, Nandaka, Nīla and Śaṅkha,[1]

[1]There are variant lists in other works which probably reflect different opinions about what constitutes 'treasure'. See Coomaraswamy, *Yakṣas*, pt ii, p. 49.

Nidrā A goddess personifying sleep (*nidrā*) who, at the end of each age, enters Viṣṇu's body as he sleeps on the causal waters until Brahmā commands Nidrā to depart so that Viṣṇu may awake and create a new world.

v. Mahākālī.

Nidrātahastamudrā 'Sleeping hand *mudrā*', in which one hand rests on the plinth and supports that side of the body.

Nikṣubhā or **Chāyā** Name of one of Sūrya's queens who bore him three children, Śani, Sāvarṇi Manu, and Tapatī. The *Bhaviṣya Purāṇa* gives the etymology of the name from the root *su* (to bring forth). Furthermore Nikṣubhā is said to be 'an appellation of the Earth, because she creates the mortals, the disembodied spirits, and the gods, and supports them with food, herbs, wine and nectar'.[1]

[1]*Iconog. Dacca*, p. 160.

v. Rājñī.

Nīla I. In the *Ṛgveda* nīla denotes dark blue or black. In post-Vedic literature it is a term for one of the eight (or nine) treasures (*nidhis*) of Kubera.

II. Name of the elephant-demon killed by Śiva. Nīla's hide was black like a dark cloud and represents *tamas* (darkness) and spiritual blindness.

Nīladevī A goddess (*devī*) sometimes regarded as Viṣṇu's third wife.

Nīla-Jyeṣṭhā The 'blue (or black) Jyeṣṭhā'. A form of the goddess Jyeṣṭhā.

Nīlakaṇṭha I. 'Blue-throated'. An epithet applied to Śiva when, at Brahmā's request, he held the *halāhala* poison in his throat after it had emerged from the churning of the ocean (*samudramathana*), and so saved all creatures from death.

According to the *Śāradātilaka Tantra* Nīlakaṇṭha shines like myriads of rising suns and wears a resplendent gleaming crescent on his matted hair. His four arms are ornamented with snakes. He holds a rosary, trident, skull and *khaṭvaṅga*. He is five-headed, each head having three eyes; his garment is a tigerskin. Sometimes he is depicted with one head, and ithyphallic. Above his head is a parasol. Usually his bull Nandī is depicted nearby gazing lovingly towards him.

II. Name of the blue-necked heron sacred to Śiva.[1]

[1]*ID*, p. 196.

Nīlakaṇṭhī A four-armed aspect of Durgā who bestows wealth and happiness on her devotees. She carries a trident, shield and drinking-vessel, her fourth hand is in *varada* pose.

Nīlotpala The blue night lotus (or water-lily) sacred to the moon. It is an emblem of a number of deities including Jñāna-Dakṣiṇāmūrti, Kīrti, Gaṇeśa, Indra and Yamunā.

Nīm (Hindi) **Nimba** (Skt) The tree (*Azadirachta indica*) whose perforated stones are made into 'rosaries' and necklaces. Every part of the tree has magical properties and hence gives protection against evil spirits, especially the dreaded smallpox goddess Śītalā who is propitiated with *nīm* garlands and jasmine which are placed on the beds of smallpox victims. Its bitter leaves are chewed during funeral rites.

Niraya v. Pātāla.

Nirguṇa 'Beyond qualities or attributes', the neuter *brahman*.

v. Deva.

Nirṛta v. Nirṛti.

Nirṛti Originally a Vedic goddess personifying misfortune, corruption, misery, decay and death, and sometimes identified with Alakṣmī. Her colour is black and she represents the dangerous aspects of the earth. Her dwelling is in the *aśvattha* tree; the owl, pigeon and hare are sacred to her. Later she was regarded as a male deity Nirṛta or Nairṛta who is portrayed with an angry countenance, side tusks, and hair standing on end. His colour is dark blue or black. His mount may be a lion, man, ass or dog; his emblems include a short javelin, rod, sword and shield. The *Viṣṇudharmottara* states that Nirṛti has four consorts named Devī, Kṛṣṇāngī, Kṛṣṇāvadanā and Kṛṣṇapāśa.[1]

[1]*EHI*, II, pt ii, p. 528.

v. Nirṛti(s); Dikpāla(s); Nairṛta.

Nirṛti(s) Destructive powers or potencies worshipped by those who wish to harm their enemies.

Nirukta A commentary on the *Nighaṇṭu* by Yāska. It is the oldest surviving Indian treatise on etymology. See Bibliography under Sarup, Lakshman.

Nirvāṇa A state attained when all opposites are transcended – an integral oneness.

Niṣka or **Hāra** 'Necklace', probably a necklace consisting of gold coins strung together.

Niṣkala The formless or undifferentiated state of the Supreme Being.

v. Pañcabrahmā(s).

Niṣkriya 'Without action'.

Nistrimśa Name of the sword carried by Rati.

Niśumbhasūdanī The form assumed by Durgā when she destroyed the demon Niśumbha.

Nṛsimhāvatāra or **Nṛsimha** v. Narasimha.

Nṛteśvara 'Lord of the Dance'.

v. Naṭarāja; Nāṭyaveda.

Nṛtta-Gaṇapati or **Nṛtya-Gaṇapati** A four- or eight-armed form of Gaṇapati dancing. He may hold a noose, cakes, axe, tusk, snake and lotus flower. One hand is stretched gracefully across his body (*gajahastamudrā*). Sometimes he carries a flower in his trunk, or

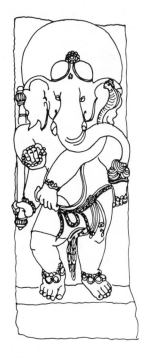

holds a ring (*anguliya*).

Nṛttamūrti or **Nṛtyamūrti** A 'dance-manifestation' of a deity, especially Śiva as lord of the dance and of music. The *Śaivāgamas* and the *Bharatanāṭyaśāstra* state that Śiva has 108 modes of dancing although only nine are described, but the 108 modes are sculptured on the Naṭarāja temple at Cidambaram (South India), with their descriptions below each one.

v. Naṭarāja; Līlā; Nṛtya-Gopāla; Nāṭyaveda.

Nṛtya-Gaṇapati v. Nṛtta-Gaṇapati.

Nṛtya-Gopāla 'The dancing cow-herd (*gopa*)'. An aspect of Kṛṣṇa when in the act of dancing.

v. Nāṭyaveda.

Nṛtyamūrti Śiva as the Cosmic Dancer.

v. Naṭarāja; Nāṭyaveda.

Nṛvarāha The 'man-boar' incarnation of Viṣṇu.

v. Varāhāvatāra.

Nūpura 'Anklet' with small bells attached which tinkle as the wearer moves.

Nyagrodha The Indian fig-tree (*Ficus indica*) which has both ordinary and aerial roots. The latter grow downwards from the branches and when the soil is reached, produce new plants. The area covered by the roots is sacred to Kālī; its wood is used to make sacrificial bowls. The *nyagrodha* is sometimes regarded as a vegetal form of Śiva.

Nyāsa Name of a ceremony in which parts of an image or of a living body are assigned to tutelary deities,

either by mentally assigning them to various organs and limbs, or by touching various parts of the body. It is a 'process of charging a part of the body . . . with a specified power through touch'.[1] The divine powers are said to take up their positions in the different parts of the icon during the ritual.

[1]*TT*, p. 91; and see *VS*, p. 66. To Śaivas 'the divinities in different parts of the body represent the five aspects or faces of Śiva' (ibid., p. 73).

OṀ or **AUṀ**[1] A sacred 'seed' (*bīja*) syllable, the source of all *mantras*. It first appears in the Upaniṣads. It is said to be the imperishable root syllable of origination and dissolution. The past, present and future are all included in this one sound, and all that exists beyond the three forms of time is also implied in it (*Māṇḍūkya Upaniṣad*, 1,1).

Much symbolism is associated with the three letters *AUM*, which *inter alia* represent the three *guṇas* and the three great gods (*trimūrti*): A represents Brahmā, U Viṣṇu, and M Śiva. A and U together mean 'truth' and 'immortality'. *AUṀ* also stands for the One Being pervading space, time, and all forms. It is uttered at the beginning of all rituals; its purpose is to enable the worshipper to attain liberation.[2]

Sometimes AUṀ is said to consist of five sounds: 'A + U + M + *bindu* (the point, signifying the *anusvāra* = nasal *m*, sometimes said to symbolize Sadāśiva) + *nāda* (here in the sense of a kind of echo, sometimes said to symbolize Īśvara).[3]

[1]In Sanskrit 'o' is constitutionally a diphthong, contracted from 'a' and 'u' which when pronounced quickly have the sound of 'o', and when combined with 'm' gives to the whole a resonant, humming sound.

[2]Its connexion with the beginning of all rituals associates it with Gaṇeśa who is worshipped before any new undertaking. For further symbolism associated with *AUṀ*, see *HP*, pp. 338ff.

[3]*ID*, p. 200.

v. Oṁ Gaṇeśāya; Mātara(s).

Oṁ Gaṇeśāya 'Hail to Gaṇeśa'. A *mantra* often written at the beginning of books, manuscripts, account books, etc.

Oṣadhi A plant or herb, especially a medicinal herb. Because of its close association with plant growth the moon is called Oṣadhigarbha (Producer of herbs) and Oṣadhipati (Lord of herbs).

v. Oṣadhipātra.

Oṣadhigarbha v. Oṣadhi.

Oṣadhipati v. Oṣadhi.

Oṣadhipātra A bowl (*pātra*) containing medicinal herbs, emblematic of the twin Aśvins, the physicians of the gods, and of Bhūmidevī.

Pādapīṭha 'Foot-stool'. A small plinth (*pīṭha*) on which a statue rests one or both feet, the whole image being supported on a larger plinth.

Pādarakṣa 'Wooden sandals', characteristic of Śiva Bhikṣāṭanamūrti.

Pādasara 'Anklet-chain'.

Pādasvastika A standing pose in which one leg is crossed over the other which is firmly placed on the plinth – a characteristic stance of Veṇugopāla and Vṛṣavāhana.

Padma I. 'Lotus'. An aquatic plant which has an important symbolic role in Jaina, Hindu and Buddhist iconography. Its stylized petals form pedestals for divinities, and its flowers and buds are emblematic of many gods and goddesses including Viṣṇu, Sūrya, Lakṣmī, Sarasvatī, the twelve Ādityas, Balarāma, Bhūmidevī, Gaṅgā, Hayagrīva, Indra and Kāma. Zimmer[1] suggests that the association of the lotus with the goddess of good fortune Lakṣmī may have been known in ancient Mesopotamia.

The lotus symbolizes the beauty and freshness of ever-renewing creation. An opened lotus flower symbolizes the sun; the lotus creeper represents 'vegetative life visualized. Its rhythmical sway is also peculiar to stems of trees, as shown in Indus art.'[2] It also denotes the eternal *dharma*, and is the basis on which existence unfolds. Lotuses and waves traditionally represent the ocean[3] although lotuses do not grow in sea-water.

The lotus also signifies perfection and purity, because its wonderful flowers are borne on long stalks high above the water, whilst the roots remain in the mud. On the eve of creation or cosmic renewal the lotus emerged from the primeval waters (representing non-manifestation), its unfolding petals signifying the evolution of the universe from the Unmanifest. Thus the lotus became the 'visible representation of the womb of creation'.[4] But when Jñāna-Dakṣiṇāmūrti (Śiva) is depicted holding a lotus bud this signifies 'the recession of existence into the peace of the Supreme'.[5]

When a two-armed goddess is portrayed carrying a lotus she is usually Lakṣmī, Bhūmidevī or Ṛddhi; but

one without a lotus may be Pārvatī.[6]

According to the *Agni Purāṇa*, the lotus represents the material aspect of evolution, its petals the consecutive forms.

[1]*AIA*, p. 165.
[2]Kramrisch, *Indian Art*, p. 26.
[3]*EHI*, I, pt i, p. 140.
[4]*CC*, p. 326.
[5]*Principles*, p. 205.
[6]*ID*, p. 203.

v. Nābhi, Anantaśāyana; Nīlotpala; Padmāsana; Padmakośa.

II. Name of one of Kubera's personified treasures (*nidhis*).

III. Name of one of the four chief yogic positions (*āsana*), the others being called *siddha*, *bhadra* and *siṁha*.

IV. Name of a snake-god.

v. Mahānāga.

Padmā 'Lotus'. An epithet applied to the goddesses Lakṣmī, Śrī and Manasā.

Padmabandhu 'Friend of the lotus (*padma*)'. An epithet of the sun whose heat causes the lotus flowers to open, and hence the sun-god Sūrya holds opened lotus flowers.

Padmahasta 'Holding a lotus (*padma*) in the hand'. A number of goddesses are depicted holding lotuses.

v. Padmā.

Padmaja or **Padmajāta** 'Lotus-born'. An epithet of Brahmā who was 'born' from the lotus (*padma*) which emerged from Viṣṇu's navel.

v. Anantaśāyana.

Padmakośa or **Padmamudrā** 'Lotus-bud' *mudrā* in which the fingers are separated and slightly bent, the palm hollowed. This *mudrā* was used by Nārāyaṇa when worshipping Śiva with lotus flowers to obtain the discus.

[11]Coomaraswamy, *The Mirror of Gesture*, p. 33. The *padmakośa* also denotes the female breast, a fruit, or an egg (*ID*, p. 204).

Padmamālā 'Lotus-garland'.

Padmanābha 'Lotus-navel'. An epithet or name of one of the twenty-four or thirty-nine incarnatory aspects of Viṣṇu from whose navel (= the womb of creation), emerged the cosmic lotus (*padma*) signifying the commencement of a new age.

v. Padmaja: Brahmā.

Padmanidhi A form of treasure sometimes personified as an attendant of Kubera.

Padmapāṇi 'Lotus-handed'; 'holding a lotus in the hand'. An epithet of Brahmā, of Viṣṇu, of Sūrya, and of some Mahāyāna Buddhist divinities.

Padmapatra A lotus-shaped ear-ornament (*kuṇḍala*).

Padmapīṭha or **Pīṭhapadma** or **Kamalāsana** or **Padmāsana** 'Lotus seat'. An oval, circular or quadrangular seat or plinth decorated with a single or double row of lotus leaves round the base. A sixteen-cornered pedestal is believed to bring good luck. The number sixteen symbolizes totality and perfection.

Padmāsana Also called Brahmāsana. 'Lotus seat'. I. Many Buddhist and Hindu divinities are portrayed in this posture in which the legs are crossed and the heels are drawn up to touch the upper thigh joints. 'According to some authorities, the toes of the feet should also be held by two hands placed crosswise at the back' (*Rudra-Yāmala Tantra*).

II. A circular or oval plinth, and also the name of one of the most suitable positions (*āsana*) for religious meditation.

v. Padmapīṭha.

Pāduka 'Footprint'. A symbol of a deity. Initially the Buddha's footprints were worshipped because they symbolized his invisible presence. In Hinduism Rāma's sandals were placed 'on his throne as a symbol of his ruling power, during his exile; hence *pāduka* is also a symbol of royalty'.[1] The footprints of the goddess Gaurī are also worshipped. Representations of the footprints usually have Vaiṣṇava emblems and other auspicious signs on them.

[1]*ID*, p. 206.

Paidva 'Pertaining to Pedu'. The mythical white horse given to the royal *ṛṣi* Pedu by the Aśvins.

Palāśa v. Parṇa.

Pāla-Sena Name of two dynasties in Bengal, and of a famous art centre from about the eighth to the twelfth centuries.

Paliyaṅga Name of Sūrya's highly ornamental belt or girdle 'with a dagger either side – perhaps an accompaniment of the "Northern" dress'.[1]

[1]*Iconog. Dacca*, p. 159.

v. Sūrya.

Pallava I. Rulers of the south-eastern coast from 400 to 750 AD, who were frequently at war with the Cālukyas. The Pallavas were first Buddhists and then Śaivas. Under the rule of Mahendravarman magnificent cave-temples were excavated, and Narasimhavarman (625–45) was the founder of Mahabalipuram, some thirty-five miles south of Madras.
II. A bunch of leaves, emblematic of Aiyaṉār.

Pānapātra 'Drinking vessel', an emblem of Balarāma.

Panasa(phala) 'Breadfruit' The fruit (phala) of the Jaka tree (*Artocarpus intergrifolia*) associated with Bāla-Gaṇapati.

Paṇava A small drum or cymbal.

Pañca 'Five'. A number having much magical and mystical significance. It is especially associated with Śiva.
v. Pañcabrahmā(s); Pañcadehamūrti; Pañcākṣara.

Pañcabrahmā(s) 'The five Brahmās'. Particular forms of Śiva which 'are meant to represent in a concrete manner some of the cardinal tenets of the Pāñcarātra and Śaiva systems, viz., those centering round . . . Śiva's five *śaktis* – Ādiśakti, Paramaśakti, Icchāśakti, Jñānaśakti and Kriyāśakti, respectively'.[1] Pañcabrahmā is also the collective name of the five aspects of Śiva, viz., Īśāna, Tatpuruṣa, Aghoramūrti, Vāmadeva and Sadyojāta, all of whom emanated from *niṣkala* Śiva, that is, the formless or undifferentiated state of the Supreme Being which, having no beginning, no limits, pervades everywhere, but is unknowable by any proof. The *Viṣṇudharmottara* states that the five Brahmās should hold a sword, shield, bow and arrow, watervessel, trident and lotus, and show the *varada* and *abhaya mudrās*.
[1]*DHI*, pp. 235f.

Pañcadehamūrti An aspect of Śiva represented by five images positioned facing the four points of the compass with the fifth placed in the centre and with its head higher than those of the others. Its significance is the same as that of the *pañcamukhalinga*.

Pañcajana Name of the sea-demon slain by Kṛṣṇa.
v. Pāñcajanya.

Pāñcajanya Name of Kṛṣṇa's conch formed from the 'bones' of the sea-demon Pañcajana who dwelt in the ocean in the form of a conch-shell (*śankha*). The conch is one of Kṛṣṇa's emblems and a special *mantra* is associated with its worship.

Pañcakapāla 'Five skulls', symbolic of Heruka (Gaṇeśa) and Mahākāla who are depicted wearing a garland of five skulls on their heads.

Pañcakoṇa A *yantra* symbolizing love and lust as well as the power of disintegration.[1]
[1]*HP*, p. 353.

Pañcakriyā 'The five activities' or manifestations of Śiva's eternal and limitless energy. They are: projection or creation (*sṛṣṭi*); maintenance or duration (*sthiti*); destruction (*samhāra*) or reabsorption; concealment (*tirobhava*) the veiling of Reality by apparitions, illusions, and the display of *māyā*; favour (*anugraha*) or grace bestowed on the devotee.
v. Naṭarāja; Pañcānana; Anugrahamūrti(s).

Pañcākṣara The five-syllabled Śaiva *mantra* – *Nama Śivāya* – which removes danger and fear and gives spiritual understanding and prosperity. Viṣṇu's *mantra* is also five-syllabled – '*Namo Viṣṇave*'.
v. Pañca.

Pañcaloha The 'five (*pañca*) metals' which make up the alloy used for images. Formerly they were copper, silver, gold, brass and white lead, but today silver and gold are usually omitted. Instead ten parts of copper, half part of brass and a quarter part of white lead are used. South Indian *pañcaloha* figures are always solid.

Pañcamakāra The 'five Ms' associated with left-hand tantric ritual, which uses *madya* (wine), *mamsa* (meat), *matsya* (fish), *mudrā* (parched grain), and *maithuna* (sexual union).

Pañcamukha 'Five-headed'. An epithet of Brahmā who, having lied by saying that he had seen the pinnacle of Śiva's *linga* of light, was deprived of one of his heads by Śiva who had assumed the form of Bhairava.

Pañcamukhalinga 'Five-faced *linga*'. A *linga* with four faces depicted on it, the *linga* itself representing the fifth face. The five faces denote that Śiva is the progenitor of the five orders of creation. Sometimes each face is regarded as a separate divinity.
v. Pañcadehamūrti; Pañcānana; Pañcāyatanalinga.

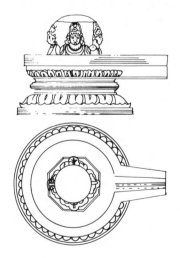

Pañcamukha-Vināyaka A five-headed form of Vināyaka (Gaṇeśa).

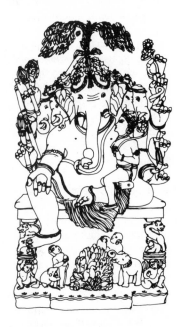

Pañcānana 'Five-faced'. An epithet of Śiva referring to the various aspects of his five-fold nature, representing the five gross elements: earth, water, heat, wind and sky, called Sadyojāta, Vāmadeva, Aghoramūrti, Tatpuruṣa and Sadāśiva (or Īśāna) respectively.

Pañcānana also represents the five directions which are called Mahādeva (E), Bhairava (S), Nandivaktra (W), Umāvaktra (N), and the fifth, the zenith, Sadāśiva (or Īśāna), which corresponds to the fifth of the gross elements. Sadāśiva cannot be seen even by the most advanced *yogins*.[1]

Meditation on these five faces leads to the attainment of true knowledge. Sadyojāta represents Śiva's creative function, Vāmadeva the maintenance of the world, Aghoramūrti its continuous process of absorption and renewal, Tatpuruṣa the power of obscuration in *saṃsāra*, and Sadāśiva the process leading to final deliverance (*mokṣa*). All the above represent the Force which absorbs and reproduces the universe.[2] The *Skanda Purāṇa* specifies the colour of each face: Tatpuruṣa, the colour of lightning, Aghoramūrti dark like a heavy cloud, Sadyojāta, white like a conch-shell or the moon, Vāmadeva gold-yellow, and Īśāna white.[3]

The *Tantrasāra* describes Pañcānana as having five faces coloured pearl, yellow, dark-blue, white and red respectively. He has three eyes, a crescent moon on his brow, and holds a spear, sword, hatchet, thunderbolt, flame, a king serpent, bell, elephant-goad and a noose. His *mudrā* is *abhaya*.[4]

[1]*DHI*, pp. 460 and 673f; *IT*, p. 205.
[2]*VS*, p. 48.
[3]Sivaramamurti, *Śatarudrīya*, p. 36.
[4]*HP*, pp. 210f.
v. Pañcamukhaliṅga; Pañcaśiras.

Pañcaratna The 'Five Gems', pearl, ruby, sapphire, diamond, emerald or gold (or silver).
v. Vaijayantīmālā.

Pañcarātra A Vaiṣṇava cult based on the sacred texts called Pañcarātra which played an important part in the dissemination of image worship. Its adherents relied not only on textual exposition, but also on three-dimensional imagery, and hence their emphasis on having images of various aspects of Viṣṇu in temples and households. The cult may have originated in Kashmir about the first or possibly the third century BC.[1]
[1]*SED*, p. 614, and see p. 577.

Pañcaśara A group of 'five (flowery) arrows' in a quiver, a symbol of Kāma.

Pañcaśiras 'Five-headed'. A number of deities are portrayed with five heads including Śiva, Gāyatrī, Hanumat and Mahākāla.
v. Pañcānana.

Pañcavṛkṣa The five trees of Indra's paradise (*svarga*), viz., *mandāra*, *pārijāta*, *saṃtāna*, *kalpavṛkṣa* and *haricandana*.

Pañcāyatana A round metal dish on which are placed five stones, aniconic symbols of Viṣṇu represented by the *śālagrāma* stone, Śiva by the *bāṇaliṅga*, Durgā by the *svarṇarekha*, Sūrya by the *sūryakānta*, and Gaṇeśa by the *svarṇabhadra*. All these symbols are worshipped (*pañcāyatana-pūjā*).

Pañcāyatanaliṅga A *liṅga* symbolizing the five chief Hindu sects. (In South India there is a sixth sect, the Kaumāra.) Four heads are portrayed on it: Gaṇeśa, Viṣṇu, Pārvatī and Sūrya, the *liṅga* itself symbolizing Śiva.

Pañcāyatana-pūjā v. Pañcāyatana.

Pāṇḍava(s) The five heroic sons of Pāṇḍu, brother of Dhṛtarāṣṭra. They are Yudhiṣṭhira, Bhīma, Arjuna by Pāṇḍu's first wife Pṛthā (Kuntī), and Nakula and Sahadeva by his second wife Mādrī. The Pāṇḍavas possessed Indra's unfailing javelin (*amoghā śakti*) made by the divine craftsman Tvaṣṭṛ.
v. Mahābhārata.

Paṇḍharinātha v. Viṭhobā.

Pāṇḍuranga 'White limbed'. A two-armed naked form

of Viṣṇu whose emblem is a conch-shell; his *mudrā* is *kaṭi*.[1]

[1]*ID*, p. 212.

Pāṇḍya An ancient South Indian Tamil kingdom with Madurai as its capital. It is famous for its art during the twelfth to the fourteenth centuries.

Pāṇigrahaṇa Holding hands in marriage, an essential part of the marriage (*vivāha*) ceremony.

v. Kalyāṇasundaramūrti.

Papī lakṣmī 'Bad luck (*lakṣmī*)' personified as a goddess. Bad luck is said to be attached to enemies by an iron hook.

v. Nirṛti.

Paramahaṁsa 'Highest gander (*haṁsa*)'. A term applied to a Hindu ascetic who has freed himself from the cycles of rebirth and attained liberation (*mokṣa*).

Paramaśakti The Supreme Śakti.

Paramaśiva v. Akṣamālā.

Paramātman The Supreme Essence, *brahman*.

Parañjaya 'Conquering foes'. Name of Indra's sword (*khaḍga*).

Paraśu 'Battleaxe', and later a heavy club made of bronze or iron, a weapon which evolved from the Neolithic cutting tool, examples of which have been found in a number of archaeological sites in India.[1] The metal axe was a favourite weapon of the warrior class (*kṣatra*); when an emblem of Śiva it signifies the destruction of the *tamas* and *rajas guṇas* and the cutting off of all worldly attachments. It also represents his divine strength and power. The axe is emblematic of some forms of Skanda, Cāmuṇḍā, Hayagrīva, Kubera, Mahākāla, and others.

[1]See illustrations in B. and R. Allchin, *The Birth of Indian Civilization*.

v. Paraśurāma; Āyudhapuruṣa; Guṇa(s).

Paraśurāma 'Rāma with the axe (*paraśu*)'. A brahmin of the Bhṛgu clan and the first historical person to be honoured as a temporary incarnation (*āveśāvatāra*) of Viṣṇu. When the seventh incarnation, Rāmacandra, appeared, Paraśurāma ceased to be an incarnation.[1] The restoration of the social order is attributed to Paraśurāma by his conquest of the warrior class (*kṣatra*) who had tried to wrest spiritual leadership from the priests.

Paraśurāma should have two or four hands. He holds an axe with the blade pointing away from him, and his left hand is as if pointing (*sūci mudrā*). He wears a *jaṭāmakuṭa* and *yajñopavīta*, and a number of ornaments. According to the *Viṣṇudharmottara* he should wear a deerskin.[2] Other texts state that he should have a bow and arrow, sword and shield. He is also regarded as a manifestation of the planet Śukra.[3]

[1]*DHI*, pp. 419f.
[2]*EHI*, I, pt i, p. 186.
[3]*ID*, p. 213.

Para-Vāc The Supreme Logos.

v. Vāc.

Paravāṇi Name of the peacock (*mayūra*), the mount of Kārttikeya.

Para-Vāsudeva 'Supreme Vāsudeva'. Vāsudeva (Kṛṣṇa = Viṣṇu) as the Supreme (*para*) deity through whom the universe exists. According to the *Agni Purāṇa*, he is portrayed standing, with his two consorts on either side, Śrī carrying a lotus and Puṣṭi a *vīṇā*. The figures of the goddesses should not be higher than Vāsudeva's hip. The *Viṣṇudharmottara* states that he should be four-armed, denoting dominion over the whole world, handsome, adorned with ornaments and wearing yellow garments and a long garland (*vanamālā*). His favourite jewel Kaustubha is worn on his chest. He wears a *kirīṭa*. His halo should be in the form of a beautifully shaped lotus. He carries a lotus flower in one right hand and a conch in one left hand. Another hand rests on the goddess who personifies his club (*gadā*).[1]

[1]*EHI*, I, pt i, pp. 241f.

v. Āyudhapuruṣa.

Parigha An iron bludgeon or club studded with iron.

Pārijāta The Indian Coral Tree (*Erythrina indica*) said to be one of the five trees produced during the churning of the ocean (*samudramathana*). It grows in Indra's paradise and its scent perfumes the worlds. Its trifoliate leaves symbolize the *trimūrti*, the middle leaflet representing Viṣṇu, the right and left Brahmā and Śiva respectively. The flowers of the Pārijāta are emblematic of Vāruṇī.

Pariṇāma 'Transformation, evolution, maturation'.[1]

[1]*Principles*, p. 254.

Pāriṣada(s) Mythical beings having animal or bird heads. They are attendant on Śiva and Skanda.

Parivāradevatā(s) Subsidiary images in temples.

v. Pārśvadevatā.

Parivīta Name of Brahmā's bow (*dhanus*).

Parjanya The personification of rain or the rain-cloud as a son of Dyauṣpitar (the sky). He moves in a chariot

laden with water stored in skin bags and in huge vessels from which he tips the water onto the earth (*RV*, V,83,7f.).

In the *soma* sacrifice when rain was desired, the priest invoked Parjanya and placed a girdle (*mekhalā*) on upside down as a rain charm, and *vice versa* if rain was not wanted (*Tait. Sam.*, VI,3.4,5).

Parṇa Later called *palāśa*, the magnificent 'flame of the forest tree' (*Butea monosperma*). Its leaf is trifoliate, the central longest one is obovate and resembles a sacrificial ladle, and is used for ritual purposes. Amulets are also made from its wood, as well as six of the twenty-one sacrificial stakes (*yūpa*). The central leaf represents the priesthood (*ŚBr.*, II, 6.2,8) and royalty.

Pārśvadevatā An icon of a deity placed in a side niche (*koṣṭha*) of a temple, but in other shrines the same deity could be the principal cult object.[1]
[1]*DHI*, p. 235.

Parvata The personification of the Himālaya whose daughter Pārvatī married Śiva. In marriage groups (*kalyāṇasundaramūrti*) Parvata sometimes stands behind Pārvatī.
v. Parvata(s).

Parvata(s) Spirits presiding over mountains and clouds.

Pārvatī Daughter of Parvata the personification of the Himālaya.[1]

Pārvatī is a composite goddess having assimilated various regional goddesses who became absorbed into Śaiva mythology, each one being regarded as a *śakti* of Śiva. Among her many names are Umā, Gaurī, Śyāmā, Kālī, Caṇḍī, Bhairavī, Durgā and Ambikā. Some of the foregoing, such as Durgā, Caṇḍī, Kālī, represent her fierce aspects.

When accompanying Śiva, Pārvatī is two-armed and wears a *channavīra*. Her mount may be a bull or lion. When depicted alone she has four arms and holds a rosary, mirror, and sometimes a small figure of Gaṇeśa, or a *liṅga*, a bell and a citron.[2]
[1]Cf. the Sumerian mother goddess known as the 'lady of the mountain' (Levy, *Gate of Horn*, p. 95).
[2]*ID*, p. 215.

Paryankāsana A seated posture in the European fashion, or with one leg resting horizontally on the seat, the other hanging down, or in *dhyānāsana*.
v. Ardhaparyankāsana.

Pāśa 'Noose, snare or fetter' – a weapon used in warfare. Indra binds Vṛtra with a noose and so releases the fecund waters. Varuṇa's noose binds evildoers (compare Satan's bonds). Illness is also represented in the form of bonds.

Śiva's threefold noose represents the bondage of incarnated life consisting of work (*karma*), delusion (*māyā*) and impurity (*mala*). Other deities who have the noose as an attribute include Rudra, Śiva, Gaṇeśa, and Agni.
v. Nāgapāśa.

Paśu I. 'Animal', 'cattle'. A collective term for cattle, goats, sheep, etc; and specifically the five sacrificial animals of the Vedic age: cows, horses, men, sheep and goats (*AV*, XI,2,9), but the list varies in some texts. The antelope (*mṛga*) symbolizes animals in general and Śiva's power over them.
v. Kirātārjunamūrti.

II. In Śaivism *paśu* represents the finite, and hence limited, individual soul, as distinct from the divine soul.

Pāśupata I. The 'herdsman's staff', also called *brahmaśiras*, a kind of trident, or bow, or *vajra*, with which Śiva destroys the universe at the end of the age.

According to the *Śaivāgamas* when this weapon is personified it has four arms, four fierce faces each with three eyes and tusks, erect hair and bristling moustaches. The four hands hold a spear, hammer, conchshell and sword. It should be placed on a lotus base (*padmāsana*).
v. Śakti II; Āyudhapuruṣa.

II. Generally considered to be the name of the earliest Śaiva cult, whose devotees induced trancelike states by means of rhythmic songs and dances.
v. Lakulīśa; Paśupati.

Paśupatamūrti A standing, three-eyed, four-armed, fierce form of Śiva. His hair stands erect. His *mudrās*

are *abhaya* and *varada*, and he may hold a rosary, skull-cup, sword, snake and trident.

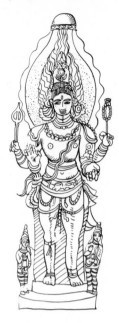

Pāśupatāstra I. A spear or bow given to Arjuna by Śiva (Paśupati).

II. A name of Śiva's trident (*triśūla*).

Paśupati 'Lord of animals (or of man)'. Name of one of the eight elemental forms of Rudra/Śiva. *Paśu* means animal and by extension, a follower of Śiva who, before initiation (*dīkṣā*) is spiritually a 'dumb brute' who must be goaded by the deity. This cult absorbed many of the local godlings of herdsmen and shepherds. Paśupati's wife is Svāhā and his son Ṣaṇmukha (Skanda). His chief emblem is the antelope.

v. Mṛga; Pāśupata II.

Patākā(hasta)mudrā The streamer hand-pose (symbolizing power), in which arm and hand are extended horizontally from the shoulder. It is characteristic of some forms of Śiva, and of Vāyu and Viśvarūpa.

Pātāla or **Niraya** 'Hell', the lowest of the seven subterranean regions (*tala* means 'lower part'). Pātāla's chief city is Bhogavatī and is ruled by the *nāga* Vāsuki. The *ṛṣi* Nārada is said to have visited Pātāla and declared it to be more magnificent than Indra's paradise (*svarga*).

Patañjali Name of the famous grammarian and author of Books I to III of the *Yoga-sūtras*, the earliest systematic treatise on *yoga*. He is regarded as attendant on Śiva. In this capacity Patañjali is represented with a fish tail.[1] His *mudrā* is *añjali*.

[1]*ID*, p. 218.

Pathyā 'Auspicious path', personified as a goddess who protects her worshippers when travelling. Her consort

Pūṣan also protects pathways.

Pati 'Lord', 'Supreme Being'.

Pātra 'Drinking bowl, cup, almsbowl'. *Pātra* 'is also used as a term equivalent to either *kamaṇḍalu* or *kapāla*'.[1]

[1]*ID*, p. 218.

Patrakuṇḍala or **Pattrakuṇḍala** An ear ornament (*kuṇḍala*) shaped like a scroll.

Patrapaṭṭa Strings of coconut leaves worn as hair decoration.

Paṭṭa I. An early type of painting or engraving associated with a funerary cult. Vaiṣṇavas worship metal *paṭṭas* on which are depicted Viṣṇu and his ten incarnations (*daśāvatāras*).[1]

[1]*IT*, p. 355.

II. An abbreviation for *yogapaṭṭa*.

Paṭṭikā 'Ribbon', characteristic of Hara (Śiva).

Paṭṭīśa A sharpened iron rod or three-pointed weapon, emblematic of Cāmuṇḍā, Hara, Tryambaka, Viśvarūpa and others.

Paulomī 'Daughter of [the *dānava*] Puloman'.

v. Indrāṇī.

Pavana I. 'Purifier'. The wind, and also a name of the god of the wind (Vāyu) whose mount is a gazelle. He seduced Añjanā, the wife of an aboriginal Vānara chief.

II. A term for vital air or breath (*prāṇa*).

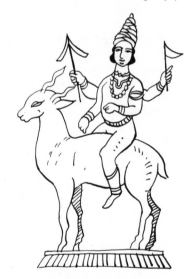

Pavitra An amulet of *kuśa* grass worn round the arm by a brahmin during the performance of ritual. It is emblematic of Aiyaṇār and of Vāmanāvatāra. The latter wears a ring of *Kuśa* grass.

Pedu v. Paidva.

Phala 'Fruit', a symbol of fertility.

Phalakahāra A necklace composed of pearls inter-

spersed with large gems set in metal.

Piḷḷaiyar (Tamil) 'Honourable child'. A South Indian epithet of Gaṇeśa.

Pināka Name of Śiva's staff or bow, which consists of a powerful serpent with seven heads and poisonous fangs.

Piṇḍikā A pedestal for an icon.

Pingala 'Tawny', 'yellow'. An attendant of the sun-god Sūrya, and the recorder of man's good and bad deeds. He is portrayed as a bearded, pot-bellied man, holding a pen and inkstand.

Pingala-Gaṇapati A six-armed form of Gaṇapati accompanied by Lakṣmī.[1] He carries a mango, bunch of *kalpakalatā* flowers, sugarcane, sesamum, *modaka* and an axe.

[1]*EHI*, I, pt i, p. 56.

Pippala The fig-tree (*Ficus religiosa*) sacred to Buddhists, Śaivas and Vaiṣṇavas.

v. Aśvattha.

Piśāca(s) Flesh-eating demons, sometimes associated with *rākṣasas*. Their origin is variously given: they were created by Brahmā; or emerged from Pulaha one of the ten mind-born sons of Brahmā; or were born of Krodhā, or Piśācā (a daughter of Dakṣa); or produced by Darkness (*Manu*, XII,44).

Piśācas dwell in cremation grounds, and move about at night frequenting lonely places, derelict houses and roads. They are portrayed as hideous, emaciated beings with their bones jutting out of their skin, and with their veins clearly visible. Their hair is staring and fanned out.

Pitā(s) or **Pitara(s)** or **Pitṛ(s)** 'Ancestors'. *Pitās* include the first progenitors of the human race as well as the ancestors who have undergone the required funeral rites. The *pitṛs* are said to be equal to the gods. They dwell in the realms of space, or in the moon. Usually they are depicted with their hair dressed in a bun, and wearing a sacred thread. Their bodies are smeared with sacred ashes (*vibhūti*).

Pitāmaha 'Grandfather'. An epithet of Brahmā, usually depicted bearded and pot-bellied.

Pitāmbara 'Yellow garment'. A thin yellow or golden veil worn round Viṣṇu's hips. The radiance of his divine body glows through it, just as divine reality shines through the words of the Veda,[1] and hence this garment represents the Veda. Brahmāṇī and Vaiṣṇavī also wear a *pītāmbara*.

[1]*HP*, p. 158.

Pitara(s) v. Pitā(s).

Pīṭha[1] 'Stool', 'seat', 'pedestal' or 'throne';[2] or a place of particular religious interest. In the latter sense *pīṭhas* were places of pilgrimage, where Devī was honoured under one or other of her many names: Śakti, Durgā,

and so on. The actual presence of Devī dwells in four *pīṭhas*. The usual cult objects in most of these shrines are stone blocks covered with a red cloth and described as this or that limb of Devī whose body the gods had cut up after her death.[3]

The pedestals of *lingas* may be square (the most usual shape), or shaped as an octagon, oblong, hexagon, elongated hexagon, duodecagon, elongated duodecagon; or be sixteen-sided, circular, elliptical, triangular or semicircular. The Śaiva *Āgamas* describe the male, female, or neuter nature of stones, timber and other objects; the *linga* should be fashioned from male stone, and the *pīṭha* from female.[4]

[1]*IAL*, 8222, suggests that the term is of non-Aryan origin.

[2]*Pīṭha* is sometimes a synonym of *āsana*.

[3]*DHI*, p. 83. For a list of tantric *pīṭhas* v. 'The Śākta Pīṭhas', *JRAS*, Bengal, 1948.

[4]*EHI*, II, pt i, p. 102.

v. Anantāsana.

Pīṭhapadma v. Padmapīṭha.

Pīṭhāsana v. Pralambapadāsana.

Pitṛloka The realm or sphere (*loka*) of the ancestors (*pitṛs*), sometimes identified with heaven (*svarga*), but more often conceived of as a nether world situated in the South, beyond the realm of the living.

Pitṛ(s) v. Pitara(s).

Plakṣa One of the trees in which *gandharvas* and *apsarasas* dwell.

Prabhā v. Prabhātoraṇa.

Prabhāmaṇḍala A large halo or glory surrounding a divine figure.[1] Kramrisch[2] suggests that it was influenced by the sacred tree arch from Mohenjodaro where it is depicted surrounding a human figure. The leaves became more and more stylized until finally they resembled the shape of flames or rays on *prabhāmaṇḍalas*.

The *prabhāmaṇḍala* depicted round Naṭarāja symbolizes the dance of nature, the vital processes of the universe and its creatures which are projected and moved by Naṭarāja. It also signifies the energy of Wisdom, or the destructive aspect of Śiva, or the fire of knowledge which burns away ignorance (*avidyā*). In some contexts it signifies the mantra *OM*, the mystical utterance of praise and incantation.

[1]Rao, *EHI*, I, pt i, p. 32, states it is a circle of light round the head of an image.

[2]*Indian Sculpture*, pp. 6 and 146, and see Pl. II, fig. 7.

v. Prabhāvalī; Prabhātoraṇa.

Prabhāsa Name of one of the Vasus representing the sky whose attributes are: a goad, rod, skull-cup and a spear.

Prabhātoraṇa or **Prabhā** A portal of rays in the middle of which an idol is placed. A *kīrttimukha* may be depicted at the top of the portal.[1]

[1]*ID*, p. 223.

v. Prabhāmaṇḍala.

Prabhāvalī A large ornamental circular or oval halo (*prabhātoraṇa*), sometimes with projecting flames (*jvālas*) which surround the whole figure of a deity. Some have the special emblems of the god to whom the *prabhāvalī* belongs depicted on its side; or the halo of Viṣṇu portrays his ten incarnations (*avatāras*) in their usual order from right to left.[1]

[1]*EHI*, I, pt i, p. 32.

v. Prabhāmaṇḍala.

Pradakṣiṇā 'Circumambulation'. Circumambulation in a clockwise direction of sacred trees, animals, temples, shrines, or teachers, is performed as an act of reverence, respect, submission or sacrifice. It bestows merit and prosperity, as well as delineating a sacred area, but circumambulation in an anti-clockwise direction (*prasavya*) has a malign influence.

Pradakṣiṇā(patha) 'Circumambulatory', a passage round the inner sanctum (*garbhagṛha*) of a temple, along which worshippers walk.

v. Pradakṣiṇā.

Pradhāna v. Navaśakti(s).

Pradoṣamūrti Śiva and Pārvatī depicted standing together, a position similar to *āliṅganamūrti*.

Pradyumna Name of the god of love Kāma, son of Kṛṣṇa by his chief wife Rukmiṇī, and one of the five Vṛṣṇi heroes who were later deified (*manuṣyaprakṛtidevas*). In the developed Pāñcarātra (Vaiṣṇava) cult, four of them, including Pradyumna, were regarded as primary emanations (*vyūhas*) of the supreme god Para-Vāsudeva.

Pradyumna's wives are Māyādevī and Kakudmatī; his emblem is a sword.

Prahlāda v. Hiraṇyakaśipu.

Prajāpati 'Lord of creatures'. A late Vedic cosmogonic concept representing the forces of nature as a single creative force. This concept also combines the creator theories of the Cosmic Man (Puruṣa) and Hiraṇyagarbha. Finally Prajāpati merged into the creative aspect of Brahmā. Prajāpati is also an epithet applied to Kaśyapa and to Indra.

The horse is sacred to Prajāpati (*Manu*, XI,38), because he assumed this form when he searched for Agni who had hidden in the waters.

Prajāpati represents Totality, since he encompasses all the gods and all creatures in himself (*Nir.*, 10,43). The Seven Ṛṣis, the progenitors of the human race, are also called Prajāpatis.

Prājāpatya-agni v. Agni.

Prakāśa An aspect of Śiva as the first radiance, or original light of godhead, which depicts him with erect *liṅga* and Durgā seated on his knee. She holds a mirror to indicate her nature as the pure mirror in which he reflects himself (Vimarśa). Or this aspect may be represented by an androgynous figure divided vertically down the centre, with the right side male with erect *liṅga*.[1]

[1]Rawson, *The Art of Tantra*, p. 183.

Prakṛti The world substance, matter or nature, source of the material universe. In the Sāṃkhya doctrine, *prakṛti* is equated with nature as distinct from spirit. Prakṛti's infinite possibilities can only be actualized in the presence of an efficient cause which is spirit (*puruṣa*).

Pralamba Name of a demon killed by Balarāma.

Pralambapadāsana or **Pīṭhāsana** A sitting posture (indicating authority) with both feet placed on the ground in European fashion.

Pralaya The dissolution of the world, aptly described by Heimann[1] as a 'de-individualizing melting process' in which all forms merge in an indiscernible mass at the end of each age. Despite partial or total dissolutions, re-creation always occurs. This theory of the eternality of the universe in some form is supported by the law of the conservation of energy which states that the basic substance of the universe is eternal.

[1]*Facets*, p. 52.

v. Mahāpralaya; Kāla; Kālī.

Pralayavarāha A four-armed form of Viṣṇu's boar (*varāha*) incarnation. He is depicted seated on a *siṃhāsana*, with the right leg hanging down, the left leg bent and resting on the seat. He carries a conch and discus, his front right hand is in *abhaya mudrā* the front left rests on his thigh. He wears yellow garments and many ornaments.[1] Bhūmidevī sits on his right and holds an *utpala* flower in her left hand.

[1]*EHI*, I, pt i, p. 136.

Pramāṇa or **Tālamāna** Canon of iconometry, including the *Śilpaśāstras*, which describes the ideal proportions associated with various deities.[1]

[1]Coomaraswamy, *Transference of Nature*, p. 167.

v. Tālamāna.

Pramatha(s) 'Tormentors', 'smiters'. Demons or sprites belonging to ancient Indian folklore. They resemble *gaṇas* and both are associated with Śiva and Gaṇeśa.

The *pramathas* are variously described as bearded, of terrifying countenance, pot-bellied, hunch-backed and dwarfish. Sometimes they are portrayed on the lower portions of temple door jambs, and are said to exert auspicious influences.

Prāṇa 'Spiration', 'breath of life or life principle'. In Indian philosophy *prāṇa* is equated with *ātman*, the

cosmic essence, and with the impersonal *brahman*.
v. Prāṇapratiṣṭhā.

Prāṇapratiṣṭhā 'Endowing with breath', the act of consecrating and endowing an image with breath (*prāṇa*), i.e., life.[1] First the eyes are opened and after various other rites the icon is endowed with the vital breath of the deity it represents.

[1]A similar belief existed in ancient Egypt (Reymond, *Mythological Origin of the Egyptian Temple*, p. 90).
v. Prāṇa; Śalākā.

Prāṇaśakti Name of a fierce goddess who presides over the life process. Her mount is a lotus, her emblem, a skull-cup filled with blood.
v. Prāṇa.

Prāṇayāma 'Breath-control'. A yogic breathing technique. Inhaled air is changed and increased by the heat of the body. The more air retained in the body the lighter it becomes until it feels as though it is soaring upwards. Many Indian sculptors were adept in *prāṇayāma* and this was reflected in their carvings of the human bodies with their well-developed breath-filled chests.

Breath is the vital manifestation of the spirit, the support and prime mover of all action.
v. Prāṇa; Gaṇa(s); Haṁsa; Prāṇapratiṣṭhā.

Prasādamudrā 'Gesture of favour', the same as the *varadamudrā*.

Prasanna-Gaṇapati 'Gracious Gaṇapati'. A form of Gaṇapati portrayed either standing erect on a lotus pedestal (*padmāsana*) or with two or three bends in the body. He holds a noose (*pāśa*) and goad (*aṅkuśa*); his *mudrās* are *abhaya* and *varada*, but in actual sculptures he does not show these *mudrās*. Instead he holds a tusk (*danta*), and the tip of his trunk touches a sweet-meat (*modaka*).[1]

.[1]*EHI* I, pt i, p. 58.

Prasavya v. Pradakṣiṇā.

Pratibhā 'Vision, imagination', the 'poetic faculty'.

Pratibimba 'Representation', or counterpart of real forms.
v. Pratimā.

Pratīka or **Rūpa** 'Outward form, image, or iconographic symbol'.

Pratimā 'Image, likeness, picture, figure' of a divinity. An image should 'not be regarded as the real god (a common misunderstanding), but as a "symbolical reflection of the deity" . . . the worship dedicated to it is reflected or redirected to the real deity'.[1]

[1]*ID*, p. 227.

Pratimākāra or **Rūpakāra** 'Image-maker', an artist-craftsman and member of a guild (*śreṇi*).

Pratiṣṭhā Consecration of an image.
v. Prāṇapratiṣṭhā.

Pratyālīḍha(pada) The stance of an archer with the left foot forward and the right drawn back; or a fighting stance which signifies destruction.
v. Ālīḍhāsana.

Pratyālīḍhāsana v. Ālīḍhāsana; Āsana.

Pratyūṣa Name of one of the Vasus whose emblems are: a goad, sword, spear and shield.

Pratyūṣā A goddess personifying 'dawn' driving away darkness. She attends Sūrya.

Pravartitahasta A position (*mudrā*) in which the hand is turned backward and the arm raised which signifies to turn, or to revolve. It is a characteristic pose of Naṭarāja in the *lalita* dance.

Preta Lit. 'deceased'.[1] The ethereal form of a dead person during the period between death and union with the ancestors (*pitṛs*). Some *pretas* may haunt their previous homes and become malevolent unless propitiated. They are described as thin and pot-bellied.

[1]Heimann, *PSPT*, p. 89, points out that *preta* is synonymous with *pra-yāta* and *pra-ita* which 'denote an intentional forward motion '*pra*' to a further state of development by means of the transition into death'. The *pretas* are born of the *tamas* or dispersing tendency, and are aspects of Śiva as the lord of sleep.
v. Pretāsana I; Bhūta; Guṇa(s).

Pretāsana I. A corpse (*preta*) which functions as a seat (*āsana*) for the goddess Cāmuṇḍā.
v. II.

II. A yogic position (*āsana*) of relaxation in which the *yogin* lies flat on his back with arms outstretched and appears as if dead. Rao[1] suggests 'that this yogic *āsana* has been materialized in the curious carcass-seat [of Cāmuṇḍā]'.

[1]*EHI*, I, pt i, p. 21.

Prīti 'Pleasure, love', personified as a daughter of Dakṣa and wife of Kāma and Viṣṇu.

Priyodbhava Name of one of Brahmā's door-keepers (*dvārapālas*) whose emblems are a rosary, staff and manuscript.

Prokṣaṇīpātra A vessel (emblematic of Agni), used as a receptacle for holy water.

Pṛśni I. 'Variegated, speckled, spotted'. Name of the dappled cow symbolizing abundance.
v. Pṛthivī.

II. The earth, personified as the goddess Pṛśni, or Pṛthivī.

Pṛthivī The earth (named after Pṛthu) and personified as a goddess. The earth is regarded as being square, and hence the square is a symbol of perfection and completeness. Thus Mount Meru, representing the *axis mundi*, is depicted rising from a square base.

Pṛthivīmātā 'Mother-Earth', a name of Bhūmidevī.
v. Dyauṣpitar.

Pṛthu The first king and culture hero said to be the inventor of agriculture. The earth-goddess Pṛthivī was named after him.

Pūjā 'Worship', 'homage'. Originally *pūjā* was 'an invocation, reception and entertainment of God as a royal guest',[1] and later a form of worship in which flowers, rice, water, oil and milk are scattered or poured over a sacred object. It replaced the basic Vedic sacrificial rite which was the fire-offering.

The growth of the devotional (*bhakti*) cults encouraged the making of icons which became essential for worship.[2]

[1]*VS*, p. 77.

[2]*DHI*, p. 78.

Pulastya Name of one of the ten (or eight, or nine) mind-born sons of Brahmā who represent cosmic principles.[1] Pulastya's offspring were the Vānaras, Yakṣas, Rākṣasas and Piśitāśanas.

[1]*HP*, p. 317.

Puṇḍarīka I. 'White lotus', symbol of purity and perfection. It is also a synonym for the manifested word, and in Tantrism, for the *yoni*.

II. A famous brahmin, later worshipped as the god Viṭhobā.

III. Name of one of the elephants supporting the southeast quarter of the world.

Puṇḍra A sectarian mark on the foreheads of ascetics.

v. Tilaka.

Purāṇa(s) A collection of ancient traditional tales describing the creation and destruction of the universe and including stories of gods, *ṛṣis*, ascetics and heroes. There are eighteen main Purāṇas. In common with the Epics and *Bhagavadgītā*, the Purāṇas are a synthesis of brahmanism and non-Aryan popular cults.

Pūrṇaghaṭa 'Vase of plenty', a kind of cornucopia. A vase overflowing with fruit, flowers and foliage.

v. Pūrṇakalaśa.

Pūrṇakalaśa 'Full (*pūrṇa*) vase', symbolizing fertility and the overflowing life-force. Hence it is also a symbol of death. A *pūrṇakalaśa* is frequently depicted on temple walls as a decorative motif.

Pūrṇakumbha A vessel filled with water, a symbol of fertility.

v. Kumbha.

Pūrṇāvatāra 'Full (or complete) incarnation (*avatāra*)'. Vaiṣṇavas regard Kṛṣṇa as the only complete incarnation of Viṣṇu.

v. Aṃśa II.

Purūravas Son of Budha (Mercury) and lover of the celestial nymph Urvaśī.

v. Anala II.

Puruṣa I. 'Man', 'male' or collectively 'mankind'.

II. The Vedic Puruṣa is depicted as a cosmogonic figure, a creative source, the primeval male who envelops the whole earth and hence represents totality. Society is compared with this giant organism: the *brahmins* are its head, the *kṣatriyas*, *vaiśyas* and *śūdras*, its arms, trunk and feet respectively. The various organs of the body are related in structural consistency and no one part may claim superiority over the others since 'collaboration and exchange of services are the essence of this organismic theory'.[1]

[1]Lannoy, *The Speaking Tree*, p. 143.

Puruṣottama 'The highest Puruṣa' – a tantric form of Viṣṇu as the Supreme Deity.

Pūṣan 'Nourisher'. A Vedic solar deity associated with Bhaga the dispenser of tribal property. Pūṣan probably signifies the beneficent power of the sun deified as a pastoral god and invoked to go before his worshippers to protect them against robbers and to lead them to rich pastures (*RV*, I,42, 1ff.).

Pūṣan's chariot is drawn by rams or goats. He carries a golden spear, goad and awl, and four lotuses are also associated with him.

v. Pathyā; Āditya(s).

Puṣkara Blue lotus flower.

v. Nīlotpala; Padma.

Puṣkaradvīpa 'Lotus island (or continent)'. One of the seven mythical insular continents surrounded by a sea of fresh water, and named after the great lotus which constitutes Brahmā's throne. In the middle of Puṣkara-dvīpa Mount Manasottara is situated on whose summit rotates the one wheel of the sun-god's chariot.

Puṣpa 'Flower', an emblem of Hayagrīva, Mārkaṇḍeya, and others.

Puṣpabodhikā A pillar capital decorated with a plantain-flower design.

Puṣpadhanvan A bow consisting of flowers and emblematic of Kāma.

Puṣpaka The magical aerial chariot (*ratha*) of flowers drawn by geese (*haṃsas*) which was given by Brahmā to Kubera. Later it was stolen by Rāvaṇa. After Rāvaṇa's death Rāma used it to take Sītā back to Ayodhyā.

Puṣpāñjali The presentation of flowers cupped in both hands during worship.

Puṣpapaṭṭa Flower-wreaths to adorn the hair.

Puṣpapuṭamudrā A gesture in which the hands are held palm upwards and slightly cupped with the sides touching. It denotes a water or flower offering.[1]

[1]*ID*, p. 231.

Puṣpaśara 'Flower-arrow'. An emblem of Śāsta.

Puṣpodaka 'Stream of flowers'. Name of one of the two rivers flowing through Yama's realm of the dead. To the virtuous it is sweet-smelling, but to the evil it

appears as a foetid river of pus.

v. Vaitaraṇī.

Pustaka 'Book', 'manuscript', made up of palm leaves and later of paper. It is emblematic of Brahmā, Sarasvatī, the Aśvins, Viṣṇu, Yajña, and other deities. It signifies the Veda.

Puṣṭi 'Growth', 'increase'. Name of one of Dakṣa's daughters personifying prosperity. She is Viṣṇu's second wife. In South India she is called Bhūmidevī.

Pūtanā 'Putrid'. A vampire-like demoness who poisons children. She tried unsuccessfully to poison the infant Kṛṣṇa with her poisoned milk, but was herself sucked to death by him.

Pūtanā is sometimes attendant on Skanda.

Pūtika or **Ādāra** A plant used as a substitute for the *soma* plant. It is said to have originated from the vital essence of the personified Sacrifice, i.e., Viṣṇu (*ŚBr.*, XIV,1.2,12).

v. Yajña.

R

Rādhā A beautiful cowherdess (*gopī*), wife of a Vṛndā-vana cowherd called Ayanaghoṣa.[1] As a young man Kṛṣṇa was on intimate terms with the *gopīs*. In the Bhāgavata-Kṛṣṇa concept 'Rādhā symbolizes the second principle necessary for duality . . . and the image became an archetype'.[2] Her emblem is a lotus (*padma*).

In Tantrism Rādhā represents the infinite love that constitutes the very essence of Kṛṣṇa. Every woman shares 'in the nature of Rādhā, and [every] man in the nature of Kṛṣṇa; hence the "truth" concerning the loves of Kṛṣṇa and Rādhā can be known only in the body itself, and this knowledge on the plane of "corpo-reality" has a universal metaphysical validity'.[3]

[1]Rādhā is sometimes regarded as an incarnation of Śrī Lakṣmī and is therefore Kṛṣṇa's chief wife.

[2]*IT*, p. 313.

[3]Eliade, *Yoga*, p. 265.

v. Bhakti.

Rāghava v. Rāma.

Rāhu 'Seizer'. The demon responsible for eclipses of the sun and moon. Rāhu was a *dānava* who appeared in the guise of a god during the churning of the ocean (*samudramathana*). He joined the other gods in drinking the elixir of immortality (*amṛta*), but Sūrya (the sun) and Soma (the moon) recognized him and informed the other gods, whereupon Viṣṇu instantly cut off his head which, uttering loud cries, rose up to the sky.

Rāhu is the regent of the south-west quarter of the heavens. His chariot is eternally yoked to eight black horses. His sons are the thirty-two comets (*ketus*), who appear in the sun's disk when famine, invasions, or the death of a king is imminent.

Some texts state that Rāhu should be seated on a lion or tortoise seat (*siṃhāsana*; *kūrmāsana*). He has two or four arms and carries a sword, shield and trident, the fourth hand is in *varada* pose according to the *Śilparatna*, but the *Viṣṇudharmottara* states that he should be two-handed, holding a book and woollen blanket in his right hand, and nothing in the left.[1] The lower part of his body ends in a tail; or he may be represented by the head only, the detached body being then known as Ketu.

[1]*EHI*, I, pt ii, p. 322; Bhattacharya, *Indian Images*, pt i, p. 32.

v. Ketu; Navagraha(s).

Rājadaṇḍa 'Sceptre', a symbol of royalty.

Rājagopāla 'The royal cowherd'. An epithet of Kṛṣṇa, usually represented with his two consorts. His emblems are a discus, conch-shell and flute.

Rājakakuda The five main objects symbolizing royalty; a sword, white parasol, crown, shoes and chowry. A lion-throne (*siṃhāsana*) and sceptre are also regarded as royal symbols.

Rājalīlāsana The seated position of royal ease, in which one foot touches the ground, the knee of the other leg is raised and one arm rests on it. The body leans slightly backwards and is supported by the other arm.

Rājamātaṅgī A form of Devī, depicted with a black complexion and with a *tilaka* mark on her forehead. Her throne is set with rubies. One foot rests on a lotus, and she plays a *vīṇā*. A parrot should be near by. A crescent moon is depicted on her crown, a wreath of blue lotuses encircles her head, and she wears many ornaments.[1]

[1]*EHI*, I, pt ii, p. 372.

Rājarājeśvarī 'Royal lady'. An epithet applied to Pārvatī, whose emblems are a goad, mirror, lotus, noose, small box, sugarcane bow, flowery arrows, and a fruit.

Rājarṣi A royal *ṛṣi*.

Rājāsana A royal seat or throne (*āsana*).
v. Simhāsana; Rājalīlāsana.

Rājasika 'Belonging to the quality *rajas* (passion)'.
v. Batuka-Bhairava; Guṇa(s).

Rājavṛkṣa 'Royal tree' associated with Vaiṣṇavī. According to the Indian Lexicons it was the *Cathartocarpus Fistula*, or *Buchania Latifolia*, or *Euphorbia Tirucalli*.

Rājñī Name of one of Sūrya's consorts. Rājñī and another consort Nikṣubhā both hold fly-whisks (*cāmara*).

Rajoguṇa One of the three *guṇas* having the quality of expansiveness and hence activity.

Rākā Name of a goddess variously described as presiding over the day of the full moon, or as its consort, or personified as one of the four daughters representing the four phases of the moon.

Rakṣā or **Kavaca** Any amulet or token used as a protective device. A piece of thread or silk bound round the wrist averts the evil eye, and protects against witchcraft and disease.

Rākṣasa or **Rakṣas** A demonic night wanderer. *Rākṣasas*, together with ghosts (*pretas*) and *nāgas*, are born of the tendency towards dispersion (*tamas*).

Rākṣasas can assume various shapes including those of dogs, donkeys, horses, eagles, vultures, owls, dwarfs, and even husbands and lovers. In their own form they have fearsome countenances with fiery eyes, sharp, prominent teeth and abnormally long tongues. They devour human beings, re-animate corpses, and afflict mankind in many ways.

Śiva Naṭarāja and some other deities are sometimes depicted dancing or trampling on *rākṣasas*.
v. Rāvaṇa; Asura; Guṇa(s).

Rākṣasa-muṇḍa 'Head or skull (*muṇḍa*) of a demon'. The goddess Kālī carries a severed head in one hand.
v. Muṇḍamālā.

Rākṣoghnamūrti An aspect of Śiva in the act of destroying Rakṣas. Śiva's emblems are a drum, skull-cup containing fire, an axe, and a trident with which he pierces Yama.[1]
[1]*ID*, p. 235.

Rakta-Cāmuṇḍā 'Blood (or red) Cāmuṇḍā'. An aspect of Devī also known as Yogeśvarī. She carries a sword, pestle, plough and bowl, and is said to permeate everything in the universe, a power supposed to be transferred to her devotees.[1]
[1]*EHI*, I, pt ii, pp. 364f.

Raktadantikā An aspect of Durgā associated with the ceremony of the Nine Plants (Navapatrikā(s)).

Rakta-Jyeṣṭhā The 'blood (or red) Jyeṣṭhā'. A form of the goddess Jyeṣṭhā.

Raktakaroṭaka A skull-cup filled with blood (*rakta*).
v. Kapāla.

Raktapadma Red (*rakta*) lotus.
v. Padma.

Raktavīja The giant *asura* who fought the goddess Caṇḍikā (Cāmuṇḍā). Caṇḍikā wounded him, but as each drop of blood fell on the ground it was transformed into a powerful warrior. Finally Caṇḍikā swallowed the blood before it reached the ground and so defeated him.

Rāma A number of men bear this name, but the three principal Rāmas are Paraśurāma, also called Jāmadagnya or Bhārgava (descendant of Bhṛgu), Rāmacandra also called Rāghava (descendant of Raghu), and Balarāma, also called Halāyudha.

Rāmacandra or **Rāma** An incarnation (*avatāra*) of Viṣṇu, the embodiment of righteousness, and the ideal hero.

Rāmacandra was the eldest son of Daśaratha, King of Kosala, and husband of Sītā, the embodiment of ideal womanhood. His adventures, virtues and courage are described in the *Rāmāyaṇa* which, when 'divested of its miraculous, fabulous, incredible and mythological elements, clearly indicates that he was a great king who spread Aryan ideas and institutions into regions far and wide'.[1]

Rāmacandra represents the ideal cultured man of the Epic period, highly skilled in law, polity, logic, music, military science, and the training of elephants and horses. It is probable that he was a human hero who became deified. He should never be portrayed with more than two arms: the right hand holds an arrow, the left a bow called Śārṅga. He stands in *tribhaṅga* pose and wears a number of ornaments and a *kirīṭamakuṭa*, the latter indicating that he is the son of an emperor.[2] He also wears *makara* earrings, the *kaustubha* jewel and the *śrīvatsa*. Sītā stands on his right. The top of her head should reach to his shoulder. Her hair may be tied in a knot, or she wears a *karaṇḍamakuṭa*. Her right arm hangs down gracefully by her side, the left hand is raised, either holding a flower or in the position (*kaṭaka*) to hold one. On Rāma's left stands Lakṣmaṇa. The top of his crown should reach to Rāma's shoulder or to his ear. He is adorned with jewels and ornaments and his figure resembles that of Rāma. Sometimes Hanuman, Rāma's faithful monkey ally, is represented on the right. Hanuman is two-armed, his right hand is placed on his mouth, a sign of loyalty, the left arm hangs down by his side – an attitude adopted by servants when in the presence of their

masters,[3] or his hands are in *añjali mudrā*.

[1]*HCIP*, I, p. 291.

[2]*EHI*, I, pt i, p. 189.

[3]Ibid., I, pt ii, p. 191.

Rāmānuja (born *c.* AD 1050) A Vaiṣṇava *bhakta* and founder, or principal exponent, of Viśiṣṭādvaita, a qualified form of monism. His teaching influenced many of the devotional (*bhakti*) cults of later times. His *mudrā* is *añjali* or *vyākhyāna*; emblem, a trident-staff (*tridaṇḍa*); and on his forehead the *ūrdhvapuṇḍra* mark.

v. Tilaka.

Rāmāyaṇa A famous work containing many stories deriving from the folk beliefs of pre-Buddhist India.

v. Rāmacandra.

Rambhā[1] A celestial nymph (*apsaras*), the embodiment of female beauty, who emerged during the churning of the ocean (*samudramathana*). Rambhā is a benign form of the great goddess (Devī) who fulfils all the desires of her devotees. Her mount is an elephant. She has four hands and carries a water-vessel, rosary, *vajra*, goad and fire.[2]

[1]Rambhā is one of the six variants of the goddess Gaurī.

[2]*EHI*, I, pt ii, p. 361; *ID*, p. 236.

Rasa 'Flavour, sap, juice, elixir, water, quintessence, emotional delight'. The emotional character of a specific work of art, and the collective name for the ten emotions expressed in dance. *Rasa* is regarded by some as the quintessence of the human body and of all substances; by others as Śiva's vital essence, i.e., semen. The substance of aesthetic experience is knowable only in the act of 'tasting' (*rasāvādana*), that is, experiencing. It is not a passive receiving of stimuli.

Yakṣas are the guardians of the vegetative source of life (*rasa* = sap in plants and trees = *soma* = *amṛta*), and hence are closely connected with the waters.[1]

[1]Coomaraswamy, *Yakṣas*, pt ii, p. 2.

For *rasa* in painting see *JAOS*, LII, 15, n.5.

Rāsa or **Rāslīlā** or **Rāsamaṇḍala** The circular dance of Kṛṣṇa and the *gopīs* during which he multiplied himself many times, so that each *gopī* thought she alone was dancing with him.

v. Rādhā.

Rasāvādana 'Tasting of *rasa*', that is, aesthetic experience.

v. Rasa.

Rāslīlā or **Rāsamaṇḍala** v. Rāsa.

Rāṣṭrakūṭa Name of a Western Deccan dynasty (750–973) claiming descent from the Yādava chief Sātyaki, one of Kṛṣṇa's kinsmen. The arts flourished

under the Rāṣṭrakūṭas, and the fine Kailāsanātha temple in Elūrā was created by King Kṛṣṇa II (757–83).

Ratha 'Chariot'. Some temples are shaped like a celestial chariot. In Vedic mythology the gods are often described as riding in chariots drawn by a number of different animals including horses, lions, geese, parrots, and hence are so depicted in Hindu iconography. The Vedas ascribe much symbolism to the various parts of the chariot. Lannoy suggests that the custom of conveying village icons in bullock carts during religious festivals was probably Neolithic in origin.[1]

[1]*The Speaking Tree*, p. 62, n.1.

Rati or **Revā** 'Desire', 'passion', 'love', personified as a beautiful nymph (*apsaras*) who radiates joy. Her husband is Kāma, god of love. Her emblems are a staff, rosary and *vīṇā*. Sometimes she carries the sword Nistrimśa.

Rati-Manmatha Kāma (Manmatha) and Rati depicted together.

Ratna 'Jewel', 'gem'. Jewellery is worn by most divinities, and is similar to that worn by royalty.

v. Kaustubha; Syamantaka.

Ratnakalaśa or **Ratnapātra** A vessel filled with gems (*ratna*).

Ratnakuṇḍala Earring (*kuṇḍala*) set with jewels.

Ratnamakuṭa A jewelled crown, characteristic of Tripurā-Bhairavī and Ucchiṣṭa-Gaṇapati.

Ratnamālā 'Garland (*mālā*) of jewels'.

Ratnamekhalā A girdle (*mekhalā*) set with gems (*ratna*).

Ratnapātra v. Ratnakalaśa.

Ratnapaṭṭa A jewelled golden headband worn by Gaṇeśa and some other divinities.

Rātri-Gaṇapati Also known as Haridrāgaṇapati.

v. Haridrā

Raudra A terrific aspect of a divinity.

v. Ugra; Ghora.

Raudrapaśupatamūrti An *ugra* form of Śiva, depicted fiery-red, with sharp tusks, curling eyebrows, a sacred thread made of snakes, flaming hair and red garments. He holds a trident with the head downwards (or horizontally), and a skull-cup, chisel (*taṅka*) and sword. To meditate on this aspect of Śiva even once destroys all enemies, but it 'should not be worshipped in actual images, but in certain symbols such as a *pīṭha*'.[1]

[1]*EHI*, II, pt i, p. 126.

Raudrī A terrific black-faced aspect of Devī who wears red garments.

Rāvaṇa King of Laṅkā (Srilanka), and half-brother of Kubera. The *Rāmāyaṇa* portrays him as the embodi-

ment of lust and the arch enemy of Rāma, whose wife he abducted.

Rāvaṇa was a Śaiva. When depicted in temples, he usually has ten heads and twenty arms. He is said to have been incarnate as Hiraṇyakaśipu and as Śiśupāla.

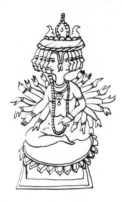

Rāvaṇānugrahaṇamūrti A gracious aspect of Śiva when seated on Mount Kailāsa with Pārvatī. Rāvaṇa tried to tip the mountain over, but Mahādeva (Śiva), knowing the cause of the upheaval, pressed the mountain down firmly with his great toe and pinned Rāvaṇa under it. Then for a thousand years Rāvaṇa wept and lauded Śiva, who finally forgave him and presented him with a divine sword, after which Rāvaṇa returned to Laṅkā.

Ravi An aspect of the sun (Sūrya), one of the twelve Ādityas. Ravi's wives are Chāyā and Uṣā.

Ṛbhu(s) 'Skilful', 'clever'. Three semi-divine craftsmen (sons of Indra and Saraṇyu), who fashioned the Aśvins' chariot. They were probably outstanding human craftsmen who introduced new skills. Their names are Ṛbhu, Vāja and Vibhu.

Ṛddhi 'Prosperity'. Name of one of Gaṇeśa's wives.

Rekhā Line, outline, drawing.

Revā v. Rati.

Revanta 'Rich'. A son of Sūrya and Saṃjñā (Sureṇu) in their equine forms. Revanta is lord of forest spirits and hence will protect his devotees from the terrors of lonely places and attacks by robbers. He is associated with hunting and horsemanship, and is lord of horses. He is seldom represented and no iconographical remains have been found in South India.

Revanta was born fully armed and riding a horse. Those who invoke him at the time of calamities, invasions, or other great dangers will be saved. When worshipped, he gives his devotees riches, happiness, health, fame and success.

According to the *Kālikā Purāṇa* (ch. 80), Revanta has an important role in the *nīrājanā* rite, a quasi-military and religious ceremony performed by kings

and generals preparatory to a campaign. The priests, ministers, warriors and weapons were consecrated by *mantras* and a mock fight then took place during which the enemy troops, represented by clay figures, were completely destroyed.

Revanta is depicted two-armed, and wearing shining armour. His hair should be covered; he holds a whip and sword and rides a white horse. A number of musicians, attendants and dogs accompany him. These attendants and animals distinguish him from representations of Kalki.

Revanta is closely associated with kingship, wealth, and with the possessors of horses.[1]

[1]*Iconog. Dacca*, pp. 174ff.

v. Guhyaka(s).

Revata 'Wealthy'. One of the eleven Rudras (Ekādaśarudra). He has sixteen arms; the right hands carry a bow, sword, trident, club, snake, discus, goad and rosary; the left hands carry a bow (?), shield, skull-topped staff, bell, axe, sharp-edged rod (*paṭṭiśa*), and alms-bowl. His *mudrā* is *tarjanī*.[1]

[1]*EHI*, II, pt ii, p. 389; *ID*, p. 240.

Revatī 'Wealthy'. I. *A yoginī*, sometimes identified with Durgā or with the earth.

II. Name of a wife of Balarāma. She should be depicted in a garment decorated with floral designs (*puṣpavastra*). Her left arm hangs down gracefully by her side, her right carries a lotus flower.[1]

[1]*EHI*, I, pt i, p. 202.

Ṛgveda 'Veda of praise'. The first and most important of the four Vedas. The *Ṛgveda* is a repository of sacred lore, consisting of a collection (*saṃhitā*) of hymns (*sūktas*) composed of verses (*ṛcs*) and addressed to the great Aryan deities Agni, Indra, Mitra, Varuṇa, Uṣas, etc.

The *RV* was both 'seen' and 'heard' by inspired seers (*ṛṣis*). Mythologically it is said to have emerged from Brahmā's eastern mouth. The book or manuscript held by some deities such as Brahmā and Viṣṇu, signifies the Veda. As there are four Vedas the term *veda* has become a symbolic name for the number four.

v. Veda.

Ripumāri-Durgā An aspect of Durgā in the act of killing enemies. She has a red complexion and terrifying countenance. One hand carries a trident, the other is in *tarjanī mudrā*. If her *mantra* is repeated 10,000 times whilst she is visualized in the disk of the sun, she will destroy all the enemies of her devotees.[1]

[1]*EHI*, I, pt ii, p. 345.

Ṛjulekhā 'Straight line'. Name of a *yantra*. A straight line represents unhindered movement and the potential for further development.[1]

[1]*HP*, p. 351.

Roga 'Disease', 'infirmity', 'sickness', personified as a demon who acts as Death's charioteer, because illness is often the forerunner of death.

v. Mṛtyu; Yama.

Rohita The 'Red One', a name of the Sun.

Rohiṇī I. 'Red'. Also called Uṣas, Sūryā, Sāvitrī, etc. A goddess, the feminine counterpart of Rohita (the personification of the rising sun), and a divinity of cattle. Hence the stellar divinity (*rohiṇī nakṣatra*) is equated with offspring and cattle (*ŚBr.*, XI,1.1,7).

II. Name of a stellar divinity personified as a daughter of Dakṣa and wife of Candra.

v. Rohiṇī I.

Ṛṣabha or **Vṛṣabha** 'Bull'.

v. Nandi.

Ṛṣabha maṇḍapa A pillared hall for Nandi, the bull (*ṛṣabha*) of Śiva.

Ṛṣi 'Seer', 'singer of sacred songs', 'inspired poet', a sage.

The seven ancient *ṛṣis* were the 'primal makers of creation', and hence are regarded as the fathers of the human race and source of all knowledge. To these superhuman beings the Vedas were revealed at the beginning of Time. In later mythology a number of human seers are mentioned.

The *ṛṣis* are sometimes divided into seven groups including *maharṣis*, *devarṣis*, *rājarṣis*, etc. Their usual emblems are a rosary, water-vessel and manuscript (representing the four Vedas); their *mudrā* is *añjali*. In bronze sculptures they are often depicted 'as human figures with the hind legs of a buck and tails.'[1]

[1]*ID*, p. 240.

v. Saptarṣis(s); Muni.

Ṛṣipatnī 'Wife (*patnī*) of a *ṛṣi*'. Images of the wives of the *ṛṣis* are often depicted in Śaiva shrines, because they are said to have fallen in love with Śiva when in his form of Bhikṣāṭanamūrti.

Ṛtu 'Any settled point of time'; 'time appointed for a sacrifice', and for other regular forms of worship. It is also a part of the year, a season. The personified Seasons are worshipped with libations.

Ṛtvij The collective designation of the priests employed to perform sacrifices. Originally there were four priests, later the number was increased to seven and then to sixteen.

Rudra 'Roarer' or the 'Red (or flashing) One'. The Vedic god of the tempest.

The Vedas describe him as a malevolent deity causing death and disease to men and cattle. He represents the devouring, fearsome form of Agni, but later the name was applied to Śiva's destructive aspect.[1]

Rudra possesses a hundred weapons. He is followed by howling dogs (*AV*, XI,2,30), and by the hosts of the dead, as was the Wild Huntsman of European mythology. Rudra is sometimes called the 'Tufted One', and is associated with Bhava and Śarva, the lords of cattle. His female attendants are the Ghoṣiṇīs, the 'Noisy Ones'. He combines in himself both the dangerous and beneficial aspects of the fertility process,[2] and dwells in the North.

The *Śatarudrīya*[3] describes Rudra as eternally young and able to assume all conceivable forms (*viśvarūpa*), both immobile and mobile, and hence the *mātaras*, *gaṇas*, Gaṇapati, Senānī, and others are all forms of Rudra. Some Vedic hymns describe him as tawny, others as fair and handsome, wearing golden ornaments, and having plaited hair. The Purāṇas state that he carries a discus, trident, axe, and sword. His girdle (*mekhalā*) and sacred thread (*yajñopavīta*) are composed of serpents. He is nude and dances and sings ecstatically.

By means of his mighty bow he protects his devotees, sustains the growth of plants, guards the woods, and presides over the sites of buildings as well as over architectural work itself.[4] His terrifying anger is directed only to the wicked.

[1]*Principles*, Glossary, p. 256. As Rudra did not share in the *soma* sacrifice, it is probable that he was a non-Aryan deity.

[2]Heesterman, *Ancient Indian Royal Consecration*, p. 90, n.44.

[3]Sivaramamurti, *Śatarudrīya*, pp. 3f.

[4]Ibid., pp. 16, 29, 79.

v. Śiva; Rudrākrīḍa.

Rudrabhāga v. Manuṣaliṅga(s).

Rudra-Cāmuṇḍā v. Cāmuṇḍā.

Rudracarcikā v. Cāmuṇḍā.

Rudrākrīḍa 'Rudra's pleasure ground', i.e., the burial or cremation place where Rudra dances at twilight.

v. Śmaśāna.

Rudrākṣa 'Rudra-eyed'. Name of the dark berries of *Elaeocarpus ganitrus*, used to make Śaiva rosaries (*mālā*), or necklaces. The berries have five divisions signifying Śiva's five faces (*pañcānana*).

Rudrāṁśa-Durgā A four-armed form of Durgā regarded as a partial incarnation (*aṁśa*) of Rudra. She wears red garments and is dark complexioned. Her *kirīṭamakuṭa* is adorned with golden ornaments set with rubies. Her emblems are: trident, sword, conch-shell and discus; her mount, a lion (*siṁha*). The Sun and Moon should be depicted on either side of her.[1]

[1]*EHI*, I, pt ii, p. 343.

Rudrāṇī Rudra's wife, a cruel goddess associated with blood sacrifices who causes sickness, terror and death. In post-Vedic works she is equated with the destructive aspect of Durgā.

Rukmin v. Rukmiṇī.

Rukmiṇī Sister of Rukmin, the eldest son of Bhīṣmaka, King of Vidarbha. Rukmiṇī fell in love with Kṛṣṇa, but her brother opposed the marriage. Shortly afterwards she was betrothed to Śiśupāla, King of Cedi, but before the marriage could take place Kṛṣṇa abducted her. Rukmin and Śiśupāla and their followers hotly pursued the couple but were defeated. According to the current rules of warfare Rukmiṇī was now one of the 'spoils of war' whom Kṛṣṇa was free to marry by the *rākṣasa* rite, i.e., marriage by capture. From their union was born Pradyumna (Kāma).

When Kṛṣṇa is depicted accompanied by his two wives, Rukmiṇī stands to his right. Her emblem is a lotus.

Ruṇḍamuṇḍadhārī 'Garland of Skulls'.
v. Śiva.

Rūpa 'Form', 'image', 'symbol', 'figure'. A term applied especially to icons or pictures of the gods to distinguish them from objects such as pebbles, rock formations and other objects not formed by man, that is, aniconic (*a-rūpa*).

Rūpabheda 'Diversity of forms and manifestations', a term for iconography.[1]

[1]*ID*, p. 242.

Rūpakāra or **Pratimākāra** 'Imager', a maker of images.
Rūpa-vidyā v. Cāmuṇḍā.
Ruru v. Bhairava.

Śabala 'Brindled', 'variegated'. Name or epithet of one of Yama's two 'four-eyed' dogs, the other being called Śyāma (black). They were the offspring of Indra's bitch Saramā.

In many mythologies, including the Avestan and Greek, dogs were associated with death, and in Indian mythology Yama's dogs guard the road to the realm of the dead (*AV*, VIII.1,9).

Śabda 'Sound'.

Sabhāmaṇḍapa Assembly hall of a temple.

Śacī A goddess personifying divine strength and power. She is Indra's consort, and is also called Indrāṇī and Aindrī.

Sadāśiva The Supreme Being, the eternal Śiva whose five aspects are manifested in one form. This abstract notion is personified and described in the *Uttara-kāmikāgama*. Sadāśiva is white and stands on a lotus plinth. He has five heads, each with a *jaṭāmakuṭa*, and ten arms. His three right hands hold a spear, trident and skull-topped staff, the fourth and fifth show the *abhaya* and *prasāda mudrās*; the five left hands hold a snake, rosary, drum, blue lotus and *mātuluṅga* fruit. Or he may be represented with one face and three eyes which denote Icchāśakti, Jñānaśakti and Kriyāśakti respectively.[1] The crescent moon adorning his hair symbolizes wisdom (*jñāna*). The Supreme Goddess Manonmanī or Bhogaśakti may stand by his side.

[1]These are three of the five *śaktis* who emerged from Śiva at the end of an eon for the purpose of creating the *śuddha-tattvas* and removing all pollution (*mala*) from *yogins* (*EHI*, II, pt ii, pp. 362, 372).

Sādhana 'Discipline'. *Sādhana* is the instrument of perfection (*siddhi*), the means by which the end is attained. Hindu *sādhana* includes religion, science, philosophy, vocation, marriage, recreation, politics, economics, literature, dance, drama and the arts. These should not be regarded as separate activities but the various ways in which man may express himself.
v. Siddhi I.

Sadharma Name of a doorkeeper (*dvārapāla*) of Brahmā. His emblems are a rod or staff, lotus, manuscript and sacrificial ladle (*sruk*).

Sādhu A teacher or saint: one who has attained particular powers as a result of intense spiritual effort.

Sādhya A class of semi-divine celestial beings or 'intermediate gods' (*vyantaradevatās*), who are the 'gods of old' who existed prior to the creation of human beings. They are depicted on lotus seats (*padmāsana*), and carry a rosary and water-pot.

Sadyojāta 'Suddenly born'. Name of one of the five faces of Śiva. When represented as a separate deity he is jasmine- or moon-coloured. He holds the Vedas and shows the *abhaya* and *varada mudrās*.[1] His *jaṭāmakuṭa* is ornamented with a crescent moon, and his countenance is joyful.[2]

[1]Śivatoṣiṇī, 1.1,11 quoted in *HP*, p. 212.
[2]*EHI*, II, pt ii, p. 378.
v. Pañcānana; Pañcabrahmā(s).

Saguṇa v. Deva.

Sahadeva Name of one of the five Pāṇḍu princes and twin brother of Nakula. The twins are regarded as incarnations of the twin Aśvins.

Sahakāra A mango tree.

Sahasra 'Thousand'. A symbol for an infinite number. Thus the gods are said to have a thousand names.

Sahasrākṣa 'Thousand-eyed', and hence 'all-perceiving'. An epithet of Indra, Vāyu, Agni and Viśvakarman.

v. Sahasra.

Sahasraliṅga A *liṅga* on which are carved one thousand (*sahasra*) miniature *liṅgas*. The main *liṅga* is divided by horizontal and vertical lines which represent one thousand *liṅgas*, which with the main one makes one thousand and one[1] and signifies totality.

[1]*EHI*, II, pt i, p. 96.

v. Aṣṭottaraśataliṅga.

Sahasrāra Name of the highest *cakra*, the thousand-petalled lotus at the top of the skull.

Śaila 'Rock'.

v. Mahodaya.

Śailaputrī 'Mountain-daughter'. An aspect of Durgā whose mount is Nandin; her emblems are the moon and a trident.

Śaiva 'Relating to Śiva', or to his cult; or a worshipper of Śiva. The Śaiva cult is one of the oldest and most widespread in India. It consisted of many sects, some of which were classed as outside the Vedas, or actually opposed to them, but only a few have survived to the present day.

v. Śaivabhakta.

Śaivabhakta A 'devotee (*bhakta*) of Śiva', or a member of the Śaiva cult. There are sixty-three Śaiva 'saints', the most famous being Appar, Sundaramūrti, Māṇikkavācakar, and Tirujñānasambandha.

v. Aḷvār(s).

Śaiva-siddhānta A South Indian Śaiva system which regards Śiva as eternal and the source of everything. The early texts were written in Sanskrit and later supplemented by Tamil texts of a devotional nature.[1]

[1]*WI*, pp. 333f; *EW*, I, pp. 370, 374.

Śāka The teak tree after which one of the seven mythical continents or islands (*dvīpas*) is named. It grows in the centre of the island which is surrounded by a sea of milk (representing abundance).

Śākambharī 'Herb-bearing', 'herb-nourishing'. A vegetal goddess, probably of pre-Vedic origin,[1] subsequently identified with Durgā who, in this form, produces from her body life-sustaining vegetables.

[1]A small Harappan seal depicts a nude figure upside down, from whose womb issues a plant.

v. Navapatrikā(s).

Śākinī A witch-like spirit attendant on Śiva and Durgā.

Śakra 'Strong', 'powerful'. An epithet applied to many gods and especially to Indra the Vedic war-god, the personification of power, strength and fearlessness.

v. Śacī.

Sakriya The creative aspect of a divinity.

Śākta A worshipper of Śakti, and the name of an important cult based on the worship of divine energy (*śakti*),[1] the activating supreme principle of all existence. There are two main divisions of the Śāktas, the so-called Right-hand (*dakṣiṇācāra*) or ascetic group, and the 'Left-hand' (*vāmācāra*) group.

Although the Śākta cult is closely associated with that of Śiva, it is clearly distinguished from the latter as indicated by the Śākta dictum: 'Śiva is a corpse without Śakti.' In Śāktaism Pārvatī is elevated to the supreme position and Śiva relegated to a secondary place.

[1]*Śakti* is not only grammatically feminine but is also notionally female.

Śakti I. 'Divine universal power or energy', the active principle of a deity. Śakti is the supreme mistress of Nature (*prakṛti*). Her weapons and emblems symbolize the powers of Nature.[1] Thus her mount is a tiger indicating the power of Nature, and she is also the consort of Śiva, who is beyond the power of Nature, and who carries a tigerskin as a trophy. Śāktas regarded Śakti as the source of all existence, the main representation of divinity and the energy from which all manifestation arises, whereas Śiva is regarded as passive[2] and inactive without Śakti.

When Śakti (Devī) killed the demon Mahiṣa, she combined in herself the powers of all the gods, and therefore became more powerful than they.

[1]*EHI*, I, pt i, p. 295.

[2]But Bharati (*TT*, p. 213), points out that in two passages of the *Mārkaṇḍeya Purāṇa*, and in a few passages of Hindu tantric works and particularly the *Periyapurāṇam* (a canonical text of Tamil Śaivism), the active function is assigned to Śiva. A number of Hindu gods have their individual Śaktis.

v. Devī.

II. 'Spear', 'javelin', the special emblem of the war-god Skanda or Kārttikeya, and of warriors. Tvaṣṭṛ (or Viśvakarman) made an unfailing javelin (*amogha-śakti*) for Indra which came into the possession of the Pāṇḍu princes who worshipped it with garlands and perfumes. A *mahāśakti* is mentioned in the *Mahābhārata*, a large and powerful weapon adorned with a hundred bells, which was probably displayed on ceremonial occasions.

v. Pāśupata; Subrahmaṇya; Śaktidhara; Mahiṣāsuramardinī.

Śaktidhara 'Holding a spear'. An aspect of Subrah-

manya (Skanda). His left hand holds a *vajra*, the right a spear (*śakti*)[1] representing knowledge. His *mudrā* is *abhaya* and he holds a cock.

[1]*EHI*, II, pt ii, p. 433.

Śakunī A demoness (sometimes associated with Durgā), who causes particular diseases in children.

Śāla A tree (*Vatica robusta*).

Śālabhañjikā A statuette or sculpture representing a girl gathering the flowers of a *śāla* tree. She stands close to the tree in the classic attitude of Indian tree-goddesses. It is also the name of the tree-nymph herself.

Śālagrāma I. A place of pilgrimage on the Gaṇḍakī river, named after the *śāla* trees growing there.

II. Name of the fossilized shells of an extinct species of mollusc found in the Gaṇḍakī river and also at Dvārakā. The shells are sacred to Vaiṣṇavas and are believed to be pervaded by Viṣṇu's presence, thereby indicating his power to assume any shape at will. If no image of Viṣṇu is available, a *śālagrāma* may be worshipped instead.

Śalākā A thin bamboo rod with a feather attached used for drawing the final lines for 'opening the eyes' of an image.[1]

[1]C. Sivaramamurti, *South Indian Paintings*, p. 23.

v. Prāṇapratiṣṭhā.

Samabhaṅga Erect pose.

v. Samapādasthānaka.

Samādhi The last stage of yogic concentration when all opposites are transcended.

Samādhimudrā A particular pose indicating deep meditation.

v. Dhyānahastamudrā.

Samapādasthānaka Standing posture with legs straight.

Sāmaveda v. Veda.

Śamba or **Samba** A synonym of *vajra*, the thunderbolt of Indra.

Śāmba or **Sāmba** Son of Kṛṣṇa. The introduction of solar worship into India is attributed to Śāmba, who cured himself of leprosy by worshipping the sun, whereupon he installed a golden image of Sūrya at Multan. His emblem is a club.

Śambhu 'Causing or granting happiness'. A beneficent aspect of Śiva when presiding over the reintegration of new life.

Śambhu represents the peaceful, changeless state when the universe comes to rest.[1] He wears a crescent moon on his head, and has as emblems a trident, bow, horn, etc. His third eye is portrayed vertically on his forehead; his mount is a bull. According to another description he has serpents as ornaments. Śambhu is also worshipped in Buddhist and Jaina Tantric disciplines.[2]

[1]*HP*, p. 197.

[2]*TT*, p. 135.

Saṃhāra v. Bhairava I.

Saṃhāramūrti(s) Destructive forms of Śiva known by many names: Gajāsuramūrti when in the act of killing the elephant-shaped demon; Kālārimūrti when he killed Kāla, god of Time and Death; and Kāmāntaka-mūrti when he burnt Kāma. These aspects of Śiva are usually ten-armed.

v. Saṃhāratāṇḍava; Śiva; Bhairava I; Saṃhāraśakti.

Saṃhāraśakti A goddess personifying Śiva's power of destruction.

v. Saṃhāramūrti(s); Vahni.

Saṃhāratāṇḍava 'Dance of destruction' by Śiva who tramples on Apasmāra. Śiva's emblems are fire, drum, skull-cup, noose and trident. One arm is held gracefully across his body (*gajahasta*). His *mudrās* are *abhaya* and *vismaya*.

v. Naṭarāja.

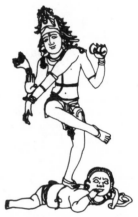

Saṃhitā(s) Texts of the Vedas; a collection of hymns, prayers and sacrificial formulas.

Śamī A hardwood tree (*Prosopis spicigera*), or perhaps *Acacia suma*), believed to contain fire, and hence used to kindle the altar fire. Agni hid in the *śamī* wood after Bhṛgu had cursed him. The wood is personified as the goddess Śamīdevī.

Śamīdevī v. Śamī.

Saṃjñā Also called Tvaṣṭrī, a daughter of Viśvakarman (Tvaṣṭṛ) (the divine artist-craftsman of the gods), and the wife of Sūrya.

Saṃkarṣaṇa A name of Balarāma who presides over agriculture. His emblems are a plough and pestle.

Sāṃkhya or **Sāṅkhya** The oldest of the six Hindu 'orthodox' philosophies (*darśanas*), a philosophy of dualistic realism attributed to the sage Kapila. It was an alternative to the monistic tendencies of the Upaniṣads, and was based on reasoned arguments instead of being an exposition of Vedic speculations.

Initially it was atheistic and known as Nirīśvara-sāmkhya, but later it was developed theistically by Patañjali and merged with the theistic Yoga system.

Sammārjanī A 'broom', an emblem of the goddess Śītalā.

Saṁsāra The cycle of birth, death and rebirth or metempsychosis which is dictated by the inexorable law of *karma*.

v. Pañcānana.

Samudramathana or **Samudramanthana** 'Churning of the [milk] ocean', an allegorical representation of the formation of land out of the sea. The churning is a 'secondary' creation myth which assumes that all things exist *in potentia* in the primordial ocean. This churning could only be achieved by superhuman effort and hence the gods and *dānavas* performed it with Mount Mandara as the churning-rod around which they coiled the serpent Vāsuki (representing the non-evolved form of nature, *prakṛti*) as the rope. The gods held the tail of the serpent, the *dānavas* the head, each group alternately pulling in opposite directions, whilst Viṣṇu, having assumed the form of a giant tortoise, served as a base for the rod. From the churned ocean emerged a number of things including Surabhi, the cow of abundance; Varuṇī, goddess of wine; the moon; the goddess Śrī seated on a lotus and holding a lotus flower; poison which was swallowed by the *nāgas* or by Śiva; and Dhanvantari, the physician of the gods, holding a chalice containing the elixir of immortality (*amṛta*).[1]

The rotary motion of churning implies expansion from a stable centre. It 'conveys a dynamic image of Cosmic Life, which is concentrated as potentiality in the immovable centre of the Supreme Being, and from there goes forth as manifested existence'.[2]

[1]The objects vary in different versions. The *Tait. Sam.*, II, 3,12,2, mentions Airāvata and the white horse Uccaiḥśravas.

[2]*Principles*, p. 172; see also Heesterman, *Ancient Indian Royal Consecration*, p. 151, n.51. According to the Homeric theory 'the Ocean was the origin of all things' (*Cults*, I, p. 265, n.b.).

Śanaiścara v. Śani.

Sanatkumāra 'Eternal Youth'. Name of one of the mind-born sons of Brahmā who chose to remain celibate. It is also an epithet applied to any great ascetic. The *Chān. Up.* (VII,26,2) equates him with Skanda, god of war, who became the 'instructor god' in Southern India.

Sandarśanamudrā v. Cinmudrā.

Sandhyā 'Juncture', i.e., twilight, personified as a daughter of Brahmā and a wife of Śiva. The *Viṣṇu Purāṇa* (I,5) states that she is an 'abandoned body' or form of Brahmā.

Śiva's dawn or twilight dance (*sandhyātāṇḍava*) symbolizes the balance of creation. He stands on his left leg with the knee slightly bent, the right leg stretched out with the heel downwards and toes pointing upwards. He is four-armed; one left hand is in *vismaya-hasta*, the other holds a bunch of peacock feathers (*mayūrapattra*). Apasmāra is not present.[1]

[1]*ID*, p. 251.

v. Devī.

Sandhyā(tāṇḍava) v. Sandhyā.

Śani or **Śanaiścara** 'Slow-moving'. Name of the inauspicious planet Saturn and of its Regent, who is depicted small, and lame in one leg, and clad in black garments. In his right hand he holds a staff or rod (indicating his destructive nature); the left is in *varada* pose according to the *Aṁśumadbhedāgama*, but the *Viṣṇudharmottara* states that he should hold a rosary. His iron chariot is drawn by eight horses,[1] or by a blue vulture (*gṛdhra*), or crow (*kāka*), or elephant. He may also have a bow and arrow, an anklet of tiny bells, and a trident.[2]

[1]Bhattacharya, *Indian Images*, pt i, pp. 32f; *EHI*, I, pt ii, p. 321.

[2]*ID*, p. 252.

v. Navagraha(s); Nikṣubhā.

Sañjalimudrā A variation of the *añjali mudrā* when an emblem is held between the two hands.

Śaṅkara 'Giver of joy'. An epithet applied to a merciful aspect of Śiva.

Śaṅkarācārya (AD 788–820) A famous commentator, philosopher and teacher, and founder of Advaita Vedānta. He taught that the world is *māyā*, or the result of *māyā*. In the context of time the world is real (*sat*), but unreal (*a-sat*) from the viewpoint of the Absolute, because ultimately it passes away. The gods (*devas*) also exist only on the phenomenal level.

Śaṅkara is sometimes regarded as an incarnation of Śiva. His *mudrās* are *cin* and *vyākhyāna*, and he is depicted as a *sannyāsin*. His emblems are a staff, water-pot, manuscript and a rosary.

Śaṅkarī v. Māheśvarī.

Śaṅkha I. General name for seashells, especially the conch-shell variety which were used from the earliest times as ornaments and amulets, and later as libation vessels. When the point of the shell is cut off the shell serves as a war-trumpet. Viṣṇu is said to have struck

terror into his enemies by the sound of his conch, but to his devotees it gives assurance and liberation. Its sound also averts calamities and destroys demons as well as ignorance (*avidyā*). Because of the shell's resemblance to the vulva (*yoni*) it is associated with fertility.

It is primarily an emblem of Viṣṇu, and occasionally of Śiva. It symbolizes eternal Space.[1] The shell and the discus (*cakra*) represent two aspects of Viṣṇu's power. Occasionally he commands them to take human form and be born among men to improve mankind's morals and welfare.[2]

Viṣṇu's conch Pāñcajanya is described as small, slender, black and melodious, and with spirals turning to the right.[3] Various accounts are given of its origin: it emerged from the ocean; it is attributed to Vṛtra in whom all things were initially contained (*ŚBr.*, V,5.5,1); derived from Soma; from lightning; or from the bones of the gods (*AV*, IV,10,7). The conch is emblematic of Indra, Balarāma, Cāmuṇḍā, Dattātreya and others. A white conch-shell containing water and placed on a tripod is an independent cult object.

[1]*Iconog. Dacca*, p. 78.
[2]*EHI*, I, pt i, p. 120.
[3]Liebert (*ID*, p. 253) states that the spirals are always represented spiralling to the right in South India, but to the left in North India.

II. Name of the demon who stole and hid the Vedas at the bottom of the sea, whence they were recovered by Viṣṇu in his fish incarnation (*matsyāvatāra*).

III. Name of one of Kubera's treasures (*nidhis*).
v. Śaṅkhapuruṣa.

IV. Name of a great Serpent (Mahānāga).

Saṅkhanidhi 'Conch-treasure (*nidhi*)', name of one of Kubera's treasures. When personified it is an attendant of Kubera.
v. Śaṅkhapuruṣa.

Śaṅkhapatra An earring (*kuṇḍala*) made from sections of shells (*śaṅkha*), and emblematic of Umā and other goddesses.

Śaṅkhapuruṣa Viṣṇu's conch-shell (*śaṅkha*) personified.
v. Āyudhapuruṣa.

Sāṅkhya v. Sāṃkhya.

Ṣaṇmukha 'Six-headed'. A twelve-armed form of Skanda who holds a number of weapons; his mount is a peacock, his *mudrās*, *abhaya*, *tarjanī* and *kaṭaka*. His two consorts are Jayā and Vijayā.
v. Kṛttikā(s); Mayūra; Ghaṇṭā.

Sannyāsin A name applied to a brahmin during the last stage of his life when he has forsaken the world as far as the individual self is concerned, but not the beings of the world.[1] His life is devoted to religious contemplation and compassion for all beings. He is assumed to have become immortal, his death being regarded as a trance-state (*samādhi*). Sannyāsins are not cremated but buried in a seated, cross-legged posture, as though engaged in meditation. Their emblem is a staff (*daṇḍa*).
[1]Organ, *Hindu Quest*, p. 132.

Śāntā A goddess, sometimes included among the seven or eight Mothers.
v. Saptamātara(s).

Śāntamūrti A peaceful aspect of a deity.
v. Saumya III.

Santāna I. One of the six aspects of Gaṇeśa worshipped by Gāṇapatyas. The five other aspects are: Mahā, Haridrā, Svarṇa, Navanīta and Unmatta-Ucchiṣṭa. These six gave rise to the six Gaṇeśa sub-cults.

II. 'Continuous succession, offspring' personified as the Son of Ugra (Śiva) and Dīkṣā who personifies 'Initiation'.

Santāna-gopāla Kṛṣṇa portrayed as a child lying on the lap of Yaśodā.
v. Bālakṛṣṇa.

Śānti I. 'Tranquillity', 'absence of passion', personified as a daughter of Śraddhā (Faith) and wife of Viṣṇu.

II. An expiatory rite for preventing disease and averting malign influences.

Śāntida 'Causing tranquillity'. A name of Viṣṇu and of the abhayamudrā.

Sapta 'Seven'.
v. Saptamātara(s).

Saptajihva 'Seven-tongued'. An epithet of Agni whose seven tongues or flames of fire are called Kālī, Karālī, Manojavā, Sulohitā, Sudhūmravarṇa, Ugrā or Sphulinginī and Pradīptā.

Saptamātara(s) or **Saptamātṛkā(s)** 'Seven Mothers'[1] who are mentioned specifically in the *Ṛgveda* (I,34,8), but are not named until post-Vedic times. The usually accepted list is Brahmāṇī, Māheśvarī, Kaumārī, Vaiṣṇavī, Vārāhī, Indrāṇī and Cāmuṇḍā (or Nāra-siṃhī). The seven represent the motherly aspects of the Great Goddess (Devī) and constitute the female counterparts of the gods Brahmā, Maheśvara, Kumāra, Viṣṇu, Varāha, Indra and Yama. The Mothers are armed with the same weapons as their respective gods and also have the same mounts and banners. Sometimes they are portrayed with identical features, only their respective weapons and emblems serving to distin-

guish them. Each Mother may be accompanied by a child either standing or seated on her lap.

The number seven is especially sacred in India and is used to express indefinite plurality, hence the seven divisions of the world, the seven sacred cities, seven rivers, etc. In Tantrism the Saptamātaras represent the female energies of the seven gods who assist Śiva and the Goddess (Devī) to destroy evil.

In the 'creation by the Word', the seven 'are identified with the seven matrices or vowels (five pure, two mixed: e, o) the basis of all language, language being the instrument of transmitted knowledge'.[2]

[1]Seven figures of indeterminate sex with long plaits and standing before a tree are often depicted on Harappan seals and may be a prototype of the Seven Mothers.
[2]*EHI*, I, pt ii, p. 381.

v. Aṣṭamātara(s).

Saptaratna 'Seven jewels', regarded as signs or marks of a universal ruler (*cakravartin*). They are the discus, elephant, horse, auspicious lucky gem (*cintāmaṇi*), wife, minister and general.

Saptarṣis(s) 'Seven Seers' all of whom were mind-born sons of Brahmā. From them, all other beings were generated.[1]

The *ṛṣis* are represented as pleasant old men, either seated or standing on a lotus plinth. They have long beards and wear *jaṭāmakuṭas*, and carry a walking stick or umbrella, or they show the *jñānamudrā*. Their clothes are made from tree bark and are held in position by *kaṭisūtras*.[2]

[1]*EHI*, II, pt ii, p. 565. Their names vary in different texts.
[2]Ibid., p. 567.

Saptasvaramaya A musical aspect of Śiva in which he personifies the seven musical notes. This aspect is beautifully portrayed in a colossal image from Parel (Bombay). The central lowermost figure is standing (*samapādasthānaka*) and holding a rosary looped over the raised hand which is in *vyākhyāna mudrā*. The left hand holds an unfinished indistinct object. The middle figure holds a water-pot in the left hand, the right is in *jñānamudrā*. The uppermost figure is depicted with ten raised arms as if dancing, and holds a noose (?), sword, rosary, and some indistinct objects. The second and third central figures are shown from the thighs upwards which emerge from behind the shoulders of the figure in front and below them, thus giving a *liṅgam*-like shape to the whole composition. The two lateral figures of the three central images show the same *mudrās* and objects as the middle figures. They wear few garments or jewels, except for the central lowermost figure which has a long *dhoti* and hanging scarves from the waist. On the lower part of the pillar some indistinct figures

of *gaṇas* are depicted playing musical instruments including a lute, flute, and a harp-*vīṇā*. Enormous power is suggested by the developed and expanded chests of the figures. The whole group portrays the tremendous centrifugal energy and multiplicity of appearances emerging from the cosmic *liṅgam*.[1]

[1]Kramrisch, *Indian Sculpture*, pp. 175f; and see Sivaramamurti, *Śatarudrīya*, pp. 5 and 59; and *Journal of the Bombay Historical Society*, 1932, p. 287.

Śara 'Arrow'; also the name of the reed from which it is made. The arrow is emblematic of Aiyaṉār, Bṛhaspati, Budha, Cāmuṇḍā, Durgā, Jyeṣṭhā, Kālacakra, Kalkin and others.

Śarabha or **Śarabheśamūrti** A fierce form, part man, beast and bird, assumed by Śiva to punish Narasiṁha for having killed the Śaiva devotee Hiraṇyakaśipu. This myth appears to be a Śaiva counterpart of the Vaiṣṇava Narasiṁhāvatāra.

Śarabha is described as having eight lion-like legs with sharp claws, a long tail, and two wings of resplendent beauty. He has one, two, or three horns, arrow-like spikes for hair, and a body glowing like fire. This fabulous being is connected with ecstasy and death.[1] A number of weapons are emblematic of Śarabha, and his *mudrās* are *abhaya*, *muṣṭi* and *varada*.

[1]Eliade, *Shamanism*, p. 469.

Śarabheśamūrti v. Śarabha.

Śāradadevī The goddess (Devī) of the lute (*śārada*)', an epithet of Sarasvatī and of Durgā.

Saramā 'Swift one'. Name of the bitch who acted as Indra's messenger, or as his watch-dog. She is regarded as the mother of all canines. Her offspring are the two 'four-eyed' dogs of Yama who guard the road to the realm of the dead.

Saraṇyū[1] A daughter of Tvaṣṭṛ and wife of Vivasvat (Sūrya) to whom she bore the twins Yama and Yamī. In her mare-form she bore the twin Aśvins and Revanta.

[1]Her name is Sureṇu in the *Bhaviṣya Purāṇa*.

v. Chāyā I; Uṣas; Ṛbhu(s).

Sārasa 'Crane', a bird symbolizing caution.[1]
[1]*ID*, p. 260.

Sarasvat Guardian of the waters and bestower of fertility, the male counterpart of the goddess Sarasvatī. Together they represent 'divine pairing', and hence those who make offerings to them are assured of offspring.[1]

[1]Heesterman, *Ancient Indian Royal Consecration*, p. 23.

v. Maithuna.

Sarasvatī 'Flowing One'. Originally the name of an ancient river of north-western India personified as a goddess of the same name. Today only its dried-up

river-bed remains. The goddess Sarasvatī has many names including Vāc, Vāgdevī, Vāgīśvarī, Bhāratī, and Vāṇī.

In Vedic times the Sarasvatī river was probably as large as the Sutlej. The *Ṛgveda* (II, 41,16) calls her 'best Mother, best of rivers, best of goddesses', and stresses her purificatory properties.

Sarasvatī is also popular among Buddhists and Jainas. She is the tutelary deity of writers, artists and poets, and embodies the spirit of all fine arts. As Brahmā's consort she represents his power. Later she was regarded as Viṣṇu's wife.

Sarasvatī is portrayed as a white beautiful woman, with two or four arms. She plays a *vīṇā* symbolizing music and the fine arts. When four-armed her emblems are a *vīṇā*, book (indicating her association with learning), and a rosary; or she may hold an arrow, mace, spear, discus, conch, bell, plough, and a bow or water-pot. Her usual mount is a goose (*haṃsa*),[1] a symbol of purity and knowledge; and occasionally a parrot (*śuka*), or a peacock (*mayūra*). Her *mudrā* is *vyākhyāna*.

[1]Sometimes a ram takes the place of the goose as Sarasvatī's mount (Bhattasali, *Iconog. Dacca*, p. 186; and see *ŚBr.*, I,7,12). Ewes were sacrificed to her. Bhattasali points out that rams are still sacrificed to her in some parts of the Dacca District, and ram fights are organized on the day of her festival.

v. Sarasvat.

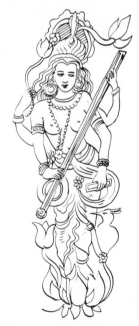

Saraṭa 'Lizard', 'chameleon', sacred to Śiva.[1]
[1]*ID*, p. 261.

Śaravaṇabhava A six-headed, twelve-armed form of Subrahmaṇya (Skanda) who was born in a thicket of reeds. He holds a rod, bow, bell, sword and other weapons, and a cock and banner. His *mudrās* are *abhaya* and *varada*.

Śārdūla A combined human and animal device; a fabulous animal which may resemble a lion, tiger, panther, leopard, or similar beast of prey, all of whom symbolize strength. Sometimes the term is applied to the mythical animal Śarabha; in temple carvings it is depicted as a kind of leogryph.

Sārikā The mynah bird, a symbol of secretiveness.

Śārṅga Name of Viṣṇu's bow (*dhanus*) made by Viśvakarman. It corresponds to the divine power of illusion (*māyā*).[1]
[1]*HP*, p. 156.

Sarpa 'Snake'.

v. Nāga.

Sarpakucabandha A breastband resembling a snake (*sarpa*) worn by snake-goddesses (*nāginīs*), and some other goddesses.

Sarpakuṇḍala or **Nāgakuṇḍala** An earring (*kuṇḍala*) made in the shape of a cobra and worn by Śiva and Gaṇeśa.

Sarpamālā A 'snake-garland (*mālā*)', worn by Śiva.

Sarpamastaka 'Snake (*sarpa*) armlet', worn by Śiva and Garuḍa.

Sarpavalaya An armlet or bracelet in the shape of a snake.

v. Bhujaṅgavalaya.

Sarpayajñopavīta or **Nāgayajñopavīta** A sacred thread in the shape of a serpent (*sarpa*) worn by some forms of Śiva. On a Naṭarāja figure the human bust of the serpent is depicted on Śiva's left shoulder, keeping time with the god's dance.

Śarva 'Archer'. One of the eight elemental forms of Rudra, the dark-haired archer, who represents the element earth, the support of life. He wears a *jaṭā-makuṭa* with a crescent moon, and holds a sword and shield. His *mudrās* are *abhaya* and *varada*.

v. Bhava.

Sarvabhūtadamanī A form of Devī, portrayed deep red in colour and with tusks. Her belly is large; she carries a skull-cup and a *vajra*.[1]
[1]*EHI*, I, pt ii, p. 364.

Sarvamaṅgalā An auspicious four-armed form of Pārvatī (Devī) seated on a lion and carrying a rosary, lotus, trident and water-pot.[1]
[1]*EHI*, I, pt ii, p. 359.

Sarvāṅgāsana A yogic posture in which the *yogin* lies on his back with legs raised vertically so that the weight of the body rests on the shoulders.

Sarvāṇī An aspect of Durgā depicted with eight arms holding an arrow, sword, discus, conch-shell, trident, bell, shield and bow. She stands on the back of a couchant lion which rests on a lotus plinth (*padmāsana*).

Śaśāṅka 'Hare-marked'. The marks on the moon which resemble a hare (*śaśa*).

Śāsta Also known as Ārya and Hariharaputra.[1] An ancient Dravidian deity taken over by Hinduism. It is customary in the Malayāḷam country to have images of Śāsta erected in the south-west corner of both Śaiva and Vaiṣṇava temples. Śāsta is predominantly a guardian of the land, and hence his temples are situated on eight mountain tops of the Western Ghats to protect the country of the Malayāḷis from all calamities.

There are variant descriptions of Śāsta in the texts. He may be four-armed and three-eyed, with a peaceful countenance, and seated in *vīrāsana* pose on a lotus. One front hand shows the *abhaya mudrā*, the other is in *varada mudrā*. His back hands carry a sword and shield respectively. He may also carry a crooked stick, and the fruits and leaves of plants, or a staff surmounted with feathers from a peacock's tail (*śikhād-aṇḍa*), or a young peacock (*śikhipota*). Occasionally he wears a half *yogapaṭṭa* supporting the left leg. His vehicle is a white, four-tusked elephant (or occasionally a horse). A cock is portrayed on his banner. His two consorts are Madanā and Varṇanī, both of whom carry lotuses.

[1] Śāsta is a form of Aiyanār worshipped especially in South India (*ID*, p. 264). For variant description of Śāsta see *EHI*, II, pt ii, pp. 485–92.

Ṣaṣṭhī A folk-goddess and protectress of children, sometimes regarded as an aspect of Durgā who is worshipped on the sixth day after the birth of a child. She is also called Skandamātā and is worshipped by Bengali women desiring offspring. The cat (*mārjāra*) is her mount. She carries a child (*bāla*), and her colour is yellow. Ṣaṣṭhī appears to have merged with the goddess Śrī (Lakṣmī).

Śāstra A treatise, scripture, or sacred book.

Śāstradevatā A deified weapon.

v. Āyudhapuruṣa.

Śāstramāna 'Canonical; according to traditional authority.'

Sasyapātra Bowl containing vegetables, emblematic of the Earth-goddess Bhūmidevī.

Sat 'Being', also a term for the good.

Śatarudrīya[1] An important 'hymn' included in the *Kṛṣṇa-Yajurveda Taittirīya Saṃhitā* which extols Rudra as the godhead with its infinite forms and aspects. There is 'no major form of Śiva which does not have its germ in the *Śatarudrīya*'.[2]

[1] Sivaramamurti, *Śatarudrīya*, p. vii.
[2] Ibid., p. 12.

Śatarūpa 'Having a hundred forms'. Name of a daughter of Brahmā. A 'hundred' stands for innumerable.

Śātavāhana or **Sātavāhana** A dynasty (100 BC to AD 200) who ruled in the northern Deccan.

Satī (English 'suttee'). A faithful wife who voluntarily immolates herself on her husband's funeral pyre. This was an ancient Indo-European custom.

The pairs of male and female skeletons buried together and discovered in the cemetery at Lothal may indicate suttee. In South India special memorial stones were erected in memory of such women.

Satī is also the name of one of Dakṣa's daughters (sometimes regarded as a former incarnation of Pārvatī) who married Bhava (Śiva). When her father insulted Śiva she burnt herself to death.

Ṣaṭkoṇa A hexagon or six-edged star which is a *yantra* and a symbol of Śiva-Śakti in *sāmarasya* (denoting the balance of equal powers).[1]

[1] *Principles*, Glossary, p. 256.

v. Trikoṇa.

Śatrughna 'Destroyer of foes'. Name of the twin brother of Lakṣmaṇa and half-brother of Rāma. Śatrughna is regarded as the incarnation of the conch (*śaṅkha*), and sometimes the conch is depicted on the top of his head-dress.

Sattvaguṇa 'Goodness', 'purity'. One of the three *guṇas*.

v. Sāttvika.

Sāttvika 'Relating to goodness, purity (*sattva*)'. Name of an icon 'represented in the *yogāsana* posture and with the *varada mudrā*'.[1] In *sāttvika* representations, frontality is predominant.[2]

[1] *ID*, p. 266.
[2] Coomaraswamy, *Transformation of Nature*, p. 148.

v. Guṇa(s).

Sātvata 'Belonging to, or sacred to, Sātvata (Kṛṣṇa)', and a term for an adherent or worshipper of Kṛṣṇa.

Satya I. 'True,' 'real'. An epithet of Viṣṇu who exemplifies truth.

II. Name of the first (the Golden Age) of the four *yugas* of the world, also called *kṛta*.

III. Name of one of Brahmā's doorkeepers, whose emblems are a lotus, rod, book, and sacrificial ladle (*sruk*).

Satyabhāmā 'Having true lustre'. Name of one of Kṛṣṇa's wives, daughter of the Yādava prince Satrājit. She induced Kṛṣṇa to steal the divine *pārijāta* tree belonging to Śacī, Indra's wife. When depicted with Kṛṣṇa, Satyabhāmā stands on his left and is identified with Puṣṭi or Bhūmi. Her emblem is a flower (*puṣpa*).

Satyaloka The highest of the seven regions above the earth, the abode of Brahmā.

Saubhāgya-Bhuvaneśvarī Name of an auspicious goddess, whose emblems are a vase of gems and a red lotus.

Saumya I. 'Relating to *soma*', i.e., the moon-god (Soma). It is also the patronymic of the planet Mercury (Budha).

II. A class of ancestors (*pitṛs*).

III. An auspicious and mild aspect of a deity, especially Śiva. Also the name of the central head of the three-headed Mahādeva.

Saunanda Name of Balarāma's club.

v. Gadā.

Saura 'Relating to Sūrya', the sun-god. Name of a cult devoted to the worship of Sūrya, the source of all things. Both Śaivas and Vaiṣṇavas recognize the sun as a symbol of enlightenment, but not as a distinct object of worship.

Saurabheya-Subrahmaṇya An eight-armed, eight-eyed form of Subrahmaṇya (Skanda). In his right hands he holds a spear, lotus, and flowery arrows; one right hand shows the *abhaya mudrā*. His left hands hold a *vajra*, sugarcane bow, trident, and one shows the *varada mudrā*. He stands with his right leg firm and straight, the left leg slightly bent.[1]

[1]*EHI*, II, pt ii, p. 441.

Sauvastika A 'left-handed swastika'.

v. Svastika.

Śava 'Corpse'. Some divinities such as Cāmuṇḍā are portrayed seated, or trampling, on a corpse. Śiva without his *śakti* is powerless and hence is unable to create or even move.[1] He is like a corpse.

[1]Śaṅkarācārya, *Saundaryalahari*, verse 1, cited in *EHI*, II, pt i, p. 60.

v. Mṛtaka; Śavāsana; Śavamālā.

Śavamālā A garland (*mālā*) of corpses', worn by Cāmuṇḍā and Kālī.

Śavāsana A corpse (*śava*)-like posture adopted by Śiva when Kālī dances on his body.

Savitar v. Savitṛ.

Savitṛ (post-Vedic) or **Savitar** (Vedic)[1] The 'Vivifier or Animator'. An epithet of Sūrya (the Sun) as the source of life and light, and the dispeller of ignorance. His emblems are a discus, club, and two open lotus flowers. His colour is golden.

[1]From the root *su* 'to bring forth'.

v. Gāyatrī; Āditya(s).

Sāvitrī v. Gāyatrī.

Śayanamūrti An image of a deity reclining. Few gods are depicted in this way, the most usual being Viṣṇu.

v. Anantaśayana.

Śekhara A diadem or ornament representing the cres-

cent of the moon depicted on Śiva's brow near his fiery third eye. The *śekhara* represents 'the power of procreation co-existent with that of destruction'.[1]

[1]Karapāṛ, 'Śrī Śiva tattva', *Siddhānta*, II, 1941–2, 116, cited in *HP*, p. 215.

Senā 'Dart', 'spear'; and a battle array and army personified as Senā, wife of Skanda the war-god.

v. Senānī; Mahāsena.

Senānī 'Leader of an army', 'commander'. An epithet applied to the war-god Skanda. Senānī (also called Devasenāpati) represents the martial prowess of Śiva.[1]

[1]Sivaramamurti, *Śatarudrīya*, p. 43.

v. Senā.

Senāpati 'Lord of Senā' or 'Lord of armies'. An aspect of Subrahmaṇya (Skanda), depicted with his *śakti* seated on his left thigh. He holds a lotus, trident, shield, *vajra*, bow, club, bell and a cock. His *mudrā* is *abhaya*.[1]

[1]*EHI*, II, pt ii, p. 435.

Śeṣa 'Remainder'. Also called Ādiśeṣa and Ananta the 'Endless'. The thousand-headed cosmic king of serpents (*nāgas*) represents cyclic time. At the end of every age his fiery breath destroys the world, and its hot ashes, the germ of what has been and will be, sink into the primordial waters (representing non-manifestation).

Śeṣa is a theriomorphic form of Viṣṇu, which represents the remains of the destroyed world.[1] He is described as dressed in dark blue, wearing a white necklace and holding a plough and pestle. In a twelfth-century inscription Śeṣa is invoked to 'grant happiness to the world'.[2]

[1]*HP*, p. 33, but Zimmer, *Myths*, p. 62, states that Śeṣa represents the residue of the world after it has 'been shaped out of the cosmic waters of the abyss'.

[2]Tewari, *Hindu Iconography*, p. 68.

v. Pātāla.

Śeṣāśāyin or **Śeṣaśāyana** An epithet of Viṣṇu when he reclines on the world serpent Śeṣa at the end of an age. Śeṣa rests on the cosmic tortoise (*kūrma*).

v. Anantaśayana.

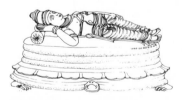

Siddha(s) 'Perfection', 'accomplishment'. A term applied to *yogins* who have acquired the 'eight *siddhis*' (supranormal faculties) and thus have reached a state of spiritual perfection. To Śaivas, Śiva is the Supreme

and first Siddha (Ādi-nātha), the divine source of perfection, hence his epithet Siddhīśvara, 'Lord of magical power'.

Siddha-Cāmuṇḍā v. Cāmuṇḍā.

Siddharātrī 'Night (*rātrī*) of realization', represented by the *mahāvidyā* Bhuvaneśvarī.

Siddhāsana 'Posture of perfection', the pose of a meditating *yogin* in which the legs are interlocked and the crossed feet lie with upturned soles on the thighs. This pose represents 'the inflow, intension, withdrawal and concentration of energy'.[1]

[1]*Principles*, p. 202.

Siddha-Yogeśvarī v. Cāmuṇḍā.

Siddhi I. 'Achievement', 'fulfilment', magico-ecstatic powers or supranormal faculties acquired by *sādhanā* and by yogic techniques. Śiva as the supreme *siddha* is called Ādinātha and Siddhīśvara, 'Lord of magical power'.

v. Siddha(s).

II. A goddess, the embodiment of perfection and achievement (*siddhi*), and one of Gaṇeśa's wives. Her body is covered with white sandalwood paste and decorated with white lotuses. She fulfils all her worshippers' desires.[1]

[1]*EHI*, I, pt ii, p. 367.

Siddhidātā 'Giver of success'. An epithet of Gaṇeśa.

v. Vignajit.

Siddhīśvara v. Siddhi I.

Śikhādaṇḍa A staff (*daṇḍa*) with peacock feathers, emblematic of Śāsta.

Śikhaṇḍaka v. Kārttikeya.

Śikhaṇḍī or **Śikhaṇḍin** An aspect of Śiva. Śikhaṇḍī is four-armed and of dark complexion. He wears a *karaṇḍamakuṭa* and ornaments. His front hands are in *abhaya* and *varada mudrās*, the back hold a sword and shield.[1]

[1]*EHI*, II, pt ii, p. 402.

Śikharamudrā 'Peak-hand pose', in which the thumb is held upwards, fingers closed on the palm. It symbolizes the erect penis, a husband, a tooth, or silence.[1]

[1]*ID*, p. 269.

Śikhī or **Śikhin** 'Peacock'.

v. Mayūra.

Śikhidhvaja A 'banner made of peacock feathers'.

v. Mayūrapattra.

Śikhipota 'Young peacock', a bird associated with Śāsta.

Śikhivāhana 'Having a peacock (*śikhi*) as a mount (*vāhana*)'. An aspect of Subrahmaṇya (Skanda) with four arms and holding a spear and *vajra*. His remaining hands are held in the *abhaya* and *varada mudrās* respectively.

Śilpa Any work of art: the practice of art.

v. Śilpin; Śilpaśāstra(s).

Śilparatna Treatise on iconography, painting, making of terracotta *liṅgas* and metal casting. Composed in the 16th century AD by Śrīkumāra.

Śilpaśāstra(s) Any book or treatise on the science of mechanics, including architecture and handicrafts. The *Śilpaśāstras* now extant deal mostly with image-making in relation to iconography and iconometry, and with the theory and practice of painting, but little with the technique of sculpture as plastic art.[1]

[1]Kramrisch, *Indian Art*, p. 213, n.90.

Śilpin 'Craftsman', an expert in any of the arts and crafts who, until modern times, was a member of a caste, guild, or of a Court.

v. Śreṇi.

Siṁha 'Lion'. The lion and its strength are identified with sovereignty, thus a king's circular or rectangular throne is called a lion seat (*siṁhāsana*). Each of the legs of the throne is carved in the shape of a lion.[1]

Jñāna-Dakṣiṇāmūrti is portrayed on a square lion throne denoting his supreme power and authority over the four corners of the universe. The square is 'a symbol of unshakeable firmness at the centre of flux and transmutation. The square, besides being the connotation of the earth-*cakra*, becomes at the end of a cosmic revolution, the symbol of re-integration into the primal Essence, the final equilibrium at the end of all manifestation'.[2]

Many varieties of Durgā have lion mounts signifying her invincible courage and victories over her enemies. A lion mask depicted on the girdles of images, symbolizes the pure radiant power of the sun, for the lion represents the solar *sattvic* principle.

[1]*EHI*, I, pt i, p. 21. Liebert (*ID*, p. 271) points out that the term *siṁhāsana* is applied to seats or thrones irrespective of their decoration.

[2]*Principles*, p. 204, citing René Guénon, *Le Roi du Monde*, pp. 130f.

v. Vāhana; Vīrabhadra; Kumbhodara; Narasiṁha; Mekhalā.

Siṁhakarṇamudrā v. Kaṭaka.

Siṁhakuṇḍala An earring (*kuṇḍala*) in the shape of a lion.

Siṁhamukha or **Siṁhamastaka** I. 'Lion-faced'. Viṣṇu incarnate as Narasiṁha has a lion face, and also in his four-faced form Caturmūrti. A lion face is often depicted on some aureoles.

v. Kīrttimukha.

II. Name of the 'knot' on the halo of an image. The halo is usually in the form of a wheel with a 'knot' of material hanging down from the hub. It may also serve as a decorative clasp for a girdle or waistband.

v. Cakra.

Siṁhāsana v. Siṁha.

Siṁha-virāla v. Gaja-virāla.

Sinīvālī A lunar goddess personifying the new moon. The other three phases are personified as the goddesses Kuhū, Anumati, and Rākā, all of whom preside over procreation.

Sinīvālī appears in the shape of the crescent moon on the head-dress of Śiva who is also called Kapardin, and hence she is called Kapardin's daughter.

Sīra 'Plough'.

v. Hala.

Śiraścakra A disc or halo behind the head of a deity representing the glory or circle of light shining around the heads of the gods. 'It should have the form of a circle [wheel] or a full-blown lotus eleven *aṅgulas* in diameter, and should be away from the head by a distance equal to a third of its diameter. This halo-circle is attached to the back of the head of images by means of a rod whose thickness is equal to one-seventh of the diameter of the *śiraścakra* . . . [in sculptures it] is considered to correspond to the *prabhāmaṇḍala* or halo of light which surrounds all divine beings.'[1] When depicted as a wheel its eight spokes denote the eight directions of space and it symbolizes world dominion.

[1]*EHI*, I, pt i, p. 32.

v. Siṁhamukha.

Śirastraka or **Śirastrāṇa** 'Turban' or a mode of dressing the hair in the shape of a turban. It is a style favoured by generals, and is emblematic of *yakṣas* and *nāgas*.

Śirastrāṇa v. Śirastraka.

Sirobandha A band worn on Viṣṇu's forehead.

Śirovarttana A technical term for the rounding of the tops of various kinds of *liṅgams*. There are a number of different tops but the five main ones are shaped like an umbrella, cucumber, egg, half-moon, or a bubble.[1]

[1]*EHI*, II, pt i, p. 93.

Sīsara A dog-demon, mate of the bitch Saramā.

Śiśupāla A king who attended Yudhiṣṭhira's royal consecration (*rājasūya*), and an enemy of Kṛṣṇa who killed him. Later he was said to be an incarnation of Rāvaṇa. Śiśupāla may have been an early name of Śiva.

Śiṣyabhāvamūrti Śiva as a pupil (*śiṣya*) of Deśika-Subrahmaṇya. Śiva should be represented seated cross-legged in front of his teacher, with one right hand across his mouth, another held near his chest in *jñāna-mudrā*; the two other hands hold a hatchet and antelope. His complexion is white and a crescent moon adorns his hair. Pārvatī may be standing by his side.[1]

[1]*EHI*, II, pt ii, pp. 443f.

Sītā 'Furrow', personified as the foster-child of Janaka, King of Videha, and wife of Rāma. She is worshipped as the divinity presiding over agriculture. As the repositories of seed, furrows were regarded as the earth's generative organs.[1]

Hopkins[2] suggests that Sītā was a kind of Corn Mother, and therefore sometimes is represented by a ploughshare. When she is portrayed with Rāma and Lakṣmana, she usually stands on Rāma's right. She wears a *channavīra*, and her hair may be dressed in a loose bun or a single plait (*ekaveṇī*). Her emblem is a blue lotus. The story of her abduction by Rāvaṇa and her rescue by her husband is recounted in the *Rāmāyaṇa*.

[1]Cf. the French synonyms for 'furrow', especially *tranche* which is also a slang term for vulva.

[2]*EM*, p. 12; see also *Aspects*, p. 116.

Śītalā Name of the goddess of smallpox, who can cause, or avert, the disease. Her shrines are usually placed under trees where she is represented by a stone, a clay image, or a piece of pinewood. Her own dwelling-place is the *kikar* tree (*Acacia arabuca*).

Śītalā is usually portrayed naked, painted red, and mounted on an ass. Her emblems are a bundle of sticks or a broom (*sammārjanī*), a winnowing fan, and an earthen pot. She is included among the Seven Mothers (Saptamātaras). Iconographically she resembles the Buddhist goddess Hārītī.

Sitār A lute with a single calabash as the resonance box.

Sitātapatra 'White parasol', emblematic of royalty.

v. Rājakakuda.

Śiva 'Auspicious'. The term *śiva* occurs frequently in the *Ṛgveda* as a euphemism applied to the fierce storm-god Rudra, who is implored to look upon his supplicants with compassion. To Vedic man Rudra represented the uncultivated, unconquered, and dangerous

part of Nature 'experienced as a divinity'.[1]

Śiva may be called *śivan*, *śivā*, or *śivam* – all his names may be rendered thus in the three genders for he is male, female and neuter.[2] He reveals himself throughout the world, in the speech of mankind and the heavens.[3] In his merciful aspects he is called Śaṅkara, Bhava, Viśvanātha, Mahādeva, etc. As the god of destruction he is known as Rudra, Bhairava, Vīrabhadra, and Mahākāla. Thus Śiva represents both death, the end of all things, and also new life which arises from destruction.

An early and unusual sculpture of Śiva from Maharashtra depicts him as a fat, dwarfish, four-armed figure, with the crescent moon and a skull on his head-dress and wearing the *tāṭaṅka* earring in his left ear, signifying his eternal androgynous form (Ardhanārīśvara). Sometimes he wears a *makara*-shaped earring in his right ear,[4] representing his maleness; in the left, a circular earring with a hole in the centre which signifies his consort Pārvatī or Devī who has various aspects corresponding to Śiva's different forms. Śiva holds a rosary and eight favourite flowers, and wears a serpent anklet. Sometimes his sacred thread is formed of snakes, and serpents form some of his other ornaments.[5] In this context the snakes represent the poisonous and polluting sensory organs that create attachments to the world and which deaden spirituality.

Śiva is sometimes depicted with the crescent moon on one side of his head and a stream of water on the other. The latter is the aquatic form of the goddess Gaṅgā, the personification of the celestial river that pervades the skies. The moon represents the goddess Sinīvālī.

Śiva's body is smeared with white ashes (*vibhūti*) and he wears white garments, a white garland, and a white sacred thread; his bull mount Nandi is white and also Śiva's banner because white exists before, and remains after, all other colours.[6] 'That in which all is found but where no differentiation takes place can be called white. . . . All the shapes of the world are potentially in Śiva yet remain undifferentiated.'[7]

His three brilliant eyes represent the sun, moon and fire, respectively. These three sources of light illumine the earth, space and sky. Through them Śiva sees the past, present and future. The vertical eye on his forehead is the eye of transcendental wisdom. It 'destroys, or rather transforms, appearance by its non-perception of duality'.[8] It is the eye of 'direct vision' that looks mainly inward, but when directed outward burns all before it. By a glance from this eye Kāma was burned to ashes, and finally it burns the universe to ashes. The crescent moon depicted on Śiva's head near the fiery third eye denotes 'the power of procreation coexistent with that of destruction'.[9] It is also the measurer of time. Śiva's matted hair (*jaṭā*) represents Vāyu, god of the wind, 'who is the subtle form of *soma*, the flow of offering. It is therefore connected with the Ganges representing the manifest *soma*, flowing from Śiva's head.'[10]

Śiva's main emblems are a drum, bow, club, or skull-topped staff, noose, and trident, but he has a variety of forms associated with different objects. Sometimes he holds a black antelope and axe. His head-dress may have a skull depicted on it. He tramples on the demon Apasmāra. A myth explains his association with the above objects. One day Śiva was passing Mount Meru and the wives of the *ṛṣis* immediately fell in love with him and lost their chastity. This so enraged the *ṛṣis* that they uttered incantations to kill him. They also sent poisonous snakes, a black antelope, Apasmāra, an axe, lion and tiger, a skull, moon, and other objects against him, but he easily overcame them. He picked up the antelope, snakes and axe, trampled on Apasmāra, killed the lion and tiger and took their skins to wear as garments, and placed the skull and crescent moon on his *jaṭāmukuṭa* as ornaments.[11]

At the end of the ages when Śiva destroys the universe leaving only a heap of ashes and calcined bones, he wears a garland of skulls (*ruṇḍamuṇḍadhārī*) signifying the continual appearances and disappearances of mankind and other creatures. He then embodies whatever consciousness is left.

The five main types of Śiva's images are: the destructive (*saṃhāramūrtis*), the boon-granting (*anugrahamūrtis*), the dancing (*nṛttamūrtis*), the yogic, and the philsophical and musical aspects (*dakṣiṇāmūrtis*).

[1] *VS*, p. 5; Heesterman, *Ancient Indian Royal Consecration*, p. 90, n.44.
[2] *EW*, I, p. 371.
[3] 'The Dance of Shiva', *Siddhānta Dīpika*, vol. XIII. i.
[4] *EHI*, I, pt ii, p. 294.
[5] Sivaramamurti, *Śatarudrīya*, p. 38.
[6] Śiva is also sometimes associated with red representing his creative force.
[7] *HP*, p. 214.
[8] Coomaraswamy, *Transformation of Nature*, p. 200, n.52.
[9] Ibid., p. 215.
[10] Ibid.
[11] *EHI*, II, pt i, pp. 113f.

v. Śivā; Śakti; Śava; Pināka; Kuṇḍalinī; Pralaya; Vibhūti; Bhikṣāṭana(mūrti); Dakṣiṇāmūrti; Ardhan-

ārīśvara; Vīrabhadra; Ḍamaru; Bilva; Bāṇaliṅga; Mahādeva; Naṭarāja; Bhairava; Trimūrti; Pārvatī.

Śivā I. 'Auspicious'. A four-armed, three-eyed *śakti* of Śiva. She may be portrayed seated on a bull. Her emblems are a drum entwined with a snake, and a trident; her *mudrās* are *abhaya* and *varada*.[1]

[1]*EHI*, I, pt ii, p. 366.

II. 'Jackal'. v. Śṛgāla.

Śivadūta 'Śiva's messenger (*dūta*)'. A name of one of Śiva's attendants.

Śivadūtī A fierce, four-armed form of Durgā portrayed with an emaciated body and jackal-like features. Her body is ornamented with snakes and a garland of skulls. Her emblems are a blood-filled bowl, a sword, trident, and a piece of flesh. She is seated in *ālīḍhāsana* pose. Sometimes her ornaments are set with nine gems (*navaratna*).[1]

[1]*EHI*, I, pt ii, p. 365.

Śivagaṇa(s) Attendants of Śiva.

Śivajyotis 'Auspicious light'. In ritual, fire as the Destroyer (an aspect of Śiva), is called a *liṅga*, an auspicious light. 'When the inner vision of pure Knowledge is attained, the *liṅga* of light is seen everywhere piercing the world'.[1]

[1]*HP*, p. 229.

Śivakāmī 'Śiva's beloved'. An epithet of Pārvatī when depicted standing at the side of Śiva Naṭarāja.

Śivalaya Name of Śiva's abode on Mount Kailāsa.

Śivaliṅga v. Liṅga.

Śivamālā 'Śiva's rosary'.

Śivanārāyaṇa v. Hari-Haramūrti.

Śiva-śava Śiva represented as a corpse (*śava*) beneath the feet of Kālī.

v. Śakti.

Śivavivāha v. Kalyāṇasundaramūrti.

Śivottama 'Highest Śiva', depicted standing erect (*samabhaṅga*). He has four arms, two eyes, and wears a *karaṇḍamakuṭa* and many ornaments. His sacred thread is white. His front hands show the *varada* and *abhaya mudrās*, the back ones carry a trident and noose.

Skambha or **Stambha** 'Support', 'pillar', often used in a cosmic sense as the pillar connecting heaven and earth.

Skanda or **Mahāsena** God of war and leader of the armies of the gods. He has a number of epithets and names, many of them regional: Sanatkumāra, Guha, etc; in South India, Brahmaṇya or Subrahmaṇya. His mount is a peacock (*mayūra*), or an elephant (*gaja*). Skanda, like Śiva, is attended by animal-headed sprites, demons, and the Seven Mothers (Saptamātaras).

Skanda is portrayed as a handsome, virile youth, with one or six heads (*ṣaṇmukha*), and two or twelve arms. His garments are red, the colour of blood and of war. Similarly his banner is red and denotes the fire of destruction. He holds a bow and arrows, sword, thunderbolt, axe and a javelin or spear. The last returns to his hand after killing his enemies.

The number of arms differ according to the region where he is worshipped. In a small town his image will have 'twelve hands in *karbaṭa*, it will have four . . . while in a forest or a village it will have two'.[1] When two-armed he holds a cock in the right hand and a spear (*śakti*) in the left; in four-armed images a cock and a bell are held in the right hands, the left hold a spear and the banner of victory.

[1]Bhattacharya, *Indian Images*, pt i, p. 26.

v. Kārttikeya; Kumāra; Somāskandamūrti; Kaumārī; Senā; Vallī.

Skandamātā 'Mother of Skanda', an epithet of Durgā whose mount is a lion. She holds lotuses.

Smarahara 'Remover of desire'. A Śaiva *yantra* consisting of five triangles. The number five is sacred to Śiva and corresponds to his generative and destructive aspects.[1]

[1]*HP*, p. 356.

Smaśāna Cremation ground; tumulus or burial ground. The dead were not always cremated in Vedic times, but abandoned to wild beasts.[1]

Śiva is said to dwell in *śmaśānas* and hence his epithet Śmaśānavāsin.

[1]*WI*, p. 177.

Śmaśānavāsin v. Śmaśāna.

Smṛti That which is 'remembered', traditional authority, as distinguished from revelation (*śruti*).

Ṣoḍaśabhuja-Durgā The 'sixteen-armed form of Durgā'. She has three eyes, and in each of her sixteen hands she holds a trident.

Ṣoḍaśī Lit. the 'maiden of sixteen'. A goddess, one of the Mahāvidyās who represents totality and perfection.

The *Ṣoḍaśī Tantra* identifies her with the goddess Tripurasundarī who represents 'the light radiating from the three eyes of Śiva'.[1]

[1]*HP*, p. 278.

Śokarahitā v. Navapatrikā(s).

Soma Name of a plant (not yet identified), and of its yellow juice which played an important part in Vedic sacrificial ritual. It was regarded as the nectar of immortality, the drink of the gods. The sap had strong hallucinogenic properties, and was 'the manifestation *par excellence* of the life-giving principle'.[1] The inspiration of the sacred 'hymns' are also ascribed to its qualities, which enabled the partaker to share – temporarily – in the divine mode of being.[2]

Soma represents the watery substance of the universe. Later it designated the moon (Candra).

[1]Heesterman, *Ancient Indian Royal Consecration*, p. 193.

[2]Eliade, *Patterns*, p. 162: and see R. G. Wasson, *Soma, Divine Mushroom of Immortality*.

Somadeva The moon-god and lord of plants.

v. Soma; Candra.

Somāskandamūrti Name of a group including Śiva, Umā and their son Skanda who stands, sits, or dances, between them. Skanda is usually nude, and wears a crown, earrings, bracelets and a *channavīra*. If standing he may hold a lotus flower in the right hand, with the left hanging by his side, or he holds two lotuses. When dancing Skanda carries a fruit in the left hand, or it is stretched out and empty; the right hand is in *sūci* pose. Śiva has four arms and shows the *abhaya* or *varada mudrās*, and holds an antelope (representative of all cattle), an axe and a hatchet. Umā's *mudrā* is the *kaṭaka*, and her emblem a lotus.

Sopāśrayāsana or **Sopāśraya** 'Having a support'. A yogic 'sitting position in which the knees are placed against a wooden bar called a *yoga-paṭṭaka*'.[1]

[1]Bhattacharya, *Indian Images*, pt i, p. 50. Sometimes this position is regarded as identical with *yogāsana* (*ID*, p. 278).

Sphaṭikaliṅga A *liṅga* usually fashioned from crystal or quartz and worshipped in the home.

v. Kāpālika.

Śreṇi A guild, a group of men practising the same occupation. An elementary guild system probably existed in Vedic times. By the fifth century BC all important towns had guilds covering most trades and industries.[1]

[1]*WI*, p. 217; Auboyer, *Daily Life in Ancient India*, p. 102.

Śṛgāla 'Jackal'. Durgā assumed the form of a jackal on the night of Kṛṣṇa's birth to protect him from the murderous King Kaṃsa.

A number of jackals are associated with Kṣamā, and one jackal is the mount of Kālī.

Śrī or **Śrīdevī** 'Prosperity', 'good fortune', 'beauty', personified as a goddess, a consort of Viṣṇu. In post-Vedic times Śrī was identified with Lakṣmī. (Śrī is also a title of respect.)

Viṣṇu wears a small image of Śrī on his right breast. The figure is usually stylized and resembles a triangle. She is described as resplendent and shining. She dwells in garlands, and hence wearing them brings good luck, prosperity and victory. Śrī also signifies the glory and prosperity of heaven, the fortune of kings, and the ideal in every household. She is associated with rice cultivation and soil, hence her epithet Karīṣin 'abounding in dung'.[1]

Śrī may be depicted seated on a lotus, holding two lotus flowers, or one lotus and a *bel* fruit (*śrīphala*). In this context the lotus symbolizes beauty which delights mankind, and also purity, the moral sense, and intellect.

[1]*VS*, p. 71; and *Aspects*, p. 220 and n. 43. Śrī is called 'the arrow of Śiva' (Sivaramamurti, *Śatarudrīya*, p. 35).

v. Gaja-Lakṣmī; Śrīvatsa.

Śrīcakra v. Yantra.

Śrīdevī v. Śrī.

Śrīdhara 'Bearer of fortune'. A form of Viṣṇu worshipped especially by *śūdras*. His *śakti* is Medhā.

v. Śrī.

Śrīkaṇṭha 'Beautiful throated'. Name of one of the eleven Rudras (Ekādaśarudra) depicted four-armed and handsome, with richly embroidered clothes (*citravastra*), and wearing a *yajñopavīta* of fine workmanship. He carries a sword, bow, arrow, and shield, or a hatchet and trident: two hands are in *varada* and *abhaya* poses.[1] The Śrīkaṇṭha aspect is another name for the Nīlakaṇṭha aspect of Śiva, reflecting the myth that his throat turned dark blue when he held the poison in it which otherwise would have destroyed all creatures.

[1]*EHI*, II, pt ii, pp. 391, 402.

v. Samudramathana.

Śrīphala Fruit of the *bilva* or *bel* tree, emblematic of Śiva, Durgā, Kārttikeya, and of Skanda when depicted as a child with his parents (Somāskandamūrti).

Śrīvatsa 'Favourite of Śrī', goddess of good fortune. Śrīvatsa is a term for a particular auspicious mark or sign (*lakṣaṇa*), denoting a great man or signifying divine status. It also represents the source of the natural world.[1]

The *śrīvatsa* may be depicted as a triangle, cruciform flower, or a whorl of hair on the side of the chest.[2] When portrayed on the chest of Kṛṣṇa or Viṣṇu it represents Śrī-Lakṣmī. This mark also appears on some Buddhist and Jaina images. The figure of Śrī is sometimes combined with the *śrīvatsa*.

[1]*HP*, p. 157.
[2]*EHI*, I, pt i, p. 25.
v. Vaijayantīmālā.

Śṛṅga 'Horn'. An emblem carried in the hands of Viśvarūpa and Yajñamūrti.

Sṛṣṭi-sthiti-saṁhāra 'Creation, preservation and dissolution of the universe'. Creation having arisen from the state of non-manifestation, enters the realm of time in which everything born dies. Creation was re-enacted in reverse in the Vedic sacrificial ritual, 'fusing multiplicity back into the primordial unity which centrifugal creation "burst asunder"'.[1]

[1]Lannoy, *The Speaking Tree*, p. 286.
v. Naṭarāja.

Sruk A large, long-handled wooden ladle with a spout, made of *palāśa* or *khadira* wood and used for pouring ghee (*ghṛta*) onto the sacrificial fire. The *sruk* is emblematic of Brahmā, Agni, Annapūrṇā, Sarasvatī, Yajñamūrti and others, and indicates that the deity is acting as a sacrificer, or in the case of Annapūrṇā it signifies her generosity.[1]

[1]*ID*, p. 281.
v. Juhū; Sruva.

Śruti v. Smṛti.

Sruva A small wooden, sacrificial spoon used for pouring ghee onto the ladle (*juhū*). A *sruva* made of *palāśa* or *vikaṅkata* wood will prevent demons (*rākṣasas*) from interfering with the sacrifice (*ŚBr.*, V,2.4,18).
v. Upabhṛt; Sruk.

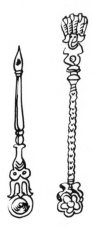

Stambha v. Skambha.

Stanabandha 'Breastband'.
v. Kucabandha.

Stanahāra A necklace which hangs down to the breasts.

Stanottarīya A breast ornament depicted in sculptures from northern India.

Sthalavṛkṣa A sacred tree (*vṛkṣa*) associated with a temple, or deity, of a particular place.

Sthānakamūrti An icon of a standing deity placed in the *garbhagṛha* of a temple.

Sthāṇu 'Immovable', 'standing firmly'. A particular posture adopted by some holy men (*sādhus*) who vow to remain for months or years perfectly motionless.

Sthāṇu is also an epithet applied to Śiva. It refers to his great ascetic practices (*tapas*), when he remains motionless like a post, until the dissolution of the universe (*pralaya*).

Sthāpana The fixing or erecting of an image.
v. Pratiṣṭhā.

Sthapati An 'architect, sculptor; metal worker; a master-craftsman.'

Sthauṇa-Narasiṁha A form of Narasiṁha (Viṣṇu) who emerged from a pillar (*sthauṇa*). Variant iconographic descriptions of this deity are given in different texts. He may be depicted four-armed, seated, and holding a conch and discus, with the front right hand in *abhaya* or *varada mudrā*, the front left resting on his thigh.

His neck is covered with a thick mane, and his fang-like teeth should be distinctly visible. Or the figure should have eight, twelve or sixteen arms and stand in *tribhaṅga* pose. Two of the man-lion's hands rip open the belly of Hiraṇyakaśipu. His other hands pull out the *asura*'s entrails like a long garland. Śrīdevī, Bhūmidevī, Nārada with his *vīṇā*, and Prahlāda with his hands in *añjali mudrā* may be depicted standing on either side of Narasiṁha. In the eight-armed forms, two hands tear out the entrails and four others carry the conch, club, discus and lotus.[1]

[1]*EHI*, I, pt i, p. 154.

v. Narasiṁha.

Strīpūjā 'Woman (*strī*) worship', a Śākta rite in which a nude woman and the *yoni* are worshipped.

v. Śākta.

Stūpa A dome-shaped monument erected over sacred relics, especially those of the Buddha.

v. Maṇḍala.

Subhadrā Sister of Kṛṣṇa and wife of Arjuna. She accompanies Viṣṇu in his form of Jagannātha.

Subrahmaṇya An ancient and popular Dravidian folk-divinity who became identified with the war-god Skanda. He has many names including Kārttikeya, Kumāra, Mahāsena, Ṣaṇmukha, Senānī, Guha, etc. His Tamil name is Murugan. These names suggest that there are a number of allied god-concepts 'at the root of the later unified idea of a deity by the name of Skanda-Kārttikeya'.[1]

Subrahmaṇya may be depicted seated or standing, with two, four, or more arms, and with one or six faces. He is portrayed as a powerful, handsome youth, seated on a lotus throne (*padmāsana*), or on a peacock. The two-armed form represents the *sattvaguṇa*; the four-armed, the *rajas guṇa*; with more arms, the *tamas guṇa*.[2]

Subrahmaṇya's four-armed representation may carry a cock, spear, rosary, *vajra* and water-pot. His *mudrās* are *abhaya* and *varada*. The two and four-armed forms are said to bestow *siddhi* on his devotees. When six-armed he holds a sword and spear. One right hand is in *abhaya mudrā*, the left hands hold a shield, rosary and a cock. Being the commander of the army of the gods most of his emblems are naturally weapons, his main one being a spear (*śakti*), an invincible weapon made by the artificer of the gods, Viśvakarman, from a portion of the sun's glory. His banner consists of peacock feathers (*śikhidhvaja*); his consorts are Devasenā and Vallī.

[1]*DHI*, p. 362.

[2]*EHI*, II, pt ii, p. 425.

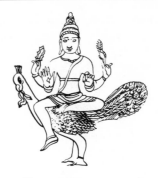

v. Śaktidhara; Śikhivāhana; Brahmaśāstā; Tārakāri; Guṇa(s).

Sūci(hasta)mudrā 'Needle (*sūci*) hand pose'. A *mudrā* with the index finger extended and pointing downward or upward, with the thumb and other fingers bent; or all the fingers stretched out with the tips joined to resemble a needle. It signifies, *inter alia*, the universe, elephant tusks, sin, one hundred, and astonishment.[1] Kālārimūrti and Kāmāntakamūrti show this *mudrā*.

[1]*ID*, p. 283.

Śudarśana 'Fair to see'. Name of Viṣṇu's wheel or discus (*cakra*) which symbolizes the boundless power of his mind and thought. It also denotes the continual changeability of mind (*manas*). Worlds are created, sustained and destroyed during Śudarśana's ceaseless revolutions. The *Ahirbudhnya-saṁhitā* defines Śudarśana as 'the original thought of Para-brahman when it, of its own accord, conceived the idea of expanding into space and thus bringing into existence the universe. This thought of the Supreme Being . . . is indestructible.'[1]

Śudarśana is personified and variously portrayed, sometimes as a small figure (*cakrapuruṣa*) with round eyes and drooping belly, on whose head the left hand of Viṣṇu rests (*Viṣṇudharmottara*, III, 85, 13f); or as an ordinary discus or wheel with a terrifying figure of Viṣṇu standing in the centre with two interlaced equilateral triangles (*ṣaṭkoṇacakra*) behind him; or as a wheel with twelve stylized lotuses as spokes, with a figure of Viṣṇu standing on Garuḍa portrayed on the hub.

Śudarśana is also worshipped as an independent cult object.
[1]*EHI*, I, pt i, p. 291n.

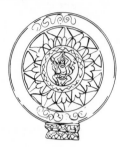

Sudeha v. Dvārapāla(s).

Śuddha-Śaiva v. Mahāsadāśivamūrti.

Śūdra The fourth social class. The *śūdras* are mythologically represented as emerging from the feet of the Cosmic Puruṣa, so indicating their lowly relationship to the other classes they are meant to serve.

Sugrīva 'Beautiful neck'. The divine monkey or ape-king (a son of Sūrya the sun-god), whose throne was usurped by his brother Bālin, but later Rāma reinstated him at Kiṣkindhyā.

Śuka 'Parrot'. A parrot is sometimes associated with Sarasvatī and Agni. Kāma's chariot is drawn by parrots.

Śukatuṇḍa mudrā 'Parrot-beak'. A hand pose (*mudrā*) with the forefingers and ring finger bent. It indicates shooting an arrow, dismissal, or ferocity.[1]
[1]*ID*, p. 285 and see Coomaraswamy, *Mirror of Gesture*.

Sukhāsana 'Sitting at ease'. Any comfortable sitting position (*āana*) similar to the *ardhaparyaṅkāsana* or the *lalitāsana*.
v. Sukhāsanamūrti.

Sukhāsanamūrti A seated form of Śiva which the *Śilparatna* describes as a three-eyed, four-armed, handsome figure with coral red complexion. The left leg is bent and rests on the seat, the right touches the floor. Sukhāsanamūrti wears a lion-skin and silk garments; his back left hand holds an antelope, the front right is in *abhaya* pose, the front left is in either *varada* or *kaṭaka* pose. A *makara* or lion-shaped earring is shown in the right ear, in the left a *patrakuṇḍala*, or he wears round earrings *vṛttakuṇḍalas* in both ears. His bracelets, sacred thread, and other ornaments are snake-shaped. Neither Devī nor Skanda should accompany Sukhāsanamūrti.[1]
[1]*EHI*, II, pt i, pp. 129f.

Śukra 'Bright', 'clear'. A mythical *ṛṣi* (also called Uśanas), teacher of the *daityas*. He became a star-god, the personification of the planet Venus, the presiding deity of semen.[1] His golden or silver chariot is drawn by eight (or ten) horses, and he holds treasure, book, staff and water-pot.[2] The treasure (*nidhi*) indicates his kingly nature. He may be two- or four-armed, and his garments are white.
[1]*HP*, p. 325.
[2]Bhattacharya, *Indian Images*, pt i, p. 31.

Sukranītisāra[1] A medieval Indian treatise primarily on statecraft and social organization, but which also contains some passages on image making.
[1]*The Sukranīti*, tr. Sarkar.

Sūkṣma I. 'Subtle', a term for mental images as opposed to material ones which are termed gross (*sthūla*). The latter is descriptive and is not to be taken in a derogatory sense.

The carvings of celestial beings in temples appear with deep shadows making them seem immaterial and unearthly. They float dreamingly in the heavenly bliss of perfect harmony. Hindus regard these forms as having been carved, not from gross matter but from the 'subtle' matter of dreams and inner contemplation.[1]
[1]*AIA*, p. 35.
v. Vidyādhara(s).

II. An aspect of Śiva, with a benign countenance, four arms and three eyes. His garments and ornaments are elaborate. His front hands are in *varada* and *abhaya mudrās* respectively; his back hands carry a hatchet and trident.[1]
[1]*EHI*, II, pt ii, pp. 410f.

Sūkta A Vedic 'hymn'. Later the term denoted a wise saying, a song of praise, etc.

Śūla 'Spear', 'trident'. In Tantrism, *śūla* symbolizes the erect penis.[1]
[1]*ID*, p. 286.
v. Śakti II; Triśūla.

Śūladhara or **Śūlapāṇi** Epithets applied to Śiva when carrying a trident (*triśūla*).

Sumeru v. Meru.

Sumitra 'Good friend (*mitra*)', name of one of Skanda's attendants.

Sumukha 'Good-faced'. Name of one of the two doorkeepers of Subrahmaṇya's shrine in the Śaiva temple at Tanjore. He wears a crown surmounted by a trident and elaborate jewellery. His emblems are a short sword and shield. The back left hand shows the *vismaya mudrā*, the back right, the *sūci* pose. His right foot rests on a couchant lion, his left on a lotus plinth.
v. Dvārapāla(s).

Sundarī The 'Fair One', an aspect of Pārvatī.

Śunā-Śīra 'Ploughshare' and 'plough' personified as agricultural divinities (*RV*, IV,57,5). Śunā-sīra is also an epithet applied to Indra, and alludes to his association with vigour and fertility.

Sundaramūrti I. An auspicious form of Śiva.

II. Name of a South Indian Swāmi, and Śaivabhakta

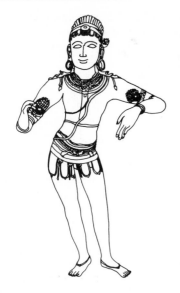

(eighth or ninth centuries AD). He may show the *añjali mudrā*.

Śuṅga Name of a dynasty (187–75 BC).

Śūnya 'Void', 'zero', 'inexhaustible potentiality'. As a Hindu philosophical term *śūnya* 'was originally conceived as a symbol of *brahman* and *nirvāṇam* . . . the unifying point of indifference and the matrix of the All and the None'.[1] *Śūnyata* is the realization of the emptiness of all existence and the comprehension of the fullness of the Supreme Being. It is symbolized by a dot (*bindu*).

[1]*Facets*, p. 94.

Suparṇa 'Having beautiful wings'. A mythical eagle or vulture noted for its strength and speed. Suparṇa may have been a prototype of Garuḍa, king of *suparṇas*. In the *Viṣṇu Purāṇa* (I, 21) Garuḍa is called Suparṇa.

Surā or **Surādevī** 'Wine', and the name of the goddess personifying it. Surā is equated with Vāruṇī, the consort of Varuṇa. She is the presiding deity of the wine used in the ritual of the 'Five Ms' (*pañcamakāra*).

Surabhi or **Surabhī** Name of the fabulous 'Cow of Plenty', also called Kāmadhenu, the first of the 'treasures' to emerge from the churning of the ocean (*samudramathana*). She represents the continuous proliferation of Nature and is specifically the progenitor of cattle. Sometimes she is represented as a beautiful woman with a cow face. Her emblem is a water-vessel, and a bunch of grass (*tṛṇa*). She is worshipped by those people desiring prosperity.

Surabhimudrā 'Cow-gesture (*mudrā*)', in which the ten fingers are held in a position resembling the four teats of the cow Surabhi.

Surādevī v. Surā.

Suranāyika A celestial damsel or nymph.

Surasundarī A celestial nymph.

Sureśvara One of the eleven Rudras (Ekadaśarudra) whose emblems include a drum, discus, trident, goad, bow and arrow, lotus, axe, bell and alms-bowl. His *mudrā* is *tarjanī*.

Śūrpa or **Sūrpa** A wicker winnowing basket or sieve used for ritual and domestic purposes. It is an emblem of the goddess Śītalā. Sometimes it is personified as a *gandharva*.[1]

[1]See Auboyer and de Mallman, 'Śītalā la Froide', pp. 207ff.

Śūrpakarṇa 'Having ears like winnowing fans'. An epithet of Gaṇeśa.

When Agni, the god of fire, was cursed by the *ṛṣis* to be extinguished, Gaṇeśa took pity on him, and with his great ears fanned him into life again.[1]

[1]*EHI*, I, pt i, p. 60.

Śūrpanakhā 'Having fingernails like winnowing fans'. Name of Rāvaṇa's sister who fell in love with Rāma.

Sūrya or **Savitar** The Sun-god, a composite deity consisting of a number of Vedic and solar divinities.[1]

Sūrya is depicted holding fully opened lotus flowers – in South India, half-opened lotus buds – which symbolize his creative function. He may be represented also as the celestial solar bird Garutmān, or as the beautiful white horse accompanying Uṣas, goddess of the dawn. Sūrya's chariot has one wheel (representing the annual cycle of the seasons), and is drawn by seven bay or red mares, or by one horse called Etaśa. The single wheel is depicted behind the centre horse.

According to the *Matsya Purāṇa*, Sūrya's feet should never be depicted. Anyone disregarding this injunction will be afflicted with leprosy.[2] Sūrya's two attendants are Daṇḍa (Daṇḍī) and Piṅgala. Sūrya's girdle is called *paliyāṅga*; sunbeams form the bridles of his horses. Both Daṇḍī and Piṅgala should be dressed in the northern fashion. Sūrya wears an elaborate necklace in the shape of flames which, when viewed from the right angle, seem to flicker and create glory in his path.[3] The two small female figures on the outer edge of the plinth are personified aspects of 'dawn' who drive away darkness with their arrows.

The Sun is the celestial door to immortality (*Chān. Up.*, 8,6,5) for it is the centre of creation, the point where the manifested and unmanifested worlds unite. As the Sun consists of fire which forever consumes itself,[4] it is identified with the Cosmic Sacrifice and represents the Cosmic Being who rises as life and fire (*Praśna Upaniṣad*, 1.6,8). But the sun is also associated with Death, since Death dwells within the immortal sun, and hence Death cannot die (*ŚBr.*, x,5.2,3; see also verse 4 and n.2).

Sūrya is generally portrayed with a halo, the

diameter of which should be twice the height of his crown. He wears armour, an ornamental girdle, and a rolled cloth over his waistband, or it may be folded and hung from the front of the girdle. The breastplate 'often takes the form of a knot formed on the chest by the interlacing of lines passing round the shoulders and under the arms: [or as] . . . a thin ornamental scarf crossed over the chest and of such fine texture that the body shows through it'.[5] He wears a *karaṇḍamakuṭa*, ruby earrings, a heavy necklace, and a garland of flowers. One authority states that half of Sūrya's body taken vertically 'should have the shape of a dark-complexioned woman, probably indicating that the sun, in spite of being a god of light, is inseparably wedded to night and its darkness'.[6] His nose, forehead, chest, knees, thigh and neck should all be raised and prominent. His banner has a lion, a solar animal, portrayed on it. When Sūrya is depicted as the chief of the Ādityas he holds a rosary, water-vessel and two lotuses.

[1]*WI*, p. 312.

[2]The *Bṛhat Saṃhitā* directs that Sūrya's body should be hidden up to the thighs or breast. In images from Bengal the legs were left uncarved and thus appeared as if covered by leggings or boots (*Iconog. Dacca*, p. 158).

[3]*Marg*, vol. XVII, Sept. 1964, no. 4, p. 15, and fig. 5.

[4]The sun is in a state of equilibrium. Thus as the result of the conversion of hydrogen to helium by nuclear reaction in its interior, the sun's mean molecular weight remains equal to the energy produced.

[5]*Iconog. Dacca*, p. 159.

[6]*EHI*, I, pt ii, p. 307.

v. Rājñī; Navagraha(s); Revanta; Pratyūṣā; Uṣā.

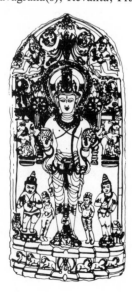

Sūryā Daughter (or wife) of Sūrya.

Sūryabhānu Name of Kubera's door-keeper who was slain by Rāvana.

Sūryakānta The Sun-stone said to be formed from the Sun's rays.

v. Pañcāyatana.

Sūrya-maṇḍala The Sun-disk or sphere. An attribute of Sūrya, Rāhu and some other deities.

Sūrya-Nārāyaṇa A representation of Viṣṇu (Nārāyaṇa) (or of Śiva), and the Sun (Sūrya). In the Vedas Viṣṇu appears as a minor solar deity. The *mudrā* of Sūrya-Nārāyaṇa is *varada*; his emblems two lotuses, an antelope and trident. The two last are especially associated with Śiva.

Sūryavaṃśa The Solar Dynasty or line of kings, whose founder Ikṣvāku, claimed descent from the sun-god Sūrya. Many kings claimed descent from the Solar Dynasty, and also the historical Buddha, the Jaina *tīrthaṅkara* Mahāvīra, and Rāmacandra.

Śuṣṇa 'Parcher'. Name of a Vedic demon causing drought who was overthrown by Indra. Śuṣṇa is described as one-horned and the possessor of 'magical devices'.

Suśrutasaṃhitā 'Compendium of Suśruta'. A medical work compiled by the *ṛṣi* Suśruta (fourth century AD) which represents the views of the school of medicine founded by Ātreya and later developed by Caraka in his *saṃhitā*. These two works are the basis of *āyurveda*, the science of Indian medicine.

Sūta I. 'Charioteer', an important position in olden times. His role was to relieve the tedium of the warrior or king on long journeys. Later the *sūta* became a Court official ranking with the Commander-in-Chief of the army.

Kṛṣṇa acted as Arjuna's charioteer during the *Mahābhārata* war; Aruṇa is Sūrya's charioteer.

II. A name of the pre-Aryan wandering minstrels.

Sūtra I. Lit. 'thread'. A term applied to compositions written in aphoristic style. *Sūtras* were compiled by individual priestly schools from about the sixth or seventh centuries BC to the second century AD.[1]

[1]*CHI*, I, p. 227.

II. Another name for a rosary (*akṣamālā*).

Sutrātman The spiritual essence (*ātman*) that passes like a thread (*sūtra*) through the whole universe.

Suvarṇavaikakṣaka A golden (*suvarṇa*) chain belt.

Svadhā An invocation uttered when offering oblations to the *pitṛs*, and to the ancestors who feed on the essence of the offerings. Both the invocation and the reverence paid to the *pitṛs* are 'ritual entities' which create a 'place' (*loka*) for them to exist in.[1]

Svadhā is personified as a daughter of Dakṣa.

[1]Gonda, *Loka*, p. 65.

v. Svāhā.

Svāhā A ritual call or invocation uttered when making oblations to the gods, and at the beginning and end of *mantras*. Svāhā is personified and identified with Umā, to whom women pray who desire children. Svāhā also possesses magical powers, and is personified as the wife of the sacrificial fire Agni (or of Śiva Paśupati), the central figure in all Vedic sacrifices.

v. Svadhā.

Svakucagrahamudrā A *mudrā* in which a person touches his breast. Hayagrīva shows this pose.

Śvan 'Dog'. Dogs were not unfavourably regarded in pre-Vedic India, as is indicated by numerous myths regarding them. Thus Indra, when disguised as a beggar, is accompanied by a dog; Rudra is called lord of dogs (*svapati*). A passage in the *Śatarudrīya* salutes dogs and pays 'homage to the dog-lords'. Sometimes Śiva assumes the guise of an outcaste (*caṇḍāla*) accompanied by four dogs, who represent the four Vedas.[1] Also Nirṛti, Vīrabhadra, and Baṭuka-Bhairava are accompanied by a dog or dogs. Indra has his own bitch called Saramā; Mallāri-Śiva is accompanied by seven dogs; Yama's realm is guarded by two hounds. Yudhiṣṭhira refused to enter the celestial realms without his dog, whereupon Indra commended his fidelity to the animal.

The huge hunting dogs of the Indian kings were greatly admired by Alexander the Great. Indian dogs were bred in Babylonia during the reign of the Persian Emperor Artaxerxes I (465–24 BC), and were also known in the Egypt of the Ptolemies.[2] A memorial or hero stone was erected to the memory of a hound which fought and killed a tiger and then dropped dead, because 'Śiva embodies the highest glory wherever it is, even in dogs as seen in the epithet śvabhyaḥ'.[3]

[1]Sivaramamurti, *Śatarudrīya*, pp. 20, 63.

[2]*WI*, p. 196.

[3]Sivaramamurti, ibid., fig. 42.

v. Dattātreya.

Śvapati v. Śvan.

Svapna 'Sleep'. Śiva as lord of sleep represents both the final dissolution of the personality, the cessation of self-manifestation, and from the cosmic viewpoint, the ultimate disintegration of the universe. Śiva symbolizes the boundless void, the substratum of existence. Beyond him there is only non-existence (*Śvetāśvatāra Upaniṣad*, 4,18). According to the *Bṛhad-Ār. Up.* 4.3,9), a sleeping person sees this world and the other world.

Svarbhānu Name of a demon who causes darkness and from whom the Atris rescued the sun. In later mythology Svarbhānu is identified with Rāhu, the eclipse demon.

Svarga The heaven or paradise of Indra.

Svarṇa 'Gold'.

v. Santāna; Anala I; Pañcaratna; Gāṇpatya.

Svarṇabhadra 'Bright stone'. An auspicious red stone found in a river at Arrah. It represents the aniconic aspect of Gaṇeśa.

Svarṇākarṣaṇa-Bhairava An aspect of Bhairava (Śiva) having three eyes, four arms and clothed in yellow garments. He wears elaborate ornaments and carries a vessel filled with gold and gems, a fly-whisk, an iron club or pestle (*tomara*), and a large trident resting against his shoulder. His countenance suggests happiness and authority.[1]

[1]*EHI*, II, pt i, p. 179.

v. Bhairava.

Svarṇarekha A piece of stone or ore regarded as the aniconic form of Durgā.

v. Pañcāyatana.

Svarūpa 'Own form or essence'; 'intrinsic aspect'.

Svasti-devī Goddess (*devī*) of the home, who may be identical with the goddess of safe paths and good fortune, Pathyāsvasti. She protects and confers prosperity on the household (*RV*, IV, 55,3).

Svastika 'Swastika'. Lit. 'of good fortune'. I. An ancient auspicious magical mark or motif common to Hindu, Buddhist and Jaina religions. It has been found also in the Indus Valley, Mesopotamia, Palestine,[1] South America, Easter Island, and many other places.

The right-handed swastika is shaped like a Greek cross, and is 'associated with the sun and hence is an emblem of the Vedic solar Viṣṇu, and symbol of the world-wheel, indicating cosmic procession and evolution round a fixed centre'.[2] It also signifies the male principle. The left-handed swastika (*sauvastika*) represents the sun during autumn and winter, and is regarded as female and inauspicious, but it is not unlucky to the female sex. It is sacred to Kālī. The male and female swastikas maintain perfect balance in the cosmos. The right-handed swastika and other auspicious marks should be depicted on temple doors, on houses and cattle sheds to protect families and animals from the evil eye. The swastika is associated with Indra, Brahmā, Sūrya, Viṣṇu, Śiva, Śakti, and with Gaṇeśa as god of the crossroads.

The swastika is especially associated with snakes (*nāgas*) and snake divinities, the 'spectacle marks' on the cobra's hood being regarded as half a swastika.[3]

[1]Arabs maintain 'that a special virtue resides in its [the swastika's] form alone' (Shah, *Oriental Magic*, p. 81).

[2]*DH*, v. Svastika.

[3]*ID*, pp. 290f.

v. Gaṇeśa; Maṅgala; Tilaka.

II. Name of a *mudrā* in which the fingers cross each

other, or the hands are in *patākāmudrā* touching each other at the wrists. It is also the term for a position in which the legs are crossed.[1]

[1]*ID*, p. 291.

v. Svastikāsana.

Svastikāpasṛta A position of the legs which cross each other but do not touch. This pose is seen in Śiva's *kaṭisama* dance.

Svastikāsana A yogic sitting posture (*āsana*) in which the toes are placed in the hollows behind the knees.[1]

[1]Bhattacharya, *Indian Images*, pt i, p. 49.

Śvāśva 'Having a dog as a mount'. An epithet of Bhairava (an aspect of Śiva) who rides, or is accompanied by, a dog (*śvan*).

Svayaṁbara A pre-marriage ceremony. In ancient times girls of noble birth were entitled to choose a husband. The *svayaṁbara* was a tournament in which eligible young men competed in archery, spear-throwing, and similar contests.[1] At the end of the contest the girl placed a garland of white flowers round the neck of the man of her choice, who was generally the most skilled competitor.

Pārvatī as a bride is called Svayaṁbarā (she who chooses a husband).

[1]Charles Autran, *L'Épopée Indoue*, p. 18, considers that the custom was general in parts of Western Asia and ancient Greece.

Svayaṁbhū 'Self-originated', an epithet applied to the creator Brahmā.

v. Liṅga.

Śveta 'White'. An aspect of Devī. She is moon-coloured and seated on a white lotus.

Śyāma v. Śabala.

Śyāmā 'Black', 'dark-coloured'. An epithet of Kālī worshipped by Tantrists.

Syamantaka Name of a fabulous gem (*ratna*) given to Prince Satrājita by the sun-god, the Āditya (Sūrya). It is an inexhaustible source of benefits when worn by virtuous persons, but brings disaster when worn by evildoers.

Śyena Eagle, hawk, falcon, or other bird of prey. The term for the mythical bird which brought the celestial *soma* down to earth.

T

Tablā A small kettle-drum.

Takṣaka A Nāga king, one of the seven great Nāgas whose colour is glistening red. A swastika is marked on his hood.[1] Bright, bluish pearls are said to be produced from the heads of serpents descended from Takṣaka and Vāsuki. These two, with Śeṣa and the goddess Manasā, are still worshipped in Bengal during the rainy season.[2]

[1]*EHI*, II, pt ii, p. 557.

[2]*DHI*, p. 346.

Takṣaṇa A maker of temple and domestic images.

Tala Name of the nether regions.

v. Naraka; Pātāla.

Tāla I. 'Cymbal'.

II. v. Aṅgula.

Tāladhvaja The 'fan-palm tree banner' of Balarāma.

Tālamāna 'Measure, canon of proportion'.

v. Pramāṇa.

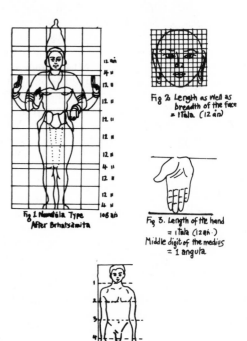

Fig 2. Length as well as breadth of the face = 1 Tala (12 aṅ)

Fig 1. Navatāla Type After Brhatsaṁhita

Fig 3. Length of the hand = 1 Tala (12 aṅ) Middle digit of the medius = 1 aṅgula

Fig 4. Proportions of the male body acc to 'Human Anatomy for Art Students'

Talasaṁsphoṭitam A dance mode of Śiva in which one foot stamps violently on the ground whilst the other is raised as high as the knee. He has eight arms, two are in *patākā* and *abhaya* poses, the others in various dance positions.

v. Nṛttamūrti.

Tāli The central part of a neck ornament (and an important part of the marriage (*vivāha*) ceremony), signifying the married state. Hindu brides wear the *tāli* from their wedding day until their deaths.

Goddesses wear a *tāli* which consists of an image of Gaṇeśa.

Tāmasa or **Tāmasika** The quality of darkness (*tamas*), ignorance, illusion, which applies to a deity when in the act of fighting and destroying demons and the enemies of his devotees.

v. Guṇa(s); Tamoguṇa.

Tamoguṇa The quality of inertia, darkness, disintegration, and the dispersing tendency (*tamas*). All manifested forms are temporary and move towards disintegration and death. Śiva embodies the *tamoguṇa*, for he represents the substratum of existence and the destruction from which creation arises.

v. Svapna; Guṇa(s).

Tāmra The father of five daughters who became the wives of Garuḍa. Their offspring comprise all species of birds.

Tāmracūḍāmudrā A *mudrā* in which the forefinger is raised and bent to resemble a cock's crest, the tips of the remaining fingers and thumb touching.

Tāṇḍava Name of Śiva's cosmic dance of creation and destruction representing the universe which rotates like a gigantic wheel. The constant movement of the dance signifies the inexorable dynamism of origination, growth, decay and disappearance, both of individual life and of the life of the universe. It also signifies his *tāmasic* aspect as Bhairava or Vīrabhadra.

The rotation of the wheel represents the two aspects of Śiva's divine play (*līlā*), 'the forthgoing activity by which he veils himself in the *māyā* of creation, and the withdrawing activity, by which he releases all created forms from . . . *saṃsāra* and reintegrates them into his own Being'.[1] Thus the orbit of his dance includes the whole universe. His purpose is the release or liberation of his devotees.[2] The connexion between dancing and creation is indicated in the *RV* (X,72,6), which relates that the gods, like dancers, stirred up the dust from which the earth was formed.

Śiva, as the cosmic dancer, is usually portrayed with ten arms and dancing wildly in burial- or burning-grounds accompanied by troops of imps, sprites, goblins, and the spirits of the dead.

[1]*Principles*, pp. 182f.
[2]Kramrisch, *Indian Sculpture*, p. 106.
v. Naṭarāja; Nṛttamūrti; Tamoguṇa; Tāmasa.

Taṅka A stonemason's small chisel or axe. When held by Śiva it usually resembles an axe, and the blade faces away from the deity. A number of gods have the *taṅka* as an emblem including Ardhanārīśvara, Īśāna, Ṣaṇmukha, and the Somāskandamūrti group.

Tantra 'Warp and woof', 'thread'. A term applied to the warp of textiles, and also to secular and religious works composed according to particular patterns. They do not belong to the Veda, but Tantrism has influenced all Indian religions.

Tantra is a term specifically applied to the texts of Hindu, Buddhist and Jaina Tantric cults whose members worship *śakti* or female energy, in conjunction with male energy.[1] The human body is conceived as a microcosm which 'is expressed ritualistically in a number of ways. Both Tantric sexual rites and images related to this ritual are metaphors for the fire sacrifice, while the body of the woman is a homology of the Vedic altar. The ritual partner becomes a mystical terrain to be explored. 'Based on a magical physiology and an erotic alchemy, Tantra aims at the restoration of unity by the conjunction of opposites. The root conjunction is the primordial mystery of the androgyne-Puruṣa, or cosmic archetype of the human species – before differentiation into male and female, pure and impure castes, good and evil.'[2] Tantrism is 'a revalorization of primitive magic and ritualized orgiasticism . . . its primitive traits are still much in evidence [in] . . . modern Hinduism'.[3]

[1]Bhattacharyya, *Indian Buddhist Iconography*, p. xviii.
[2]Lannoy, *The Speaking Tree*, pp. 28f.
[3]Ibid., p. 171.
v. Dakṣiṇācāra; Vāmācāra; Śakti; Śākta.

Tapas 'Heat', 'asceticism'. A yogic physiological technique intended to overcome the mental and physical weaknesses of ordinary men. By the retention of semen the life energies are believed to build up tremendous reservoirs of power, which causes even the gods to tremble. By the practice of *tapas* the fire of the spirit is kindled. This enormous glowing energy gives rise to the *tapasvin* the 'glowing ascetic', and finally attracts to him one of the highest gods who perforce must grant whatever the *yogin* desires.

'The two mutually opposed forms of heat in Indian symbolism are *kāma*, the heat of sexual desire, and *tapas*, the heat generated by ascetic practices, particularly by chastity'.[1] Asceticism is an effort to provide a proper milieu in which the spiritual life can be lived. It is *not* self-mortification for its own sake.

[1]O'Flaherty, 'The Submarine Mare in the Mythology of Śiva', p. 9; see also Chauncey Blair, *Heat in the Rigveda and Atharvaveda*.

Tārā or **Tārakā** 'Star',[1] or 'Saviouress'. Wife of Bṛhaspati, preceptor of the gods. Tārā is also an epithet common to all the great Hindu goddesses.[2] Eliade[3] suggests that Tārā is 'the epiphany of the Great Goddess of aboriginal India', who represents the religion of the Mother-goddess that 'in ancient times

reigned over an immense Aegeo-Afrasiatic territory and which was always the chief form of devotion among authochthonous peoples of India'.

Tārā is worshipped by Jainas and Buddhists. She is 'an aspect of Kālī with whom she shares the dominion of the void, that is, the substratum of the universe'.[4] Her four arms and hair are entwined with serpents. She holds the severed head of a *rākṣasa* and a chalice from which she drinks blood, the sap of the world. As a *mahāvidyā* she personifies the power of hunger.

[1]As the stars are used in navigation Tārā is sometimes depicted holding a rudder. A star was the Sumerian symbol for divinity (Levy, *Gate of Horn*, p. 160).
[2]*TT*, p. 61.
[3]*Yoga*, p. 202.
[4]*HP*, p. 276.

Tāraka Name of a valiant *daitya*, son of Hiraṇyākṣa and Diti.

Tārakā v. Tārā.

Tārakāri An aspect of Subrahmaṇya (Skanda) in the act of killing the *asura* Tāraka. Tārakāri has twelve arms and holds various weapons including a goad, banner, sword, noose, discus and spear. His *mudrās* are *abhaya*, *kaṭaka* and *varada*. According to the *Śrītatvanidhi*, his mount is an elephant, and he carries a sword, spear, shield and rosary.[1]
[1]*EHI*, II, pt ii, p. 438.

Tarjanīmudrā A threatening or admonitory position of the hand (*mudrā*) in which the index finger is extended and points upward, the other fingers closed to form a fist. A number of deities show this *mudrā* including the eleven Rudras (*ekadaśarudra*), Ekapādamūrti, Hayagrīva, the Nine Durgās, and others.

Tārkṣa v. Tārkṣya.

Tārkṣya or **Tārkṣa** Originally a fabulous white horse (symbolizing the sun), which draws the solar chariot across the sky. Later Tārkṣya was identified with Garuḍa.

Taruṇa-Gaṇapati 'The young Gaṇapati'. A youthful aspect of Gaṇapati. He carries a noose, goad, wood-apple, a *jambu* fruit, sesamum, and a bamboo stick. His colour is red.

Tāṭaṅka A woman's heavy circular earring (*kuṇḍala*). When worn by Śiva in his left ear it signifies his eternal androgynous form (Ardhanārīśvara).
v. Śiva; Vama.

Tatpuruṣa The Supreme Spirit. Name of the eastern face of the five-headed form of Śiva (Sadāśiva). When depicted as an independent deity he is golden, or the colour of a blazing thunderbolt. He has four faces and three eyes; his garments and ornaments are yellow. He dwells with his consort Gāyatrī, the personification of the solar hymn of the same name.[1]

Tatpuruṣa may hold a *mātuluṅga* fruit in his left hand and a rosary in the right.[2] His *mudrās* are *abhaya*, *jñāna* and *varada*. In three-headed figures of Śiva Mahādeva, Tatpuruṣa is the central figure.
[1]*Śivatoṣiṇī*, 1.1,13 cited in *HP*, p. 212.
[2]*EHI*, II, pt ii, p. 376.
v. Pañcānana; Pañcabrahmā(s).

Tattva Primary subtle elements; categories in the evolution of the universe.
v. Sāṃkhya.

Taxila An ancient city near Islamabad containing a number of Gandharan type temples.

Tejas 'The burning essence of fire; vital power; spiritual or magical power'. Caṇḍikā was formed from the *tejas* of the gods to overcome the demon Mahiṣa. Viśvakarman made Viṣṇu's *cakra* and Śiva's *triśūla* from the *tejas* of the Sun (Sūrya).

Ṭhag(s) 'Thug'. Members of a religious fraternity of professional assassins[1] who were active in the seventh century AD until suppressed, with great difficulty, by the British in 1861. There were bands of both Hindu and Moslem Thugs.

The Thugs were devotees of the goddess Bhavānī (an aspect of Kālī), to whom they offered their victims and a third of the proceeds of their robberies. The victims were usually garrotted because it was forbidden to shed blood, and their graves were dug with a sacred pickaxe which was worshipped. It was also used for divinatory purposes.
[1]There are some parallels with the Assassins of the Arab world, members of the Shi'ite branch of Islam.

Tila A plant (*Sesamum indicum*), an emblem of Piṅgala-Gaṇapati.

Tilaka or **Puṇḍra** I. A sectarial mark (believed to have protective powers), made on the forehead with unguents, or mineral or vegetal colouring matter.
v. Tiryakpuṇḍra; Triphala.

II. A round mark on the forehead made before jour-

neys or during the ceremony of betrothal. The red mark worn by women signifies married status.

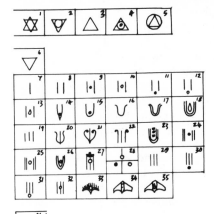

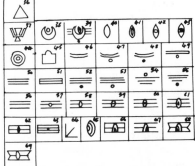

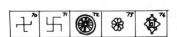

Tīrtha A shrine, or sacred bathing place, or place of pilgrimage. *Tīrthas* may be dedicated to both gods and goddesses and may contain images of them, but those connected only with goddesses are usually termed *pīṭhas*, i.e., 'the holy seats or resorts of the Mother-Goddess',[1] or the places where the pieces of Satī's dead body fell.

[1]*TT*, p. 87.

Tirujñānasambandha v. Tiruppāṇālvār.

Tiruppāṇālvār A Vaiṣṇava *bhakta* depicted with cymbals in his hands. The Śaiva *bhakta* Tirujñānasambandha also holds cymbals.

v. Ālvār(s).

Tiryakpuṇḍra 'Horizontal mark'. A Śaiva sectarial mark consisting of three horizontal marks on the forehead (and sometimes on other limbs). One mark is red and two white, and often with a point (= an eye) on the middle mark.

v. Tilaka.

Tomara A long lance, iron club (or pestle), used in fighting from the backs of war-elephants. The *tomara* is emblematic of Agni, Hara, Viśvarūpa, the Kṣetrapālas, and others.

Toraṇa 'Arch, doorway'. Arches were erected at particular festive ceremonies. *Toraṇa* is also the name of the aureole of flames in which Naṭarāja dances which symbolizes the universe.

v. Prabhāmaṇḍala.

Totalā A four-armed form of Gaurī, who destroys all sins. She carries a trident, rosary, staff, and white chowrie (*caurī*).[1]

[1]*EHI*, I, pt ii, p. 361.

v. Cāmara.

Trailokya 'Pertaining to the three worlds', the divine or celestial, the terrestrial, and the netherworld.

v. Loka.

Trailokyamohana A form of Viṣṇu somewhat similar to that of Vaikuṇṭhanātha, but sixteen- instead of eight-armed. His four faces are those of a man, of Narasimha, Varāha and Kapila.[1] Six of his right hands hold a club, discus, goad, arrow, spear, and an unidentifiable object, the seventh hand is in *varada* pose. The seven left hands hold a hammer, noose, bow, conch-shell, lotus, water-vessel and a horn (*śṛṅga*). The remaining right and left hands are in *yogamudrā*.

[1]*EHI*, I, pt i, p. 257.

Trailokyamohanī-Lakṣmī A form of Lakṣmī, the female counterpart of Trailokyamohana.

Trāyastriṅśa 'Thirty-three'. The gods are said to number thirty-three.

v. Tri; Deva.

Tri 'Three'. A sacred and auspicious number,[1] which may be represented by an equilateral triangle (*trikoṇa*). It also signifies the triad (*trimūrti*) of the three great gods, Brahmā, Viṣṇu and Śiva.

[1]Multiples of three are also auspicious such as the thirty-three gods (*trāyastriṅśa*).

v. Tribhuvana; Trilocana.

Tribhaṅga 'Three-bends'. A common stance of many figures in which the body shows three sideway bends, from feet to hip, from hip to shoulder, and from shoulder to crown.

Tribhuvana The three cosmic regions: earth, firmament and heaven.

Tridaṇḍa 'Trident-staff' carried by Śiva, Rāmānuja and others.

v. Tridaṇḍin.

Tridaṇḍin 'Carrying a trident (or trident-staff)'. Name of a Śaiva or Vaiṣṇava devotee who carries a trident (*tridaṇḍa* or *triśūla*).

Trikoṇa An 'equilateral triangle'. Geometrical symbols represent the unapproachable Divine; involved triangles are used as 'aids' to meditation and concentration.[1]

An upward-pointing triangle, or a vertical arrowhead or flame denote development, and also fire, and the *liṅga* of Śiva. A downward pointing triangle represents Nature consisting of the three fundamental qualities (*guṇas*), but in 'the stage beyond manifestation the *yoni* is represented by the circle, the central point being the root of the *liṅga*'.[2] The *yoni trikoṇa* signifies the watery element, and the downward tendency of the force of inertia. It is also emblematic of *śakti* (energy) or Cosmic Nature (*prakṛti*).

When two triangles are depicted penetrating one another, the upward pointing one represents the Cosmic Person (Puruṣa), the downward, Cosmic Nature. When united to form a star (hexagon) they represent a state of equilibrium, the basis of the wheel symbol of the revolving tendency (*rajas*) from which the universe is manifested. A hexagon also denotes the Śākta cult. The circle surrounding the hexagon signifies the field of time in which manifestation takes place. When the triangles are separated the world is destroyed, and time ceases to exist as the world dissolves into the state of non-manifestation.[3]

When a halo is depicted with triangular indentations it indicates rays.

[1]*IWP*, pp. 124f.

[2]*HP*, p. 231.

[3]Ibid., pp. 353f.

v. Ḍamaru, Yantra; Trimūrti; Tri; Guṇa(s); Pralaya.

Trilocana or **Trinetra** 'Three-eyed'. An epithet of Śiva, referring to his third eye which is depicted vertically on his forehead. It is said to have appeared on his forehead when his consort Pārvatī playfully covered his eyes with her hands whereupon the world was plunged into darkness.

Trimukha 'Three-headed'; 'Three-faced'.

v. Triśiras; Brahmā; Mahādeva; Agni.

Trimūrti 'Having three forms', 'triad'. The Vedic triad of gods was Agni, Vāyu (or Indra), and Sūrya. The later triad consists of Brahmā, Viṣṇu and Śiva, each of whom are associated with a specific cosmic function.

Brahmā signifies the equilibrium between two opposing principles – the centripetal and the centrifugal represented by Viṣṇu and Śiva respectively. Therefore Viṣṇu primarily symbolizes preservation and renewal, Śiva disintegration and destruction.

Much symbolism is associated with the triad. The three gods are in essence the *one* aspect of the Supreme Being who assumes three forms in the act of creating, preserving and destroying, the three aspects of the life process. The triad may also signify the stages of life: childhood, youth and old age; or the main divisions of the day: morning, noon and evening. Metaphysically it represents the *guṇas*, the three main principles of the universe – *rajas, sattva* and *tamas*. Bhattacharya[1] suggests that the idea of the triad was drawn from the three main periods of Aryan life, that of the *brahmacārī, gṛhastha* and *sannyasī*, especially as Brahmā and the objects he carries are objects associated with the *brahmacārī*, that is, a water-pot, and a manuscript representing the Vedas. Viṣṇu represents the ideal householder, enjoying, working, and flourishing in the world. Śiva represents the Hindu ascetic and therefore is depicted half-naked, with matted hair, and wearing a tigerskin. His weapon is a trident.

Some icons represent the triad with Brahmā and Viṣṇu emerging from either side of a large *liṅga*, or standing side by side on three separate lotus plinths, or in three separate shrines in a temple. The middle shrine contains a *liṅga*, and Brahmā and Viṣṇu are in the right and left shrines respectively.[2] Sometimes figures of their mounts are depicted with them. The triad may be symbolically represented by a snake and trident (= Śiva), a lotus (= Viṣṇu), and a rosary and water-pot (= Brahmā). Also the '*yantra trikoṇa* and the syllable *OM* . . . symbolically represent the triad'.[3]

[1]*Indian Images*, pt i, p. 5.

[2]*EHI*, II, pt ii, p. 400.

[3]*ID*, p. 302.

v. Ekapādamūrti; Āśrama II.

Trinayana 'Three-eyed'. Śiva, in most of his aspects, is represented with three eyes, the third shown vertically on the forehead. According to the *Liṅga Purāṇa*, *jñāna, ichā* and *kṛyā* are his three eyes.[1] Other texts state that the three eyes represent the sun, moon and fire. Most of Śiva's *śaktis* are depicted with three eyes, and also Indra, but his third eye is shown horizontally on his forehead.

[1]*EHI*, II, pt ii, p. 404.

Trinetra v. Trilocana.

Tripādaka 'Three-footed'. A few deities are sometimes represented three-footed, including Kubera, Śarabha, Yajñamūrti and very occasionally Agni.

v. Bhṛṅgi.

Tripāṭaka(hasta)mudrā or **Tripatākā(hasta)mudrā**[1] A position of the upper arm which is lifted horizontally as high, or higher, than the shoulder, with the forearm reversed, palm bent upwards at right angles to the forearm. Three fingers are extended and erect, the ring-finger down. This position is seen in images of Viṣṇu and Śiva when carrying emblems, or in some of Śiva's dance-forms.

[1]*ID*, p. 303.

Triphala Name of a Vaiṣṇava mark made on the forehead and consisting of three vertical strokes, the centre one being coloured red.

v. Tilaka I.

Tripura 'Three cities'.[1] Three fabulous cities of the *asuras* constructed of gold, silver and iron, by the architect Maya for Tāraka's three sons.

[1]In the *Brāhmaṇas* a 'tripartite stronghold' is said to be invincible.

v. Tripurā-Bhairavī; Tripurāntakamūrti.

Tripurā A form of Gaurī with four arms. She carries a goad and noose; the remaining hands are in *varada* and *abhaya* poses.

Tripurā-Bhairavī or **Mahāmāyā** An aspect of Pārvatī as the goddess of the Three Cities (Tripura), and the *śakti* of Tripurāntakamūrti. She emerged from the *liṅgam* which then divided into three parts. She is four-armed and three-eyed. A garland of skulls decorates her head, and a jewelled crown, on which the crescent moon is depicted. Her breast is daubed with blood, and she carries a rosary and a *vidyā* (a book of knowledge), the other two hands are in the *varada* and *abhaya mudrās*.[1]

[1]*EHI*, I, pt ii, p. 366, and see *ID*, p. 336 for *vidyā*.

v. Tripurasundarī.

Tripurāntakamūrti Śiva in the act of burning the three cities of the *asuras*. Brahmā had given the three sons of Tāraka the boon that they should inhabit three cities which would move about wherever they wished. After a thousand years the cities would become one and indestructible, except by Śiva's arrow.

Tripurāntaka is occasionally depicted with two arms, but usually four. The upper pair carry an axe and a figure of a deer, the lower may hold a bow and arrow. A third form represents him with one leg resting on the demon Apasmāra. Tripurāntaka is the enemy of *asuras*, but to his devotees his arrow, bow and quiver are harbingers of good.[1] A relief on the Shore Temple at Mahabalipuram depicts Tripurāntaka seated and holding the Pināka bow and the arrow tipped by the protector Viṣṇu himself. The shaft is said to be Soma, the feathers Agni. Another image of Tripurāntaka from Conjeevaram portrays him seated in *āliḍhāsana* pose, with eight arms, holding a bow, arrow, and other weapons.

[1]Sivaramamurti, *Śatarudrīya*, p. 34.

v. Tripura; Tripurasundarī; Tripurā-Bhairavī.

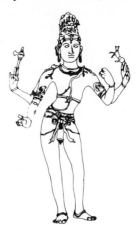

Tripurasundarī The beautiful goddess (Devī) of the Three Cities (*tripura*) worshipped by Tantrists. She represents universal creative energy, and is an aspect of Pārvatī called the 'Fair One' (Sundarī). She is portrayed as a sixteen-year-old girl, holding a noose, bow, mirror, five arrows, lotus, and a fruit. The number sixteen symbolizes totality and perfection.

v. Tripurā-Bhairavī; Tripurāntakamūrti.

Tripuratāṇḍava A dance (*tāṇḍava*) form of Tripura (Śiva), with sixteen arms, each hand holding a weapon. Gaurī may be depicted on his left and Skanda on his right.

Triśiras I. 'Three-headed', also called Viśvarūpa (multi-formed). According to the *Mahābhārata*, Indra beheaded Triśiras from whose dead body rose Vṛtra. This crime of brahminicide so terrified Indra that he fled and hid in a lotus stem.

II. A name of Fever (*jvara*) personified as a three-headed demon. The three heads denote the three stages of fever: heat, cold and sweating.

Triśūla or **Śūla** 'Trident'. An emblem of Śiva denoting his functions as creator, preserver and destroyer. It also signifies the three *guṇas* or 'instruments' of the evolutionary process. When held vertically it may denote the axis of the universe. In Yoga it denotes the three subtle arteries of the body, *iḍā*, *piṅgalā* and *suṣumnā*, which ascend from the base of the spinal cord to the lotus of a thousand petals at the top of the skull.[1]

The goddess Gaurī, as *śakti* of Śiva, has a curious-looking trident resembling a branch of a tree.[2] Another *śakti*, Durgā, carries the usual type of trident. Gonda points out that the divine weapons of the gods have a place in ritual as well as 'in ceremonies for protection'.[3] 'The trident is also the giver of punishment on the

spiritual, subtle and physical planes.'[4] Iron tridents have been discovered in some South Indian Iron Age burials, and were probably of ritual significance.[5]

Great magical powers are attributed to the trident. It can overcome the powers of evil, and in Tantrism it is used for exorcism. It is also an independent cult object, as well as being an emblem of Agni, Bhadra-Kālī, Cāmuṇḍā, Dattātreya, Devī, Gaṇeśa, Hari-Hara, Kālī, Lakulīśa, Yama, and others.

Benares (Kāśī) is said to be erected on Śiva's trident, and hence the whole city is sacred to him. When personified the trident is shown as a handsome black man.

[1]*HP*, p. 216; *EHI*, I, pt i, p. 293.

[2]v. *Iconog. Dacca*, P1. LXVII.

[3]*VS*, p. 178, n. 91.

[4]*HP*, p. 216.

[5]Allchin, *Birth of Indian Civilization*, p. 229.

v. Āyudhapuruṣa; Cakra; Pināka; Śūla.

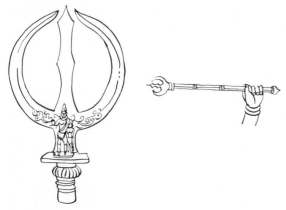

Trita Āptya A minor Vedic deity, the counterpart of the Avestan Thrita.

Trita is sometimes regarded as a double of Indra, or is closely associated with him in his demon-killing role (*RV*, I.52,5), and so became a kind of 'scapegoat' for Indra's many murders, as well as for the 'sins' of the gods (*AV*, VI.1).

Trivali Three folds or lines on the skin of the neck and waist are signs of beauty and indicative of good luck.

Trivikrama 'He of the three strides'. An epithet of the dwarf (*vāmana*) incarnation of Viṣṇu when he tricked Bali by requesting as much land as he could cover in three strides. This is really a creation myth based on the Vedic notion that 'to measure out' the elements of the earth is to create.

Trivikrama may be depicted in three different ways: with the left foot raised to the level of the right knee, or to the navel, or to the forehead. These three positions signify his three great strides which encompassed the earth, atmosphere, and celestial region respectively.

Trivikrama has four or eight hands. In four-handed forms he holds a *cakra* and a club, and may be accompanied by Lakṣmī and Sarasvatī. One right hand is in *abhaya* or *varada* pose. In eight-armed forms he carries a conch, discus, club, bow and plough. Behind the deity the tree *kalpaka* should be depicted. Indra holds a parasol above Trivikrama's head. On either side of the deity Varuṇa and Vāyu wave fly-whisks (*cāmaras*); above them, to the right and left, Sūrya and Candra may be seen, and other subsidiary figures.[1] Trivikrama's *śakti* is Śānti.

[1]*EHI*, I, pt i, pp. 164ff.

v. Bali I.

Tṛṇa 'Bundle of grass', held by the anthropomorphized form of the wealth-giving cow Surabhi.

Tṛṇāvarta A whirlwind-demon who seized the infant Kṛṣṇa and whirled him up into the sky, but Kṛṣṇa clutched his throat and the demon fell to the ground under the prodigious weight of the divine infant.

Tṛṣā v. Mahālakṣmī.

Tryambaka 'Three-mothered'.[1] An epithet of Agni, referring to his triple birth from the sun, lightning and fire, and a name of one of the eleven Rudras (Ekadaśarudra) whose emblems include a discus, drum, trident, goad, snake, club, bow and arrow, and axe. His *mudrā* is *tarjanī*.[2]

[1]Or 'three-eyed'.

[2]*EHI*, II, pt i, p. 41; II, pt ii, p. 390.

Tulasī or **Tulsī** (Hindī) The basil plant (*Ocimum sanctum* or *O. basilicum*). The vegetal manifestation of Viṣṇu, and hence the plant is sacred to his *śakti* Lakṣmī. The essence of both Viṣṇu and Lakṣmī pervades the *tulasī*, and hence it is an object of worship.

The *tulasī* possesses curative properties and is an antidote to snake-venom. It even wards off the messengers of Yama, the ruler of the dead, who will not enter a house containing this plant. It is personified as the goddess Tulasīdevī who is probably identical with Lakṣmī. Tulasīdevī is represented seated on a lotus throne (*padmāsana*). She has a dark complexion and is four-armed. Her emblems are a blue and white lotus; her *mudrās*, *abhaya* and *varada*. She wears a crown and many ornaments and is clothed in white.

Tulasīdevī v. Tulasī.

Tumburu Also called Virādha. The leader of the celestial musicians (*gandharvas*), whose magic lute is called Kalāvatī. Hopkins suggests that Tumburu is the personified tambour.[1]

[1]*EM*, p. 155.

Tūṇa 'Quiver'.

Tuṇava A wooden musical instrument, probably a flute.

Tuṇḍa or **Tuṇḍaka** 'Trunk (of an elephant)'.

Tundila 'Pot-bellied', a characteristic of Kubera, Gaṇeśa, Varuṇa, and of *yakṣas* and others. It indicates prosperity and well being.

Turaga Name of the white horse which emerged from the churning of the ocean (*samudramathana*), and was claimed by the sun-god Sūrya.

Tvaṣṭar or **Tvaṣṭṛ**[1] The divine artisan of the gods who is the embodiment of craftsmanship. He can create all forms and hence is invoked by people desiring offspring. He fashioned the sacrificial ladles, the chalice of the gods, and Indra's great *vajra*.

[1]The name is derived from the root *tvakṣ* meaning 'to form or fashion'. In this sense his function is similar to that of the ancient Egyptian god of craftsmen Ptah, to the Babylonian Mummu, the Phoenician Chusor, the Greek Hephaistos, and others.

v. Āditya(s); Viśvakarman.

Tvaṣṭṛ v. Tvaṣṭar.

U

Uccadevatā Time personified.

v. Kāla.

Uccaiḥśravas 'Long-eared'[1] or 'neighing aloud'. The mythical King of horses and prototype of all equines, who emerged from the churning of the ocean (*samudramathana*). The horse-headed solar Viṣṇu called Hayaśiras is identified with Uccaiḥśravas who is described as moon-coloured and with a black tail. Uccaiḥśravas is one of the mounts of Indra.

[1]Uccaiḥśravas may have represented a powerful ass, like the wild asses of Ethiopia who are faster and stronger than horses, or it may have been an onager who have longer ears than horses.

Ucchiṣṭa-Gaṇapati Also called Heramba. Gaṇeśa as the deity of the Ucchiṣṭa-Gāṇapatya cult[1] whose members, as a ritual act, leave the remains (*ucchiṣṭa*) of food in their mouths. This may be based on the belief that the remains of sacrificial offerings were of great potency and ritualistic importance (*AV*, XI.7).

Ucchiṣṭa-Gaṇapati is described as four-armed, three-eyed, and holding a noose, elephant-goad, club, and showing the *abhaya mudrā*. The tip of his trunk touches a pot of strong wine, and he embraces his nude *śakti*, seated on his left thigh, or she stands touching his left side.[2] There are variant lists describing his appearance and emblems. The latter include a rosary, goad, bow and arrow, cake, lotus, noose, pomegranate and *vīṇā*.

[1]There are six sub-divisions of the Gāṇapatya cult and

Gaṇeśa is the supreme deity of all of them.

[2]*PTR*, pp. 154f; *EHI*, I, pt i, p. 54.

Udarabandha A broad band or belt worn at the junction of the thorax and abdomen.[1] Some forms of Kṛṣṇa wear it and also Gaṇeśa. The latter's belt is a snake (*nāga*).

[1]*EHI*, I, pt i, p. 23.

Udīcyaveṣa Lit. 'the dress of the North'. Sūrya, whose cult came from the North, wears this style of dress which consists of trousers, a long jacket, a round flat cap and high boots. Bhattacharya[1] maintains that the 'long boots' which Sūrya is said to wear are really 'a pair of hose as worn by the Tibetans and other people of the hills to serve as shoes and socks'.

[1]*Indian Images*, pt i, p. 56.

v. Colaka.

Uḍumbara or **Udumbara** A sacred tree (*Ficus glomerata*) from which sacrificial articles and amulets are made. Its fruit contains the essence of all fruits, its wood, the properties of all woods. It symbolizes food and strength (*Ait. Br.*, V.24).

Udvāhita A dance pose in which one side of the pelvis is raised higher than the other. Śiva adopts this pose in the *kaṭisama* dance.

Ugra I. 'Powerful', 'mighty', 'terrible'. Its basic meaning is 'powerful'. It is a neutral force which may be utilized for good or bad purposes. *Devas* and *asuras* are exponents of this ambiguous concept of power.[1]

[1]*Facets*, p. 101.

II. Name of one of Śiva's four terrible (*ugra* or *ghora*) aspects, the others being Rudra, Śarva and Aśani (or Bhīma),[1] which are balanced by his four gentle (*saumya*) aspects: Bhava, Paśupati, Mahādeva and Īśāna.

[1]*ID*, p. 185.

v. Mūrtyaṣṭaka.

III. A name of the black buffalo, the mount of Yama.

Ugramūrti A terrible (*ugra*) form of Śiva when in vengeful and punishing moods.

v. Ugra II.

Ugra-Narasiṁha The 'terrible (*ugra*) Narasiṁha'. An aspect of Narasiṁha when in the act of tearing apart the demon Hiraṇyakaśipu.

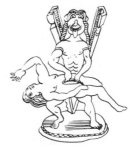

Ugrāsana

Ugrāsana Name of a yogic position (*āsana*) in which the *yogin* sits with his legs stretched out flat on the ground and his forehead touching his knees.

Ugra-Tārā A fierce form of the Tantric goddess Tārā, one of the ten Mahāvidyās. She stands on a white lotus rising from the waters, and is four-armed and three-eyed. A number of ornaments and snakes decorate her body. Her emblems are a knife, sword, blue lotus and skull. Her hair is piled up in a single plait, and sometimes the figure of a corpse is depicted on it. Her tongue hangs out. An elephant hide covers her waist and she wears a necklace of skulls, and a flat piece of white bone on her head. A corpse between two lotuses is shown beneath her feet. Ugra-Tārā appears to have been taken over from Tantric Buddhism.[1]

[1]*Iconog. Dacca*, pp. 205f; Bhattacharyya, *Indian Buddhist Iconography*, p. 76.

Ulūka 'Owl'. A bird of ill-omen and one of the many forms assumed by demonic powers. It is sacred to the inauspicious goddesses Nirṛti and Cāmuṇḍā, and to Rāhu.

Ulūkhala(s) Demons having sunken eyes and protruding tongues who wear mortars or bowls as ornaments.

Umā A non-Vedic mother-goddess with whom many local goddesses have become identified and by whose names she is also known, viz., Pārvatī, Durgā, Aparṇā, Ambikā, Bhadra-Kālī, Mahākālī, Gaurī, etc. She nourishes the world with life-sustaining vegetables which emerge from her body during the rains (*Mark. Pur.*, xxxiv,1ff.).

Umā represents 'eternal knowledge, whose shape is limitless space'.[1] and she is even worshipped by the gods. Her emblems are a rosary, mirror, water-pot and lotus. According to the *Śatarudrīya* she 'is the grace of Śiva as Paramātmā [Transcendent Spirit], who remains unrevealed, though through his grace, Umā, who reveals herself, he is comprehended'.[2]

[1]*HP*, p. 285.

[2]Sivaramamurti, *Śatarudrīya*, p. 80. Umā Haimavatī may be the original name of Umā. It has been suggested that the name is derived from the Sumerian *umu*, 'mother' (*ID*, p. 310).

Umā-Maheśvara or **Hara-Gaurī** A form of Śiva seated with his consort Umā. Sometimes he is depicted with Umā seated on his left thigh. He may have two or four arms, and holds a trident in his right hand, the palm of the left rests on Umā's breast. According to Hemādri, Śiva should have eight heads, his left hand rests on Umā's shoulder, his right holds a lotus. Umā's right hand is placed on her husband's shoulder, her left holds a mirror.[1]

[1]Bhattacharya, *Indian Images*, pt i, p. 21.

Umāpati 'Husband of Umā', that is, Śiva.

Umāsahita or **Umāsahitacandraśekhara** A representation of Umā depicted with Śiva (Candraśekhara). When accompanied by their child Skanda the group is called Somāskandamūrti. Another group called Āliṅganacandraśekhara depicts Śiva seated and embracing Pārvatī.[1]

Sometimes the figures of both deities stand on lotus pedestals fixed on a base (*bhadrapīṭha*). Śiva's right hand is in *abhaya mudrā*, his left holds a water-pot. His *liṅga* is erect.

[1]Tewari, *Hindu Iconography*, p. 21.

v. Candraśekharamūrti; Bhadrāsana.

Umā-tāṇḍava Umā and Śiva dancing together. Śiva has six arms and holds a trident. His *mudrā* is *vismaya*. His left foot and Umā's are placed on the demon Apasmāra. Umā holds a drum, skull-cup and trident.

Umāvakha v. Pañcānana.

Unmatta v. Bhairava.

Unmatta-Ucchiṣṭa-Gaṇapati A four-armed, three-eyed figure of Gaṇapati seated on a lotus pedestal (*padmāsana*). His body is red; he carries a noose, goad, bowl of sweetmeats (*modaka*), and a tusk. He should be represented as if in rut.

Unnati Wife of the fabulous bird Garuḍa.

Upabhṛt One of the three sets of sacrificial ladles, each made of a different wood.[1] The *upabhṛt* is said to sustain the atmosphere (*AV*, XVIII.4,5). It is made of *aśvattha* wood.

[1]Caland and Henry, *L'Agniṣṭoma*, pp. 253ff.

v. Juhū; Sruk.

Upacāra A vessel or pot used for making libations to the gods.

Upamanyu A Śaiva ascetic whose Himālayan hermitage became a sanctuary for all kinds of animals, snakes and birds, who lived peacefully together. This idyllic state was made possible by the power of the *tapas* of the ascetic.

Upanayana 'Initiation'. A ceremony in which a *guru* initiates a boy (between the ages of eight to twelve), into one of the three 'twice-born' castes, and invests him with the sacred thread (*yajñopavīta*).

Upaniṣad(s) Esoteric, philosophical, and metaphysical interpretations of the Vedas.

Upavīta I. A mode of wearing a deerskin, in which the skin is placed over the left shoulder and below the right arm, and across again to the left shoulder. The head of the animal hangs down in front over the chest.

II. A term for the sacred thread (*yajñopavīta*).

Upendra I. The younger brother of Indra.

II. Name of one of the twenty-four aspects (*caturviṃśatimūrti*) of Viṣṇu.

Uraga I. A snake (*nāga*) sometimes depicted with a human face. A snake may also form a *vāhana* for

particular divinities such as Manasā and Anantaśāyana.
II. The lunar asterism (*nakṣatra*) Āśleṣā presided over
by *nāgas*.

Uraṇa 'Ram'.

v. Meṣa.

Uras-sūtra A band placed round the chest and worn
by Śiva-Naṭarāja.

Ūrdhva A variety of drum.

Ūrdhva-Gaṇapati A form of Gaṇapati depicted with
one arm embracing his *śakti*. In his other hands he
carries a *kalhāra* flower, ears of paddy, a sugarcane
bow, an arrow and a tusk. He is golden yellow; his
śakti is the colour of lightning.[1]

[1]*EHI*, I, pt i, p. 56.

Ūrdhvakeśa Having the hair erect and forming a kind
of head-dress. It indicates the destructive or terrifying
aspect of the deity portrayed.

Ūrdhvaliṅga or **Ūrdhvameḍhra** 'Erect phallus (*liṅga*)',
signifying complete control of the senses.[1] 'Lifting the
seed up' refers both to the storing up of sexual energy
by non-emission,[2] and also to the erect phallus. The
proto-Śiva portrayed on some Indus Valley seals repre-
sents an ithyphallic deity.

[1]Sivaramamurti, *Art of India*, p. 556. It is also emblem-
atic of fertility. Some forms of Śiva, Gaṇeśa, and
others are represented ithyphallicly.

[2]In Indian thought eroticism is understood as the
expending of energy, whereas non-emission is said to
give the *yogin* great powers not shared by ordinary
men.

Ūrdhvameḍhra v. Ūrdhvaliṅga.

Ūrdhvapuṇḍra A vertical Vaiṣṇava mark on the fore-
head in the shape of a U or Y with a dot in the middle,
a characteristic of Rāmānuja.

v. Tilaka.

Ūrdhvatāṇḍava v. Lalāṭatilakam.

Ūrumālā Ropes of ribbons, gems, tassels, etc., hanging
from a waistband.

Ūrusaṃsthitamudrā A position in which one hand rests
on the thigh (*ūru*).

v. Kaṭimudrā.

Urvaśī A celestial nymph born from the thigh of
Nārāyaṇa.

v. Nara-Nārāyaṇa.

Uṣas or **Uṣā** Goddess of the dawn, wife of the sun-god
Sūrya. Uṣas and the rising sun dispel the evils associ-
ated with night and free men from the power of curses
(*AV*, VI.6,7). Her chariot is drawn by seven reddish
cows or horses, which represent the days of the week.

v. Usrā.

Uṣṇīṣa A turban or headband. A turban is placed on
the head of a king during his consecration, and is
regarded as a source of special power. The epithet

Uṣṇīṣin (wearing a turban) is applied to Śiva. The
ritual donning of a turban and other garments symbol-
izes the 'vestures of the embryo' and the stages of birth,
by which the initiant is reborn (*ŚBr.*, V.3,5,23f, and
see n.3).

Uṣṇīṣin v. Uṣṇīṣa.

Usrā 'Daybreak', personified as a red cow, the source
of all good things.

Uṣṭra 'Camel', sacred to Śukra.

Uṣṭrapāda Name of a *yakṣa*, 'a being either human or
animal with the feet of a camel'.[1]

[1]*DHI*, p. 134.

Utkaṭāsana A yogic posture in which the *yogin* stands
on his head keeping the body erect and his hands in
añjali mudrā.[1]

[1]*ID*, p. 314.

Utkuṭikāsana A yogic posture (*āsana*) in which the *yogī*
squats on his heels and with his back slightly curved.
A *yogapaṭṭa* supports his raised knees. This posture is
also described as having the right leg bent and resting
at an angle to the plinth, and the left leg hanging down.
Caṇḍikeśvara and Yoga-Dakṣiṇāmūrti are depicted in
this posture.[1]

[1]*EHI*, I, pt i, p. 19; *ID*, p. 314.

Utpala 'Lily' or 'blue lotus'.

v. Nīlotpala; Padma.

Utsāha 'Effort': the spiritual energy exerted in aesthetic
reproduction.[1]

[1]Coomaraswamy, *Transference of Nature*, p. 228.

Utsavabera, **Utsavamūrti**, **Utsavavigraha** or **Bhoga(-
mūrti)** An image carried in procession at festivals
(*utsava*). Such processional images are also common in
Roman Catholic countries.

v. Bhoga.

Utsavavigraha v. Utsavabera.

Uttaravedi The upper or northern (*uttara*) part of an
altar (*vedi*) which represents the realm of the gods
(*devas*); the southern part represents the *pitṛs*. The
complete altar denotes the whole world, and is equated
with Vāc, the goddess of speech, the supreme medium
of communication (*ŚBr.*, III.5.1,23).

Vāc 'Speech', personified as a goddess. This feminine
designation for the Holy Word (*bṛh-brahman*) is the
magical power 'manifested at each Vedic sacrifice',[1]
and the first principle of the Universe.

Vāc is identified with Sarasvatī and thus became
associated with nature as well as learning. The creation

of *mantras* was attributed to her which 'gave rise in Tantric circles to the idea of the *mantra*-mother (*mātṛkā śakti*) or Para-Vāc, the supreme Logos'.[2]

[1]Organ, *Hindu Quest*, p. 52.

[2]*DH*, p. 315, n.2; and see Coomaraswamy, *Transference of Nature*, p. 228.

v. Vāgīśvara; Mātara(s).

Vaḍabā 'Mare'. Name of the *apsaras* Aśvinī who assumed the form of a mare and became the mother of the twin Aśvins by Vivasvat (the Sun) who took the shape of a horse.

Vādya 'Music' which forms part of worship (*pūjā*).

Vāgīśvara 'Lord of speech'. An epithet of Brahmā, whose consort is Vāc (Sarasvatī).

v. Vāgīśvarī.

Vāgīśvarī 'Lady of speech'. An epithet of Sarasvatī.

v. Vāc.

Vāhana A mount or seat of a Jaina, Hindu, or Buddhist divinity. The animal mounts are seldom shared by divinities and hence are more reliable iconographic guides to the identity of any particular deity than are attributes and emblems. Usually the mounts of goddesses are the same as their consorts, but not always.

It seems probable that originally the figure of a divinity was not represented, but that the animal associated with it conveyed its presence. Lannoy[1] suggests that animal incarnations are probably totemic as are the trees and snakes which are worshipped. Particular inanimate objects also serve as *vāhanas*, the most common being the lotus (*padma*). Occasionally a demon, or a man, or a corpse, serve as mounts.

Zimmer[2] maintains that a mount 'is a duplicate representation of the energy and character of the god'. Many ancient Mesopotamian and Hittite divinities are represented with mounts before 1500 BC, and probably the idea was taken to India by traders.

Below are listed the mounts of some deities:

Ass, of Cāmuṇḍā and Śītalā
Bull, of Śiva
Corpse, of Cāmuṇḍā
Donkey, of Śītalā
Garuḍa, of Viṣṇu and Lakṣmī
Goose, of Brahmā, Gaurī, Sarasvatī
Lion, of Durgā, Gaurī, Caṇḍī, Heramba, Pārvatī and Mahiṣāsuramardinī
Makara, of Varuṇa, Gaṅgā
Man, of Nairṛta, Kubera
Monkey, of Vasanta
Parrot, of Kāma, Sarasvatī
Peacock, of Kārttikeya, Sarasvatī
Ram, of Agni and Sarasvatī
Rat or mouse, of Gaṇeśa

Snake, of Viṣṇu, Manasā
Tortoise, of Yamunā and the Earth-Goddess

[1]*The Speaking Tree*, p. 188.

[2]*Myths*, p. 70, and see p. 146.

Vahni 'Fire'. Śiva often holds a bowl of fire (*agni*) with seven flames representing Agni's seven tongues of fire. The fire signifies Śiva's power of destruction (*saṃhāra-śakti*) which destroys all bonds (*pāśas*) and attachments, and consequently denotes enlightenment and freedom.

v. Ardhacandramudrā; Saṃhāramūrti(s).

Vahnikuṇḍa 'Fire (*vahni*) receptacle'.

Vaijayanta 'Victorious'. Name of Indra's dark blue banner of victory which hangs from a yellow pole attached to his golden chariot, Jaitraratha. Great magical powers are attributed to the banner which became 'the object of a separate cult'.[1]

[1]*HP*, p. 110.

Vaijayantīmālā 'Garland of Victory'. The long garland (*mālā*) worn by Viṣṇu and consisting of five precious gems (*pañcaratna*); emeralds, pearls, blue-stones (sapphires?), rubies and diamonds, which represent the five elements. According to the *Agni Purāṇa* (201,1–8) the garland consists of fragrant wild flowers, symbolizing the different worlds and solar systems. The very presence of the garland is said to ensure victory.

v. Vanamālā.

Vaijayantīpatākā A banner ensuring victory and emblematic of the war-gods Skanda and Indra.

v. Vaijayanta; Dhvaja.

Vaikuṇṭha I. An epithet of Indra; in post-Vedic mythology a name of Viṣṇu and of his sphere (*loka*) or paradise, where no fear exists.

v. Svarga; Vaikuṇṭhanātha.

II. Name of an icon combining the three (or four) aspects of Viṣṇu (*Viṣṇudharmottara*, III. ch. 85).

Vaikuṇṭhanātha or **Vaikuṇṭha-Nārāyaṇa** 'Lord of

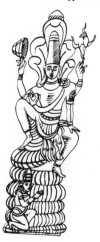

Vaikuṇṭha', i.e. Viṣṇu when he resides in his heaven, Vaikuṇṭha. He is depicted with one or four faces and four or eight arms, and seated on Garuḍa or Ananta. In his four right hands he holds a club, sword, arrow and discus; in the left hands, a conch, shield, bow, and lotus. The front face should be that of a man, the south face, Narasiṃha, the west one Śakti, the north, Varāha.[1]

[1]*EHI*, I, pt i, p. 256.

v. Trailokyamohana.

Vaiśākhāsana The stance of a bowman with arms raised.

Vaiṣṇava Relating to Viṣṇu; a term for a follower of the cult of Viṣṇu. The Vaiṣṇava cult is one of the three great divisions of modern Hinduism, the others being the Śaiva and Śākta.

v. Avatāra; Kṛṣṇa.

Vaiṣṇavasthāna A pose in which one foot is placed firmly on the ground, the other leg is bent and placed across the first. Śiva shows this stance in the *kaṭisama* dance.

Vaiṣṇavī A four- (or six-) armed form of Lakṣmī who has the same mount and emblems as her consort Viṣṇu.

Vaiṣṇavī is lovely and of dark complexion. She dwells under a *rājavṛkṣa*. The *Viṣṇudharmottara* states that she has six hands, the two right hands hold a club and lotus, the third is in *abhaya mudrā*. Two left hands hold a conch-shell and discus, the third is in *varada mudrā*. The *Devī Purāṇa* states that she has four hands and carries a conch-shell, discus, club and lotus, and wears a long garland (*vanamālā*).[1]

[1]Bhattacharya, *Indian Images*, pt i, p. 37.

Vaiśrāvaṇa v. Kubera.

Vaiśya A member of the *viś*, the third of the four classes of the community, the other three being the *brāhmaṇa*, *rājanya* and *śūdra*. The occupation of a *vaiśya* was cattle-raising, agriculture, and trading.

v. Varṇa.

Vaitaraṇī I. Name of the foetid river which flows between the earth and the nether regions. The dead pass over it to reach Yama's realm.

II. Name of the cow presented to the priest during funerary rites, in the belief that it will carry the deceased safely across the dreaded river Vaitaraṇī.

Vaivāhikamūrti v. Kalyāṇasundaramūrti.

Vaivasvata 'Coming from, or belonging to, the sun (Vivasvat)', the patronymic of the seventh Manu, son of Vivasvat, and an epithet of Yama.

Vaivasvata, finding himself alone after the Deluge, performed arduous austerities (*tapas*) and finally cast an oblation into the waters. A year later the personified oblation (*iḍā*), in the form of a beautiful girl, rose from the waters and informed him that she was his daughter Iḍā (*ŚBr.*, I.8.1,1ff.).

Vāja I. v. Ṛbhu(s).

Vāja II. Sexual and creative vigour.

v. Vajra.

Vājin 'Horse'. This term also implies strength, speed and potency as well as the heroic qualities of warriors and kings. In Ṛgvedic poetic imagery the sun-gods are described as horses (or as having horse-heads); in the *ŚBr.* (VI.3.2,7) the horse is urged to tread down evil and avert curses.

v. Varuṇa; Aśva; Haya.

Vajra The so-called 'thunderbolt'[1] which whirls down from the misty realms of the sky. It was the favourite weapon of Indra, the divine war-leader of the Vedic Aryans.

The *vajra* is deified and drives away evil spirits, and is equated with vigour (*vāja*). In Tantrism it represents the creative principle of the *liṅga*.

The *vajra* may have one, three, four, seven or eight tines. When a small *vajra* is placed on a plinth near a deity it indicates the god is meditating. The *vajra* has much the same significance as the trident (*triśūla*).

A number of Mahāyāna Buddhist and Hindu deities are associated with the *vajra*, including Agni, Haya-grīva, Indra, Kārttikeya, Mahākālī, Mahiṣāsuramardinī and Śiva.

[1]Apte considers the *vajra* was a club or hammer ('Vajra in the Ṛgveda', *ABORI*, vol. xxxvii, 1956, pp. 292–5). Liebert (*ID*, p. 318) suggests that it 'originally signified the bull's penis, and was from very early times used as a magical symbol'.

v. Āyudhapuruṣa; Vajrapatākāmudrā; Asthisambhava.

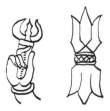

Vajranābha 'Having a hard (adamantine) nave'. An epithet of Viṣṇu's discus or wheel, Sudarśana.

v. Cakra I.

Vajraparyaṅkāsana 'Sitting on a throne with a *vajra*'. A yogic posture similar to the *padmāsana*, but with a *vajra* depicted beside the image. In this context the *vajra* denotes meditation.

Vajrapatākāmudrā A *mudrā* representing the *vajra*. It is similar to the *patākāmudrā* except that the tips of the thumb and ring-finger touch.

Vajrāsana A yogic posture (*āsana*) rarely portrayed, in which the lower parts of the legs are inversely placed upon both the thighs.

Vakradaṇḍa

[1]Bhattacharya, *Indian Images*, pt i, p. 50.

Vāk v. Vāc.

Vakradaṇḍa A weapon (?) resembling a crooked stick, emblematic of Aiyaṉār.

Vālakhilya I. A class of 60,000 'thumb-sized' *ṛṣis* produced from Brahmā's (or the *ṛṣi* Kratu's) body. They accompany the sun's chariot and live for a thousand years. Sometimes they are classed as Siddhas who have attained their status through asceticism (*tapas*), but remain in contact with mortals.

II. Name of an ascetic order of mendicants whose clothing consisted of rags or bark, and whose hair was uncut and matted.[1]

[1]Eliade, *Yoga*, p. 139.

Valaya Bracelet, worn by men and women. Sometimes it is serpent-shaped (*nāga-* or *sarpavalaya*), and worn by Garuḍa, Bhairava and others.

Vallabha Name of a Vaiṣṇava *bhakta* (AD 1479–1513), and of the religious sect named after him.

Vallakī The Indian flute, an emblem of Sarasvatī.[1]

[1]Bhattacharya, *Indian Images*, pt i, p. 54.

Valli or **Vallī** A wife of Skanda who stands on his right. She wears a breastband (*kucabandha*) and holds a lotus.

v. Vallīkalyāṇasundaramūrti.

Vallīkalyāṇasundaramūrti An aspect of Subrahmaṇya in the act of being married to Vallī. Brahmā, with a sacrificial utensil (*sruva*) in his hand, officiated at the ceremony, and is seated before a fire burning in a *kuṇḍa*. Viṣṇu holds a water-vessel ready to pour out the water during the giving away of the bride.[1]

[1]*EHI*, II, pt ii, p. 440.

Vālmīki Name of the author of the *Rāmāyaṇa*.

Vāma 'Left'. The left side is usually regarded as inauspicious and hence weapons and other destructive attributes are usually carried in the left hand, but as *vāma* also signifies the female principle it is not inauspicious for the female sex. Śiva, when in androgynous form, wears a woman's earring in his left ear to represent his feminine aspect. *Vāma* also signifies the Śākta cult.

Offerings made to placate demons (*bhūtas*) and other dangerous beings, are proffered with the left hand, as are offerings to the ancestors (*pitṛs*). In the latter context it indicates the difference between this world and the world of the dead.

v. Vāmācāra; Svastika; Laṅkā.

Vāmā A terrifying aspect of the great goddess Devī. She has three eyes and holds a skull-cup in one hand, the other is in *abhaya* pose. She wears a *jaṭāmakuṭa* and is said to fulfil the wishes of her devotees.[1]

[1]*EHI*, I, pt ii, pp. 362f.

v. Vāma; Vāmācāra.

Vāmācāra The so-called 'left-hand' Tantric cult, to distinguish it from the 'right-hand' discipline (*dakṣiṇā-cāra*). Sexual symbolism has an important role in *vāmācāra* practices and female 'Saviouresses' are worshipped, whereas in right-handed Tantrism male deities are predominant. Bharati maintains that the central rule of both Hindu and Buddhist *vāmācāras* 'is the retention of semen during the sexual act'.[1]

[1]*TT*, p. 179.

v. Śakti; Śākta; Vāma; Pañcamakāra.

Vāmadeva The 'left-hand deity'. Name of the western face[1] of the five-headed aspect of Śiva representing the notion of 'I-ness' (*ahaṁkāra*). When depicted as a separate deity Vāmadeva has three eyes, four arms, and wears red garments and ornaments. His *mudrās* are *abhaya* and *varada*; he holds a rosary and hatchet,[2] or a sword and shield. A crescent moon adorns his *jaṭāmakuṭa*.

[1]Liebert, *ID*, p. 328, states that it is the head 'directed to the north'.

[2]*HP*, p. 212.

v. Pañcānana; Pañcabrahmā(s).

Vāmadeva-Umā Śiva's *śakti*.

v. Mahādeva.

Vāmana v. Vāmanāvatāra.

Vāmanāvatāra 'Dwarf incarnation (*avatāra*)', of Viṣṇu.

The gods, having been deprived of their abode and the sacrifices due to them by the tremendous spiritual powers of the virtuous King Bali, begged Viṣṇu to aid them. He agreed, and requested Bali to give him the amount of land which he could cover in three[1] strides. Bali agreed and immediately Vāmana transformed himself into the gigantic figure of Trivikrama who could cover the whole universe. His third giant step[2] rested on Bali's head and pushed him down to the nether world, but in recognition of his many virtues he allowed him to have dominion over the lower regions. This myth is represented iconographically, either showing Vāmana requesting the land, or depicting the giant with one leg raised high (denoting the celestial sphere), and the other resting on the earth. The two legs signify the entire span of the universe.

Bali carries a water-vessel (*kamaṇḍalu*), a book and a parasol. His hair is twisted into a knot and he wears earrings, a deerskin in the *upavīta* fashion, and a loincloth (*kaupīna*). A ring (*pavitra*) of sacred *kuśa* grass is on his third finger. The above objects indicate that he is a Vedic student or *brahmacārin*. He may be depicted either as a small, intelligent youth, or as a deformed hunchbacked dwarf with a big belly.[3]

[1]The number three indicates Viṣṇu's universal character, for the universe is tripartite: the upper regions, the earth, and the waters (*RV*, I. 139,11). If a sacrificer performs these three strides ritually, evil is annihilated (*Tait. Saṃ.*, I.6,5; and see *Aspects*, pp. 55f.).

[2]According to the *RV*, Viṣṇu's third step reached the abode of the gods. This myth is paralleled by the three steps of the Avestan Ameśa Spenta.

[3]*EHI*, I, pt i, p. 164.

v. Bali I; Trivikrama.

Vāṇa 'Arrow'.

v. Bāṇa.

Vana-Durgā 'Forest Durgā', who is depicted green and eight-armed. She carries a conch-shell, discus, sword, shield, arrow and trident. Her *mudrā* is *tarjanī*.

Vanamālā The long fragrant garland (*mālā*) of woodland flowers (or gems) worn by Viṣṇu. It represents Nature.[1] The garland may be carried or worn. Gaurī is also depicted with a *vanamālā*.

[1]*Iconog. Dacca*, p. 78n.

Vānaprastha Name of a *brāhmaṇa* in the third stage of his life when he lives in a forest.

Vānara 'Monkey'; also a name for a 'forest dweller'. South Indian forest dwellers were derisively called monkeys, but when properly led they were formidable fighters. Their leader was the legendary Sugrīva, whose army commander was Hanumat.

The Vānaras assisted Rāma to find Sītā, as well as aiding him in his fight against Rāvaṇa. Sometimes the Vānaras are described as having tails,[1] but these were probably emblems, which would account for the story that Hanumat did not feel pain when his tail was set on fire in Laṅkā (Srilanka).

Vasanta, the personification of Spring, has a monkey as a mount.

[1]S. Ramdas mentions a class of 'tailed' aboriginals among the Śabaras of Vizagapatnam in 'Aboriginal Tribes in the Rāmāyaṇa', *Man in India*, vol. V. pp. 46ff.

Vanaspati 'Lord of the forest', a large tree, or a term for the wooden sacrificial post (*yūpa*), said to be a form of Agni, the overlord of forest trees. Fire is frequently identified with wood in the belief that it exists within the fire-sticks (*araṇis*).

v. Vṛkṣa.

Vandanamudrā or **Vandanīmudrā** A similar hand-pose to the *añjali*. It is sometimes performed with only one hand.[1]

[1]*ID*, p. 329.

Vāṇī v. Sarasvatī.

Varadamudrā 'Bestower of boons'. A *mudrā* indicating the giving of boons in which the left hand is held out palm uppermost with the fingers pointing downwards. This *mudrā* and the *abhaya* are the two most commonly seen in Hindu and Buddhist icons.

v. Varadarāja.

Varadarāja or **Karivarada** 'King among boon-bestowers'. An epithet of Viṣṇu when he rescued Gajendra, the lord of elephants, from the clutches of a crocodile. He also bestowed boons on Gajendra.

Varadarāja is depicted eight-armed and seated in *āliḍhāsana* position on Garuḍa. He holds a discus, conch, club, sword, shield, bow, arrow and lotus. Sometimes the figures of the elephant and crocodile are also depicted.

Varāha 'Boar', a symbol of ploughing and of agriculture.

v. Yajña: Varāhāvatāra.

Varāhamukha or **Varāhamastaka** 'Having a boar's head'. A characteristic of Viṣṇu in his boar-incarnation (Varāhāvatāra), and of his four-headed form (Caturmūrti).

Varāhāvatāra The Boar (*varāha*) incarnation of Viṣṇu. The boar is 'a form composed of the Vedas and the sacrifice',[1] and hence symbolizes the Vedic sacrifice.

Viṣṇu assumed the form of a boar to rescue the earth which had disappeared under the waters. In Vedic literature Prajāpati (when in the form of the black boar Emūṣa), raised the Earth-goddess from the primeval waters. As the water poured off his body it purified the sages and the *munis* sheltering amongst his bristles. In some texts the black boar is said to have a hundred arms. Sometimes he is depicted entirely in boar form with rows and rows of small human figures on his body, indicating his cosmic nature. Or he is portrayed with a powerful human body and boar's head.

[1]*EHI*, I, pt ii, p. 129.

v. Hiraṇyākṣa; Yajña; Varāhī.

Vārāhī

Vārāhī A form of Devī, the consort of Varāha. She may be depicted with the head of a boar and a woman's body. She wears a *karaṇḍamakuṭa* and coral ornaments. Her emblems are: a plough and spear; her sacred tree, the *karañja*. Her mount is an elephant,[1] and an elephant is also depicted on her banner. The *Viṣṇudharmottara* adds that she has six hands and carries a staff, sword, shield, and noose, the remaining hands being in *abhaya* and *varada mudrās* respectively.

[1]Or a buffalo or boar.

v. Varāhamukha; Saptamātara(s).

Varaṇa The tree (*Crataeva Roxburghii*) believed to possess both medicinal and magical properties (*AV*, VI.85,1). Amulets are made from its wood.

Vārāṇasī Benares.

v. Kāśī.

Vardhanī 'Water-pot', in which Umā is invoked and worshipped.

v. Kumbha.

Varṇa Lit. 'colour'; 'caste'. Theoretically there were four main classes or castes: the brahmin (*brāhmaṇa*), warrior (*kṣatriya*) trader and agriculturist (*vaiśya*), and *śūdra*. The many 'sub-castes derived clearly from the tribal groups of different ethnic origin'.[1] Today there are over 3,000 caste groupings in India. Those persons outside the caste system are the Untouchables or Harijans, whose status Mahatma Gandhi did so much to improve.

Caste duty is by definition social duty and thus it has an integrative effect. Colour symbolism was the usual method of classifying the social order in tribal societies throughout the world. In India white was associated with the brahman, red with the warrior, yellow with the agriculturist, and black with the *śūdra*.

[1]Kosambi, *Culture and Civilisation of Ancient India*, p. 15.

Varṇanī A wife of Śāsta.

Varuṇa One of the earliest and most important of the Vedic gods who resembles in many respects, the Avestan deity Ahura Mazda. Varuṇa is one of the Ādityas and hence is associated with celestial order, as well as with mundane morality and law and order (*ṛta*). Radhakrishnan maintains that Vaiṣṇava theism, with its emphasis on *bhakti*, derived from 'the Vedic worship of Varuṇa, with its consciousness of sin and trust in divine forgiveness'.[1]

Varuṇa's informants or spies report any infringements of the law whether on earth or in the heavens, for from the sun, 'the eye of Varuṇa', nothing is hidden.

Varuṇa is associated with kingship, having been the first consecrated king. He is also regarded as a rain-giver. As overlord of the primordial waters his vehicle is the *makara*, the fabulous aquatic animal, which Coomaraswamy[2] suggests 'may have been the theriomorphic form of the deity in person'. All people and animals who drown go to Varuṇa. His favourite sacrificial animal is the stallion, and in the horse sacrifice (*aśvamedha*), Varuṇa's generative force is identified with that of the horse.

Varuṇa wears an elaborate necklace of pearls, and holds a noose (*pāśa*) with which to catch evildoers,[3] and a pitcher, or his right hand is in *varada mudrā*. He stands on a lotus rooted in the primordial waters and a *makara* looks towards him. His physique is powerful and he is two- or four-armed. When two-armed he has one hand in *varada mudrā*, the other carrying a noose; when four-armed he carries a noose, snake, and sometimes a water-vessel. But the *Viṣṇudharmottara* gives a different description from those found in the *Āgamas*, and states that Varuṇa should be seated in a chariot drawn by four geese (*haṃsa*), he should be four-armed, clothed in white, and adorned with ornaments. His banner depicts a *makara*. His right hands hold a lotus and noose, left, a conch-shell and pot of gems (*ratna-pātra*), because in Hindu mythology the sea is said to be the repository of gems. His beautiful consort should be seated on his left lap. She holds a blue lotus in her left hand, her right arm embraces Varuṇa. To Varuṇa's right and left stand the river-goddesses Gaṅgā and Yamunā on their respective mounts. In later Hinduism Varuṇa became the guardian (*dikpāla*) of the westerly direction.

[1]*Indian Philosophy*, I, p. 78.

[2]*Yakṣas*, pt ii, p. 53. Or his mount may be a deer (Bhattacharya, *Indian Images*, pt i, p. 28).

[3]Bhattacharya, ibid., pt i, p. 29, considers the noose is really a rope net as used by fishermen and pearl-fishers.

v. Vāruṇī.

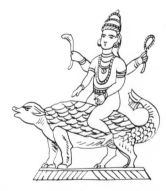

Varuṇapāśa Also called *dharmapāśa*. The noose (*pāśa*) with which Varuṇa seizes, or ensnares, evildoers and demons.

Vāruṇī or **Varuṇānī** Goddess of wine and intoxication, the wife (or daughter) of Varuṇa. Thus the term *varuṇ-atmajā* 'Varuṇa's daughter' is applied to intoxicating liquors. She is also associated with boats and is often depicted seated in one. Her emblems are a wine cup (*caṣaka*), a piece of meat, a lotus and *pārijāta* flowers.

Vāruṇī-Cāmuṇḍā A dual goddess. Vāruṇī may be depicted either with pendulous breasts, sagging belly, and carrying a trident and arrow, or as a beautiful woman. Cāmuṇḍā may be represented with several arms and long nails. She is said to be capable of attracting everyone to her by means of her power.[1]

[1]*EHI*, I, pt ii, p. 364.

Vasanta 'Spring', the season from the middle of March to the middle of May. When personified, Vasanta has a monkey (*vānara*) as a mount.

Vasiṣṭha A Vedic *ṛṣi* representing the power of wealth, who figures prominently in the seventh *maṇḍala* of the *Ṛgveda*. In post-Vedic mythology he became one of the seven stellar *devarṣis* who rise and set in the region of Mount Meru.[1] His wife is Arundhatī.

[1]*EM*, p. 182.

v. Agastya.

Vāstoṣpati 'Protector of the house'. Name of a deity who presides over the foundation of a house. It is also an epithet applied to Indra who may at one time have been a house-guardian.[1]

[1]Bhattacharyya, *Canons of Indian Art*, p. 3.

Vastrayajñopavīta A sacred thread (*yajñopavīta*) made of cloth.

Vāstumaṇḍala v. Vāstunara.

Vāstunara or **Vāstupuruṣa** The archetype or ideal design of a house (*vāstu-maṇḍala*)[1] personified as a being whose huge body obstructed both earth and heaven.

[1]Kramrisch, *Hindu Temple*, I, p. 22; Bhattacharyya, *Canons of Indian Art*, p. 30.

v. Vāstoṣpati.

Vāstuvidyā The science of architecture attributed to Viśvakarman.

Vasu A demi-god. There are eight Vasus, usually depicted two-armed and red complexioned. They wear *karaṇḍamakuṭas* and many ornaments. Their garments are yellow, and each carries a sword, spear and shield.

Vasudeva The father of Kṛṣṇa and Balarāma.

v. Vāsudeva.

Vāsudeva The patronymic of Kṛṣṇa, son of Vasudeva, but the earliest tradition does not mention Kṛṣṇa's father, only his mother Devakī.

In his divine aspect Kṛṣṇa is regarded as the Supreme God of the universe and is known as Para-Vāsudeva. His emblems are a conch, discus, club and lotus. In his human aspect (*mānuṣa*-Vāsudeva) he has two hands and carries a conch and discus. His emblems denote his transcendental nature. The discus represents cyclic time, the circular paths of the planets, the round of existence, and so on; the conch signifies sound which is an attribute of space, the abode of Viṣṇu; the lotus, the type of his created power; the club the power to destroy the enemies of the world.[1]

[1]Bhattacharya, *Indian Images*, p. 11.

Vāsudeva-Kamalajā A composite form of Viṣṇu (Vāsudeva) and Lakṣmī, which is a parallel to the Ardhanārīśvara aspect of Śiva and Pārvatī.[1]

[1]See Bhattacharyya, *Iconology of Composite Images*, pp. 29f.

Vāsudeva-Kṛṣṇa I. An epithet of Kṛṣṇa as the son of Vasudeva.

II. A cult based on a culture-hero of the Vṛṣṇi or Sātvata clan of the warrior caste in north-west India. It was a revolt against the complex and mechanical ritual of the Vedic sacrificial system, and against the power of the brahmins.

Vasudhārā Name of Kubera's *śakti*.

v. Bhūmidevī.

Vāsuki A serpent (*nāga*) king and son of Kadrū. In mythology the world is said to be supported on Vāsuki's many heads. When he moves earthquakes result.[1]

During the churning of the ocean (*samudramathana*), his body formed the churning-rope. Vāsuki also appears on Śiva's body, and forms an armlet worn by Aparājitā (Durgā). When represented anthropomorphically Vāsuki holds a rosary and water-pot. A swastika is depicted on his hood.

[1]Cf. the Scandinavian serpent Miŏgarŏsormr.

Vaṭa The Indian fig-tree (*Ficus indica*), a symbol of the cosmos. It is sacred to Śiva who is called Vaṭeśvara 'Lord of the *vaṭa* tree', and also to Viṣṇu and Cāmuṇḍā.

Vaṭapattraśāyin or **Vaṭapattrāśāyin** Kṛṣṇa depicted as an infant lying on a banyan (*vaṭa*) leaf floating on the waters. 'This form is symbolic of God brooding over the ocean of chaos caused after the destruction of the universe at the end of the aeon', and indicates 'that the dissolution of the cosmos is in fact the infancy of its evolution'.[1]

[1]*EHI*, I, pt i, pp. 215, 264.

v. Santāna-gopāla; Anantaśāyana.

Vaṭavṛkṣa A banyan tree.

Vaṭeśvara v. Vaṭa.

Vaṭuka-Bhairava v. Baṭuka-Bhairava.

Vāyu The Vedic god of the wind. Vāyu is said to be 'the breath of the [cosmic] Puruṣa', or 'sprung from the breath of Puruṣa', a description which gave rise to much mystical speculation concerning 'vital breath' (*prāṇa*).

Vāyu's mount is the swift-moving antelope, or a lion. He is associated with Indra whom he conveys in a shining car, drawn by a pair of red or purple horses, or by teams of a hundred or a thousand horses.

Vāyu is portrayed as a dark-complexioned, handsome youth with two or four arms. He wears elaborate ornaments and holds a banner (*dhvaja*),[1] or a goad in his right hand and a staff in his left. The *Viṣṇudharmottara* states that he should carry a discus and banner, and have his mouth open.[2] In later mythology he is regarded as the guardian of the north-westerly direction.

[1]Bhattacharya, *Indian Images*, pt i, p. 30.

[2]*EHI*, II, pt ii, pp. 532f.

v. Dikpāla(s); Mṛga; Hanumān.

Veda Lit. 'knowledge', a term specifically applied to the 'supreme sacred knowledge' contained in the four collections (*saṃhitās*) of prayers and 'hymns' addressed to various gods, and consisting of the *Ṛgveda*, *Sāmaveda*, *Yajurveda*, and later the *Atharvaveda*. Also included in the Veda corpus are the *Brāhmaṇas* (treatises on sacrificial ritual), appended to the above texts, and the *Āraṇyakas* and *Upaniṣads* (metaphysical and philosophical speculations on ultimate Reality). So great was the impact of the *Āraṇyakas* and *Upaniṣads* that they were finally regarded as the fulfilment of Vedic nascent aspirations and hence called Vedānta, the end or conclusion, 'anta', of the Veda.

The Vedic 'hymns' were probably collected and arranged before 1000 BC, and passed down orally with incredible accuracy, but although the language changed over the centuries making much of the original meaning unclear, the basic teaching of the Veda is the unity of the One Reality manifested in diversity. The 'hymns' when uttered by a trained priest and accompanied with the right ritual gestures are said to be irresistible, even gods and demons being subject to their power.[1]

Although the Veda is regarded as forming an unalterable scriptural corpus, it has none the less been constantly reinterpreted over the centuries, as well as assimilating many 'autochthonous "popular" divinities'.[2] It also includes the rudiments of classical *yoga*.[3]

Viṣṇu sometimes holds a manuscript representing the Veda, as does Brahmā who, as the embodiment of divine knowledge, is said to have revealed the Vedas to the ancient *ṛṣis*.

[1]W. Norman Brown 'Class and Cultural Traditions in India', p. 36.

[2]Eliade, *Yoga*, p. 113.

[3]Ibid., p. 102.

v. Dikpāla(s); Sūkta.

Vedāṅga(s) 'Limbs' (*aṅgas*) of the Veda, comprising six treatises dealing with the correct performance of sacrificial ceremonies.

Vedānta 'The end (*anta*) of the Veda'. Name of one of the six schools of Hindu philosophy (*darśana*).

Vedānta Śaiva A Śaiva cult based on the Vedas and Upaniṣads.

Veda-Vyāsa 'Arranger of the Veda'. Title of a mythical compiler of the collections comprising the Veda – a task which could have been only accomplished by many people over many centuries.

Vedi 'Altar'. An elevated, or sometimes an excavated, piece of ground serving as an altar, with receptacles for the sacrificial fire. In Vedic India the invisible gods to whom the sacrifice was dedicated were believed to descend into the altar which was conceived as being at the 'centre of the world', and hence Agni is said to be kindled in the earth's navel. The sacred *kuśa* grass was spread over the sacrificial area to provide a seat for the gods.

The *Śulva Sūtra* states that altars should be constructed so that their size could be increased without altering their basic shape. This involved advanced geometrical skills.[1]

[1]Filliozat in *Ancient and Medieval Science*, p. 148; *IWP*, p. 124.

Veṇi A hair style in which the hair is twisted into one unornamented plait hanging down the back. Widows wear this style and also women 'mourning' absent husbands.

Veṅkaṭeśa 'Lord of Veṅkaṭa'. Vaiṣṇavas claim that this deity is Viṣṇu, and Śaivas that it is Śiva. The icon itself resembles that of Hari-Hara, the right half being Hara (Śiva), the left, Hari (Viṣṇu).

Veṅkaṭeśa is depicted with four arms. He wears a snake armlet (*bhujaṅgavalaya*). Two back hands hold a conch-shell (?) and a discus. One right hand is in *abhaya mudrā*, the remaining left rests on the hip.[1]

[1]*EHI*, I, pt i, p. 271.

Veṇu A bamboo flute, emblematic of Veṇugopāla, Kṛṣṇa and Rājagopāla.

Veṇugopāla 'Cowherd with the flute.' A form of Kṛṣṇa when playing the flute. He stands firmly on one leg,

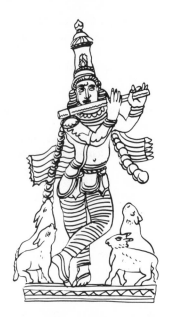

with the other leg crossed in front of it (*pādasvastika*).

v. Gānagopāla; Madanagopāla.

Vesara An ornament worn on the nose and characteristic of Rādhā.

Vetāla(s) I. A class of hideous demons, ghouls or vampires, who reanimate the dead, and whose eerie singing can be heard in burial grounds. Kosambi[1] states that they are independent and highly primitive gods still popular in village worship.

Aghoramūrti and Vīra-Vighneśa sometimes grasp a Vetāla in one hand.

[1]*Culture and Civilization of Ancient India*, p. 170.

II. Name of a form of black magic.

Vibhava 'Manifestation', a deity who manifests himself in a special manner and for a special purpose.

v. Avatāra.

Vibhavā 'Rich', name of Kubera's wife.

Vibhīṣaṇa I. 'Frightful', name of Rāvaṇa's brother.

II. An epithet of Śiva.

Vibhu v. Ṛbhu(s).

Vibhūti I. The manifestation of superhuman powers, consisting of eight special faculties experienced by *yogins*. These faculties are especially attributed to Śiva, but his devotees may also attain them.

II. 'Ashes'. The purifying properties of fire were well known in Vedic times, and hence ashes were said to share the same properties. Ashes also possess fecundating qualities as well as the power to avert evil.[1]

After Śiva had reduced the gods to ashes at the end of the ages, he rubbed their ashes on his limbs, and hence Śaiva *yogins* rub the ashes of the ritual fire, or of a funerary fire, on their bodies. In Yoga, the ashes symbolize the sublimated power of procreation and reflect the theory that the semen of a completely chaste man is burned within his body. The body of the goddess Kālī is also smeared with ashes.

[1]*Aspects*, p. 193.

v. Bhasman; Yoga.

Vidhavā 'Widow'. An epithet of Dhūmāvatī, one of the Mahāvidyās, who personifies the destruction of the world by fire. When only its ashes remain Dhūmāvatī is called Vidhavā, widow of a dead world.

Vidyā 'Knowledge', 'wisdom', 'insight', the knowing of 'all things however apparently different and divergent'.[1] It is the synoptic vision of totality, whereas the ignorant see everything as separate and differentiated.

Initially there were four branches of knowledge: *trayī-vidyā*, knowledge of the triple Veda; *ānvīkṣikī*, logic and metaphysics; *daṇḍa-nīti*, science of government; *vārttā*, agriculture, commerce, and medicine. To these Manu (VII.43) adds *ātma-vidyā*, the knowledge of the Supreme Essence (*ātman*). Another enumeration comprises fourteen *vidyās*, viz., the four Vedas, six Vedāṅgas, the Purāṇas, the Mīmāṃsā, the Nyāya, and Dharma or Law. Other lists enumerate thirty-three or sixty-four sciences (*vidyās*) including the arts of astronomy, geometry, architecture, dancing, and music.

Knowledge is personified as a goddess who is identified with Durgā.

[1]*IWP*, pp. 94f.

v. Vidyādhara(s); Jñāna.

Vidyādhara(s) 'Bearers of divine knowledge (*vidyā*)', depicted as wingless, celestial figures of great beauty and grace, formed from 'mind stuff' or 'subtle matter' (*sūkṣma*). These aerial spirits may assume any shape at will.

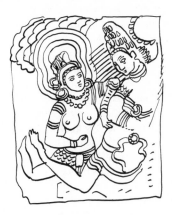

Their abode is the heavenly realm and hence they are depicted floating between earth and heaven and moving towards the main deity of a composition. They hold the sword of knowledge which cuts through ignorance and evil; or a garland representing victory. Sometimes they are represented as hybrid forms, with the upper half of the body human, the lower half bird-like, or completely human.

v. Vidyādharī(s).

Vidyādharī(s) The female counterparts of the Vidyādharas.

Vidyāmudrā v. Jñānamudrā.

Vidyāśakti A form of Kālī, whose destructive power increases the further she is removed from her consort Śiva. She represents the disintegration of the world at the end of the age.[1]

[1]*Principles*, p. 228.

Vidyeśvara(s) 'Lords of knowledge'. Eight beings, said to be aspects of Śiva, through whom the lower order of beings may attain to higher evolutionary stages.[1] Each one is associated with a particular colour. They are depicted three-eyed. The *Viṣṇudharmottara* states that their front hands should be in *añjali mudrā*, and the back hands should carry an arrow and trident.

[1]*EHI*, II, pt ii, p. 396.

Vighna An 'obstacle' personified, which may be removed by the gods. Gaṇeśa is the remover of obstacles *par excellence*.

v. Vighnajit; Vighnarāja-Gaṇapati.

Vighnajit 'Conqueror of obstacles'. An epithet of Gaṇeśa who can be both the originator and remover of obstacles and difficulties, and therefore homage is paid to him before commencing any undertaking.

v. Vighna; Vighnarāja-Gaṇapati; Siddhidātā; Vināyaka.

Vighnarāja-Gaṇapati King (or ruler or controller) of obstacles. A form of Gaṇapati (Gaṇeśa), which denotes his victory over the *asura* Vighna, the personification of obstruction. Gaṇapati carries a noose and goad, and eats a mango fruit.

v. Vighna.

Vighneśa or **Vighneśvara** 'Lord of obstacles'. An epithet of Gaṇeśa.

Vighneśvara may be represented seated or standing. The seat may be a lotus (*padmāsana*), or a mouse, or occasionally a lion. When seated Vighneśa's left leg is folded and resting on the seat. The right leg is crossed and resting on the thigh, but when the belly is too big, the legs cannot cross and hence the right leg is bent and placed vertically on the seat.[1]

Vighneśa is represented two-eyed and with four, six, eight, ten or sixteen arms, but the usual number is four. His sacred thread is composed of the body of a snake; another snake serves as a girdle. He carries a noose and goad, and wears a *kirīṭamakuṭa*.[2]

[1]*EHI*, I, pt i, p. 49.

[2]Ibid., p. 60; II, pt i, p. 214.

Vighneśvarānugrahamūrti A group portraying Śiva, Pārvatī and Gaṇeśa. Śiva is black; his *mudrās* are the *abhaya* and *varada*; his emblems, an antelope and axe. Pārvatī shows the *varada mudrā* and holds a blue lotus. Gaṇeśa shows the *añjali mudrā*, and holds a goad and noose.

Vighneśvarī The *śakti* of Vighneśa.

Vigrahaṇa v. Vyūha(s).

Vijaya I. 'Victory', 'conquest'. Name of Indra's magic bow, i.e., the rainbow.

II. Name of Rudra's personified lance or spear.

v. Āyudhapuruṣa.

III. Name of a door-keeper (*dvārapāla*) of Brahmā or Viṣṇu.

Vijayā 'Victory'. I. Name of Durgā who is sometimes associated with the goddess Jayā. Both are four-armed and hold a trident, lotus and rosary. The fourth hand is in *varada* pose. Their vehicle is a lion. Both goddesses fulfil the desires of their votaries.[1]

[1]*EHI*, I, pt ii, p. 368.

II. Hemp (*Cannabis indica*), used by some Tantrists to attain an ecstatic state of mind.

v. Bhaṅgā I.

III. Name of the *śakti* of Ṣaṇmukha.

Vikasitapadma A fully opened lotus flower (*padma*). Two lotuses in full bloom are emblematic of Sūrya.

Vimalāsana A hexagonal seat (*āsana*).

Vimāna I. A divine, self-propelling chariot.

II. Name of a palace in the sky.

III. A term 'applied to a temple as a whole, comprising the sanctuary and attached porches'.[1]

[1]*ID*, p. 338.

IV. Name of a throne.

Vimānadevatā An image placed in a niche on the outer wall of a temple.

Vimānapāla A temple guardian.

Vimarṣa An aspect of Śiva.

v. Prakāśa.

Vīṇā An ancient Indian musical instrument, said to have been invented by the *ṛṣi* Nārada. Originally it was a bow-shaped harp, examples of which have been found in the Indus Valley, and which are also depicted on ancient Buddhist monuments. But after the sixth or seventh centuries AD the term was applied to a kind of bamboo lute with a gourd suspended from either

end. It has been much elaborated over the centuries, resulting in variants according to the number of strings.[1]

When Śiva is depicted as master of music he plays a *vīṇā* and is then known as Vīṇādhara-Dakṣiṇāmūrti. The *vīṇā* is also emblematic of Sarasvatī, Bhūmidevī, Rati, Nārada and others.

[1]See Marcel-Dubois, *Les instruments de musique dans l'Inde ancienne*, pt iv, Paris, 1941.

Vīṇādhara-Dakṣiṇā(mūrti) An aspect of Dakṣiṇā (Śiva) as the great teacher of music, both instrumental and vocal. He is depicted four-armed and standing with the left leg placed firmly on the head of Apasmāra, the right resting on the ground. The two front hands are in *kaṭaka* pose to hold a *vīṇā*. The latter was separately cast so that it could be inserted into the hands when required. The back hands hold an axe and antelope, and his bull stands behind him.

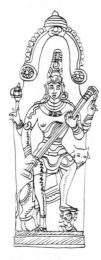

Vinatā Wife of the mythical *ṛṣi* Kaśyapa and sister of Kadrū. Sometimes Vinatā is regarded as the mother of the egg-born Garuḍa, who was hatched after a thousand years.

Vināyaka 'Taking away', 'removing', and hence 'remover of obstacles', an aspect of Gaṇeśa who leads the good in the way of righteousness.[1] His wife is Vināyikā (also called Gaṇeśānī or Siddhi).

Vināyaka conveys the notion of auspicious kingship. The elephant head signifies royalty, power, and victory. Thus Indra as the celestial king has the white elephant Airāvata as his mount.

[1]*EHI*, I, pt i, p. 47.

v. Vighnajit.

Vināyikā v. Vināyaka.

Vindhyavāsi-Durgā or **Vindhyavāsinī-Durgā** One of the most prominent goddesses of the Vindhya mountains. She was adopted by Vaiṣṇavas and connected with Viṣṇu by making her an incarnation of his fecund sleep (Yoganidrā).[1]

Vindhyavāsi is three-eyed and seated on a golden lotus. She has four arms and carries a conch-shell and discus, the remaining hands are in the *varada* and *abhaya mudrās* respectively. A crescent moon is depicted on her head-dress, and she wears elaborate necklaces, earrings and other ornaments. Her mount is a lion, or a golden lotus.[2]

[1]*VS*, p. 63.

[2]*EHI*, I, pt i, p. 344; *ID*, p. 339.

Vīra 'Hero, chief, leader'. An epithet applied to Indra and the solar Viṣṇu, and to the Buddha, the Jaina tīrthaṅkara Mahāvīra, as well as to any eminent *siddha* who has overcome all earthly impediments by asceticism (*tapas*) – thus Śiva is called Vīreśvara, 'chief of heroes'. The ideal hero 'Rāma represents the *vīra* aspect of Viṣṇu'.[1]

[1]Bhattacharyya, *Iconology of Composite Images*, p. 14.

Vīrabhadra Name of the terrible manifestation of Śiva's wrath. Vīrabhadra was created for the express purpose of wrecking Dakṣa's sacrifice, to which Śiva had not been invited.

Vīrabhadra is depicted three-eyed, four-armed, and with tusks protruding from his mouth. He wears sandals and a *jaṭāmakuṭa*, and is decked with garlands of skulls and various ornaments. One of his right hands is in *abhaya mudrā*, one left hand is in *varada mudrā*. The others hold a trident and a club respectively. His sacred tree is the banyan under which he sits on a lotus seat. The figure of a bull is shown on his banner.[1]

The *Kāraṇāgama* describes Vīrabhadra as having *jaṭās* which emit fire, garlands composed of skulls, small bells and scorpions, and a sacred thread consisting of a snake. His expression is angry. His weapons are a sword, shield, and bow and arrow. The setting up of this icon is said to remove all major sins and to have curative properties.[2] Vīrabhadra's mount may be Dakṣa, or a lotus, or a dog. Sometimes Dakṣa is portrayed with a ram's head.

According to the *Varāha Purāṇa*, Śiva-Vīrabhadra assumes the form of a lion to kill the elephant demon Gajāsura. Thus a lion depicted standing over a vanquished elephant refers to the above myth.[3]

Gaṇeśa and Vīrabhadra are generally placed one at each end of reliefs depicting the Seven Mothers (Saptamātaras), to whom they act as guardians.

[1]*EHI*, I, pt ii, pp. 388f.

Virādha

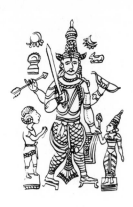

²Ibid., II, pt i, pp. 185f.
³*Principles*, p. 226.
Virādha v. Tumburu.
Virāj v. Aditi.
Vīrarātrī 'The night (*rātrī*) of Courage'. An aspect of Chinnamastā.
v. Mahāvidyā(s).
Vīraśaiva v. Liṅgāyat.
Vīrāsana A seated yogic posture of a hero (*vīra*) in which one foot is placed on the ground. The other leg is placed on the knee of the other.
Vīrāsana(mūrti) A form (*mūrti*) of Viṣṇu represented as seated on a lion throne (*siṃhāsana*), with the left leg bent and the right slightly extended. Lakṣmī and Bhūmidevī kneel on one knee on either side of him. One right hand holds a *cakra*, the other is in *abhaya mudrā*; one left hand holds a conch-shell, the other is in *kaṭaka* pose.¹
¹*EHI*, I, pt i, p. 89.
Vīraśāyana(mūrti) A reclining form of Viṣṇu. One of his right hands serves as a pillar for his head, another holds a discus. One left hand carries a conch, the other is stretched out parallel to the body. Lakṣmī and Bhūmidevī are seated near Viṣṇu's feet. The two demons, Madhu and Kaiṭabha, hold the god's feet as if in supplication. Brahmā is seated on the lotus rising from Viṣṇu's navel.¹
¹*EHI*, I, pt i, pp. 94f.
v. Anantaśāyana.
Vīrasthānaka(mūrti) A heroic standing position of Viṣṇu. His emblems are a discus and conch.
v. Vīra.
Vīra-Vighneśa 'The hero (*vīra*) Vighneśa' who overcomes all difficulties and obstacles. He is a form of Gaṇeśa, and has sixteen hands carrying a vampire (*vetāla*), spear (*śakti*), bow and arrows, sword, shield, hammer (*mudgara*), club, goad, noose, trident, axe, a banner, and a jasmine flower. His colour is red.¹
¹*EHI*, I, pt i, pp. 52f.

Virocana 'Shining'. An epithet of Sūrya and sometimes of Viṣṇu.
Virūpākṣa Name of one of the eleven Rudras and an epithet of Śiva who carries in his right hands a sword, trident, drum, goad, snake, discus, club and rosary; in his left hands, a shield, skull-topped staff, spear, axe, bell, skull-cup and a pot-shaped drum (*ghaṭa*). One hand is in *tarjanī mudrā*.¹
¹*EHI*, II, pt ii, p. 389.
Viṣaharī 'Poison (*viṣa*) remover'. An epithet of Manasā, the goddess of snakes, who protects her devotees from snake venom.
Viśākha Name of Nandin, Śiva's bull.
Viṣāpahara v. Viṣaprahara(mūrti).
Viṣaprahara(mūrti) or **Viṣapraharaṇa(mūrti)** or **Viṣāpahara** A representation of Śiva in the act of holding the poison in his throat which otherwise would have killed all beings. As this deadly poison had no effect on him¹ he is regarded as the highest of the divine physicians. Furthermore he can cure the ills of *saṃsāra*, the cycle of births and deaths.

Viṣaprahara is depicted three-eyed and four-armed, and carries a small cup in his right hand, and a snake in his left. His two upper hands hold an axe and an antelope, or one hand may be in *varadamudrā*. Another description states that he should wear tiger-skin garments and many ornaments including a garland composed of small bells. Some of his ornaments may consist of scorpions (*vṛścika*). His right hands hold a trident and vessel with a spout (*gokarṇa*) containing poison (*viṣa*); in one left hand he holds a skull-cup. Sometimes Śiva is accompanied by Pārvatī, and is seated on his bull mount.²
¹Sivaramamurti, *Śatarudrīya*, p. 7.
²*EHI*, II, pt i, pp. 357f.
Vismayahasta or **Āścaryamudrā**. A gesture expressing astonishment or praise. One arm is bent and the hand raised, palm facing towards the image.
v. Mudrā; Vismaya-vitarkamudrā.

Vismaya-vitarkamudrā A *mudrā* indicating astonishment in which the index and middle fingers are placed on the chin.
v. Vismayahasta.
Viṣṇu 'Pervader'¹ An important Hindu deity. In the *Ṛgveda* Viṣṇu is a minor personification of solar energy, but later became a deity of major importance and a member of the Hindu triad (*trimūrti*). He is

the maintainer and preserver of the universe, and the embodiment of truth, goodness and mercy. Thus he personifies 'the *sattvic* principle . . . the eternal aspiration of the spirit.'[2]

Viṣṇu's usual emblems are: the conch, symbol of the five elements denoting the origin of existence; the discus, symbol of mind and of the cohesive tendency; a bow (or lotus), signifying the causal power of illusion from which the universe arises and the tendency towards dispersion and liberation; and the mace or club, signifying primeval knowledge and the notion of individual existence.[3] His *mudrā* is *abhaya*.

The brilliant gem called Kaustubha shines on Viṣṇu's chest, and symbolizes the consciousness of all beings which manifests itself in all that shines. A lock of golden hair called *śrīvatsa* (beloved of fortune) is portrayed on his left breast and denotes basic Nature, the source of the world. His *makara*-shaped earrings signify intellectual knowledge and intuitive perception; his armlets, the three aims of worldly life, righteousness, success and pleasure; his crown, the unknowable Reality; his three-stranded sacred thread, the three letters of the sacred *mantra AUṀ*.

Both Viṣṇu and all his incarnations (*avatāras*) are depicted wearing a thin golden veil (*pītāmbara*) round the hips which represents the sacred Vedas through which divine reality shines even as the radiance of Viṣṇu's dark body shines through the golden veil. His dark complexion signifies the infinite formless, pervasive substance of the spatial universe. His incarnations are depicted in different colours according to the ages of the world and the predominant qualities of each age (*yuga*). Similarly, his colour changes in the different ages, being white in the first – the 'golden' age – when goodness and truth predominated; red in the second, yellow in the third, and black in the fourth, the present age.

In *vaiṣṇava* temples Viṣṇu may be represented standing, sitting, or reclining. The images in each of the three attitudes are further classified into the *yoga*, *bhoga*, *vīra* and *abhicārika* varieties, which are intended to be worshipped by devotees with different desires and objects in view; thus a *yogī* should worship the *yoga* form; persons desiring enjoyment, the *bhoga* form; those wanting prowess, the *vīra* form; and kings and others who wish to conquer their enemies, the *ābhicārika* aspect.[4]

[1]Or it may mean 'taking various forms' (*IAL*, 11991). Renou and Filliozat (*L'Inde classique*, p. 323), and others, consider that the name is non-Aryan.
[2]*Principles*, p. 152.
[3]*HP*, pp. 153ff.
[4]*EHI*, I, pt i, pp. 78f.

v. Āyudhapuruṣa; Viṣṇupaṭṭa(s); Kṛṣṇa; Cakra; Sudarśana; Vaikuṇṭha I; Ananta; Śālagrāma; Viṣṇuyantra; Vanamālā.

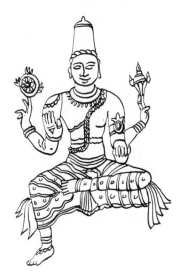

Viṣṇubhāga v. Mānuṣaliṅga(s).

Viṣṇudharmottara An important textbook of medieval artists.
See Bibliography under Kramrisch, S.

Viṣṇupaṭṭa(s) Square votive slabs of stone or metal with the image of Viṣṇu carved on one side and his ten incarnations (*daśāvatāras*) on the other.

Viṣṇuyantra A *yantra* of Viṣṇu representing the all-pervasiveness of the *sattvaguṇa*.
v. Guṇa(s); Yantra.

Viṣṇuyaśas An eminent *brāhmaṇa*, one of whose descendants will be born at the close of the *kali* age as Kalkin, the future incarnation of Viṣṇu.

Viṣṇvanugraha(mūrti) or **Cakradāna(mūrti)** A benign form (*mūrti*) of Śiva when in the act of presenting Viṣṇu with a discus, the *kaustubha* jewel, and the yellow veil (*pītāmbara*).

Śiva is portrayed three-eyed and four-armed, and seated with Pārvatī on a *bhadrāsana*. In one left hand he holds a hatchet, the other left hand passes the discus to Viṣṇu whose hands are held out to receive it. One of Śiva's right hands holds an antelope, the other is in *varada mudrā*. The two ends of the *prabhāmaṇḍala* round the group rises from the mouths of *makaras*.

Viśvajit 'All-conquering', a name of Varuṇa's noose (*pāśa*).

Viśvakarman 'All maker'. Name of the architect of the universe. He embodies supreme creative power, universal knowledge and wisdom, and is also regarded as the founder of the science of architecture (*vāstuvidyā*). Later he is sometimes identified with Tvaṣṭar.

The human craftsman is an analogy of the divine architect.

Viṣvaksena I. 'Whose hosts (or powers) go everywhere'. An epithet of Viṣṇu-Kṛṣṇa to whom the fragments of a sacrifice are offered.

II. Name of Viṣṇu's gate-keeper killed by Śiva in his Bhairava aspect, when he was refused entry to Viṣṇu's abode. This heinous crime of brahminicide became personified as a woman who followed Śiva wherever he went, until finally his sin was expiated and she disappeared into the nether world.

The body of Viṣvaksena is sometimes portrayed on the top of Śiva's trident.

v. Kaṅkāla(mūrti).

Viśvāmitra 'Universal friend (*mitra*)'. Name of one of the most eminent of the Vedic seers, who represents the power of the social laws which hold society together. He also embodies will and longevity.[1]

[1]*HP*, p. 320.

Viśvanātha 'Lord of the Universe', an epithet of Śiva.

Viśvarūpa I. 'Multiform'. The cosmic form of any god, (especially of Viṣṇu), showing the whole universe contained in his body. To Śaivas, Śiva represents the universe and hence is the embodiment of every manifested form. Gods, goddesses, men, animals, trees, plants, water, clouds, rain, lightning, and so on, are all included under his *viśvarūpa* aspect.[1]

[1]Sivaramamurti, *Śatarudrīya*, pp. 60f; Bhattacharyya, *Iconology of Composite Images*, pp. 8, 49, 52, 54.

II. Name of the three-headed demon Triśiras, son of Tvaṣṭṛ.

III. One of the thirty-nine incarnatory forms of Viṣṇu, listed in the *Sātvata saṃhitā*.[1]

[1]*DHI*, p. 391.

Viśvarūpiṇī The creative aspect of Śakti.

Viśva(s) or **Viśvedeva(s)** 'All-gods'. A group of ten, twelve or thirteen minor divinities representing universal principles, and personified as the sons of Dakṣa (or Dharma) and Viśvā.

Viśvāvasu The chief *gandharva* of Indra's paradise.

Viśvedeva(s) v. Viśva(s).

Viśveśvara 'Lord of the universe', an aspect of Śiva.

Vitarkamudrā The *mudrā* of reasoning, similar to the *vyākhyānamudrā*.

Viṭhobā, Viṭṭhala or **Paṇḍharinātha** A form of Viṣṇu. Viṭhobā is usually depicted standing (*samabhaṅga*) with his hands resting on his hips. He wears 'a *kirīṭa* which is said to have a *liṅga* mark on it',[1] and he stands on a brick (*vīṭ*).[2]

[1]*EHI*, I, pt i, p. 273.

[2]*ID*, p. 345.

Viṭṭhala v. Viṭhobā.

Vivāha 'Marriage', of which there are six (or eight) different kinds.[1]

[1]See *DH*, under Vivāha.

v. Kalyāṇasundara(mūrti).

Vivasvat or **Vivasvān** 'Brilliant One', an epithet of Sūrya. Vivasvat was the father of Yama, Yamī, Manu Vaivasvata and the twin Aśvins. His emblems are two lotuses, a trident, and a long garland.

v. Āditya(s).

Vṛddhi 'Growth', 'increase', personified as the wife of Kubera.

Vṛka 'Wolf', an animal associated with Śiva Bhairava and with Gaurī.[1]

[1]*ID*, p. 346.

Vṛkṣa A tree or its wood. Particular trees are associated with particular divinities: Agni with the *śamī*; Viṣṇu with the *uḍumbara*, *nyagrodha* and *aśvattha*; Śiva with the *bilva* and *bakula*, and so on. *Nāgas* and *yakṣas* are also closely connected with trees, and hence any large tree in a village or nearby is revered as a power which sustains the community.

The notion that a woman can conceive through eating the fruit of a tree is still current in some rural areas.

v. Araṇi; Pārijātā; Tulasī; Śālabhañjikā; Vṛkṣadevatā(s); Vṛkṣāsana.

Vṛkṣadevatā(s) Tree (*vṛkṣa*) goddesses were, like the snake deities of the forest tribes, taken over by brahmanism. In many respects the tree goddesses resemble *yakṣiṇīs*. Their characteristic stance is *śālabhañjikā*.

Vṛkṣāsana 'Tree (*vṛkṣa*) posture', in which a *yogin* stands on one leg with the sole of the other foot placed on the thigh.

Vṛṣabha 'Bull'.

v. Nandin; Vṛṣan.

Vṛṣabhadhvaja 'Bull banner (*dhvaja*)', emblematic of Śiva and Indra.

v. Vṛṣan; Vṛṣavāhana.

Vṛṣamastaka 'Bull (*vṛṣa*) headed'. Yama is sometimes depicted with a bull's head.

Vṛṣan or **Vṛṣā** A male animal, especially a bull, which symbolizes sexual power. Thus Śiva, the great *yogin*, stands by, or on a white bull, signifying that his power is so great that all sexual energy and desire have been sublimated. Indra is also associated with the bull which in this context signifies strength. A bull is also depicted on his banner (*dhvaja*). When associated with Rudra, a cobra and a bull, both known for their idleness and torpor, express his sorrowful and inert nature.[1]

To touch a bull's tail removes the pollution incurred by being in contact with a corpse.

The bull symbolizes *dharma*. Its four feet represent truth (*satya*), purity (*śauca*), compassion (*dayā*), and charity (*dāna*).

[1]Bhattacharya, *Indian Images*, pt i, p. 23.

v. Vṛsavāhana(mūrti).

Vṛsārūḍha 'Mounted on a bull (*vṛṣa*)'. A name of Śiva when mounted on his bull Nandin, and accompanied by Skanda and Pārvatī (Gaurī). Śiva holds an antelope and hatchet.

Vṛsāsana 'Bull (*vṛṣa*) throne', a seat or throne supported by Śiva's white bull Nandin.

Vṛsavāhana(mūrti) or **Vṛsabhārūḍha(mūrti)** Name of Śiva when standing by, or seated on, his bull mount (*vāhana*). When depicted beside the bull[1] one of Śiva's arms is bent (*kūrpara*) and rests on the animal. He may carry a crooked stick (*vakradaṇḍa*), a hatchet or axe, and an antelope, and may be portrayed with a *jaṭāmakuṭa*, a hanging *jaṭābhāra*, or a *jaṭābandha*. When accompanied by Pārvatī, she stands on his right, carries a *utpala* flower in her right hand, and her left arm hangs down gracefully by her side.

[1]Sometimes the figure of the bull is missing.

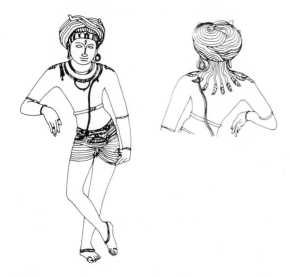

Vṛścika 'Scorpion'. A yogic position in which one left leg is lifted as high as, and touching, the forehead, a position which resembles the tail of a scorpion.

v. Vṛścikamālā.

Vṛścikamālā A garland (*mālā*) of scorpions which signifies poison, and hence Śiva Viṣapraharaṇamūrti as the destroyer of poison wears a scorpion-garland.

Vṛṣṇi A branch of the Yādava tribe to which Vāsudeva (Kṛṣṇa) belonged.

Vṛtra 'Obstacle', 'barrier'; the personified power of obstruction.[1]

Indra slew Vṛtra with an amulet made of *srāktya* wood (*AV*, VIII.5,3). After his death the personification of this crime of brahminicide, wearing a garland of skulls, emerged from the corpse and stuck fast to Indra 'like a spell' (*kṛtyā*).[2]

[1]From the root *vṛ* 'to hold back', 'restrain' (*SED*); see also Gonda, *Loka*, p. 21.

[2]Cf. the myth of Brahmā's skull adhering to Śiva's hand. See Brahmaśiraśchedakamūrti.

Vṛttakuṇḍala A round earring worn by Sukhāsana-mūrti and some other deities.

Vyāghracarma 'Tiger-skin'.

v. Ajina.

Vyāghraṇakha A necklace of tiger-claws emblematic of boyhood, and worn by Kārttikeya.

Vyāghrapāda 'Having tiger-feet'. Name of a youthful *ṛṣi* and devotee of Śiva. He holds a rosary and goad. His *mudrā* is *añjali*. His feet are those of a tiger.

Vyāhṛti(s) 'Utterance', 'declaration'. The *vyāhṛtis* represent the mystical names of the seven worlds: *bhur, bhuvar, svar, mahar, janar, tapar* and *satya*, and are personified as the daughters of Savitṛ and Pṛśnī.[1] The first three are the 'great *vyāhṛtis*', and are uttered after the *mantra OṀ* by every brahmin at the commencement of his daily prayers.

Prajāpati is the supreme divinity of the 'great *vyāhṛtis*'. Their individual deities are Agni, Vāyu and Sūrya respectively (*Bṛhadd.*, II. 123f).

[1]*SED*.

Vyākhyānadakṣiṇā(mūrti) An aspect of Śiva as the *yogi par excellence*, and expounder of the *śāstras* or sciences. He may be depicted seated in the *vīraśaiva* position under a banyan tree, or on a white lotus. He has three eyes and four arms. His front right hand is held in *jñānamudrā*, the front left in *varada* or *daṇḍa* pose. If the latter, his elbow rests on his left knee. The back right hand holds a rosary, the back left, fire, or a snake. His body is erect and rigid signifying his firm resolute will. His matted hair is ornamented with *dhattūra* flowers, a serpent, and a crescent moon. He wears earrings and other ornaments, a white sacred thread, and a *rudrākṣa* garland. His countenance is calm and meditative.

v. Vyākhyānamudrā.

Vyākhyānamudrā The gesture (*mudrā*) of explanation or teaching in which the tips of the index finger and the thumb are pressed together to form a circle, with the palm of the hand facing the spectator. The other fingers are stretched upwards.

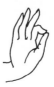

Vyakta An image which is either anthropomorphic, or partly theriomorphic in form.
v. Vyaktāvyakta.

Vyaktāvyakta An image 'which combines the characteristics of an adorned, sculptured form of an idol (*vyakta*) and a form not worked by human agency (as e.g. a *śālagrāma* or a *baṇaliṅga*: i.e., *avyakta*'.[1]

[1]*ID*, p. 348, citing Rao, *EHI*, I, p. 18; and see Coomaraswamy, *Transformation of Nature*, p. 168.

Vyālaka 'Horned lion'.

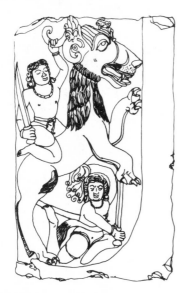

Vyālayajñopavīta or **Nāgayajñopavīta**. A sacred thread (*yajñopavīta*) formed from a snake and worn by Gaṇeśa.

Vyantaradevatā(s) or **Vyantara(s)** Folk-godlings worshipped by villagers and agriculturists. These godlings became associated with the major cult deities, especially Śiva, and are usually represented as attendant on him. Occasionally they are adversaries of the gods.

The Vyantaras include *rākṣasas*, *yakṣas*, *bhūtas*, *piśācas* and *gandharvas*.

Vyāsa or **Veda-Vyāsa** A general name in late post-Vedic times for an 'arranger, editor or compiler' of 'literary' compositions including the *Mahābhārata*, *Purāṇas* and the *Veda*.[1]

The *Viṣṇudharmottara* describes Vyāsa as of slender physique, black complexion, and wearing dark brown *jaṭās*. He should be accompanied by his four disciples. Vyāsa is regarded as an incarnation (*avatāra*) of Viṣṇu.

[1]Although the *Veda* had many 'arrangers' over the centuries.

Vyūha(s) Name of the four manifestations of Viṣṇu, viz: *vyūha* the emanatory; *vibhava* or *avatāra* the incarnatory; *antaryāmin*, the divine presence in all beings; and *vigrahaṇa*, the visible embodiment and expression of the divine. But this concept has been variously interpreted among Vaiṣṇavas. The absence of any *vyūhas* in the early Bhāgavata texts supports the view that they were a late development in Vaiṣṇava theology.[1]

The concept of the 'One in four' is described in cult treatises as 'caturvyūha' or 'Viṣṇu Caturmūrti', and represented iconographically as a four-faced and usually four-armed figure. The four faces are those of Vāsudeva (East), a lion-face representing Saṁkarṣaṇa (South), a boar face representing Pradyumna (North), and a demonic face representing Aniruddha (West). This body is 'the greatest in the universe and sustains the whole world'.[2] The *Viṣṇudharmottara* (III. ch. 85, verses 43ff.) calls this icon Vaikuṇṭha.

[1]V. M. Apte, in *HCIP*, II, p. 447.
[2]Bhattacharyya, *Iconology of Composite images*, p. 3.
v. Avatāra; Caturmūrti(s); Caturviṁśatimūrti(s).

Vyūhavada 'Manifestation or appearance' of a deity, 'especially of Viṣṇu which is not regarded as cultic in the same way as *avatāra*.'[1]

[1]*ID*, p. 349.
v. Vyūha(s).

Y

Yāga 'Offering', 'sacrifice'.
v. Yajña.

Yajña 'Sacrifice', 'oblation' offered to the gods. The offerings vary according to the purpose of the sacrifice. The sacrifice was predominantly magical, and the sacrificial instruments also shared in this magical power.[1] The Vedic sacrifice ensured the continuation of the cosmos and the welfare and prosperity of the community as well as identifying the individual and the group with the divine powers of nature. Without sacrifice the gods could not sustain the world, and hence they were invoked to attend the sacrifices. Gradually the sacrifice became more important than the deity to whom it was offered. 'The act itself acted.'[2]

In the *Brāhmaṇas* and *Sūtras* the solar Viṣṇu was the 'personal manifestation of the Sacrifice'; in the later cult of Viṣṇu, all his incarnations (*avatāras*) were connected with particular aspects of sacrifice,[3] which helped to turn this minor Vedic god into a major cult deity.

The *Vāyu* and *Padma Purāṇas* state that the sacrifice is symbolized by the boar which embodies the universe (*Bṛhad. Ār. Up.*, 1.1). Its various limbs represent the

limbs of the sacrifice. Its grunt corresponds to the Sāmaghoṣa and the four legs to the four Vedas; the tusk is the sacrificial post (*yūpa*); the tongue stands for *agni* (the sacrificial fire); its bristles, the sacred *darbha* grass; its head, the brahmin priests, its bowels the *udgātṛ* priest, and the genital organ the *hotṛ* the chief priest. The boar's eyes signify day and night; its ear ornaments, the Vedāṅgas; its bones constitute the *mantras*; its blood the *soma* juice, and so on.[4]

[1]*EBS*, p. 17; *HCIP*, I, p. 500.

[2]Organ, *Hindu Quest*, p. 33.

[3]*VS*, p. 80.

[4]*EHI*, I, pt i, pp. 144f.

v. Vedi; Yūpa; Varāhāvatāra; Yajña(mūrti); Yajñavarāha.

Yajñabhadra 'Skilful in sacrifice (*yajña*)'. Name of a door-keeper (*dvarapāla*) of Brahmā. His emblems are a rosary, staff and club.

Yajña(mūrti) or **Yajñeśa** or **Yajñeśvara** An incarnation (*avatāra*) of Viṣṇu, the personification and embodiment of ritual sacrifice. Yajña is depicted sometimes with the head of a deer. According to the *Vaikhānasāgama* he should have two heads, three legs, seven hands and four horns, and carry a conch, *cakra*, bowl of ghee (*ājyapātra*), and the three sacrificial spoons, the *sruk*, *sruva* and *juhū*. The Ṛgveda describes Yajña as a four-horned, two-headed bull. The four horns represent the four Vedas.[1]

Yajña was killed by Vīrabhadra and rose to the celestial sphere to become the constellation called the Deer's Head (Mṛgaśiras).

[1]*EHI*, I, pt i, p. 249 and note.

v. Yajña.

Yajña-Nārāyaṇa Viṣṇu (Nārāyaṇa) as the personification of the Sacrifice (*yajña*).

v. Yajñamūrti.

Yajñavarāha 'Sacrificial boar (*varāha*)'. The boar incarnation (*varāhāvatāra*) of Viṣṇu portrayed white and four-armed. Two hands carry a shell and discus. Yajñavarāha should be seated in *siṁhāsana*, with the right leg hanging down, the left resting on the seat. Lakṣmī and Bhūdevī should be seated to the right and left side of the deity respectively.

v. Yajña.

Yajñeśa or **Yajñeśvara** v. Yajñamūrti.

Yajñopavīta 'Sacred thread', conferred in an initiatory ceremony on all members of the three upper castes. It signifies the second birth, that is, spiritual birth. The thread is worn over the left shoulder and across the chest to hang down under the right arm. The date when the *yajñopavīta* was first represented in Indian sculpture is not known, but it appears in the Gupta and early Cāḷukya-Pallava period portrayed as a ribbon placed across the body in the usual manner and tied in front in a knot.[1]

The sacred thread usually consists of three cotton strings which symbolize the three *guṇas* or constituents of primordial matter. It also stands for control of thoughts, actions and desires, and to remind the wearer that throughout his life he lives under *dharma*. The thread is only worn by men, but gods and goddesses are depicted with it. It may consist of a snake, a deer-skin, or other materials.

[1]*EHI*, I, pt i, p. 23.

v. Upanayana.

Yajurveda The Veda of the Yajus. A manual for the guidance of the *adhvaryu* priest whose duties were concerned with the correct performance of the sacrifice. It consists of two closely connected but separate collections (*saṁhitās*), the *Taittirīya* or *Black Yajurveda*, and the *Vājasaneyi* or *White Yajurveda*.

v. Veda.

Yajus Mantras uttered in a particular manner during the performance of sacrifices.

v. Yajurveda.

Yakṣa[1] Formerly a designation of the world-creator, equivalent to the Cosmic Puruṣa or Prajāpati. Śiva, and some other gods, were frequently called *yakṣas*,[2] but later the term became the collective name of the mysterious godlings who frequent field, forest and jungle, and who play a large part in Indian folklore. Their worship stems from pre-Vedic days and they appear in Hindu, Jaina and Buddhist mythology, associated with trees (which are often depicted behind their figures), and with local hills or mountains (cf. the German *Rübezahl*).

Yakṣas embody the notion of plenty and power denoted by their powerful chests and slightly obese bodies, plumpness in the East being associated with wealth and wellbeing. They are attendant on Kubera, god of wealth.

In common with *kinnaras* and *daityas*, *yakṣas* are supernatural beings born of the *rajas* or revolving tendency, and are therefore aspects of the creator, Brahmā[3] because all rotatory movements are said to be creative.

[1]The etymology of *yakṣa* is uncertain. Daniélou (*HP*, p. 137) considers it to be derived from a Vedic word meaning 'mysterious' or 'marvellous'. The Pāli Text Society's Dictionary suggests 'quick ray of light'; or 'ghost' from *yakṣ*, 'to move quickly'. The Pāli Commentators derive it from *yaj*, 'to sacrifice'; Turner (*IAL*, 10395) suggests a 'supernatural being'.

[2]Coomaraswamy, *Yakṣas*, pt i, p. 12; *Principles*, Glossary, p. 259.

[3]*HP*, p. 301.

v. Mahāyogin; Kubera.

Yakṣī or **Yakṣiṇī** The feminine of *yakṣa*, and a name of Kubera's wife.

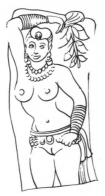

Yāḷi (Tamil) A fabulous lion-faced (leogryph) animal, sometimes portrayed in the ornamentation of temples and on the tops of *kīrttimukhas*.

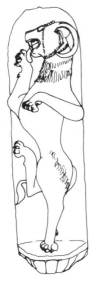

Yama The ruler and, later, the judge of the dead. The Vedic Yama is never regarded as a punisher of sins. He was the first man to die and therefore he conducts the dead to the realm of the ancestors (*pitṛs*). His celestial sphere (*yamaloka*) is the 'home of heroes' (*RV*, X. 14,1), situated in the South. His mount is a black buffalo, a form which he sometimes assumes.[1] His weapons are the club or mace (*gadā*) representing authority, and a noose (*pāśa*) with which he seizes his victims. He stands on a lotus which signifies all manifested forms which inevitably die and enter his realm.

Yama is described as of dark complexion resembling a rain-cloud. His eyes are red and tusks protrude from the corners of his mouth. He wears a *kirīṭamakuṭa*, red ornaments and a garland of red flowers. Sometimes he carries a sword and shield, or fruit and leaves. The personification of Death (Mṛtyu) stands at his side with terrifying face, and coloured a dazzling blue and red. Other beings may accompany him including two women holding fly-whisks, Citragupta, Kālī, *asuras* and *devas*, and good and bad people.[2]

The *Viṣṇudharmottara* states that Yama's garments should be yellow. His consort Dhūmornā sits on his left thigh, embraces him with one arm, and holds a pomegranate in the other. Citragupta stands on his right ready to record the acts of the mortals; on the left stands Time personified (Kāla) armed with a noose.

[1]Thus when represented anthropomorphically he is usually depicted with horns.

[2]*EHI*, II, pt ii, p. 526.

v. Mṛtyu; Saramā; Vaitaraṇī I; Vaivasvata; Yamī; Yamadaṇḍa.

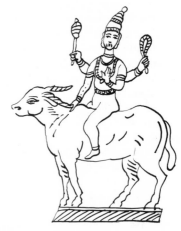

Yamadaṇḍa 'Yama's staff', a symbol of sovereign power.

v. Daṇḍa.

Yamalārjuna The two magic trees called *yamala* and *arjuna* respectively. They were personified as the enemies of the child Kṛṣṇa who uprooted them when they blocked his path.

Yamaloka 'The world or realm (*loka*) of Yama'.

Yamī Twin sister of Yama. She is sometimes identified with the river goddess Yamunā and included among the seven (or eight) Mothers (Saptamātaras). Her emblem is a skull-cup (*kapāla*).

Yamunā A name of the river Jumna, one of the tributaries of the Ganges. It is personified as a goddess of the same name and is mythically identified with Yamī, sister of Yama, ruler of the dead.

Yamunā and the river-goddess Gaṅgā are often depicted on the door-jambs of temples. Yamunā carries a water-pot, fly-whisk, and a blue lotus. A tortoise is

her mount, probably because the Jumna teems with tortoises.[1]

[1]Bhattacharya, *Indian Images*, pt i, p. 45.

v. Kūrma.

Yānaka-Narasiṁha A rare variety of Viṣṇu's *avatāra* Narasiṁha. This form may be represented either seated on the shoulders of Garuḍa, or on the coils of Ādiśeṣa. Yānaka is four-armed and wears many ornaments. Two of his hands carry a conch and discus. Above his head the five hoods of the snake Ādiśeṣa form a canopy.

Yantra A mystical or symbolic geometrical diagram indicating, in a synthetic form, the basic energies of the natural world which are represented by the deities.[1] *Yantras* are frequently used by Śāktas.

Yantras are employed as 'aids' to worship and meditation, and also as cosmographical ground-plans for temple architecture. Every measurement is determined by specific laws of proportion to put the 'structure in harmony with the mystical numerical basis of the universe and of time itself'.[2] The spiritual ascent of the worshipper is from the circumference inwards, the highest state being the centre.[3]

Although *yantras* are drawn on the flat, they must be conceived of as solid. They 'are the necessary basis for all attempts at symbolic representations, all sacred forms, all images, all sacred architecture, altars, temples, and ritual gestures. They are used in most kinds of worship, the deity being evoked by drawing its *yantra* and calling its subtle name.'[4]

A typical *yantra* is the *śrīcakrayantra* consisting of an outer frame indented on four sides to form a regular pattern. Inside the frame are concentric circles and stylized lotus petals surrounding a series of nine intersecting triangles,[5] the apexes of four pointing upwards (symbolizing the male principle), and five pointing downwards (the female principle) which represent 'the static and kinetic aspects of the Two-in-One'.[6] The central point (*bindu*) signifies the eternal, undifferentiated principle, *brahman*, or the polar axis seen from above. In Tantrism the *bindu* represents the point of concentration of all creative forces: the nine triangles 'signify the primitive revelation of the Absolute as it differentiates into graduated polarities, the creative activity of the cosmic male and female energies on successive stages of evolution'.[7] The Śaiva 'remover-of-desire' (*smarahara*) *yantra*, consists of five triangles, each representing a fiery *liṅga*, five being the number corresponding to the procreative and destructive principle. By the power of this *yantra* lust may be overcome. It is also used for black magic purposes. The king of *yantras* (*yantra-rāja*) is intended to create contacts with supranormal worlds. In its centre is the

mantra hrīṁ which stands for Lakṣmī, goddess of good fortune. The fiery triangle (*trikoṇa*) round *hrīṁ* attracts the coiled energy (*kuṇḍalinī*) represented by the circle; the eight lotus petals signify Viṣṇu, the all-pervading ascending tendency; the outer circle, the rotatory movement of which all things are born; the square, the earth; and the four gates leading from this world to the worlds beyond. The Viṣṇu *yantra* expresses the pervasiveness of truth and goodness, the ascending quality *sattva*.

Each deity has its own *yantra* in which it dwells during the ritual use of the *yantra* in meditation. The *mantras*, sometimes written on particular parts of a *yantra*, act as 'code words' to the initiated.

The mathematical relations underlying every work of art are important since each icon also fulfils the function of a *yantra* which serves as a means to attain realisation of the ultimate goal.[8]

Yantras may be engraved on thin pieces of gold, silver or copper and rolled into a cylinder shape, placed in a container (*yantrapātra*) and worn as amulets.

[1]*HP*, p. 350.

[2]Lannoy, *The Speaking Tree*, p. 21.

[3]*Myths*, p. 142; *Principles*, p. 25.

[4]*HP*, p. 350.

[5]Examples of symbolic genitalia appear in the fifth millennium BC. Mesopotamian temple-compounds (A. Parrot, *Ziggurate et Tour de Babel*, p. 167). Incised triangles representing the *yoni* are depicted on female figurines of al 'Ubaid which were 'to characterize the female clay figures of Western Asia in the Bronze Age' (Levy, *Gate of Horn*, p. 94).

[6]Coomaraswamy, *Transformation of Nature*, p. 168.

[7]*HP*, p. 147.

[8]Kramrisch, *Indian Sculpture*, p. 93.

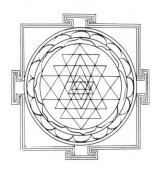

Yantrapātra A container or receptacle for a *yantra*.

Yantra-rāja v. Yantra.

Yāska The writer of a famous commentary on the *Nirukta*.

Yaśodā Name of the wife of the cowherd Nanda who lived on the banks of the Yamunā (Jumna) river. She

became the foster-mother of the infant Kṛṣṇa, who was placed in her care to prevent his murder by King Kaṃsa.

Yaśodā-Kṛṣṇa The *gopī* Yaśodā portrayed with the infant Kṛṣṇa.

Yātu or **Yātudhāna** A demonic spirit; the demonic power of evil spirits and sorcerers. The *yātus*, like the medieval Christian devil, had animal hoofs (*RV*, X.44.9; 87,12).

Yātus are sometimes identified with *yakṣas*, the mere sight of whom results in pestilence unless it is averted by the required expiatory rites.

Yāvīyāṅga Name of Sūrya's broad belt.

Yoga The 'act of yoking [to] another'. Physical and mental discipline and control of breath and of the other bodily functions designed to achieve enhanced states of consciousness. It is a curbing of the physical to advance the spiritual.

The ultimate goal of *yoga* is 'final concentration of the spirit and "escape" from the cosmos'.[1] There are many yogic techniques, based on the infinite variations of human nature, and hence its appeal is universal.[2] Although yogic techniques contain a number of archaisms, they also contain many insights into the psychology of perception.

The yogic ideal of the identity of opposites and the union of the self with the divine is represented in the icon of Śiva holding his consort Pārvatī on his knee. The *yogin* who is identified with all-pervading consciousness looks on all creatures and things equally and sees the self in all being and all beings in the self (*Bhagavadgītā*).

[1]Eliade, *Shamanism*, pp. 416f. Edgerton, *Beginnings of Indian Philosophy*, p. 37, n.1, stresses that *yoga* never means union with *brahman*; see also *IAL*, 10526, 10528–9. According to Patañjali the final goal is the total suppression of consciousness. 'Pure consciousness, absolutely free and unconditioned, ultimately replaces psychological self-analysis' (Lannoy, *The Speaking Tree*, p. 349).

[2]For the influence of *yoga* in Christian mysticism see Benz, *Indische Einflüsse*.

Yogabera v. Dhruvabera.

Yoga-Dakṣiṇā(mūrti) A four-armed form of Śiva as Dakṣiṇā the great teacher of *yoga*. He may be portrayed in *yogāsana* posture and holding a trident and skull-cup in his back hands. The front right hand is in *cinmudrā*, the front left in the pose characteristic of an expounder of the sciences, or he may be seated with one leg resting on the ground, the other raised and bent with the ankle resting on the thigh. A *yogapaṭṭa* supports the raised leg. His front right hand is in *yogamudrā*, the front left in *abhaya*. The back right hand holds a rosary, the left, fire (or a lotus flower). He is seated beneath his sacred tree the banyan (*vaṭa*). Below his seat two deer look upwards towards him, and a cobra below his right elbow looks towards him.

Yogandaṇḍa A staff or rod used by ascetics, and an emblem of Aiyaṉār.

Yogahasta v. Dhyāna(hasta)mudrā.

Yogamudrā v. Dhyānahastamudrā.

Yoga-Narasiṃha A yogic aspect of Narasiṃha, the man-lion incarnation (*avatāra*) of Viṣṇu. He is portrayed squatting (*utkuṭikāsana*) with a band to hold one or both knees in position (*yogapaṭṭa*).

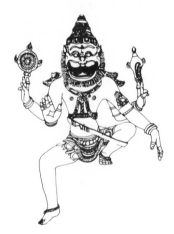

Yoganidrā 'Meditation-sleep'. A light form of 'sleep' peculiar to *yogins* which allows them to withdraw from the stimuli of the outer world, at the same time retaining full use of their mental powers. This 'sleep' is personified as a goddess of the same name. She is regarded as identical with the Bhairavīs and with Mahāmāyā.[1] Yoganidrā is also the term applied to Viṣṇu's sleep during the vast interval between cosmic periods.

The goddess may be portrayed as a beautiful woman asleep on a bed, with a drinking vessel nearby.[2]

[1]*Kālikā Purāṇa*, cited in *Iconog. Dacca*, pp. 193f.
[2]*EHI*, I, pt ii, p. 362.
v. Anantaśāyana.

Yogapaṭṭa or **Yogapaṭṭaka** A band used to bind and support both legs when a *yogin* is seated in meditative pose (*yogāsana*).

v. Ardhayogapaṭṭa.

Yogāsana A seat or throne;[1] and a yogic position (*āsana*) equivalent to *padmāsana*, assumed when meditation is practised and signifying 'transcendence'.[2] The *yogin* sits cross-legged with his hands laid on his lap, or on his knees.

[1]*EHI*, I, pt i, p. 19.
[2]*ID*, p. 354.

Yogāsana(mūrti) or **Yogeśvara-Viṣṇu** I. A seated figure of Viṣṇu with four arms, and white complexion. He is seated in *yogāsana* and wears a *jaṭāmakuṭa*. His front hands are in *yoga mudrā*. His emblems are a discus and conch. He wears earrings (*kuṇḍalas*), armlets (*keyūras*), and a necklace (*hāra*). His eyes should be slightly closed.[1]

[1]*EHI*, I, pt i, p. 86.

II. Name of a small image depicted on Viṣṇu's crown.

Yogaśāyana(mūrti) A yogic aspect of Viṣṇu portrayed two-armed and reclining. His head is slightly raised, the rest of the body lies flat on the coils of a serpent. Viṣṇu's right leg is stretched out, the left slightly bent. He wears various ornaments. His *mudrā* is *kaṭaka*. Bhṛgu and Mārkaṇḍeya are depicted nearby as well as the demons Madhu and Kaiṭabha. On the lotus emerging from Viṣṇu's navel, Brahmā is seated.

v. Anantaśāyana.

Yogasthānaka(mūrti) A yogic, four-armed form of Viṣṇu depicted standing. His emblems are a discus and a conch; his *mudrās*, the *abhaya*, *kaṭi* and *varada*.

Yogasūtra(s) A collection of *sūtras* traditionally attributed to Patañjali (second century BC).

Yogeśvara-Viṣṇu v. Yogāsana(mūrti).

Yogeśvara 'Lord of yoga'. An epithet applied to Śiva.

Yogeśvarī The terrific form of Cinmāyā Devī who represents the light of pure consciousness.[1] Yogeśvarī is depicted at Ellora (Cave XV) as a fearsome, emaciated woman, holding a sacrificial knife, and a blood-filled skull-cup. She should have ten hands and three eyes, and carry a spear, sword, and drum in three of her right hands. Nothing is mentioned concerning the remaining hands.[2]

Yogeśvarī is included among the Seven (or Eight) Mothers (Saptamātaras), and is also identified with Rakta-Cāmuṇḍā.[3]

[1]*Principles*, pp. 218; 220.
[2]*EHI*, I, pt ii, p. 365.
[3]*ID*, p. 354.

Yogī or **Yogin** One who practises *yoga*; a possessor of yogic spiritual powers. The true *yogin* finally achieves a state of unity where there is no longer any feeling of self as opposed to the not-self, and hence he loves all things and beings alike.

Yoginī I. A demoness or sorceress, or any woman possessing magical powers. Durgā created the *yoginīs* to attend her and Śiva. She herself is sometimes called Yoginī.

Originally there were eight *yoginīs*, and later as many as sixty-four. They were said to assume the form of village deities (*grāmadevatās*), or were minor epiphanies of Durgā. They represent deities of vegetation and destiny bringing death and destruction, or wealth. The forces of shamanistic magic and *yoga* are incarnated in them.[1]

The sixty-four *yoginīs* are often depicted together in temples and are also represented in *yantras*. Although the name *yoginī* suggests a meditative nature, their appearance is usually fierce and ugly.[2]

[1]Eliade, *Yoga*, pp. 343f; and see Coomaraswamy, *Yakṣas*, pt i, p. 9.
[2]Bhattacharya, *Indian Images*, pt i, p. 45; de Mallman, *Enseignements . . . de l'Agni Purāṇa*, pp. 169, 304.

II. A female protective deity associated with *śakti* worship and with the Bhairavas.

Yoni 'Female generative organs', 'vulva'. When depicted with the *linga* the two represent the cosmic Puruṣa and Prakṛti. Śiva and his *śakti* together also signify the *yoni* and the *linga*.[1] The lower part of the base and the middle are said to represent Brahmā and Viṣṇu respectively, and the *linga* itself, Śiva.

When the *yoni* is depicted alone it is referred to as a chalice or water-vessel. It is symbolized by a downward pointing triangle (*trikoṇa*),[2] or by a shell of the cowrie type.

Local village divinities (*grāmadevatās*) are regarded as manifestations of the great goddess. Their icons are 'simple stone images of the female organ of generation'.[3] Śāktas worship the *yoni* as an aspect of Śakti.

[1]*EHI*, II, pt i, p. 69. A *linga* and *yoni* icon placed in temples is felt to be a repository of power which benefits the community (Rawson, *Indian Sculpture*, p. 22).

[2]In old Sumerian script a downward pointing triangle means both 'vulva' and 'woman' (*ID*, p. 355).

[3]Eliade, *Yoga*, p. 349.

v. Yantra; Tantra; Ardhanārīśvara; Yonimudrā.

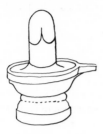

Yonimudrā A *mudrā* representing the vulva (*yoni*). The fingers are placed to form a triangle (*trikoṇa*) which symbolizes the *yoni*.

Yudhiṣṭhira The eldest of the five sons of King Pāṇḍu and Pṛthā (Kuntī). He led the Pāṇḍavas in the battle recounted in the Epic *Mahābhārata*.

Yuga I. An age of the world. There are four ages in each cycle of creation and they are called *kṛta* or *satya*, *tretā*, *dvāpara*, and *kali*. The first three periods have elapsed and we are now in the *kali* age, at the end of which Kālī, the black goddess of destruction, will destroy the world in a cosmic holocaust after which the cyclical process begins again. Thus all change is a process of perishing. After the first 'golden age', each age successively declines both in length and in the virtue of its inhabitants. Together the four *yugas* total 4,320,000 years which constitute a 'great yuga' (*mahā-yuga*).

v. Kalpa.

II. 'Pair' or 'couple'.

v. Maithuna.

Yukti 'Skill, accomplishment, or acquired facility'.

Yūpa 'Post', 'pillar', especially a sacrificial post or stake to which the victim is attached. Viṣṇu, who personifies the Sacrifice, is the deity of the *yūpa* (*Tait. Saṁ.*, VI.3.4,1ff.).

The post is extolled as 'evergreen, golden-hued, refulgent, thousand-branched (*RV*, IX.5,10), and represents the cosmic tree which is 'an intermediary between the divine world and earthly life'.[1] It also symbolizes, *inter alia*, the phallus, represented by a knob (*caṣāla*) on the top of the *yūpa* to which the sacrificial horse was tied during the horse sacrifice (*aśvamedha*).

Sometimes the post consisted of three stakes, either bound together, or tied at one end to form a tripod, but usually it was octagonal and likened to an eight-sided *vajra* which protects the sacrificers from enemies on all sides. The octagonal pillars, so common in Indian architecture, are probably derived from the eight-sided sacrificial post.

The base of the post was dedicated to the ancestors (*pitṛs*), from there to the middle, to men; the middle, to plants; above that to the Viśvedevas; and the top to Indra.[2]

[1]*Aspects*, pp. 81f.

[2]*DH*, under Yūpa. Different woods were used for the posts according to the purpose intended by the sacrificers.

v. Vedi; Yajña.

Bibliography

Agrawala, Vasudeva S., *Sparks from the Vedic Fire*, Varanasi, 1962.

Allchin, B. and R., *The Birth of Indian Civilization, India and Pakistan before 500 B.C.*, Harmondsworth, 1968.

Anand, M. R., *The Hindu View of Art*, London, 1957.

Anand, M. R. and S. Kramrish, *Homage to Khajuraho*, Marg Monograph, Bombay, 1960.

Archer, W. G., *Vertical Man: A Study in Primitive Indian Sculpture*, London, 1947.

Auboyer, J., *Le Irône et son symbolisme dans l'Inde ancienne*, Paris, 1949.

Auboyer, J., 'Moudrā et hasta ou le langage par signes', *Oriental Art*, III, pp. 153ff., 1951.

Auboyer, J., *Daily Life in Ancient India from 200 B.C. to 700 A.D.*, tr. S. M. Taylor, London, 1965.

Auboyer, J., *Les Arts de l'Inde*, Paris, 1968.

Auboyer, J., 'Kajurāho' in *Encyclopaedia Universalis*, Paris, 1971.

Auboyer, J., and de Mallman, M. T., 'Śītalā la Froide', *Artibus Asiae*, XIII, 1950.

Autran, Charles, *L'Épopée Indoue*, Paris, 1946.

Avalon, Arthur, v. Woodroffe, S. J.

Bachhofer, L., *Early Indian Sculpture*, New York, 1929.

Banerjea, J. N., (ed. and tr.), *Pratimālakṣaṇam*, Calcutta, 1932.

Banerjea, J. N., 'Some Folk Goddesses of Ancient and Mediaeval India', *IHQ*, XIV, 1938.

Banerjea, J. N., 'Lakulīśa, the Founder or Systematiser of the Pāśupata Order', in *Proceedings of the Jaipur Session of the Indian Historical Congress*, 1951.

Banerjea, J. N., *The Development of Hindu Iconography*, 2nd edn., Calcutta, 1956.

Banerjea, J. N., *Paurānic and Tantric Religion*, Calcutta, 1966.

Barua, B. K., Kālikā Purāṇa on 'Iconographic Representations of some Śākta Goddesses and their Worship in Medieval Assam', in Professor P. K. Gode's Commemoration volume, Poona, 1960.

Basham, A. L., *The Wonder that was India*, London, 1954.

Benz, E., *Indische Einflüsse auf die frühchristliche Theologie*, Wiesbaden.

Bhandarkar, R. G., *Vaiṣṇavism, Śaivism and Minor Religious Systems*, Strasburg, 1913; repr. 1965.

Bharati, Agehananda, *The Tantric Tradition*, London, 1965.

Bhattacharji, S., *The Indian Theogony*, Cambridge, 1970.

Bhattacharya, Brindavan C., *Indian Images*, pt I, The Brahmanic Iconography, Calcutta, 1921.

Bhattacharyya, Benoytosh, *The Indian Buddhist Iconography*, Oxford, 1924.

Bhattacharyya, D. C., *Iconology of Composite Images*, New Delhi, 1980.

Bhattacharyya, T., *The Canons of Indian Art*, 2nd edn., Calcutta, 1963.

Bhattasali, N. K., *Iconography of Buddhist and Brahmanical Sculptures in the Dacca Museum*, Dacca, 1929.

Bhishgratna, K. K. L., (tr. and ed.), *The Suśruta Samhitā*, 3 vols, 2nd edn., Varanasi, 1963.

Blair, Chauncey J., *Heat in the Rig Veda and Atharva Veda*, American Oriental Series, vol. 45, New Haven, 1961.

Boner, Alice, *Principles of Composition in Hindu Sculpture*, Leiden, 1962.

Bosch, F. D. K., 'The god with the Horse's Head', in *Selected Studies in Indonesian Archaeology*.

Bosch, F. D. K., *The Golden Germ: An Introduction to Indian Symbolism*, The Hague, 1960.

Bose, N. K., *Canons of Orissan Architecture*, Calcutta, 1933.

Bose, P. N., *Principles of Indian Śilpaśāstra*, Punjab Oriental Series XI, Lahore, 1926.

Bose, P. N., *Pratimā-Māna-Lakṣaṇam*, Punjab Oriental Series, XVIII, Lahore, 1929.

Bowes, Pratima, *The Hindu Religious Tradition*, London, 1977.

Brough, J., *The Early Brahmanical System of Gotra and Pravara*, Cambridge, 1953.

Brown, C. Mackenzie, *God as Mother – Feminine Theology in India*, Hartford, 1974.

Brown, W. Norman, 'Class and Cultural Traditions in India' in *Traditional India; Structure and Change*, American Folklore Society, Special Series, X, Philadelphia, 1959.

Campbell, J., *Masks of God*, II, London, 1962.

Capra, F., *The Tao of Physics*, Wildwood House, 1975. Reprint Fontana, 1976.

Chandra, M., *Stone Sculpture in the Prince of Wales Museum*, Bombay, 1974.

Combaz, Gisbert, 'L'Évolution du stūpa en Asie', *Mélanges chinois et bouddhiques*, Brussels, 4 vols, 1932–6.

Bibliography

Coomaraswamy, A. K., *The Aims of Indian Art*, Broad Campden, 1908.

Coomaraswamy, A. K., *History of Indian and Indonesian Art*, London, 1927, repr. New York, 1965.

Coomaraswamy, A. K., *The Indian Craftsman*, London, 1909.

Coomaraswamy, A. K., *The Mirror of Gesture*, Harvard, 1917, 2nd edn., New Delhi, 1970.

Coomaraswamy, A. K., Citra-lakṣaṇa (*Śilparatna*, ch. 64), in Sir Ashutosh Mukerjee Memorial vol., Patna, 1926ff.

Coomaraswamy, A. K., 'The Old Indian Vīṇā', *JAOS*, vol. 51, 1928.

Coomaraswamy, A. K., *Yakṣas*, 2 vols, Washington, 1928, repr., 1931, 1971.

Coomaraswamy, A. K., 'Viṣṇudharmottara' (III), *JAOS*, 52, 1932.

Coomaraswamy, A. K., *The Transference of Nature in Indian Art*, Harvard, 1934; repr. New York, 1956.

Coomaraswamy, A. K., *Artibus Asiae* (1928–9), pp. 122f.

Crooke, William, *Things Indian*, London, 1906.

Daniélou, Alain, *Yoga: The Method of Re-Integration*, London, 1949.

Daniélou, Alain, *L'Érotisme divinisé*, Paris, 1962.

Daniélou, Alain, *Hindu Polytheism*, London, 1963.

de Mallmann, M. T., *Les Enseignements iconographiques de l'Agni Purāṇa*, Paris, 1963.

Dhaky, M. A., 'The Nandi Images of Tamilnadu and Kannadanadu', *Artibus Asiae*, Ascona, vol. XXXIV.

Dhavalikar, M. K., *Masterpieces of Indian Terracottas*, Bombay, 1977.

Diehl, C. G., *Instrument and Purpose: Studies on Rites and Rituals in South India*, Lund, 1956.

Dowson, John, *A Classical Dictionary of Hindu Mythology*, London, 1928, repr. 1979.

Edgerton, F., *The Beginnings of Indian Philosophy*, London, 1965.

Eggeling, Julius, *The Śatapatha Brāhmaṇa*, 5 vols. Sacred Books of the East Series. Reprint 1966. Varanasi.

Eliade, Mircea, *The Myth of the Eternal Return* (tr. W. R. Trask), New York, 1954.

Eliade, Mircea, *Patterns in Comparative Religion* (tr. Rosemary Sheed), London, 1958.

Eliade, Mircea, *Yoga: Immortality and Freedom* (tr. W. R. Trask), London, 1964.

Eliade, Mircea, *Shamanism: Archaic Techniques of Ecstasy* (tr. W. R. Trask), London, 1964.

Eliade, Mircea, *From Primitives to Zen*, London, 1967.

Eliade, Mircea, *A History of Religious Ideas*, I, London, 1979.

Elwin, Verrier, *Tribal Art of Middle India*, Oxford, 1951.

Fabri, C. F., 'Mesopotamian and Early Indian Art: Comparisons', in *Études d'orientalisme*, published by the Musée Guimet in memory of Raymonde Linossier, vol. I, Paris, 1932.

Farnell, L. R., *The Cults of the Greek States*, 5 vols, Oxford, 1896–1909.

Filliozat, J., 'Les images d'un jeu de Śiva a Khajuraho', *Artibus Asiae*, Ascona, vol. XXIV.

Gangoly, O. C., 'Maithuna', *Rūpam*, 1925.

Ghosh, Manomohan (tr.) *The Nāṭyaśāstra*, Royal Asiatic Society, Bengal, 1952.

Gnoli, R., *The Aesthetic Experience according to Abhinavagupta*, Istituto per il Medio ed Estremo Oriente, Rome, 1956.

Goetz, Hermann, *India: Five Thousand Years of Indian Art*, London, 1969.

Gonda, J., *Change and Continuity in Indian Religion*, The Hague, 1965.

Gonda, J., *Loka: World and Heaven in the Veda*, Amsterdam, 1966.

Gonda, J., *Aspects of Early Viṣṇuism*, Utrecht, 1954; 2nd edn Delhi, 1969.

Gonda, J., *Viṣṇuism and Śivaism: A Comparison*, London, 1970.

Gonda, J., *Some Observations on the Relations between 'Gods' and 'Powers'* Hawthorne, NY, 1957.

Griffith, R. T. H. (tr.), *The Hymns of the Rgveda*, 2 vols, Varanasi, 1963.

Gulik, R. H. van, *Hayagrīva: The Mantrayānic Aspect of Horse-Cult in China and Japan*, Leiden, 1935.

Gupta, S. B., *The Roots of Indian Art*, 1980.

Haldar, R., 'The Oedipus Wish in Iconography', *Indian Journal of Psychology*, vol. XIII, no. 1, Calcutta, 1938.

Harle, J. C., *Temple Gateways in South India*, Oxford, 1963.

Hartman, C. G., *Aspects de la déese Kālī dans son culte et dans la littérature indienne*, Helsinki, 1969.

Hastings, James (ed.), *Encyclopaedia of Religion and Ethics*, 13 vols, Edinburgh 1908–21. Reprinted in 1960s.

Heesterman, J. C., *The Ancient Indian Royal Consecration*, Disputationes Rheno-Trajectinae, The Hague, 1957.

Heimann, Betty, *Indian and Western Philosophy: A Study in Contrasts*, London, 1937.

Heimann, Betty, *The Significance of Prefixes in Sanskrit Philosophical Terminology*, RAS Monographs, vol. XXV, 1951.

Heimann, Betty, *Facets of Indian Thought*, London, 1964.

Hendley, T. Holbein, *Indian Jewellery*, London, 1909.

Hertz, Robert, *Death and the Right Hand*, tr. R. and C. Needham, London, 1960.

Hinnells, J. R. and Sharpe, E. J., *Hinduism*, Newcastle-on-Tyne, 1972.

Hopkins, E. W., *Epic Mythology*, repr. Varanasi, 1968.

Hume, R. E. (tr.), *The Thirteen Principal Upanishads*, London, 1921.

Ippel, A., *Indische Kunst und Triumphalbild*, Leipzig, 1929.

Joshi, N. P., *Catalogue of the Brahmanical Images in the State Museum*, Lucknow, 1972.

Jung, C. G., (ed.), *Man and His Symbols*, Aldus, London, 1964.

Keith, A. B., *The Veda of the Black Yajus School entitled Taittirīya*, HOS, 2 vols, 1914, repr 1967.

Kennedy, Melville T., *The Chaitanya Movement*, Calcutta, 1925.

Kirfel, W., *Symbolik des Hinduismus*, Stuttgart, 1959.

Kosambi, D. D., *The Culture and Civilization of Ancient India in Historical Outline*, 1965, repr. 1969.

Kramrisch, Stella, *Viṣṇudharmottara*, part translated with notes, Calcutta, 2nd edn. 1928.

Kramrisch, Stella, 'Pāla and Sena Sculpture', *Rūpam*, 1929.

Kramrisch, Stella, *The Hindu Temple*, 2 vols, Calcutta, 1946; repr. Delhi, 1976.

Kramrisch, Stella, *Indian Sculpture*, Philadelphia, 1960.

Kramrisch, Stella, *The Banner of Indra in Art and Thought*, in honour of A. K. Coomaraswamy, London, 1947.

Lancaster, University of, *Image and Iconography East and West*, Lancaster Religious Colloquia, 1977.

Lannoy, Richard, *The Speaking Tree*, Oxford, 1971; repr. 1975.

Laufer, B., *Dokumente der indischen Kunst I. Das Citralakṣaṇa*, Leipzig, 1913.

Law, B. C., *Tribes in Ancient India*, Calcutta, 1920, reprint Poona, 1943.

Levy, G. R., *The Gate of Horn*, London, 1953.

Liebert, Gösta, *Iconographic Dictionary of the Indian Religions*, Leiden, 1976.

Lorenzen, D. N., *The Kāpālikas and the Kālāmukhas*, Australian National University, Centre of Oriental Studies, Oriental monograph series, vol. XII.

Macdonell, A. A., 'The History of Hindu Iconography', *Rūpam*, 1930.

Macdonell, A. A. (tr.), *Bṛhaddevatā*, HOS, vols V and VI, 1904. 2nd issue Delhi, 1965.

Mackay, E., 'Sumerian Connections with Ancient India', *JRAS*, 1925.

Majumdar, R. C. (Gen. ed), *The History and Culture of the Indian People*, Bombay, repr. 1960.

Marshall, John, *et al.*, *Mohenjo-daro and the Indus Civilization*, 3 vols, London, 1931.

Meyer, John Jacob, *Trilogie altindischer Mächte und Feste der Vegetation*, Zürich and Leipzig, 3 vols in 1, 1937.

Mirashi, V. V., 'The Śaiva Ācāryas of the Māttamayūra Clan', *IHQ*, XXVI, no. 1, 1950.

Monier-Williams, M., *Brahmanism and Hinduism*, London, 1891.

Monier-Williams, M., *Sanskrit–English Dictionary*, rev. edn, Oxford, 1899.

Mookerjee, Ajit, *Tantra Art: its Philosophy and Physics*, New Delhi, 1967.

Mukerjee, Radhakamal, *The Cosmic Art of India*, Bombay, 1965.

Mukerji, S. C., *Le Rasa, Essai sur l'esthétique indienne*, Paris, 1928.

O'Flaherty, W. D., 'The Submarine Mare in the Mythology of Śiva', *JRAS*, no. 1, 1971.

Organ, Troy Wilson, *The Hindu Quest for the Perfection of Man*, Ohio State Univ., 1970.

Payne, E. A., *The Śāktas: An Introductory Comparative Study*, Calcutta, 1933.

Poduval, R. K., Administration Report of the Archaeological Department, Travancore State, 1107ME, 1930.

Poduval, R. V., *Kathākala and Diagram of Hand Poses*, Trivandrum, 1930.

Potter, Karl H., *Presuppositions of India's Philosophies*, Englewood Cliffs, NY, 1963, repr. 1972.

Radhakrishnan, S. (ed.), *History of Philosophy: Eastern and Western*, 2 vols, London, 1952–3.

Radhakrishnan, S., and C. A. Moore (eds), *A Sourcebook in Indian Philosophy*, Princeton, 1957.

Rahurkar, V. G., *The Seers of the Ṛgveda*, Poona, 1964.

Rao, T. A. G., 'Tālamāna', Memoirs of the Archaeological Survey of India, 3, Calcutta, 1920.

Rao, T. A. G., *Elements of Hindu Iconography*, 4 vols, Madras, 1914–16; repr. 1968, 4 vols in 2.

Rapson, E. J., *The Cambridge History of India*, 6 vols, 1922–

Rawson, Philip, *Music and Dance in Indian Art*, Edinburgh Festival Committee, 1963.

Bibliography

Rawson, Philip, *Indian Sculpture*, London, 1966.

Rawson, Philip, *The Art of Tantra*, London, 1973.

Renou, L., and J. Filliozat, *L'Inde classique*, 2 vols, Paris, 1947–53.

Reymond, E. A. E., *The Mythological Origin of the Egyptian Temple*, Manchester, 1969.

Rogers, B., 'An Archaeological Pilgrimage to Santiago de Compostela', *Science*, vol. 131, 1180.

Roy, J. C., 'Food and Drink in Ancient India', *Man in India*, vol. XIII.

Roy, P. C., *The Mahābhārata*, (tr.) 2nd edn. 12 vols, Calcutta, N.D.

Roy, U. N., *Śālabhañjikā in Art, Philosophy and Literature*, 1979.

Sahi, Jyoti, *The Child and the Serpent: Reflections on Popular Indian Symbols*, London, 1980.

Saraswati, S. K., *A Survey of Indian Sculpture*, Calcutta, 1957.

Sarkar, B. K. (tr.), *The Sukranīti*, Sacred Books of the Hindus, vol. xiii, 1914.

Sarup, Lakshman, *The Nighaṇṭu and the Nirukta* (text tr. and notes), 2nd repr. Delhi, 1967.

Sastri, H. K., *South Indian Images of Gods and Goddesses*, Madras, 1916.

Shah, S. Idries, *Oriental Magic*, London, 1968.

Sharma, B. N., *Iconographic Parallelism in India and Nepal*, Hyderabad, 1975.

Shastri, M. D., 'History of the word Īśvara and its Idea', All India Oriental Conference, VII, Baroda.

Shastri, M. N. D., (tr.) *Agni Purāṇam*, 2 vols, Varanasi, 1967.

Shukla, D. N., *Vastu Shastra*, vol. II, Hindu Canons of Iconography and Painting, Punjab University, 1958.

Singer, Milton (ed.), *Krishna: Myths, Rites and Attitudes*, Honolulu, 1966.

Singh, S. B., *Brahmanical Icons in Northern India*, New Delhi, 1977.

Singh, S. B., *Dakṣiṇāmūrti Sculptures in Uttar Pradesh*, Vishveshvaranand Indological Journal, XIV, pp. 107–11.

Sivaramamurti, C., 'Parallels and Opposites in Indian Iconography', *Journal Asiatic Soc. Letters, Calcutta*, XXI, 2, 1955.

Sivaramamurti, C., *Indian Sculpture*, New Delhi, 1961.

Sivaramamurti, C., *South Indian Paintings*, New Delhi, 1968.

Sivaramamurti, C., *The Art of India*, New York, 1977.

Sivaramamurti, C., *Approach to Nature in Indian Art and Thought*, 1979.

Sivaramamurti, C., *Naṭarāja in Literature, Art and Thought*, New Delhi, 1974.

Sivaramamurti, C., 'Geographical and Chronological Factors in Indian Iconography', *Ancient India*, no. 6, New Delhi, 1952.

Sivaramamurti, C., (tr.), *Śatarudrīya: Vibhūti of Siva's Iconography*, New Delhi, 1976.

Stutley, M. and J., *A Dictionary of Hinduism*, London, 1977.

Stutley, M., *Ancient Indian Magic and Folklore*, London, 1980.

Tagore, A., 'Indian Iconography', *Modern Review*, March 1914.

Tagore, A., *L'Alpona*, Paris, 1921.

Tagore, A., *Art et anatomie hindoue*, Paris, 1921.

Tewari, S. P., *Hindu Iconography*, New Delhi, 1979.

Thapar, D. R., *Icons in Bronze*, London, 1961.

Tucci, Guiseppe, *Tibetan Painted Scrolls*, Rome, 1949.

Tucci, Guiseppe, 'Earth in India and Tibet', in *Spirit and Nature*, Eranos Yearbook, vol. XXII, Princeton, 1953.

Tucci, Guiseppe, *The Theory and Practice of the Maṇḍala*, London, 1961; repr. 1969.

Turner, R. L., *A Comparative Dictionary of the Indo-Āryan Languages*, London, 1969.

van Lohuizen-de Leeuw, J. E., *Indian Sculpture in the von der Heydt Collection*, Museum Rietberg, Zürich, 1964.

Venkata, Rao, 'Aesthetics in India', *Aryan Path*, IV, pp. 715ff., 1933.

Viennot, O., *Les Divinités fluviales Gaṅgā et Yamunā aux portes des sanctuaires de l'Inde*, Paris, 1944.

Vogel, J. Ph., *Catalogue of the Archaeological Museum of Mathura*, Allahabad, 1910.

Vogel, J. Ph., 'The Woman and Tree, or Śālabhañjikā in Indian Literature and Art', *Acta Orientalia*, VII, 1929.

Vogel, J. Ph., 'Le Makara dans la sculpture de l'Inde', *Revue des Arts Asiatiques*, 1930.

Vogel, J. Ph., *The Goose in Indian Religion and Art*, Leiden, 1962.

Volwahsen, Andreas, *Living Architecture: Indian*, London, 1969.

Wasson, R. G., *Soma, Divine Mushroom of Immortality*, Ethno-Mycological Studies I, 1968; repr. London, 1971.

Watters, Thomas, *On Yüan Chwang's Travels in India AD 629–645*, ed. T. W. Rhys Davids and S. W. Bushell, 1904–5, 2 vols, repr. 1962.

Whitney, W. D. (tr.), *Atharva-Veda Saṁhitā*, Cambridge (Mass) 1905, repr. Delhi, 1962.

Heimann, Betty, *The Significance of Prefixes in Sanskrit Philosophical Terminology*, RAS Monographs, vol. XXV, 1951.

Heimann, Betty, *Facets of Indian Thought*, London, 1964.

Hendley, T. Holbein, *Indian Jewellery*, London, 1909.

Hertz, Robert, *Death and the Right Hand*, tr. R. and C. Needham, London, 1960.

Hinnells, J. R. and Sharpe, E. J., *Hinduism*, Newcastle-on-Tyne, 1972.

Hopkins, E. W., *Epic Mythology*, repr. Varanasi, 1968.

Hume, R. E. (tr.), *The Thirteen Principal Upanishads*, London, 1921.

Ippel, A., *Indische Kunst und Triumphalbild*, Leipzig, 1929.

Joshi, N. P., *Catalogue of the Brahmanical Images in the State Museum*, Lucknow, 1972.

Jung, C. G., (ed.), *Man and His Symbols*, Aldus, London, 1964.

Keith, A. B., *The Veda of the Black Yajus School entitled Taittirīya*, HOS, 2 vols, 1914, repr 1967.

Kennedy, Melville T., *The Chaitanya Movement*, Calcutta, 1925.

Kirfel, W., *Symbolik des Hinduismus*, Stuttgart, 1959.

Kosambi, D. D., *The Culture and Civilization of Ancient India in Historical Outline*, 1965, repr. 1969.

Kramrisch, Stella, *Viṣṇudharmottara*, part translated with notes, Calcutta, 2nd edn. 1928.

Kramrisch, Stella, 'Pāla and Sena Sculpture', *Rūpam*, 1929.

Kramrisch, Stella, *The Hindu Temple*, 2 vols, Calcutta, 1946; repr. Delhi, 1976.

Kramrisch, Stella, *Indian Sculpture*, Philadelphia, 1960.

Kramrisch, Stella, *The Banner of Indra in Art and Thought*, in honour of A. K. Coomaraswamy, London, 1947.

Lancaster, University of, *Image and Iconography East and West*, Lancaster Religious Colloquia, 1977.

Lannoy, Richard, *The Speaking Tree*, Oxford, 1971; repr. 1975.

Laufer, B., *Dokumente der indischen Kunst I. Das Citralakṣaṇa*, Leipzig, 1913.

Law, B. C., *Tribes in Ancient India*, Calcutta, 1920, reprint Poona, 1943.

Levy, G. R., *The Gate of Horn*, London, 1953.

Liebert, Gösta, *Iconographic Dictionary of the Indian Religions*, Leiden, 1976.

Lorenzen, D. N., *The Kāpālikas and the Kālāmukhas*, Australian National University, Centre of Oriental Studies, Oriental monograph series, vol. XII.

Macdonell, A. A., 'The History of Hindu Iconography', *Rūpam*, 1930.

Macdonell, A. A. (tr.), *Bṛhaddevatā*, HOS, vols V and VI, 1904. 2nd issue Delhi, 1965.

Mackay, E., 'Sumerian Connections with Ancient India', *JRAS*, 1925.

Majumdar, R. C. (Gen. ed), *The History and Culture of the Indian People*, Bombay, repr. 1960.

Marshall, John, *et al.*, *Mohenjo-daro and the Indus Civilization*, 3 vols, London, 1931.

Meyer, John Jacob, *Trilogie altindischer Mächte und Feste der Vegetation*, Zürich and Leipzig, 3 vols in 1, 1937.

Mirashi, V. V., 'The Śaiva Ācāryas of the Māttamayūra Clan', *IHQ*, XXVI, no. 1, 1950.

Monier-Williams, M., *Brahmanism and Hinduism*, London, 1891.

Monier-Williams, M., *Sanskrit–English Dictionary*, rev. edn, Oxford, 1899.

Mookerjee, Ajit, *Tantra Art: its Philosophy and Physics*, New Delhi, 1967.

Mukerjee, Radhakamal, *The Cosmic Art of India*, Bombay, 1965.

Mukerji, S. C., *Le Rasa, Essai sur l'esthétique indienne*, Paris, 1928.

O'Flaherty, W. D., 'The Submarine Mare in the Mythology of Śiva', *JRAS*, no. 1, 1971.

Organ, Troy Wilson, *The Hindu Quest for the Perfection of Man*, Ohio State Univ., 1970.

Payne, E. A., *The Śāktas: An Introductory Comparative Study*, Calcutta, 1933.

Poduval, R. K., Administration Report of the Archaeological Department, Travancore State, 1107ME, 1930.

Poduval, R. V., *Kathākala and Diagram of Hand Poses*, Trivandrum, 1930.

Potter, Karl H., *Presuppositions of India's Philosophies*, Englewood Cliffs, NY, 1963, repr. 1972.

Radhakrishnan, S. (ed.), *History of Philosophy: Eastern and Western*, 2 vols, London, 1952–3.

Radhakrishnan, S., and C. A. Moore (eds), *A Sourcebook in Indian Philosophy*, Princeton, 1957.

Rahurkar, V. G., *The Seers of the Ṛgveda*, Poona, 1964.

Rao, T. A. G., 'Tālamāna', Memoirs of the Archaeological Survey of India, 3, Calcutta, 1920.

Rao, T. A. G., *Elements of Hindu Iconography*, 4 vols, Madras, 1914–16; repr. 1968, 4 vols in 2.

Rapson, E. J., *The Cambridge History of India*, 6 vols, 1922–

Rawson, Philip, *Music and Dance in Indian Art*, Edinburgh Festival Committee, 1963.

Bibliography

Rawson, Philip, *Indian Sculpture*, London, 1966.

Rawson, Philip, *The Art of Tantra*, London, 1973.

Renou, L., and J. Filliozat, *L'Inde classique*, 2 vols, Paris, 1947–53.

Reymond, E. A. E., *The Mythological Origin of the Egyptian Temple*, Manchester, 1969.

Rogers, B., 'An Archaeological Pilgrimage to Santiago de Compostela', *Science*, vol. 131, 1180.

Roy, J. C., 'Food and Drink in Ancient India', *Man in India*, vol. XIII.

Roy, P. C., *The Mahābhārata*, (tr.) 2nd edn. 12 vols, Calcutta, N.D.

Roy, U. N., *Śālabhañjikā in Art, Philosophy and Literature*, 1979.

Sahi, Jyoti, *The Child and the Serpent: Reflections on Popular Indian Symbols*, London, 1980.

Saraswati, S. K., *A Survey of Indian Sculpture*, Calcutta, 1957.

Sarkar, B. K. (tr.), *The Sukranīti*, Sacred Books of the Hindus, vol. xiii, 1914.

Sarup, Lakshman, *The Nighan̞tu and the Nirukta* (text tr. and notes), 2nd repr. Delhi, 1967.

Sastri, H. K., *South Indian Images of Gods and Goddesses*, Madras, 1916.

Shah, S. Idries, *Oriental Magic*, London, 1968.

Sharma, B. N., *Iconographic Parallelism in India and Nepal*, Hyderabad, 1975.

Shastri, M. D., 'History of the word Īśvara and its Idea', All India Oriental Conference, VII, Baroda.

Shastri, M. N. D., (tr.) *Agni Purāṇam*, 2 vols, Varanasi, 1967.

Shukla, D. N., *Vastu Shastra*, vol. II, Hindu Canons of Iconography and Painting, Punjab University, 1958.

Singer, Milton (ed.), *Krishna: Myths, Rites and Attitudes*, Honolulu, 1966.

Singh, S. B., *Brahmanical Icons in Northern India*, New Delhi, 1977.

Singh, S. B., *Dakṣiṇāmūrti Sculptures in Uttar Pradesh*, Vishveshvaranand Indological Journal, XIV, pp. 107–11.

Sivaramamurti, C., 'Parallels and Opposites in Indian Iconography', *Journal Asiatic Soc. Letters, Calcutta*, XXI, 2, 1955.

Sivaramamurti, C., *Indian Sculpture*, New Delhi, 1961.

Sivaramamurti, C., *South Indian Paintings*, New Delhi, 1968.

Sivaramamurti, C., *The Art of India*, New York, 1977.

Sivaramamurti, C., *Approach to Nature in Indian Art and Thought*, 1979.

Sivaramamurti, C., *Naṭarāja in Literature, Art and Thought*, New Delhi, 1974.

Sivaramamurti, C., 'Geographical and Chronological Factors in Indian Iconography', *Ancient India*, no. 6, New Delhi, 1952.

Sivaramamurti, C., (tr.), *Śatarudrīya: Vibhūti of Siva's Iconography*, New Delhi, 1976.

Stutley, M. and J., *A Dictionary of Hinduism*, London, 1977.

Stutley, M., *Ancient Indian Magic and Folklore*, London, 1980.

Tagore, A., 'Indian Iconography', *Modern Review*, March 1914.

Tagore, A., *L'Alpona*, Paris, 1921.

Tagore, A., *Art et anatomie hindoue*, Paris, 1921.

Tewari, S. P., *Hindu Iconography*, New Delhi, 1979.

Thapar, D. R., *Icons in Bronze*, London, 1961.

Tucci, Guiseppe, *Tibetan Painted Scrolls*, Rome, 1949.

Tucci, Guiseppe, 'Earth in India and Tibet', in *Spirit and Nature*, Eranos Yearbook, vol. XXII, Princeton, 1953.

Tucci, Guiseppe, *The Theory and Practice of the Maṇḍala*, London, 1961; repr. 1969.

Turner, R. L., *A Comparative Dictionary of the Indo-Āryan Languages*, London, 1969.

van Lohuizen-de Leeuw, J. E., *Indian Sculpture in the von der Heydt Collection*, Museum Rietberg, Zürich, 1964.

Venkata, Rao, 'Aesthetics in India', *Aryan Path*, IV, pp. 715ff., 1933.

Viennot, O., *Les Divinités fluviales Gaṅgā et Yamunā aux portes des sanctuaires de l'Inde*, Paris, 1944.

Vogel, J. Ph., *Catalogue of the Archaeological Museum of Mathura*, Allahabad, 1910.

Vogel, J. Ph., 'The Woman and Tree, or Śālabhañjikā in Indian Literature and Art', *Acta Orientalia*, VII, 1929.

Vogel, J. Ph., 'Le Makara dans la sculpture de l'Inde', *Revue des Arts Asiatiques*, 1930.

Vogel, J. Ph., *The Goose in Indian Religion and Art*, Leiden, 1962.

Volwahsen, Andreas, *Living Architecture: Indian*, London, 1969.

Wasson, R. G., *Soma, Divine Mushroom of Immortality*, Ethno-Mycological Studies I, 1968; repr. London, 1971.

Watters, Thomas, *On Yüan Chwang's Travels in India AD 629–645*, ed. T. W. Rhys Davids and S. W. Bushell, 1904–5, 2 vols, repr. 1962.

Whitney, W. D. (tr.), *Atharva-Veda Saṁhitā*, Cambridge (Mass) 1905, repr. Delhi, 1962.

Wikander, Stig, *Feuerpriester in Kleinasien und Iran*, Lund, 1946.

Wilson, H. H., *The Vishnu Purāna*, London, 1840, 1888; Calcutta, 1961.

Woodroffe, S. J. (Arthur Avalon) 'Psychology of Hindu Religious Ritual', *Indian Art and Letters*, I, 1925.

Woodroffe, S. J., 'The Indian Magna Mater', *Indian Art and Letters*, II, 1926.

Woodroffe, S. J., *The Serpent Power*, 3rd edn, Madras, 1931.

Woodroffe, S. J., *Hymns to the Goddess*, 2nd edn, Madras, 1953.

Zimmer, Heinrich, 'Some Aspects of Time in Indian Art', *Journal Indian Soc. of Oriental Art*, I, pp. 30ff., 1933.

Zimmer, Heinrich, *The Art of Indian Asia*, completed and ed. J. Campbell, 2 vols, New York, 1955.

Zimmer, Heinrich, *Myths and Symbols in Indian Art and Civilization*, ed. J. Campbell, New York, 1946; repr. 1972.

DATE DUE

DEMCO 38-297